VAN GOGH

VAN GOGH

A RETROSPECTIVE

Edited by Susan Alyson Stein

BEAUX ARTS EDITIONS

ISBN: 0-88363-310-8

Elizabeth du Quesne-Van Gogh, *Vincent van Gogh: Persoonlijke Herinneringen Aangaande een Kunstenaar*, Baarn, 1910.

The Complete Letters of Vincent van Gogh, reprinted by permission of Little, Brown and Company/ Graphic Society Books.

M. J. Brusse, "Onder de Menschen: Vincent van Gogh als Boekverkopersbediene," *Nieuwe Rotterdamsche Courant*, May 26, June 2, 1914.

Dr. M. B. Mendes da Costa, "Persoonlijke herinneringen aan Vincent van Gogh," *Het Handelsblad*, December 2, 1910.

Louis Piérard, *La vie tragique de Vincent van Gogh* © Editions Labor, Brussels, 1939.

Anton C. Kerssemakers, "Herinneringen aan Vincent van Gogh," *De Amsterdammer: Weekblad voor Nederland*, April 14, 1912.

Museeumjournaal, Journal of the Rijksmuseum, Amsterdam © 1969, 1970.

Walter Pach, *Letters to an Artist*, translated from the Dutch by Rela van Messel. English translation © 1936 by the Viking Press, Inc. Copyright renewed © 1964 by the Viking Press, Inc. Reprinted by permission of Viking Penguin, Inc.

Louis Piérard, "Van Gogh à Anvers," *Les Marges* 13, January 1914.

Verzamelde Brieven van Vincent van Gogh, 1954: Richard Baseleer Reminiscences, © Vincent van Gogh Foundation/Rijksmuseum Vincent van Gogh, Amsterdam.

François Gauzi, *Lautrec et son Temps* © 1954 by David Perret et Cie, Paris.

A. S. Hartrick, *A Painter's Pilgrimage through Fifty Years* © 1939 by and reprinted with permission of Cambridge University Press, New York.

Florent Fels, *Vincent van Gogh* © 1928 by Henry Floury, Editeur, Paris.

Paul Gachet, *Lettres Impressionnistes* © 1957 by Editions Bernard Grasset, Paris.

Max Osborn. *Der Bunte Spiegel*, © Verlag Frederich Krause, New York, 1945.

Gustave Coquiot, *Vincent van Gogh* © 1923 by Librairie Ollendorf, Paris.

Emile Bernard, *Lettres de Vincent van gogh à Emile Bernard*, Ambroise Vollard, Publisher, Paris, 1911.

Emile Bernard, "Julien Tanguy," *Mercure de France*, November 1908.

Gaston Lesaulx, "Tanguy," *Le Memorial Artistique*, February 17, 1894.

Charles Morice, "Paul Gauguin," *Mercure de France*, October 1903.

Trublot, *Cri du Peuple*, September 7, 1887.

Andries Bonger, "Letteren en Kunst: Vincent," *Nieuwe Rotterdamsche Courant*, September 5, 1893.

Gauguin og Van Gogh: Kobenhavn i 1893 © 1984 by Ordrupgaard Samlingen, Copenhagen. By permission of H. P. Rohde.

"Lau's Dodge Macknight," Archives of American Art.

Pierre Weiller, "Nous avons retrouvé le Zouave de Van Gogh," *Lettres Françaises*, March 24–31, 1955.

Paul Gauguin, "Natures Mortes," *Essais d'Art Libre*, January 4, 1894, E. Girard, Editeur, Paris.

Forum Républicain, December 30, 1888.

Max Braumann, "Bei Freunden Van Goghs in Arles," *Kunst und Künstler* XXVI © 1928 by Verlag von Bruno Cassirer, Berlin.

Marc Edo Tralbaut, "L'Heure de verité," *Van Goghiana* X, P. Péré, Antwerp, 1975 © 1974 by Mark Edo Tralbaut and Pierre Péré.

Victor Doiteau and Edgard Leroy, *La Folie de Vincent van Gogh* © 1928 by Editions Aesculape, Paris.

Gustave Kahn, "Peinture: Expositions des Indépendants," *La Revue indépendante*, April 18, 1888.

Luc le Flaneur, "En Quête de Chose d'Art," *Le Moderniste*, April 13, and May 11, 1889, G.-Albert Aurier, Paris.

Félix Fénéon, "Salon des Indépandants, Paris, 1889," *La Vogue*, September 1889.

G.-Albert Aurier, "Les isolés: Vincent van Gogh," *Mercure de France*, January 1, 1890.

G.-Albert Aurier, *L'Art Moderne*, January 19, 1890.

S. P., "Catalogue de l'Exposition des XX," *Art et Critique*, February 1, 1890, S. Imbert, Paris.

Georges Lecomte, *Art et Critique*, March 29, 1890, S. Imbert, Paris.

Julien Leclercq, "Beaux-Arts aux Indépendants," *Mercure de France*, May 1890.

A. H., "Les XX," *La Wallonie*, no. 5, 1890.

A. Bredius, "Herinneringen aan Vincent van Gogh," *Oud-Holland* LI, no. 1 © 1934 by J. H. de Bussy, Amsterdam.

Adeline Ravoux Carrié, "Les Souvenirs d'Adeline Ravoux sur le séjour de Vincent van Gogh à Auvers-sur-Oise," *Les Cahiers de Van Gogh* I © 1957 by Pierre Cailler, Lausanne.

L'Echo Pontoisien, August 7, 1890.

Emile Bernard, "L'Enterrement de Vincent van Gogh," *Art Documents*, February 1953 © Pierre Cailler, Lausanne.

Octave Mirbeau, "Le Père Tanguy," *Des artistes*, February 1894. Ernest Flammarion, Paris.

Douglas Cooper, *Paul Gauguin: 45 Lettres à Vincent, Theo et Jo Van Gogh* © 1983 by Vincent van Gogh Foundation/Rijksmuseum Vincent van Gogh, Amsterdam.

Paul Gachet, *Deux Amis des Impressionnistes—Le Docteur Gachet et Murer* © 1956 by Editions des Musées Nationaux, Paris.

Maurice Malingue, *Lettres de Gauguin à Sa Femme et à Ses Amis* © 1946 by Editions Bernard Grasset, Paris.

Maurice Joyant, *Henri de Toulouse-Lautrec*, H. Floury, Editeur, Paris, 1927.

Julien Leclercq, "Vincent van Gogh," *Mercure de France*, December 1890.

Frederik van Eeden, "Vincent van Gogh," *De Nieuwe Gids*, December 1, 1890, W. Versluys, Amsterdam.

Maurice Beaubourg, *La Revue indépendante*, July 30, 1890.

Johan de Meester, *De Nederlandsche Spectator*, March 1891.

José Hennebicq, "Les XX," *Les Jeunes*, 1891.

Gustave Lagye, "Chronique des Beaux-Arts, Le Salon des XX," 1891.

Ernest Closson, "Peinture Symbolique," *Impartial Bruxelles*, March 22, 1891.

George Lecomte, *L'art dans les deux mondes*, March 28, 1891, Le Figaro, Paris.

Octave Mirbeau, "Vincent van Gogh," *Echo de Paris*, March 31, 1891.

Emile Verhaeren, *L'Art Moderne*, April 5, 1891.

Eugène Tardieu, "Salon des Indépendants," *Le Magazine Français Illustré*, April 25, 1891.

Jules Antoine, "Critique d'Art, Pavillons de la Ville de Paris, Expositions des Artistes Indépendants," *La Plume*, May 1, 1891.

Tonio, "Notes et Souvenirs: Vincent van Gogh," *La Butte*, May 21, 1891.

Emile Bernard, "Vincent van Gogh," *La Plume*, September 1, 1891.

Emile Bernard, "Vincent van Gogh," *Les Hommes d'Aujourd'hui* VIII, no. 390, 1891, Mercure de France, Paris.

Johan Rohde, *Den Frie Udstilling: Journal fra en Rejse i 1892*. Courtesy of H. P. Rohde.

Cecilia Waern, "Some Notes on French Impressionism," *Atlantic Monthly*, April 1892.

Francis, "Exposition Van Gogh," *La Vie Moderne*, April 24, 1892.

Camille Mauclair, "Galerie le Barc de Boutteville," *La Revue indépendante* 23, 1892.

Charles Saunier, "Vincent van Gogh," *L'Endehors*, April 24, 1892.

Charles Merki, "Apologie pour le Peintre," *Mercure de France*, June 1893.

August Vermeylen, ed., *Van Nu En Straks*, August 1893.

Ambroise Vollara, *Recollections of a Picture Dealer*, translated by Violet M. MacDonald. By permission of Little, Brown and Company.

Jean Renoir, *Renoir, My Father*, Little, Brown and Company © 1958, 1962 by Jean Renoir.

Leon Daudet, *L'Action Française*, December 8, 1926.

Julien Leclercq, *Exposition d'Oeuvres de Vincent van Gogh*, March 15–31, 1901, Bernheim Jeune, Paris.

Hugo von Hofmannsthal, *Die Prosaischen Schriften Gesammelt*, 1920. By permission of S. Fischer Verlag GmbH, Frankfurt am Main.

Maurice Vlaminck, *Portraits avant décès* © 1943 by Flammarion, Paris.

Julius Meier-Graefe, *Entwickelungsgeschichte der Modernen Kunst*, Stuttgart, 1904.

August Endell, "Vincent van Gogh," *Freistatt*, June 17, 1905.

Felix Klee, ed., *The Diaries of Paul Klee, 1898–1918* III (Munich 1908, p. 224; Munich 1911, pp. 259–60) © 1964 by The Regents of the University of California Press.

Kenneth C. Lindsay and Peter Vergo, eds., *Kandinsky: Complete Writings on Art* © G. K. Hall, Boston, 1982.

Maurice Denis, "De Gauguin et de van Goghs au Classicisme," *L'Occident*, 1909 © L. Rouart et J. Watelin, Editeurs, Paris.

Walter Sickert, "Post-Impressionists," *The Fortnightly Review*, January 2, 1911. By kind permission of Contemporary Review Company, incorporating *The Fortnightly Review*.

Kenyon Cox, "The 'Modern' Spirit in Art," *Harper's Weekly* LVII, March 1913.

Wilhelm Trübner, "Van Gogh und die Neuen Richtungen der Malerei," *Die Kunst für Alle* XXX, F. Bruckmann, A.-G., Munich, 1915.

Kasimir Malevich, *Essays on Art 1915–1933* I © 1968 by Borgens Forlag A-S.

Guy Pene du Bois, "Vincent and the Family Heirlooms," *Art and Decoration*, November 1920 © Joseph A. Judd Publishing Company, New York.

Theo van Doesburg, translated by Joost Baligeu © 1974 by Joost Balijeu. Reprinted with permission of Macmillan Publishing Company.

The Memoirs of Oliver Brown, Evelyn, Adams & Mackay Ltd., London © 1968 by Monica and Nicholas Brown.

Roger Fry, "Monthly Chronicle: Vincent van Gogh," *Burlington Magazine*, December 1923.

Hans Purrmann, "Van Gogh und Wir," *Kunst und Künstler* XXVI, Verlag von Bruno Cassirer, Berlin, 1928.

John Sloan, *Gist of Art* © 1939 by American Artists Group, Inc., New York.

David, Marussia, and Nicholas Burliuk, "Our Editorial: Why Van Gogh?" *Color and Rhyme*, New York, 1950–51; "Our Travel to Europe," *Color and Rhyme*, New York, 1950–51. Courtesy of Mr. and Mrs. Nicholas Burliuk.

Georges Rouault, Charley Toorop, and Jan Sluyters, *1853/1953 Vincent van Gogh*, Rijksmuseum Kröller-Müller and Stedelijk Museum, 1953. Courtesy of Stedelijk Museum, Amsterdam, Rijksmuseum Kröller-Müller, Otterlo, and authors.

Oskar Kokoschka, "Van Gogh's Influence on Modern Painting" © 1986 by Cosmopress, Geneva.

René Magritte, "Van Gogh et la Liberté" © 1955 by *Cahier de Nevelulek-Van Gogh*, Antwerp.

Françoise Gilot and Carlton Lake, *Life with Picasso* © 1964 McGraw-Hill Book Company, New York.

In memory of my father,

Alfred E. Stein (1928–1980)

ACKNOWLEDGMENTS

This book owes its existence to the coordinated efforts of many people to whom I extend my thanks. First, the researchers, Marie Therese Berger, Patricia Berman, Linda Glass, Ellen Konowitz, Karl Johns, and Ann Levy, and the translators, Rebecca Anderson, Ellen Ducat, Alexandra Bonfante-Warren, Hallberg Hallmundsson, Nadine Orenstein, and Thomas Spear, were indispensable in preparing the text material. For documentary and photo material, I am grateful to Mr. and Mrs. Nicholas Burliuk, Ay-Wang Hsia of Wildenstein and Co., Inc. (New York), Drs. M. M. Op de Coul of the Rijksbureau, Voor Kunsthistorische, Documentatie (The Hague), Sharon Schultz of Sotheby's (New York), Mr. Graham Mason of Orbis Publishing, Ltd. (London), and the staff of The Watson Library, The Metropolitan Museum.

Special thanks go to the Rijksmuseum Vincent van Gogh and the Vincent van Gogh Foundation (Amsterdam), Dr. Han van Crimpen, Curator, and Mrs. A. M. Daalder-Vos, Rights and Reproductions, and to the Rijksmuseum Kröller-Müller (Otterlo), Dr. Johannes van der Wolk, Curator, and Ms. Nab-van Wakeren.

In the creation and editing of the manuscript and throughout the production process, the talents of Michael Harkavy, Maria Chiarino, and Dale Ramsey of Harkavy Publishing Service were invaluable to me. Likewise, I am grateful to the designer, Philip Grushkin and to the typesetter, A&S Graphics. Hugh L. Levin and Ellin Yassky of Hugh Lauter Levin Associates deserve great credit and my sincere thanks.

I am especially grateful to Charles F. Stuckey, from whose example and encouragement this book has greatly profitted, and to Bogomila Welsh-Ovcharov, who generously provided documentation and material, as did Kenneth C. Lindsay, with whom I had the great fortune to study. I also thank my colleagues at The Metropolitan Museum, particularly Gary Tinterow and Anne Norton, for their invaluable support and Philippe de Montebello, Director, who kindly allowed me to undertake the project. My warmest thanks go to my family, upon whom I've relied in countless ways, and especially to my husband, Robert D. Burwasser, in many respects a collaborator, for without his support from the start— and patience, good humor, and always sound advice throughout—this book would not have been possible.

SUSAN ALYSON STEIN

CONTENTS

CHRONOLOGY

1853
30 MARCH. Vincent Willem van Gogh born in Groot-Zundert, the Netherlands, the eldest son of Reverend Theodorus van Gogh (1822–1885) and Anna Cornelia Carbentus (1819–1907).

1857
1 MAY. Birth of his brother Theodorus. Among his siblings—three sisters, Anna Cornelia (1855–1930), Elizabeth Huberta (1859–1936), and Wilhelmien Jacoba (1862–1941), Theo, and another brother, Cornelius Vincent (1867–1900)—Theo was closest to Vincent.

1864
OCTOBER. Attends the boarding school of Jan Provily at Zevenbergen until the summer of 1866.

1866
SEPTEMBER. Attends the state Secondary School King Willem II at Tilburg until March 1868.

1868
MARCH. Returns to his parents' home in Zundert.

1869
SUMMER. Leaves Zundert. Works as a junior clerk for the art firm of Goupil and Co. in The Hague.

1873
LATE MAY. Transferred to the London branch of Goupil's.
AUGUST. Finds lodgings with Mrs. Sarah Ursula Loyer and falls in love with her daughter, Eugénie (b. 1854).

1874
JUNE–JULY. Learns Eugénie is engaged; spends three weeks with his family in Holland.
OCTOBER–DECEMBER. Temporarily transferred, against his will, to Goupil's branch in Paris.

1875
JANUARY. Returns to the London branch of Goupil's.
MID-MAY. Permanently assigned to Goupil's Paris branch.

1876
31 MARCH. Discharged from Goupil's; leaves for England.
APRIL–JUNE. Spends two months in Ramsgate as a teacher (of elementary French, German, arithmetic) at the school of William Port Stokes (1832?–1890).
JULY–DECEMBER. Takes a teaching position at a boys' school run by Reverend T. Slade Jones (1829–1883) in Isleworth, where he also works in the parish and preaches occasionally.

1877
JANUARY–APRIL. Works at a bookshop run by the firm of Blussé and Van Braam in Dordrecht; finds lodgings at the home of the Rijkens, merchants of corn and flour, in Tolbrugstraatje.
MAY. In Amsterdam, prepares for entrance examinations to the faculty of theology at the university; stays with his uncle Jan (Johannes van Gogh, 1817–1885), a widower, then Commandant of the Navy Yard, later, Vice-Admiral.

1878
JULY. Abandons theological studies; enrolls in a preparatory course for evangelists in Brussels.

AUGUST–NOVEMBER. After three-month trial period at the mission school in Laeken, fails to qualify and returns to his parents' home, now in Etten.
26 DECEMBER. Leaves for the Borinage, the coal-mining district of Belgium, where he begins missionary work in Pâturages.

1879
JANUARY. Serves as mission preacher in Wasmes until his dismissal in July.
AUGUST. Continues missionary work, on his own, in Cuesmes until August 1880.

1880
AUGUST. Abandons evangelical work. Begins to draw with serious ambitions of becoming an artist.
FALL. Leaves the Borinage for Brussels.
Seeks advice from the painters Willem Roelofs (1822–1897) and Anthon G. A. Ridder van Rappard (1858–1892).
Takes steps to enter the Académie des Beaux-Arts.

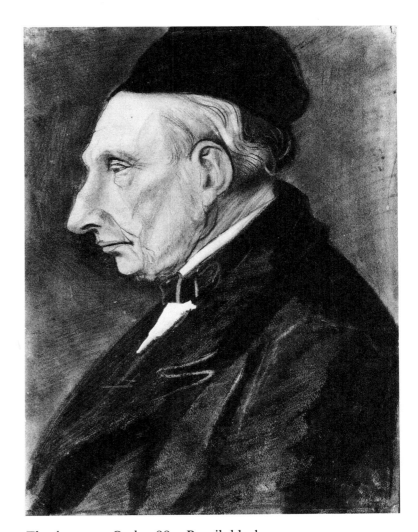

Theodorus van Gogh. 1881. Pencil, black ink, and wash, heightened with white. 13 × 9⅞″ (33 × 25 cm). Collection Mrs. A. R. N. Nieuwenhuizen Segaar, The Hague.

1881

APRIL. Returns to Etten.

SUMMER. Meets and later falls in love with his widowed cousin, Kee Vos Stricker; she rejects his affections.

FALL–WINTER. Visits The Hague, where he receives instruction from his cousin, the noted Hague school painter of peasant life, Anton Mauve (1838–1888). Meets artists Theophile de Bock (1851–1904) and Johannes Bosboom (1817–1891).

1882

JANUARY. Moves into a small studio at 138 Schenkweg in The Hague, where he lives with a prostitute, then pregnant, Clasina Maria Hoornik ("Sien"), and her five-year-old daughter.

FEBRUARY–MARCH. Paints street scenes, sometimes in the company of the painter George Hendrik Breitner (1857–1923).

Receives his first commission, a series of twelve drawings of city views, from his uncle, art dealer Cornelius Marinus ("C. M.") van Gogh (1824–1908).

APRIL. Receives a second commission from C. M. for six detailed views.

Complete break with Mauve following differences that had erupted by January.

JUNE. Undergoes treatment for venereal disease at the Municipal Hospital on the Brouwersgracht.

2 JULY. Sien has her second child. They move to larger quarters, next door, at 136 Schenkweg.

SUMMER. Begins painting in oils.

NOVEMBER. Experiments with lithography.

DECEMBER. Considers finding employment as an illustrator, possibly in England.

1883

Enjoys contacts with other artists working in The Hague: H. J. van der Weele (1852–1930), J. H. Weissenbruch (1824–1903), Hans-Olaf Heyerdahl (1857–1913), Willem Nakken (1835–1926), Otto Eerelman (1839–1926), Paulus van der Velden (1837–1915), and B. J. Blommers (1845–1914).

SEPTEMBER–DECEMBER. Breaks with Sien. Leaves The Hague for Drenthe, where he stays until December, living first in the village of Hoogeveen, and then, Nieuw-Amsterdam.

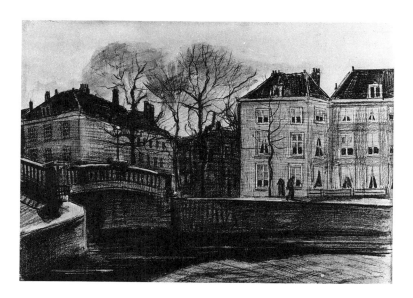

Bridge near the Herengracht. 1882. Pencil and ink wash, heightened with white. 9½ × 13⅜″ (24 × 33.5 cm). Rijksmuseum Vincent van Gogh, Amsterdam.

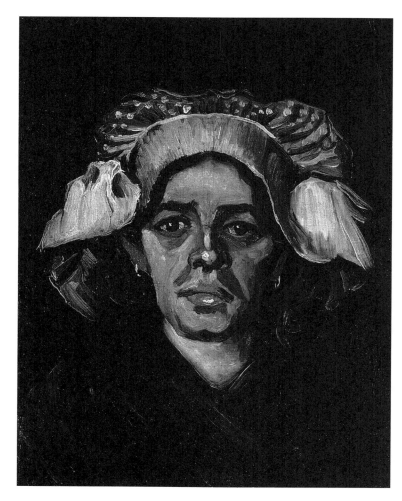

Head of a Peasant Woman. 1885. Canvas on panel. 17¾ × 14⅛″ (45 × 36 cm). Rijksmuseum Vincent van Gogh, Amsterdam.

DECEMBER. Returns to his parents' home, now in Nuenen, where he remains for the next two years.

1884

MAY. Rents a studio from the sexton of the Roman Catholic church. Ten-day visit from Van Rappard.

AUGUST. Begins working on a commission for a decorative scheme for the dining room of a retired goldsmith, named Hermans, in Eindhoven.

SEPTEMBER. Love affair with an older woman who lives next door, Margo Begemann, leads to scandal and her attempted suicide.

OCTOBER. Ten-day visit from Van Rappard.

NOVEMBER. Begins giving painting lessons to three people in Eindhoven: Hermans; Willem de Wakker, a postal worker; and Anton C. Kerssemakers (1846–1926), a tanner and amateur artist who becomes a close friend.

1885

26 MARCH. Father dies.

1 MAY. Takes up residence at his studio.

His work receives some attention in Paris; endeavors to enlist the support of French painter Charles-Emmanuel Serret (1824–1900) and dealer Arsène Portier (d. 1902).

AUGUST. A paint dealer, Leurs, agrees to exhibit some of his work in two shop windows in his store on the Molenstraat in The Hague.

OCTOBER. Three-day visit to Amsterdam to study the paint-

ings in the Rijksmuseum; especially admires Rembrandt and Hals.

LATE NOVEMBER. Leaves for Antwerp. Rents a room over a paint shop on 194 (now 224), rue des Images, which he decorates with Japanese prints.

1886

JANUARY. Enrolls at the Academy at Antwerp on the 18th. Studies painting and drawing under Charles Verlat (1824–1890) and Eugène Sieberdt (1851–1931). Meets fellow students Victor Hageman (1868–1938), H. M. Levens (1862–1936), and Richard Baseleer (b. 1867). At night, works from live models.

CA. 28 FEBRUARY. Arrives in Paris, where he meets his brother Theo, a dealer in Barbizon and Impressionist paintings for the firm of Boussod & Valadon (Goupil's successors), at the Louvre.

Moves into Theo's apartment at 25, rue Laval (now rue Victor-Massé).

SPRING AND/OR FALL. Studies at the atelier of Fernand-Anne Piestre, called Cormon (1845–1924). Works from models and plaster casts. Meets fellow students Louis Anquetin (1861–1932), Henri de Toulouse-Lautrec (1864–1901), and John Russell (1858–1931).

Abandons somber palette; experiments with complementary colors.

SUMMER. Moves with Theo to 54, rue Lepic in Montmartre.

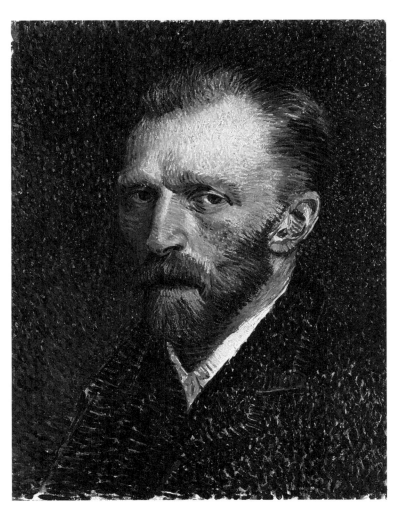

Self-Portrait. 1887. Cardboard. 16½ × 13¼" (42 × 34 cm). The Art Institute of Chicago; Winterbotham Collection.

Recovers from dental operation and stomach problems.

The art dealer Portier takes four paintings on commission; introduces Vincent to Armand Guillaumin (1841–1927).

Friendship with Camille Pissarro (1831–1903); meets his son, Lucien (1863–1944).

FALL. Proposes, unsuccessfully, an exchange of works with Charles Angrand (1854–1926).

Meets the Scottish artist A. S. Hartrick (1864–1950) at John Russell's studio.

Frequents the shop of Julien "père" Tanguy (1825–1894) at 14, rue Clauzel, where he meets Emile Bernard (1868–1941); they exchange paintings in commemoration of their first meeting.

Meets, possibly, Paul Gauguin (1848–1903)—but perhaps not until the fall of 1887.

LATE DECEMBER. Theo falls ill.

1887

JANUARY–FEBRUARY. Meets Paul Signac (1863–1935).

Receives two portrait commissions from Tanguy.

Frequents the shop of Samuel Bing, a dealer in oriental art, from whom he purchases many Japanese prints.

FEBRUARY–MARCH. Organizes an exhibition of Japanese prints at the café Le Tambourin, a cabaret owned by a former artist's model, Agostina Segatori, at 62, boulevard de Clichy.

Meets Scottish art dealer Alexander Reid (1854–1928).

SPRING. Painting outings with Signac along the banks of the Seine at Asnières and St. Ouen.

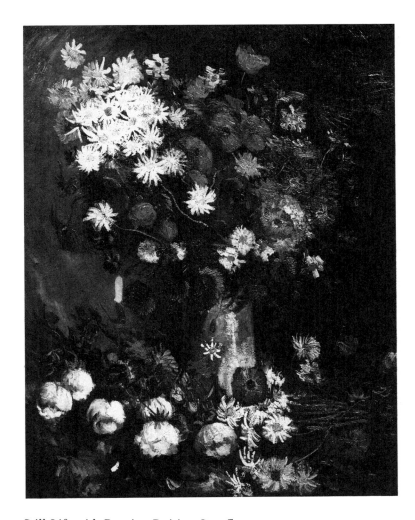

Still Life with Poppies, Daisies, Cornflowers, and Peonies. 1886. Canvas. 39 × 31⅛" (99 × 79 cm). Rijksmuseum Kröller-Müller, Otterlo.

SUMMER–FALL. Paints with Bernard at Asnières.

NOVEMBER–DECEMBER. Organizes a group exhibition of the "Petit Boulevard," including a number of his own paintings and those of Bernard, Anquetin, Lautrec, A. H. Koning (1860–1944), and possibly Guillaumin, at the Grand Bouillon-Restaurant du Chalet, 43, avenue du Clichy.

Meets Georges Seurat (1859–1891).

Along with Seurat and Signac, accepts invitation of André Antoine (1858–1943) to hang their paintings in the "salle de répétition" of the newly founded Théâtre Libre, 96, rue Blanche.

1888

19 FEBRUARY. Before leaving Paris, visits Seurat's studio with Theo.

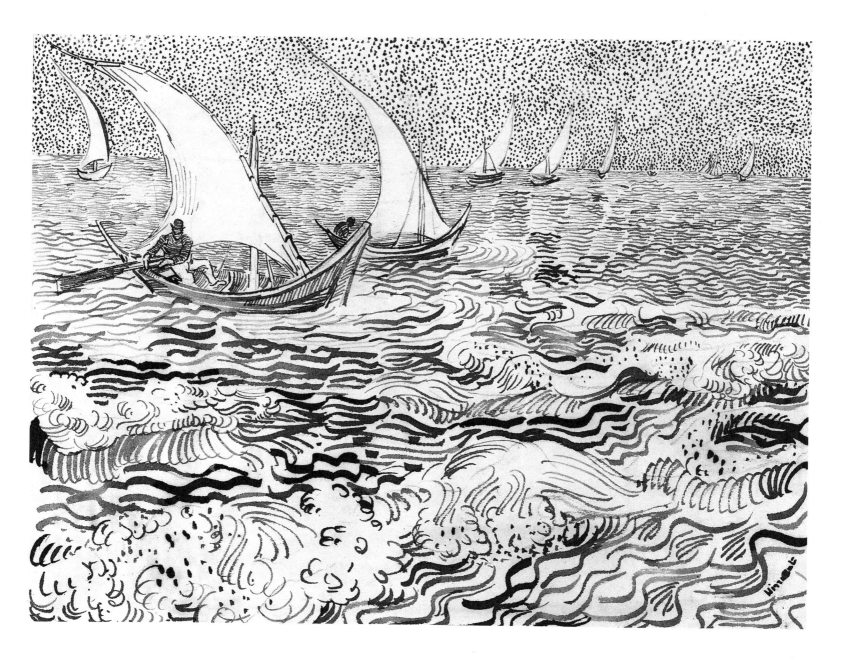

Seascape at Saintes-Maries. 1888. Reed pen and ink. 9½ × 12⅝" (24 × 31.5 cm). Musée d'Art Moderne, Musées Royaux des Beaux-Arts de Belgique, Brussels. Photograph: A. C. L.

Public Garden with Van Gogh's House in the Background. 1888. Pencil, reed pen, and brown ink. 12⅝ × 19⅝" (31.5 × 49.5 cm). Rijksmuseum Vincent van Gogh, Amsterdam.

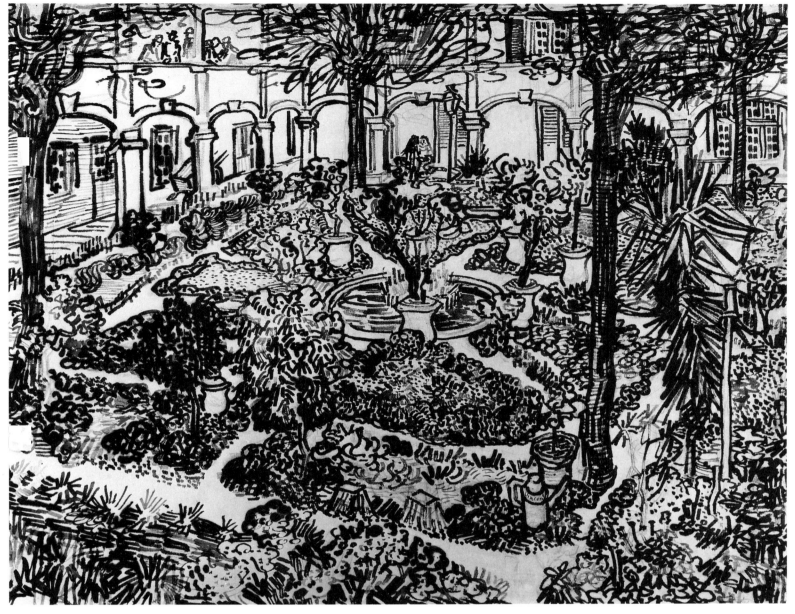

Courtyard of the Hospital at Arles. 1889. Pencil, reed pen, and brown ink.
18⅛ × 23¼″ (45.5 × 59 cm). Rijksmuseum Vincent van Gogh, Amsterdam.

20 FEBRUARY. Arrives in Arles. Takes a room at the Hôtel-Restaurant Carrel at 30, rue Cavalerie.

MARCH. Meets the Danish artist Christian Vilhelm Mourier-Petersen (1858–1954), who becomes his companion for the next two months.

22 MARCH–3 MAY. Exhibits three paintings with the Société des Artistes Indépendants.

APRIL. Visited by the American painter Dodge Macknight (1860–1950), who is staying at the nearby village of Fontvieille.

1 MAY. Rents four rooms as a studio in the "Yellow House," 2, Place Lamartine. Visits Macknight in Fontvieille.

Following a dispute over his bill, finds lodgings at another hotel, Café de la Gare, run by Joseph (1836–1902) and Marie (1848–1911) Ginoux, 30, Place Lamartine, where he stays until September.

Executes a series of drawings at Montmajour (does a second series in July).

30 MAY–3 JUNE. Spends five days at the nearby fishing village of Saintes-Maries-de-la-Mer.

JUNE. Becomes acquainted with the Zouave, Paul-Eugène Milliet, to whom he gives drawing lessons, and Macknight's friend, the Belgian artist Eugène Boch (1855–1941).

JULY. Meets the postmaster, Joseph Roulin (1841–1903), who becomes a dear friend.

Macknight visits him in Arles; by August, he visits regularly.

16 SEPTEMBER. Moves into the Yellow House.

23 OCTOBER. Gauguin arrives in Arles.

NOVEMBER. At Gauguin's urging, experiments with painting from memory.

MID-DECEMBER. Together with Gauguin, visits the Alfred Bruyas collection at the Musée Fabre in Montpellier, noted for its impressive collection of works by Delacroix and Courbet.

23 DECEMBER. Following a quarrel with Gauguin, severs the lower part of his ear and presents it to a woman named Rachel at the "*maison de tolérance*, No. 1."

24 DECEMBER. Discovered in critical state by police; admitted to the local hospital, Hôtel Dieu, where he is attended to by Dr. Félix Rey (1867–1932). Theo is summoned to Arles.

26 DECEMBER. Theo, probably in the company of Gauguin, returns to Paris.

1889

7 JANUARY. Returns to the Yellow House. Begins painting the following day.

7–17 FEBRUARY. Hospitalized for ten days following an attack during which he has had hallucinations and has feared he was being poisoned.

CA. 25 FEBRUARY. Petition of some thirty neighbors leads to police investigation and his subsequent internment in a hospital cell; the Yellow House is closed by the police.

23–24 MARCH. Visited by Signac, who is en route to Cassis. Begins painting again the following week.

17 APRIL. Theo marries Johanna Bonger (1862–1925) in the Netherlands.

8 MAY. By his own choice, Vincent leaves Arles in the company of Reverend Frédéric Salles for the asylum of Saint-Paul-de-Mausole in Saint-Rémy. Here he is diagnosed by the attending physician, Dr. Théophile Peyron, as suffering from an epileptic disorder.

Receives permission to work in the garden and environs of the hospital.

EARLY JULY. One-day visit to Arles to fetch a group of paintings not yet dry when he left. Shortly afterward, he has an attack while painting outside; works indoors for the next six weeks.

3 SEPTEMBER–4 OCTOBER. Two paintings, *Irises* and *Starry Night on the Rhône*, are included in the Indépendants exhibition in Paris.

NOVEMBER. Spends two days in Arles, where he visits Reverend Salles and M. and Mme. Ginoux.

DECEMBER. Suffers a week-long relapse.

1890

JANUARY. G.-Albert Aurier's pioneering article, "Les Isolés: Vincent van Gogh," is published in the *Mercure de France*.

JANUARY–FEBRUARY. Six paintings are included in the exhibition of Les Vingt in Brussels.

LATE FEBRUARY. Visits his sick friend, Mme. Ginoux, in Arles. Suffers another attack following his visit.

31 JANUARY. Birth of Theo's son, Vincent Wilhelm.

LATE FEBRUARY. Suffers a severe attack during a two-day visit to Arles and is brought back to the hospital.

Remains quite ill through April.

19 MARCH–27 APRIL. Exhibits ten paintings with the Indépendants in Paris.

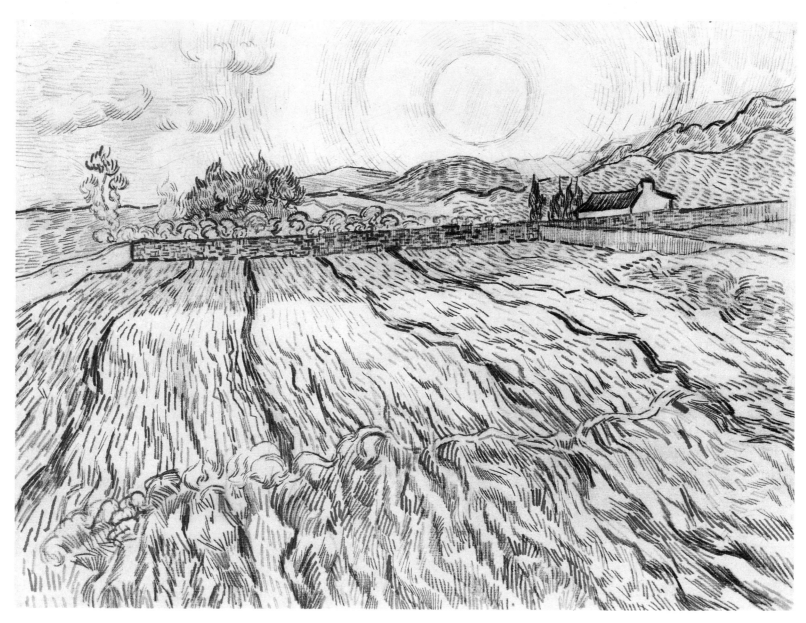

Wheat Field with Rising Sun. 1889. Black chalk and reed pen. 18½ × 24⅜″ (47 × 62 cm). Staatliche Graphische Sammlungen, Munich:

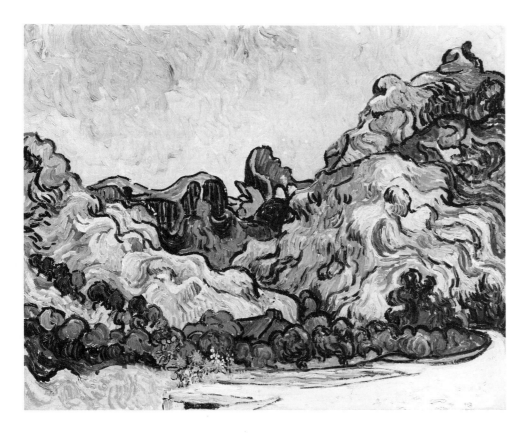

Mountains with Dark Hut. 1889.
28¾ × 36⅝″ (73 × 93 cm). Solomon R.
Guggenheim Museum, Justin K.
Thannhauser Collection, New York.

MAY. Leaves asylum on the 16th. Spends four days in Paris with Theo and his family before leaving for Auvers. Receives several visitors, probably Tanguy, Lautrec, Pissarro, and Guillaumin. Visits the Salon, where he admires Puvis de Chavannes' works.

20 MAY. Arrives in Auvers, where he remains under the care and supervision of Dr. Paul-Ferdinand Gachet (1828–1909). Takes up lodgings at an inn owned by Arthur Gustave Ravoux.

8 JUNE. Visited by Theo and his family.

Experiments with etching.

16 JUNE. Meets Dutch artist Anton Hirschig (1867–1939), who upon his arrival in Auvers takes an adjacent room at Ravoux's inn.

6 JULY. Short visit to Paris. Visits Aurier and Lautrec. Sees Gauguin's recent work.

27 JULY. Shoots himself in the Auvers countryside and returns to the inn, wounded.

29 JULY. Dies with Theo by his side, 1:30 A.M.

30 JULY. Burial at the cemetery at Auvers attended by Bernard, Andries Bonger (1822–1897), Gachet, Charles Laval (1862–1904), A.-M. Lauzet (1865–1898), Lucien Pissarro, père Tanguy, and others.

AUGUST–SEPTEMBER. Theo solicits Bernard's help in organizing a showing of Vincent's works in his Montmartre apartment.

OCTOBER. Theo becomes seriously ill and is taken to Holland following his breakdown.

1891

25 JANUARY. Theo dies in Utrecht, the Netherlands.

INTRODUCTION

Hollywood producers are frequently faced with problems such as that facing Gordon Wiles in 1946 on the set of the motion picture *Bel-Ami*: how do you film a rainstorm without ruining the expensive costumes and scenery with water? But the solutions are rarely as out of the ordinary as in Wiles's case, for he later attributed his solution not to the wizardry of cinematographers but to Vincent van Gogh. The Dutch painter's 1885 canvas *The Garden of the Vicarage at Nuenen* had suggested a way that the illusion of a downpour could be created through the use of plastics, gauzes, and lighting effects, and had thus inspired a breakthrough in movie special effects.[1] In 1957, a Turkish opera premiered in Ankara, Nevit Kondalli's *Van Gogh*, based on the life of the artist. In 1971, "Vincent," a song by the pop recording artist Don McLean, had teenagers everywhere singing "Starry, starry night. . . ."

Vincent van Gogh's rich legacy of over 800 letters to family and friends and over 2,000 paintings and drawings has been consulted by a veritable who's who of twentieth-century arts and letters. Alongside art historians, critics, and artists, the impressive roster includes filmmakers, dramatists, songwriters, poets, novelists, and philosophers. Nor has the scientific community been immune: witness the numerous clinical reports on his illness or the more recent investigations of his night skies by astronomers.

It is no wonder that even the most adventurous bibliophile has shied from the challenge first tackled in 1942 by Charles Mattoon Brooks, Jr., with his pioneering 777-item Van Gogh bibliography. One candidate, Edward Buckman, lamented in 1955: "You will realize, I'm sure, that the material published on Van Gogh long ago reached truly fantastic proportions. . . . Since 1940 there have been at least as many items published [as those listed by Brooks]. I have been collecting these and card cataloging them but recently I have not had the time to keep up a complete typed listing—the items have snowballed to such an extent that I am literally snowed under! It takes all my spare time—which is all I have devoted to Vincent—just to read and catalogue on cards the items and enter them in short (by long hand) on the typed pages I started long ago."[2]

Buckman, then in the thick of cataloging the backwash from the centennial celebrations of Van Gogh's birth, was likewise in the wake of a new flood of literary activity. As he has surmised, with the 1956 release of the Metro-Goldwyn-Mayer film version of Irving Stone's *Lust for Life*, Van Gogh was to become very topical in the United States. He was also, with the publication the same year of John Rewald's *Post-Impressionism from Van Gogh to Gauguin*, to become heir to the most rigorous follow-up fact-finding campaign ever devoted to a single artist.

Over the course of the twentieth century, the Van Gogh literature has been supplemented by pioneering exhibitions: The 1901 retrospective at the Galerie Bernheim Jeune in Paris and the first monographic showings in Germany at Paul Cassirer's (1905), in the United States at the Montross Gallery (1920), and in England at the Leicester Galleries (1923) added to the momentum. During the same decades new territory was charted with the influx of witness accounts just prior to World War I and psychological studies just after, the publication of the first definitive volume of the letters to Theo (1914), and J. B. de la Faille's four-volume *catalogue raisonné* (1928). The artist who, in the 1890s, had been more or

[1] "Film's Dry Rain Based on '85 Van Gogh Canvas," *New York Herald*, May 26, 1946.

[2] Edward Buckman, Letter to the friends of Vincent van Gogh (25 August 1955), *Color and Rhyme*, no. 31, 1956, p. 33.

less the province of a small, albeit dispersed, group of Symbolist writers and artists—in France, the Netherlands, Belgium, and Denmark—became by the 1910s popular enough to inspire novelists, even in Hungary; to be forged in Germany in the 1920s; and to set new attendance records by the 120,000-strong who came to the 1935–36 exhibition at The Museum of Modern Art.

The subject of Van Gogh's legacy gives pause for reflection. How vast is the discrepancy between the paucity of attention he received while alive and today's abundance! So often has this contrast served as a platform for retracing the saga of "poor Vincent," who struggled along in anonymity and isolation and whose efforts were little appreciated until after his death, that it is a useful corrective to the genuflections of many biographers to review the facts in a plainer light.

Van Gogh's career began in the summer of 1880 when he took up drawing with serious ambitions of becoming an artist; it ended with his suicide in the summer of 1890. Ten years: not a long time to establish oneself as an artist. After all, it wasn't until 1886–87 that Van Gogh first exhibited and perhaps not until the following years—when experimentation gave way to synthesis—that his work really came into its own. In either event, this was a short gestation period for his art to mature and become known, let alone—as Braque remarked in front of the shocking newness of Picasso's *Les Demoiselles d'Avignon*—for the public to be ready to exchange their "usual diet for one of tow and paraffin."[3]

Van Gogh was not insensitive to such considerations. Alongside his reproaches to Theo for not doing enough for him and his personal, at times substantial, efforts to promote his own work, we find him begging off opportunities for immediate success with pleas for patience. By 1889, Van Gogh's reaction to the critic J. J. Isaäcson's notice—"persuade him to wait. . . . with yet another year of work, I could—I hope—put before him some more characteristic things with more decisive drawing, and more expert knowledge with regard to the Provençal south" (*609*)*—had become a familiar rejoinder. In August 1883, for example, he put off the question of potential sales by asking Theo to wait: "If I were only a little more advanced . . ." (*312*). In March 1884 he declared to Anthon van Rappard: "I certainly hope to sell in the course of time, but I think I shall be able to influence it most effectively by working steadily on, and that at the present moment making desperate 'efforts' to force the work I am doing now upon the public would be pretty useless" (*R41*). In early November 1888, he stated: ". . . with a little more work behind me, I shall have enough not to exhibit at all, that is what I am aiming at" (*561*); and later that month: "Let's quietly postpone exhibiting until I have some thirty size-30 canvases. . . . There are quite a few reasons not to make a stir at present. At the age of forty when I make a picture of figures or portraits in the way I feel it, I think this will be worth more than a more or less success at present" (*558a*).

Does his constraint betray simply a "fear of success" or a "fear of failure"? We know that Van Gogh placed enormous faith in the future, not only in the future potential of his own work, but in "an art of the future . . . so lovely and so young" (*489*) that it was worth sacrificing his youth and ultimately his life in the making. Furthermore, he tended to be a rather harsh self-critic; many pictures now considered masterpieces were to his mind merely studies. The combination of these long-standing views—and indeed others—may well have eclipsed contemporary notice from the start.

Van Gogh maintained a certain, and not untypical, love–hate atti-

[3] Leo Steinberg, "Contemporary Art and the Plight of the Public," *Other Criteria*, Oxford University Press, New York, 1972, p. 6.

*Quotations from Van Gogh's correspondence are followed by standard numerical designations for the letters as reprinted in *The Complete Letters of Vincent van Gogh*, The New York Graphic Society, 1958.

tude toward selling his work. Of course, it is a rare breed of artist who is equally adept at the creative and the marketing ends of art. And few in Van Gogh's enviable position of having a brother in the trade would care to take on the added, often discouraging, task of promoting his own art. Certainly, he did not have any easy time of it. He knew he made "an unfavorable impression" (*312*). His manner of dress, behavior, temperament and various circumstances—from living with a prostitute in The Hague to staying in a mental asylum in Saint-Rémy—worked against him. He had also chosen, as had Cézanne in Aix-en-Provence, Monet in Giverny, Sisley in Moret, and Gauguin in the tropics—each with profit to his development—to work at some remove from the mainstream. So it is to his credit that at certain junctures of his career, he did set out personally to stir up business—with dealers in The Hague, Antwerp, and Paris and to organize café-exhibitions in Paris in 1887.

Van Gogh also responded energetically to the least hint of interest expressed by dealers (such as Arsène Portier in 1885) or by fellow artists (such as Emile Bernard in 1888), either by letter or by sending out batches of drawings based on his canvases. Nor was he so removed from the practical side of things as to fail to suggest, following his first notices, that he and Theo should "take advantage of it to dispose of something in Scotland" through the dealer Alexander Reid or in the Netherlands, through dealers H. G. Tersteeg and his uncle Cornelius Marinus van Gogh (*626*).

But, certain other attitudes tended to keep sales at bay: "If I were not *forced* to do it, I should very much prefer to keep the studies myself, and I *would never* sell them. But . . . you know the rest" (*R44*). Like most artists he was motivated more by the making, rather than by the selling, of his works. Perhaps he was even more idealistic than most: "My opinion is that the best thing would be to work on till art lovers feel drawn toward it of their own accord, instead of having to praise or to explain it"; in such an event, he could leave the "business part" to Theo, of whom he asked only "patience" (*312*).

A like ambivalence colored his view toward exhibition. The indifference Van Gogh expressed toward exhibiting his work with the Indépendants in Paris and Les Vingt in Brussels in 1889 has a history in his artistic thinking. It was not that he was "indifferent to appreciation," as he confessed early on to Van Rappard (*R16*), but that he seemed to prefer showing or circulating his works among a coterie of friends and sympathetic art lovers than featuring them publicly. Ever-interested in feedback from fellow artists, Van Gogh actively sought out local painters, consistently exchanged letters or drawings to evoke responses, and even, as in Nuenen and in Arles, gave lessons to amateurs.

Public exhibition was an altogether different matter. From 1882 to 1889, he gave various reasons for his professed indifference: a disillusionment with the results of exhibitions, based on his five years' employment at Goupil's, an idealism that favored the collective, as opposed to the individual, success of artists, a sensitivity to the "old files of superficial judgments, generalizations, *conventional* criticism" that came from the trade (*R44*), an aversion to being "dependent on the opinion of others" simply to be "awarded a prize or a medal like a 'good boy'" (*W4*), a let's-wait attitude that placed greater stock in his future work than in his present efforts, an assigning of greater importance to producing pictures over working expressly for notoriety, a fear of "being an obstacle to others" (*534*), and outright feelings of "inferiority" beside painters "who have tremendous talent" (*604*).

One senses that if Van Gogh had had his own way, he would have reserved only a marginal, a very secondary, place for himself in the history of modern art. On the one hand, he was quick to defend his own efforts against ridicule; indeed his responses to the criticism of Tersteeg, Van Rappard, Bernard, Gauguin, and others prove him to be an

able polemicist for his art. But on the other hand, he tended, to a fault, to be highly critical of his own progress and perhaps overly generous in noting the achievements of others. In responding to his first notices, those by Isaäcson and G.-Albert Aurier, Van Gogh immediately deflected praise from himself to other painters, such as Monticelli, Gauguin, Quost, and Jeannin, who were "doing the same thing I am, so why an article on me and not those six or seven others [?] . . ." (629).

As reflected in his selfless devotion to the miners of the Borinage or in the dour humanitarianism of his Dutch pictures, Van Gogh professed great altruism. Did social ideals temper his otherwise egotistic nature and account for the generous credit he conferred on other painters, no less than to the grand schemes he proposed for communities of artists working together toward a common cause? To interpret these sentiments as "safety in numbers"—a subtle form of fear of success—seems rather reductive.

This is not to deny the obvious confessions: "my back is not broad enough" to withstand praise (625); "As soon as I read that my work was having some success . . . I feared at once that I will suffer for it; this is how things nearly always go in a painter's life: success is about the worst thing that can happen (629a); "pride, like drink, is intoxicating, when one is praised and drunk the praise up. It makes one sad" (W20). It is simply to suggest that other, more insidious, features of his artistic thinking played a part in discouraging contemporary fame.

In any event, at the time of his death, Van Gogh had sold very few works, had been represented by only a few dealers (in the main by Julien Tanguy), had participated in some half-dozen exhibitions and had succeeded in dissuading both Isaäcson and Aurier from further writing about his art. In all, there were but a handful of notices when he died in 1890.

The plans Theo initiated in the months that followed to ensure his brother's legacy produced little more in the way of response. The hopes Theo pinned on Durand-Ruel for exhibition space and on potential biographers Aurier and Gachet all came to nothing. Durand-Ruel refused, Aurier died in 1892, and Gachet apparently lost interest. With Theo's own demise just six months after Vincent's, in the early 1890s Van Gogh might indeed have been shrouded in utter silence were it not for the efforts of an interested few and for the gumption of Theo's widow, Johanna van Gogh-Bonger.

Among the first and most loyal promoters of Van Gogh's memory were artists. In Paris, Emile Bernard oversaw the exhibitions at Theo's vacant Montmartre apartment at the end of 1890 and at Le Barc de Boutteville in the spring of 1892. Thanks to Bernard, Van Gogh's letters were published in issues of *Mercure de France* from 1893 to 1895. Paul Signac also rallied to the cause, organizing a modest retrospective with the Indépendants in 1891 and assisting Octave Maus with that year's memorial tribute with Les Vingt in Brussels.

Johanna van Gogh-Bonger took most of Van Gogh's pictures to the Netherlands in 1891. What was left in Paris in the 1890s were largely those works that the artist had given, often in an exchange, to his friends Bernard, Gauguin, Signac, and Lucien Pissarro, the few that remained with Tanguy until his death in 1894, and those acquired by the enterprising Schuffenecker and Vollard as well as a smattering of bold collectors, among them the artists Degas, Rodin, Camille Pissarro, and Medardo Rosso, and his earliest critics, Aurier, Julien Leclercq, and Octave Mirbeau.

Nonetheless, by 1894 Van Gogh had received a modicum of notoriety, enough so that Gauguin, who had refused to support Bernard's and Signac's plans, was prompted to pen *"Natures mortes"* ("Still Lifes"), his recollections of his Arles companion, even if just to state for the record that Van Gogh was "decidedly mad." And enough so that his faith-

ful friend Signac would begrudge the greater attention given posthumously to Van Gogh than to Seurat (who had died in 1891): "The young people are full of admiration for . . . Van Gogh. And for Seurat, oblivion, silence. Yet he is a greater painter than Van Gogh, who is interesting merely as an insane phenomenon."[4]

The discovery by the young Fauve artists of Van Gogh's works at the 1901 Bernheim Jeune retrospective ushered in an era of wider appreciation in France. Matisse, who met Derain and Vlaminck at the exhibition, became a collector with the acquisition of two drawings. Vlaminck, who found his "inner being deeply shaken" by the genius that loomed before him, set out to acquire a work himself despite the fact that he "owed money to the butcher, the baker, and the grocer."[5] His desire to own "one or two paintings by Van Gogh" and his pilgrimage to Auvers twenty years later may be likened to the odysseys of discovery undertaken earlier by the Danish artist Johan Rohde in 1892 and by the Russian-American artist David Burliuk in 1949.

Rohde, more successful than Vlaminck (he acquired a drawing in 1892), recounts in his *Journal fra en Rejse i 1892* how he traveled from town to town in the Netherlands in search of Van Gogh's works. Ultimately, he was instrumental in bringing 29 paintings and drawings to *Den frei Udstilling* in Copenhagen in 1893. Likewise, a group of Dutch artists gathered around Johanna van Gogh-Bonger to further Van Gogh's reputation in the Netherlands. Chief among them were the Symbolist painters Jan Toorop, who spearheaded the 89-work retrospective at The Hague Kunstkring in the spring of 1892, and R. N. Roland-Holst, who organized the exhibition and catalogue for the 112-work showing in Amsterdam at the Kunstzaal Panorama from 1892 to 1893.

Heirs to 1890s Symbolism and progenitors of prewar Expressionism, the Art Nouveau and Jugendstil movements in Belgium, the Netherlands, and Germany showed, not surprisingly, a marked interest in Van Gogh. This may be traced from the dedicatory prints in an Art Nouveau idiom that adorned the special 1893 Van Gogh issue of the Flemish journal *Van Nu En Straks*, to the 1898 exhibition hosted by Plasschaert's Art and Crafts Gallery in The Hague, to the tributes paid by leading polemicists for the Jugendstil movement in Germany, August Endell and Julius Meier-Graefe. The response owed as much to Van Gogh's spirituality as it did to his expressive manipulation of color, shape, and line. The rich tapestry of intertwining floral motifs, sinuous plant tendrils, and tear-drop and diamond shapes that pattern the background of *La Berceuse* was but a step away from the decorative organicism of Art Nouveau and Jugendstil design. The restless line of the Arles drawings, where dots, cross-hatchings, slashes, curves, and whirls transform Nature into a glorious syncopation, realized a formal vocabulary that, in Endell's words, could "stimulate our souls as deeply as only the tones of music have been able to do."[6] Here was fertile soil for the cultivation of an organic, non-referential aesthetic of great immediacy and emotive power.

Van Gogh's vision was one that easily lent itself to the *fin-de-siècle* protest against materialism and, in turn, to the aesthetic of the Expressionists. Without recourse to Van Gogh's example, one might be hard-pressed to explain Kandinsky's 1904 *Sunflowers*, Nolde's 1907–08 garden pictures, where plants burgeon more from the painter's emotion than from flower beds, or Kirchner's luminous and emphatically brushed landscapes. But for the generation of prewar Expressionists a far greater

[4]John Rewald, ed., "Excerpts from the Unpublished Diary of Paul Signac, 1894–1895," *Gazette des Beaux-Arts*, July–September 1949, p. 168.

[5]Maurice Vlaminck, *Portraits avant décès*, Flammarion, Paris, 1943, p. 31.

[6]August Endell, "Formenschönheit und Dekorative Kunst," *Dekorative Kunst*, November 1897, pp. 75–76.

debt to Van Gogh lay in a great longing which presaged their own, "to learn to make those very incorrectnesses, those deviations, remodelings, changes in reality, so that they become, yes, lies if you like—but truer than literal truth" (*418*). His efforts "to exaggerate the essential, and purposely leave the obvious things vague" (*490*) and to "use color more arbitrarily so as to express myself forcibly" (*520*) had more or less prefigured the major tenets of such manifestos as *Der Blaue Reiter Almanac* and Kandinsky's *Concerning the Spiritual in Art* (1912).

Van Gogh may have left the torch to be carried by a "colorist such as has never yet existed" (*470*), but he certainly lighted the way for the breakthroughs of a Matisse, Kandinsky, or Rothko. His explorations of the expressive, as opposed to the descriptive, potential of color had progressed by 1888 to the point that he had begun to think of his paintings almost exclusively in terms of color: "the orchards meant pink and white; the wheat fields, yellow; and the marines, blue. Perhaps I shall begin to look around a bit for greens. There's the autumn, and that will give the whole scale of the lyre" (*504*). Completing this color scale with the "greens" in the *Public Garden* and the orange of autumn in *Les Alyscamps*, Van Gogh anticipated the Fauve and Expressionist landscape, which was essentially a ground for the rich orchestration of color.

Although Van Gogh was the rage among avant-garde factions in Germany—Der Blaue Reiter in Munich and Die Brücke in Dresden—appreciation was slower in coming from other circles. Kandinsky, in a review for *Apollon*, noted that the 1908 exhibition at Brakl's had occasioned violent protest, and though in a subsequent notice he stated that some of these critics had come around by the time of Brakl's 1909 show, they remained guilty of idolizing "not the really profound aspect of his art, but on the contrary, its wholly unimportant and accidental characteristics."[7] At roughly this time, George Grosz, who was studying at the Royal Academy in Dresden, came up against another sort of negative reaction to Van Gogh, that of his professor, Richard Mueller: "Smears together a sunset in one afternoon! What is this? I paint one picture for two years and such a Gogh smears . . . in half an hour and sells it for fifteen thousand marks!"[8]

Other contemporary artists had found his technique lacking. In a notice following Van Gogh's London debut "Manet and the Post-Impressionists," the Grafton Galleries exhibition of 1910–11, Walter Sickert confessed: "I have always disliked Van Gogh's execution most cordially."[9] Kenyon Cox responded to the eighteen Van Goghs included in the 1913 New York Armory show with the disclaimer: "All I can be sure of is an experiment in impressionist technique by a painter too unskilled to give quality to an evenly laid coat of pigment."[10] Neither of these shows evoked widespread response. In England, his works were championed by a few, but ignored or merely mentioned by many more. In the United States, fewer still paid attention to Van Gogh. Yet, perhaps in reaction to general condemnations such as that of Theodore Roosevelt, who remarked that the "lunatic fringe was fully in evidence especially in the rooms devoted to the Cubists and the Futurists or Near-Impressionists,"[11] Arthur Davies championed Van Gogh's art for its "soundness and lucidity of mind, in form and color."[12]

[7] K. C. Lindsay and P. Vergo, eds., *Kandinsky: Complete Writings on Art*, G. K. Hall, Boston, 1982, Vol. I, pp. 56, 61.

[8] George Grosz, *A Little Yes and a Big No: The Autobiography of George Grosz*, Dial Press, New York, 1946, p. 85.

[9] Walter Sickert, "Post-Impressionists," *The Fortnightly Review*, January 2, 1911, p. 89.

[10] Kenyon Cox, "The 'Modern' Spirit in Art," *Harper's Weekly*, March 1913, p. 10.

[11] Theodore Roosevelt, "A Layman's View of an Art Exhibition," *Outlook*, March 29, 1913, p. 718.

[12] Foreword to E. du Quesne-van Gogh, *Personal Recollections of Vincent van Gogh*, Houghton Mifflin, Boston, 1913.

Neither uniform nor always favorable in response to Van Gogh, artists gravitated to or reacted against features that seem to tell us as much about those artists' concerns as about Van Gogh's. Paul Klee was awestruck by Van Gogh's line, Vlaminck by his color, Kokoschka by "his strange ability to catch the passing thoughts of *malaise de la vie* of our time," and Picasso by "the way he asserts his freedom from nature."[13] Malevich, while working in a Cubo-Futurist idiom, admired Van Gogh's "dynamic expression," and the de Stijl artist Van Doesburg his "struggle for direct expression."[14] Characteristically, Magritte found "the story of the ear, cut off and cleaned up, put in an envelope, and given as a gift to prostitutes . . . more important than the actual pictures that elicit the obligatory admiration of intellectuals"![15]

So sensational are the details of Van Gogh's 37-year-long life that they have, albeit in more subtle but more pervasive ways, tended to eclipse his artistic contribution. The fears of early critics Aurier and Holst were not unfounded: Van Gogh's work has suffered under the burdens of his biography.

The story of Vincent van Gogh's life—garnered from the letters and supplemented with varying degrees of fact or fiction—has been told in many languages and in many forms. It is a familiar story—the young Vincent daily passing by the gravestone of a still-born brother, also named Vincent and also born on March 30 a year earlier; suffering his ill-fated love affairs with a landlord's daughter, a widowed cousin, a prostitute, and an older woman, and his failures as an art dealer, teacher, bookshop clerk, evangelist and preacher; passionately heeding the call to serve the miners of the Borinage; and, the monumental turning point, discovering in 1880 his vocation for the next ten years. Van Gogh's artistic career—marked as it was by such incidents as the mutilation of his ear, periodic breakdowns, his voluntary commitment to an insane asylum, and his suicide—was, of course, no less episodic. Yet one might prefer to measure his genius by other milestones: his mastery of the reed pen in drawings of great spontaneity, his evocative use of color harmonies and contrasts, and his *purposeful* exaggerations and distortion of form for expressive ends.

Van Gogh's art is remarkable not only for its innovations but for its continuities. This is not merely in his acknowledged debts to The Hague school and the Barbizon artists, among others, but in the glorious synthesis he realized of Southern light and color with his Northern sensibility toward subject matter. The strong family resemblance between the cottages of Saintes-Maries (1888) and the earlier farmhouses of Drenthe (1883), between the shady avenue of Les Alyscamps (1888) and the poplar-lined lanes of Nuenen (1884), and between the plains of Auvers (1890) and the bulb fields of The Hague (1883) serve as reminders—like the Montmartre windmills in Paris—of Van Gogh's heritage: He was a Dutchman, a foreigner, who for the last four and a half years of his life made France his home.

This Dutchman, his last name so difficult to pronounce that he opted to sign himself simply *Vincent*, left lasting impressions on those who knew him, and on the generations of artists who followed. These impressions,

[13] Oskar Kokoschka, "Van Gogh's Influence on Modern Painting," *Mededelingen*, Vol. VIII, no. 5–6, 1953, pp. 78–79; Françoise Gilot and Carlton Lake, *Life with Picasso*, McGraw-Hill, New York, 1964, p. 272.

[14] T. Andersen, ed., *Essays on Art: 1915–1933*, Vol. I, Dufour, Chester Springs, Pa., 1968, pp. 109–12; Joost Balijeu, *Theo van Doesburg*. Macmillan, New York, 1974, p. 21.

[15] In a letter of March 8, 1955, to G. Puel, Magritte confessed: "I don't really respond to Van Gogh's paintings. I mention this because I've been asked to write something about this painter; I don't know if I'll manage to do it [since] I'm not very 'enthused.' There is, of course, the story of the ear. . . . If I do write something, I'll try to convey what happened as being more important than the actual pictures that elicit the obligatory admiration of intellectuals." From Harry Torczyner, *Magritte: The True Art of Painting*, Abrams, New York, 1979, p. 49. Magritte's essay appears on p. 378.

through first-hand witness accounts and artists' statements about his art, may be gleaned from the writings selected for this volume. Special emphasis has been placed on the genesis of his fame, from the earliest reviews to the first significant showings of his art in Europe and America.

Van Gogh: A Retrospective, a tribute to the century-long reception and perception of Vincent van Gogh, endeavors to strike a happy balance between interest in the *man* and his life and in the *artist* and his impact on the history of art. Yet unlike a biographical study, this selection has not wrestled with the difficult and delicate task, masterfully handled by John Rewald's *Post-Impressionism from Van Gogh to Gauguin*, of determining just how much weight should be attached to various personal or incidental factors in the evaluation of Van Gogh's art. Nor has it attempted systematically to trace shifting attitudes toward his art, a subject most recently addressed by Carol Zemel's *The Formation of a Legend: Van Gogh Criticism, 1890–1920* and given currency by the fairly representative cross-section of the literature to date in Bogomila Welsh-Ovcharov's *Van Gogh in Perspective*.

The work of these art historians has contributed greatly to the selection and annotation of material in this volume, as have the researches of other scholars: C. M. Brooks, J. B. de la Faille, A. M. Hammacher, Jan Hulsker, J. M. Joosten, Ronald Pickvance, Mark Roskill, Mark E. Tralbaut in particular, and Sophie Monneret, in her four-volume *L'Impressionisme et son époque* (1978–81) more generally. In the interest of allowing the individual articles to speak for themselves, translations have been kept as literal as possible and annotations confined to a minimum.

<div align="right">SUSAN ALYSON STEIN</div>

VAN GOGH

Elizabeth du Quesne-Van Gogh

The author was Vincent's sister, Elizabeth Huberta (1859–1936).

VINCENT VAN GOGH

1910

Their brother walked past the children without a word; out of the garden gate, through the fields, and along the path that leads to the meadows. He was going to the brook; the children saw this by the flask and the fishing net that he carried with him, but none of them would have called after him: "Can I go along, brother?"

And yet, they knew only too well how clever he was at catching water insects. This he showed them when he came back with different types of beetles with shiny, dark-brown shells, great round eyes, and crooked legs that nervously pulled up as soon as they were brought from the water onto dry land.

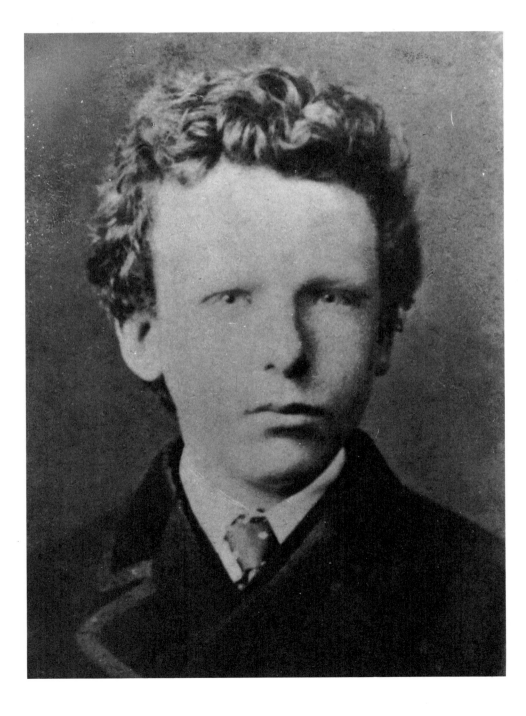

Photograph of Vincent at about age thirteen. Ca. 1866. Rijksmuseum Vincent van Gogh, Amsterdam.

All the beetles, even those with enormously long antennae, had names, difficult to remember, but their brother already knew all the names by heart. After he had prepared them in camphor he pinned them in small cardboard boxes lined with white paper, labelling each with a little strip of paper above each animal on which its name was written—and that was in Latin!

Far from making fun of him, they spoke about him with respect, but they dared not ask to go to the brook where it would be so cool and fresh, where one could plunge one's hands in the glittering white sand without getting them dirty.

On the bank of the brook bloomed the most beautiful forget-me-nots and rose-colored water lilies. The girls, who loved flowers above all, longed for the inaccessible; they were not allowed to leave the garden alone, and on walks with their parents it was always: "Not by the water, children!"

They felt it by instinct, as children are wont to do: their brother preferred to be alone.

If he had a vacation from the boarding school where his father had sent him, he sought not their companionship but, rather, solitude.

He knew the places where the rarest flowers bloomed. He avoided the village, with its straight streets and stately little houses from which old biddies peered with glasses over the curtains at the passersby. Since the once important town on the Belgian border was no longer a stop for the coaches, it lay dead and deserted. So instead he sought his way through hill and dale, each time discovering surprising views and spying upon rare animals and birds in their natural habitat. About the latter he knew exactly where each nested or lived, and if he saw a pair of larks descend in the rye field, he knew how to approach their nest without snapping the surrounding blades or harming the birds in the least.

With a thousand voices Nature spoke to him, and his soul listened. . . . As of yet he was only able to listen.

Not one stroke of the pen or pencil sketch remains from that time. He did not think of drawing, the future draftsman. He simply mused and meditated. While still a small boy he modeled—with the greatest curiosity—a little elephant from clay given to him by a sculptor's assistant. At eight years of age, he surprised his mother with a drawing of a cat flying in a mad rage up a bare apple tree in the winter garden. These spontaneous expressions of artistic feeling were surprising, especially since they occurred so rarely—too rarely to be mentioned; so that only much later were they remembered by his parents.

Photograph of Vincent's sister Elizabeth Huberta (1859–1936). Rijksmuseum Vincent van Gogh, Amsterdam.

Letter from Vincent to Rev. T. Slade Jones

An Early Autobiography

17 June 1876

Reverend Jones (1829–1883) ran a boys' school in Isleworth, England, where Van Gogh taught and occasionally preached from July to December 1876.

A clergyman's son who, as he has to work for his living, has neither the time nor the money to study at King's College, and who besides is already a few years beyond the age at which one usually enters there and has as yet not even begun preparatory studies in Latin and Greek, would, notwithstanding this, be happy to find a position related to the Church, though the position of a graduated clergyman is beyond his reach.

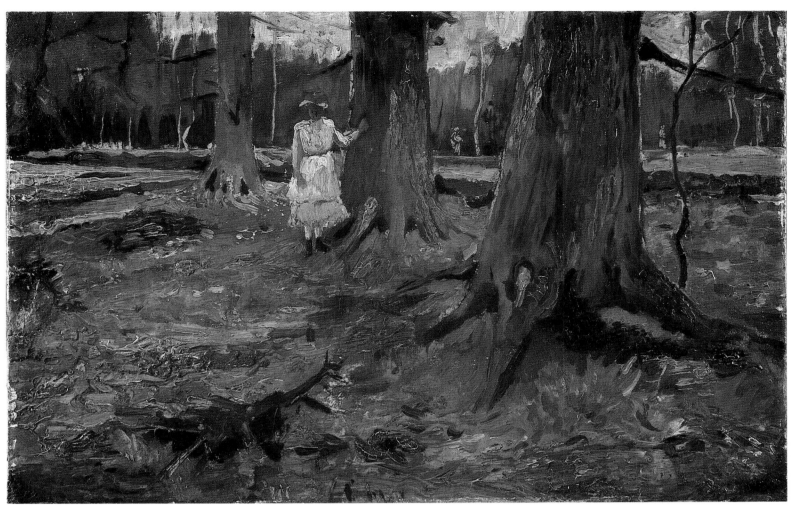

COLORPLATE 1. *A Girl in a Wood.* 1882. Canvas. 15⅜ × 23¼″ (39 × 59 cm).
Rijksmuseum Kröller-Müller, Otterlo.

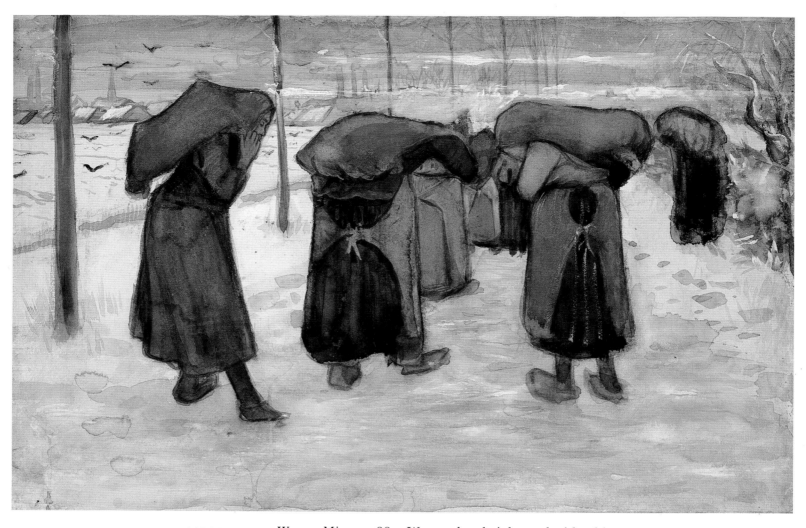

COLORPLATE 2. *Women Miners.* 1882. Watercolor, heightened with white.
12⅝ × 19⅝″ (32 × 50 cm). Rijksmuseum Kröller-Müller, Otterlo.

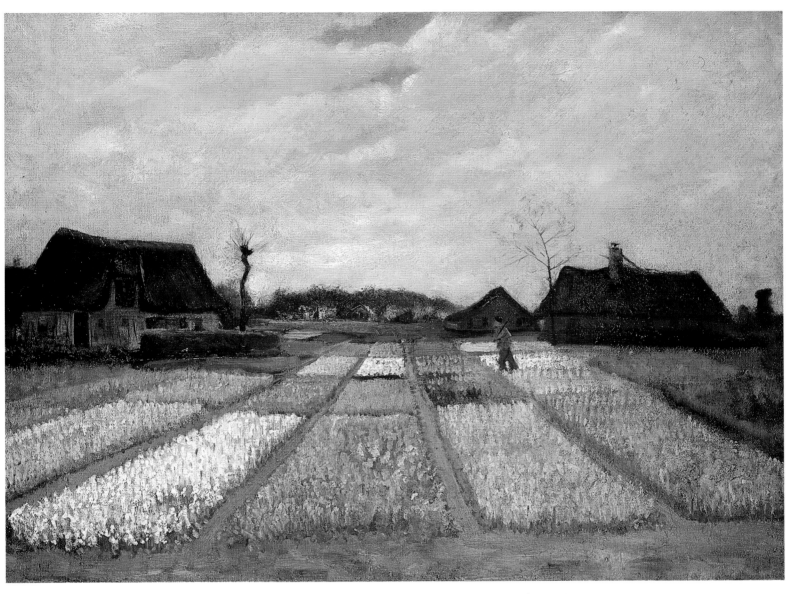

COLORPLATE 3. *Flower Beds in Holland*. 1883. Canvas on wood. 19¼ × 26″ (48.9 × 66 cm).
National Gallery of Art, Washington; Collection of Mr. and Mrs. Paul Mellon.

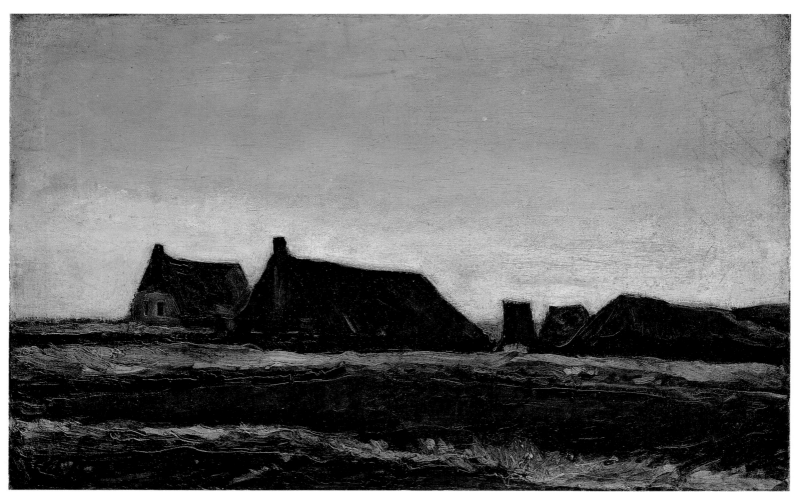

COLORPLATE 4. *Farms.* 1883. Canvas on cardboard. 14⅛ × 22″ (36 × 55.5 cm).
Rijksmuseum Vincent van Gogh, Amsterdam.

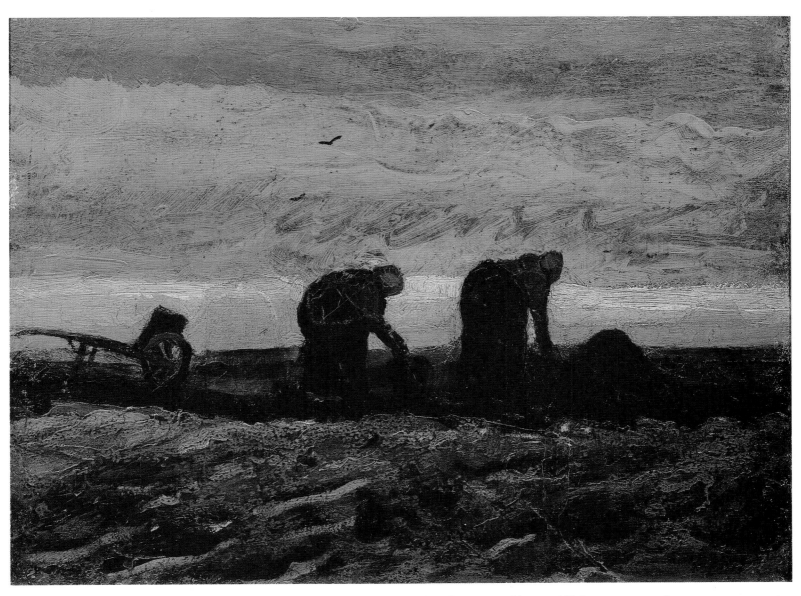

COLORPLATE 5. *Two Women Working in a Peat.* 1883. Canvas. 10⅝ × 14⅛″ (27 × 35.5 cm).
Rijksmuseum Vincent van Gogh, Amsterdam.

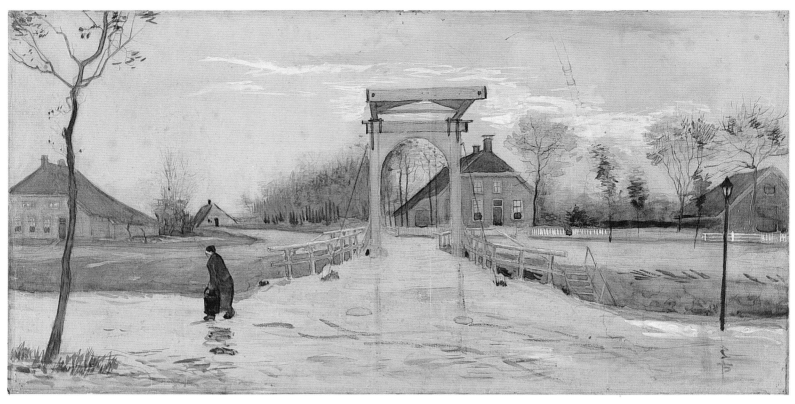

COLORPLATE 6. *Drawbridge in Nieuw-Amsterdam.* 1883. Watercolor.
15⅜ × 31⅞″ (38.5 × 81 cm). Groninger Museum, Groningen.

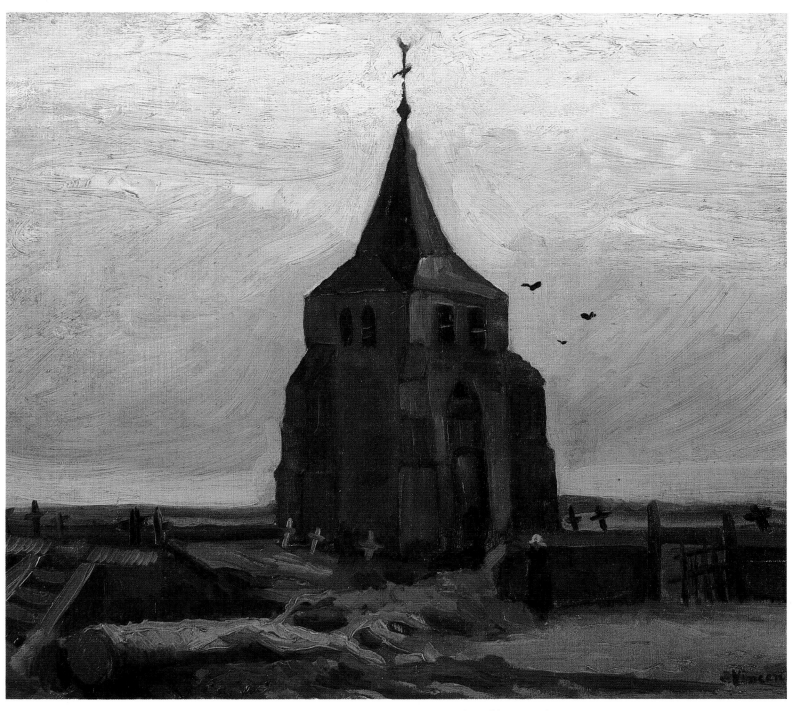

COLORPLATE 7. *The Old Tower*. 1884. Canvas on panel. 18⅞ × 21⅝″ (47.5 × 55 cm).
Foundation E. G. Bührle Collection, Zurich.

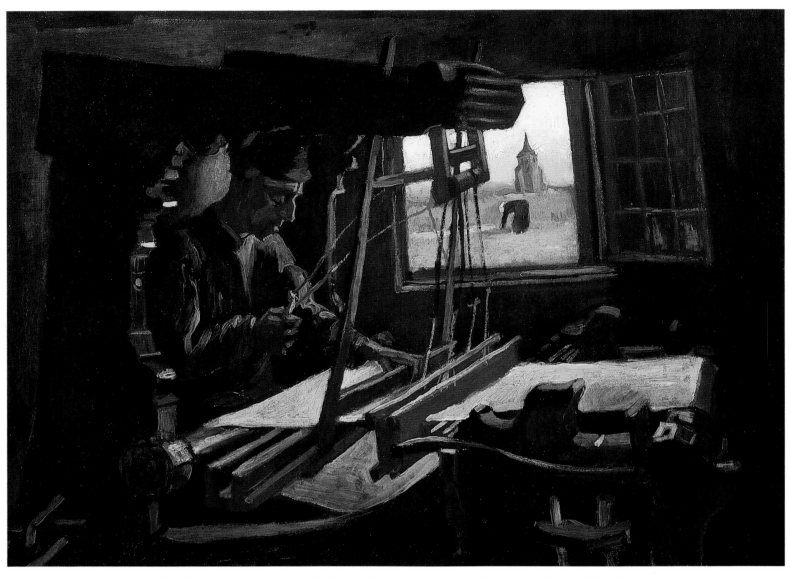

COLORPLATE 8. *Weaver near an Open Window.* 1884. Canvas on cardboard. 27⅛ × 36⅝″ (68.5 × 93 cm).
Bayerische Staatsgemäldesammlungen, Munich. Photograph: Artothek.

My father is a clergyman in a village in Holland. I went to school when I was eleven and stayed till I was sixteen. Then I had to choose a profession, but did not know which. Through the influence of one of my uncles, partner in the firm of Goupil & Co., Art Dealers and Publishers of Engravings, I obtained a situation in this business at The Hague. I was employed there for three years. From there I went to London to learn English, and after two years I left London for Paris.

Compelled by various circumstances, I have left the house of Goupil & Co., and for two months I have been a teacher at Mr. Stokes's school in Ramsgate. But as my aim is a situation in connection with the Church, I must look for something else. Though I have not been educated for the Church, perhaps my travels, my experiences in different countries, of mixing with various people, poor and rich, religious and irreligious, of different kinds of work—manual labor and office work—perhaps also my speaking a number of languages, may partly make up for the fact that I have not studied at college. But the reason which I would rather give for introducing myself to you is my innate love for the Church and everything connected with it. It may have slumbered now and then, but is always roused again. Also, if I may say so, though with a feeling of great insufficiency and shortcoming, "The love of God and man." And also, when I think of my past life and my father's home in the Dutch village, there comes to me the feeling of "Father, I have sinned against heaven, and before thee, and am no more worthy to be called thy son: make me as one of thy hired servants. Be merciful to me a sinner."

When I lived in London, I often went to church to hear you and have not forgotten you. Now I ask your recommendation in looking for a position, and also that you keep your fatherly eye on me if I find such a position. I have been left very much to myself, and I think your fatherly eye will do me good. Thanking you in advance for what you may be able to do for me. . . .

Letter from P. C. Görlitz to M. J. Brusse

NIEUWE ROTTERDAMSCHE COURANT

"Among the People"

26 May and 2 June 1914

When I was an assistant teacher and also a volunteer in the book and art shop of Blussé and Van Braam I took lodgings with Mr. Rijken and his wife. Mr. Vincent van Gogh, who was employed by this firm as both a bookkeeper and an art salesman, had at this time applied for lodgings with Mr. Rijken. The boss, as we called our landlord, asked me: "Sir, would you object to sharing your room with Mr. Van Gogh? Otherwise I have no space for him; yet I would like to accommodate him."—"Sure, on the condition that he is a suitable person." So it came about that Mr. V.v.G. and I became fellow boarders and roommates.

He was a singular man with a singular appearance as well. He was well-built and had reddish hair that stood straight up from his head; his face was homely and full of freckles, but changed and brightened when he became enthusiastic—and that happened quite often. . . . Van Gogh's attitudes and behavior often provoked amusement because he acted,

While associated with the Dordrecht bookshop owned by D. Braat from January to April 1877, Van Gogh and Görlitz (who later became a history teacher at the Secondary School in Nimeguen) were among the lodgers in Tolbrugstraatje at the home of a corn and flour merchant named Rijken.

thought, felt and lived so differently from others his age: he prayed for a long time at the table, ate like a hermit—consuming, for example, no meat, no gravy, etc.—and he invariably had a withdrawn, pensive, deeply serious, melancholy look on his face. But when he laughed he did so with such gusto and geniality that his whole face brightened.

He was frugal by nature and also from necessity, as his income was, like my own, limited—even more so because he was still only a novice in the business. Nor did he want to appeal to his parents for supplementary income [his father was a minister in Etten and Leur].

At night when he came home, he would find me studying, as I was then working for my high school teaching certificate; and then after an encouraging word to me, he likewise went to work. That work was not, as one might have expected, art, but religion. Van Gogh sat night after night reading the Bible, making extracts from it, and writing sermons; at that time [he would have then been about 25] strict piety was the core of his being. Only when we took walks together did the glorious views and vistas, in which Dordrecht is so rich, prompt him to single out what seemed beautiful to him.

Actually, Van Gogh was 23–24 years old at the time.

His religious feeling was vast and noble, the opposite of narrow-minded; although he was an orthodox Protestant in those days, on Sundays he went not only to the Dutch Reformed Church but also, on the same day, to the Jansenist, the Roman Catholic, and the Lutheran churches. And when I expressed my surprise and astonishment to him, he answered with a good-natured smile: "Do you think, G., that God cannot be found in the other churches?"

He lived like a sort of ascetic and permitted himself only one luxury, a pipe full of tobacco. Cigars were too expensive, and for that matter, he liked to smoke tobacco, and a lot of it.

As time went on, he became more melancholy, and his daily work cost him increasingly more effort; he was not suited to his job and his job was not suited to him. While at his bookkeeping, sometimes, a beautiful text or a pious thought came to him and he wrote it down; he could not resist doing so, *ce fut plus fort que lui*. And when he had to provide information to women and other clients, about prints exhibited by Mr. Braat, he did not take the interests of his boss into account but said precisely and plainly what he thought about the artistic value of each one. Once again, he was unsuited to business. To become a minister of a religious parish: that was his dream, and that obsessed him, although he condemned, or, better, disapproved of the fact that knowledge of Latin and Greek should be required for the ministry.

Thus religion occupied his free time and his thoughts, not art; although anything he had occasion to say about art was sound, instructive, and to the point. That sense of religion had also inspired him while he was in London, where he assisted an old minister with the education of neglected boys and worse. Of this he would tell such lively stories.

So he plodded along, pretending for his parents' sake that he was content. But when I stayed with his parents on the occasion of a job application, I informed Mrs. Van Gogh what the trouble was: that V. was unhappy in his work, although his employer was a good man, and that he had only one fervent wish: to become a minister. I told Van Gogh what I had revealed to them; he answered: "I regret you did so, but it is true." His parents then urged him to leave his situation, and he went to Amsterdam to stay with his uncle Van Gogh, the rear-admiral. But we who knew his sober and simple ways realized that he would feel immensely lonely there; indeed, his stay, as might be expected, didn't last long.

Upon leaving, he gave me as a souvenir *L'Oiseau* by Michelet, a book he passionately admired. At that time Spurgeon was also one of his favorite writers. Mr. Rijken and his wife were very kind to him, for they respected his deep earnestness and his gentleness. . . .

Van Gogh left for Amsterdam in May to prepare for entrance examinations at the faculty of theology at the University; by July of the following year, he had abandoned these studies. Vincent's uncle was Johannes van Gogh (1817–1885), a widower, Commandant of the Navy Yard, and, later, a vice-admiral.

C. H. Spurgeon (1834–1892), a popular Baptist preacher and author.

Photograph of Vincent at about age eighteen. Ca. 1871. Rijksmuseum Vincent van Gogh, Amsterdam.

Dr. M. B. Mendes da Costa

HET ALGEMEEN HANDELSBLAD

"Personal Reminiscences of Vincent van Gogh"

2 December 1910

It was about 1877 that the Reverend J. P. Stricker, who was widely respected in Amsterdam, asked me if I was willing to give lessons in Latin and Greek to his nephew Vincent, the son of the Reverend T. van Gogh, minister at Etten and De Hoeven, to prepare him for the matriculation exams for the university; he advised me to be well aware that I would not be dealing with an ordinary pupil, so I was already somewhat forewarned about his unusual behavior. That hardly discouraged me, especially since the Reverend Mr. Stricker spoke with so much affection about both Vincent himself and his parents.

Our first meeting, so critical for the relationship between teacher and student, was quite pleasant. The seemingly reticent young man—we differed only slightly in age, for I was then twenty-six and he was definitely over twenty—immediately felt comfortable, and despite his lank reddish-blond hair and many freckles, his appearance was by no means unpleasant. Let me say in passing that I do not at all understand why his sister speaks of "his more or less rough appearance." It is possible that since I last saw him, as a result of his slovenliness, or perhaps his growing a beard, his appearance lost something of its charming strangeness;

Reverend Stricker was Vincent's uncle through marriage to his mother's sister, and father of Kee Vos-Stricker, with whom Vincent fell in love (she rejected him) in 1881.

but certainly it was never rough, neither his nervous hands nor his face, although considered homely, expressed so much yet hid even more.

I soon discovered what was absolutely necessary in this case: to gain his confidence and his friendship. Since he had begun his studies with the best intentions, we made rapid progress from the start, and soon I was able to let him translate an easy Latin author. Needless to say, fanatic as he was at that time, he immediately started applying that little knowledge of Latin to reading Thomas a Kempis in the original.

Up to this point everything went well, including mathematics, which, in the meantime, he had begun studying with another teacher; but the Greek verbs soon became too much for him. No matter how I approached it, whatever means I invented to make the task less tedious, it was to no avail. "Mendes," he said (we called each other by surname), "Mendes, do you really think such horrors are necessary for someone who wants what I want: to give poor creatures a peacefulness in their existence on earth?" And I, who as his teacher could not possibly agree, but in the depth of my soul found that he—mind you I say: he, *Vincent van Gogh*—was entirely right, I defended myself as staunchly as possible; but it was futile.

"John Bunyan's *Pilgrim's Progress* is of much more use to me, as is Thomas a Kempis and a translation of the Bible; more than that I don't need." I no longer know how many times he said that to me, nor the number of times I went to the Reverend Mr. Stricker to discuss the matter. In any event, each time it was decided once again that Vincent should give it another try.

But before long it was the same old song, and then he would arrive in the morning with the all-too-familiar announcement: "Mendes, last night I used the cudgel again," or "Mendes, last night I let myself be locked out again." It should be noted that this was some sort of self-chastisement practiced whenever he found that he had neglected his duty. In fact, in those days he lived with his uncle, the Rear-Admiral J. van Gogh, director and commandant of the naval base in Amsterdam, whose large house was situated inside the naval dockyard. Whenever Vincent felt that his thoughts had deviated too much from what he considered proper, he took a cudgel to bed with him and scourged his back; if he felt that he had forfeited the privilege of spending that night in bed, he would slip out of the house unnoticed and, upon returning late to find the door locked for the night, he forced himself to lie on the ground in a small wooden shed, without bed or blanket. And he preferred to do this in the winter, so that the punishment, which I suspect was a form of mental or spiritual masochism, would be more severe. He certainly knew that such an announcement from him was anything but pleasant to me, and thus in order to appease me to some extent, he used to go early in the morning, either before his announcement or the next day, to what was then the Oosterbegraafsplaats, his favorite place to walk, to pick

snowdrops for me, preferably from under the snow. I still see him—I lived then on the Jonas Daniël Meyerplein and had my study on the third floor—crossing the wide square from the bridge over the Nieuwe Heerengracht without an overcoat, also a form of self-punishment, with books under his right arm, pressed closely against his body, holding snowdrops in his left hand to his chest, his head cocked to the right, while his face, because the corners of his mouth tended to droop down, displayed that indescribable veil of sad despair. And then when he had come upstairs, his voice resounded in that curious, deeply melancholy low tone: "Mendes, don't be angry at me; I have brought you some flowers again, because you are so good to me."

It was my feeling that to be angry, under such circumstances, would have been impossible for anyone, not just for me, who had readily understood, at that time, how much he was consumed by a need to help the unfortunate. Indeed, I had even noticed this in my own home; that

is to say, he not only paid much attention to my deaf-mute brother, but also he always had a kind word for and about a poor, slightly disfigured aunt who lived with us, who was not very intelligent and who spoke with such difficulty that many ridiculed her. This aunt tried to make herself useful by what one calls "minding the doorbell," and when she saw Vincent arriving, she hurried to the front door as fast as her old, short legs allowed to welcome him with a "Good morning, Mister van Gort." "Mendes," Vincent often said, "However strangely that aunt of yours pronounces my name, she is a good soul; I rather like her."

Since I was not so busy in those days, he often stayed on after the lesson to chat a little, and naturally we often discussed his former occupation, the art trade. He still had a number of prints that he had collected in those days, small lithographs after paintings and so on. Repeatedly he brought along prints for me, but invariably they were totally ruined, for he had literally filled the white borders with scribbled quotations from Thomas a Kempis or the Bible that more or less related to the subject. Once, as a gift, he gave me a copy of *De Imitatione Christi*, not at all with an unspoken intention of converting me, but simply to make me aware of the humanity in it.

Dr. Mendes da Costa was Jewish.

In no way could I suppose in those days—indeed, no more than anyone else or even himself—that the essence of the future color-visionary lay nascent in the depths of his soul. I remember only the following: proud of the fact that I could do it with the pennies I had earned myself, I replaced an oriental rug in my room, at least fifty years old and worn to tatters, with a very modest yet lively carpet of cow's hair. "Mendes," Vincent said when he saw it, "I had not expected this of you! Do you really consider that more beautiful than those old faded colors, which had so much to say?" And Mendes was ashamed of himself; he felt that the unusual young man was right.

Our association lasted a little less than a year. By then I had become convinced that he would never be able to pass the required examination. Thus what Mrs. Du Quesne maintains, that within a few months he had mastered Latin and Greek, is not correct, nor is it correct that Vincent stopped at the point when he was about to begin his actual studies at the Academy. No, at least one year before there might have even been talk of this (even with the utmost effort on his part), I advised his uncle, completely in accordance with Vincent's wishes, to let him stop. And so it happened. After our cordial leave-taking, before he went to the Borinage, I never saw him again. From there one letter from him to me, and an answer from me to him, and . . . after that, nothing more.

Reference to Elizabeth du Quesne-Van Gogh's Vincent van Gogh, *which is quite unreliable on later events in the artist's life.*

In July 1878, Van Gogh abandoned theological studies; in late December, he left for the Borinage.

Louis Piérard

LA VIE TRAGIQUE DE VINCENT VAN GOGH

"Among the Miners of the Borinage"

1939

INTERVIEW WITH REV. BONTE:

I hope to satisfy you as best as I can by putting together some reminiscences of Vincent van Gogh. In fact, I knew him forty-five years ago in the Borinage, where he was an evangelist (not a pastor, as he held no theological degree). He worked at Wasmes for about one year.

Rev. Bonte was a pastor who was installed in Warquignies, the neighboring village to Wasmes, in 1878. In late December 1878, Van Gogh had left his parents' Etten home for the Borinage, the coal-mining district of Belgium. As a mission preacher, he began in Pâturages; from January until his dismissal in July 1879, he was in Wasmes.

He was the son of a Dutch minister. I remember when he arrived at Pâturages: He was a blond young man of average height with a pleasant face; he was well dressed, had fine manners, and displayed in his person all the characteristics of Dutch cleanliness.

He expressed himself correctly in French and was capable of speaking quite suitably in the religious meetings of the small Protestant group at Wasmes to which he had been assigned. Another congregation at Wasmes had its own minister, while Vincent van Gogh's appointment was near the woods in the direction of Warquignies. He conducted services in a former dance hall.

Our young man took lodgings in a farm at Petit-Wasmes. The house was relatively pretty; it conspicuously stood out among the others in the neighborhood, where one saw only the miners' small cottages.

The family with whom Vincent van Gogh boarded had simple habits and lived like workers.

But our evangelist soon displayed toward his residence the particular sensibilities that possessed him. He found his lodgings too luxurious; it offended his Christian humility; he could not bear his shelter to be so different from that of the miners. So he left these people who surrounded him with sympathy to go live in a little shack. He lived alone; he had no furniture, and it is said that he slept huddled in a corner of the hearth.

Moreover, the clothing he wore outdoors revealed the originality of his aspirations; one saw him dressed to go out in an old soldier's jacket and a shabby cap, and in this attire he roamed around the village.

We never again saw the fine clothes with which he had arrived, and he did not buy new ones.

And while his salary was low, it was sufficient to have enabled him to dress more appropriately for his station.

How did this lad come to such a pass?

Confronted with the miseries he encountered in his visits, his pity had moved him to give away nearly all his clothing; his money, too, had gone to the poor; he had kept virtually nothing for himself. His religious beliefs were very ardent, and he desired to obey the teachings of Jesus Christ to the letter.

He felt bound to imitate the early Christians, to sacrifice everything he could do without, and he sought to be even more destitute than most of the miners to whom he preached the Gospel.

I may add that his Dutch cleanliness had also been conspicuously abandoned; soap was dismissed as a sinful luxury, and even when our evangelist was not covered with a layer of coal dust, his face was customarily dirtier than those of the miners.

These externals did not preoccupy him; he was absorbed in his ideal of renunciation. He made it clear that his attitude was not one of carelessness, but rather of the faithful practice of the beliefs that ruled his conscience.

And though he gave no thought to his own well-being, his heart was aroused by the needs of others.

He preferred to go to the most unfortunate, the injured and the sick, and stayed a long time with them; he was prepared to make any sacrifice to ease their suffering.

His profound sensibility extended beyond human things. Vincent van Gogh respected the lives of animals, even to the most lowly creature.

He did not disdain even the most wretched caterpillar; it was a living creature that must be protected.

The family with whom he had stayed told me that if he saw a caterpillar on the ground in the garden, he would gather it up delicately and go place it on a tree. Aside from this character trait that some might judge to be insignificant or even stupid, I have held the impression that Vincent van Gogh was obsessed with a high ideal; that of self-abnega-

This farmhouse was the home of Jean-Baptiste Denis, a baker on the rue du Petit-Wasmes.

Photograph of Vincent's father, Pastor Theodorus van Gogh (1822–1885). Rijksmuseum Vincent van Gogh, Amsterdam.

tion and devotion to all other beings—this was the guiding principle that he accepted with all his heart.

I am not disparaging the man when I confess that, in my opinion, he still had one fault: he was an incorrigible smoker. I sometimes needled him about it; myself opposed to tobacco, I told him that he was wrong not to give it up. He did nothing about it, a small shadow across his image, such as all painters must have.

As for his painting, I cannot speak as a connoisseur; *in any event, it was not taken seriously*.

He used to squat on the slag heaps and make portraits of the women gathering coal there, or leaving, burdened with sacks.

We noticed that he did not reproduce things of splendor, to which we attribute beauty.

He did a few portraits of old women. Besides, we didn't attach any importance to what we considered his hobby.

Also, however, it seems that in painting, our young man was partial to the rather more wretched-looking subjects.

And there you have, sir, the few recollections that my aged memory has been able to muster.

<p style="text-align:center">* * *</p>

REPORT OF THE UNION OF PROTESTANT CHURCHES OF BELGIUM, WASMES CHAPTER (1879–1880):

The experiment represented by accepting the services of a young Dutchman, M. Vincent van Gogh, who believed himself called to evangelize in the Borinage, has not produced the anticipated results. If, to the admirable qualities that he had shown in the care of the sick and the injured, to the devotion and the spirit of sacrifice, of which he had furnished ample proof in consecrating to them sleepless nights and by casting off, for their benefit, his clothing and linen, he had joined a talent for speaking, indispensable to anyone placed at the head of a congregation, M. Van Gogh would certainly have been an accomplished evangelist.

No doubt it would be unreasonable to demand extraordinary talents. But it is a fact that the absence of certain qualities can render the exercise of an evangelist's principal duty entirely unsatisfactory.

Unfortunately, this was the case of M. Van Gogh. Thus, when the trial period of some few months had expired, we were obliged to abandon the idea of keeping him on any longer.

The current evangelist, M. Hutton [sic], took over his duties on October 1, 1879!

<p style="text-align:center">* * *</p>

INTERVIEW WITH M. G. DELSAUT:

He was an intelligent young man, speaking little—always pensive. He lived very soberly: upon rising in the morning, he breakfasted on two pieces of dry bread, drank a large cup of black, cold coffee. Between meals, he drank only water. He always ate alone, and arranged not to eat in the company of others. While eating, he made drawings in his lap, or read. All his time was given to drawing. He often went to the Ghlin woods, to the Mons cemetery, and often into the countryside.

He drew mostly landscapes, castles, a shepherd with his flock, cows at pasture.

The most striking picture, the one that has stayed in the memory of my sister-in-law, with whom he lodged, is the drawing that shows the family harvesting potatoes; some are digging, the others (the women) are gathering up the potatoes.

He left behind some drawings and some books, but they have now all disappeared because of the dispersion of the family.

After Van Gogh's dismissal from this post in July, he continued missionary work on his own in Cuesmes, another village in the Borinage, from August 1879 through August 1880. He left for Brussels in October.

Gustave Delsaut, a Protestant, knew Van Gogh at Cuesmes in the late summer through the early fall of 1880.

In August 1880, Van Gogh began to draw with serious ambitions of becoming an artist. He was lodging at the home of a miner, Charles Decrucq, and his family at rue de Pavillon, 3, Cuesmes.

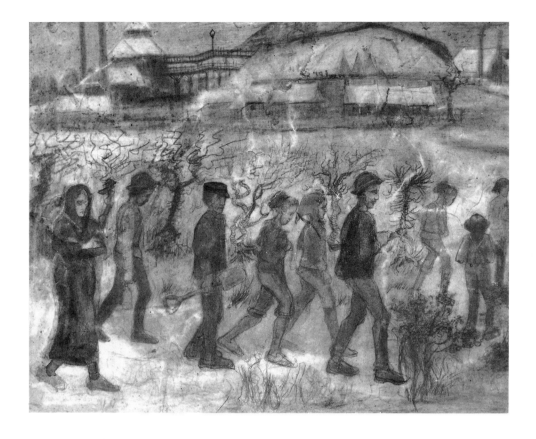

Miners. 1880. Pencil, lightly colored on wove paper. 17½ × 22″ (44.5 × 56 cm). Rijksmuseum Kröller-Müller, Otterlo.

His board was paid by his father, who sent him money. He spent a lot of money buying Bibles and New Testaments that he gave away when he went to paint.

Once his father had to come to Cuesmes to stop him from spending money on books.

He would go out painting with a camp stool under his arm and his box of paints on his back, like a peddler.

When he was stricken with boredom, he used to rub his hands endlessly.

Anton Kerssemakers

DE AMSTERDAMMER ("DE GROENE")

"Reminiscences of Vincent van Gogh"

14 and 21 April 1912

In Eindhoven beginning in November 1884, Van Gogh gave painting lessons to Anton C. Kerssemakers (1846–1926), a tanner and amateur artist; Hermans, a retired goldsmith who, in August, had commissioned Van Gogh to paint a decorative scheme for his dining room; Willem van der Wakker, a postal worker; and, beginning in 1885, Dimmen Gestel, a printer.

I became acquainted with the painter several years after his stay in the Borinage, when, after having worked in The Hague and in Drenthe, he moved to Nuenen around the year 1884.

At the time, I was engaged in painting a few landscapes on the walls of my office, instead of having them papered, and in his own way my house painter, who supplied me with paint, found this so nice that on one occasion he brought along Van Gogh to show him my work.

Van Gogh was of the opinion that I could draw fairly well, and good-natured as he was, immediately expressed his willingness to help me with my painting. The result was our further acquaintance and, on his

Kerssemakers and Van Gogh were introduced by Jan Baaiens, who owned a paint shop that stocked artist's oils as well as house paint.

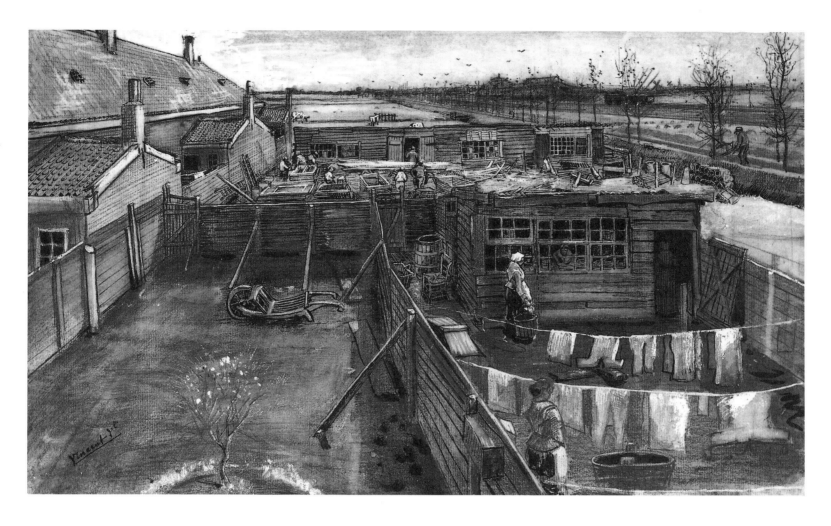

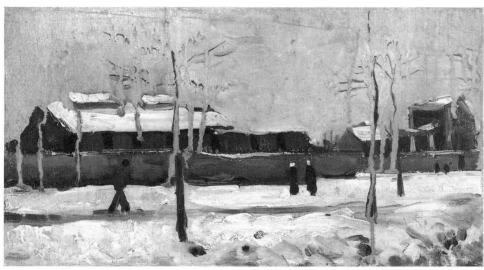

View from the Artist's Studio Window. 1882. Pencil, pen, and brush, heightened with white. 11⅜ × 18½″ (28.5 × 47 cm). Rijksmuseum Kröller-Müller, Otterlo.

The Old Station at Eindhoven. 1885. Canvas. 5⅞ × 10¼″ (15 × 26 cm). Private Collection.

friendly invitation, my visit to his studio in Nuenen, which I will discuss later. My house painter had great confidence in Van Gogh and prepared for him the colors he needed most, such as white and ochre and several others.

Since, however, this house painter was no expert, these colors often left much to be desired, but pressed by lack of money, Van Gogh had to make the best of it. I still have a small study as a souvenir of this unmanageable paint.

He painted this rapidly at my home to teach me; it was a view from my window during winter when the snow was melting; the thin white color flowed across the landscape.

On my first visit to his studio in Nuenen I had not yet acquired an eye for his work. It was so entirely different from what I had imag-

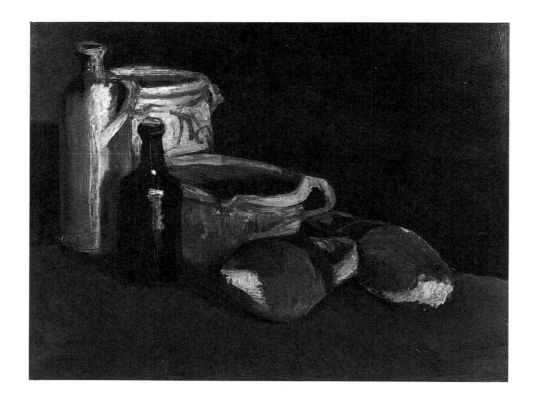

Still Life with Pottery and Clogs. 1884. Canvas on panel. 16½ × 21¼″ (42 × 54 cm). Centraal Museum Der Gemeente Utrecht (on loan from the Museum van Baaren Foundation).

ined—so brutal, so raw and unfinished—that with the best intention in the world I could not consider it either good or beautiful, and, extremely disappointed, I decided not to visit him again and to go my own way.

I soon noticed, however, that his work had after all made an impression on me that I could not get out of my head; his studies repeatedly came to mind; so I decided to visit him again. I was, as it were, drawn there.

On my second visit the impression was already considerably better indeed, although in my ignorance I still thought that he either could not draw or had totally neglected the drawing of figures, etc.; and I took the liberty of telling him this frankly.

He did not become angry at all, laughed a little, and said: "Later on you shall think otherwise about that." When I left he presented me with several prints from *The Graphic* and some by Adolf Menzel and others, advising me to look leisurely at them at home and to study and draw after them. "You will learn something from them."

On a subsequent occasion I brought along a few pieces that I had painted in the interim, in order to hear what he would say about them. Probably to avoid discouraging me, he said: "There is indeed some good in it, but now I advise you first to make several still lifes instead of landscapes; you will learn much from that; once you have painted fifty or so of these, you certainly shall see how you have improved by it, and I am prepared to help you and to paint the same subjects along with you. I likewise have much to learn, and there is no better way than this for learning about the proper placement and separation of things in space."

So, for days and weeks, with the utmost patience, he helped me to make some progress, all the while continuing to work hard himself, making countless drawings and sketches in watercolor and oil paint both indoors and outdoors. Once when I had pretty much lost heart and said, "Ah, it's no use any more, after all, I am too old to become a painter," he named several painters, among others H. W. Mesdag, who, starting out late in life, had still become great masters.

Once when we sat together in my studio painting the same still life, just a pair of wooden shoes and several pots, and I sat brushing away in my own style, laying on the color and scraping it off again, without being able to achieve volume, suddenly he walked over to me: "Look here, just

The Graphic was one of many English illustrated periodicals that Van Gogh avidly collected and studied. For the impact of these prints on his art, see Ronald Pickvance, English Influences on Vincent van Gogh *(1974).*

Adolf Menzel (1815–1905), German painter, engraver, and illustrator of realistic and minutely rendered historical scenes.

Hendrik Willem Mesdag (1831–1915), Hague school artist who achieved success with seascapes and paintings of fishermen and harbors. His impressive collection of nineteenth-century French and Dutch pictures is housed in the Rijksmuseum Mesdag, The Hague.

put a firm, dark transparent stroke there and there; no, don't be afraid, I will not destroy your drawing," and immediately he sat before it with his large, wide brush assaulting my small canvas. "You see, like this; look, now the other part comes forward; you must not keep brushing away in the same place for so long, you must just put it down and let it sit; you must not be afraid and not concern yourself with making it pretty.

"We will quit here for today, and now we must go and paint outdoors together. If you like I will certainly come here; otherwise you can just come to Nuenen again. I know enough beautiful, interesting spots there." So several times we made painting excursions in the Nuenen area: for instance, to that small old medieval chapel that stood in the middle of a field and to that beautiful old windmill near Lieshout, the subject of those forceful, strong studies which I saw later at his place, with those square little sheep along the bottom of the mill.

COLORPLATE 10

In those days he suffered poverty like a true Bohemian; it sometimes happened that for six weeks he went without meat but had only dry bread with a hunk of cheese, which did not spoil on the road, he said. The following may serve as proof that he was totally accustomed to this and, moreover, did not want anything else.

Once in Nuenen, when we were supposed to set out together in the heat of a summer afternoon, I said, "We shall first have coffee made in the inn and have a decent meal of sandwiches; then we will hold up until late in the evening."

No sooner said than done; what one proposed was always agreeable to him.

The table was well-provisioned with various breads, cheese, sliced ham, etc. When at a certain point I looked up, I noticed that he was eating dry bread with cheese, and I said, "Come on, Vincent, do eat some ham, put butter on your bread, and take sugar in your coffee; it has to be paid for whether you eat it or not." "No," he said, "that would be pampering myself too much; I am used to bread and cheese," and he calmly continued eating.

On his excursions, however, he did like to take along a flask with some brandy; that he would have sorely missed. But this was also virtually the only luxury he allowed himself.

His studio (he had rented some space at the sexton's) also looked quite Bohemian. One was amazed at how floors and walls were covered with paintings and drawings in watercolor and crayon, heads of men and women with boorish pug noses, prominent cheekbones, large ears sharply accentuated, and calloused and wrinkled fists; weavers and weaving looms, spinners, potato planters, weeders; countless still lifes; at least ten studies in oil of the previously mentioned small old chapel in Nuenen that he was so enthusiastic about that he painted it at every time of the year and in all weather conditions. Later this chapel was destroyed by the Nuenen vandals, as he called them.

COLORPLATES 8, 9, 12, 14, 16

A great pile of ashes around the stove that had never seen a brush or polish, a few chairs with frayed cane seats, a cupboard with about thirty different birds' nests, all sorts of moss and plants brought along from the heath, several stuffed birds, a bobbin, a spinning wheel, a bed-warmer, all kinds of farm tools, old caps and hats, dusty bonnets, wooden shoes, etc.

He had a paintbox and palette made to order in Nuenen, in addition to a perspective frame; this consisted of a sharply pointed iron bar onto which he could screw a frame at the desired height. He had said, "Indeed, the old masters used a perspective frame, so why shouldn't we?"

Some time later I visited several museums with him, and the Rijksmuseum [in Amsterdam] was the first on the agenda.

Because of domestic reasons I could not spend the night away from home, so he went the day before, and made an appointment to meet me the next day in the third-class waiting room at the Central Station.

When I entered the room, I saw a large crowd of people of all types and from all walks of life—conductors, workmen, tourists, etc.—standing near the windows in front of the waiting room; surrounded by this crowd, he sat quite calmly in his shaggy overcoat and his ever-present fur cap, fervently busy making a few small city views (he had taken along a small tin paintbox), undisturbed by the contemptuous comments and remarks loudly voiced by the "distinguished" (?) public.

When he caught sight of me, he calmly packed up his things, and we set out for the museum. Since it had then begun to pour, and Van Gogh in his fur cap and shaggy overcoat soon looked like a drowned tomcat, I hailed a cab, about which he grumbled considerably, saying, "What do I care what all of Amsterdam thinks? I prefer to walk, but if you will not have it otherwise. . . ."

In the museum he knew precisely where to find what interested him most; he brought me primarily to the Van Goyens, the Bols, and above all to the Rembrandts; he spent the most time in front of *The Jewish Bride.* He could not be torn away from it; he went and sat there at length, while I went on to see other things. "You will certainly find me here when you return," he said.

When I came back after a considerable time and asked if we shouldn't be off, he looked surprised and said, "Can you believe it, and I mean this sincerely, I would give ten years of my life if I could remain sitting here in front of this painting for two weeks with a crust of dry bread to eat?" Finally he got up. "Anyway," he said, "we can hardly stay here forever."

Then we stopped by the Gallery Van Gogh, where at his recommendation I bought two books, *Musées de Hollande* and *Trésors d'art en Angleterre* by W. Burger (Thoré). When I asked whether he was not going inside, he answered: "No, I must not show myself to such a proper, rich family." He still seemed to be at odds with the family; he remained outside waiting for me.

The gallery was run by Vincent's uncle, Cornelius Marinus ("C. M.") van Gogh (1824–1908).

Some time later we visited the museums of Antwerp. I remember vividly one particularly striking moment. It was when he caught sight of the fisher boy with the basket on his back [I believe by Velásquez]. Suddenly he had left my side, and I saw him running towards the painting, and I followed. When I caught up with him, he was standing before the painting with hands clasped as in prayer and murmured, "My God . . . look at that," and after a pause he said: "that is truly a painting, look," and tracing with his thumb the direction of the broad brushstrokes: "he indeed left it just the way he had put it down," and embracing the room with a wide gesture: "Almost everything else is as outdated as periwigs and pigtails."

He harbored deep respect for Corot, Daubigny, Diaz, Millet, and, further, the entire Barbizon school; he was always full of admiration for them, and in conversation about his dearly beloved art always reverted to them.

He never spoke about art with those who were totally uninformed, and he was terribly upset when a so-called art lover from this area liked one of his works; he always said that then he knew for sure that it was bad, and as a rule such studies were destroyed or repainted. Only with certain friends, among whom I had the fortune to be included, did he readily speak about painting, drawing, etching, etc., although in those days they could not completely accept his manner of painting. I have blamed myself many times for not understanding him better at the time; how much more I could have learned from him.

He was always comparing painting to music, and in order to gain an even better understanding of the value and nuances of tones, he began to take piano lessons with an old music teacher who was also the organist in E[indhoven]. This did not last long, however, because during the lessons Van Gogh incessantly compared the tones of the piano with Prussian blue and dark green, or dark ochre with bright cadmium, so that the good man thought that he was dealing with a madman and became so afraid of him that he discontinued the lessons.

I was also present at the painting of the water mill at Gestel, a picture that I later saw at Oldenzeel's and at the Boymans [museum in Rotterdam]. At the time he believed that with copaiba balsam he had found the means to counteract the loss of the brilliance of paint, but since he applied this as liberally as he did his paints, he used too much of it and the entire sky of the painting sagged to the bottom. So he had to remove it with his palette knife and paint it over, which one can still detect upon close scrutiny.

He signed only a few pieces. Once, when I asked him why he did not sign his name in full he answered, "Van Gogh is such an impossible name for many foreigners to pronounce; if my pieces turn up later in France or in England or wherever, then the name would certainly be butchered, while the whole world can pronounce the name Vincent correctly."

He frequently visited me at my home in E[indhoven]; once while I was painting in my garden, I suddenly heard behind me: "Look, yes, it is good that you are painting outdoors; you must do that often. . . . Yes, you see, the slant of that roof, that must be at least a 45-degree angle, but it appears too steep like that. And then I do not know how you will handle your colors, but that matters little. Just continue on: there is no better education than painting outdoors; you must always compare things thoroughly with one another, especially in tone. Painting is like algebra; that is to that as that is to that; and above all, study perspective closely, including aerial perspective. If you have already used green objects in the background, then how can you effectively use green in the foreground?"

Whenever he saw a beautiful evening sky, he became ecstatic, so to say. Once when we were coming from Nuenen to E[indhoven] toward evening, he suddenly stood still before a splendid sunset, and using his

Actually, the painting of a fisher boy was by Frans Hals.

Van Gogh studied music with a Mr. Vandersanden, the organist at St. Catherine's Church.

COLORPLATE 11

two hands to frame it somehow, and with his eyes half closed, he cried out: "My God, how does such a fellow, or God, or whatever you want to call him, how does he do that? We must be able to do that too. God, God, how beautiful that is; what a pity that we haven't a palette already set up, because it will surely be gone soon.

"Let's sit here for a little while. Take care that you never forget to close your eyes halfway when you paint outside; of course the louts in Nuenen say that I am crazy when they see me shuffling across the heath, standing still, squatting, squinting, holding my hands now like this, then like that in front of my eyes in order to frame the whole, but I don't care, I just go my own way."

For weeks at a stretch, he could be exclusively preoccupied with the drawing of hands, feet, or wooden shoes. "That must become second nature," he said.

According to the village gossip one of the models that he used for his paintings of peasant heads was his mistress. One recognizes her often in his studies of heads. He had even been reprimanded for it by one of the lay preachers, and he likewise attributed to this same person's influence the fact that he was refused the lease of his studio. Then, as he told me himself, he had taken a curious revenge but, too lacking in propriety to be recounted here, we shall cover this with the cloak of charity.

When he had finished his painting of the peasants sitting at a table, a very dark painting with a hanging lamp over the table and in which a peasant family sits eating from a plate of steaming potatoes, he carried it all the way to E[indhoven] to show me.

Afterward, he made a lithograph of this painting in a label factory, from which he took twenty impressions, some of which must still exist; mine, however, disintegrated later on because it was printed on ordinary, inferior paper.

Another time he came to me with a study of a spinner. He had not painted any spokes in the wheel, but rather a continuous, monochrome round smear of transparent gray. This was such a strange sight that at first I did not understand it and asked him why he had done it that way; "You don't understand?" he asked. "Sometimes the movement of the wheel is indicated this way."

He always spoke about Anton Mauve with much respect, though he had been unable to get along with him for quite some time and had only worked with him briefly. According to his explanation, Mauve once commented that he used his fingers too much in painting, whereupon he had become angry and had snapped at Mauve, "What does it matter, even if I do it with my heels, as long as it is good and it works."

The latter was actually a favorite expression of his; he always spoke that way: those little sheep work well or that small birch could work somewhat better or how beautifully it works against the evening light, etc.

He had already let it be known more than once that he wanted to leave, although I had not paid much attention to it, thinking that he was not serious. But finally he came to announce his departure for Antwerp and, after that, to France.

Before leaving he stopped by my place once more to say goodbye and brought along as a souvenir a splendid not-yet-dry autumn study, measuring one meter by eighty centimeters, that was finished entirely out-of-doors, and he took away a small canvas from me as a souvenir in return.

I still have this autumn picture. It is painted in very light tones and is very simple in subject: in the foreground, three knotty oaks still in full foliage and a gawky, bare pollard birch; in the background a tangled array of various partially bare trees and shrubs that shut off the horizon, and in the center a little woman in a white cap, jotted down simply in three touches but which works beautifully, as he would have said himself.

There is a gripping atmosphere of autumn in this painting; it is painted broadly, with thick impasto. When I remarked to him that he had not yet signed it, he said, "Perhaps I shall still do so since I will probably come back someday. But actually it is not really necessary. Later on they are bound to recognize my work, and they will surely write about me when I am dead. I will make sure of that if life grants me the time."

Sketch of Vincent's studio at Nuenen. Letter from Anton Kerssemakers to Johan Briedé. 23 June 1914.

Letter from Anton Kerssemakers to Johan Briedé

On Van Gogh's Studio in Nuenen

23 June 1914

Eindhoven, 23 June 1914
Mr. Johan Briedé
Rijswijk.

As far as it is still possible for me, I will gladly satisfy your request. It was, however, almost 30 years ago, so my memories (except the personal ones) have faded somewhat or become rather vague. I will jot down below what is still in my mind, and you will have to make do further with my article in *De Groene*. The cupboards were neither old nor antique; he had, as a matter of fact, nothing expensive in his possession. Everything testified to a lack of money, yet he knew how to make do with everything. He made a lot himself or just had everything made by a common carpen-

Kerssemakers refers to the preceding article, "Reminiscences of Vincent van Gogh."

ter—but according to his instructions—such as an easel, paintboxes, a perspective frame, a stool—everything; once, though, he ordered a small paintbox of lacquered tin from Schoefeld in Düsseldorf, and that was very complex.

1., 2. Man-high benches, upon which were studies and all sorts of things.

3., 4. Cupboards with birds' nests, clogs, etc.

5. Stove with a mountain of ashes around it. In all corners, farm tools, etc., etc. Everywhere, left and right on the floor and on chairs, sketches and illustrations, mostly from *The Graphic*. In short, a real mess.

I hope that you can do something with this scribble, but it is impossible for me to find the time to answer you properly. Please don't hold it against me.

<div style="text-align: right">

Yours truly,
Ant. Kerssemakers

</div>

Letters from Vincent to Theo
On Anton Kerssemakers
1884–1885

NOVEMBER 1884 *(386)*

Yesterday I brought home that study of the water mill at Gennep, which I painted with pleasure, and which has procured me a new friend in Eindhoven, who passionately wants to learn to paint, and to whom I paid a visit, after which we set to work at once. So that very evening he had already brushed a still life, and he has promised me he will try to paint about thirty of them this winter, which I will come and look at now and then, and help him to make. He is a tanner who has time and money, and is about forty years old, so he has more chances than Hermans, who wonderfully keeps up his ardor for all that, however, and works just as hard as he did the first days, *i.e.* gives almost *all* his time to it. I think this new fellow will soon get an eye for color. . . .

NOVEMBER 1884 *(387)*

Recently I really haven't been doing so badly. It is true that I can't have any financial success with my work here, but I am making really good friends here, who I believe will become even better.

Last week I painted still life day after day with the people who paint at Eindhoven.

That new acquaintance, the tanner whom I told you about, applies himself wonderfully. But I, for my part, must do something in return to keep up the friendship. But I don't see that I am the loser by it, as I work with more animation when I have some conversation. . . .

30 APRIL 1885 *(404)*

Yesterday I brought it to a friend of mine in Eindhoven who has taken up painting. After three days or so, I shall go and wash it there with the white of an egg, and finish some details.

The man, who himself is trying very hard to learn to paint, and to get a good palette, was very much pleased with it. He had already seen the study after which I had made the lithograph, and said he hadn't

COLORPLATE 11

Numbers in parentheses refer to the standard designations given to Van Gogh's letters; these numbers usually appear wherever the letters, which Van Gogh rarely dated, are reprinted.

COLORPLATE 13

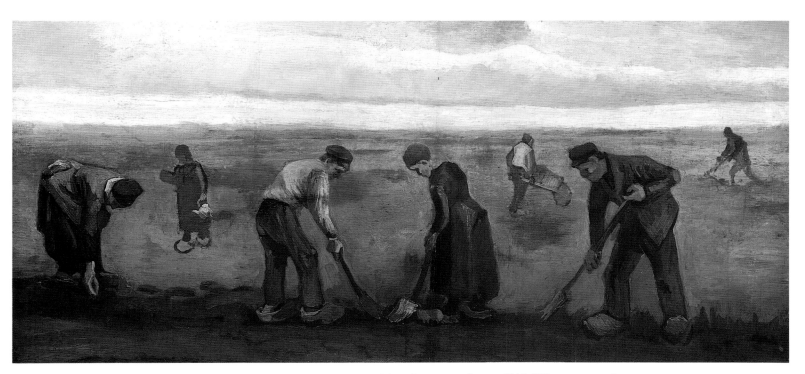

COLORPLATE 9. *Potato Harvest.* 1884. Canvas. 26 × 58⅝″ (66 × 149 cm).
Rijksmuseum Kröller-Müller, Otterlo.

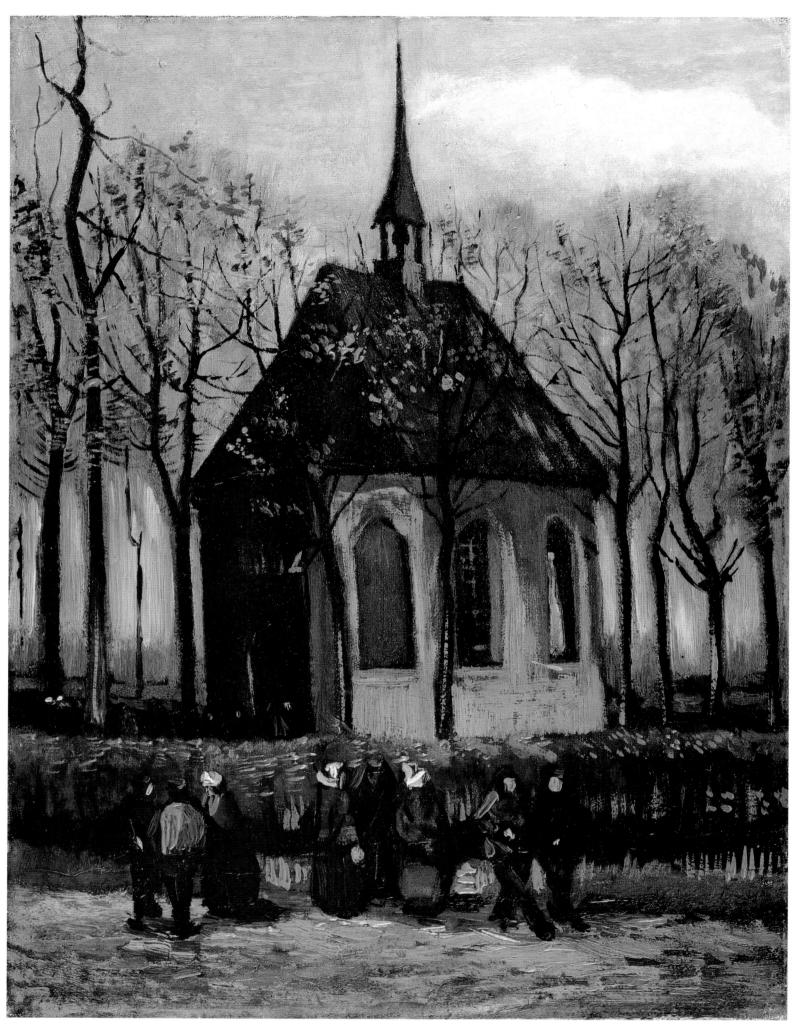

COLORPLATE 10. *Chapel at Nuenen*. 1884. Canvas. 16⅛ × 12⅝″ (41 × 32 cm).
Rijksmuseum Vincent van Gogh, Amsterdam.

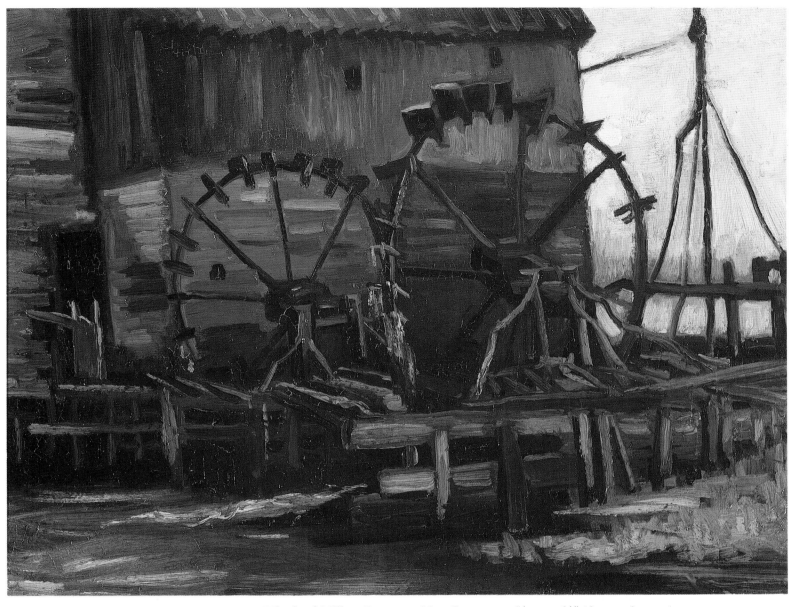

COLORPLATE 11. *Water Wheels of Mill at Gennep.* 1884. Canvas. 23⅝ × 31⅛″ (60 × 78.5 cm).
Stedelijk Museum, Amsterdam.

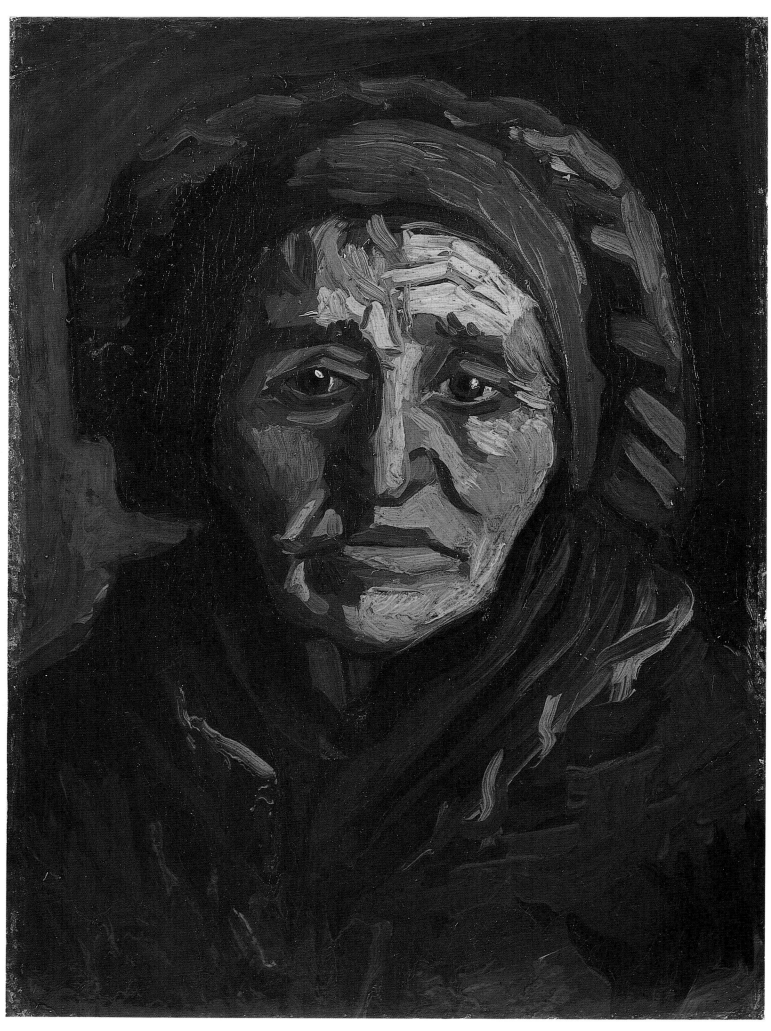

COLORPLATE 12. *Head of a Peasant Woman.* 1885. Canvas. 15 × 11″ (37.5 × 28 cm).
Rijksmuseum Kröller-Müller, Otterlo.

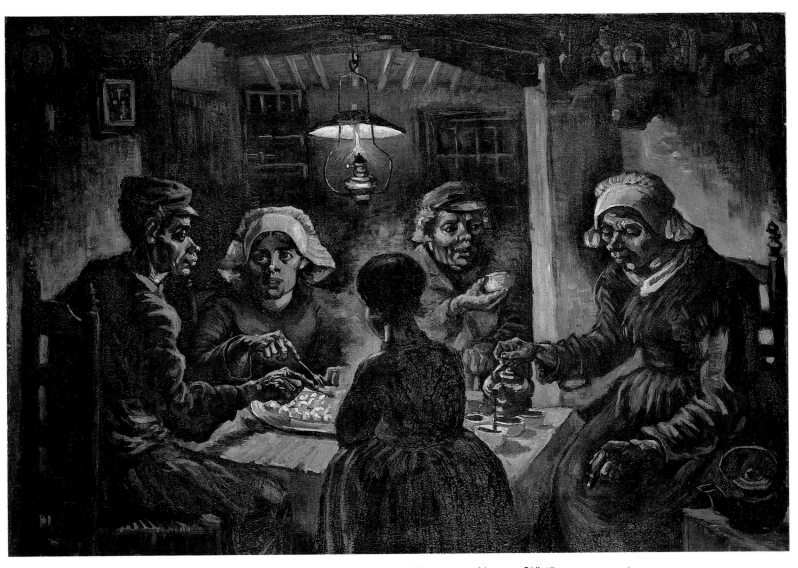

COLORPLATE 13. *The Potato Eaters.* 1885. Canvas. 32¼ × 44⅞″ (82 × 114 cm).
Rijksmuseum Vincent van Gogh, Amsterdam.

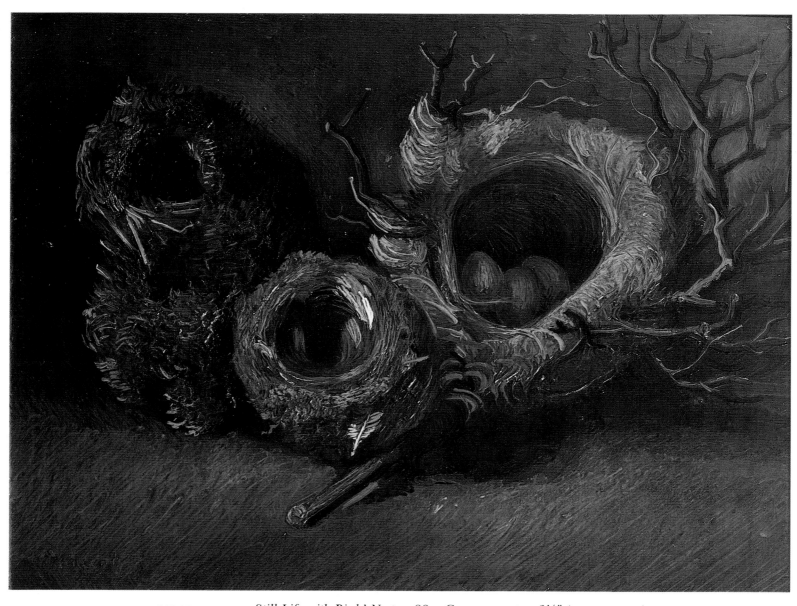

COLORPLATE 14. *Still Life with Birds' Nests*. 1885. Canvas. 13 × 16½″ (33 × 42 cm).
Rijksmuseum Kröller-Müller, Otterlo.

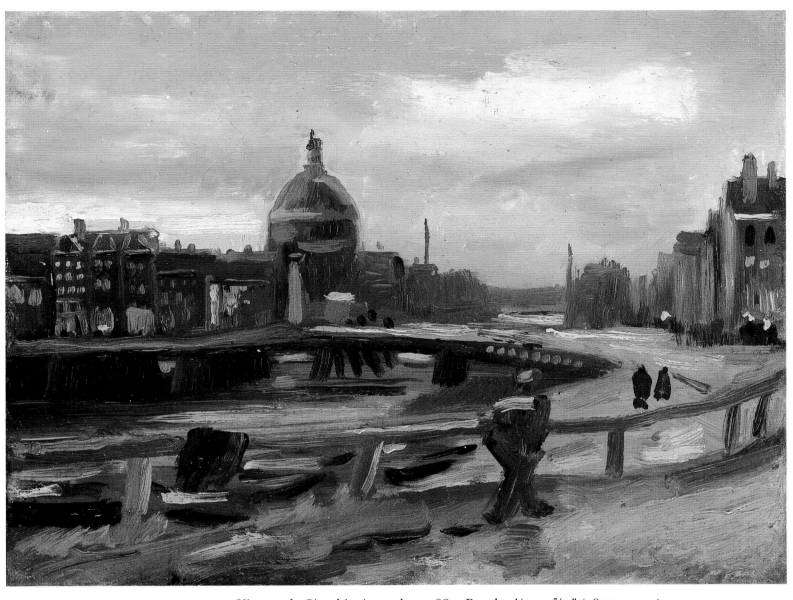

COLORPLATE 15. *View on the Singel in Amsterdam.* 1885. Panel. 7⅛ × 9⁷/₁₆″ (18 × 24 cm).
P. and N. de Boer Foundation, Amsterdam.

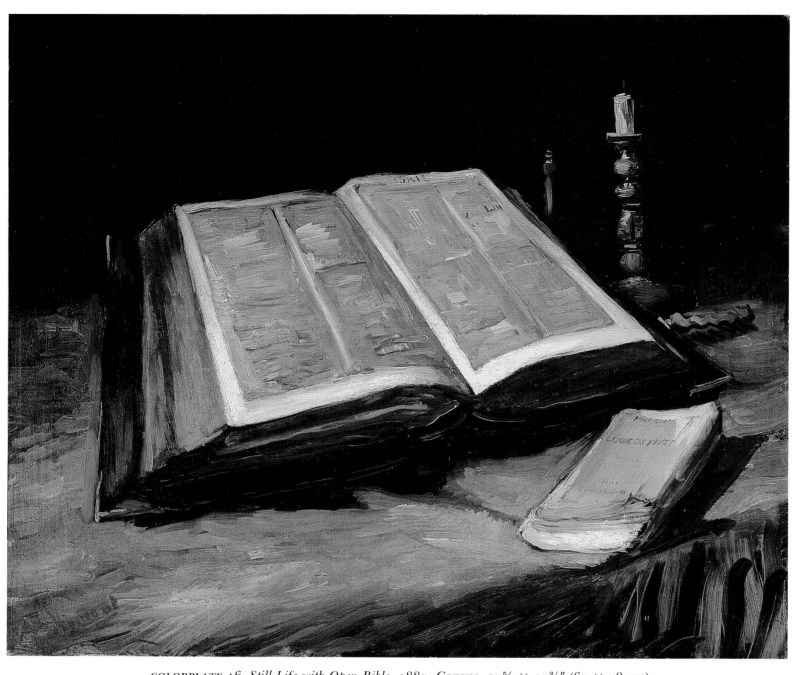

COLORPLATE 16. *Still Life with Open Bible.* 1885. Canvas. 25⅝ × 30¾″ (65 × 78 cm).
Rijksmuseum Vincent van Gogh, Amsterdam.

thought I could carry both the drawing and the color to such a pitch. As he paints from the model too, he also knows what is in a peasant's head or fist; and about the hands, he said that he himself had now got quite a different notion of how to paint them.

I have tried to emphasize that those people, eating their potatoes in the lamplight, have dug the earth with those very hands they put in the dish, and so it speaks of *manual labor*, and how they have honestly earned their food.

I have wanted to give the impression of a way of life quite different from that of us civilized people. Therefore I am not at all anxious for everyone to like it or to admire it at once. . . .

FIRST HALF OF NOVEMBER 1885 *(431)*

I think that I am making progress with my work. Last night something happened to me which I will tell you as minutely as I can. You know those three pollard oaks at the bottom of the garden at home; I have plodded on them for the fourth time. I had been at them for three days with a canvas the size of, let's say, the cottage, and the country churchyard which you have.

The Potato Eaters. 1885. Lithograph. 10½ × 12″ (26.5 × 30.5 cm). Rijksmuseum Vincent van Gogh, Amsterdam.

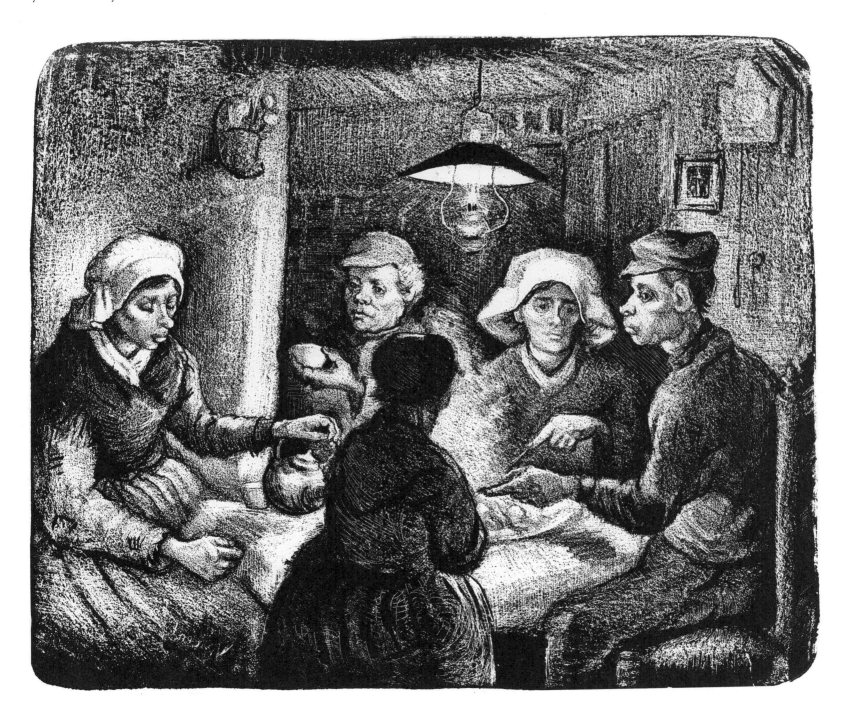

The difficulty was the tufts of havana leaves, to model them and give them form, color, tone. Then in the evening I took it to that acquaintance of mine in Eindhoven, who has a rather stylish drawing room, where we put it on the wall (gray paper, furniture black with gold). Well, never before was I so convinced that I shall make things that do well, that I shall succeed in calculating my colors, so that I have it in my power to make the right effect.

<p style="text-align:center">* * *</p>

Now, though that man has money, though he took a fancy to it, I felt such a glow of courage when I saw that it was good that, as it hung there, it created an atmosphere by the soft melancholy harmony of that combination of colors *that I could not sell it.*

But as he had a fancy for it, I gave it to him, and he accepted it just as I had intended, without many words, namely little more than, "The thing is damned good."

<p style="text-align:center">* * *</p>

Now as to that acquaintance of mine and his opinion of pictures; when someone with a clear, intelligent head paints still life and works out-of-doors every day, if only for a year, he need not therefore be an art critic, neither does he feel he is a painter yet, but for all that he will observe more originally than many others.

Besides, his character is not just like everybody's, for instance, he was originally intended to become a priest; at a certain moment he flatly refused this, *and carried his point*, in which not exactly every one in Brabant succeeds. And there is something broad-minded and loyal about him.

<p style="text-align:center">* * *</p>

I refer once more to that acquaintance of mine; it is exactly a year ago that I saw him for the first time, when I made that large sketch of a water mill which you perhaps know (its color is ripening well). Herewith a description of a study by that acquaintance of mine—some roofs, backs of houses, factory chimneys, dark against an evening sky. That evening sky blue, changing at the horizon into a glow between clouds of smoky color, with orange or rather ruddy reflections. The masses of houses, dark yet of a warm stone color, a silhouette that has something gloomy and threatening. The foreground, a vague plot in the dusk, black sand, faded grass, a bit of garden with a few dark melancholy apple trunks, with here and there a tuft of yellow autumn leaves.

It was all his idea alone, but isn't it a good conception, a real *impression*, well felt? But one doesn't become a *painter* in one year, nor is it necessary.

But there is already one good thing among the lot, and one feels hopeful, instead of feeling helpless before a stone wall. . . .

Ludwig 'Willem' Reijmert Wenkebach, *Interviewed by Mrs. Johan de Meester*

LETTERS TO AN ARTIST

1936

L. W. R. Wenkebach (1860–1937), Dutch landscape painter and illustrator.

My friend Van Rappard, being terribly upset at the violent quarrel which had arisen between him and Van Gogh, asked me to go and see Vincent

and try to bring about a reconciliation. I went to Nuenen, where Van Gogh lived, and the visit still stands out vividly in my memory. It was the most remarkable experience I ever had.

The big room was in a farmhouse of the sexton of the Catholic church. It was crowded with all sorts of articles, spread around in the greatest disorder. The first things my eyes caught were the characteristic, violently painted canvases as well as the expressive drawings which covered the walls. They were most striking. Then I discovered a great many birds' nests and eggs on several tables. Then there were wooden shoes, old caps and bonnets such as the womenfolk wear, some very dirty; old chairs without seats, rickety and broken, and in a corner all sorts of working tools. In a little room at the back sat Vincent before an easel; the room seemed much too small for a studio.

After shaking hands, it seemed to me as if Vincent was very pleased to see me. He showed me everything and he talked volubly and interestingly about his aim and his work, his difficulties in working with the peasants, and so forth.

It seemed so strange to me that, although he lived amongst them, he flew into a rage and was so provoked at them. Yet even more he railed against the "decent" people and the bourgeois, kicking now and then against his easel. During the conversation some of his drawings fell to the floor and, as I picked them up, my shirt cuff, which was fastened with a gold cufflink, showed. Vincent's eye fell on it, and looking at me in a contemptuous manner, he said furiously: "I can't stand people who wear such luxuries!" This unusual, unkind, and rude remark made me feel most uncomfortable, but I pretended not to notice it and paid no attention to it. Vincent himself forgot it immediately, for in the pleasantest way he proposed that we take a walk through the country.

It was during this walk that he gave me a glimpse of his sublime soul, his sensitive artistic feeling; he noticed all the colors, the delicate atmosphere, the bright sun and mighty clouds, the crops, the shady trees; he was full of enthusiasm about all the beauty of the country, every detail of light and shade on cottage and field, and so on. I felt that I had met a mighty artist!

This seemed to me the right moment to bring up the subject that had brought me there, and Vincent seemed also to have read my thoughts, for he told me how often he had walked there with Van Rappard, and how he regretted their variance about his drawings.

I then replied: "Anton did not intend to hurt you, but spoke his meaning freely as a friend to a friend, and he apologizes to you."

"Well, if he takes back what he said, it is all right," Vincent replied, and we dropped the subject.

The road on which we were walking was deeply furrowed, and taking the smoother side, I said: "Won't you walk behind instead of beside me? The road is so rough and uneven."

Vincent answered: "No, thank you. It is not good to take the smooth path in one's life! I never do!"

That same day we dined at the house of one of Van Gogh's friends in Eindhoven, and during dinner I talked about the French painter Stengelin, whom I had met in Drenthe. I mentioned that the peasants there did not like Stengelin. Imagine our consternation when Vincent suddenly flew into a rage, threw down his fork, cursed the peasants, and left the room!

There we sat. I was dumbfounded, but my host, knowing these fits of anger, did not seem to mind and said good-naturedly: "Oh, he is all right, just don't mind, he'll turn up again."

And indeed he did; just as I had arrived at the station to take the train back to Utrecht, Van Gogh appeared to bid me farewell, and as the train moved out of the station, he said, waving his hand:

"I hope you'll soon come again!"

Van Gogh quarreled with the artist Anton G. A. Ridder van Rappard (1858–1892) following his attack on the Potato Eaters *lithograph in May 1885. Wenkebach's attempt to mend the five-year friendship is also recorded in letters of Van Gogh to Theo, Van Rappard, and Kerssemakers.*

COLORPLATE 14

The dinner may have been at the home of Kerssemakers, for in late June 1885 Van Gogh wrote to him: "You probably saw that I was rude to him [Wenkebach] for a moment when he said that Stengelin was 'an eccentric person'. . . . I think his example is so good and practical that it makes me miserable that the Dutch painters who looked him up had all sorts of things to say against him." Alphonse Stengelin (1852–1938) was a French painter with a studio in Drenthe.

Seated Female Nude. 1886. Charcoal. 29⅛ × 23¼″ (73.5 × 59 cm). Rijksmuseum Vincent van Gogh, Amsterdam.

Victor Hageman, Interviewed by Louis Piérard

LES MARGES

"Van Gogh in Antwerp"

January 1914

At the time, I was a student in the drawing class. . . . I remember very well that disheveled, nervous, and restless man who fell like a bomb on the Academy of Antwerp, overwhelming the director, the drawing master, and the students.

Van Gogh, who was then thirty-one, first went into the painting class taught by Verlat, the director of the academy, who was the perfect example of an official and characterless painter, charged with transmitting for posterity the memory of great patriotic events by means of painting.

Victor Hageman (1868–1938), Belgian painter, was a fellow-student at the Academy of Antwerp during Van Gogh's attendance from January to February 1886 when he was—despite Hageman's testimony—32 years old.

Charles Verlat (1824–1890), Belgian history and animal painter.

Into this class of approximately sixty students, a good fifteen of them German or English, Van Gogh arrived one morning, dressed in the sort of blue smock worn by Flemish livestock merchants, and wearing a fur cap on his head. In place of a palette, he used a board torn from a crate that had contained sugar or yeast. That day, the students were to paint two wrestlers posing on the modeling platform, stripped to the waist.

Van Gogh began painting feverishly, furiously, with a speed that stupefied his fellow students. He had laid on his impasto so thickly that his colors literally dripped from the canvas onto the floor.

When Verlat saw this work and its extraordinary creator, he asked in Flemish, somewhat bewilderedly, "Who are you?"

Van Gogh answered quietly, "Wel, Ik ben Vincent, Hollandsch." ("Well, I am Vincent, a Dutchman.")

Then, the very academic director, while pointing to the newcomer's canvas, proclaimed disdainfully, "I cannot correct such putrid dogs. My boy, go quickly to the drawing class."

Cheeks flushed, Van Gogh contained his rage and fled to the class of the good M. Sieber [sic], who was also frightened by novelty, but who had a less irascible temperament than his director.

Vincent stayed there for a few weeks, drawing ardently, applying himself with visible forbearance to capture the subject, working rapidly

M. Sieber refers to Eugène F. J. Siberdt (1851–1931), Belgian painter of portraits and historical genre scenes.

Seated Man with Cap. 1886. Black chalk and charcoal. 29½ × 22⅞″ (74.5 × 58 cm). Rijksmuseum Vincent van Gogh, Amsterdam.

without retouching and more often than not tearing up his drawing or throwing it behind him as soon as he finished it. He would sketch everything that was to be found in the classroom: the students, their clothing, or the furniture, but forgetting the plaster cast that the professor had assigned to copy. Already Van Gogh had astonished everyone with the speed at which he worked, redoing the same drawing or painting ten or fifteen times.

One day in the drawing class of the Academy of Antwerp, the students were given, as if by chance, a cast of the Venus de Milo to copy. Van Gogh, struck by one of the essential characteristics of the model, strongly accentuated the width of her hips and subjected the Venus to the same deformations that he brought to *The Sower* by Millet and *The Good Samaritan* by Delacroix—other works which he was also to copy in the course of his career. The beautiful Greek goddess had become a robust Flemish matron. When the honest M. Sieber saw this, he tore Van Gogh's sheet of paper with the furious strokes of his crayon, correcting his drawing while reminding him of the immutable canons of art.

Then the young Dutchman, . . . whose gruffness had frightened off the refined female clientele at Goupil's in Paris, flew into a violent rage and shouted at the horrified professor: "You clearly don't know what a young woman is like, *God damn it*! A woman must have hips, buttocks, a pelvis in which she can carry a baby!" This was the last lesson that Van Gogh took—or gave—at the Academy of Antwerp. There he had made some staunch friends among the students, especially among the English, such as Levens. . . . With those who understood him, who sensed his nascent genius, he showed himself to be communicative, enthusiastic, and fraternal. Very often he spoke to them of the rough and good-hearted miners of the Borinage whom he had catechized, cared for, and helped with so much love. During the tragic strikes of 1886, he even wanted to return to that black country.

Millet's Sowers *pictures served as the basis for a number of works by Van Gogh. Van Gogh's copy after Delacroix is in the Rijksmuseum Kröller-Müller, Otterlo.*

Van Gogh had worked at the Paris branch of Goupil's from October to December 1874 and from May 1875 to March 1876.

Horace Mann Levens (1862–1936), a minor British painter of figures and landscapes with whom Van Gogh later corresponded from Paris.

Richard Baseleer, *Interviewed by Marc E. Tralbaut*

VINCENT VAN GOGH IN ZIJN ANTWERPSE PERIODE

1948

Richard Baseleer (b. 1867), Belgian seascape painter, engraver, and a fellow-student (and years later, an instructor) at the Academy of Antwerp.

The drawing class, as well as the painting class, was housed in the courtyard; thus, they were separated from each other by a wooden partition. One-third of the space was reserved for the drawing class and the remaining two-thirds served the painting class. Owing to this arrangement, if one wanted to go to the drawing class, one was obliged to cross through the painting class. All-in-all, such a situation seemed for the youthful draftsmen and painters of the Antwerp Academy a very unfortunate solution to the ticklish problem of the *Lebensraum*! But the climax of what may be looked upon as a miniature Babel-like confusion was reached every time there was a break, when the young people swarmed about, bustling pell-mell just like a dispersed ant colony. . . . It is true that there was an attendant to maintain order among the students in Mr. Verlat's class, and, in his absence, in the form of a retired Flemish police officer, Van Havermaet, who under any circumstance felt obliged to jabber a sort of gibberish that he himself took for French and that (for exam-

Piet van Havermaet (1834–1897), Belgian portrait and landscape painter who later taught at the Academy.

ple) culminated in his favorite insult: "Me, I rub my ass at all your jokes!"

But on the day that Vincent came rushing in like a bull in a china-shop and spread out all over the floor a roll of studies that he carried under his arm—what to the uninitiated would seem most singular, but in the world of artists is a very normal manner of exposing one's work— the ex-police officer was entirely unable to assert his already questionable authority. Everyone crowded around the newly arrived Dutchman, who gave more of an impression of an itinerant oilcloth dealer, unrolling and unfolding at a flea market his marked-down samples of easily foldable tablecloths, than of an artist—let alone of the by-this-time-famous master, who already had behind him his Nuenen period, with the world-famous *Potato Eaters*!

Indeed, what a funny spectacle! And what an effect it had! The majority of the young chaps laughed their heads off. . . .

Soon, the news that a wild man had surfaced spread like wildfire throughout the building complex, and people looked on Vincent as if he were a rare specimen from the human wonders collection in a traveling circus. But Vincent himself didn't notice—or at least pretended as though he didn't, for with such acute powers of observation as his, it could hardly have escaped him—and he withdrew further into that stoic silence which soon earned him a reputation for self-centeredness.

COLORPLATE 13

François Gauzi

LAUTREC ET SON TEMPS

1954

François Gauzi (1862–1933), artist and Henri de Toulouse-Lautrec's close friend, neighbor (at 7, rue Tourlacque), and biographer.

When Vincent van Gogh entered the Cormon atelier, he wanted to be called only by his first name, and for a long time we didn't know his real last name. He was an excellent companion who had to be left in peace. A man of the north, he didn't appreciate the Parisian spirit; for that reason, the mischievous members of the atelier avoided kidding him. They were a bit afraid of him.

When discussing "art," if one disagreed with him and pushed him to the limit, he would flare up in a disturbing way. Color drove him mad. Delacroix was his god, and when he spoke of this painter, his lips would quiver with emotion. For a long time, Van Gogh contented himself with drawing; his drawings had nothing remarkable about them nor had they shown any particular stylistic tendency, and then, one Monday, he placed a canvas on an easel: for the first time, he was going to paint at the atelier.

A woman posed on the modeling platform, seated on a stool. Van Gogh quickly sketched out his design on the canvas and took up his palette.

In his corrections, Cormon asked his students to limit themselves to the study of the model, that is, they were to copy strictly what they had in front of them without changing anything; and the students strictly followed the master's advice. Van Gogh no doubt ignored this advice. In any event, instead of a study, he wanted to make a painting.

Transforming the stool into a couch, he seated the woman on a blue drapery, an intense, unexpected blue, which, placed in opposition to the golden yellow of the woman's skin, resulted in a relationship of violent new tones, one inflaming the other. He worked with a disorderly fury, throwing colors on the canvas with feverish speed. He gathered up the color as though with a shovel, and the globs of paint, covering the length

Van Gogh attended the atelier of Fernand-Anne Piestre, called Cormon (1845–1924), 104, boulevard de Clichy, for "three or four months" (459a), in the spring and/or fall of 1886. On this subject see: Bogomila Welsh-Ovcharov, Vincent van Gogh and His Paris Period 1886–1888 (1976).

of the paintbrush, stuck to his fingers. When the model rested, he didn't stop painting. The violence of his study surprised the atelier; the classically-oriented remained bewildered by it.

When Cormon entered the atelier on Wednesday, conversations stopped and, as was usual, everyone kept a relative silence, broken only by the grating of charcoal on paper, erasers rubbing, or shuffling feet.

But the moment Cormon had placed himself in front of Van Gogh's study, the silence became absolute, impressive; everyone looked at his drawing and listened closely: What would the master say?

Situated not far from Vincent, I watched Cormon from the corner of my eye. Impassively he looked at Van Gogh's painting without uttering a word. Finally he spoke, and the correction he gave, neglecting color, was solely directed at the drawing.

So, without paying any more attention to Cormon or Vincent, everyone returned to his work.

One day when he had come to my place, Vincent glanced at my table when leaving and noticed a volume of Balzac: *César Birotteau*.

"You read Balzac," he said to me. "You're correct in doing so. What an astonishing author; everyone should know him by heart."

I hadn't attached any importance to this incident, but a few days later Lautrec said to me, "You know that Van Gogh has special esteem for you since he learned that Balzac was your favorite author." Chance sometimes brings about special consideration; Van Gogh might just as easily have found a work of Zola on my table, or of Musset, or even—God forbid!—"a passing whim" of Willy. Then what would he have thought of me?

I returned his visit. He lived in a spacious, well-lit room that also served as his studio. Just then he was finishing a still life, which he showed me. At the flea market he'd bought an old pair of clumsy, bulky shoes—peddler's shoes—but clean and freshly shined. They were fine old clonkers, but unexceptional. He put them on one afternoon when it rained and went for a walk along the old city walls. Spotted with mud, they had become interesting. A study is not necessarily a painting; old clodhoppers or roses—one would have served just as well as the other.

Vincent faithfully copied his pair of shoes. This idea, which wasn't at all revolutionary, seemed bizarre to some of our atelier friends, who couldn't imagine that, in a dining room, a plate of apples could hang as a pendant to a pair of clodhoppers.

An avid reader, Van Gogh highly regarded the writings of Honoré de Balzac (1799–1850) as well as those of the naturalist writer, Emile Zola (1840–1902).

Also mentioned: Alfred de Musset (1810–1857), one of the great figures of the Romantic literary movement, and Sidonie-Gabrielle Colette (1873–1954), whose sensuous and at times perverse fiction, published under the pen-name "Willy," achieved popularity and some scandal in the early twentieth century.

COLORPLATES 25, 28

Photograph of students at Cormon's atelier. Ca. 1886. Emile Bernard is at the top right (indicated by white arrow) and Henri de Toulouse-Lautrec is seated at left on a stool.

COLORPLATE 17. *The Parsonage at Nuenen.* 1885. Canvas. 13 × 16⅞″ (33 × 43 cm).
Rijksmuseum Vincent van Gogh, Amsterdam.

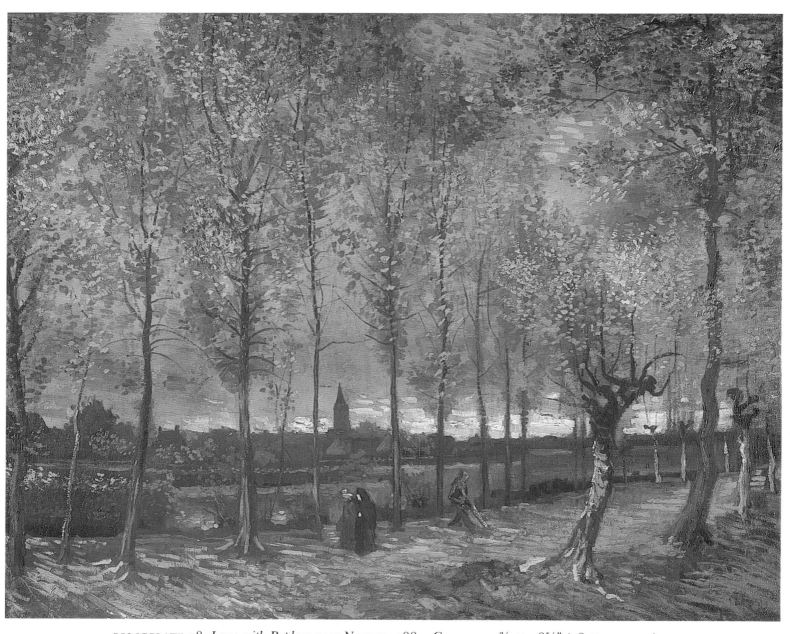

COLORPLATE 18. *Lane with Poplars near Nuenen.* 1885. Canvas. 30¾ × 38⅝″ (78 × 97.5 cm).
Museum Boymans-van Beuningen, Rotterdam.

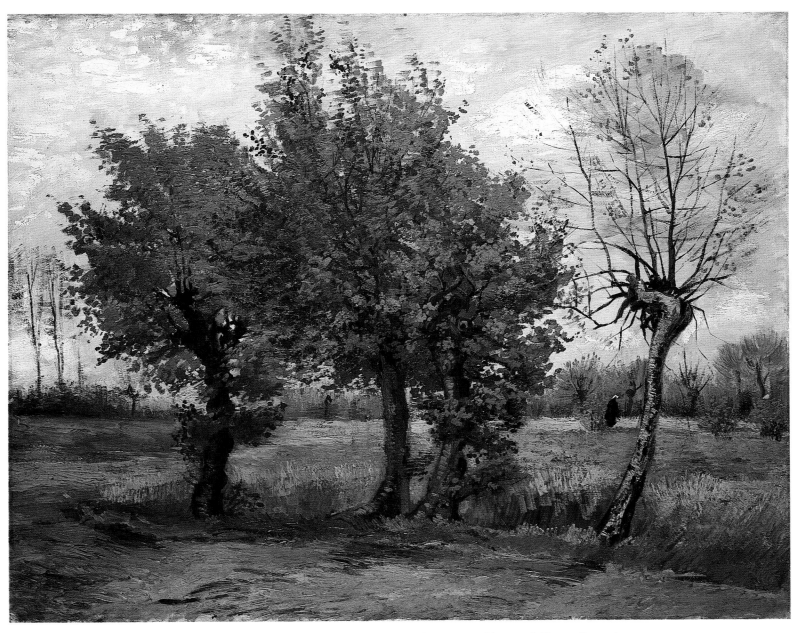

COLORPLATE 19. *Autumn Landscape*. 1885. Canvas. 25¼ × 35″ (64 × 89 cm).
Rijksmuseum Kröller-Müller, Otterlo.

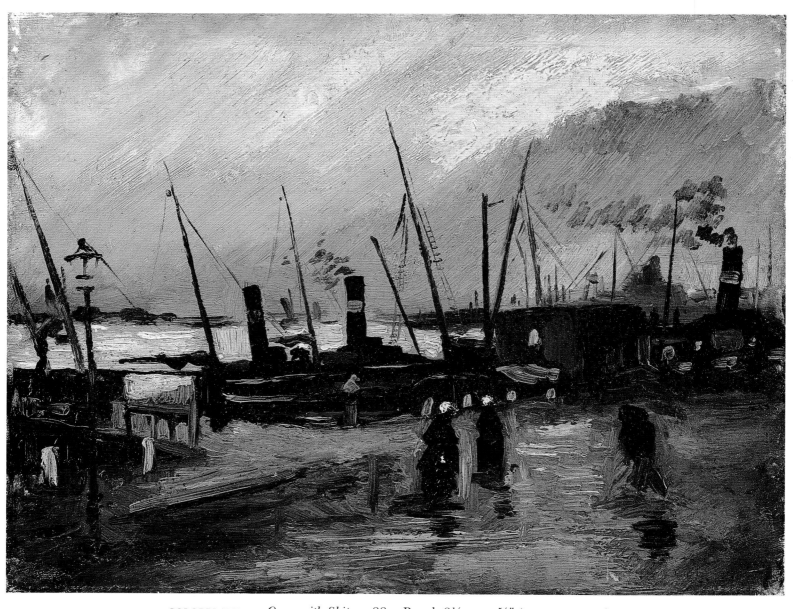

COLORPLATE 20. *Quay with Ships.* 1885. Panel. 8¼ × 10⅝″ (20.5 × 27 cm).
Rijksmuseum Vincent van Gogh, Amsterdam.

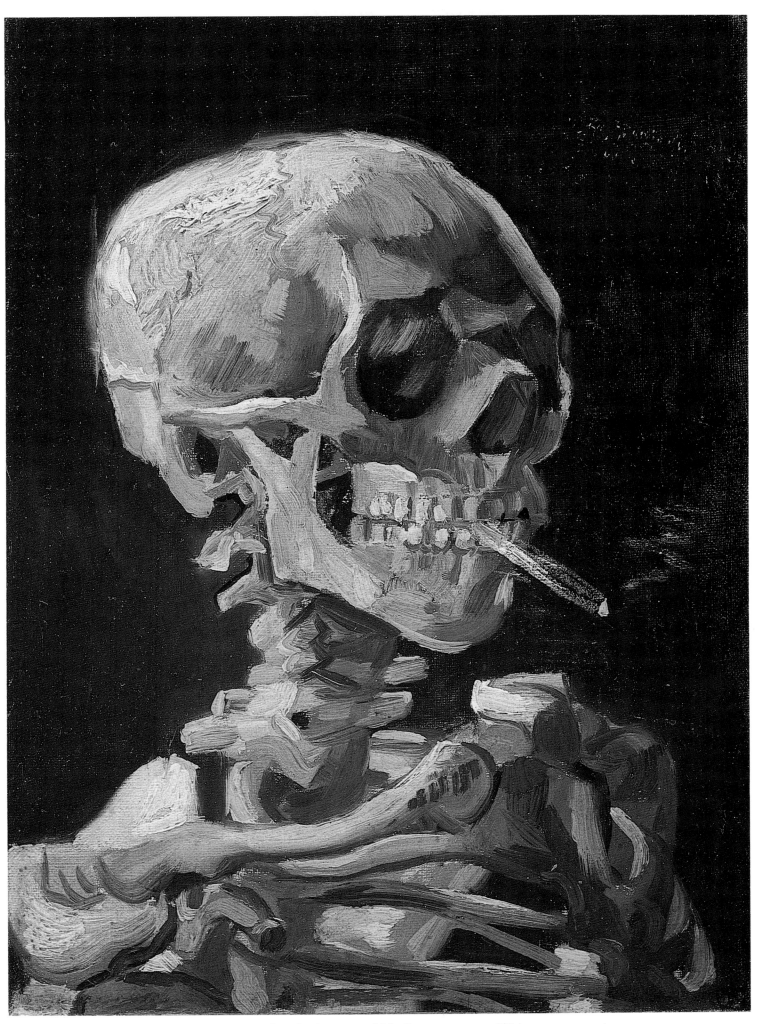

COLORPLATE 21. *Skull with Cigarette.* 1886. Canvas. 13 × 9½″ (32.5 × 24 cm).
Rijksmuseum Vincent van Gogh, Amsterdam.

COLORPLATE 22. *Male Nude*. 1886. Cardboard. 13¾ × 10⅝″ (35 × 27 cm).
Rijksmuseum Vincent van Gogh, Amsterdam.

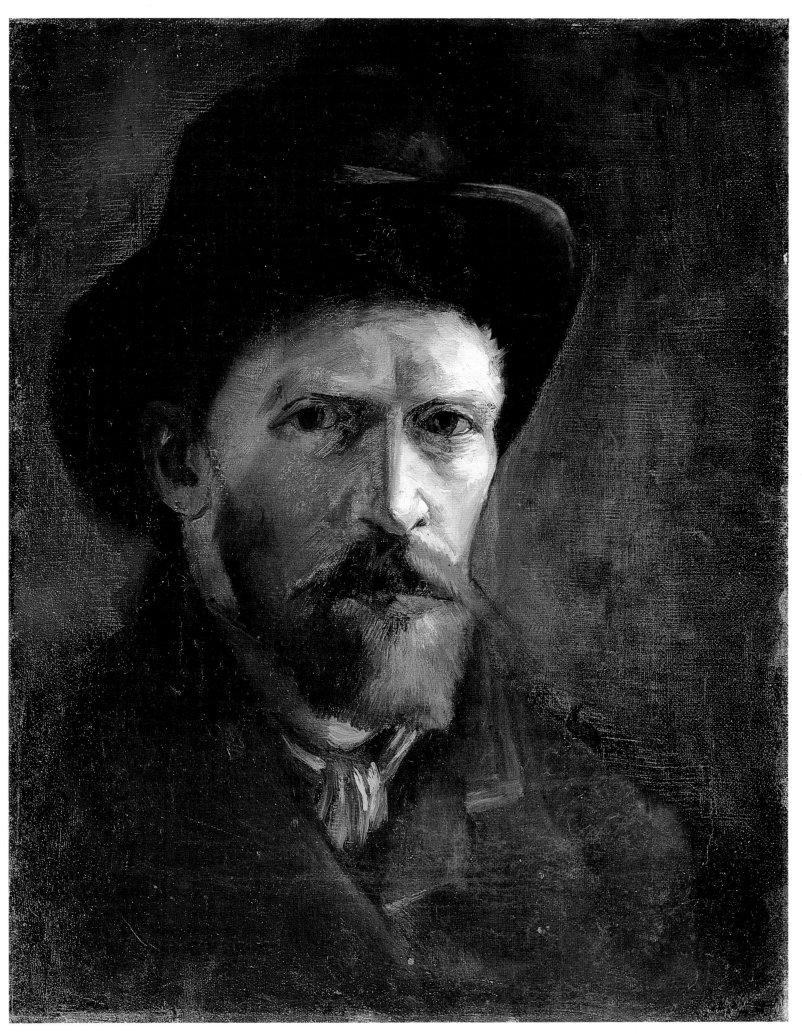

COLORPLATE 23. *Self-Portrait with Felt Hat.* 1886. Canvas. 16⅛ × 13″ (41 × 32.5 cm).
Rijksmuseum Vincent van Gogh, Amsterdam.

COLORPLATE 24. *The Roofs of Paris.* 1886. Canvas. 21¼ × 28⅜″ (54 × 72 cm).
Rijksmuseum Vincent van Gogh, Amsterdam.

A. S. Hartrick

A PAINTER'S PILGRIMAGE THROUGH FIFTY YEARS

1939

My return to Paris, after the summer at Pont-Aven, was delayed till some time in November. I remember this because, when I left, the leaves had not all fallen from the trees. . . . Some time before this, I had made the acquaintance of J. P. Russell, a big Australian, who had become notable among art students in Paris by his athletic prowess in a boxing club he had formed. He was the son of a great Australian engineer, who founded a school of engineering in Sydney University; he was a man of means, but had quarreled with his people in Australia, married an Italian model and was living permanently in Paris. He had been working for some time in the Atelier Cormon, which was situated in the Clichy quarter, where, I learnt, were the homes of the painters with new ideas. Russell also had his studio in the neighborhood.

Here it was, then, that guided by pure chance I first set eyes on Van Gogh, or "Vincent," as he was generally known and signed himself in Paris, because the French could not pronounce Van Gogh. It so happened that he, too, had been working *chez* Cormon, up to the summer of 1886, when that atelier was suddenly closed down by Cormon himself on account of a disturbance among the pupils there. In spite of certain quite erroneous theories . . . that Van Gogh was of robust appearance (to fit the fury of his painting, no doubt), I can affirm that to my eye Van Gogh was a rather weedy little man, with pinched features, red hair and beard, and a light blue eye. He had an extraordinary way of pouring out sentences, if he got started, in Dutch, English and French, then glancing back at you over his shoulder, and hissing through his teeth. In fact, when thus excited, he looked more than a little mad; at other times he was apt to be morose, as if suspicious. To tell the truth, I fancy the French were civil to him largely because his brother Theodore was employed by Goupil and Company and so bought pictures.

* * *

I saw him first in Russell's studio in the Impasse Hélène, Clichy quarter. Russell had just painted that portrait of him in a striped blue suit, looking over his shoulder. . . . It was an admirable likeness, more so than any of those by himself or Gauguin. I am told it has darkened very much. Formerly it was catalogued as by an American—Australia being a *terra incognita* in art.

In the summer of 1886, Anquetin, Cormon's best pupil, who had painted and had on the walls some very powerful studies, rather in the manner of Courbet, quite orthodox academics, which would have won medals in any school, turned "intransigeant"; that is, he went over to the advanced section of the "pointillists" led by Signac and Seurat and carried most of the studio with him. Among those working in the studio was a young man called Bernard, about eighteen years of age, in whom Cormon took an interest. Cormon came round one morning, as usual, to find Bernard painting the old brown sail that served for a background to the model, in alternate streaks of vermilion and vert veronese. On asking the youth what he was doing, Bernard replied, "that he saw it that way." Thereupon Cormon announced that if that was the case he had better go and see things that way somewhere else. In the light of later experi-

Archibald Standish Hartrick (1864–1950), Scottish painter, had spent the summer of 1886 in Pont-Aven, where he met Paul Gauguin.

This account, written well after his acquaintance with Van Gogh in Paris, is a curious amalgam of reminiscence and secondary elaboration. It cannot be considered entirely accurate, particularly for chronology.

John Peter Russell (1858–1931), since the beginning of 1885 at Cormon's atelier, lived at 73, boulevard de Clichy. Other sometimes residents on the boulevard de Clichy: Degas (no. 61), Renoir (no. 11), and Seurat (no. 128).

Louis Anquetin (1861–1932), Post-Impressionist affiliated with the Synthetist group and credited (by Dujardin in the 1 March 1888 La Revue indépendante) as the inventor of the style "le Cloissonisme."

Emile Bernard (1868–1941) had entered Cormon's in 1884 and left, before Van Gogh's arrival, in April 1886 for a six-month walking tour of Brittany. Bernard recalled first noticing Van Gogh in the fall 1886, when he saw Lautrec at Cormon's. The pistol incident, below, is probably fictitious.

ences this action was not so outrageous as might appear to the unini-
tiated. It was quite a common thing in the studio to make a flesh-gray by
mixing these two colors together on the palette; very bad chemically, no
doubt. Bernard was religiously carrying out this experiment on the the-
ory that, put down side by side in spots or streaks, these colors at a dis-
tance would combine and make a gray to the eye. But immediately "the
fat was in the fire." Someone, I forget whom, told Cormon he was an old
Academician, hidebound with prejudice, and that he was interfering with
genius in the bud. In short, there was a great uproar about little—a dis-
turbance of the sort that could only happen in a studio in Paris. Cormon
closed down the studio at once for some months, and all the more ag-
gressive students were sent away. During this period, the story goes that
Vincent, full of indignation, took this interference with the free expres-
sion of the artist so much to heart that he went round with a pistol to
shoot Cormon, but, fortunately, did not find him in.

* * *

Although he was using impressionist theories of the division of tones, I
do not think he was ever a scientific painter in the sense that Seurat and
Lautrec became in dealing with complementary colors; but he was par-
ticularly pleased with a theory that the eye carried a portion of the last
sensation it had enjoyed into the next, so that something of both must
be included in every picture made. The difficulty was to decide what
were the proper sensations so colored to combine together.

An obvious instance of this sort of idea will be found in the fact that
the entering of a lamplit room out of the night increases the orange ef-
fect of the light, and in the contrary case, the blue. Hence to depict it
properly, according to the theory, it was necessary in the former case to
include some blue in the picture and in the latter some orange. Van Gogh
would roll his eyes and hiss through his teeth with gusto, as he brought
out the words "blue," "orange"—complementary colors of course.

* * *

In some aspects Van Gogh was personally as simple as a child, express-
ing pleasure and pain loudly in a childlike manner. The direct way he
showed his likes and dislikes was sometimes very disconcerting, but
without malice or conscious knowledge that he was giving offense. When
in Paris he did not appear so poverty-stricken to me as one would sup-
pose from the various tales written of him. He dressed quite well and in
an ordinary way, better than many in the atelier. I have been to the flat
where he was living with his brother Theodore, 54, rue Lepic. It was
quite a comfortable one, even rather cluttered up with all sorts of fur-
niture and works of art. On an easel was the yellow picture called "Ro-
mans Parisiens," the first of a series of yellow pictures. Then he drew my
attention specially to a number of what he called "crêpes," i.e. Japanese
prints printed on crinkled paper like crêpe. It was clear they interested
him greatly, and I am convinced, from the way he talked, that what he
was aiming at in his own painting was to get a similar effect of little cast
shadows in oil paint from roughness of surface, and this he finally
achieved. He showed me some etchings given him by Matthew Maris
(Tyse Maris as he called him), an old friend evidently, also a bundle of
lithographs by himself of Dutch peasant women working in the fields,
and among them a proof of that terrible litho he called "Sorrow" done
from the woman he lived with in Amsterdam [sic]: naked, pregnant and
starving. When I admired some of these he offered me the bundle, but
I, perhaps foolishly, refused to deprive him, as he was apt to act thus
impulsively if anyone praised his work.

* * *

As a matter of fact, Van Gogh could not sell any of his work at this time.
He used to rage from time to time that, though he was closely con-

COLORPLATE 38

*Matthijs Maris (1837–1917), an artist
admired by Van Gogh as early as 1874,
when he was at Goupil's in London.
During that time he had spoken once or
twice to Maris, who recalled in a 1907
letter to David Croal Thompson: "after
the war or siege of Paris, a young fellow
of the name of Vincent van Gogh came
around asking for advice."*

*The model for "Sorrow" was Sien
(Clasina Maria Hoornik), with whom Van
Gogh lived in The Hague (1882 to
1883).*

John Russell. *Portrait of Vincent van Gogh.*
1886. Canvas. 23⅝ × 17¾″ (60 × 45 cm).
Rijksmuseum Vincent van Gogh,
Amsterdam.

nected with the picture-trade, no one would buy anything he had done. He actually told me that he had never had more than 10 francs for a picture. Tanguy used, I believe, to let him have colors sometimes in exchange.

While I knew him, I don't think anybody in Paris called him mad; but I frankly confess that neither myself, nor any of those I remember of his friends, foresaw that Van Gogh would be talked of specially and considered a great genius in the future. We thought him "cracked" but harmless, perhaps not interesting enough to bother much about. Though he was always an artist in temperament, we considered his work too unskilful in handling to make an appeal to the student mind; for there were many who could surpass him from that point of view, and, as I have said, I think the French generally rather tolerated him on account of his brother Theodore's position in Goupil's.

Russell had kindly offered to sponsor my entry into the Atelier Cormon. I had taken some of my work to show the great man at his private studio; he had been interested and accepted me as a pupil—quite a feather in my cap, I thought, because Cormon's studio at that time was

Julien François Tanguy (1825–1894), a color merchant and art dealer, who around 1873 opened his own shop at 14, rue Clauzel in Paris. While a number of artists had deposited their works with him, Vignon, Cézanne, and (from late 1886) Van Gogh were his most loyal clients.

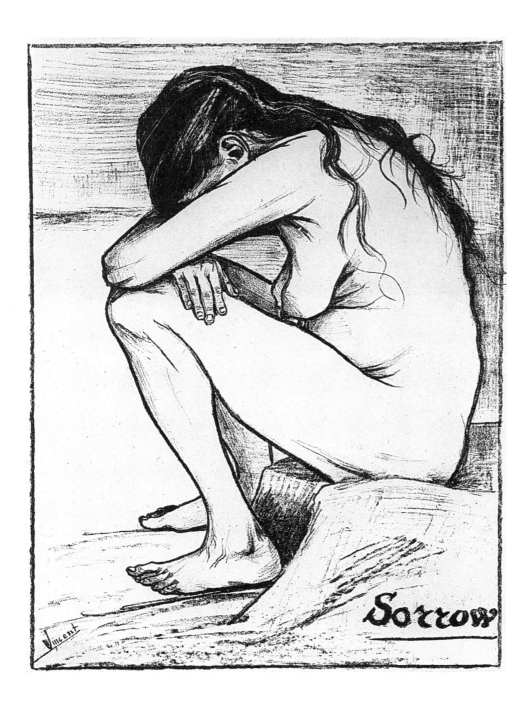

"Sorrow." 1882. Lithograph. 15⅜ × 11⅜″ (38.5 × 29 cm). Rijksmuseum Vincent van Gogh, Amsterdam.

small and select, not more than thirty to thirty-five pupils all told, of whom few were foreigners. Indeed English and Americans rarely got into it.

The studio had just been reopened after the row in the summer, and some of the former pupils had been permitted to return. Among them, Toulouse Lautrec may be mentioned especially. . . . At the same time, Russell, who was going to Sicily with his wife and child for the winter and spring, let part of his house to Henry Ryland (a follower of Burne-Jones) and myself; a very convenient arrangement this, for me working at Cormon's, in the rue Constance, and also for Ryland, who was working in Benjamin Constant's studio.

Henry Ryland (1856–1924), British academic figure painter.

Cormon was a sharp-featured little man, dark-haired, with the quick movements of a small bird, which he somehow resembled. He painted enormous pictures of prehistoric man, with titles such as "Le chasse de l'Ours, l'âge de pierre" or "La famille de Caïn" fleeing through a wilderness. . . . In spite of the abuse which has been showered on him for failing to recognize genius in his studio—a failing common to his contemporaries—I should say that he had excellent brains, was an admirable teacher, more sympathetic to novelties than most of his kind. No doubt he was particular about drawing, and especially construction,

as a true Frenchman and member of the Institute. In my time he was respected as an artist and as a teacher. . . . The crown of his reputation in the studio, however, was that he kept three mistresses at one time! He was unmarried at this period and was accustomed to receive any of his pupils, who wished to go, at his private studio on Sundays, when he would look at and criticize any work, even a sketchbook, that might be brought to him. There were several former pupils, grown men and quite well-known artists, who used to consult him freely; or before the Salon he would go to see their work in their own studios without any pose at all.

*　　*　　*

Theodore van Gogh's gallery was in the Boulevard Montmartre, quite separate from the main galleries of the house of Goupil, or rather Boussod, Valadon et Cie, as it was beginning to be known. Here, rather against the instincts of his superiors in the firm, Theodore was being allowed to try to work up a business in the work of the great impressionists, Manet, Renoir, Monet, etc., with Degas a lone figure rather apart. On the quiet he was also seeking to find buyers for the latest experiments by the "intransigeants," as they were named—Signac, Seurat, Lautrec, Gauguin and even by Vincent himself. There, in his brother's shop, Van Gogh at last met and made contact with the artists, whose experiments with pure color were to open his eyes and to create a new art

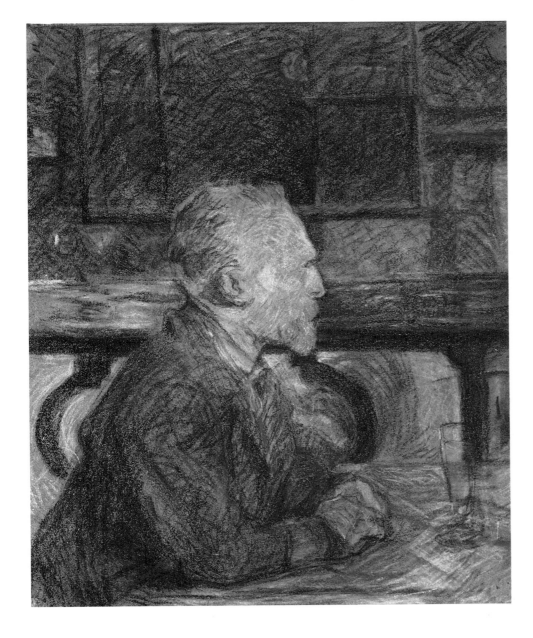

Henri de Toulouse-Lautrec. *Portrait of Vincent van Gogh.* 1887. Pastel. 21¼ × 18½" (54 × 47 cm). Rijksmuseum Vincent van Gogh, Amsterdam.

of his own. Though I cannot remember seeing Lautrec in the company of Vincent, I know they foregathered, and about this time Lautrec made his well-known Pastel Portrait of "Vincent," which is a good likeness and very characteristic of its author as well.

A man I did see going about with him was Alexander Reid, the Glasgow picture dealer, who later was the first to introduce impressionist pictures to collectors in Scotland. As my home was in the west of Scotland, I also foregathered with him. Reid had tried some painting himself not very successfully, but enough to enable him to understand and become enthusiastic about new movements. His father and principals in Glasgow were interested in the Barbizon School; Corot, Millet, and Daubigny were the artists he had been sent to France to study and acquire.

He was a young man then, younger, I fancy, than Van Gogh, but physically remarkably like him, so that certain portraits Vincent made of him were for long believed to be self-portraits. The likeness was so marked that they might have been twins. I have often hesitated, until I got close, as to which of them I was meeting. They even dressed somewhat similarly, though I doubt if Vincent ever possessed anything like the Harris tweeds Reid usually wore. Reid got into serious trouble with his father for acquiring or investing in some of Van Gogh's work, but I cannot believe he gave much money for them or I should have heard about it from the painter! It was the contact with such atrocities, as they

Alexander Reid (1854–1928) came to Paris in 1887 where, during a few months of employment at Boussod & Valadon (Goupil's successors), he worked with Theo van Gogh, director of the smaller branch on the boulevard Montmartre. Vincent became a friend of Reid and twice painted his portrait in 1887. In 1889 Reid returned to Glasgow with a portrait and a still life of apples, both gifts from Van Gogh, but he did not handle Van Gogh's works until 1920.

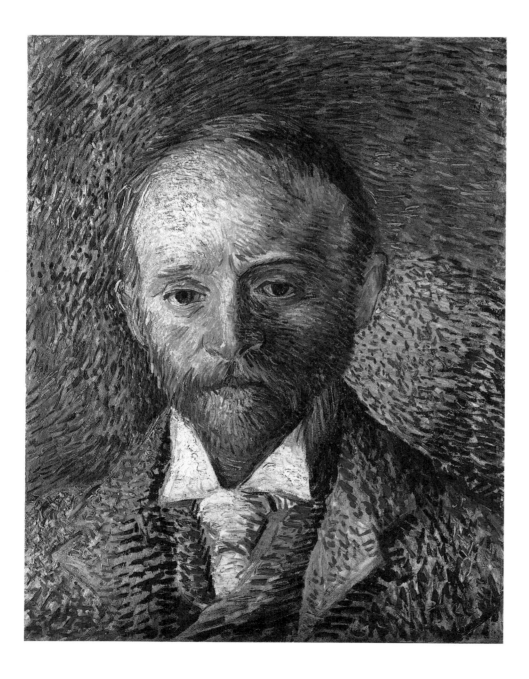

Portrait of Alexander Reid. 1887. Cardboard. 16½ × 13⅜″ (41.5 × 33.5 cm). Glasgow Art Gallery and Museum.

seemed, that roused the ire of the parent; for, in the view of the elder picture dealer, Reid was destroying his taste for what was salable.

All through the early part of 1887, Vincent frequently came to see me in the Impasse Hélène, to the horror of poor Ryland, who, having hung up a set of weak watercolors of the "La belle dame sans merci" type, found himself unmercifully attacked by the free tongue of Van Gogh, who promptly told him that they were anemic and useless reflections of Pre-Raphaelites—a kind of artist that he mostly despised. I would return, from going up and down in Paris, to find Ryland, who suffered from sick headaches, with his head wrapped in a towel soaked in vinegar and looking a sickly yellow, while he wailed: "Where have you been? That terrible man has been here for two hours waiting for you and I can't stand it any more."

On another occasion I would be in to greet him. Now Vincent had a habit of carrying a thick stick of red and one of blue chalk in each pocket of his coat. With these he used to illustrate his latest impressions or theories of art. As he would start work on the wall or anything that was handy, I immediately placed a newspaper or two on the table, where he would at once begin to set out his latest "motif" in lines a quarter to half an inch thick. I recall the set-out of one such, depicting the scene in a restaurant he favored at that time. It was a long narrow room, with a narrow table, and seats against the wall, a tall window filling the end. In the foreground he showed some overcoats hanging up, then a line of eaters in perspective. Through the window, as he eagerly informed me, was a dung heap and on it "un petit bonhomme qui pisse." "Voilà!" he said. The design was certainly striking and, again, I wish I had kept it.

During the summer, Vincent kept going out to paint the river at Surennes or Bougival, carrying his painting traps with him and usually covering himself and others with paint from his canvas when his work was complete!

Russell, whose child had died while away, came back suddenly from Sicily, so I had to move out and go to a hotel for the remainder of my time in Paris, and with this move I lost touch with Vincent.

Russell returned to Paris in the late spring–early summer of 1887.

Suzanne Valadon, Interviewed by Florent Fels

VINCENT VAN GOGH

1928

Suzanne Valadon (1867–1938), a painter; an artist's model, especially for Puvis de Chavannes and Renoir; and mother of Maurice Utrillo.

Suzanne Valadon told me one day, "I remember Van Gogh coming to our weekly gatherings at Lautrec's. He arrived carrying a heavy canvas under his arm, put it down in a corner but well in the light, and waited for us to pay some attention to it. No one took notice. He sat across from it, surveying the glances, seldom joining in the conversation. Then, tired, he would leave, carrying back his latest work. But the next week he would come back, commencing and recommencing with the same stratagem."

Lautrec and Valadon were good friends and neighbors at 7, rue Tourlacque; Van Gogh lived nearby on the rue Lepic.

Letter from Lucien Pissarro to Dr. Paul Gachet

On Van Gogh in Paris

26 January 1928

Lucien Pissarro (1863–1944), French painter and printmaker; his father, Camille Pissarro (1831–1903), among the Impressionists promoted by Theo van Gogh, suggested that Vincent go for treatment to Dr. Paul Gachet in Auvers in 1890.

Hôtel Terrass
12 and 14, rue de Maistre
Paris
26 January 1928

My dear Gachet,

* * *

No, I didn't keep a record of my recollections of the events and achievements of my father and of his friends—that is hardly in my capacity—writing is for me such drudgery. To answer your questions I will tell you[:]

* * *

The *Apples* by Van Gogh belonged to me and it is dedicated to me. We had made an exchange: I had given him a collection of my wood engravings. It would be quite difficult to present a composite portrait of Van Gogh. However I can tell you a small incident:

One day my father and I met him on rue Lepic. He was returning from Asnières with canvases, drawn from the motifs he found there. He was dressed in a blue canvas smock, like a zinc worker, and he had insisted on showing his studies to my father: to do so he lined them up against the wall in the street, to the great amazement of the passersby.

Basket with Apples (dedicated to Lucien Pissarro). 1887. Canvas. 21¼ × 25⅜″ (54 × 64.5 cm). Rijksmuseum Kröller-Müller, Otterlo.

Yes, I attended an evening gathering at the rue Lepic, a gathering where we made some experiments in autosuggestion—nothing very extraordinary. It must have been around 1886–87. . . .

* * *

Lucien Pissarro

Max Osborn

DER BUNTE SPIEGEL

1945

Pissarro had obviously made up his mind to give me "lessons in Impressionism." Therefore, he insisted that I visit, on the following day for "an hour," Durand-Ruel's, then the headquarters of the avant-garde. Entirely new worlds revealed themselves to me. At that time I first heard the name Van Gogh—the sort of thing one does not forget. "Many times I have said," stated Pissarro, who, in a sense, was Van Gogh's teacher, "that this man will either go mad or outpace us all. That he would do both, I did not foresee."

Gustave Coquiot

VINCENT VAN GOGH

1923

PAUL SIGNAC TO COQUIOT

Yes, I knew Van Gogh from the shop of père Tanguy. I would meet him other times at Asnières and at Saint-Ouen; we painted on the riverbanks; we lunched at an open-air roadhouse, and we returned by foot to Paris, by the avenues of Saint-Ouen and Clichy. Van Gogh, dressed in a blue jacket of a zinc worker, had small dots of color painted on his sleeves. Sticking quite close to me, he shouted and gesticulated, brandishing his large, freshly painted size 30 canvas in such a way that he polychromed himself and the passersby.

* * *

CHARLES ANGRAND, IN CONVERSATION

About Van Gogh I have very few memories. Without a doubt, we found ourselves sometimes at père Tanguy's; but what has most remained in my memory is the visit he paid me at the end of one November at the Collège Chaptal. I could meet him only at the café. I remember that he didn't want to drink anything. He came above all to make an exchange, an instance, I believe, of his mania. I had at père Tanguy's then a thickly painted canvas of a woman followed by chickens. Had he been seduced by the impasto?

A little later, he had to leave Paris. Anyway, we didn't stay in contact. I knew his brother better than him.

* * *

Max Osborn (1870–1946), polemicist for Expressionist art who was among the first critics to support the emergent Die Brücke artists, recorded these recollections of Camille Pissarro.

Paul Durand-Ruel (1831–1922), the pioneering art dealer of Impressionist pictures.

Paul Signac (1863–1935), French Neo-Impressionist painter and theorist. Signac visited Van Gogh in Arles in March 1888 and was instrumental in organizing the posthumous exhibitions in Paris and Brussels in 1891.

A size 30 canvas measures approximately 28³/₄ × 36¹/₄ in. (ca. 73 × 92 cm).

Charles Angrand (1854–1926), Neo-Impressionist artist and founding member of the Salon des Indépendants with whom Van Gogh proposed an exchange in October 1886, without success, of Angrand's In the Farmyard (1884).

Van Gogh's "mania" for exchanging works with other artists is a leitmotif in the correspondence; most of the works he acquired in this way are in the Rijksmuseum Vincent van Gogh, Amsterdam.

Letter from Georges Seurat to Maurice Beaubourg

On Van Gogh in Paris

28 August 1890

I was less close to Van Gogh. In 1887, I spoke with him for the first time in a working-class restaurant located near *la Fourche*, avenue de Clichy (closed). An immense skylighted hall was decorated with his canvases. He exhibited with the Indépendants in 1888, 1889, 1890.

Georges Seurat (1859–1891), Neo-Impressionist painter.

Van Gogh organized a group exhibition in November–December 1887 (himself, Anquetin, Bernard, A. H. Koning, Lautrec, and possibly Guillaumin) at the Grand Bouillon-Restaurant du Chalet, at 43, avenue de Clichy. Prior to leaving for Arles, on 19 February 1888, he visited Seurat.

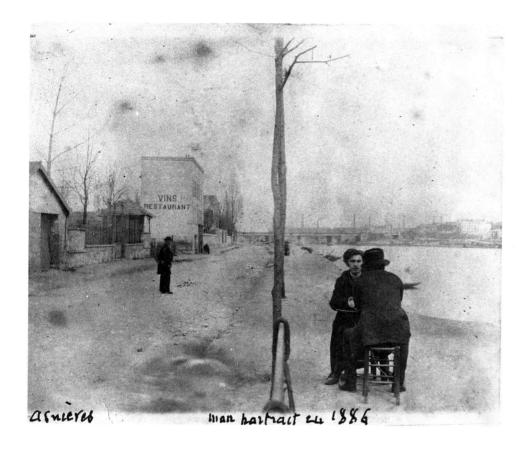

asnières mon portrait en 1886

Photograph of Emile Bernard and Van Gogh in Asnières. 1886. Private Collection.

Emile Bernard

LETTRES DE VINCENT VAN GOGH À EMILE BERNARD

Preface

1911

I can see him again at Cormon's, in the afternoon, when the atelier, empty of students, became for him a sort of cell. Seated before an antique plaster cast, he copies the beautiful forms with angelic patience. He wants to seize hold of these contours, these masses, these reliefs. He corrects himself, starts over with passion, erases, and finally wears a hole in

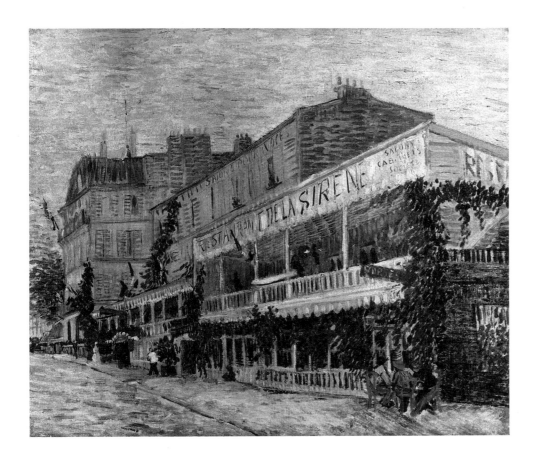

Restaurant de la Sirène at Asnières. 1887.
Canvas. 22½ × 26¾″ (57 × 68 cm).
Musée d'Orsay, Paris. Photograph:
Musées Nationaux.

his sheet of paper from rubbing it with an eraser. What he does not yet suspect, before this Roman marvel, is that everything in his Dutch nature is an obstacle to the conquest he seeks; and he will find a better avenue, and sooner, in the Impressionists, with their free fantasy, their easy lyricism, than in this calm perfection revealed to serene men of civilizations close to nature and thought.

How quickly Vincent has understood this! And it is here that he leaves Cormon's, and abandons himself to it. He is not thinking of drawing from the antique any more than of painting—as he used to do under the master he once chose—nude women surrounded by imaginary carpets, odalisques in a misty, dreamy seraglio. But if he is not becoming classic, at least he believes he is becoming French.

By following the Impressionists, by joining their glowing school, "we are working at the French Renaissance"—he wrote to his brother, who at his persuasion, exhibited Monet at Boussod's—"and I feel more French than ever in this task; we are in a homeland here." Yet this was true; Vincent was becoming French: he painted Montmartre, its little scraggy gardens; the Moulin de la Galette, its open-air roadhouses; his excursions took him as far afield as Asnières. He became a guest at the Ile de la Grande-Jatte, which Seurat had already made famous with his schematic studies.

COLORPLATES 29, 30

Vincent would start out with a large canvas mounted on his back, then divide it up in as many sections as demanded by the motifs he found. In the evening he brought it home filled, and it was like a little portable museum, wherein were culled all the emotions of the day. There were bits of the Seine filled with boats, houses with blue *balancoires*; smart, bustling restaurants with multicolored blinds, with oleander; corners of abandoned parks or of properties up for sale. A vernal poetry emanated from these fragments seized by the tip of his brush as if stolen from the fleeting hours. I savored their charm all the more because at that time I lived in those places, because they were the objects of my solitary walks, and because they were rendered with the soul that I felt in them. Vincent often came to see me at the wooden atelier built in my parents' garden in Asnières. It was there that we both set out to do por-

COLORPLATES 31, 32, 33, 36

traits of Tanguy. He even started a portrait of me, but having quarreled with my father, who refused to go along with his advice concerning my future, he grew so angry that he abandoned my portrait and carried off, unfinished, that of Tanguy, flinging it still wet under his arm. Then he left without a backward glance and never set foot in our house again. So I took to frequenting the apartment of the two brothers at 54, rue Lepic.

One evening Vincent said to me, "I'm leaving tomorrow; let's arrange the atelier in such a way that my brother will feel that I'm still here." He nailed Japanese prints on the walls and put some canvases on easels, leaving others in piles. He rolled up some things for me that I untied: they were of Chinese paintings, one of his finds, rescued from the hands of a junk-shop owner who used them to wrap the merchandise he sold. After this he announced that he was leaving for the Midi, for Arles, and that he hoped I would join him. "For," he said, "the Midi is now where the atelier of the future must be established." I accompanied him as far down as the avenue de Clichy—so well named by him the "little boulevard." I clasped his hands; and it was over forever. I will never see him again, I will never be so close to him again, except when we are joined by death.

Van Gogh had decorated his room in Antwerp with Japanese prints and became an enthusiastic collector during his years in Paris. He exhibited these prints in the spring of 1887; in the fall he began to make his own japonaiseries.

Van Gogh and Bernard continued their friendship through their correspondence. After Van Gogh's death, Bernard promoted his friend's legacy through his own writings, the publication of the letters, and exhibitions.

Emile Bernard

MERCURE DE FRANCE

"Julien Tanguy, Called Le Père Tanguy"

November–December 1908

Vignon and Cézanne were the most devoted of the lot, but both of them had the misfortune of being poor; moreover, they had to live endlessly on credit, to their great embarrassment. The years rolled on. Guillaumin, Pissarro, Renoir, Gauguin, Van Gogh, Oller, Mesureur, Anquetin, Signac, Lautrec, and countless others strolled into the little black shop at 14, rue Clauzel to simultaneously put up their works.

The ill treatment he had suffered on the pontoons had been the finishing touch to whatever natural instincts and street-sense the city had sown in the hale and hearty spirit of Julien Tanguy. He had become a kind of sage, very rebellious in his wisdom and very thoughtful in his rebelliousness. His encounter with an art form that corresponded to his own spiritual awakening was such that it did not terrify him; rather, he took to it by affinity. Moreover, he loved to chat about painting and could not stand simply "chewing the cud." He was moved by the freshness and light of new landscapes that provided a unique joy to his somber workshop; furthermore, he was the only Parisian to have canvases by Cézanne. This monopoly alone earned him glory among the young school. One visited his shop as one would go to a museum, in order to see the small number of studies by that unknown artist who lived in Aix-en-Provence.

* * *

In addition to his canvases by Cézanne, Tanguy had many works by Vincent van Gogh. The latter, a very recent acquaintance (1886), was the most frequent visitor in the shop. He practically lived there. Upon arrival, he emptied out the drawers containing tubes of colored paint, for his work habits were extremely wasteful: he painted with the tube itself, squeezing the paint from it, rather than using a brush. He had immediately taken a liking to this good working-class man who looked

Emile Bernard. *Portrait of Père Tanguy.* 1887. Canvas. 14⅛ × 12³/₁₆″ (36 × 31 cm). Öffentliche Kunstsammlung, Kunstmuseum, Basel.

Van Gogh's three paintings and one drawing of père (father) Tanguy attest to their friendship in Paris; he also seems to have done a portrait of his wife. During the last years of Van Gogh's life, Tanguy framed, displayed, and stored his canvases.

so favorably upon all the innovations and who wore his heart on his sleeve, as conventional wisdom so accurately puts it. It didn't take long for them to become fast friends. Van Gogh, who in all respects behaved like an apostle (derived originally from his Protestantism), swept him along into his own artistic movement and defined numerous ideas for him that, in Tanguy's mind, had been only vague or intuitive. Then there was socialism . . . Julien Tanguy, a faithful reader of *le Cri du Peuple* and *l'Intransigeant*, espoused a doctrine of single-minded love of the poor, fixing his ideal on a future filled with goodness and love, when all human beings would turn toward one another and personal struggles and ambitions, always so bitter and bloody, would come to an end. Vincent only diverged from this ideal in that his artistic nature sought to make a kind of religion and esthetic credo of the notion of social harmony. In his letters, previously published in the *Mercure*, there are many enlightening revelations on this subject. I am convinced that Julien Tanguy was more strongly seduced by Vincent's socialism than he was by his paintings, which he nonetheless venerated as a kind of tangible manifestation of his dreams and hopes. While they waited for their age of felicity to come, both men suffered great poverty, and both gave what they could give—the painter his canvases, the dealer his tubes of colored paint, money, and worktable. Sometimes these would go to friends, sometimes to workingmen; at yet other times the recipients might be prostitutes who, for next to nothing, would sell the paintings to junk dealers. All this was not without interest for people whom they didn't even know.

It was at about this time that Vincent frequented a tavern called Le Tambourin, owned by an extremely beautiful Italian woman, a former model, who let sprawl her robust and imposing charms onto a bar-top she made exclusively hers. The fact that he led Tanguy into this establishment greatly upset Tanguy's good wife, who could scarcely imagine innocent and infantile reasons for such . . . escapades. Vincent agreed to do several paintings a week for Le Tambourin in exchange for meals. He wound up covering the large walls of the establishment with his studies. They were mostly flower studies, and there were some excellent ones. This went on for a few months; then the place went to ruin, was sold, and all the paintings, in a pile, were sold off for a laughable sum. What is certain is that no one ever knew reprobation and financial straits as Vincent did, except for Tanguy. In the case of the latter, it hadn't been his own fault, but for Vincent, though supported by his brother, it was voluntary destitution.

Therefore, when the canvases piled up too high (and they accumulated rapidly, because Van Gogh produced up to three per day), they had to be sold. Putting them under his arm, the painter would take them to the nearest junk seller for prices that didn't even pay for the cost of the materials he'd used.

One afternoon when Cézanne was over at Tanguy's, Vincent, who was there for lunch, met him. They spoke together and, after talking about art in general, got around to discussing their particular views. Van Gogh thought he could not do better to explain his ideas than by showing his canvases to Cézanne and asking for his opinion. He showed him several kinds: portraits, still lifes, and landscapes. After inspecting everything, Cézanne, who was a timid but violent person, told him, "Honestly, your painting is that of a madman."

They were, after all, of completely different natures. In this case, it was the man from the North, the Dutchman, who was enthusiastic and passionate and the man from the South, from Provence, who was calm and thoughtful. From the start, they felt that they would never have anything in common, so they never met again. I must say, though, that Vincent did not understand Cézanne's style in the least; he could not acknowledge that one could admire it. No matter how hard he looked at Cézanne's paintings, he found nothing in these efforts that he liked.

Bernard published extracts from Vincent's letters to himself and Theo in the Mercure de France *from 1893 to 1895.*

COLORPLATE 27

Presumably, a number of flower studies are now lost as a result of Van Gogh's bestowing of them in this way.

It is true that Cézanne was a technician, concerned solely with the abstract qualities of painting in the pursuit of a harmonious system of color, and a stylist, striving simply for a few elegant formulas. Vincent, on the other hand, saw painting as a spiritual means of expression, a literature of sorts, written in color and lines. I think it is useless to argue at length how they were both wrong. To be a master, a complete artist, all one has to do is unite the two things that they were seeking separately.

* * *

Vincent made a portrait of Tanguy in about 1886. He represented him sitting in a room covered with Japanese prints, wearing a big planter's hat and symmetrically viewed from the front like a Buddha. Perhaps I am not well-informed, but this painting, which appeared in a recent exhibit at Bernheim's, supposedly belongs to Rodin. In it Van Gogh expressed very well the contentedness, the stoicism, and the hearty self-confidence that Tanguy's upright character assured him; for although he might have appeared to have a character rough as granite, he was really altogether tender and soft. His nose, like Socrates', was very short and wide. His small kind eyes were full of emotion. His head was rather elongated; the lower part of his face was short and round. He was of normal height, and he had the strong limbs of a workingman. He would bend over a little and rub his hands together when speaking to you. He had the cautious and somewhat fearful gait of a man who moved around only in an interior region. He embodied *humility*, a perfection that saints would have asked from men. Anyone who spoke to him, he took as his superior. Anyone meeting him would have immediately thought him a "good man," for it was written all over his person. Yet the depths of his heart were the most unknown and the most profound.

COLORPLATE 39

His work was important in that very often it consisted of putting into the hands of artists (to whom he was something of a father), tactfully and almost without their knowing it, the materials for their work. This was his accomplishment, summed up in a gesture of infinite goodness, and we can see that this goodness has found its own reward by *unconsciously* opening up the path to glory.

Gaston Lesaulx

LE MEMORIAL-ARTISTIQUE

"Tanguy"

17 February 1894

It was five years ago that I passed for the first time in front of the humble shop in the rue Clauzel, where two Van Goghs blazed.

* * *

I will never forget this first visit to Tanguy because it was one of the most sacred emotions of my life. Many times I would return to the dark jewel case in the rue Clauzel: I would find there the same joys for the eyes and the spirit, the same moving reception, the same communion with the ideal.

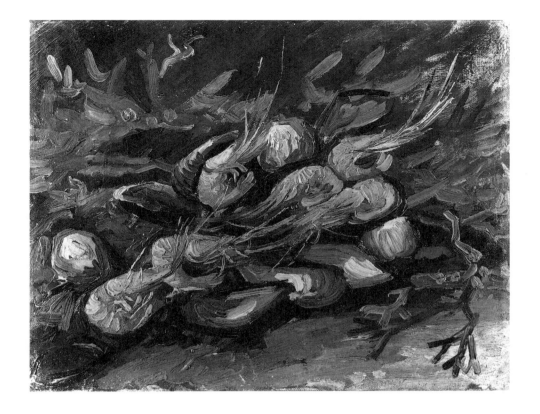

Mussels and Shrimps. 1886.
Canvas. 10⅝ × 13⅜" (27 × 34 cm).
Rijksmuseum Vincent van Gogh,
Amsterdam.

Paul Gauguin

MERCURE DE FRANCE

"Avant et Après: The Pink Shrimps"

October 1903

*This account, from Gauguin's 1903
manuscript "Avant et Après" ("Before and
After"), was first published in Charles
Morice's obituary on Gauguin.*

AVANT. Winter '86—The snow is beginning to fall, it is winter; I will
spare you the shroud, it is simply the snow. The poor people are suf-
fering: often the landlords do not understand that.

Now, on this December day, in the rue Lepic of our good city of Paris,
the pedestrians hasten more than usual without any desire to dawdle.
Among them a shivering man, bizarrely outfitted, hurries to reach the
outer boulevard. Goatskin envelops him, a fur cap—rabbit, no doubt—
the red beard bristling. Like a cowherd.

Do not observe him with half a glance; do not go your way without
carefully examining, despite the cold, the white and harmonious hand,
the blue eyes so clear, so childlike. Surely this is a poor beggar.

His name is Vincent van Gogh.

Hastily, he enters the shop of a dealer in primitive arrows, old scrap
iron, and cheap oil paintings.

Poor artist! You put a part of your soul into the painting of this can-
vas that you have come to sell.

It is a small still life—pink shrimps on pink paper.

"Can you give me a little money for this canvas to help me pay my
rent?"

"My God, my friend, the clientele is becoming difficult, they ask me
for cheap Millets; then, you know," the dealer adds, "your painting is not
very gay. The Renaissance is in demand today. Well, they say you have
talent, and I want to do something for you. Here, take a hundred sous."

And the round coin clinked on the counter. Van Gogh took the coin without a murmur, thanked the dealer, and went out. Painfully, he made his way back up the rue Lepic. When he had almost reached his lodgings, a poor woman, just out of Saint-Lazare, smiled at the painter, desiring his patronage. The beautiful white hand emerged from the overcoat: Van Gogh was a reader, he thought of *la fille Elisa*, and his five-franc piece became the property of the unfortunate girl. Rapidly, as if ashamed of his charity, he fled, his stomach empty.

APRÈS. A day will come, and I see it as if it had already come. I enter room no. 9 of the auction house: the auctioneer is selling a collection of paintings.

"400 francs, *The Pink Shrimps* . . . 450 . . . 500. . . . Come, gentlemen, it's worth more than that. . . . No one says a word? . . . Sold, *The Pink Shrimps*, by Vincent van Gogh. . . .

La Fille Elisa: Edmond de Goncourt's 1877 novel about the tragic life of a prostitute who is imprisoned for murder.

Trublot

LE CRI DU PEUPLE

"At Midnight"

7 September 1887

Trublot was a name that Paul Alexis (1847–1901) borrowed from a character (that had, in fact, been inspired by him) in Emile Zola's 1882 novel, Pot-bouille. *Alexis, a journalist, dramatist, and naturalist author, was a loyal defender of Impressionism and Neo-Impressionism and helped found the Théâtre-Libre.*

It's not enough to have a place: it's also a question of decorating it with chic. M. Antoine writes:

My dear Trublot,

I have sixty or eighty square meters of wall to decorate in the rehearsal hall. I have thought of those young people who sometimes paint or sculpt marvels and keep them in their attics. Would you make an appeal in your *Cri*?

At my place they can hang their finished canvases, and since there will be a coming and going of chic people it will be a very modest exhibition, but perhaps a useful one. Just think, I already have princes and millionaires on my list of subscribers. If a bit of canvas so much as catches their eye, they will buy it. The artists can carry that off at their pleasure.

Isn't this a good idea? And won't it perhaps be to everyone's advantage? No need for frames; I want the foyer of the Théâtre-Libre to keep a purely artistic character, not at all bourgeois. There will be artistic things of all kinds there. Tell these young people to get in touch with me, a short note via 42, rue de Dunkerque, all right?

Thank you.

Yours truly,
A. Antoine

André-Leonard Antoine (1858–1943), experimental theater director who, in 1887, founded the Théâtre-Libre, where new plays and methods of production and acting were innovated.

There you are, my boy.

Now there's a man of action, ole Antoine, who deserves success and who will succeed, I predict. Brilliant ideas, an extraordinary sense of organization and determination—that's for certain. Don't doubt this, for in the year since the Théâtre-Libre was founded, he—its secretary—wrote something like 1,500 letters. From that, you may judge the rest.

Yes, the painters—and the sculptors, too—won't go wrong at all by coming to embellish the foyer of our Théâtre-Libre. I myself guarantee the Impressionists.

In November and December 1887, Van Gogh, Seurat, and Signac exhibited in the "salle de répétition" at the Théâtre-Libre, 96, rue Blanche.

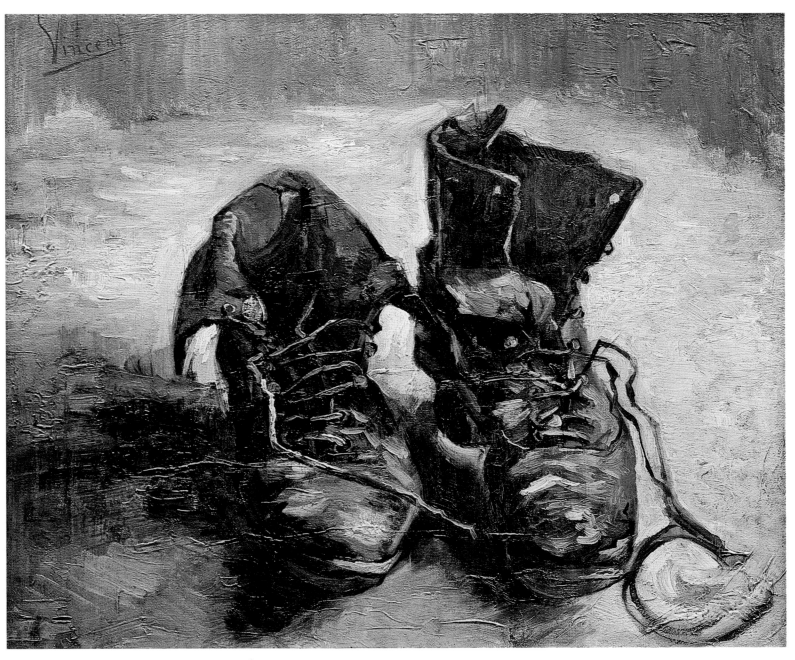

COLORPLATE 25. *A Pair of Shoes.* 1886. Canvas. 15 × 18⅛″ (37.5 × 45.5 cm).
Rijksmuseum Vincent van Gogh, Amsterdam.

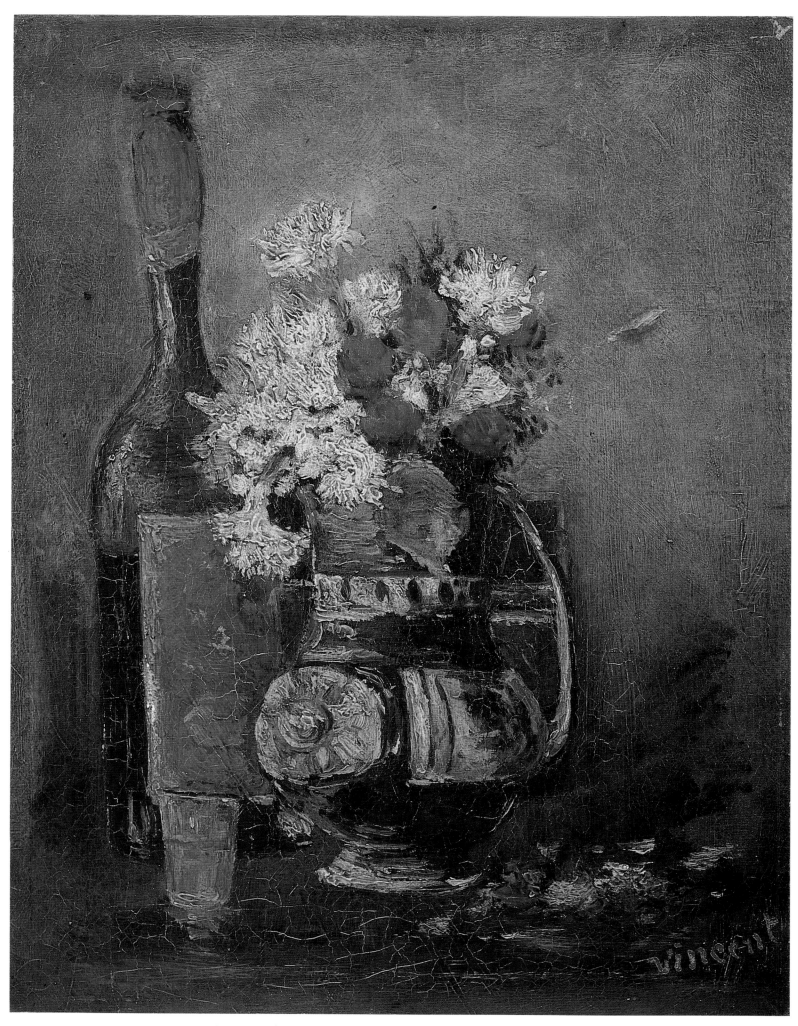

COLORPLATE 26. *Vase with Carnations and Bottle*. 1886. Canvas. 15¾ × 12⅝″ (40 × 32 cm).
Rijksmuseum Kröller-Müller, Otterlo.

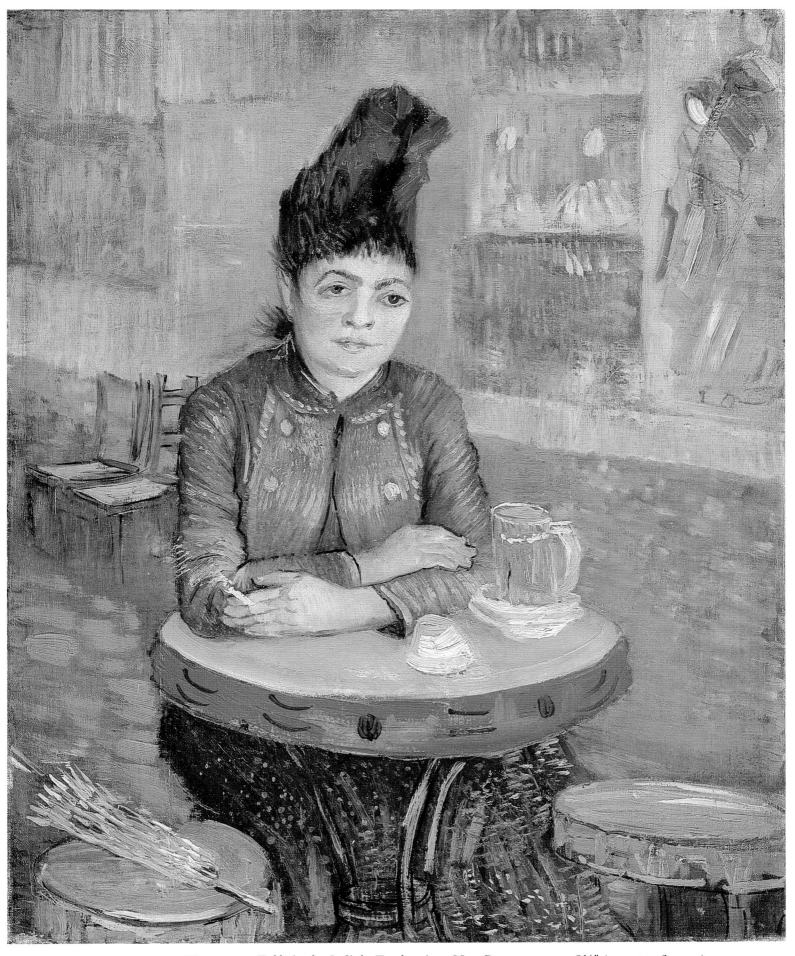

COLORPLATE 27. *Woman at a Table in the Café du Tambourin*. 1887. Canvas. 22 × 18½″ (55.5 × 46.5 cm).
Rijksmuseum Vincent van Gogh, Amsterdam.

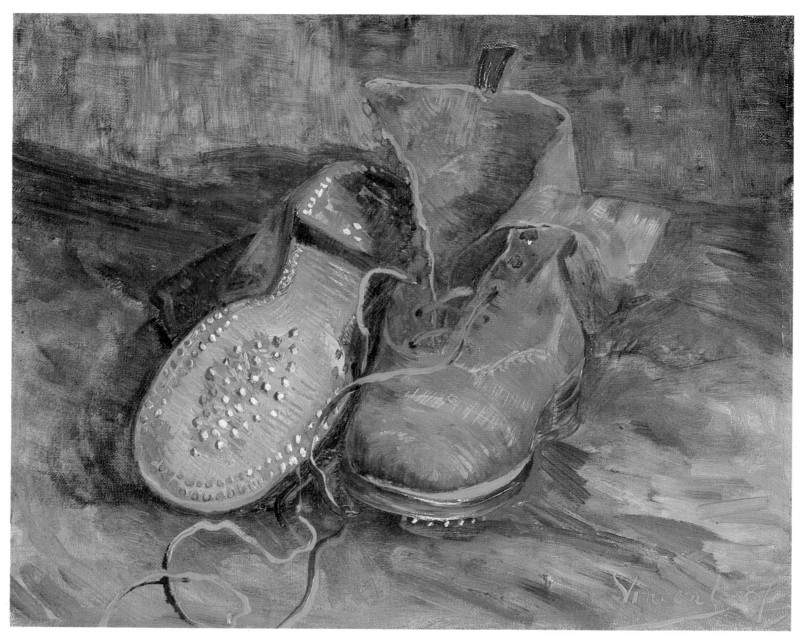

COLORPLATE 28. *A Pair of Shoes.* 1887. Canvas. 13⅜ × 16⅜″ (34 × 41.5 cm). The Baltimore Museum of Art;
The Cone Collection, formed by Dr. Claribel Cone and Miss Etta Cone of Baltimore, Maryland.

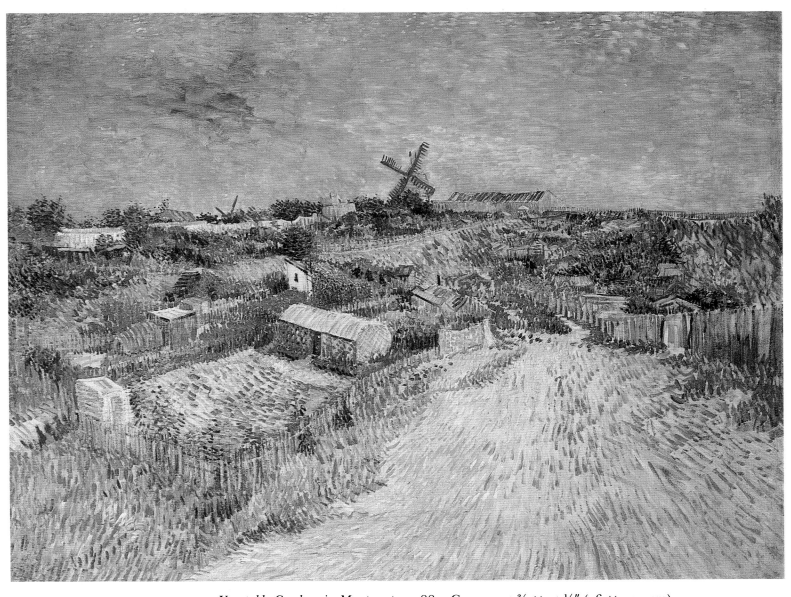

COLORPLATE 29. *Vegetable Gardens in Montmartre.* 1887. Canvas. 37¾ × 47¼″ (96 × 120 cm).
Stedelijk Museum, Amsterdam.

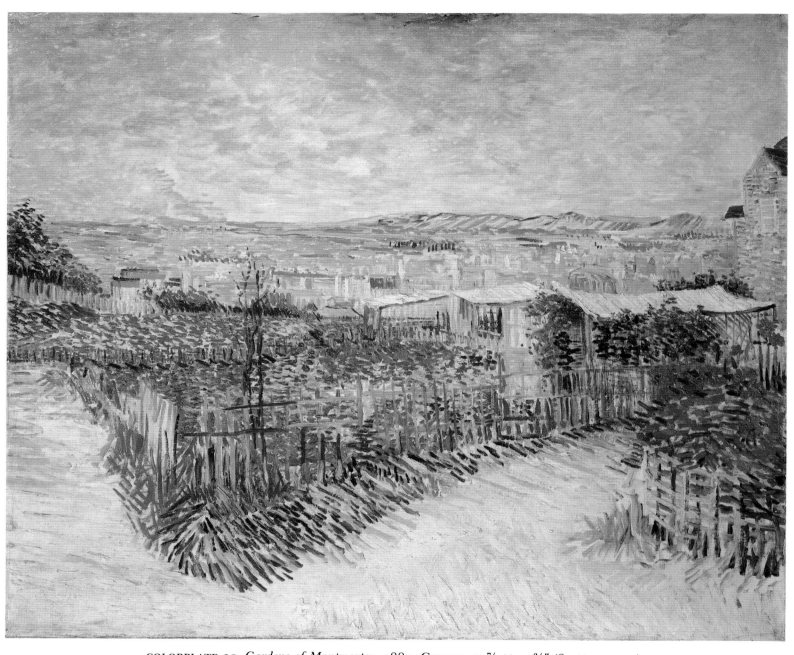

COLORPLATE 30. *Gardens of Montmartre*. 1887. Canvas. 31⅞ × 39⅜″ (81 × 100 cm).
Rijksmuseum Vincent van Gogh, Amsterdam.

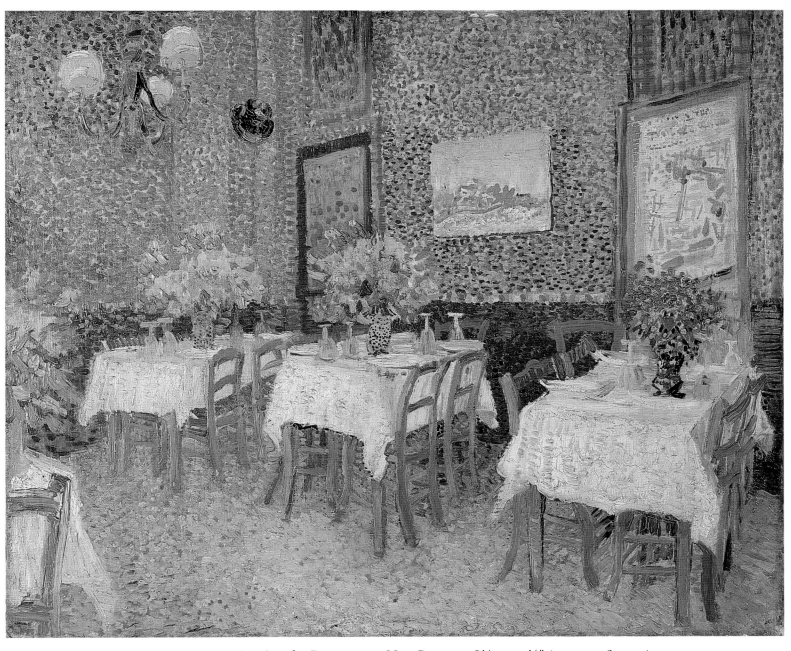

COLORPLATE 31. *Interior of a Restaurant*. 1887. Canvas. 18⅛ × 22½″ (45.5 × 56.5 cm).
Rijksmuseum Kröller-Müller, Otterlo.

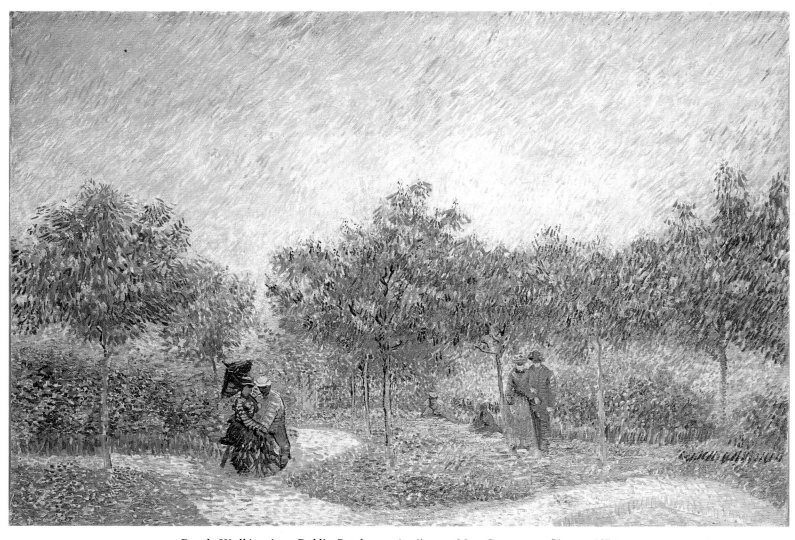

COLORPLATE 32. *People Walking in a Public Garden at Asnières.* 1887. Canvas. 29⅞ x 44½″ (75.5 × 113 cm). Rijksmuseum Vincent van Gogh, Amsterdam.

Andries Bonger

NIEUWE ROTTERDAMSCHE COURANT

"Letters and Art"

5 September 1893

Andries Bonger (1861–1934), Theo's close friend and, from 1889, brother-in-law.

However tied to each other Vincent and Theo were, and even though one could not do without the other, they were never able to live together. At the end of eight days Vincent would begin interminable discussions about Impressionism, during which he would touch on all possible subjects. One day, Theo, exasperated, left the house and swore that he would only return when Vincent had a place to himself. Shortly thereafter, Vincent left for the South. Vincent was a stimulant for Theo in his work, but there was no question of a collaboration between them. Vincent always wanted to dominate his brother. Theo often violently opposed Vincent's theories.

Theo's Letters

On Vincent in Paris

1886–1888

TO HIS MOTHER, JUNE 1886

We are fortunately all right in our new apartment. You wouldn't recognize Vincent, so much he has changed, and it strikes others even more than me. He has had a major operation to his mouth, for he had nearly lost all his teeth as a result of the bad state of his stomach. The doctor says that he has now completely got over it. He is progressing tremendously in his work and this is proved by the fact that he is becoming successful. He has not yet sold paintings for money, but is exchanging his work for other pictures. In that way we obtain a fine collection which, of course, also has a certain value. There is a dealer in pictures who has now taken four of his paintings and has promised him to arrange for an exhibition of his work next year. He is mainly painting flowers—with the object to put a more lively color into his next pictures. He is also much more cheerful than in the past and people like him here. To give you proof: hardly a day passes or he is asked to come to the studios of well-known painters, or they come to see him. He also has acquaintances who give him a collection of flowers every week which may serve him as models. If they are able to keep it up I think his difficult times are over and he will be able to make it by himself. . . .

The dealer is most likely Arsène Portier (d. 1902), Parisian art dealer who seems to have specialized in nineteenth-century pictures, handling the works of Degas, Cézanne, and Pissarro, among others. He lived in the same building as Vincent and Theo, 54, rue Lepic.

TO HIS MOTHER, 28 FEBRUARY 1887

He has painted a few portraits which have turned out well, but he always does them for no payment. It is a pity that he does not seem to want to earn something, for if he did want to he could make something here, but you can't change a person. . . .

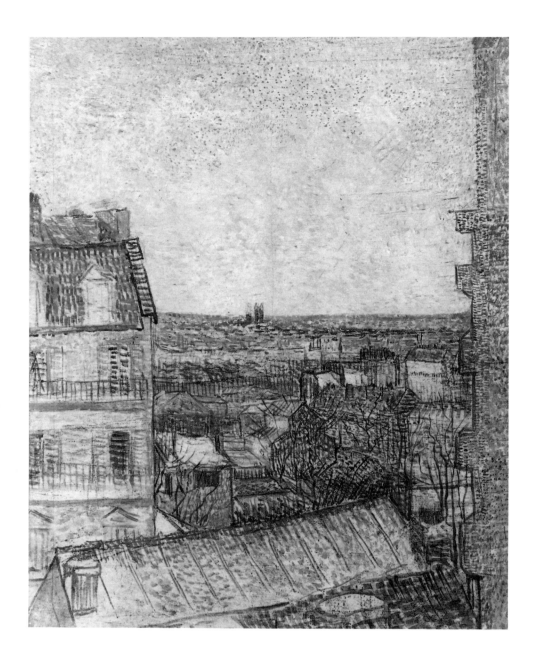

View from Vincent's Room in the Rue Lepic.
1887. Cardboard. 18 × 15" (46 × 38 cm).
The Lefevre Gallery, London.

TO COR, 11 MARCH 1887

Vincent continues his studies and he works with talent. But it is a pity
that he has so much difficulty with his character, for in the long run it
is quite impossible to get on with him. When he came here last year he
was difficult, it is true, but I thought I could see some progress. But now
he is his old self again and he won't listen to reason. That does not make
it too pleasant here and I hope for improvement. It will come, but it is
a pity for him, for if we had worked together it would have been better
for both of us. . . .

TO WIL, 14 MARCH 1887

It is certain that he is an artist and what he makes now may sometimes
not be beautiful, but it will surely be of use to him later and then it may
possibly be sublime and it would be a shame if one kept him from his
regular studies.

However impractical he may be, when he becomes more skillful the
day will undoubtedly come when he will start to begin selling. You should
not think either that the money side worries me most. It is mostly the
idea that we sympathize so little any more. There was a time when I
loved Vincent a lot and he was my best friend, but that is over now. It
seems to be even worse from his side, for he never loses an opportunity

to show me that he despises me and that I revolt him. That makes the situation at home almost unbearable. Nobody wants to come and see me, for that always leads to reproaches and he is also so dirty and untidy that the household looks far from attractive. All I hope is that he will go and live by himself and he has talked about this for a long time, for if I told him to leave that would only give him a reason to stay on. Since I cannot do any good for him I only ask for one thing, and that is that he won't do any harm to me and that is what he does by staying, for it weighs heavily on me. It appears as if there are two different beings in him, the one marvelously gifted, fine and delicate, and the other selfish and heartless. They appear alternately so that one hears him talk now this way and then that way and always with arguments to prove pro and contra. It is a pity that he is his own enemy, for he makes life difficult not only for others but also for himself. I have firmly decided to continue as I have done up to now, but I hope that for some reason or other he will move to other quarters and I will do my best for that. Now, dear sister, you will say what a litany. Don't talk about it too much. . . .

TO WIL, 25 APRIL 1887

A lot has changed since I wrote you last. We have made peace, for it didn't do anybody any good to continue in that way. I hope it will last. So there will be no change and I am glad. It would have been strange for me to live alone again and he would not have gained anything either. I asked him to stay. That will seem strange after all I wrote you recently, but it is no weakness on my side and as I feel much stronger than this winter, I am confident that I will be able to create an improvement in our relationship. We have drifted apart enough than that it would serve any purpose to make the rift any larger. *L'Oeuvre* of which you write I have read and before I read it I also thought according to the criticism that Vincent had much in common with the hero. But that is not so. That painter was looking for the unattainable, while Vincent loves the *things that exist* far too much to fall for *that.* . . .

TO LIES, 15 MAY 1887

There is not much I can tell you from here. Vincent is working hard as always and keeps on progressing. His paintings are becoming lighter and he is trying very hard to put more sunlight into them. He is a curious chap, but what a head he has got, most enviable. . . .

TO WIL, 24 FEBRUARY 1888

When he came here two years ago I had not expected that we would become so much attached to each other, for now that I am alone in the apartment there is a decided emptiness about me. If I can find someone I will take him in, but it is not easy to replace someone like Vincent. It is unbelievable how much he knows and what a sane view he has of the world. If he has still some years to live I am certain that he will make a name for himself. Through him I got to know many painters who regarded him very highly. He is one of the avant-garde for new ideas, that is to say, there is nothing new under the sun and so it would be better to say for the regeneration of the old ideas which through routine have been diluted and worn out. In addition he has such a big heart that he always tries to do something for others. It's a pity for those who cannot or refuse to understand him. . . .

L'Oeuvre: *Emile Zola's 1886 novel about a fictitious artist, Claude Lantier, who commits suicide when he realizes the impossibility of rendering his ideal vision of feminine beauty. Zola based the character of Claude on such friends as Cézanne and Manet.*

Letter from Christian Mourier-Petersen to Johan Rohde

On Van Gogh in Arles

March 1888

Christian Vilhelm Mourier-Petersen (1858–1954), Danish artist, met Van Gogh in March 1888; they were close companions in Arles for the next two months.

I thought he was mad at first, yet I am finding out gradually that there is method in his madness. He knows Jastrau's friends—but I do not remember his name at the moment—Van Prut or something like that. . . . More next time about my Dutchman, who is telling me at great length about his country.

Viggo Jastrau (1857–1946), Danish illustrator.

Dodge Macknight

On Van Gogh in Arles

20 March 1913

Dodge Macknight (1860–1950), American painter, watercolorist, and friend of John Russell's, was staying in Fontvieille, near Arles; from mid-April–August 1888 Van Gogh frequently saw him.

The following account, from a conversation recorded by an unidentified journalist, was preserved in "Lau's Dodge Macknight," an undated newspaper review of Desmond Fitzgerald's 1916 monograph on Macknight.

The day of luminarists has about passed. You know I was a contemporary of Van Gogh and Bernard. I saw a great deal of the former at Arles when he was making landscapes. He was an interesting fellow and when he felt like it very companionable. But he was moody and quarrelsome, especially if any one did not agree with his opinions about art. He was perfectly sincere. He and Gauguin and Bernard had been affected, as we all had, by the Impressionist kind of thing and had revolted from it. Instead of working with little dots and dashes of color, they had formed the habit of using great masses of color, either pure or blended, according to the need of the case.

Pierre Weiller

LES LETTRES FRANÇAISES

"We've Tracked Down Van Gogh's Zouave"

24–31 March 1955

Paul-Eugène Milliet was a second lieutenant in the third regiment of the Zouaves, of the French light infantry. He died in World War II. These reminiscences were gathered some twenty years prior to their publication.

On several visits, either at his house or mine, while savoring a cup of coffee spiked with a large dose of rum, he insisted above all on the necessity and on the primacy of drawing. Even though he possessed a certain education and was interested in all that is beautiful, I remained astonished by his clear sense and interest in an art not yet appreciated worldwide. One day, when he was particularly determined, he con-

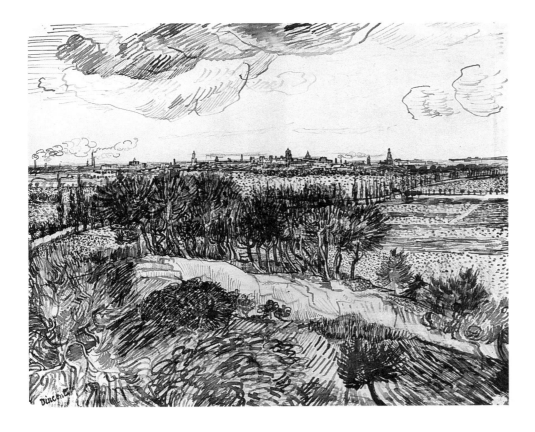

View of Arles from Montmajour. 1888.
Pencil, reed pen, quill pen, and ink. 19⅛
× 23⅝″ (48.5 × 60 cm).
Nasjonalgalleriet, Oslo.

fessed to me that in his youth he had toyed with pencil, pen, and charcoal: "As an amateur, dear friend, as an amateur, because I was always a soldier—a soldier, a fighter, and a zouave in the Algerian infantry. That is to say, I did not often have the opportunity to make sketches. Even so, at a certain point in my life, I had a drawing teacher, of whom they speak quite highly, who gave me several lessons during a leave between two campaigns." He told me his name, a sound seemingly half-consumed by snores and imitative harmonies of debatable taste but indisputably picturesque. I vaguely understood a surname resembling "vogue," but I did not take it upon myself to gather any more than that. It was much later that I ended up realizing that "vogue" could, quite literally signify Van Gogh! But such a thing seemed so unbelievable that I held still for a good while before asking for further details. "*Mais oui,*" answered the colonel, "it was certainly Van Gogh who had been my drawing teacher. No worse than any other, for all that, and certainly a better draftsman than all the scatterbrains that reign in your country. But listen, even if he was my drawing teacher, I would never have allowed him to become my painting teacher. . . ."

"But in which period did you know him?"

"In 1888. . . ."

"And where?"

"In Arles, where he lived after having left Paris. I myself was on holiday in that city between two campaigns."

"Could you give me some details about him, about his behavior?"

"Certainly. He was a curious fellow. His head was a little sunburnt, like that of a zouave. But he wasn't one: no disposition for the art of the military, no. An artist? Evidently an artist, and one who drew in an estimable way. A charming companion, when he put his mind to it, which didn't happen every day. We often took some nice walks on the outskirts of Arles, and in the country, we both made numerous sketches. Sometimes he set up his canvas and began to daub it with colors. Now that didn't take him anywhere at all. This boy, who had the taste and talent for drawing, became abnormal as soon as he touched a paintbrush."

"He drew well, by your estimation. You aren't going to make me be-

Van Gogh had met Milliet by mid-June 1888 and enthusiastically set out to give him drawing lessons; he also enjoyed the Zouave's company on sketching outings to Montmajour in early July. In September, prior to Milliet's departure for Algeria, he painted his portrait.

lieve at the same time that he painted like an apprentice or an amateur. . . ."

"He painted like a staff-officer. . . ."

"My dear Colonel, all the amateurs and all the art critics, and all the connoisseurs as well, recognize in Van Gogh. . . ."

"The talents that he doesn't have. Still, I am in a better position than many to know about this. I saw him at work. I benefited from his instruction. I even gave *him* some lessons—drawing lessons, of course, because it happened, especially in the country, that each of us would do a sketch of the same landscape and then mutually correct each other, independently. Well, Van Gogh sometimes found my remarks justified. Sometimes, not always. And again, it was a question of drawing. Because as soon as he started to paint, either I distanced myself, or I refused to give any opinion, or we argued. He didn't have an easygoing personality, and when he was mad, he seemed crazy. Only it scarcely affected me at all: in my errant life as a soldier, I had seen and heard of others. . . ."

"But what do you find wrong with Van Gogh's paintings?"

"What I find wrong in them is that they are not drawn. He painted too broadly, he gave no attention to details, he never sketched out his design. Even though, (and I repeat,) when he wanted to, he knew how to draw. He let color take the place of drawing, which is nonsense, because color completes the design. And then what color . . . excessive, abnormal, inadmissible. Tones too hot, too violent, not restrained enough. You see, my friend, the painter has to make a painting with love, not with passion. A painting has to be "cuddled"; Van Gogh, he, he raped it. . . . Sometimes, he was a veritable brute—"hard-assed," as they say. . . ."

"His character, then, was irascible?"

"Yes and no. Rather agreeable, on the whole but quite changeable from day to day. Very nervous. Furious when I offered a criticism of his painting. But that didn't last, and we always ended up reconciling."

"If I understand you, he was a powerhouse, high-strung, but a sensitive being."

"Of an exaggerated sensitivity. The reactions of a woman, sometimes. The consciousness of being a great artist. He had faith, a faith in his talent, a somewhat blind faith. Pride. His constitution didn't seem to me very strong. But, on the whole, a good friend, not a bad guy. . . ."

"Beside his nervousness, did you have the impression that he was sick?"

"He would complain from time to time about his stomach. That's all."

"What did he paint during the period when you saw him frequently?"

"A little of everything. Above all landscapes, still lifes, especially flowers. Some portraits, including mine."

COLORPLATE 68

"How did Van Gogh do your portrait? Where is it?"

"I don't know that much. They told me that it was in a museum. In Holland, I believe."

"And how did he paint you?"

"In the uniform of a zouave officer. I was returning from Tonkin, don't forget."

"Did you have to pose often?"

"I should have. But that didn't amuse me at all. That is not in my character, as you may suspect. As well as I remember it, it didn't take very long. Furthermore, he had not sketched out the portrait, so that made for relatively little time lost to the artist. . . ."

"The portrait, did it at least resemble you?"

"Very much. A good likeness. But with a dark blue uniform that was not very becoming."

Thus, faithfully reported, were the few appraisals that my friend Milliet had offered me on his relations with Van Gogh. What a strange

encounter—that between this artist, in full possession of his talent, and this young officer who came to the South of France to relax after a long campaign! What a coincidence—the shared love of drawing by two men so different one from the other! And how but not to excuse, on the part of the brave colonel, the severe opinions that he voiced about a manner of painting that he could not understand, and that, furthermore, for his time in particular, so few appreciated. His worthy policeman of a father could have given him only a modest artistic education, and I am not sure that he, as an officer's child, had received very clear notions on the art of painting. Furthermore, the reflections of my friend, as intransigent as they were, have the value of being sincere ones. And the glory of Van Gogh will not suffer in the least from them.

Vincent's Letters

On His Artistic Contacts in Arles

March–September 1888

TO THEO, 10 MARCH 1888 *(468)*

I have made the acquaintance of a Danish artist who talks about Heyerdahl and other northerners, Kroyer, etc. His work is dry, but very conscientious, and he is still young. Some time ago he saw the exhibition of the impressionists in the Rue Lafitte. He is probably going to Paris for the Salon, and wants to make a tour in Holland to see the museums. . . .

Van Gogh tended to refer to Mourier-Petersen as "the Danish artist" or "the Dane." Hans-Olaf Heyerdahl (1857–1913), Swedish artist whom Van Gogh knew in The Hague. Peter-Severin Kröyer (1851–1909), Danish artist.

TO THEO, CA. 14 MARCH 1888 *(469)*

I have company in the evening, for the young Danish painter who is here is a decent soul: his work is dry, correct and timid, but I do not object to that when the painter is young and intelligent. He originally began studying medicine: he has read Zola, de Goncourt, and Guy de Maupassant, and he has enough money to do himself well. And with all this, a very genuine desire to do very different work from what he is actually producing now.

I think he would be wise to delay his return home for a year, or to come back here after a short visit to his friends. . . .

TO JOHN RUSSELL, CA. 21 APRIL 1888 *(477a)*

Last Sunday I have met MacKnight and a Danish painter, and I intend to go to see him at Fontvieille next Monday. I feel sure I shall prefer him as an artist to what he is as an art critic, his views as such being so narrow that they make me smile. . . .

TO THEO, CA. 24 APRIL 1888 *(479)*

That being so, I will repeat what was in the letter as though it just happened, the visit of McKnight, Russell's friend, who also came again last Sunday. I am to go to see him, and his work, of which I have so far seen nothing.

He is a Yankee, and probably paints better than most Yankees do, but a Yankee all the same.

Have I said enough? When I have seen his pictures or drawings, I'll tell you what I think of his work. Meantime, so much for the man. . . .

TO THEO, CA. 3 MAY 1888 (481)

I was in Fontvieilles [sic] yesterday at McKnight's; he had a good pastel—a pink tree—and two watercolors just started, and I found him working on the head of an old woman in charcoal. He has reached the stage where he is plagued by new color theories, and while they prevent him from working on the old system, he is not sufficiently master of his new palette to succeed in this one. He seemed very shy about showing me the things, I had to go there for that express purpose, and tell him that I was *absolutely* set on seeing his work.

It is not impossible that he may come to stay for some time with me here. I think we should both benefit by it. . . .

TO THEO, 26 MAY 1888 (490)

Have you met the Dane, Mourier Petersen? He will have brought you two more drawings.

He has studied medicine, but I suppose he was discouraged by the student's life, and by the other fellows and the professors as well. He never said anything to me about it though, except once when he stated, "It's the doctors that kill people."

When he came here, he was suffering from a nervous disorder, which had been brought on by the strain of the examinations. I do not know how long he has been painting—he certainly hasn't gone very far as a painter—but he's a good fellow to knock around with, and he observes people and often sums them up very accurately. . . .

TO THEO, CA. 15 JUNE 1888 (498)

The "Harvest" is rather more serious.

That is the subject I have worked on this week on a size 30 canvas; it isn't at all finished, but it kills everything else I have, except a still life which I patiently worked out. McKnight and one of his friends who has also been in Africa saw it today, this study, and said it was the best I had done. Like Anquetin and friend Thomas—you can't help thinking something of yourself when you hear that said, but then I say, "The rest certainly must seem damn bad." And the days when I bring home a study I say to myself—If it was like this every day, we might be able to get on; but the days when you come back empty-handed, and eat and sleep and spend money all the same, you don't think much of yourself, and you feel like a fool and a shirker and a good-for-nothing. . . .

COLORPLATE 45

COLORPLATE 44

Eugène Boch (1855–1941), Belgian artist and Macknight's friend, joined the American in Fontvieille from mid-June through late August 1888. Van Gogh painted his portrait in early September.

TO EMILE BERNARD, CA. 18 JUNE 1888 (B7)

I am acquainted with a second lieutenant of the Zouaves here, called Milliet. I give him drawing lessons—with my perspective frame—and he is beginning to make drawings; by God, I've seen worse! He is zealously intent upon learning, has been in Tonkin, etc. . . . This fellow is leaving for Africa in October. If you were in the Zouaves he would take you under his wing, and would guarantee you a relatively large margin of free time for painting, at any rate, if you were willing to help him with his own artistic blunderings. Do you think this may be of any use to you? If so, let me know as soon as possible. . . .

TO THEO, 31 JULY 1888 (516)

McKnight came again yesterday to see me, and he also liked the portrait of the girl, and said besides that he liked my Garden. I really do not know if he has money or not.

COLORPLATES 52, 53

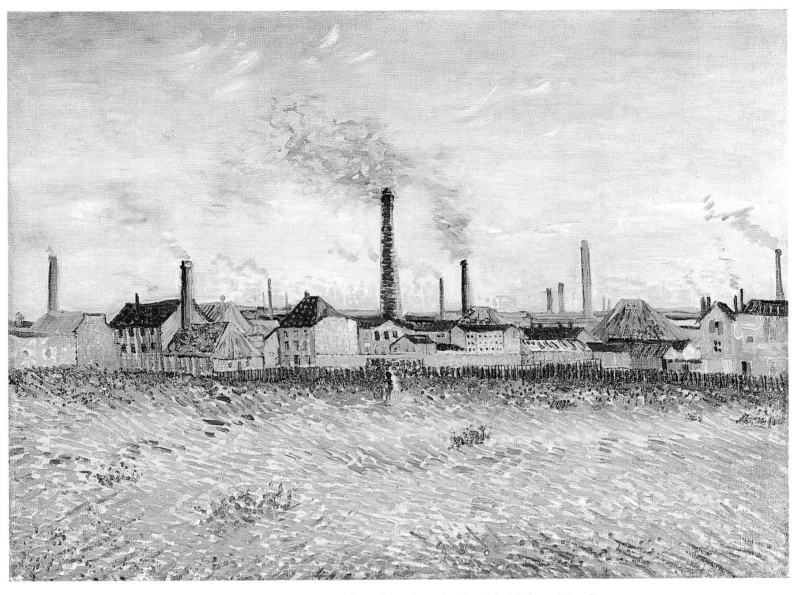

COLORPLATE 33. *Factories at Asnières, Seen from the Quai de Clichy.* 1887. Canvas.
21¼ × 28¹¹/₁₆″ (53.9 × 72.8 cm).
The Saint Louis Art Museum; Gift of Mrs. Mark C. Steinberg.

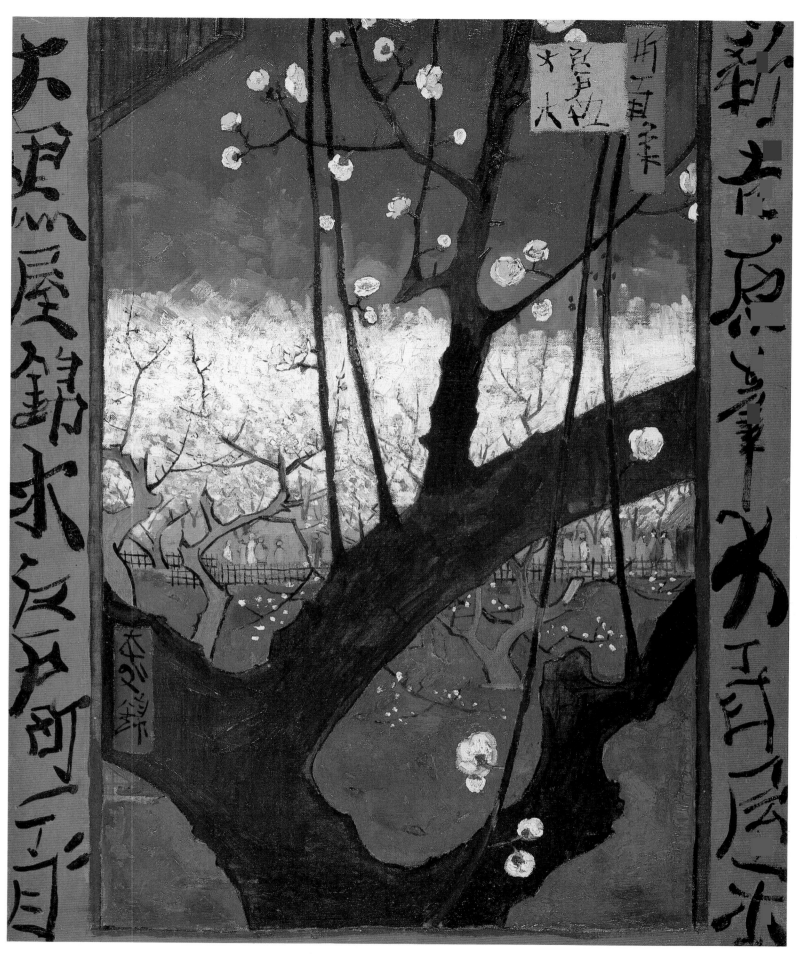

COLORPLATE 34. *Japonaiserie* (after Hiroshige). 1887. Canvas. 21⅝ × 18⅛″ (55 × 46 cm).
Rijksmuseum Vincent van Gogh, Amsterdam.

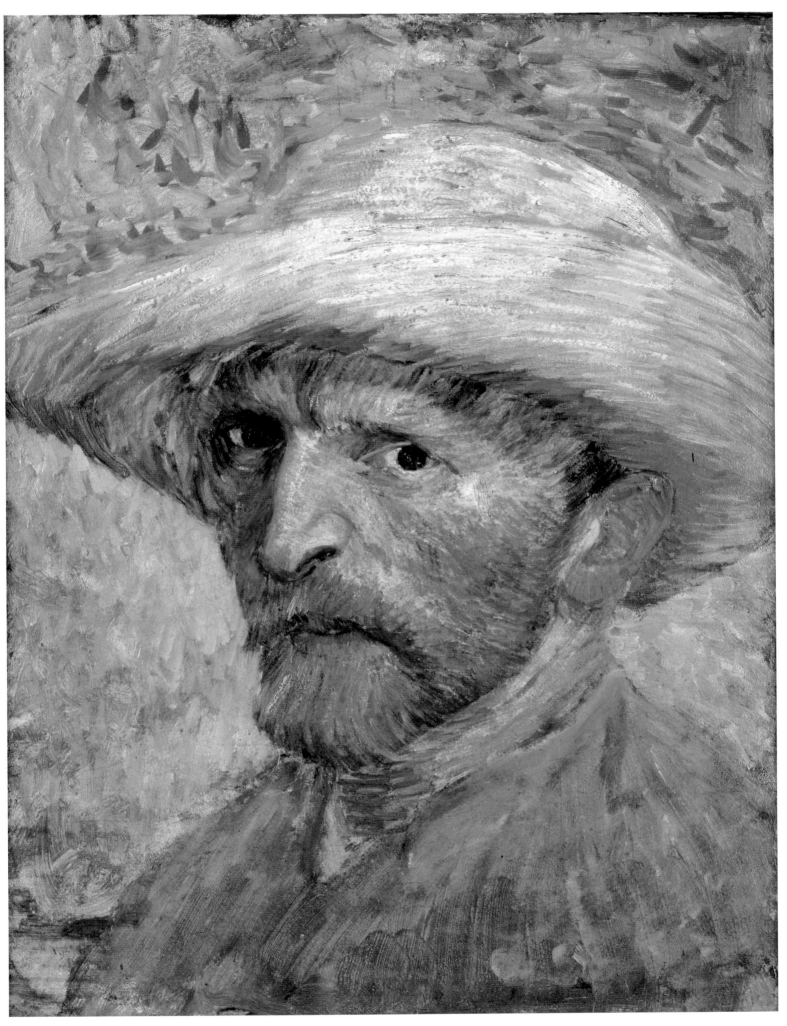

COLORPLATE 35. *Self-Portrait*. 1887. Canvas on panel. 13¾ x 10½″ (34.9 × 26.7 cm).
The Detroit Institute of Arts; City of Detroit Purchase.

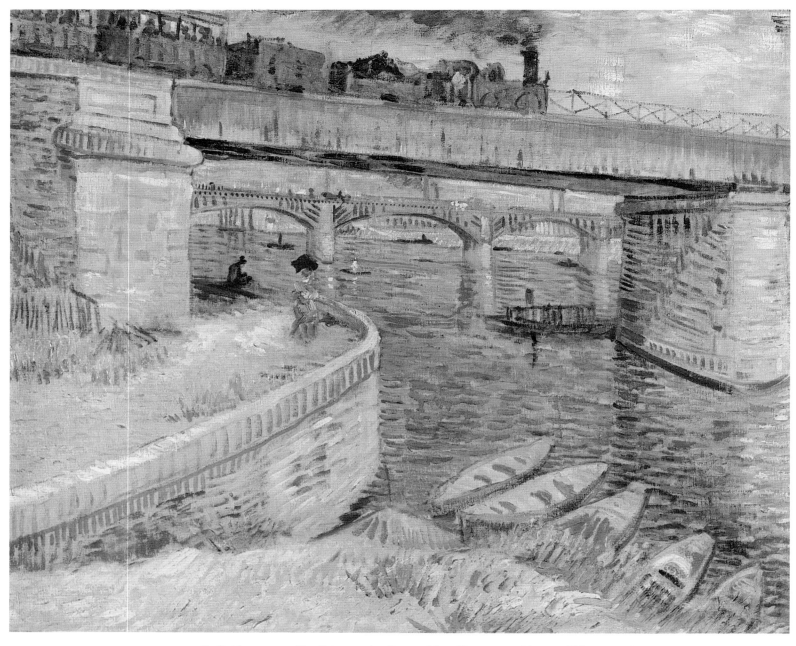

COLORPLATE 36. *Bridges across the Seine at Asnières.* 1887. Canvas. 20½ × 25⅝″ (52 × 65 cm).
Foundation E. G. Bührle Collection, Zurich.

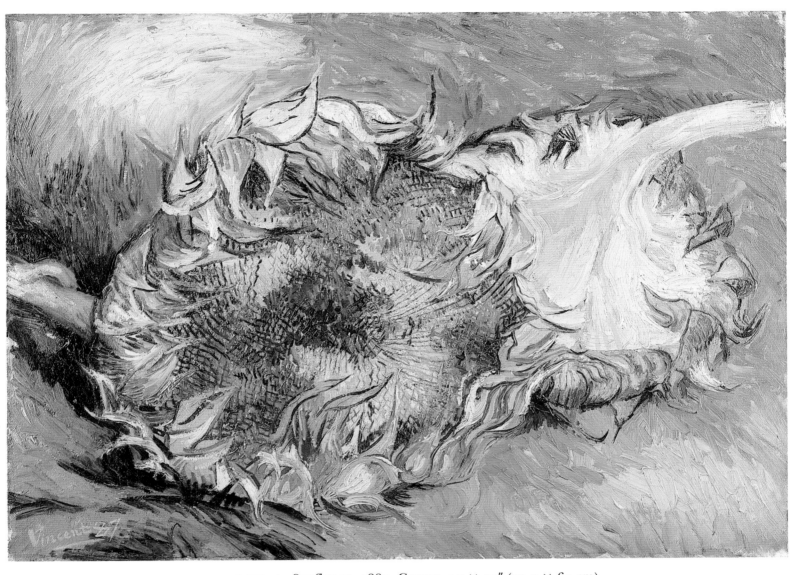

COLORPLATE 37. *Sunflowers*. 1887. Canvas. 17 × 24″ (43.2 × 61 cm).
The Metropolitan Museum of Art, New York; Rogers Fund, 1949.

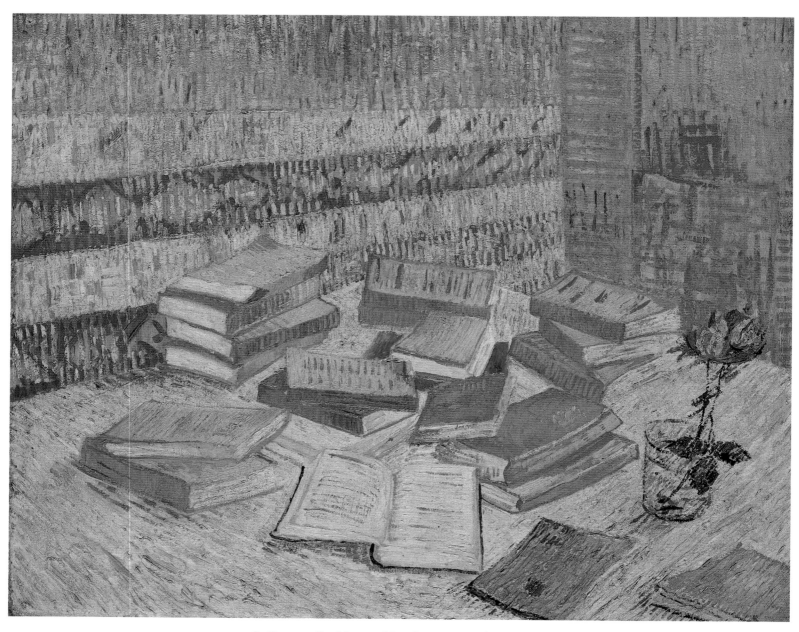

COLORPLATE 38. *Romans Parisiens.* 1887. Canvas. 28¾ × 36⅝″ (73 × 93 cm).
Private Collection.

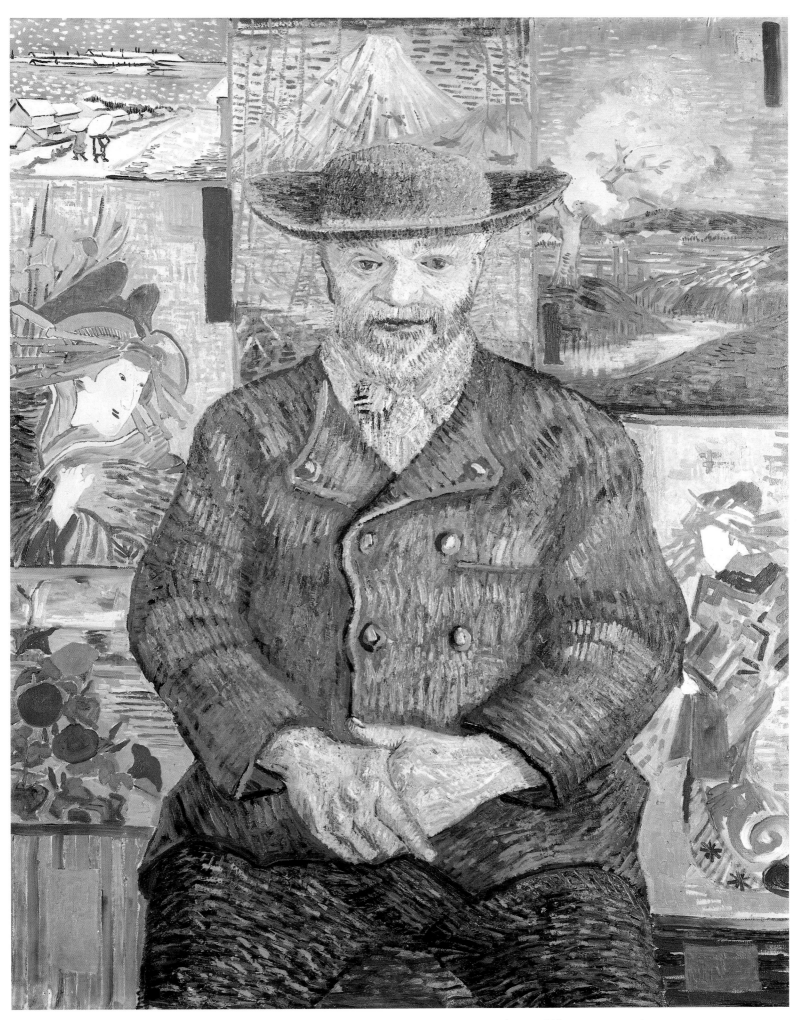

COLORPLATE 39. *Portrait of Père Tanguy*. 1887. Canvas. 36¼ × 29½″ (92 × 75 cm).
Musée Rodin, Paris.

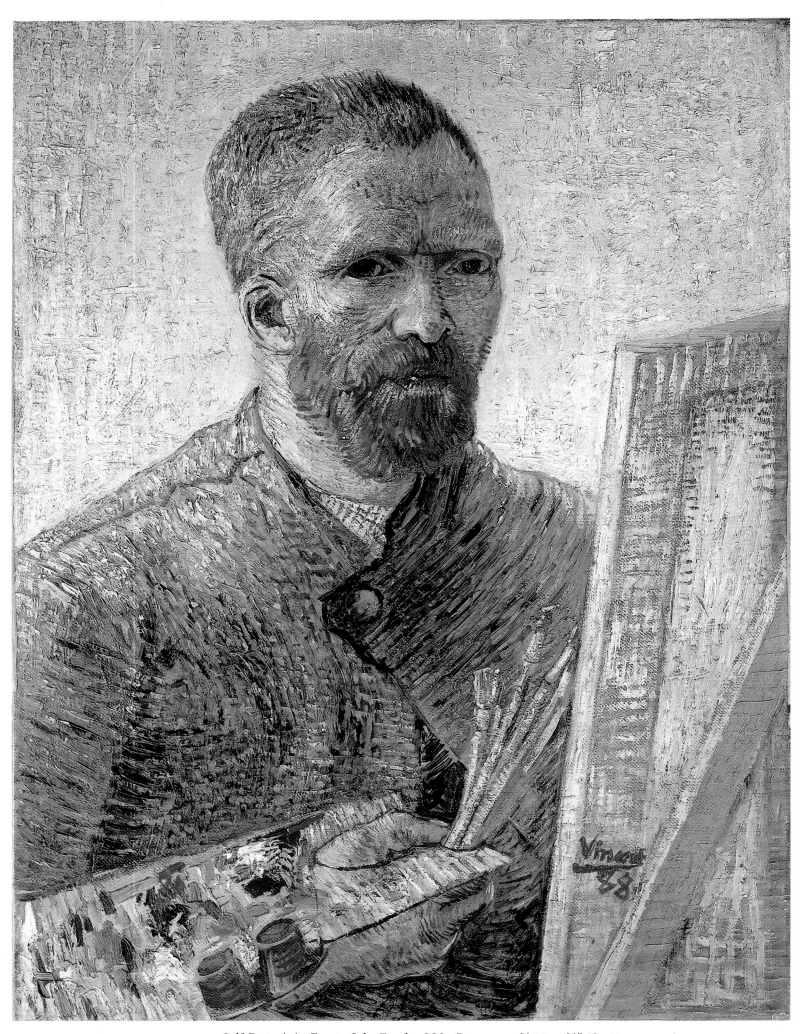

COLORPLATE 40. *Self-Portrait in Front of the Easel.* 1888. Canvas. 25⅝ × 20⅛″ (65 × 50.5 cm).
Rijksmuseum Vincent van Gogh, Amsterdam.

But you may be quite sure that I shall try to put *style* into them. Milliet today was pleased with what I had done—the "Plowed Field"; generally he does not like what I do, but because the color of the lumps of earth is as soft as a pair of sabots, it did not offend him, with the forget-me-not blue sky flecked with white clouds. If he posed better, he would give me great pleasure, and he would have a more distinctive portrait than I can manage now, though the subject is good—the mat pale tints of his face, the red soldier's cap against an emerald background. . . .

COLORPLATE 67

COLORPLATE 68

Paul Gauguin

ESSAIS D'ART LIBRE
"Still Lifes"

January 1894

In my yellow room, sunflowers with purple eyes stand out on a yellow background; they bathe their stems in a yellow pot on a yellow table. In a corner of the painting, the signature of the painter: Vincent. And the yellow sun that passes through the yellow curtains of my room floods all this fluorescence with gold; and in the morning upon awakening from my bed, I imagine that all this smells very good.

Oh yes! he loved yellow, this good Vincent, this painter from Holland—those glimmers of sunlight rekindled his soul, that abhorred the fog, that needed the warmth.

When the two of us were together in Arles, both of us mad, and at constant war over the beauty of color—me, I loved the color red; where to find a perfect vermilion? He traced with his most yellow brush on the wall, suddenly turned violet:

> *Je suis Saint Esprit.*
> *Je suis sain d'esprit!*

In my yellow room there was a small still life: this one in violet. Two enormous shoes, worn, misshapen. The shoes of Vincent. Those that, when new, he put on one nice morning to embark on a journey by foot from Holland to Belgium. The young preacher (he had just finished his theological studies to become, like his father, a pastor) was on his way to see those in the mines whom he called his brothers, like the simple workers, such as he had read of in the Bible, oppressed for the luxury of the great.

Contrary to the teachings of his instructors, the wise Dutchmen, Vincent believed in Jesus who loved the poor; his soul, entirely suffused with charity, desired by means of consoling words and self-sacrifice to help the weak, to combat the great. Decidedly, decidedly, Vincent was already mad.

His teaching of the Bible in the mines was, I believe, profitable to the miners below, but disagreeable to the authorities on high, above ground. He was quickly recalled, dismissed, and a family council convened that judged him mad, and advised rest at a sanatorium. He was not, however, confined, thanks to his brother Theo.

One day the somber black mine was flooded by chrome yellow, the fierce flash of firedamp fire, a mighty dynamite that never misfires. The beings who were crawling and teeming about in filthy carbon when this occurred bid, on that day, farewell to life, farewell to men, without blasphemy.

COLORPLATES 59, 61

Van Gogh's late-August 1888 series of sunflower paintings were planned as a decorative scheme for the Yellow House. Also dating to this time is a still life of shoes which differs in color from Gauguin's description.

Subsequent to a devastating 1879 explosion in a mine in the Borinage, Van Gogh tended the wounded.

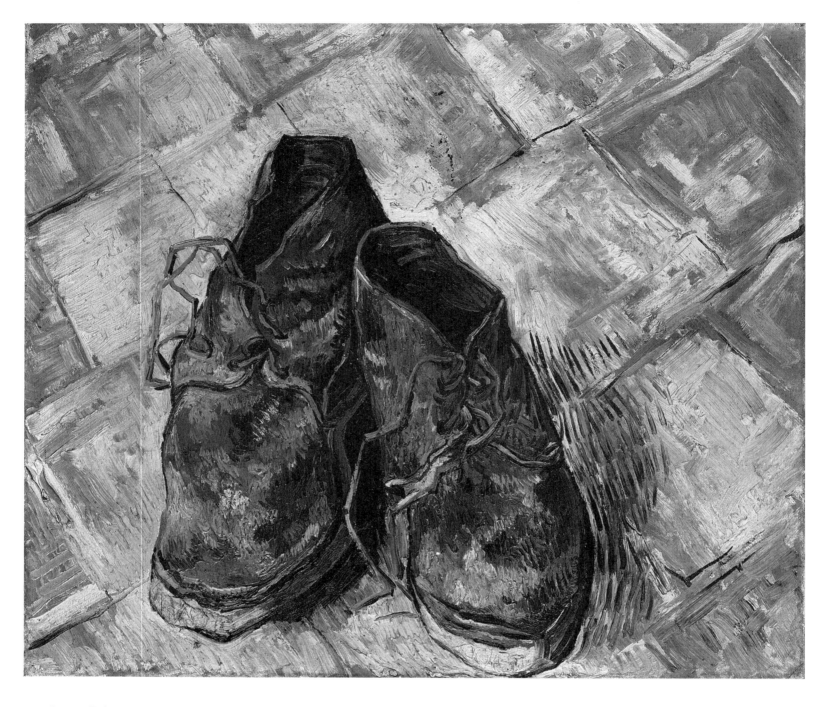

One of them, terribly mutilated, his face burnt, was taken in by Vincent. "And yet," the company doctor had said, "he is a finished man, barring a miracle or very costly nursing. No, it would be folly to attend to him."

Vincent believed in miracles, in maternity.

The mad man (decidedly he was mad) kept watch for forty days at the bedside of the dying man; he prevented the air from ruthlessly penetrating into his wounds and paid for the medications. He spoke as a consoling priest (decidedly he was mad). The work of a madman had revived a Christian from the dead.

When the wounded man, finally saved, descended into the mine again to resume his work, you could have seen, said Vincent, the head of Jesus the martyr, carrying on his forehead the halo and the jagged crown of thorns, red scabs on the dirty yellow forehead of a miner.

And me . . . I painted him—Vincent—who traced with his yellow brush on the suddenly violet wall:

> *I am the Holy Spirit,*
> *. . . sound of Spirit.*

Decidedly, this man was mad.

A Pair of Shoes. 1888. Canvas. 17⅜ × 20⅞″ (44 × 53 cm). Private Collection, U.S.A.

122

Paul Gauguin

MERCURE DE FRANCE

"Avant et Après"

October 1903

Shortly after completing "Avant et Après" in Atuana in the Marquesas in January to February 1903, Gauguin submitted it to the Mercure de France *for publication. First published, by Charles Morice, were the sections of it devoted to Van Gogh. On this subject see Mark Roskill,* Van Gogh, Gauguin and the Impressionist Circle *(1970).*

For a long time I have wished to write about Van Gogh, and I will certainly do so one fine day when I am in the mood: for the moment, I intend to recount about him—or, better, about us—certain things that are apt to correct an error that has circulated in certain circles.

It is surely chance that in the course of my existence several men who have spent time in my company and with whom I've enjoyed discussions have gone mad.

This was the case with the two Van Gogh brothers, and some, from evil intentions, and others, from naiveté, have attributed their madness to my doing. Certainly, some people may have more or less of an influence over their friends, but that is a far cry from provoking madness. Well after the catastrophe, Vincent wrote me from the mental asylum where he was being treated:

"How fortunate you are to be in Paris! This is still where one can find the leading authorities, and certainly you should consult a specialist in order to cure you of madness." Aren't we all a little mad? The advice was good, that is why I did not follow it, from contrariness, no doubt.

The readers of the *Mercure* were able to see, in a letter of Vincent's published a few years ago, how insistent he was that I come to Arles to found, according to his idea, an atelier of which I would be the director.

I was working at the time at Pont-Aven, in Brittany, and whether because the studies I had undertaken bound me to that place, or because by some vague instinct I foresaw something abnormal, I resisted for a

The Mercure de France *excerpts (1893–1895) do not refer to these hopeful plans, but Van Gogh did dwell on the subject in a number of letters dating from May to October 1888.*

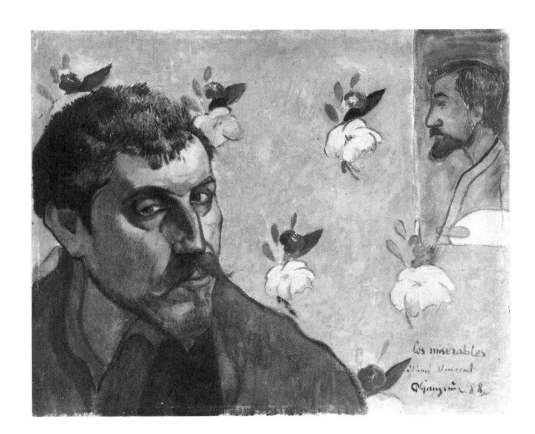

Paul Gauguin. *Self-Portrait ("Les Misérables")* (dedicated to Van Gogh). 1888. Canvas. 16⅞ × 21¼" (43 × 54 cm). Rijksmuseum Vincent van Gogh, Amsterdam.

long time, until the day when, won over by Vincent's sincere flights of friendship, I set out.

I arrived at Arles toward the end of night and awaited daybreak in an all-night café. The owner looked at me and cried out: "It's you, his pal, I recognize you."

A self-portrait that I had sent to Vincent suffices to explain this proprietor's exclamation. While showing him my portrait, Vincent had explained that it was of a pal who was to arrive soon.

Neither too early, nor too late, I went to awaken Vincent. The day was devoted to my settling in, to much chatting, to a bit of strolling to admire the beauties of Arles and the Arlésiennes (for whom, incidentally, I was unable to work up any enthusiasm).

Beginning the following day, we were at work, he continuing, and I, starting fresh. You should know that I have never had the cerebral facility that others, without any trouble, find at the tip of their brushes. Those others get off the train, pick up their palette, and in no time at all set you down a sunlight effect. When it's dry, it goes to the Luxembourg and it's signed: Carolus Duran.

I do not admire such painting, but I admire the man: he so sure, so tranquil!—I so uncertain, so restless!

In every country, I need a period of incubation to learn each time the essence of the plants, the trees, of all of nature, in short—so varied and so capricious, never wanting to let itself be divined or revealed.

So it was several weeks before I clearly sensed the sharp flavor of Arles and its environs. That did not prevent our working steadily, especially Vincent. Between the two beings, he and I, the one entirely a volcano and the other, boiling as well, but inside. Some sort of struggle was bound to occur.

First of all, I was shocked to find a disorder everywhere and in every respect. His box of colors barely sufficed to contain all those squeezed tubes, which were never closed up, and despite all this disorder, all this mess, everything glowed on the canvas—and in his words as well. Daudet, de Goncourt, the Bible fueled the brain of this Dutchman. At Arles, the quays, the bridges, the boats, the whole Midi became another Holland for him. He even forgot how to write in Dutch and, as one could see from the publication of his letters to his brother, he always wrote in French only, and did so admirably, with no end of phrases like *tant que* and *quant á*.

Despite all my efforts to disentangle from that disordered brain a logical reasoning behind his critical opinions, I could not explain to myself the complete contradiction between his painting and his opinions. So that, for example, he had an unlimited admiration for Meissonnier and a profound hatred for Ingres. Degas was his despair and Cézanne was nothing but a fraud. When thinking of Monticelli, he wept.

What angered him was to be forced to admit that I had great intelligence, although my forehead was too small, a sign of imbecility. In the midst of all this, a great tenderness, or rather, the altruism of the Gospel.

From the very first month, I saw our common finances taking on the same appearance of disorder. What to do? The situation was delicate as the cash box being filled, only modestly, by his brother employed at Goupil's, and, for my part, through the exchange of paintings. I was obliged to speak, and to come up against that great sensitivity of his. It was thus only with many precautions and quite a bit of coaxing hardly compatible with my character that I approached the question. I must confess, I succeeded far more easily than I had supposed.

In a box, so much for nightly outings and hygiene, so much for tobacco, so much, too, for unforeseen expenses, including the rent. On top of it all, a piece of paper and a pencil to inscribe honestly what each took from this till. In another box, the balance of the sum, divided into four parts, for the cost of food each week. Our little restaurant was given up

Gauguin's decision to go to Arles had other motivations, for, after months of negotiation between Theo, Vincent, and Gauguin, Theo agreed to give Gauguin 150 francs a month and free lodging in exchange for a painting each month. Gauguin also hoped that the southern climate of Arles would restore his health and that Theo's purchase of his paintings would finance his return to the tropics. Van Gogh and Gauguin spent two months together in Arles, from 23 October to 26 December 1888.

Charles Emile Auguste Carolus-Duran (1838–1917), highly successful fin-de-siècle *portraitist who shared his friend Manet's great admiration for Velásquez.*

Van Gogh zealously read the novels of Provençal author Alphonse Daudet (1840–1897), and the naturalist writers, Edmond (1822–1896) and Jules (1830–1870) de Goncourt.

Van Gogh was trilingual, with fluency in Dutch, French, and English; while most of his later correspondence is in French, the occasional letters written in Dutch up through 1890 show clearly that he had not forgotten his native tongue.

and, with the aid of a little gas stove, I did the cooking while Vincent, without going very far from the house, did the shopping. Once, however, Vincent wanted to make a soup, but I don't know how he mixed it—no doubt like the colors on his paintings—in any event, we couldn't eat it. And my Vincent exclaimed in laughter: "Tarascon! La casquette au père Daudet!"

On the wall, with chalk, he wrote:

Je suis Saint Esprit.
Je suis sain d'esprit!

How long did we remain together? I couldn't say, having entirely forgotten. Despite the rapidity with which the catastrophe arrived, despite the fever of working that had overtaken me, that whole time seemed like a century.

Without the public having any suspicion, two men had done there a colossal work, useful to them both—perhaps to others. Certain things bear fruit.

Vincent, at the moment when I arrived in Arles, was fully immersed in the Neo-Impressionist school, and he was floundering considerably, which caused him to suffer; the point is not that this school, like all schools, was bad, but that it did not correspond to his nature, which was so far from patient and so independent.

With all these yellows on violets, all this work in complementary colors—disordered work on his part—he only arrived at subdued, incomplete, and monotonous harmonies; the sound of the clarion was missing.

I undertook the task of enlightening him, which was easy for me, for I found a rich and fertile soil. Like all natures that are original and marked with the stamp of personality, Vincent had no fear of his neighbor and was not stubborn.

From that day on, my Van Gogh made astonishing progress: he seemed to catch a glimpse of all that was within him, and hence that whole series of suns on suns in full sunlight.

COLORPLATE 62

Have you seen the portrait of the poet?

1. The face and hair, chrome yellow.

2. The clothing chrome yellow.

3. The tie chrome yellow. With an emerald, green-emerald pin.

4. On a background of chrome yellow.

This is what an Italian painter said to me and he added:

"[Merde, merde], everything is yellow: I don't know what *painting* is any longer!"

It would be idle to go into details of technique here. This is said only to inform you that Van Gogh, without losing one inch of his originality, gained a fruitful lesson from me. And each day he would thank me for it. And that is what he means when he writes to M. Aurier that he owes much to Paul Gauguin.

When I arrived in Arles, Vincent was trying to find his way, whereas I, much older, was a mature man. I do owe something to Vincent; namely, in the awareness of having been useful to him, the *affirmation* of my earlier ideas about painting. Moreover, for the recollection at difficult moments that there are those unhappier than oneself.

When I read this passage: "Gauguin's drawing somewhat recalls that of Van Gogh," I smile.

During the latter part of my stay, Vincent became excessively brusque and noisy, then silent. Several nights I surprised Vincent who, having risen, was standing over my bed.

To what can I attribute my awakening just at that moment?

See Van Gogh's letter to G.-Albert Aurier (in this volume), a copy of which he sent to Gauguin.

Gauguin, then forty years old, was only five years Van Gogh's senior.

Here Gauguin paraphrases the critic Fontainas, who in the January 1889 Mercure de France, had written: "Gauguin has invented his own manner of drawing, though perhaps it comes close to Van Gogh's or even to Cézanne's."

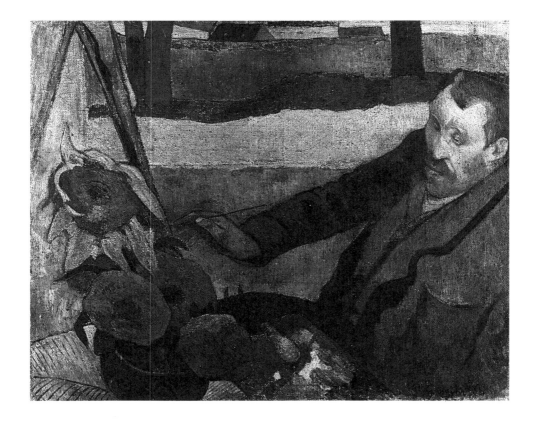

Paul Gauguin. *Van Gogh Painting Sunflowers*. 1888. Canvas. 28¾ × 36¼″ (73 × 92 cm). Rijksmuseum Vincent van Gogh, Amsterdam.

Invariably it sufficed for me to say to him very gravely:

"What's the matter, Vincent?" for him to go back to bed without a word and to fall into a deep sleep.

I came upon the idea of doing his portrait while he painted the still life that he so loved—some sunflowers. And, the portrait finished, he said to me: "That's me all right, but me gone mad."

That same evening, we went to the café: he took a light absinthe.

Suddenly he threw the glass and its contents at my head. I avoided the blow and, taking him bodily in my arms, left the café and crossed the Place Victor-Hugo; some minutes later, Vincent found himself in bed, where he fell asleep in a few seconds, not to awaken again until morning.

When he awoke, he said to me very calmly:

"My dear Gauguin, I have a vague memory of having offended you last evening."

"I gladly forgive you with all my heart, but yesterday's scene could happen again, and if I were struck I might lose control of myself and strangle you. So permit me to write your brother and announce my return."

My God, what a day!

When evening had arrived and I had quickly eaten my dinner, I felt the need to go out alone and take in the air, scented with flowering laurels. I had already almost crossed the Place Victor Hugo, when I heard behind me a familiar short footstep, rapid and irregular. I turned just at the moment when Vincent rushed towards me, an open razor in his hand. My look at that moment must have been powerful indeed, for he stopped, and lowering his head, took off running in the direction of the house.

Was I lax at that moment, and oughtn't I to have disarmed him and sought to calm him down? Often I have questioned my conscience, but I do not reproach myself at all.

Let him who will cast the stone at me.

Only a short stretch, and I was in a good hotel in Arles, where, after asking the time, I took a room and went to bed.

Very agitated, I could not fall asleep until about three in the morning, and I awoke rather late, about seven-thirty.

Six days after this incident, Gauguin described the details to Bernard, but made no mention of the razor.

Upon arriving at the square, I saw a large crowd assembled. Near our house, some gendarmes and a little gentleman in a bowler hat, who was the police commissioner.

Here is what had happened.

Van Gogh returned to the house and, immediately, cut off his ear close to the head. He must have taken some time in stopping the hemorrhage, for the next day there were many wet towels scattered about on the floor tiles of the two rooms downstairs.

The blood had stained the two rooms and the little staircase that led up to our bedroom.

When he was in good enough condition to go out, his head covered up by a Basque beret pulled all the way down, he went straight to a house where, for want of a fellow-countrywoman, one can find a chance acquaintance, and gave the "sentry" his ear, carefully washed and enclosed in an envelope. "Here," he said, "a remembrance of me." Then he fled and returned home, where he went to bed and slept. He took the trouble, however, to close the shutters and to set a lighted lamp on a table near the window.

In fact, Van Gogh had only cut off the lower part of his ear.

Ten minutes later, the whole street given over to the *filles au joie* was in commotion and chattering about the event.

I had not the slightest inkling of all this when I appeared on the threshold of our house and the gentleman with the bowler hat said to me point-blank, in a more than severe tone:

"What have you done, sir, to your comrade?"—"I don't know."—"Oh, yes, . . . you know very well, . . . he is dead."

I would not wish anyone such a moment, and it took me a few long minutes to be able to think clearly and to repress the beating of my heart.

Anger, indignation, and grief as well, and the shame of all those gazes that were tearing my entire being to pieces suffocated me, and I stuttered when I said, "Alright, sir, let us go upstairs, and we can explain ourselves up there." In the bed, Vincent lay completely enveloped in the sheets, curled up like a gun hammer; he appeared lifeless. Gently, very gently, I touched the body, whose warmth surely announced life. For me it was as if I had regained all my powers of thought and energy.

Almost in a whisper, I said to the commissioner of police:

"Be so kind, sir, as to awaken this man with great care and, if he asks for me, tell him that I have left for Paris. The sight of me could be fatal to him."

I must avow that from this moment on the commissioner of police was as reasonable as possible and intelligently sent for a doctor and a carriage.

Once awake, Vincent asked for his comrade, his pipe, and his tobacco, and he even thought of asking for the box that was downstairs containing our money. A suspicion, without a doubt, that barely touched me, having already armed myself against all suffering.

Vincent was taken to the hospital where, upon arrival, his brain began to wander about again.

All the rest of it is known to everyone that it could be of interest to, and it would be useless to speak of it, were it not for the extreme suffering of a man who, cared for in a madhouse, at monthly intervals, regained his reason sufficiently to understand his condition and furiously paint the admirable paintings that we know.

The last letter that I had from him was dated from Auvers, near Pontoise. He told me that he had hoped to recover enough to come to visit me in Brittany, but that now he was obliged to recognize the impossibility of a cure.

"Dear master (the only time that he had used this word), after having known you and caused you pain, it is more dignified to die in a good state of mind than in a degraded state."

And he put a pistol shot in his stomach, and it was not until a few

hours later, lying in his bed and smoking his pipe, that he died having complete lucidity of mind, with love for his art, and without hatred for others.

In *Les Monstres*, Jean Dolent writes:

"When Gauguin says 'Vincent,' his voice is gentle."

Without knowing it, but having guessed it, Jean Dolent is right. One knows why. . . .

Jean Dolent—pseudonym of Antoine Fournier (1835–1909)—in Les Monstres *(1896) had characterized Gauguin as "softening his tone for Vincent, Gustave Moreau, Puvis de Chavannes, and the old masters. . . ."*

Letters from Vincent and Gauguin

On Working Together in Arles

October–December 1888

VINCENT TO THEO, 28 OCTOBER 1888 *(588)*

I do not yet know what Gauguin thinks of my decorations in general, I only know that there are already some studies which he really likes, like the sower, the sunflowers, and the bedroom.

COLORPLATES 49, 55, 59, 61, 73

And as for the whole, I do not in the least know myself yet, because I need some more canvases of the other seasons. Gauguin has already very nearly found his Arlésienne, and I wish I had got that far, but for my part it is the landscape that comes to me, and I find it varied enough. So after all my modest work is going on as usual.

I venture to think that you will like the new "Sower."

I am writing in haste; we have loads of work to do. He and I intend to make a tour of the brothels pretty often, so as to study them. . . .

VINCENT TO EMILE BERNARD, CA. 2 NOVEMBER 1888 *(B19a)*

Well, here we are without the slightest doubt in the presence of a virgin creature with savage instincts. With Gauguin blood and sex prevail over ambition.

But enough, you have seen him at close range for a longer time than I have; I only wanted to tell you in a few words what my first impressions are. . . .

VINCENT TO THEO, CA. 12 NOVEMBER 1888 *(561)*

We are having wind and rain here, and I am very glad not to be alone. I work from memory on bad days, and that would not do if I were alone.

Gauguin has also almost finished his night café. He is very interesting as a friend, I must tell you that he knows how to cook *perfectly*; I think I shall learn from him, it is very convenient. We find it very easy to make frames with plain strips of wood nailed on the stretcher and painted, and I have begun doing this. Do you know that Gauguin is really partly the inventor of the white frame? But the frame of four strips nailed on the stretcher costs 5 *sous*, and we are certainly going to perfect it. It does very well, because the frame has no projection, and is one with the picture. . . .

GAUGUIN TO THEO, CA. 16 NOVEMBER 1888

The good Vincent and *le grièche* Gauguin continue to make a happy couple and eat at home the little meals they prepare themselves. But *coquin de Diou* (as they say), the damn rainy season drives them crazy for

In the January 1888 La Revue indépendante, *Félix Fénéon had described Gauguin as "ce grièche artiste"—a grumpy or disagreeable artist.*

the outdoors, and so they indulge in painting without a model. In this manner, your brother has made a good Dutch garden that you know, with the family. I also made one from memory of a poor, utterly bewitched woman in an open field of red vines, and your rather indulgent brother thinks it's good. My health has improved little by little, and I greatly hope that a year from now I will be strong enough to return to the tropics to attack, this time for good, the negresses, nude, clothed, etc. But to do so, I'll need to save up a bit of money; so it's best that we wait to speak about this. This damned Midi sun has you always making plans. . . .

VINCENT TO THEO, CA. 23 NOVEMBER 1888 (563)

Gauguin, in spite of himself and in spite of me, has more or less proved to me that it is time I was varying my work a little. I am beginning to compose from memory, and all my studies will still be useful for that sort of work, recalling to me things I have seen. What then does selling matter, unless we are absolutely pressed for money?

* * *

Gauguin was telling me the other day that he had seen a picture by Claude Monet of sunflowers in a large Japanese vase, very fine, but—he likes mine better. I don't agree—only don't think that I am weakening.

I regret—as always, how well you know—the scarcity of models and the thousand obstacles in overcoming that difficulty. If I were a different sort of man, and if I were better off, I could force the issue, but as it is I do not give in, but plod on quietly.

If by the time I am forty I have done a picture of figures like the flowers Gauguin was speaking of, I shall have a position in art equal to that of anyone, no matter who. So, perseverance. . . .

VINCENT TO THEO, CA. 4 DECEMBER 1888 (560)

Our days pass in working, working all the time, in the evening we are dead beat and go off to the café, and after that, early to bed! Such is our life. . . .

COLORPLATE 78

Gauguin's painting was Grape Gathering: Human Misery, *which is now in The Ordrupgaard Collection, Copenhagen.*

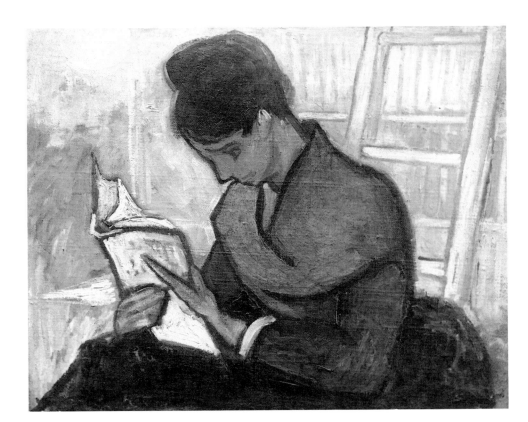

The Novel Reader. 1888. Canvas. 28¾ × 36¼″ (73 × 92 cm). Private Collection, Japan.

GAUGUIN TO THEO, CA. 12 DECEMBER 1888

I would be most obliged to you if you would send me part of the money from the paintings that were sold. All things considered, I'm obliged to return to Paris; Vincent and I absolutely cannot live side-by-side any longer without friction because of the incompatibility of our temperaments and because he and I both need tranquillity for our work. He's a man of a remarkable intelligence whom I hold in great esteem and leave with regret, but, I repeat, it is necessary that I leave. I appreciate how tactfully you have handled all your dealings with me and ask you please to forgive my decision. . . .

GAUGUIN TO EMILE BERNARD, DECEMBER 1888

I'm in Arles, completely out of place because I find everything, the landscape and the people, so petty and shabby. In general, Vincent and I rarely agree on anything, especially on painting. He admires Daumier, Daubigny, Ziem, and the great Rousseau, none of whom I can stand. And, on the other hand, he detests Ingres, Raphaël, Degas, all of whom I admire. I reply, "Corporal, you're right to be quiet." He loves my paintings, but when I'm doing them, he always finds that I've done this or that wrong. He is a romantic and I am more inclined to a primitive state. Regarding color, he sees the possibilities of impasto as in Monticelli, whereas I hate the mess of execution, etc. . . .

Adolphe Monticelli (1824–1886), Provençal painter whose rich impasto and synthesis of Romantic, Impressionist, and even proto-Expressionist tendencies Van Gogh nearly idolized.

VINCENT TO THEO, CA. 16–17 DECEMBER 1888 *(565)*

I think myself that Gauguin was a little out of sorts with the good town of Arles, the little yellow house where we work, and especially with me.

As a matter of fact, there are bound to be grave difficulties to overcome here too, for him as well as for me.

But these difficulties are more within ourselves than outside.

Altogether I think that either he will definitely go, or else definitely stay.

I told him to think it over and make his calculations all over again before doing anything.

Gauguin is very powerful, strongly creative, but just because of that he must have peace.

Will he find it anywhere if he does not find it here?

I am waiting for him to make a decision with absolute serenity. . . .

VINCENT TO THEO, CA. 17–18 DECEMBER 1888 *(564)*

Gauguin and I talked a lot about Delacroix, Rembrandt, etc. Our arguments are terribly *electric*, sometimes we come out of them with our heads as exhausted as a used electric battery. We were in the midst of magic, for as Fromentin says so well: Rembrandt is above all a magician.

* * *

Gauguin was saying to me this morning when I asked how he felt "that he felt his old self coming back," which gave me enormous pleasure. When I came here myself last winter, tired out and almost dazed in mind, before being able to recover, I had some inner suffering too. . . .

FORUM RÉPUBLICAIN

"Local News"

30 December 1888

Last Sunday at 11:30 at night, one Vincent Vaugogh [sic], painter and native of Holland, presented himself at the *maison de tolérance* no. 1, asked for one Rachel, and gave her . . . his ear, saying, "Guard this object carefully." Then he disappeared. Informed of this act, which could only have been that of a poor, deranged person, the police went the next morning to his house, and found him lying in his bed, giving almost no sign of life.

The unfortunate man was immediately admitted to the asylum.

Dr. Félix Rey, Interviewed by Max Braumann

KUNST UND KÜNSTLER

"With Van Gogh's Friends in Arles"

1928

Vincent was above all a miserable, wretched man, short—Please get up! About your height—and thin. He always wore a sort of overcoat, smeared with paint—as he painted with his thumb, he would then wipe it on his coat—and an enormous straw hat without a band, as is the custom with the shepherds of the Camargue, for protection against the scorching sun. He often complained that he was the only painter in town and therefore could not talk to anyone about his art. For lack of such a colleague, he would talk to me about complementary colors. But I really could not understand why red should not be red, and green not green! . . .

Before he would set out to go to work in the morning with canvas and easel, he would put a pot of chick-peas on the coal fire. When he returned in the evening, usually extremely tired, the fire, naturally, was out and the dish of peas usually half-cooked and inedible. Nevertheless, he would eat this very unappetizing food, unless he chose to calm his stomach with alcohol.

* * *

When I saw that he outlined my head entirely in green (he had only two main colors, red and green), that he painted my hair and my mustache—I really did not have red hair—in a blazing red on a biting green background, I was simply horrified. What should I do with this present? Nor did I know what to do with other paintings, *The Hospital Garden* and *Dormitory in the Hospital*, that were also presented to me. I offered them to the Administrator of Hospitals, who happened to be visiting, but he would have no part of them and passed them on to the secretary of the clinic. You see, this gentleman is himself a painter. . . . Unfortunately,

Report published in the local paper *Forum Républicain* (30 December 1888).

Dr. Félix Rey (1867–1932), resident surgeon who attended Van Gogh from 24 December 1888 to 7 January 1889 in the hospital at Arles following the mutilation of his ear.

COLORPLATE 82

Supposedly, this picture was so disliked by Dr. Rey's mother that it was used to close up a gap in the hen house. Discovered by the artist Charles Camoin in 1901, the picture was sold with other Van Gogh canvases to a dealer in Marseilles; it is now in the Pushkin Museum, Moscow.

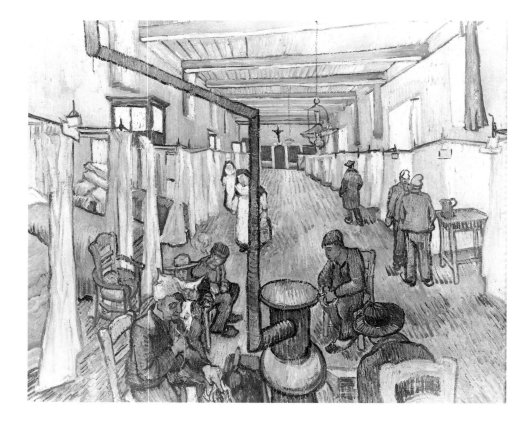

The Hospital at Arles. 1889. Canvas. 29⅛ × 36¼" (74 × 92 cm). Sammlung Oskar Reinhart "Am Römerholz," Winterthur.

Van Gogh's paintings did not find favor with him either. This gentleman called them "dirty obscenities" and presented them, now for the fourth time, to the druggist. More careful than the previous owners, this man kept them and sold them much later, when the value of the works by the dead Van Gogh had reached a very high level, for fabulous prices.

COLORPLATE 86

The City of Arles vs. Vincent van Gogh
PETITION AND INVESTIGATION REPORT
February – March 1889

From 7 to 17 February 1889, Van Gogh was again at the hospital in Arles after having hallucinations and believing he was being poisoned. About 25 February, a petition of some thirty neighbors led to a police investigation and his internment in the hospital. The Yellow House was closed by the police.

PETITION

M. Mayor, We the undersigned residents of the city of Arles, Place Lamartine, have the honor of informing you that the Dutch subject named Vood (Vincent), landscape painter residing on the aforementioned square, has for some time and on several occasions furnished proof that he is not in full possession of his mental faculties and that he indulges in excessive drinking, after which he finds himself in such a state of excitement that he no longer knows either what he does or what he says, and that his instability causes fear for all the residents of the neighborhood, particularly for the women and children.

In consequence, the undersigned have the honor of asking in the name of public security that the said Vood (Vincent) be returned to his family as soon as possible, or that his family take the steps necessary to have him admitted to a mental asylum, in order to prevent whatever misfortune which will certainly occur one day or another if vigorous measures are not taken.

We dare to hope, M. Mayor, that, taking into consideration the serious concern that we are putting forward, you will be so kind as to take action in pursuance with our request.

We have the honor of being, with the most profound respect, M. Mayor, your devoted constituents.

<p align="center">* * *</p>

POLICE INVESTIGATION REPORT

The year eighteen hundred and eighty-nine and the twenty-seventh of February; we, the Police Commissioner of the city of Arles, the officer of the judiciary police, the Assistant to the Public Prosecutor; given the attached petition of the inhabitants of the Place Lamartine, concerning the actions of one Vincent van Goghe [sic], Dutch subject, suffering from mental alienation; in view of the attached report by Doctor Delon of the seventh of this month and the orders of the Mayor of Arles, prescribing that the degree of Van Goghe's madness be established; proceeded with an investigation and heard the following, enumerated below:

INVESTIGATION

M. A, 63 years of age, proprietor, residing on 53, avenue Montmajour, who made the following declaration: In my capacity as manager of the building inhabited by M. Vincent van Goghe, I had occasion to have a conversation with him yesterday and to observe that he is suffering from mental alienation, for his conversation is incoherent and his reasoning impaired. On the other hand, I have heard it said that this man indulges in touching women who live in the neighborhood; I was even assured that they are no longer even safe at home because he comes into their domiciles. In short, it is urgent that this lunatic be confined in an asylum; given above all that the presence of Van Goghe in our neighborhood compromises public safety.

One B, 32 years of age, grocery-store keeper residing Place Lamartine, who said to us as follows: I live in the same building as the said Vincent van Goghe, who is truly mad. This individual comes into my store and imposes himself. He insults my clients and indulges in touching women of the neighborhood, whom he follows right into their homes. In short, everyone in the neighborhood is scared because of the presence of the aforesaid Van Goghe, who will certainly become a public danger.

One C, 40 years of age, tobacco retailer, residing Place Lamartine, who confirmed the declaration of the preceding witness.

One D, 42 years of age, dressmaker, residing 24, Place Lamartine, who made the following declaration: M. Van Goghe, who lives in the same neighborhood as I do, has become increasingly mad in the last few days; consequently everyone in the neighborhood is frightened. The women especially no longer feel safe, for he indulges in touching them and makes obscene remarks in their presence. As for me, I was grabbed by the waist and lifted into the air by this individual in front of the shop of Mme. B [the second witness] the day before yesterday, Monday. In short, this madman is becoming dangerous to public safety, and everyone demands that he be confined in a special institution.

M. E, 45 years of age, café keeper, residing Place Lamartine, who acknowledged that the facts revealed by the preceding witness are true and sincere and declares that he has nothing to add to her deposition.

OBSERVATIONS

The said Vincent van Goghe is truly suffering from mental derangement; nevertheless we have observed on several occasions that this disturbed man has moments of lucidity. Van Goghe does not yet constitute

a public danger, but we fear that he may become one. All his neighbors
are frightened, and with reason, for, a few weeks ago, the madman of
whom we speak cut off his ear in a fit of madness; such a fit could reoc-
cur and be fatal for some person in his neighborhood.

CONCLUSIONS

Whereas the result of the preceding investigation and our personal ob-
servations is that the said Vincent van Goghe is suffering from mental
derangement and that he could become dangerous to public safety; we
are of the opinion that there are grounds for confining this madman in
a special asylum.

All of which we have documented in the present report to be trans-
mitted for legal ends and have signed:

> In Arles, the third of March,
> eighteen hundred and eighty-nine,
> Le Cre Central.

Letters from Rev. Frédéric Salles to Theo
On the Petition and Investigation Report
March–April 1889

*It was Reverend Salles of the Reformed
Protestant Church who accompanied Van
Gogh to the maison de santé, or asylum, of
Saint-Paul-de-Mausole in Saint-Rémy on
8 May 1889.*

1 MARCH 1889

I have just been to see your brother at the hospital and found him rea-
sonably well. Everyone, the house physician, the administrator and the
board of management, are well disposed towards him and it has been
decided that someone will go with him in order that he may collect his
brushes and paints so that he may find some distraction during his stay
at the hospital. Nevertheless, the problem remains the same. The super-
intendent of police, who has the petition about which I have written to
you and who has made inquiries in the district, remains convinced that
suitable measures should be taken. Yet it seems to me, and this view is

shared by M. Rey, that it would constitute an act of cruelty to lock up a man permanently who has done nobody any harm and who, as a result of treatment based on kindness, can return to his normal state. I repeat, all who are concerned with him at the hospital want to do what is best for him and everyone is prepared to do all that is possible to prevent his transfer to a mental home.

However, if one succeeds in bringing him back to normal, it would be advisable for him to give up his present lodgings and find quarters in another part of the town. This is the opinion of all. . . .

2 MARCH 1889

I have just received your letter and hasten to reply with a few words.

Your brother has been placed in the hospital by order of the police and as a result of the petition signed by the neighbors.

This petition, which I have read, claims that his behavior and acts are those of someone who is not in his right mind and that there would be a real danger if he were allowed his freedom!

After his entry into the hospital, the superintendent of police has interviewed those who signed the petition. You will understand that a thing like this cannot be done discreetly and without causing a stir: the statements have been collected and actually form a file. I have read some of them and am of the opinion that exaggeration plays a part in it. It is clear, however, that as things stand, the people are scared of your brother and have egged each other on. The things they accuse your brother of (assuming that they are true), do not justify declaring a man mad and claiming that he ought to be locked up. One says that the children collect round him and run after him and that he pursues them to catch them and that he might do them harm; that he drinks a lot (the innkeeper, his neighbor, who told me just the opposite, has confirmed this) and finally that the women are scared of him "because he has caught some of them round the waist and has permitted himself to fondle them." The latter expression returns often in the statements.

Unfortunately, the crazy act which necessitated his first hospitalization has resulted in a most unfavorable interpretation of anything out of the ordinary which this unfortunate young man may do. In the case of another person they might possibly not have drawn much attention, in his case they immediately assume a special importance.

In spite of the conviction of the superintendent of police, and his decision to have your brother locked up, I hope that we will succeed in keeping him here and that we will be able to avoid that which you so rightly fear. As I told you yesterday, everyone in the hospital is well disposed towards him and, when all is said and done, it should be the doctors and not the superintendent of police who ought to be the judges in a case like this. . . .

P.S. I have taken good note of all you say in your letter and will regard it as my duty to comply with it when I will consider it necessary. At the moment your brother is getting on quite well and is able to look after his own affairs.

18 MARCH 1889

Your brother spoke to me calmly and with a perfect lucidity regarding his position and also with regard to the petition signed by his neighbors, of which the superintendent had not kept him in ignorance. That document bothers him a great deal. If the police, he said, had protected my liberty by preventing the children and even grown-ups to collect round my lodgings and climb up to my window as they have done (as if I were a strange animal), I would have remained more calm; in any case I have done nobody any harm and I am no danger to anyone. He understands,

of course, that he is being treated as someone who is out of his mind and this both troubles and revolts him. I told him that when he would be completely cured, it would be in his own interest and better for his peace of mind if he were to live in another part of the town. He appeared to accept this suggestion, but pointed out to me that it might be difficult for him to find an apartment elsewhere after all that had taken place.

To sum up the situation: I have found your brother a quite different person and God may grant this improvement will be maintained. His condition is undefinable and it is impossible to understand the sudden and complete changes taking place in him. It is clear that so long as he remains as I have just seen him, there could be no question of taking him out of circulation; no one I know would have that sad courage. . . .

19 MARCH 1889

He is entirely conscious of his condition and talks to me of what he has been through and which he fears may return, with a candor and simplicity which is touching. "I am unable," he told me the day before yesterday, "to look after myself and control myself; I feel quite different from what I used to be." In view of this there was no reason to look for an apartment and we have given up all attempts in this direction. He has, therefore, requested me to obtain the necessary particulars, in order that he may be admitted somewhere and also to write to you in this sense.

Considering this decision, taken after mature deliberation, I thought that, before turning to you, I would obtain some information regarding a private institution near Arles, at Saint-Rémy, where it appears that the inmates are very well treated. I send you the reply which I have received and the prospectus that came with it. . . .

Letter from Paul Signac to Gustave Coquiot
VINCENT VAN GOGH

1923

The last time I saw Vincent . . . was in Arles in the spring of 1889. He was already at the hospital of this city. Several days earlier, he had cut off the lobe of his ear (and not his entire ear) under circumstances of which you know. But the day of my visit he had his wits about him, and the intern permitted me to go out with him. He had the famous bandage on, and the fur cap. He took me to his lodgings at the Place Lamartine, where I saw the marvelous paintings, his masterpieces: *Les Alyscamps; The Night Café; La Berceuse; The Drawbridge;* the *Saintes-Maries; The Starry Night*; etc. Imagine the splendor of those whitewashed walls from which these colors radiated in all their freshness!

The whole day he spoke to me about painting, literature, socialism. That night he was a little tired. There was a frightful mistral blowing which might have unnerved him. He wanted to drink a liter of oil of turpentine out of a bottle that sat on the table in the room. It was time to return to the hospital.

The next day I went to say good-bye to him; I was leaving for Cassis. There he wrote me a good letter about art and friendship, in which he told me the pleasure my visit had given him and which he illustrated with a beautiful drawing (two, actually). I didn't see him again.

At Theo's request, Signac stopped in Arles on his way to Cassis on 23 and 24 March 1888.

COLORPLATES 74, 63, 60, 43, 46, 69

COLORPLATE 41. *Snowy Landscape with Arles in the Background.* 1888. Canvas. 19⅝ × 23⅝″ (50 × 60 cm).
Private Collection, London.

COLORPLATE 42. *View of Arles with Irises.* 1888. Canvas. 21¼ × 25⅝″ (54 × 65 cm).
Rijksmuseum Vincent van Gogh, Amsterdam.

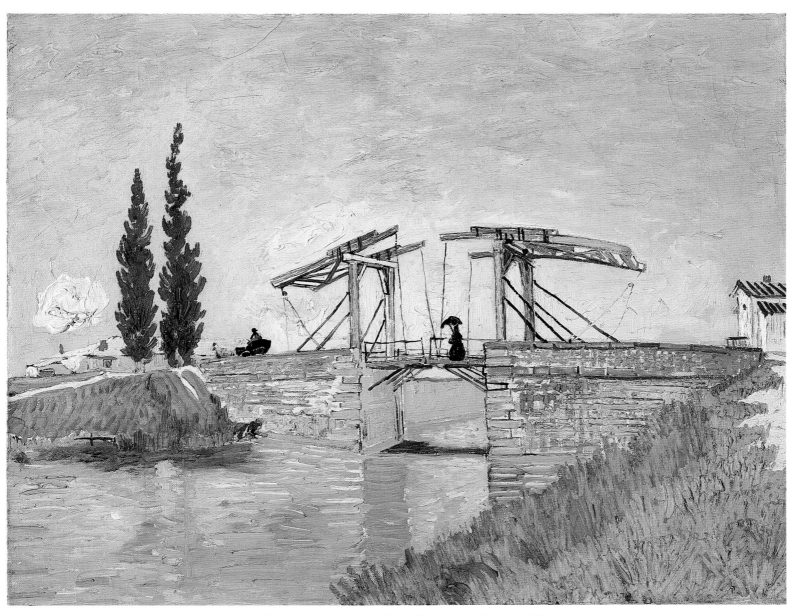

COLORPLATE 43. *The Langlois Bridge.* 1888. Canvas. 19½ × 25¼″ (49.5 × 64 cm).
Wallraf-Richartz Museum, Cologne.

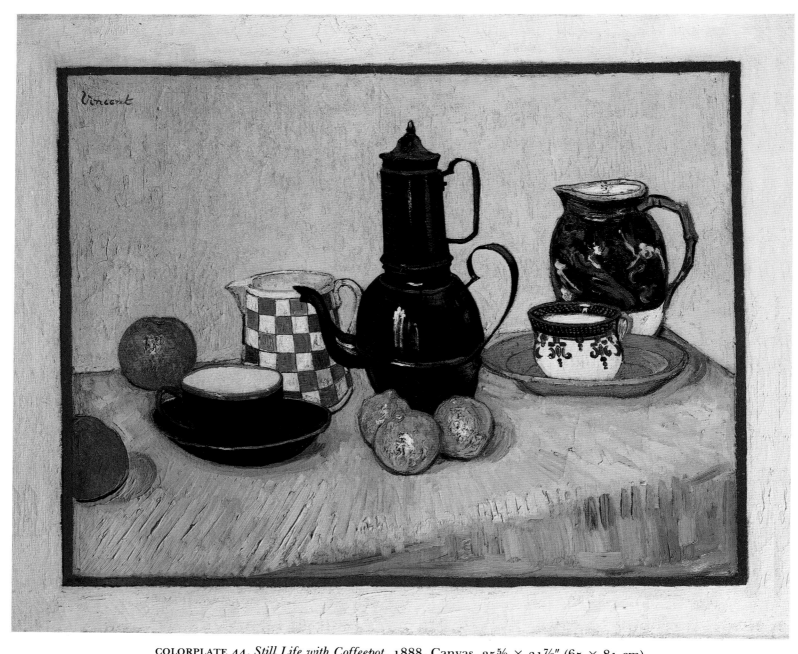

COLORPLATE 44. *Still Life with Coffeepot.* 1888. Canvas. 25⅝ × 31⅞″ (65 × 81 cm).
Private Collection, Lausanne.

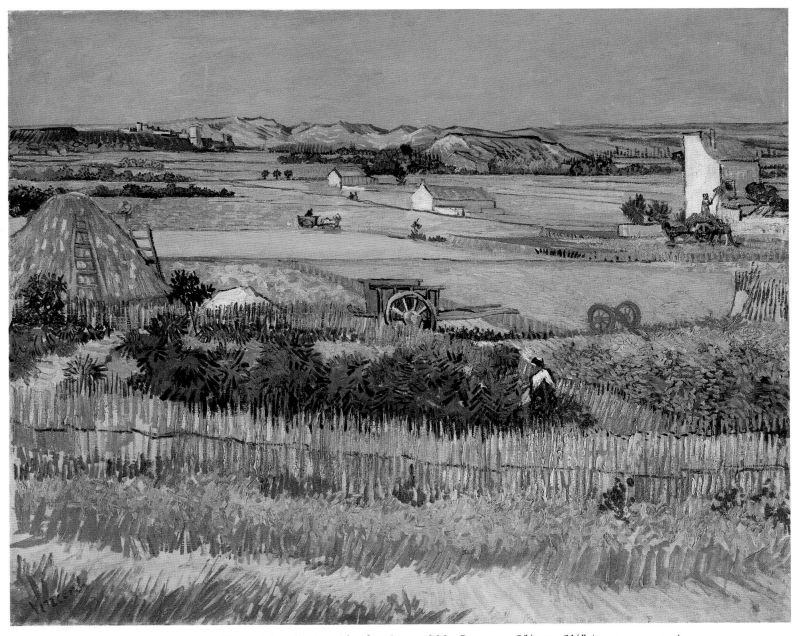

COLORPLATE 45. *Harvest Landscape with Blue Cart.* 1888. Canvas. 28¾ × 36¼″ (72.5 × 92 cm).
Rijksmuseum Vincent van Gogh, Amsterdam.

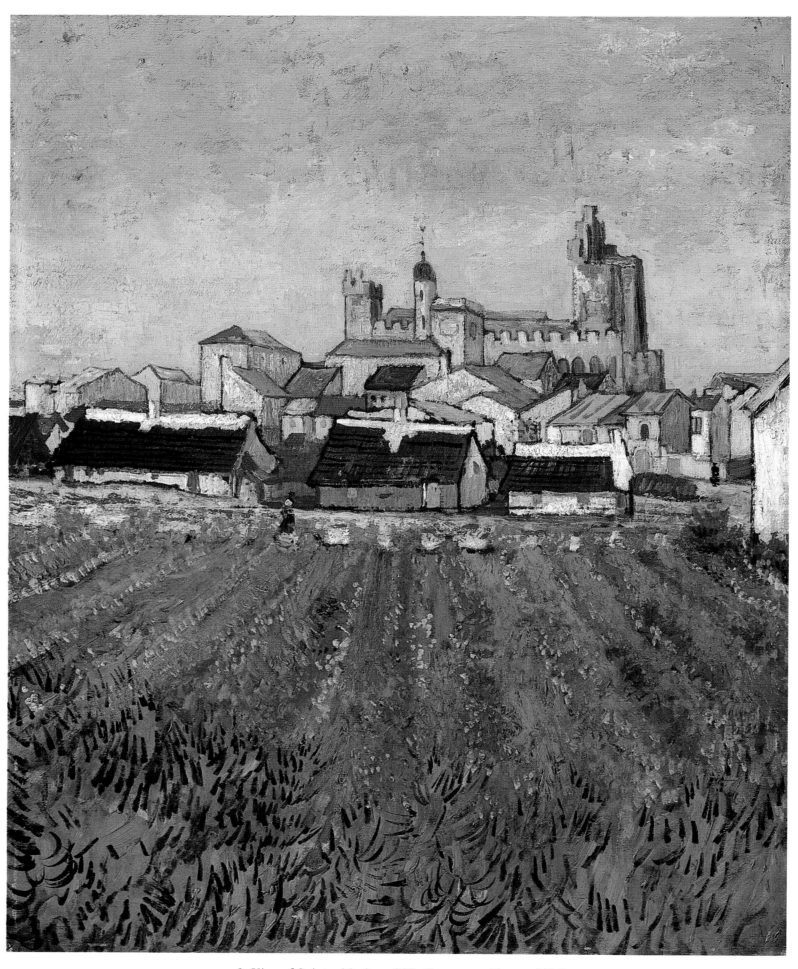

COLORPLATE 46. *View of Saintes-Maries.* 1888. Canvas. 25¼ × 20⅞″ (64 × 53 cm).
Rijksmuseum Kröller-Müller, Otterlo.

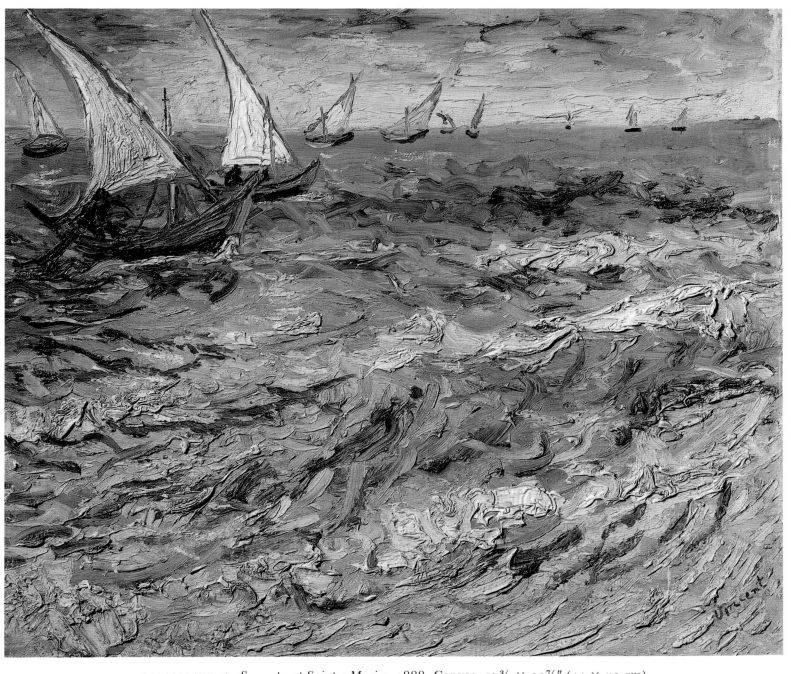

COLORPLATE 47. *Seascape at Saintes-Maries.* 1888. Canvas. 17⅜ × 20⅞″ (44 × 53 cm).
Pushkin State Museum of Fine Arts, Moscow.

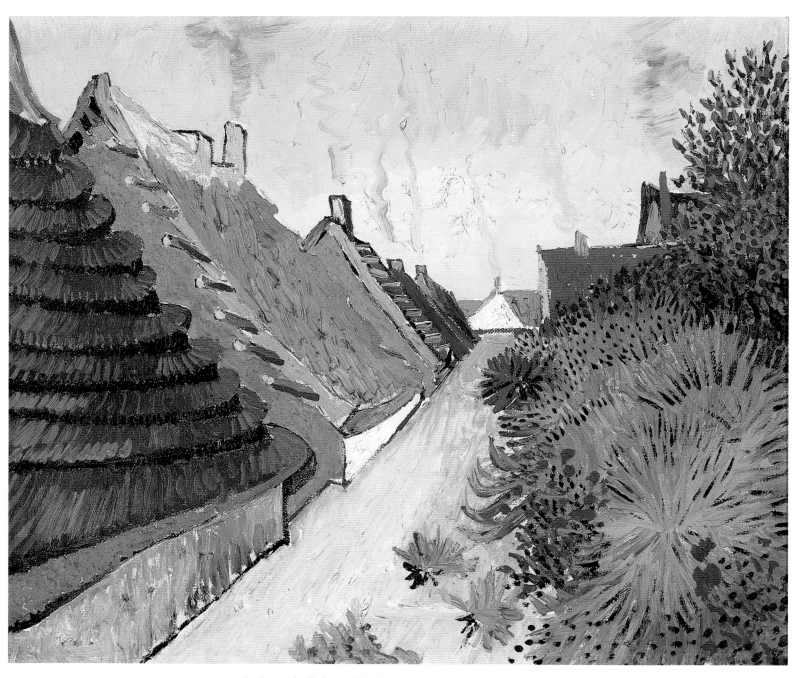

COLORPLATE 48. *Street in Saintes-Maries*. 1888. Canvas. 15 × 18⅛″ (38 × 46 cm).
Private Collection, U.S.A.

Letters from Vincent and Signac

On Signac's Visit to Arles

March–April 1889

VINCENT TO THEO, 24 MARCH 1889 (581)

I am writing to tell you that I have seen Signac, and it has done me quite
a lot of good. He was so good and straightforward and simple when the
difficulty of opening the door by force or not presented itself—the po-
lice had closed up the house and destroyed the lock. They began by re-
fusing to let us do it, but all the same we finally got in. I gave him as a
keepsake a still life which had annoyed the good gendarmes of the town
of Arles, because it represented two bloaters, and as you know they, the
gendarmes, are called that. You remember that I did this same still life
two or three times in Paris, and exchanged it once for a carpet in the old
days. That is enough to show you how meddlesome and what idiots these
people are.

Sketches after two paintings of orchards.
Letter to Paul Signac. Ca. 5 April 1889
(583b). Private Collection, Paris.

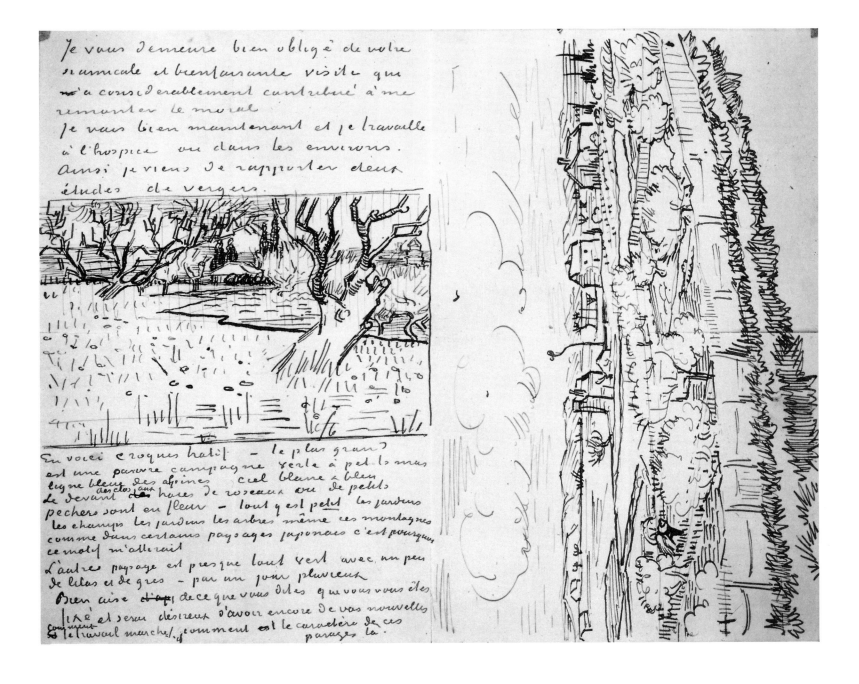

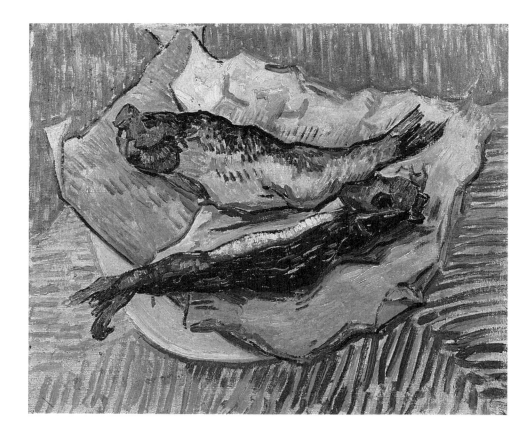

Still Life with Herring. 1889. Canvas. 13 × 16⅛″ (33 × 41 cm). Private Collection, Paris.

I found Signac very quiet, though he is said to be so violent; he gave me the impression of someone who has balance and poise, that is all. Rarely or never have I had a conversation with an impressionist so free from discords or conflict on both sides. For instance he has been to see Jules Dupré, and he admires him. Doubtless you had a hand in his coming to stiffen my morale a bit, and thank you for it. . . .

Jules Dupré (1811–1889), noted Barbizon artist.

SIGNAC TO THEO, 24 MARCH 1889 *(581a)*

I found your brother in perfect health, physically and mentally. Yesterday afternoon and again this morning we went for a walk together. He took me along to see his pictures, many of which are very good, and all of which are very curious.

His courteous doctor, the house physician Rey, is of the opinion that, if he should lead a very methodical life, eating and drinking normally and at regular hours, there would be every chance that the terrible crises would not repeat themselves at all.

He is quite willing to keep him all the time that would be necessary. He thinks that all the expenses of his stay in the hospital will have to be defrayed by the municipality, because it was at the administration's demand that he was kept in the asylum.

At any rate, if he does not go back to Paris, which in M. Rey's opinion would be preferable, it would be necessary for him to move to another house, as his neighbors are hostile to him. This is also what your brother desires, for at the earliest possible date he wants to leave this asylum, where after all he must necessarily suffer under the continual surveillance, which often has to be of a petty nature.

Summarizing, I emphatically assure you that I found him in a condition of perfect health and sanity. There is only one thing he wishes— to be able to work in tranquillity. So do your best to grant him this happiness. How dismal the life he is living must be for him.

I shake your hand cordially, dear M. Van Gogh.

VINCENT TO SIGNAC, CA. 5 APRIL 1889 *(583b)*

I remain greatly obliged to you for your friendly and beneficial visit,

which contributed considerably to raising of my spirits. At present I am well, and I work at the sanatorium and its environs. I have just come back with two studies of orchards.

Here is a crude sketch of them—the big one is a poor landscape with little cottages, blue skyline of the Alpine foothills, sky white and blue. The foreground, patches of land surrounded by cane hedges, where small peach trees are in bloom—everything is small there, the gardens, the fields, the orchards, and the trees, even the mountains, as in certain Japanese landscapes, which is the reason why the subject attracted me.

COLORPLATE 84

The other landscape is nearly all green with a little lilac and gray—on a rainy day.

I was very pleased to hear that you have settled down now, and I am longing for news about the progress of your work and about the character of the seaside scenery there.

Since your visit my head has just about returned to its normal state, and for the time being I desire nothing better than that this will last. Above all it will depend on a very sober way of living.

I intend to stay here for the next few months at least; I have rented an apartment consisting of two very small rooms.

But at times it is not easy for me to take up living again, for there remain inner seizures of despair of a pretty large caliber.

My God, those anxieties—who can live in the modern world without catching his share of them? The best consolation, if not the best remedy, is to be found in deep friendships, even though they have the disadvantage of anchoring us more firmly in life than would seem desirable in the days of our great sufferings.

Once more many thanks for your visit, which gave me so much pleasure. . . .

Maison de Santé de Saint-Rémy-de-Provence

Brochure for the Asylum

ca. 1865

This vast institution was founded at the beginning of the [nineteenth] century by Dr. Mercurin, Knight of the Legion of Honor, specialist in insanity, and remarkable practitioner, student, and emulator of the great masters who gave this period such a welcome impetus towards psychological studies.

His conscious choice of locale could not have been more suitable than its present topographical position.

The house, built on the northern slope of a hill in the Alpine chain, at first consisted of only a chapel—a graceful cloister, similar to Saint-Trophime at Arles, constructed in the twelfth or early thirteenth century, as attested to by diverse inscriptions—and a small annexed building. Occupied in turn by Augustinian monks, erected in provostship, secularized, and, in the end, inhabited by observant Franciscan priests, this chapel constituted the center or core of the institution.

By incessant efforts of enlargement and successive ameliorations, as well as by following the progress of science, the institution reached its present function as an asylum, better designed than most for service to the sick.

The institution, which covers about 54,000 square meters, 8,500 of which are covered with buildings, is entirely consecrated to the sick. It is

bounded on three sides by the grounds of a farm belonging to the same owner. The Alps rise above it in the south, ending in strange crests that leave between them and the asylum a very uneven ground interspersed with small picturesque valleys, in which the infirm are often taken on walks. In the west, at the gates of the institution, there stand a triumphal arch and a mausoleum, antique monuments sufficiently well-preserved, the glorious remains of Roman grandeur.

The asylum dominates a rich, spacious, and pleasant countryside; in the north, one kilometer lower, is the city of Saint-Rémy, the ancient city of Glanum, well-known for its salubrious and pure climate, which preserved it from the sicknesses and epidemics that flourished in the south of France. Beyond is a vast, rich plain in which the small cities of Eragues, Château-Renard, Maillane, etc., can be seen. The horizon extends up to the mountains of the Gard and the Vaucluse and forms a magnificent panorama in which Avignon on one side and Tarascon on the other can be distinguished. Several times a day, the regular services of public and private cars connect the railway stations of these cities with Saint-Rémy.

Air, light, space, large and beautiful trees, drinkable waters—fresh, abundant, of good quality, originating from the mountains—and sufficient remoteness from all large population centers: such are the principal justifications for the learned founder's choice of location.

In the richly decorated chapel at the center, religious ceremonies are nobly observed. Next to it is the antique cloister, where are grouped the general services, kitchen, stores and offices, refectories of the sisters and the ladies, and a parlor for family visits. Above are the lodgings of the sisters, the linen closet, the dressing rooms, and a few apartments consigned to boarders of higher social rank. On each side of the chapel and cloister in opposite directions to one another are single-story buildings set back at right angles. These constitute the men's quarters—at the head of which is the director's pavilion—and that of the ladies, completely separated from one another, yet permitting the sick to go under cover to the chapel in all seasons.

These well-lit quarters are heated in winter primarily by radiators, which provide a gentle, uniform heat that is always safe for the boarders. These quarters are made up of several divisions with rooms and bathrooms provided with showers, spacious dormitories, a long series of rooms and private apartments, and common living rooms. All these parts are more or less furnished and decorated according to the class of the boarders. The ladies' parlors are provided with lateral workrooms; those of the men, with billiard rooms, music, and a bureau for writing or drawing. Illustrated journals, books, and various games fit for recreation are at their disposal. Shady, well-planted gardens and parks, provided with fountains and maintained with care, surround the buildings and provide diversions. The changing terrain offers up a variety of scenic views.

These details should appreciably convey the advantages of this beautiful institution, to which the sick are admitted only in numbers proportionate to its capacity. However, we should say, above all, several words for the doctors about our primary object—the special care of the sick and the personnel designated to their service.

We cannot discuss here the subject of the medical care or treatment except in generalities concerning those illnesses falling under the name of mental alienation; these evidence among them such differences that it would be very difficult to describe the treatments. Let us say only that since founding the institution, the cruelty with which we once treated the mentally ill has been replaced by humane understanding. Moreover, incomparably superior treatments, without constraints but by means of gentleness and benevolence, were put into practice in this asylum well before we published their fine results. The use of medications, whose

Vestibule of the Asylum. 1889. Black chalk and gouache. 24⅜ × 18½″ (61.5 × 47 cm). Rijksmuseum Vincent van Gogh, Amsterdam.

efficacy has been demonstrated, and variety in works of the spirit, including manual work and amusements; such are the customary means to which we have recourse.

But, it must be said, in most mental illnesses that the physical and moral treatment is personal. It is no longer the *illness* which the doctor has to treat, but, rather, the sick *person*, for whom the complex treatment varies according to the diverse circumstances which led to the illness.

Good hygiene, a comfort many wrongly think these sick people do not perceive, always lends great power to the treatment. A skillful kitchen chef is charged with preparing choice, first-quality foods. The sick are guaranteed healthy food—abundant, varied, and even rare—according to the class of boarders to which they belong. The institution's Swiss cow barn provides plentiful natural dairy foods. These are the means by which we have so often obtained satisfactory results.

* * *

Let us say, finally, that the private asylum of Saint-Rémy-de-Provence responds to a social need, in that it is the only institution of its kind in the south of France. There is none like it in all the surrounding areas, both up to the Italian border as well as in all of Algeria.

Because of the low-priced board, this beautiful institution is a resource for numerous families whose finances prevent them from placing their sick in very high-priced private asylums and yet who find the public asylums greatly repugnant.

Let us voice our regret that we see this class of society still dominated by the prejudices to which the mentally affected are subjected. Too often families do not decide to bring their mentally ill person to a special institution until the sickness has progressed so far that we cannot promise a good recovery following the care they require.

<p style="text-align:center">*　*　*</p>

PECUNIARY CONDITIONS

All the sick receive the same medical care, but lodgings, food, and comforts will be provided according to how the family would like to see them surrounded.

From this stems the division of the boarders into several distinct classes.

Third class, 800 francs per year: Lodging in the dormitory and communal living rooms, unless the necessity of isolation or incidental illness exists. Sufficient, suitable board.

Second class, 1,200 francs per year: Single room, modestly furnished. Healthy, abundant food as in the third class, but more varied; common, more comfortable living rooms, often in the company of the first class, unless agitated.

First class, 1,600 francs per year: Single room furnished with a certain elegance, and board very complete and well-served.

Finally, those admitted under the title of higher boarders are furnished apartments of several rooms with luxury; their food is not only complete and varied but even rare. Moreover, they enjoy several special privileges; some have a male or female domestic designated to their service, who sleeps next to the sick person. In this case, the price of board is established amiably with the director.

The pension is payed in advance, by trimester or by month; the first month is due in full to the institution (by regulation of the Ministry of the Interior).

A letter of 24 April 1889 from Theo to the director of the asylum, Dr. Peyron, requests that Vincent be admitted as a third-class patient.

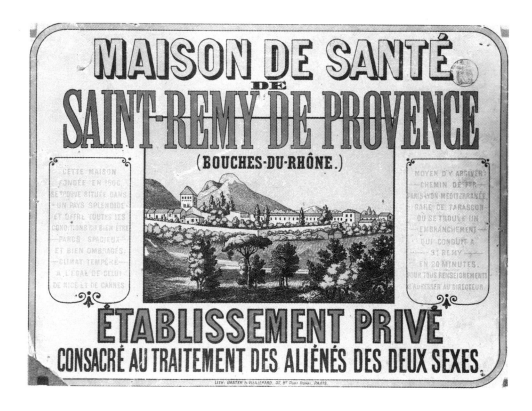

Advertisement for the Saint-Paul-de-Mausole asylum in Saint-Rémy. Ca. 1889. Rijksmuseum Vincent van Gogh, Amsterdam.

Maison de Santé de Saint-Rémy-de-Provence
Advertisement for the Asylum
ca. 1889-1890

A PRIVATE ESTABLISHMENT DEDICATED TO THE
TREATMENT OF THE MENTALLY ILL OF BOTH SEXES

This home, founded in 1806, is situated in a splendid countryside and
offers all the conditions for well-being—spacious and well-shaded parks,
temperate climate—equal to that of Nice and Cannes.

How to get there: Railway Paris–Lyon Mediterranean. Tarascon station,
from where a branch line reaches Saint-Rémy in 80 minutes. For infor-
mation, contact the director.

Maison de Santé de Saint-Rémy-de-Provence
Register of Voluntary Commitments
1889

REGISTER NO. 4, PAGE 142:

COLUMN 1:

Monsieur Van Gogh, Vincent, thirty-six years of age, painter, born in
Holland at Groot-Zandeel [sic], presently residing in Arles (B.-du-R.).

Groot-Zandeel: that is, Groot-Zundert.

COLUMN 2: SURNAMES, CHRISTIAN NAMES, AGE, ADDRESS,
PROFESSION, AND DESCRIPTION OF THE PERSON COMMITTING

M. Van Gogh, Theodorus, thirty-two years of age, born in Holland, re-
siding in Paris (Seine), brother of the patient.

COLUMN 3: TRANSCRIPT OF THE DOCTOR'S CERTIFICATE ATTACHED
TO THE APPLICATION

I, the undersigned, chief of staff of the hospital, certify that one Van
Gogh (Vincent), thirty-five [sic] years of age, was stricken six months ago
by acute mental derangement with generalized delirium. At that time he
cut off his ear. Presently his condition has greatly improved, but never-
theless, he feels that it is to his benefit to be treated in a mental asylum.

> Arles, 7 May 1889
> Signed: *Dr. Urpar*
> Certified true copy: *Dr. Peyron, Director*

*Dr. Théophile Peyron, a former Navy
doctor and asylum director, was also the
attending physician during Van Gogh's
internment from 8 May 1889 to 16 May
1890.*

COLUMN 4: CERTIFICATE FOR THE 24 HOURS AND (BELOW) FOR THE
FORTNIGHT

I, the undersigned, medical doctor and director of the Saint-Rémy San-
atorium, certify that one Van Gogh (Vincent), thirty-six years of age, na-
tive of Holland, and presently living in Arles (B.-du-R.), undergoing
treatment at that city's hospital, was stricken by acute mental derange-

ment, with hallucinations of his sight and hearing, which led him to mutilate himself by cutting off his ear. Today, he appears to have regained his reason, but he feels neither the strength nor the courage to live at liberty and has himself applied for admission to the home. I believe, in light of all the preceding facts, that M. Van Gogh is subject to epileptic fits, at very great intervals, and that there is reason to put him under extended observation at this establishment.

Saint-Rémy, 9 May 1889
Signed: *Dr. Peyron*

I, the undersigned, doctor of medicine, director of the Saint-Rémy Sanatorium, certify that one Van Gogh, Vincent, thirty-six years of age, native of Holland, entered 8 May 1889, stricken with acute mental derangement with hallucinations of his sight and hearing, has experienced a perceptible improvement in his condition, but that there is reason to keep him in this establishment to continue his treatment.

Saint-Rémy, 25 May 1889
Signed: *Dr. Peyron*

* * *

COLUMN 6: MONTHLY NOTES OF THE ASYLUM DOCTOR, DR. PEYRON

This patient comes from the Arles hospital, which he had entered following an attack of acute mental derangement that had come on suddenly, with hallucinations of his sight and hearing, which terrified him. During this attack, he cut off his left ear, but he retains only a very vague memory of this and cannot explain it. He tells us that one of his mother's sisters was epileptic, and that there are several cases in the family. What happened to this patient would be only the continuation of what has happened to several members of his family. He wanted to resume his usual life upon leaving the Arles hospital, but he was obliged to return after two days because he experienced distressing sensations and nightmares again during the night. It is from that hospital that he comes directly to the sanatorium, at his request.

Letter from Dr. Théophile Peyron to Theo
On His New Patient, Vincent
26 May 1889

In reply to your letter of the 23rd inst., I am pleased to tell you that since his entry into this house M. Vincent is completely calm and that he finds that his health is improving day by day. At first he was subject to painful nightmares which upset him, but he reports that these bad dreams tend to disappear and become less and less intense, so that now he has a more peaceful and restoring sleep; he also eats with better appetite.

To sum up: since his arrival here there has been a slight improvement in his condition which makes him hope for a complete recovery.

He spends the whole day drawing in the park here, but as I find him entirely tranquil, I have promised to let him go out in order to find scenery outside this establishment.

You ask for my opinion regarding the probable cause of his illness. I must tell you that for the time being I will not make any prognosis, but I fear that it may be serious, as I have every reason to believe that the attack which he has had is the result of a state of epilepsy and if this should be confirmed one should be concerned about the future.

Fountain in the Garden of the Asylum. 1889. Black chalk, pen, reed pen, and brown ink. 19⅝ × 18⅛" (49.5 × 46 cm). Rijksmuseum Vincent van Gogh, Amsterdam.

I hope to go to Paris in the course of June. It will be an honor to come and see you and talk to you about your patient better than one can do by letter. . . .

<p style="text-align:center">* * *</p>

Letters from Vincent to Theo

On the Asylum at Saint-Rémy

1889

LATE MAY 1889 *(592)*

I have a little room with greenish-gray paper with two curtains of sea-green with a design of very pale roses, brightened by slight touches of blood-red.

These curtains, probably the relics of some rich and ruined deceased, are very pretty in design. A very worn armchair probably comes from the same source; it is upholstered with tapestry splashed over like a Diaz or a Monticelli, with brown, red, pink, white, cream, black, forget-me-not blue and bottle green. Through the iron-barred window I see a square field of wheat in an enclosure, a perspective like Van Goyen,

Window of Vincent's Studio at the Asylum.
1889. Black chalk and gouache.
24⅜ × 18½″ (61.5 × 47 cm).
Rijksmuseum Vincent van Gogh,
Amsterdam.

above which I see the morning sun rising in all its glory. Besides this one—as there are more than thirty empty rooms—I have another one to work in.

The food is so-so. Naturally it tastes rather moldy, like in a cockroach-infested restaurant in Paris or in a boardinghouse. As these poor souls do absolutely nothing (not a book, nothing to distract them but a game of bowls and a game of checkers) they have no other daily distraction than to stuff themselves with chick peas, beans, lentils, and other groceries and merchandise from the colonies in fixed quantities and at regular hours.

As the digestion of these commodities offers certain difficulties, they fill their days in a way as inoffensive as it is cheap.

But all joking aside, the *fear* of madness is leaving me to a great extent, as I see at close quarters those who are affected by it in the same way as I may very easily be in the future.

Formerly I felt an aversion to these creatures, and it was a harrowing thought for me to reflect that so many of our profession, Troyon, Marchal, Méryon, Jundt, M. Maris, Monticelli and many more had ended like this. I could not even bring myself to picture them in that condition. Well, now I think of all this without fear, that is to say I find it no more frightful than if these people had been stricken with something else,

Van Gogh seems to have had an encyclopedic knowledge of cases of mental illness in the history of art; in fact, he first broached the subject of his own "madness" in connection with the fifteenth-century Flemish artist Hugo van der Goes, a monk and alcoholic who went insane.

phthisis or syphilis for instance. These artists, I see them take on their old serenity again, and is it a little thing, I ask you, thus to meet the old ones of our profession again? That, joking aside, is a thing I am profoundly thankful for.

For though there are some who howl or rave continually, there is much real friendship here among them; they say we must put up with others so that others will put up with us, and other very sound arguments, which they really put into practice. And among ourselves we understand each other very well. For instance I can sometimes chat with one of them who can only answer in incoherent sounds, because he is not afraid of me.

If someone has an attack, the others look after him and interfere so that he does not harm himself.

The same for those whose mania is to fly often into a rage. The old inhabitants of the menagerie come running and separate the combatants, if combat there is. . . .

It is true that there are some whose condition is more serious, who are either dirty or dangerous. These are in another ward.

I take a bath twice a week now, and stay in it for two hours; my stomach is infinitely better than it was a year ago; so as far as I know, I have only to go on. Besides, I shall spend less here, I think, considering that I have work in prospect again, for the scenery is lovely.

The room where we stay on wet days is like a third-class waiting room in some stagnant village, the more so as there are some distinguished lunatics who always wear a hat, spectacles, and a cane, and traveling cloak, almost like at a watering place, and they represent the passengers.

I am again—speaking of my condition—so grateful for another thing. I gather from others that during their attacks they have also heard strange sounds and voices as I did, and that in their eyes too things seemed to be changing. And that lessens the horror that I retained at first of the attack I have had, and which, when it comes on you unawares, cannot but frighten you beyond measure. Once you know that it is part of the disease, you take it like anything else. If I had not seen other lunatics close up, I should not have been able to free myself from dwelling on it constantly. For the anguish and suffering are no joke once you are caught by an attack. Most epileptics bite their tongue and injure themselves. Rey told me that he had seen a case where someone had mutilated his own ear, as I did, and I think I heard a doctor here say, when he came to see me with the director, that he had also seen it before. I really think that once you know what it is, once you are conscious of your condition and of being subject to attacks, then you can do something yourself to prevent your being taken unawares by the suffering or the terror. Now that it has gone on decreasing for five months, I have good hope of getting over it, or at least of not having such violent attacks. There is someone here who has been shouting and talking like me *all the time* for a fortnight; he thinks he hears voices and words in the echoes of the corridors, probably because the nerves of the ear are diseased and too sensitive, and in my case it was my sight as well as my hearing, which, according to what Rey told me one day, is usual in the beginning of epilepsy. Then the shock was such that it sickened me even to move, and nothing would have pleased me better than never to have woken up again. At present this *horror of life* is less strong already and the melancholy less acute. . . .

EARLY SEPTEMBER 1889 *(605)*

The treatment of patients in this hospital is certainly easy, one could follow it even while traveling, for they do absolutely *nothing*; they leave them to vegetate in idleness and feed them with stale and slightly spoiled food. . . .

Letters from Vincent, Theo, and Gauguin

On Exhibition Plans and Responses to Vincent's Work

1888–1890

VINCENT TO THEO, CA. 3 MARCH 1888 (*466*)

Do as you think best about the exhibition of the Indépendants. What do you say to showing the two big landscapes of the Butte Montmartre? It is all more or less the same to me. I am counting rather more on this year's work....

COLORPLATES 29, 30

VINCENT TO THEO, 10 MARCH 1888 (*468*)

I quite approve of your exhibiting the "Livres" with the Indépendants; its title ought to be "Romans Parisiens." . . .

COLORPLATE 38

THEO TO WIL, 14 MARCH 1888

At the end of the month an exhibition will be opened with three of Vincent's paintings on view. He does not attach much importance to this exhibition, but here where there are so many painters it is essential to become known and an exhibition is, after all, the best thing for that....

VINCENT TO THEO, 24 MARCH 1888 (*471*)

Thank you very much too for all the steps you have taken toward the exhibition of the Indépendants. On the whole I'm very glad that they've been put with the other impressionists.

But though it doesn't matter in the least this time, in the future my name ought to be put in the catalogue as I sign it on the canvas, namely Vincent and not Van Gogh, for the simple reason that they do not know how to pronounce the latter name here....

VINCENT TO THEO, 3 FEBRUARY 1889 (*576*)

As for the Indépendants, I think that six pictures is too much by half. To my mind the "Harvest" and the "White Orchard" are enough, with the little "Provençal Girl" or the "Sower" if you like. But I care so little. The one thing I have set my heart on is someday to give you a more encouraging impression of this painting job of ours by means of a collection of thirty or so more serious studies. That will prove again to our real friends like Gauguin, Guillaumin, Bernard, etc., that we are producing something....

COLORPLATES 45, 58, 53, 49

VINCENT TO THEO, EARLY JUNE 1889 (*593*)

I hope you will destroy a lot of the things that are too bad in the batch I have sent you, or at least only show what is most passable. As for the exhibition of the Indépendants, it's all one to me, just act as if I weren't here. So as not to be indifferent, and not to exhibit anything too mad, perhaps the "Starry Night" and the landscape with yellow vegetation, which was in the walnut frame. Since these are two with contrasting colors, it might give somebody else the idea of doing those night effects better than I did....

COLORPLATE 69

THEO TO VINCENT, 16 JULY 1889 (*T12*)

I have invited quite a number of people to see your pictures, the Pissarros, père Tangui [sic], Verenskiold, a Norwegian who has a lot of talent and who got the medal of honor in his country's section at the Universal Exhibition at Maus's.

The latter is the secretary of the "XX" at Brussels. He came to ask me whether you would be willing to send in work for their next exhibition. There is plenty of time for it, but he did not know whether he could come to Paris before the event. I told him that I did not suppose you would have any objections. He ought to invite Bernard too. In general people like the night effect and the sunflowers. I have put one of the sunflower pieces in our dining room against the mantelpiece. It has the effect of a piece of cloth with satin and gold embroidery; it is magnificent.

Obviously, Theo tended to spell Julien Tanguy's name with an "i".

Erik Theodor Verenskiold (1855–1938), Norwegian painter and engraver.

COLORPLATES 69, 59, 61

VINCENT TO THEO, LATE AUGUST–EARLY SEPTEMBER 1889 (*604*)

It is curious that Maus had the idea of inviting little Bernard and me for the next exhibition of Les Vingt. I should very much like to exhibit there, though I feel my inferiority beside so many of the Belgians, who have tremendous talent.

* * *

How can I tell, but I think I have one or two canvases going that are not so bad, first the reaper in the yellow wheat and the portrait against a light background, that will do for Les Vingt, if indeed they remember me at the right moment, but then I am absolutely indifferent to it all, perhaps it is even preferable if they should forget me.

For I do not forget the inspiration it gives me to let my thoughts dwell on some of the Belgians. That is positive, and the rest, very secondary.

* * *

Of course I shall work at this with as much pleasure as for Les Vingt, and with more calm; since I have the strength, you may be sure that I am going to try to polish off some work. I am choosing the best from the twelve subjects so that the things they are going to get will be really a little studied and well chosen. And then it does one good to work for people who do not know what a picture is. . . .

COLORPLATES 92, 96

THEO TO VINCENT, 5 SEPTEMBER 1889 (*T16*)

Now I still have to tell you that the exhibition of the Indépendants is open, and that your two pictures are there, the "Irises" and "The Starlit Night." The latter is hung badly, for one cannot put oneself at a sufficient distance, as the room is very narrow, but the other one makes an extremely good showing. They have put it on the narrow wall of the room, and it strikes the eye from afar. It is a beautiful study full of air and life. There are some Lautrecs, which are very powerful in effect, among other things a Ball at the Moulin de la Galette, which is very good. The painters could only send in two pictures each, as the exhibition is held in a much smaller place than the one it was held in till now.

Seurat has sea beaches, Signac two landscapes. There is also a picture by Hayet, that friend of Lucien Pissarro's, the Place de la Concorde in the evening with carriages, the gas jets, etc. It is something like that picture of the Tumblers [Saltimbanques] by Seurat, but it is more harmonious. . . .

COLORPLATES 87, 69

Louis Hayet (1864–1940), Neo-Impressionist painter and decorator.

THEO TO VINCENT, 22 OCTOBER 1889 (*T19*)

I have had quite a number of people calling on me to see your work. Israëls's son, who is staying in Paris for some time; Veth, a Dutchman who

paints portraits, and who writes in the *Nieuwe Gids*, that periodical you may have heard some talk about—it rouses the indignation of so many people but there are often good things in it; and then Van Rysselberghe, one of Les Vingt of Brussels. The latter also saw everything there is at Tangui's, and your pictures seem to interest him quite a lot.

THEO TO VINCENT, 16 NOVEMBER 1889 (T20)

A letter came for you this morning from the "XX" at Brussels. I have put your address on it. A note from Maus, which I received at the same time, tells me that they will be happy if you will send in things, paintings and drawings. When he came here he liked the apple trees in bloom very much, but Van Rysselberghe knew better what you are after in your more recent things, the portrait of Roulin, the sunflowers, etc. It is necessary for you to tell me what you think of the exhibition, and what you would like to send. I think there are from 5 to 7 meters [approx. 17 to 23 ft.] of ledge length. For this year they invited Puvis de Chavannes, Bartholomé, Cézanne, Dubois, Pillot, Forain, Signac, L. Pissarro, Hayet, Renoir, Sisley and De Lautrec, and you. However bad the exhibition of the Indépendants was, the "Irises" was seen by a lot of people who now talk to me about them every once in a while. It would be a good thing if we could have a regular exhibition in Paris of the works of artists who are not well known to the public, but it is almost unavoidable that this should be a permanent exhibition. The places here are so expensive that this will always be an obstacle. . . .

COLORPLATE 87

VINCENT TO OCTAVE MAUS, MID-NOVEMBER 1889 (614b)

I accept with pleasure your invitation to exhibit with Les Vingt. Here is the list of paintings that I'm sending you:
 #1. *Sunflowers*; #2. *Sunflowers*; #3. *Ivy.* #4. *Flowering Orchard (Arles)*; #5. *Wheat Field at Sunrise (Saint-Rémy)*; #6. *The Red Vineyard (Mont Majour* [sic]*).*
 (All these paintings are size 30 canvases.)
 Perhaps I exceed the four meters of space, but thinking that these six together, chosen in this manner, will give a somewhat varied effect of color, perhaps you will find a way to accommodate them.
 I send my best regards to Les Vingt.

COLORPLATES 59, 61, 85, 107, 76

THEO TO WIL, 27 NOVEMBER 1889

During the recent past Vincent sent me much of what he made, amongst which a lot that is good. For the exhibition of the Indépendants I sent in two pictures which made a very good impression. A field of irises and a starry night, view of Arles with the lanterns and the stars which show their reflections in the Rhône. Next year he will be invited to show his work in Brussels in a society of young artists, two of which came to see his work and found it most interesting. His health is fortunately good again and when no new crisis takes place he will be nearer to us in the spring. . . .

COLORPLATES 87, 69

THEO TO VINCENT, 8 DECEMBER 1889 (T21)

Tangui has been exhibiting a great many of your pictures recently; he told me he hopes to sell the bench with the ivy. It was a fine choice you made for Brussels. I have ordered the frames. For the sunflowers I am leaving the narrow wooden rim which is around it, and then I shall add a white frame. For the others white frames or frames in natural wood. You did not say whether you want to exhibit drawings. When Maus was here he greatly admired them, and urgently requested them to be sent in. Perhaps it is possible to send a number of them in one frame.

COLORPLATES 59, 61

In the 1891 memorial exhibition with Les Vingt in Brussels, seven drawings by Van Gogh were exhibited.

* * *

Isaac Israëls (1865–1934), Dutch Impressionist and son of The Hague school artist, Joseph Israëls (1824–1911). Jan Veth (1864–1925), Dutch portraitist and foremost art critic for De Nieuwe Gids. *Theo van Rysselberghe (1862–1926), Neo-Impressionist and founding member of Les Vingt.*

THEO TO VINCENT, 22 JANUARY 1890 *(T25)*

It seems that the exhibition of the "XX" at Brussels is open; I read in a paper that the canvases which arouse the curiosity of the public the most are the open-air study by Cézanne, the landscapes by Sisley, the symphonies by Van Gogh and the works of Renoir. For the month of March they are now preparing here a new exhibition of the impressionists at the pavilion of the "Ville de Paris." Everyone can send in as many canvases as he likes. Guillaumin is going to exhibit his work there too. Please think over whether you will exhibit too, and which pictures you want to send. The exhibition of the "XX" will be closed by that time. I think we can wait patiently for success to come; you will surely live to see it. It is necessary to get well known without obtruding oneself, and it will come of its own accord by reason of your beautiful pictures. . . .

THEO TO WIL, 14 MARCH 1890

On the 19th will be the opening of the exhibition of the Indépendants here where there are ten of his paintings. I had hoped that he would have been here for the opening, for amongst the public which follows the movement of the younger school he would certainly have been successful. But that is just not possible. . . .

THEO TO VINCENT, 19 MARCH 1890 *(T29)*

How happy I should have been if you could have gone to the Exhibition of the Indépendants. It was the Preview Showing, when Carnot was there. I was there with Jo; your pictures are very well placed and make a good effect. A lot of people came to us and asked us to send you their compliments. Gauguin said that your pictures were the chief attraction of the exhibition—the "clou," he said. He proposed an exchange of one of his canvases for the one of the Alpine foothills. I told him I supposed you would not object, but that on the contrary you would be very pleased to know that he likes your picture. I like it very much too—that picture, I mean—it makes an admirable impression in the exhibition.

Marie François Sadi Carnot (1837–1894), president of the French Republic.

COLORPLATE 108

* * *

Bernard and Aurier intend to come to see your latest pictures next Sunday. Enclosed you will find a letter from Aurier. He will be back before long to look at the Gauguins, and to write an article about him.

I received the money for your picture from Brussels, and Maus writes me, "As soon as an opportunity presents itself please tell your brother that I was extremely glad of his participation in the Salon of the 'XX,' where he has found many lively artistic sympathies in the confusion of the discussions." . . .

GAUGUIN TO VINCENT, LATE MARCH 1890

I saw with great interest at your brother's first of all and at the exhibit of the Indépendants, your work done since we parted company. It is above all at the latter place that one could judge well your accomplishments, either because of what hangs next to one another, or because of the vicinity.

I give you my sincere compliments; for many artists you are the most remarkable part of the exhibit. With subjects drawn from nature you are *the only one who thinks* there. I chatted about it with your brother, and there is one painting that I would like *to trade with you for one thing of your choice.* The one I am talking about is a mountain landscape. Two travelers, very small, appear to climb there in the search for the unknown. There is in this work an emotion as in Delacroix, with very suggestive color. Here and there, red touches like lights, and the whole in a violet tone. It is beautiful and grand.

COLORPLATE 108

159

à votre choix.

Celui dont je parle c'est un paysage de montagnes. Deux voyageurs tout petits semblent monter là à la recherche de l'inconnu. Il y a là une émotion à la Delacroix avec une couleur très suggestive. Par ci par là des notes rouges comme des lumières, le tout dans une note violette. C'est beau et grandiose.

J'en ai causé longuement avec Aurier Bernard et beaucoup d'autres.

Tous vous font leurs compliments. Guillaumin seul hausse les épaules quand il entend parler de cela. Je le comprends du reste

Paul Gauguin. Sketch of Van Gogh's *Ravine.* Letter to Van Gogh. Late March 1890. Rijksmuseum Vincent van Gogh, Amsterdam.

I talked about it for a long time with Aurier, Bernard and many others.

Everyone gives you their compliments. Only Guillaumin shrugs his shoulders when he hears us talking about this. I understand him being apart from the rest, for it is a given that he only sees the subject with an eye without a brain. For my painting of these last years he holds the same opinion and does not understand anything about it.

I hesitated to write you, knowing that you just had a somewhat long crisis, and I beg you to answer me only when you feel completely strong. Let's hope that with the approaching warm weather you will at last get better—the winter is always dangerous for you. . . .

JOHANNA TO VINCENT, 29 MARCH 1890 *(T30)*

I managed to escape for a little while at the opening of the Indépendants to see your pictures there—there was a seat directly in front of them, and while Theo was talking to all sorts of people I sat there for a

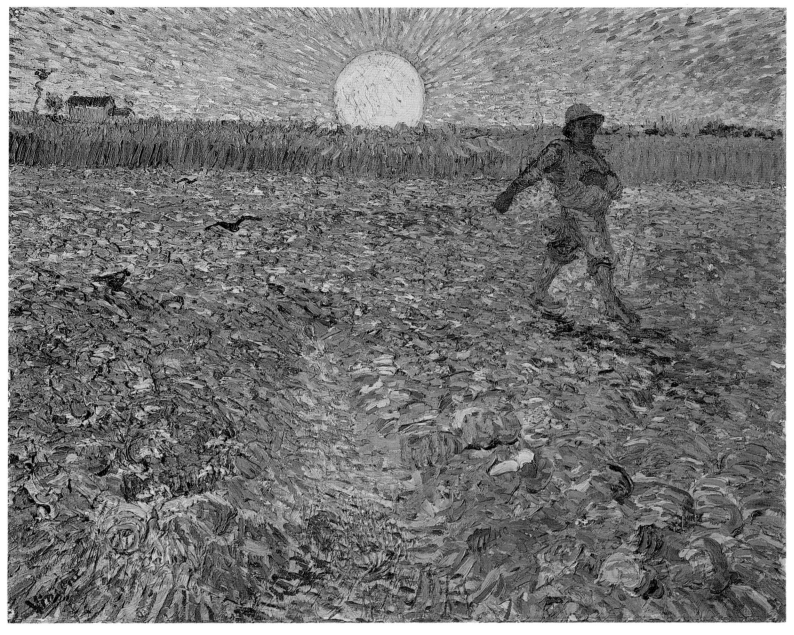

COLORPLATE 49. *Sower with Setting Sun.* 1888. Canvas. 25¼ × 31⅞" (64 × 80.5 cm).
Rijksmuseum Kröller-Müller, Otterlo.

COLORPLATE 50. *Wheat Field with Setting Sun.* 1888. Canvas. 29⅛ × 35⅞″ (74 × 91 cm).
Kunstmuseum, Winterthur.

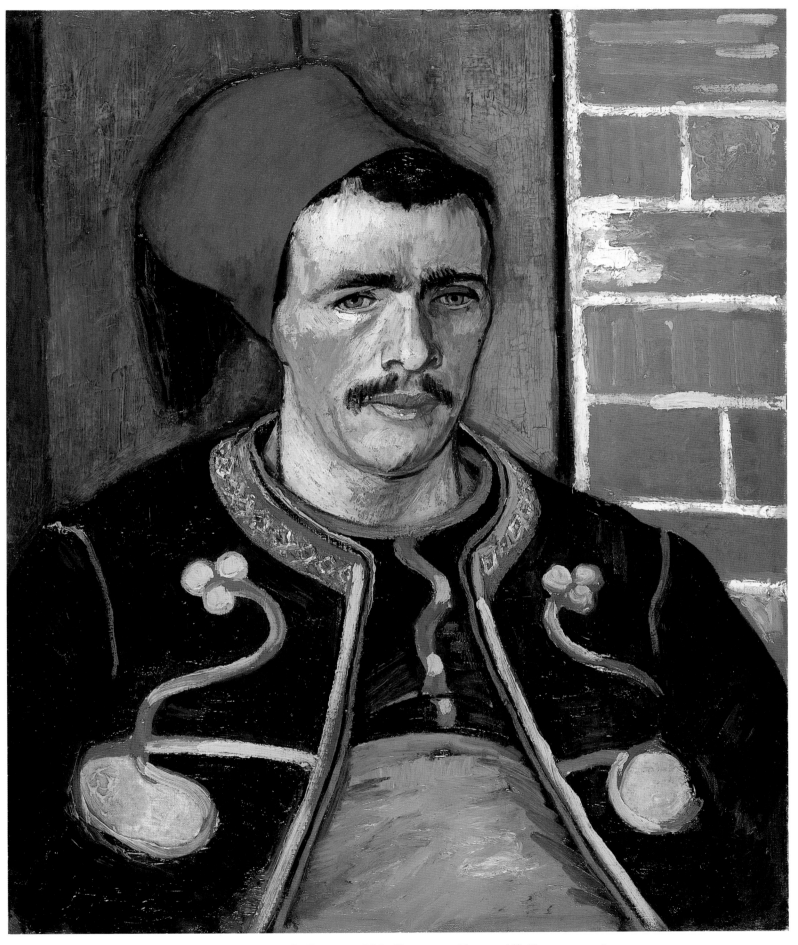

COLORPLATE 51. *The Zouave.* 1888. Canvas. 25⅝ × 21¼″ (65 × 54 cm).
Rijksmuseum Vincent van Gogh, Amsterdam.

COLORPLATE 52. *Flowering Garden*. 1888. Canvas. 36¼ × 28¾″ (92 × 73 cm).
Private Collection; on loan to The Metropolitan Museum of Art, New York.

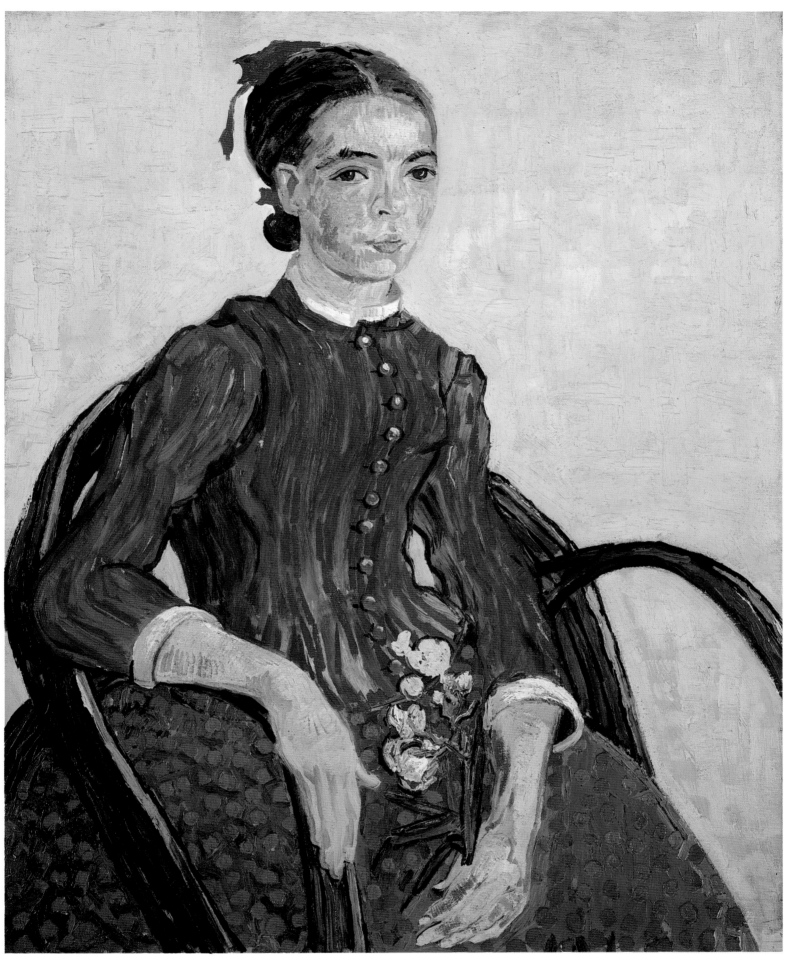

COLORPLATE 53. *La Mousmé*. 1888. Canvas. 28⅞ × 23¾" (73.3 × 60.3 cm).
National Gallery of Art, Washington; Chester Dale Collection.

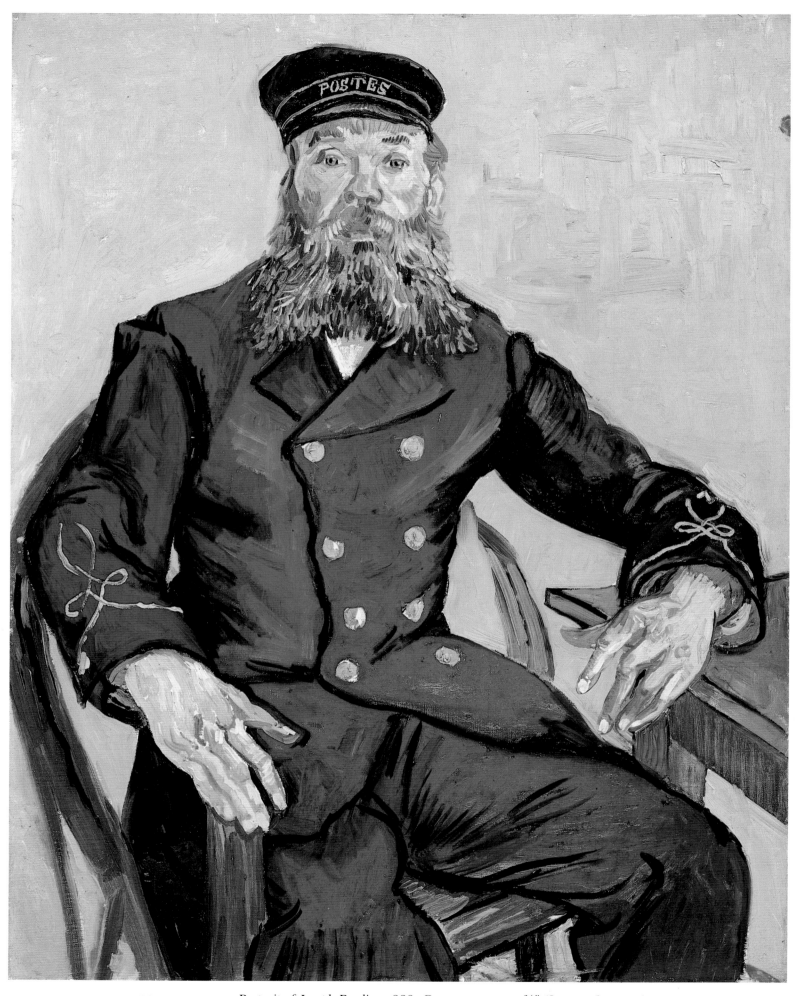

COLORPLATE 54. *Portrait of Joseph Roulin.* 1888. Canvas. 32 × 25¾" (81.2 × 65.3 cm).
Museum of Fine Arts, Boston; Gift of Robert Treat Paine 2nd.

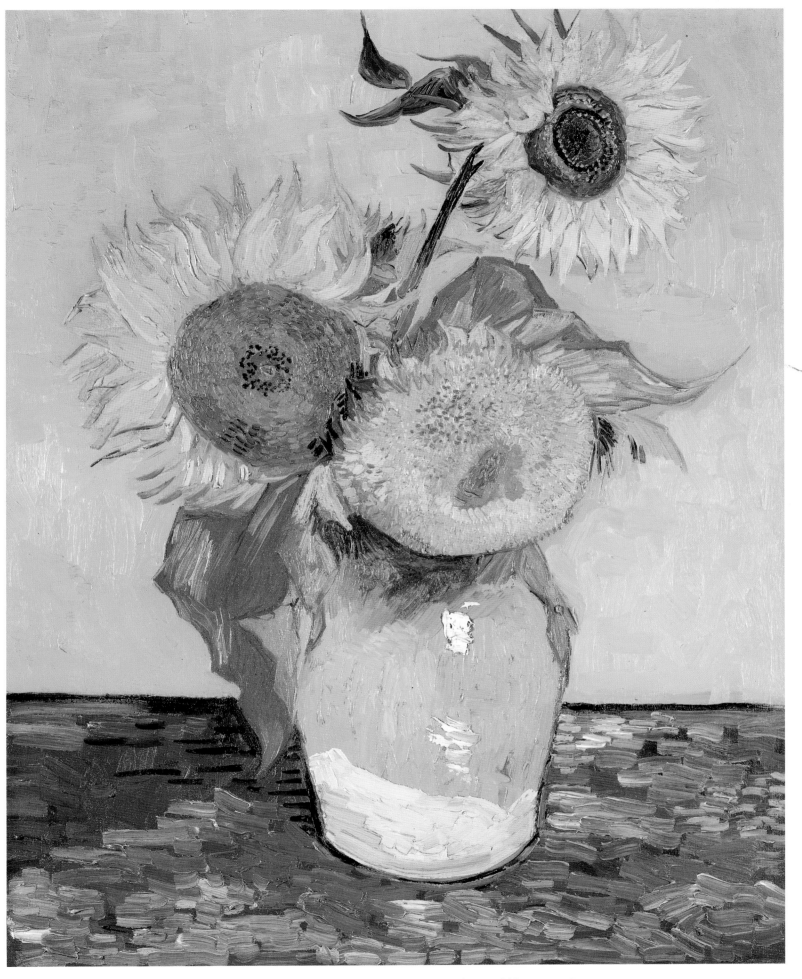

COLORPLATE 55. *Sunflowers*. 1888. Canvas. 28¾ × 22⅞″ (73 × 58 cm).
Private Collection, Switzerland.

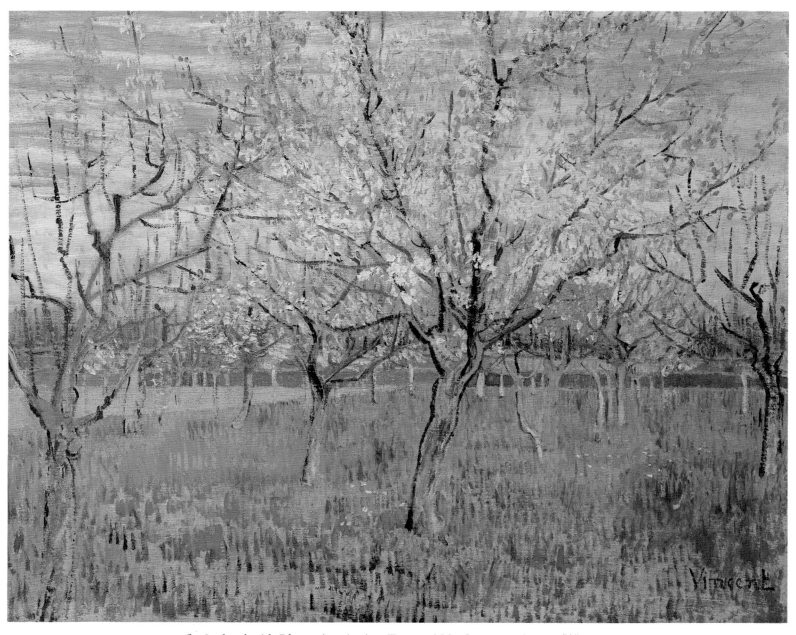

COLORPLATE 56. *Orchard with Blossoming Apricot Trees.* 1888. Canvas. 26 × 31⅞″ (65.5 × 80.5 cm).
Rijksmuseum Vincent van Gogh, Amsterdam.

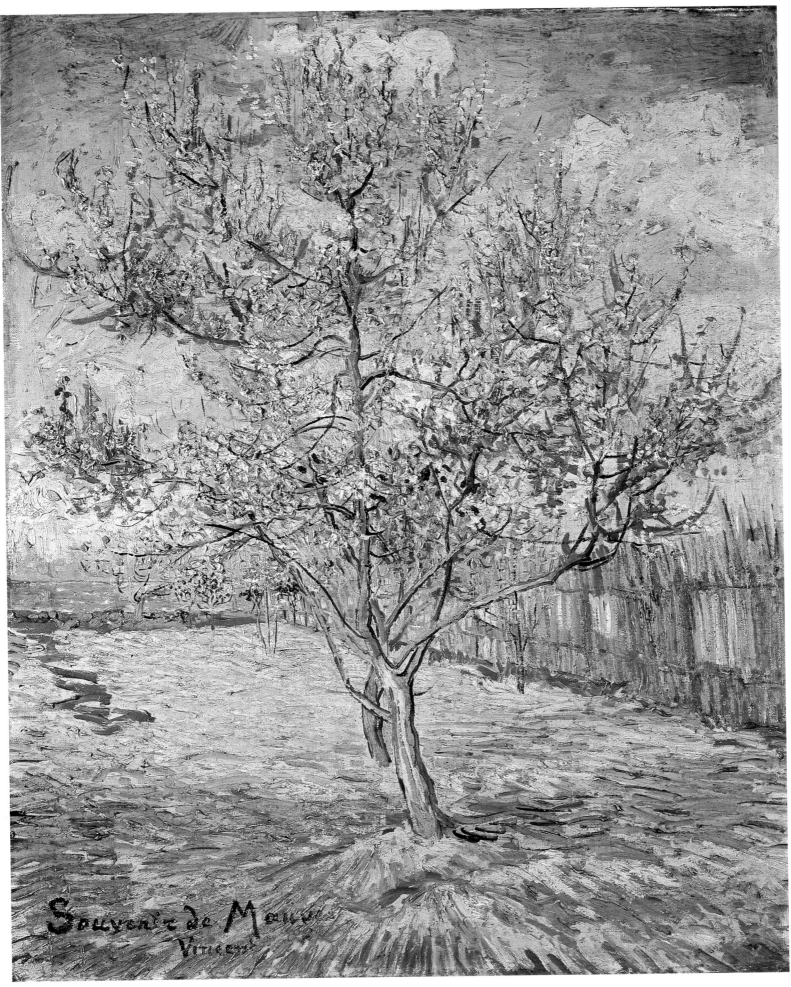

COLORPLATE 57. *Pink Peach Trees (Souvenir de Mauve)*. 1888. Canvas. 28¾ × 23⅝″ (73 × 59.5 cm).
Rijksmuseum Kröller-Müller, Otterlo.

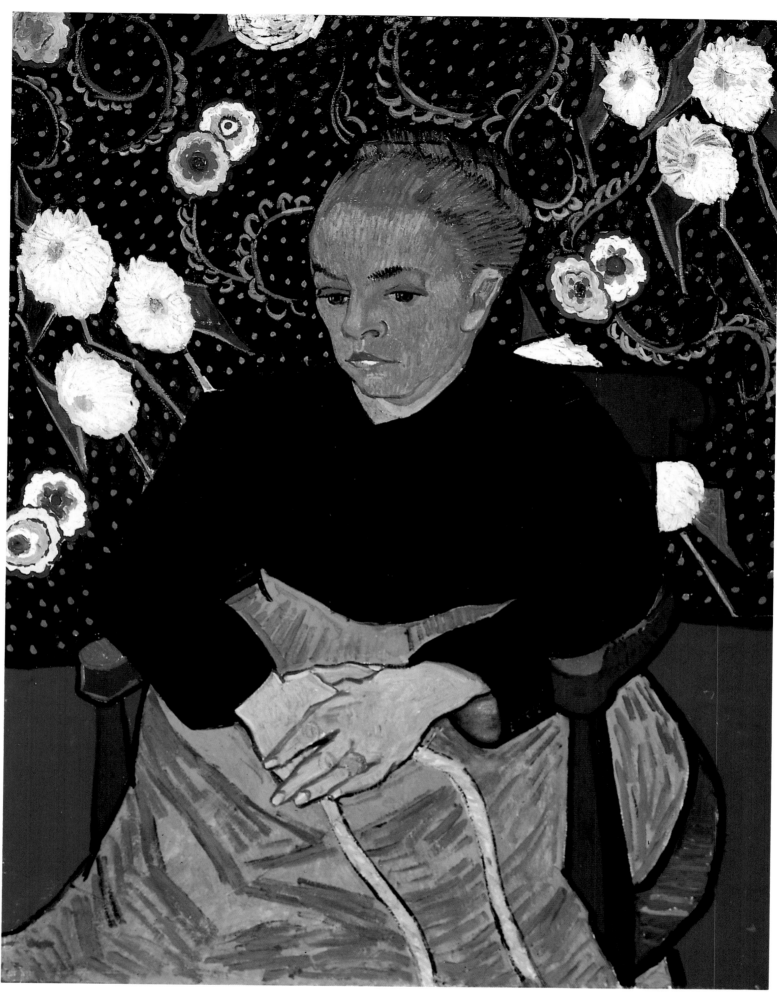

COLORPLATE 60. *La Berceuse*. 1889. Canvas. 36 × 28″ (91.4 × 71.1 cm).
The Art Institute of Chicago; Helen Birch Bartlett Collection.

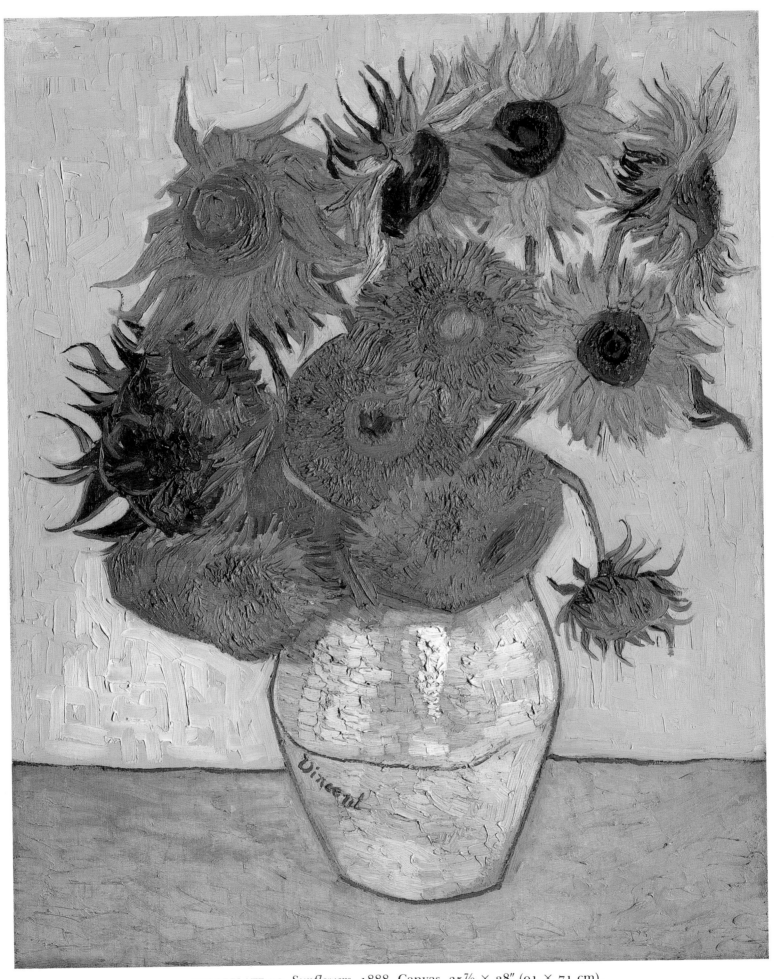

COLORPLATE 59. *Sunflowers*. 1888. Canvas. 35⅞ × 28″ (91 × 71 cm).
Bayerische Staatsgemäldesammlungen, Munich. Photograph: Artothek.

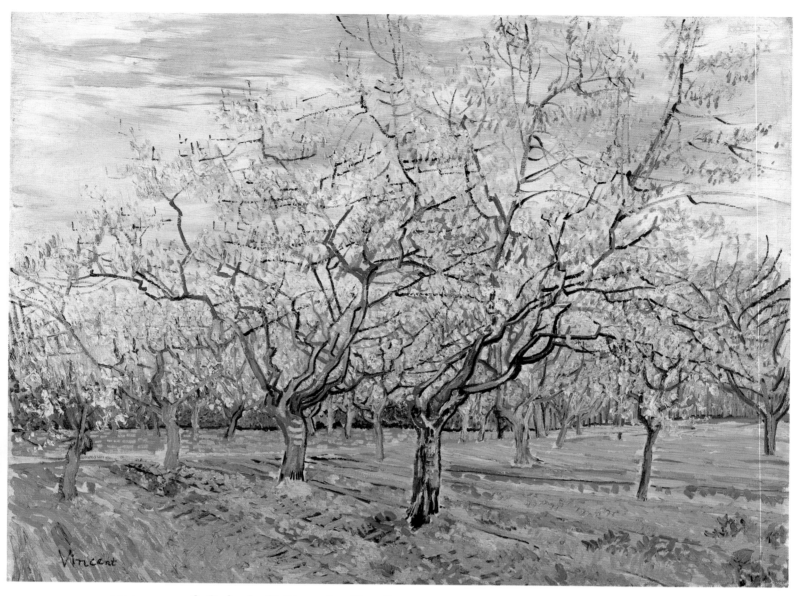

COLORPLATE 58. *Orchard with Blossoming Plum Trees.* 1888. Canvas. 23⅝ × 31½″ (60 × 80 cm).
Rijksmuseum Vincent van Gogh, Amsterdam.

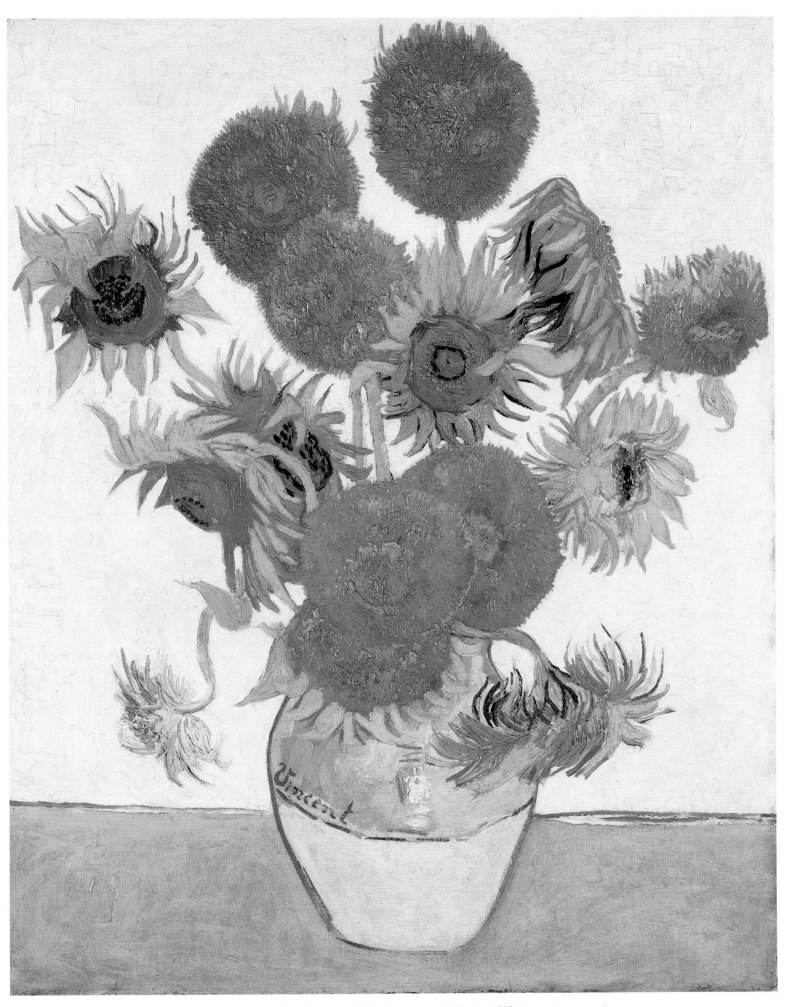

COLORPLATE 61. *Sunflowers*. 1888. Canvas. 36¼ × 28¾″ (92.1 × 73 cm).
The National Gallery, London.

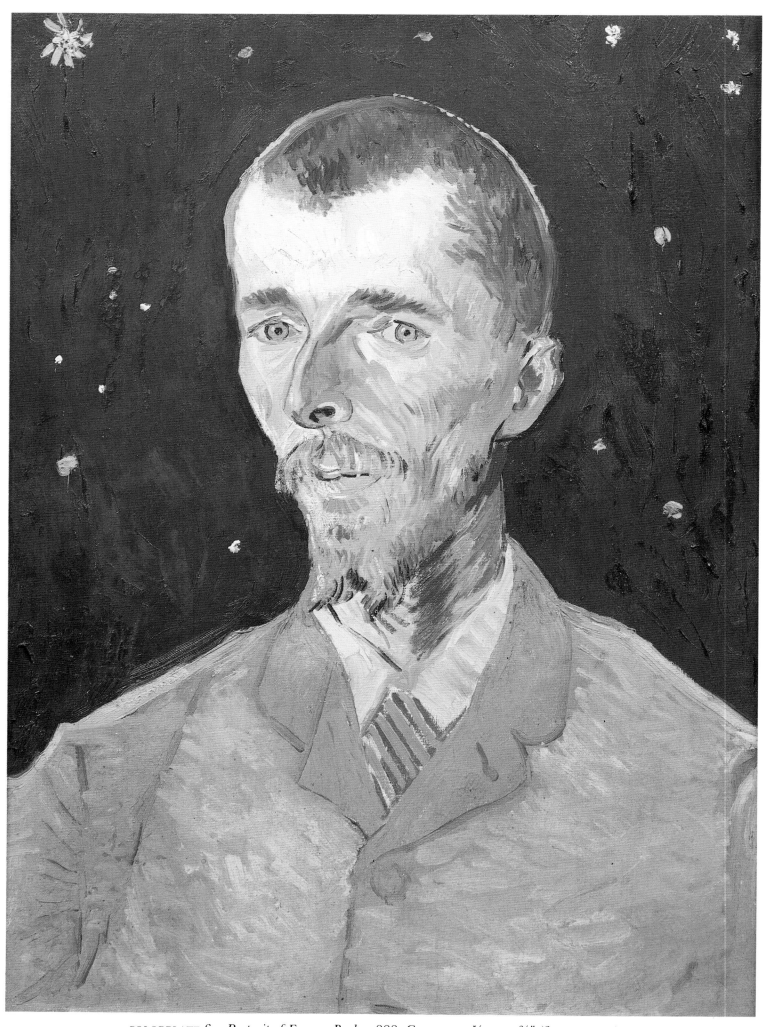

COLORPLATE 62. *Portrait of Eugene Boch.* 1888. Canvas. 23⅝ × 17¾″ (60 × 45 cm).
Musée d'Orsay, Paris. Photograph: Musées Nationaux.

Trees with Ivy. 1889. Canvas. 36¼ × 28⅜″ (92 × 72 cm). Location unknown.

whole fifteen minutes enjoying the delicious coolness and freshness of the "Undergrowth"—it's as though I knew this spot, and had been there several times—I'm so fond of it.

THEO TO VINCENT, 29 MARCH 1890 *(T31)*

I have not yet gone back to the Indépendants, but Pissarro, who went there every day, tells me that you have achieved real success with the artists. There were also art lovers who discussed your pictures with me without my drawing their attention to them. The papers which publish reports on the exhibition are silent about the hall of the impressionists. And it is the best thing they can do, for the majority of those criticisms—well, you know what they are worth.

THEO TO VINCENT, 23 APRIL 1890 *(T32)*

Your pictures at the exhibition are having a lot of success. The other day Diaz stopped me in the street and said, Give your brother my compliments and tell him that his pictures are highly remarkable. Monet said that your pictures were the best of all in the exhibition. A lot of other

artists have spoken to me about them. Serret came to our house to see the other pictures, and he was enraptured. He said that if he had no style of his own in which he could still express some things, he would change his course and go seek what you are seeking. . . .

Gustave Kahn

LA REVUE INDÉPENDANTE

"Painting: Indépendants Exhibition"

April 1888

Gustave Kahn (1859–1936), Symbolist writer, critic, and poet of vers libre, *was among the earliest supporters of Neo-Impressionism.*

M. Van Gogh has vigorously brushed some large landscapes without a great enough concern for the value and exactitude of his tones. A polychromatic multitude of books nearly resembles an oriental tapestry; a fine motif for a study, perhaps, but not a pretext for a painting.

COLORPLATES 29, 30

COLORPLATE 38

Letter from Vincent to Theo

On the Review by Gustave Kahn

early April 1888

I think what Kahn said is very true, that I have not sufficiently considered values, but they'll be saying very different things in a little while— and no less true.

It isn't possible to get values and color.

Th. Rousseau did it better than anyone else, and with the mixing of his colors, the darkening caused by time has increased and his pictures are now unrecognizable.

You can't be at the pole and the equator at the same time.

You must choose your own line, as I hope to do, and it will probably be color. . . . [474]

Théodore Rousseau (1812–1867), noted Barbizon painter.

Luc le Flaneur

LE MODERNISTE

"In Search of Artistic Things"

April–May 1889

Luc le Flaneur was the pseudonym of G.- Albert Aurier (1865–1892), then editor-in-chief of the Symbolist review, Le Moderniste. *A poet, novelist, critic, and Sunday painter, Aurier came to know Van Gogh's works through his friendship with Emile Bernard, whom he met in Saint-Briac in the spring of 1888.*

13 APRIL 1889

Let's stroll around Paris, if you will, in search of artistic things. First, Tanguy's! Do you know Tanguy? Yes, no? Rue Clauzel, number 14: an

ugly boutique, and so small! But good things come in small packages. Enter, and you will see treasures out of *A Thousand-and-One Nights.* . . . This père Tanguy, what a shrewd unearther of masterpieces. How he has a knack for discovering them: the unrecognized of today, the masters of tomorrow. But let's go in without delay. Look, here are incomparable marvels by Cézanne! Look, here are canvases by Vincent, formidable in passion, in intensity, in brilliant sunlight; here are corners of the Seine, the skies of the suburbs, dirtied by the whirling smoke of the factory chimneys, landscapes bathed in pink light, all of them signed Guillaumin; here are—in a synthesis of drawing, composition, and color worthy of certain Primitive masters—views of Brittany by Emile Bernard.

And now, at Van Gogh's, the house of Boussod & Valadon, 19, boulevard Montmartre, dancers, jockeys, races, exquisite feminine movements by Degas; country scenes by Pissarro in his older style—and by the way, this master's former style seems to us preferable to the one he has recently adopted under the pretext of scientific coloration by decom-

Photograph of Theo van Gogh. Ca. 1888–1890. Rijksmuseum Vincent van Gogh, Amsterdam.

position and recomposition of light; marvelous canvases by the great poet Gauguin, among others, a springtime *Landscape at Pont-Aven*, in such a pure style, and such delicate harmony, a delightfully melancholy *Presbytery* and *Two Breton Women* in a field enclosed within foliated walls; the originals of those spiritual drawings of the *Fifer* by Forain—bravo Forain! A *Fisherwoman on the Line* by Guillaumin, of a very beautiful firmness of forms.

At Galerie Durand-Ruel: very fine studies of women by Renoir; Corots; drawings by Puvis de Chavannes.

At Clozet, rue de Châteaudun, in the window, a beautiful, romantic landscape signed: Armand Guillaumin.

Finally, looking around the street, you may see pasted on walls all over the place Chéret's lively poster, *The Fair of Seville*. . . .

11 MAY 1889

At Van Gogh's:
A magnificent arboreous landscape by Corot, of the most beautiful style and bathed in one of those twilight atmospheres that the master loved.

By Degas, some little dancers, some naughtiness in the wings, some jockeys, and some horses.

By Gauguin, a plump Breton woman in the hay and a large seascape dating from 1886, of a very romantic effect and an extraordinary eloquence of line.

By Pissarro, an album of sketches heightened with color.

By Guillaumin, some entangled bushes, very beautiful in color, amidst which blue water vibrates with gaiety.

By Millet, three remarkable drawings: a return from the fields which recalls certain flights into Egypt by the Primitives; a peasant hunting birds; an entrance into a wood.

At père Tanguy's are to be seen the masterly canvases by Monet, by Guillaumin, by Gauguin, by Emile Bernard, by Vincent.

J. J. Isaäcson

DE PORTEFEUILLE

"Letters from Paris"

17 August 1889

Joseph Jacob Isaäcson (1859–1942), Dutch critic and artist, wrote a series of articles on young artists for his weekly column while in Paris from 1887 to 1890. It was through his friend Meyer de Haan, who had stayed with Theo in 1888–1889, that he was introduced to Vincent's works.

Who interprets for us, in forms and colors, this immense life, this great nineteenth-century life that is becoming conscious of itself again? Where is the man who reveals anew our domain, our earth, our heritage; who restores happiness by revealing the divine in matter; who allows us to perceive, once again, that tangible, wildly rushing, pulsing life that shakes us down to our bones, and also that other life that really is one with ours, that of wood and stone, of marble and gold, of tin, zinc, pewter, iron, and also of water, of fire. . . . Where is the re-animator who lets us see that? . . .

I know one, a unique pioneer; he stands alone to struggle in the great night. His name, Vincent, is for posterity.

In a note to this article, Isaäcson vowed to write again about this "remarkable hero," but was discouraged by Van Gogh from doing so.

Vincent's Letters

On Critic J. J. Isaäcson

1889–1890

FROM THEO TO VINCENT, EARLY OCTOBER 1889 (*T18*)

Isaäcson, who has been writing for a Dutch paper recently, wants to write something about your work. He asked me to let him have certain pictures to keep at his home for a while, including the mountains and the wheat field.

As soon as I send you the reproductions of the Millets, I shall include the articles by Isaäcson; I don't particularly like his search for new words, but as a matter of fact he says good things, which the majority of the art critics do not. . . .

FROM VINCENT TO THEO, EARLY OCTOBER 1889 (*609*)

It surprises me very much that M. Isaäcson wants to write an article on my studies. I should be glad to persuade him to wait, his article will lose absolutely nothing by it, and with yet another year of work, I could—I hope—put before him some more characteristic things, with more decisive drawing, and more expert knowledge with regard to the Provençal south. . . .

FROM VINCENT TO HIS MOTHER, LATE OCTOBER 1889 (*612*)

You know I never met him personally—but lately I have written him because he intended to write about my work in a Dutch paper, and I asked him not to do it; but also to thank him for his faithful sympathy, as from the beginning we have often thought of each other's work and have the same ideas about our old Dutch and modern French painters. . . .

FROM VINCENT TO WIL, LATE OCTOBER 1889 (*W15*)

That good fellow Isaäcson wants to write an article about me in one of the Dutch papers, on the subject of pictures which are *exactly* like those I am sending you, but reading such an article would make me very sad, and I wrote to tell him so. . . .

FROM VINCENT TO THEO, LATE OCTOBER 1889 (*611*)

No need to tell you that I think what he says of me in a note extremely exaggerated, and that's another reason why I should prefer him to say nothing about me. And in all these articles I find, side by side with very fine things, something, I don't quite know what, that seems to me unhealthy.

He has stayed in Paris a long time—I suppose he is wiser than I, and has not been drinking, etc., but all the same I find in him again, as it were, my own mental weariness of Paris. And I think that soon his spirit will become dimmed with sadness, wearied out with the fixed idea of seeking after what is good, if he stays there much longer. You feel so much in what he says that he's a grievously suffering human being, and is very kind, happy when he can admire. . . .

This early letter to Isaäcson is lost.

J. J. Isaäcson. *Portrait of Theo van Gogh.* Ca. 1889–1890. Pen and ink. 5¾ × 4⅝″ (20.8 × 14.3 cm). Rijksmuseum Vincent van Gogh, Amsterdam.

Back in Paris I read the continuation of your articles on impressionism.

Without wanting to enter into a discussion of the details of the subject that you have attacked, I wish to inform you that it seems to me that you are conscientiously trying to tell our fellow-countrymen how things are, basing yourself on facts. As it is possible that in your next article you will put in a few words about me, I will repeat my scruples, so that you will not go beyond a *few* words, because it is *absolutely certain* that I shall never do important things.

And this, although I believe in the possibility that a later generation will be, and will go on being, concerned with the interesting research on the subject of colors and modern sentiment along the same lines as, and of equal value to, those of Delacroix, of Puvis de Chavannes—and that impressionism will be their source, if you like, and future Dutchmen will likewise be engaged in the struggle—all this is within the realm of possibility and certainly your articles have their raison d'être. . . .

After leaving the asylum in Saint-Rémy, Van Gogh spent four days in Paris, 17 to 20 May 1890, before leaving for Auvers.

Lucien Pissarro. Van Gogh in Conversation with Félix Fénéon. *Black crayon. 8⅝ × 6⅞″ (22 × 17.5 cm). Ashmolean Museum, Oxford.*

Félix Fénéon

LA VOGUE

"The Fifth Exhibition of the Société des Artistes Indépendants"

September 1889

Félix Fénéon (1861–1944), early and avid spokesman for the Neo-Impressionists, contributed this account to the well-known Symbolist review, La Vogue, *which he had co-founded with Gustave Kahn in 1886.*

These painters smitten with optical painting would be the only ones to justify the existence of the Société des Artistes Indépendants, if this disparate confraternity did not poll MM. Anquetin, Lemmen, de Toulouse-Lautrec, and Van Gogh.

The latter's *Irises* violently slash into long strips their violet petals on sword-like leaves. M. Van Gogh is an amusing colorist, even in such extravagances as his *Starry Night*: against the sky, a rough, cross-hatched pattern of flat brushstrokes, stars appear as strobes of white, pink, yellow that have been laid directly from the tube; orange triangles are engulfed by the river, and, near the moored boats, baroquely sinister figures scurry by.

COLORPLATE 87

COLORPLATE 69

G.-Albert Aurier

MERCURE DE FRANCE

"The Isolated Ones: Vincent van Gogh"

January 1890

This article, the first in a projected series on "isolated" artists, aligned Van Gogh with the Symbolist and Synthetist movements that Aurier championed in the early 1890s.

And then, all of a sudden, upon my return to the ignoble and muddy hustle and bustle of the dirty street and ugly, disjointed world of reality, in spite of myself, these scraps of verse resounded in my memory:

> The intoxicating monotony
> Of the metal, of marble and of water. . . .
> And everything, even the color black,
> Seemed furbished, bright, iridescent;
> The liquid encased its glory
> In the crystallized ray. . . .
> And waterfalls weighty
> As crystal curtains
> Hung, dazzling,
> On great metal walls. . . .

This poem has been identified as a pastiche of the "Rêve Parisien" from Baudelaire's Les Fleurs du Mal, *yet it is entirely in the spirit of Aurier's own poetry.*

Beneath skies, that sometimes dazzle like faceted sapphires or turquoises, that sometimes are molded of infernal, hot, noxious and blinding sulfurs; beneath skies like streams of molten metals and crystals, which, at times, expose radiating, torrid solar disks; beneath the incessant and formidable streaming of every conceivable effect of light, in heavy, flaming, burning atmospheres that seem to be exhaled from fantastic furnaces where gold and diamonds and singular gems are volatilized—there is the disquieting and disturbing display of a strange nature, that is at once entirely realistic and yet almost supernatural, of an excessive nature where everything— beings and things, shadows and lights, forms and colors—rears and rises up with a raging will to howl its own essential song in the most intense and fiercely high-pitched timbre: Trees, twisted like giants in battle, proclaiming with the gestures of their gnarled menacing arms and with the tragic waving of their green manes their indomitable power, the pride of their musculature, their blood-hot sap, their eternal defiance of hurricane, lightning and malevolent Nature; cypresses which expose their nightmarish, flame-like, black silhouettes; mountains which arch their backs like mammoths or rhinoceroses; white and pink and golden orchards, like the idealizing dreams of virgins; squatting, passionately contorted houses, in a like manner to beings who exult, who suffer, who think; stones, terrains, bushes, grassy fields, gardens, and rivers that seem sculpted out of unknown minerals, polished, glimmering, iridescent, enchanted; flaming landscapes, like the effervescence of multicolored enamels in some alchemist's diabolical crucible; foliage that seems of ancient bronze, of new copper, of spun

glass; flowerbeds that appear less like flowers than opulent jewelry fashioned from rubies, agates, onyx, emeralds, corundums, chrysoberyls, amethysts and chalcedonies; it is the universal, mad and blinding coruscation of things; it is matter and all of Nature frenetically contorted in paroxysms, raised to the heights of exacerbation; it is form, becoming nightmare; color, becoming flame, lava and precious stone; light turning into conflagration; life, into burning fever.

Such—and it is by no means an exaggeration, though one might think so—is the impression left upon the retina when it first views the strange, intense and feverish work of Vincent van Gogh, that compatriot and not unworthy descendant of the old Dutch masters.

Oh! how far we are—are we not?—from the beautiful, great traditional art, so healthy and very well-balanced, of the Dutch past. How far from the Gerard Dows, the Albert Cuyps, the Terburgs, the Metzus, the Peter de Hooghes, the Van der Meers, the Van der Heydens and from their charming canvases, a bit bourgeois, so patiently detailed, so phlegmatically over-finished, so scrupulously meticulous! How far from the handsome landscapes, so restrained, so well-balanced, so timelessly enveloped in soft tones, grays, and indistinct haze, those Van der Heydens, Berghems, Van Ostades, Potters, Van Goyens, Ruysdaëls, Hobbemas! How far from the somewhat cold elegance of Wouwermans; from Schalken's eternal candlelight; or from the fine brushwork and magnifying-glass vision of the good Pierre Slingelandt's timid myopia! How far from the delicate, always somewhat cloudy and somber colors of the northern countries and from the tireless exactitude of those wholesome artists of yore who painted "in their manner" with calm spirits, warm feet and bellies full of beer; and how far from that very honest, very conscientious, very scrupulous, very Protestant, very republican, very congenially banal art of those incomparable old masters whose only fault—if to them it was a fault—was that they were all family men and burgomasters! . . .

Citations are to seventeenth-century Dutch masters.

And yet, make no mistake, Vincent van Gogh has by no means transcended his heritage. He was subject to the effect of ineluctable atavistic laws. He is good and duly Dutch, of the sublime lineage of Franz Hals.

And foremost, like all his illustrious compatriots, he is, indeed, a realist, a realist in the fullest sense of the term. *Ars est homo, additus naturae*, Chancellor Bacon said, and M. Emile Zola defined naturalism as "nature seen through the temperament." Well, it is this "homo additus," this "through a temperament," or this molding of the objective unity into a subjective diversity that complicates the question and abolishes the possibility of any absolute criterion for gauging the degrees of the artist's sincerity. To determine this, the critic is thus inevitably reduced to more or less hypothetical, but always questionable, conclusions. Nevertheless, in the case of Vincent van Gogh, in my opinion, despite the sometimes misleading strangeness of his works, it is difficult, for an unprejudiced and knowledgeable viewer, to deny or question the naive truthfulness of his art, the ingenuousness of his vision. Indeed, independent of this indefinable aroma of good faith and of the truly-seen that all his paintings exude, the choice of subjects, the constant harmony between the most excessive color notes, the conscientious study of character, the continual search for the essential sign of each thing, a thousand significant details undeniably assert his profound and almost childlike sincerity, his great love for nature and for truth—his own personal truth.

"Atavistic laws": Philosopher Hippolyte Taine (1828–1893) postulated that art as a social product is historically determined by "la race, le milieu, et la moment."

Francis Bacon (1561–1626), English philosopher, and Emile Zola (1840–1902), novelist—advocates of naturalism, albeit separated by centuries.

Given this, we are thus able to infer legitimately from Vincent van Gogh's works themselves his temperament as a man, or rather, as an artist—an inference that I could, if I wished, corroborate with biographical facts. What characterizes his work as a whole is its excess, its excess of strength, of nervousness, its violence of expression. In his categorical affirmation of the character of things, in his often daring simplification of forms, in his insolence in confronting the sun head-on, in

Aurier ignored the biographical notes about Van Gogh that Bernard had sent to him.

COLORPLATE 63. *The Night Café.* 1888. Canvas. 28½ × 36¼″ (72.4 × 92.1 cm).
Yale University Art Gallery, New Haven; Bequest of Stephen Carlton Clark.

COLORPLATE 64. *Café Terrace at Night*. 1888. Canvas. 31⅞ × 26″ (81 × 65.5 cm).
Rijksmuseum Kröller-Müller, Otterlo.

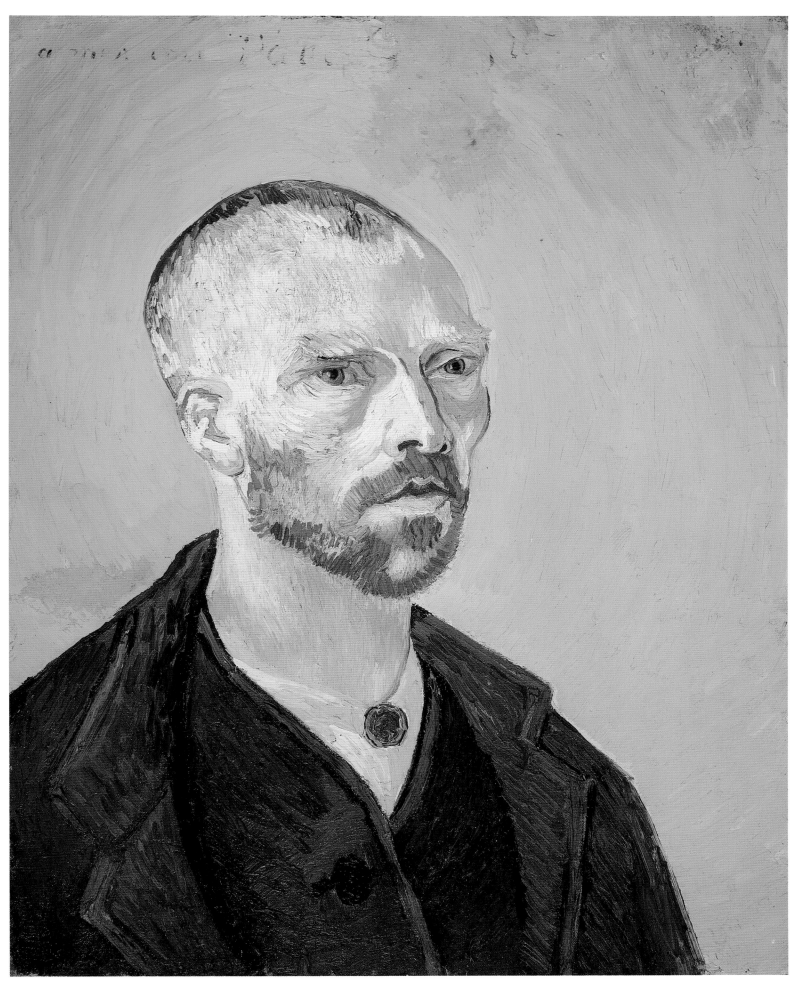

COLORPLATE 65. *Self-Portrait* (dedicated to Paul Gauguin). 1888. Canvas. 23⅝ × 19⅝″ (60 × 49.9 cm).
Harvard University Art Museums: Fogg Art Museum, Cambridge; Bequest-collection of Maurice Wertheim,
Class of 1906.

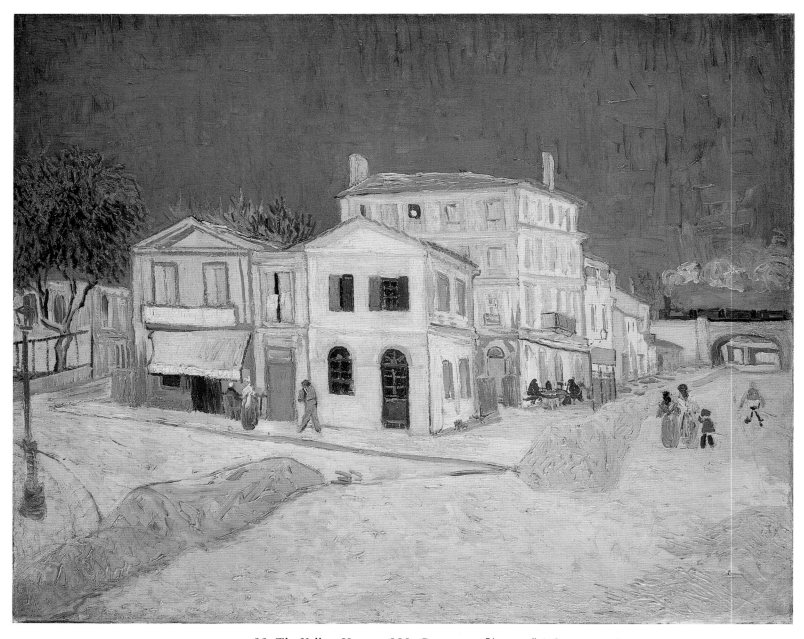

COLORPLATE 66. *The Yellow House*. 1888. Canvas. 29⅞ × 37″ (76 × 94 cm).
Rijksmuseum Vincent van Gogh, Amsterdam.

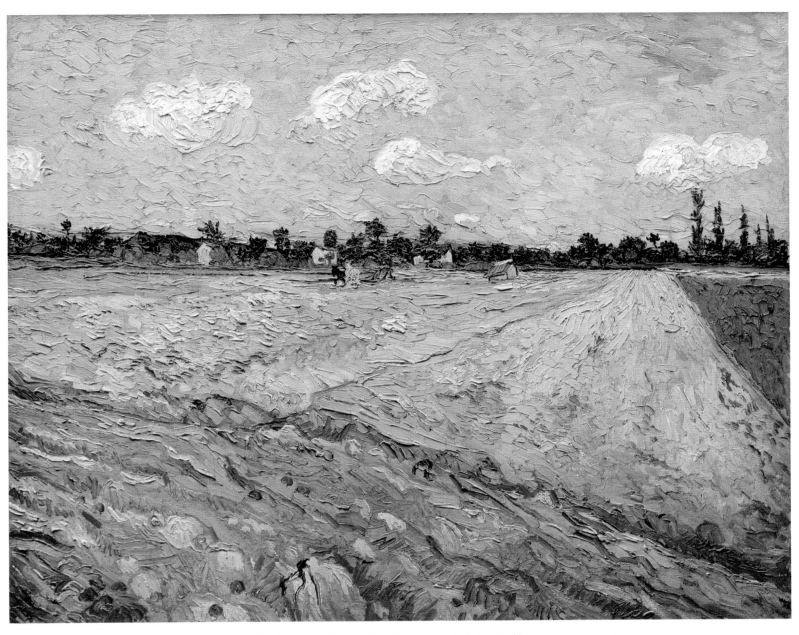

COLORPLATE 67. *Plowed Field*. 1888. Canvas. 28¾ × 36¼″ (72.5 × 92 cm).
Rijksmuseum Vincent van Gogh, Amsterdam.

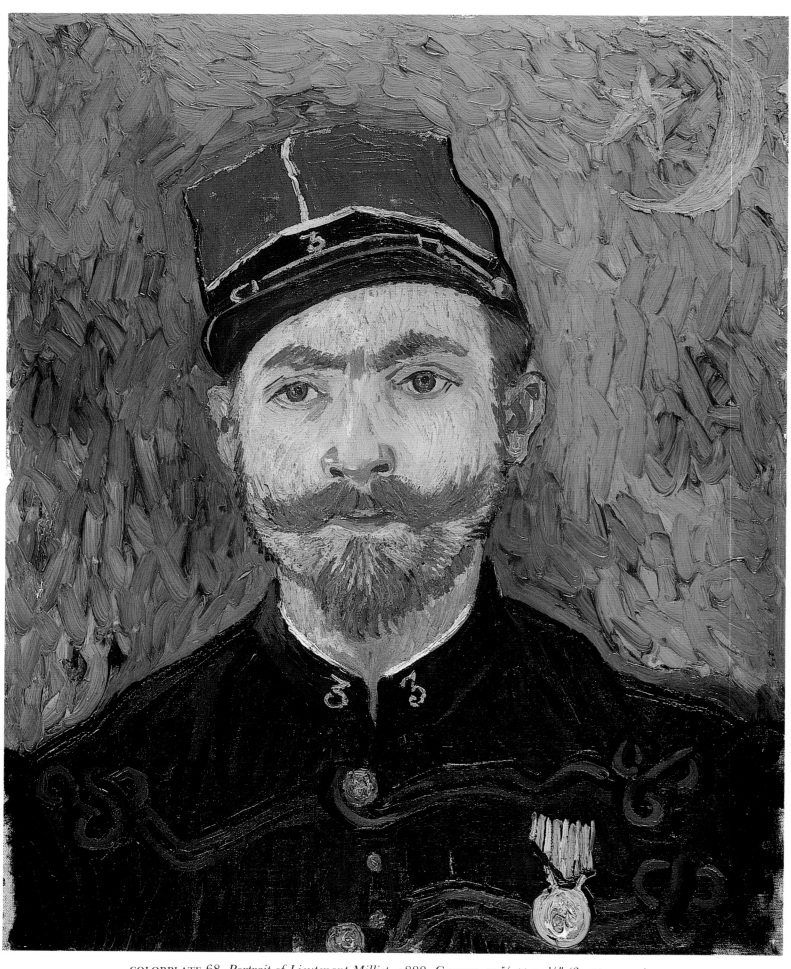

COLORPLATE 68. *Portrait of Lieutenant Milliet.* 1888. Canvas. 23⅝ × 19¼″ (60 × 49 cm).
Rijksmuseum Kröller-Müller, Otterlo.

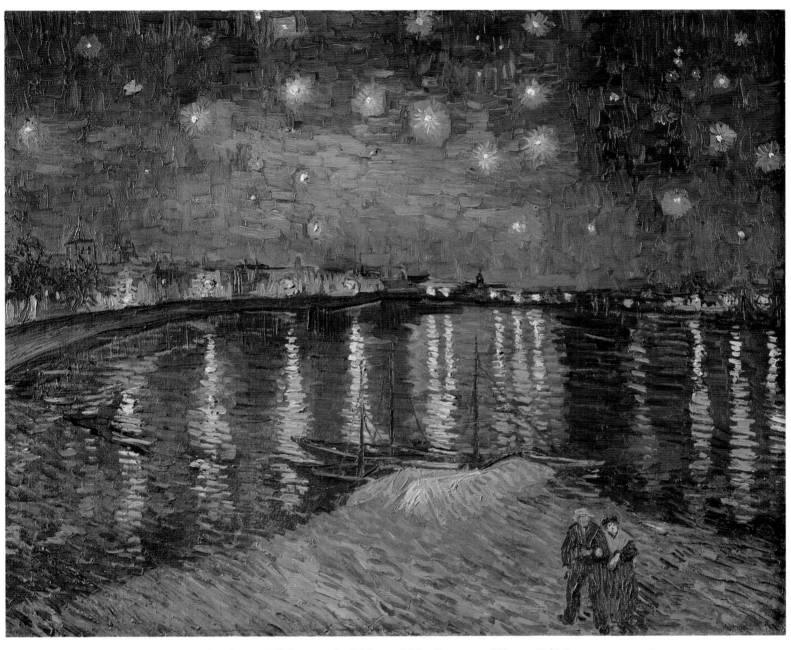

COLORPLATE 69. *Starry Night over the Rhône.* 1888. Canvas. 28¾ × 36¼″ (72.5 × 92 cm).
Collection Mr. and Mrs. R. Kahn-Sriber; Gift, reserving life interest, to the Musées Nationaux
(Musée d'Orsay), Paris.

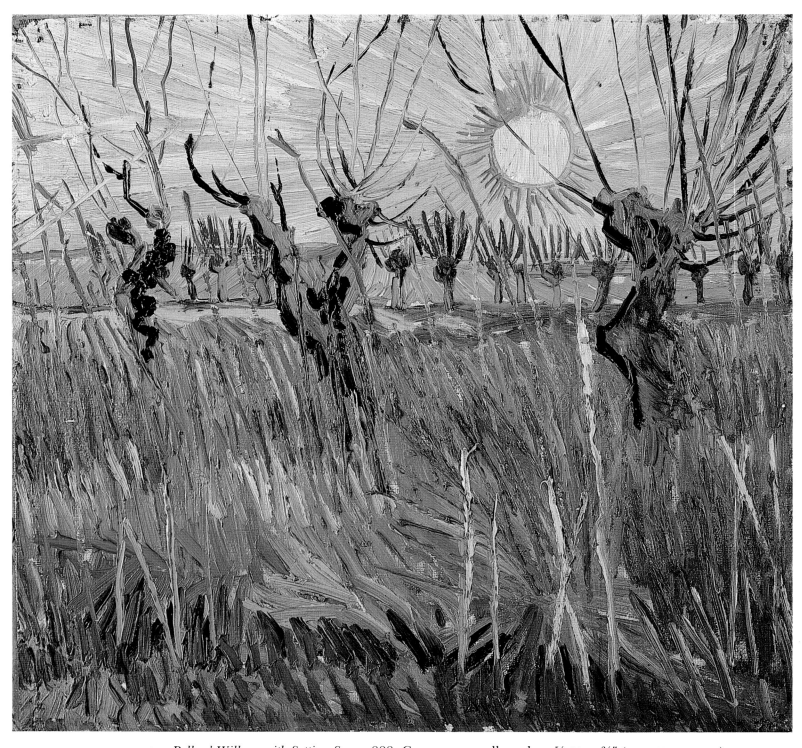

COLORPLATE 70. *Pollard Willows with Setting Sun.* 1888. Canvas on cardboard. 12⅝ × 13¾″ (31.5 × 34.5 cm).
Rijksmuseum Kröller-Müller, Otterlo.

the vehement passion of his drawing and color, even to the smallest details of his technique, a powerful figure is revealed—a masculine, daring, very often brutal, and yet sometimes ingenuously delicate. Furthermore, as can be divined from the almost orgiastic extravagances of everything he painted, he is a fanatic, an enemy of the bourgeois sobriety and minutiae, a sort of drunken giant, more suited to disrupting mountains than to handling bric-a-brac on whatnots, a brain at its boiling point irresistibly pouring down its lava into all of the ravines of art, a terrible and demented genius, often sublime, sometimes grotesque, always at the brink of the pathological. Finally, and above all, he is a hyper-aesthetic, with clearly shown symptoms, who perceives with abnormal, perhaps even painful, intensities the imperceptible and secret characters of line and form, but still more the colors, the lights, the nuances invisible to healthy eyes, the magic iridescence of shadows. And hence, the personal realism of this neurotic, and likewise his sincerity and his truth are so different from the realism, the sincerity and the truth of those great *petit-bourgeois* of Holland, those so healthy of body, so well balanced of mind, who were his ancestors and his masters.

Yet, this respect and this love for the reality of things does not suffice alone to explain or to characterize the profound, complex, and quite distinctive art of Vincent van Gogh. No doubt, like all the painters of his race, he is very conscious of material reality, of its importance and its beauty, but even more often, he considers this enchantress only as a sort of marvelous language destined to translate the Idea. He is, almost always, a Symbolist. Not at all a Symbolist in the manner of the Italian primitives, those mystics who barely felt the necessity to materialize their dreams, but a Symbolist who feels the continual need to clothe his ideas in precise, ponderable, tangible forms, in intensely sensual and material exteriors. In almost all his canvases, beneath this morphic exterior, beneath this flesh that is very much flesh, beneath this matter that is very much matter, there lies, for the spirit that knows how to find it, a thought, an Idea, and this Idea, the essential substratum of the work, is, at the same time, its efficient and final cause. As for the brilliant and radiant symphonies of color and line, whatever may be their importance for the painter, in his work they are simply expressive *means*, simply *methods* of symbolization. Indeed, if we refuse to acknowledge the existence of these idealistic tendencies beneath this naturalist art, a large part of the body of work that we are studying would remain utterly incomprehensible. How would one explain, for example, *The Sower*, that august and disturbing sower, that rustic with his brutally brilliant forehead (bearing at times a distant resemblance to the artist himself), whose silhouette, gesture and labor have always obsessed Vincent van Gogh, and whom he painted and repainted so often, sometimes beneath skies rubescent at sunset, sometimes amid the golden dust of blazing noons—how could we explain *The Sower* without considering that *idée fixe* that COLORPLATES 49, 77 haunts his brain about the necessary advent of a man, a messiah, sower of truth, who would regenerate the decrepitude of our art and perhaps of our imbecile and industrialist society? And how could we explain that obsessive passion for the solar disk that he loves to make shine forth from his emblazoned skies, and, at the same time, for that other sun, that vegetable-star, the sumptuous sunflower, which he repeats, tirelessly, COLORPLATES 37, 55, 59, 61 monomaniacally if we refuse to accept his persistent preoccupation with some vague and glorious heliomythic allegory?

Vincent van Gogh, indeed, is not only a great painter, enthusiastic about his art, his palette and nature; he is, furthermore, a dreamer, a fanatical believer, a devourer of beautiful Utopias, living on ideas and dreams.

For a long time, he took pleasure in imagining a renovation of art, made possible by displacing the center of civilization: an art of the tropical regions, the natives imperiously demanding works corresponding to

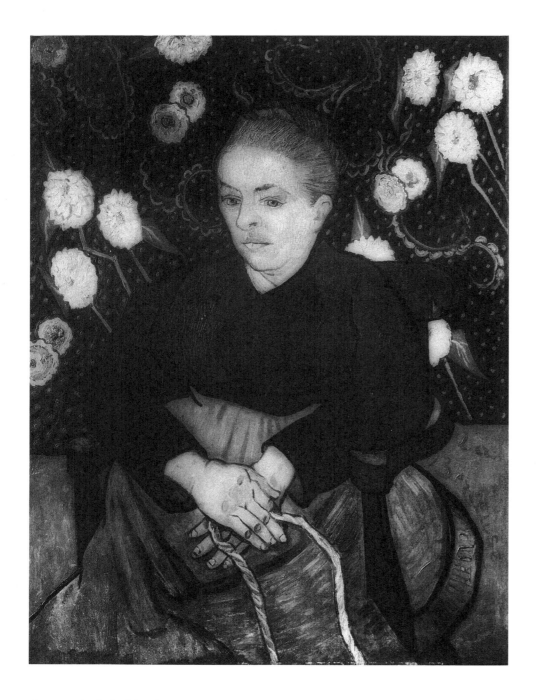

La Berceuse. 1889. Canvas. 36⅝ × 29⅛" (93 × 74 cm). Collection Mr. and Mrs. Walter H. Annenberg.

the newly inhabited surroundings; the painters finding themselves face-to-face with a hitherto unknown nature, radiant with light, at last admitting to themselves the impotence of the old academic tricks, and naively setting out to discover the direct translation of all these new sensations! . . . Wouldn't he, the intense and fantastic colorist, grinder of golds and of precious stones, have been the most well-suited painter, rather than the Guillaumets, the insipid Fromentins and the muddy Gérômes, of these countries of resplendence, of glowing sun and blinding colors?

Then, as a consequence of this conviction of the need to begin entirely from the beginning in art, he had long cherished the idea of inventing a very simple, popular, almost childlike sort of painting capable of moving the humble folk, who do not seek refinement, and of being understood by the most naive in spirit. The *Berceuse*, that gigantic and brilliant *image d'Epinal* that he repeated, with curious variations several times, the portrait of the phlegmatic and indescribably jubilant *Postmaster*, the *Drawbridge*, so crudely luminous and so exquisitely banal, the ingenuous *Young Girl with a Rose*, the *Zouave*, the *Provençal Woman*, all display with the greatest clarity this tendency toward the simplification of art, which one finds again more or less in all his work and which neither appears so absurd nor so negligible in these times of excessive complication, myopia and clumsy analysis.

August Achille Guillaumet (1840–1887), Eugène Fromentin (1820–1876), and Jean Leon Gérôme (1824–1904), French orientalist painters.

COLORPLATE 60

COLORPLATES 54, 43

COLORPLATES 53, 51, 75

All these theories, all these hopes of Vincent van Gogh, are they practicable? Are they not merely vain and beautiful chimeras? Who knows? In any case, I will not go into that here. It will suffice, in order to come to the end, to characterize somewhat further this curious spirit, so removed from all banal paths, by saying a few more words about his technique.

The external and material side of his painting is absolutely in keeping with his artistic temperament. In all his works, the execution is vigorous, exalted, brutal, intense. His drawing, excited, powerful, often clumsy and somewhat heavy-handed, exaggerates the character, simplifies, leaps—master and conqueror—over detail, attains a masterful synthesis and sometimes, but by no means always, great style.

We are already familiar with his color. It is unbelievably dazzling. He is, as far as I know, the only painter who perceives the coloring of things with such intensity, with such metallic, gemlike quality. His studies on the coloring of shadows, of the influences of one tone upon another, of the effect of full sunlight, are among the most curious. He is, however, not always able to avoid a certain disagreeable crudeness, disharmony, dissonance. . . . As for his actual technique, his approach to coloring the canvas is like everything else with him, passionate, very powerful and very nervous. He directs his brush with enormous dabs of impasto of very pure color in sinuous trails broken by rectilinear strokes, . . . in sometimes awkward piles, of quite shining masonry, and all this gives to certain of his canvases the solid appearance of great dazzling walls made of crystal and sun.

This robust and true artist, a thoroughbred with the brutal hands of a giant, the nerves of a hysterical woman, the soul of a mystic, so original and so removed from the milieu of our pitiful art of today, will he one day know—anything is possible—the joys of rehabilitation, the repentant flatteries of fashion? Perhaps. But whatever happens, even if it became fashionable to buy his canvases—which is unlikely—at the prices of M. Meissonnier's little infamies, I don't think that much sincerity could ever enter into that belated admiration of the general public. Vincent van Gogh is at once too simple and too subtle for the contemporary bourgeois spirit. He will never be fully understood except by his brothers, the true artists . . . and by the fortunate among the little people, the lowest social level, who have, by chance, escaped the good-intentioned teachings of public education! . . .

Ernest Meissonier (1815–1890), highly successful French academic painter of meticulously detailed historical scenes.

L'ART MODERNE

"Vincent van Gogh"

19 January 1890

Aurier's article would make way for more "Symbolist" evaluations of Van Gogh's art. Excerpts, preceded by this short introduction, were soon reprinted in L'Art Moderne, the organ of the avant-garde Belgian exhibition group Les Vingt, with whom Van Gogh was showing six canvases in Brussels.

One of the artists who will be most discussed at the Salon of Les Vingt and about whom a host of misunderstandings and absurdities have accumulated—Vincent van Gogh—has just been the subject of an intimate study by M. G.-Albert Aurier in a discerning and very interesting article published by *Mercure de France* (formerly *Pléiade*), in the January 1890 issue.

Being unable to reproduce the complete study because of its length, we find it useful to give excerpts from it. They accurately characterize the synthetic art of Vincent van Gogh.

Vincent's Letters

On the Article by G.-Albert Aurier

February and April 1890

TO JOHN RUSSELL, 1 FEBRUARY 1890 *(623a)*

You will find [an] article about some canvases I have at the exhibition of Les Vingt. I assure you that I owe much to the things Gauguin told me on the subject of drawing, and I have the highest respect for the way he loves nature. For in my opinion he is worth even more as a man than as an artist. . . .

TO THEO, 2 FEBRUARY 1890 *(625)*

I was extremely surprised at the article on my pictures which you sent me. I needn't tell you that I hope to go on thinking that I do not paint like that, but I do see in it how I ought to paint. For the article is very right as far as indicating the gap to be filled, and I think that the writer really wrote it more to guide, not only me, but the other impressionists as well, and even partly to make the breach at a good place. So he proposed an ideal collective ego to the others quite as much as to me; he simply tells me that there is something good, if you like, here and there in my work, which is at the same time so imperfect; and that is the comforting part of it which I appreciate and for which I hope to be grateful. Only it must be understood that my back is not broad enough to carry such an undertaking, and in concentrating the article on me, there's no need to tell you how immersed in flattery I feel, and in my opinion it is as exaggerated as what a certain article by Isaäcson said about you, namely that at present the artists had given up squabbling and that an important movement was silently being launched in the little shop on the Boulevard Montmartre. I admit that it is difficult to say what one wants, to express one's ideas differently—in the same way as you cannot paint things as you see them—and so I do not mean to criticize Isaäcson's or the other critic's daring, but as far as we are concerned, really, we are *posing* a bit for *the model*, and indeed that is a duty and a bit of one's job like any other. So if some sort of reputation comes to you and me, the thing is to try to keep some sort of calm and, if possible, clarity of mind.

Why not say what he said of my sunflowers, *with far more grounds*, of those magnificent and perfect hollyhocks of Quost's, and his yellow irises, and those splendid peonies of Jeannin's? And you will foresee, as I do, that such praise *must* have its opposite, the other side of the medal. But I am glad and grateful for the article, or rather *"le coeur à l'aise,"* as the song in the *Revue* has it, since one may need it, as one may really need a medal. Besides, an article like that has its own merit as a critical work of art; as such I think it is to be respected, and the writer *must* heighten the tones, synthesize his conclusions, etc. . . .

TO THEO, EARLY FEBRUARY 1890 *(626)*

And so Gauguin has returned to Paris. I am going to copy my reply to M. Aurier to send to him, and you must make him read this article in the *Mercure*, for really I think they ought to say things like that of Gauguin, and of me only very secondarily.

* * *

Wouldn't it be a good idea to send Reid, and perhaps Tersteeg too, or rather C. M., a copy of Aurier's article? It seems to me that we ought to

Ernest Quost (1842–1931) and Georges Jeannin (1841–1925), French painters of landscapes and still lifes whose flower pieces were exhibited at the Salon.

Art dealers: the Scot, Alexander Reid, whom Van Gogh knew in Paris; H. G. Tersteeg (b. 1845), director of Goupil's in The Hague, where Van Gogh worked from 1869 to 1873; and his uncle Cornelius Marinus van Gogh, head of the Amsterdam art firm C. M. van Gogh.

take advantage of it to dispose of something in Scotland, either now or later.

I think you will like the canvas for M. Aurier; it is in a terribly thick impasto and worked over like some Monticellis; I have kept it for almost a year. But I think I must try to give him something good for this article, which is very much a work of art in itself; and it will do us a real service against the day when we, like everybody else, shall be obliged to try to recover what the pictures cost. Anything beyond that leaves me pretty cold, but recovering the money it costs to produce is the very condition of being able to go on

* * *

Aurier's article would encourage me if I dared to let myself go, and venture even further, dropping reality and making a kind of music of tones with color, like some Monticellis. But it is so dear to me, this truth, *trying to make it true*, after all I think, I think, that I would still rather be a shoemaker than a musician in colors.

In any case, trying to remain true is perhaps a remedy in fighting the disease which still continues to disquiet me.

TO AURIER, EARLY FEBRUARY 1890 (626a)

Many thanks for your article in the *Mercure de France*, which greatly surprised me. I like it very much as a work of art in itself, in my opinion your words produce color, in short, I rediscover my canvases in your article, but better than they are, richer, more full of meaning. However, I feel uneasy in my mind when I reflect that what you say is due to others rather than to myself. For example, Monticelli in particular. Saying as you do: "As far as I know, he is the only painter to perceive the chromatism of things with such intensity, with such a metallic, gemlike luster," be so kind as to go and see a certain bouquet by Monticelli at my brother's—a bouquet in white, forget-me-not blue and orange—then you will feel what I want to say. But the best, the most amazing Monticellis have long been in Scotland and England. In a museum in the North—the one in Lisle, I believe—there is said to be a very marvel, rich in another way and certainly no less French than Watteau's "Départ pour Cythère." At the moment M. Lauzet is engaged in reproducing some thirty works of Monticelli's.

Here you are; as far as I know, there is no colorist who is descended so straightly and directly from Delacroix, and yet I am of the opinion that Monticelli probably had Delacroix's color theories only at second hand; that is to say, that he got them more particularly from Diaz and Ziem. It seems to me that Monticelli's personal artistic temperament is exactly the same as that of the author of the *Decameron*—Boccaccio—a melancholic, somewhat resigned, unhappy man, who saw the wedding party of the world pass by, painting and analyzing the lovers of his time—he, the one who had been left out of things. Oh! he no more imitated Boccaccio than Henri Leys imitated the primitives. You see, what I mean to say is that it seems there are things which have found their way to my name, which you could better say of Monticelli, to whom I owe so much. And further, I owe much to Paul Gauguin, with whom I worked in Arles for some months, and whom I already knew in Paris, for that matter.

Gauguin, that curious artist, that alien whose mien and the look in whose eyes vaguely remind one of Rembrandt's "Portrait of a Man" in the Galerie Lacaze—this friend of mine likes to make one feel that a good picture is equivalent to a good deed; not that he says so, but it is difficult to be on intimate terms with him without being aware of a certain moral responsibility. A few days before parting company, when my disease forced me to go into a lunatic asylum, I tried to paint "his empty seat."

It is a study of his armchair of somber reddish-brown wood, the seat

COLORPLATE 90

Narcisse Virgile Diaz de la Peña (1807–1876), well-known Barbizon painter, and Félix Ziem (1821–1911), prolific pre-Impressionist painter noted for views of Venice and Constantinople, lived on the same block as Theo, at 72, rue Lepic.

Galerie Lacaze, in the Louvre.

COLORPLATE 80

of greenish straw, and in the absent one's place a lighted torch and modern novels.

If an opportunity presents itself, be so kind as to have a look at this study, by way of a memento of him; it is done entirely in broken tones of green and red. Then you will perceive that your article would have been fairer, and consequently more powerful, I think, if, when discussing the question of the future of "tropical painting" and of colors, you had done justice to Gauguin and Monticelli before speaking of me. *For the part which is allotted to me, or will be allotted to me, will remain, I assure you, very secondary.*

Aurier, in fact, dedicated his second study to Gauguin: "Le Symbolisme en Peinture: Paul Gauguin," Mercure de France (*March 1891*).

COLORPLATES 59, 61

And then there is another question I want to ask you. Suppose that the two pictures of sunflowers, which are now at the Les Vingt exhibition, have certain qualities of color, and that they also express an idea symbolizing "gratitude." Is this different from so many flower pieces, more skillfully painted, and which are not yet sufficiently appreciated, such as "Hollyhocks," "Yellow Irises" by Father Quost? The magnificent bouquets of peonies which Jeannin produces so abundantly? You see, it seems so difficult to me to make a distinction between impressionism and other things; I do not see the use of so much sectarian spirit as we have seen these last years, *but I am afraid of the preposterousness of it.*

And in conclusion, I declare that I do not understand why *you* should speak of Meissonier's "infamies." It is possible that I have inherited from the excellent Mauve an absolutely unlimited admiration for Meissonier; Mauve's eulogies on Troyon and Meissonier used to be inexhaustible— a strange pair.

I say this to draw your attention to the extent to which people in foreign countries admire the artists of France, without making the least fuss about what divides them, often enough so damnably. What Mauve repeated so often was something like this: "If one wants to paint colors, one should also be able to draw a chimney corner or an interior as Meissonier does."

In the next batch that I send my brother, I shall include a study of cypresses for you, if you will do me the favor of accepting it in remembrance of your article. I am still working on it at the moment, as I want to put in a little figure. The cypress is so characteristic of the scenery of Provence; you will feel it and say: "Even the color is black." Until now I have not been able to do them as I feel them; the emotions that grip me in front of nature can cause me to lose consciousness, and then follows a fortnight during which I cannot work. Nevertheless, before leaving here I feel sure I shall return to the charge and attack the cypresses. The study I have set aside for you represents a group of them in the corner of a wheat field during a summer mistral. So it is a note of a certain nameless black in the restless gusty blue of the wide sky, and the vermilion of the poppies contrasting with this dark note.

COLORPLATE 90

You will see that this constitutes something like the combination of tones in those pretty Scotch tartans of green, blue, red, yellow, black, which at the time seemed so charming to you as well as to me, and which, alas, one hardly sees any more nowadays.

Meanwhile, dear Sir, accept my gratitude for your article. When I go to Paris in the spring, I certainly shall not fail to call on you to thank you in person. . . .

[Postscript:] It will be a year before the study that I am going to send you will be thoroughly dry, also in the thick layers of paint; I think you will do well to lay on a goodly coat of varnish.

In the meantime it will be necessary to wash it a good many times with plenty of water in order to get the oil out. The study is painted with plain Prussian blue, the much-maligned color nevertheless used so often by Delacroix. I believe that as soon as the tones of this Prussian blue are quite dry, you will, by varnishing, get the black, the very black tones, necessary to bring out the various somber greens.

I am not quite sure how this study ought to be framed, but seeing that it makes one think of those nice Scotch materials, I mention that I have observed that a *very simple flat frame* in VIVID ORANGE LEAD would produce the desired effect in conjunction with the blues of the background and the dark greens of the trees. Without it there would not be enough red in the picture, and the upper part would seem a little cold.

TO HIS MOTHER, LATE FEBRUARY 1890 *(627)*

I was rather surprised at the article they wrote about me. Isaäcson wanted to do one some time ago, and I asked him not to; I was sorry when I read it, because it is so exaggerated; the problem is different— what sustains me in my work is the very feeling that there are several others doing the same thing I am, so why an article on me and not on those six or seven others, etc.?

But I must admit that afterward, when my surprise had passed off a little, I felt at times very much cheered by it; moreover, yesterday Theo wrote me that they had sold one of my pictures at Brussels for 400 francs. Compared with other prices, also those in Holland, this is little, but therefore I try to be productive to be able to go on working at a reasonable cost. And if we have to try to earn our bread with our hands, I have to make up for pretty considerable expenses. . . .

TO WIL, LATE FEBRUARY 1890 *(W20)*

I thought the article by M. Aurier—leaving out of consideration whether I deserve what he says of me—very artistic and very curious in itself. But it is rather like this that I *ought to be*, instead of the sad reality of how I do feel. I wrote to tell him that in any case it seems to me that Monticelli and Gauguin are more like this—that it seems to me that the part which should be assigned to me is of a secondary, very secondary order.

The ideas he speaks of are not my property, for in general all the impressionists are like that, are under the same influence, and we are all of us more or less neurotic. This renders us very sensitive to colors and their particular language, the effects of complementary colors, of their contrasts and harmony. But when I had read that article I felt almost mournful, for I thought: I ought to be like that, and I feel so inferior. And pride, like drink, is intoxicating, when one is praised, and has drunk the praise up. It makes one sad, or rather—I don't know how to express it, I feel it—but it seems to me that the best work one can do is what is done in the privacy of one's home without praise. And then you do not always find a *sufficiently* friendly disposition among artists. Either they exaggerate a person's qualities, or else they neglect him too much. However, I should be pleased to be able to believe that justice is better done after all than appears to be the case.

TO THEO, LATE APRIL 1890 *(629)*

Please ask M. Aurier not to write any more articles on my painting, insist upon this, that to begin with he is mistaken about me, since I am too overwhelmed with grief to be able to face publicity. Making pictures distracts me, but if I hear them spoken of, it pains me more than he knows. . . .

TO HIS MOTHER AND WIL, LATE APRIL 1890 *(629a)*

As soon as I heard that my work was having some success, and read the article in question, I feared at once that I should be punished for it; this is how things nearly always go in a painter's life: success is about the worst thing that can happen. . . .

The painting—once thought to have been The Red Vineyard—*was purchased by the Belgian artist Anna Boch (1848–1936) from the exhibition of Les Vingt in Brussels; of interest is: T. Faider-Thomas, "Anna Boch et le groupe de XX,"* Miscellanea Jozef Duverger *(1968).*

Octave Maus

The "La Lanterne Magique" Lecture

1918

On Van Gogh's participation in the 1890 exhibition of Les Vingt in Brussels, Octave Maus (1856–1919), founder and secretary of this group, delivered a lecture, "La Lanterne Magique," in Lausanne in 1918.

Anarchy, autocracy: experience has taught me that these two forms of government are the only possible ones for running an art salon.

During the period of anarchy, the exhibitors bickered amongst themselves while exchanging blows with the public; under my autocracy, they no longer fought except against the crowd's incomprehension. Undoubtedly, this was progress.

Two heated scenes come to mind—one interior, one exterior. I must tell them to you.

The first one nearly ended in a duel with swords in hand between Henri de Toulouse-Lautrec and Henri de Groux. Those of you with some notion of the physical appearance of these two men can imagine the farce of such an encounter.

Henry de Groux (1867–1930), Belgian history and religious painter, whose works Van Gogh and Aurier admired.

A childhood accident that fractured both legs had reduced Lautrec to the height of a dwarf. His torso, which had remained normal in size, was so close to the ground that his companions had nicknamed him—we are among men—"Low-Assed" [Bas du cul]. De Groux, sickly in profile and of ashen complexion, was hardly any taller. A long greenish cape, from which emerged only a small, slender head and his feet, gave him the appearance of a little bell. At Bayreuth, they called him "Die Glocke."

At the *Vernissage* banquet—because in Belgium the two events go hand-in-hand—a discussion arose about Van Gogh, several of whose febrile and schematic canvases brightened the wall.

Vernissage: literally, the "varnishing day."

These paintings exasperated De Groux. And so he began to criticize severely the painter of Arles, calling him an ignoramus and a charlatan. At the other end of the table, Lautrec jumped up, arms in the air, shouting that it was scandalous to slander such an artist. De Groux retorted. Tumult. Seconds were appointed. Signac declared coldly that if Lautrec were killed, he would take up the affair himself.

I had all the trouble in the world the following day persuading De Groux to make a retraction.

S. P.

ART ET CRITIQUE

Catalogue of the Exhibition of Les Vingt

1 February 1890

This review, published anonymously by Paul Signac, favored his own contributions to Les Vingt with an entire paragraph, but made only a passing reference to Van Gogh.

M. Vincent van Gogh, Saint-Rémy-en-Provence—The tomb of yellow, chrome, and Veronese green: *Sunflowers, Ivy, Red Vineyard.*

COLORPLATES 59, 61, 76

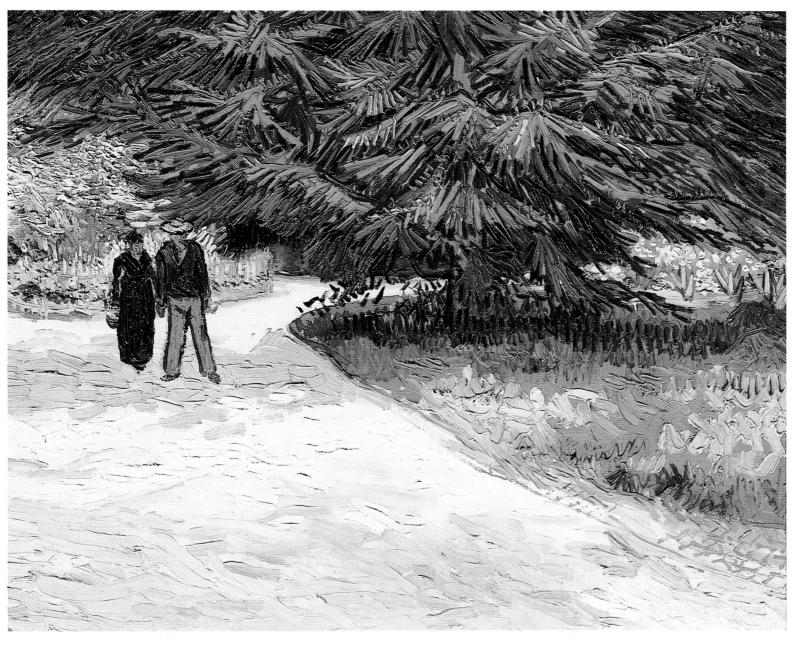

COLORPLATE 71. *Public Garden with Couple and Blue Fir Tree.* 1888. Canvas.
28¾ × 36¼" (73 × 92 cm). Private Collection.

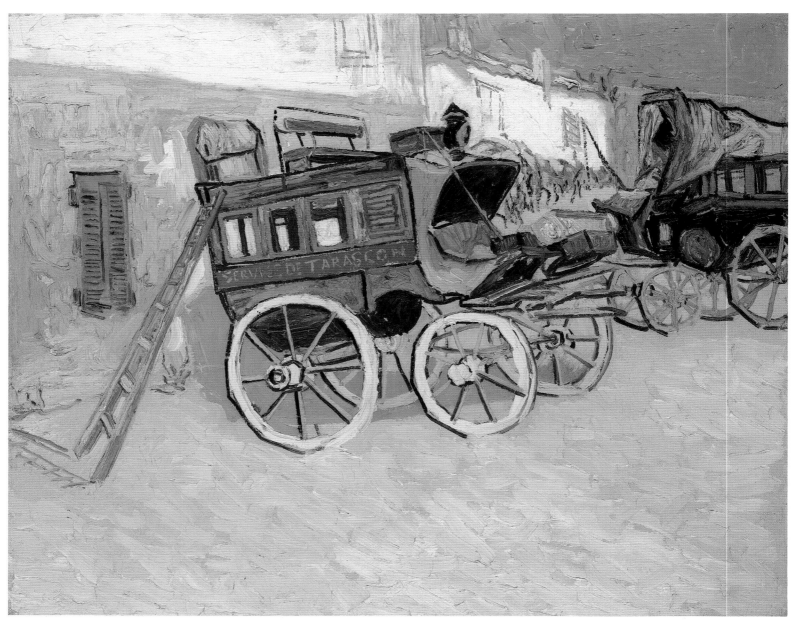

COLORPLATE 72. *Tarascon Diligence*. 1888. Canvas. 28¼ × 36⁷/₁₆″ (71.8 × 92.7 cm).
The Henry and Rose Pearlman Foundation, Inc.

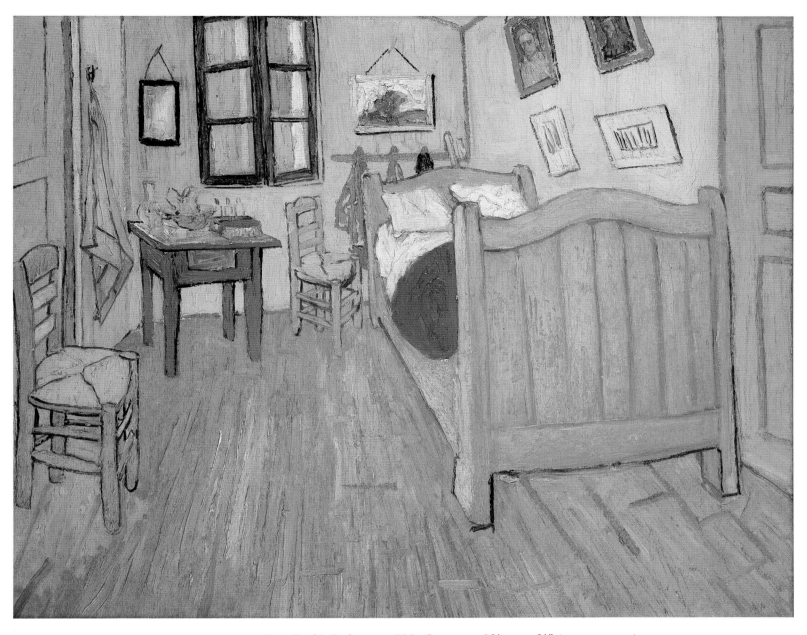

COLORPLATE 73. *Van Gogh's Bedroom*. 1888. Canvas. 28⅜ × 35⅜″ (72 × 90 cm).
Rijksmuseum Vincent van Gogh, Amsterdam.

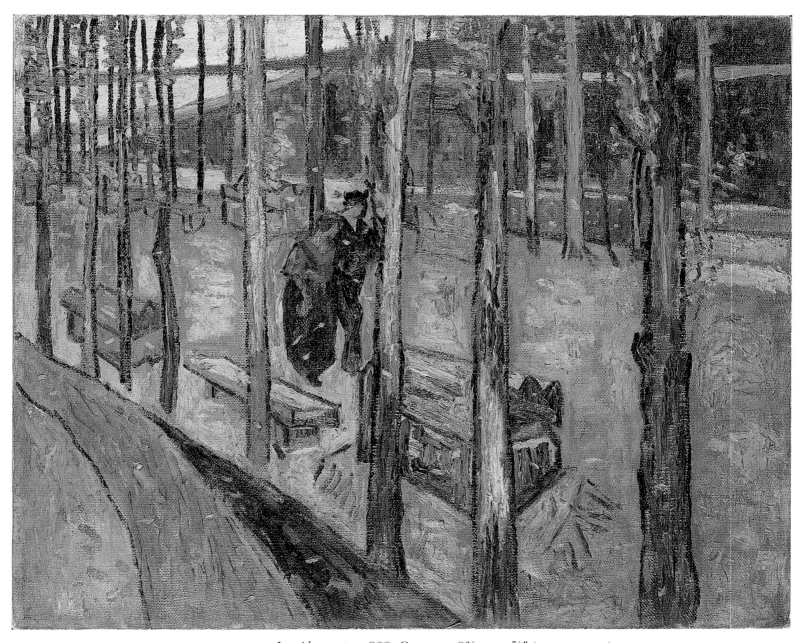

COLORPLATE 74. *Les Alyscamps*. 1888. Canvas. 28⅜ × 35⅞″ (72 × 91 cm).
Private Collection.

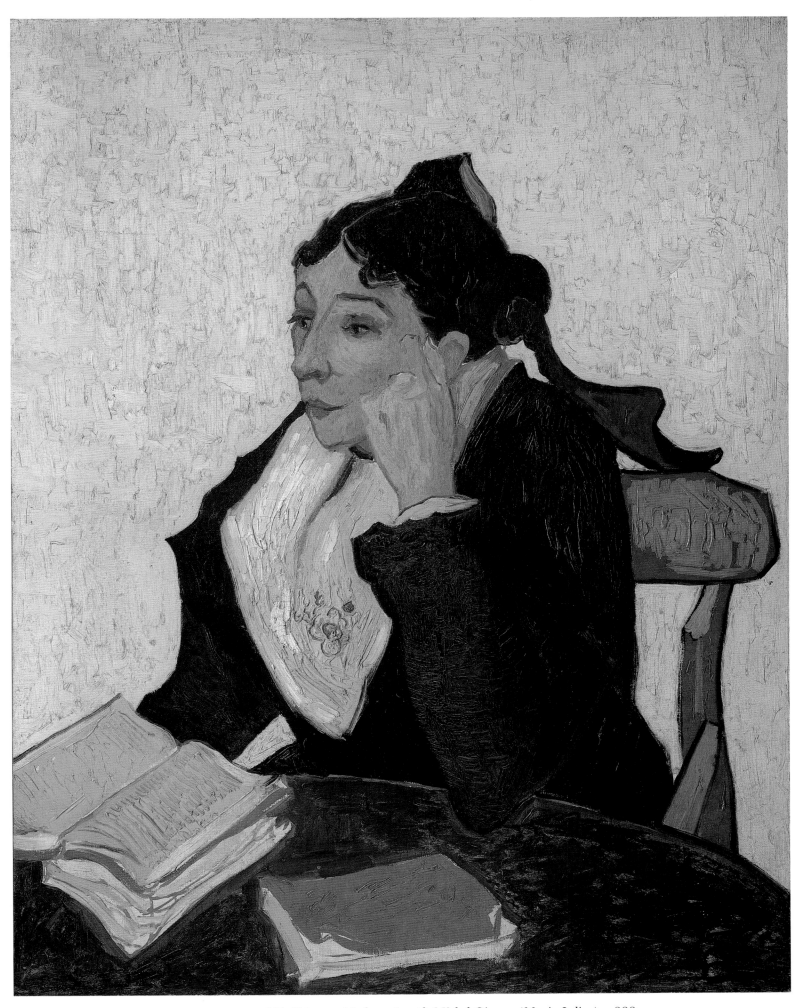

COLORPLATE 75. *L'Arlésienne: Madame Joseph-Michel Ginoux (Marie Julien).* 1888.
Canvas. 36 × 29″ (91.4 × 73.7 cm).
The Metropolitan Museum of Art, New York; Bequest of Sam A. Lewisohn, 1951.

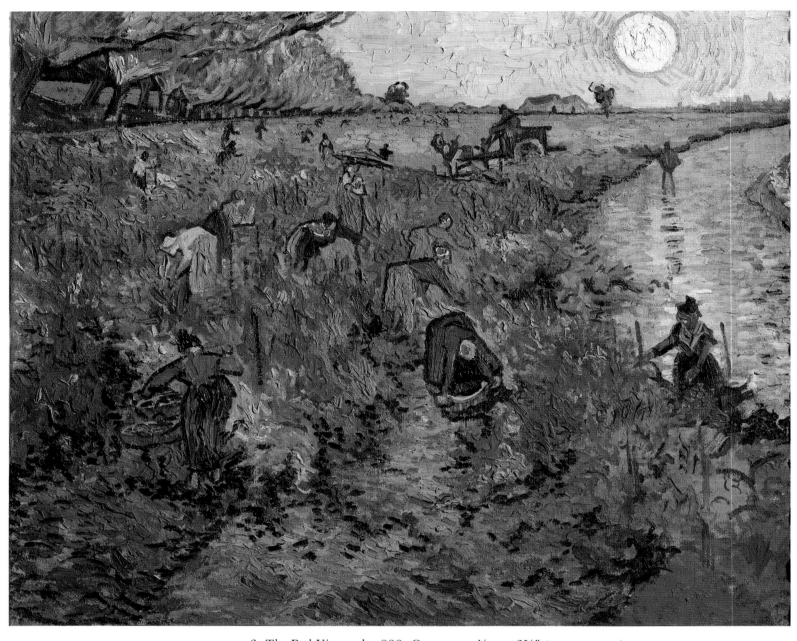

COLORPLATE 76. *The Red Vineyard.* 1888. Canvas. 29½ × 36⅝″ (75 × 93 cm).
Pushkin State Museum of Fine Arts, Moscow.

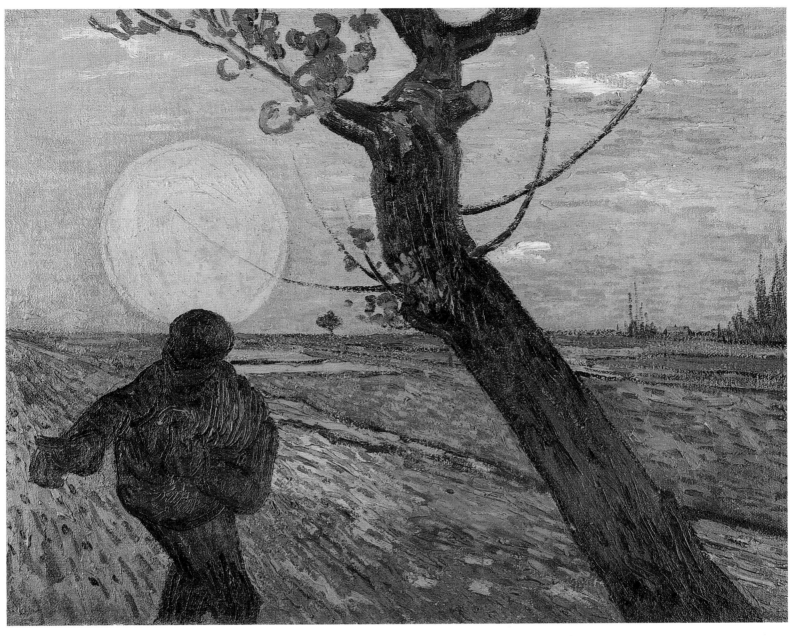

COLORPLATE 77. *Sower with Setting Sun.* 1888. Burlap on canvas. 28⅞ × 36¼″ (73.5 × 92 cm).
Foundation E. G. Bührle Collection, Zurich.

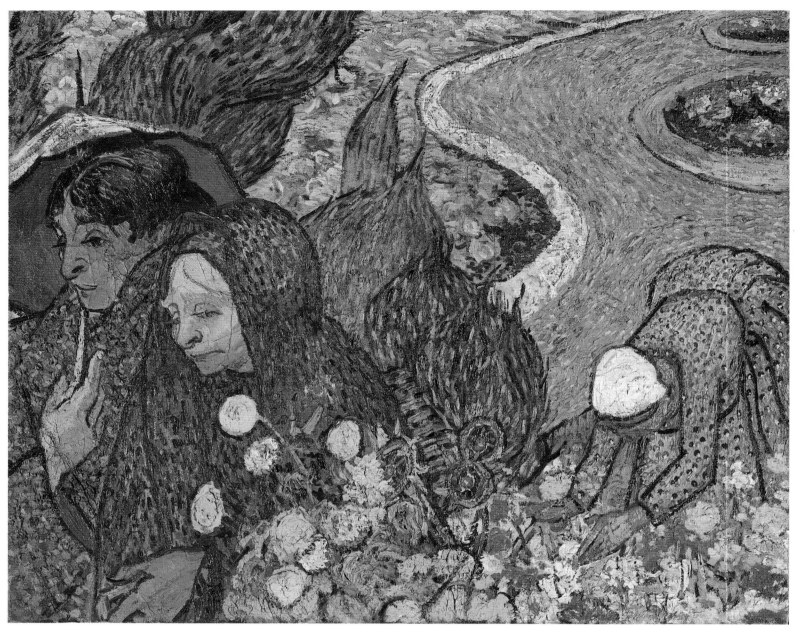

COLORPLATE 78. *Memory of the Garden at Etten*. 1888. Canvas. 29⅛ × 36⅝″ (73.5 × 92.5 cm).
The Hermitage, Leningrad.

Georges Lecomte
ART ET CRITIQUE
"The Exhibition of the Neo-Impressionists"
29 March 1890

Georges Lecomte (1867–1958), noted French writer, dramatist, collector, and anarchist sympathizer.

M. Vincent van Gogh's fierce impasto and his exclusive use of gentle harmonies of color result in powerful effects: the violet background of *Cypresses* and the symphony of greens in an undergrowth make a vivid impression.

COLORPLATES 90, 94

Julien Leclercq
MERCURE DE FRANCE
"Fine Arts at the Indépendants"
May 1890

Julien Leclercq (1865–1901), journalist, poet, and critic who contributed to a number of Symbolist reviews.

Our friend G.-Albert Aurier has, in this journal, all too well defined the nature of Vincent van Gogh's talent for us to retrace his steps. But what a great artist! Instinctive, he was a born painter; it was in him, without hesitation. Like Salvator Rosa, he is a tormented spirit. His power of expression is extraordinary, and everything in his *oeuvre* derives its life from his own life. It is painting that cannot be analyzed; he did not fall sway to the search for technique. His was an impassioned temperament, through which nature appears as it does in dreams—or rather, in nightmares. It is well-balanced, because line and color become one in a harmonious strangeness. He glimpses objects in nature, but they only become a reflection of himself; for example, this quasi-mythological cypress with its glints of metal, like a fabulous dragon. Those sunflowers in a pot are magnificent. At the Salon of the Indépendants there are ten paintings by Van Gogh that bear witness to a rare genius.

Salvator Rosa (1615–1673), Italian landscape painter.

COLORPLATES 90, 59, 61

A. H.
LA WALLONIE
"Les Vingt"
1890

La Wallonie, a monthly literary and artistic review, was the organ of the Symbolist movement in Belgium from 1886 to 1892.

We do not share the enthusiasm that the art of M. Vincent van Gogh evokes in some profound and sincere artists. The *Sunflowers*, very pow-

COLORPLATES 59, 61

erful in color and very beautiful in design, are above all decorative and agreeable to look at: In the *Red Vineyard* the use of lively tones, specially arranged, produces certain interesting, very curious, metallic effects of light. The value of his other canvases absolutely escapes us.

Vincent's Letters

On Dr. Paul Gachet

May–June 1890

TO THEO, LATE MAY 1890 *(635)*

I have seen Dr. Gachet, who gives me the impression of being rather eccentric, but his experience as a doctor must keep him balanced enough to combat the nervous trouble from which he certainly seems to me to be suffering at least as seriously as I.

* * *

Probably you will see Dr. Gachet this week—he has a *very* fine Pissarro winter with a red house in the snow, and two fine flower pieces by Cézanne.

Also another Cézanne, of the village. And I in my turn will gladly, very gladly, do a bit of brushwork here.

* * *

His house is full of black antiques, black, black, black, except for the impressionist pictures mentioned. The impression I got of him was not unfavorable. When he spoke of Belgium and the days of the old painters, his grief-hardened face grew smiling again, and I really think that I shall go on being friends with him and that I shall do his portrait.

Then he said that I must work boldly on, and not think at all of what was wrong with me. . . .

TO THEO, EARLY JUNE 1890 *(638)*

He certainly seems to me as ill and distraught as you or me, and he is older and lost his wife several years ago, but he is very much the doctor, and his profession and faith still sustain him. We are great friends already, and as it happens, he already knew Brias [Bruyas] of Montpellier and has the same idea of him that I have, that there you have someone significant in the history of modern art.

I am working at his portrait, the head with a white cap, very fair, very light, the hands also a light flesh tint, a blue frock coat and a cobalt blue background, leaning on a red table, on which are a yellow book and a foxglove plant with purple flowers. It has the same sentiment as the self-portrait I did when I left for this place.

M. Gachet is absolutely *fanatical* about this portrait, and wants me to do one for him, if I can, exactly like it. I should like to myself. He has now got so far as to understand the last portrait of the Arlésienne, of which you have one in pink; he always comes back to these two portraits when he comes to see the studies, and he understands them exactly, exactly, I tell you, as they are.

* * *

Gachet also told me, that if I wished to give him great pleasure, he would like me to do again the "Pietà" by Delacroix for him, he looked at it for

COLORPLATE 76

Dr. Paul-Ferdinand Gachet (1828–1909), physician, artist, and art collector who numbered among his friends Cézanne, Guillaumin, Pissarro, and Renoir. In his care, Van Gogh spent the last two months of his life, 20 May to 29 July 1890, in the town of Auvers, just north of Paris.

In mid-December 1888 Van Gogh and Gauguin had made a day-trip from Arles to see the Alfred Bruyas collection—with its impressive works by Delacroix and Courbet—in the Musée Fabre in Montpellier.

COLORPLATE 116

Van Gogh had executed four paintings after Gauguin's November 1888 drawing of L'Arlèsienne (Mme. Ginoux); three versions were painted against various pink-colored backgrounds.

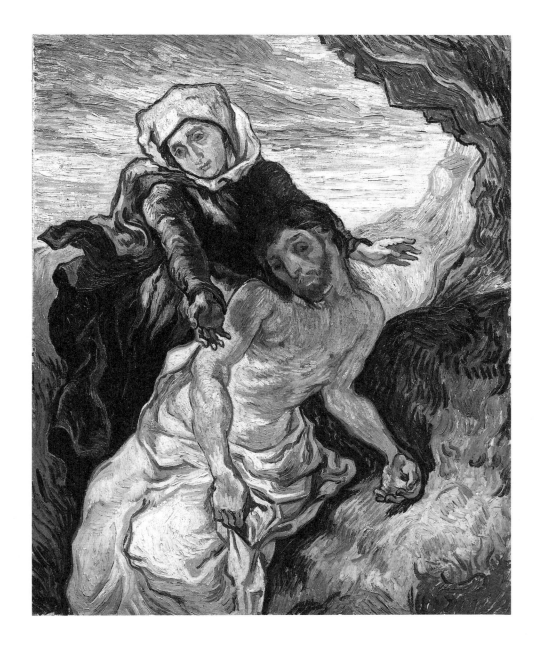

Pietà (after Delacroix). 1889. Canvas. 28¾ × 24″ (73 × 60.5 cm). Rijksmuseum Vincent van Gogh, Amsterdam.

a long time. In the future he will probably lend me a hand in getting models; I feel that he understands us perfectly and that he will work with you and me to the best of his power, without any reserve, for the love of art for art's sake. And he will perhaps really get me portraits to do. Now in order to get some clients for portraits, one must be able to show different ones that one has done. That is the only possibility I see of selling anything. Yet notwithstanding everything, some canvases will find purchasers someday. Only I think that all the talk that has been started on account of the high prices paid for Millets, etc., lately has made the chances of merely getting back one's painting expenses even worse. It is enough to make you dizzy. So why think about it?—it would only daze our minds. Better perhaps to seek a little friendship and to live from day to day. . . .

TO WIL, EARLY JUNE 1890 *(W22)*

And then I have found a true friend in Dr. Gachet, something like another brother, so much do we resemble each other physically and also mentally. He is a very nervous man himself and very queer in his behavior; he has extended much friendliness to the artists of the new school, and he has helped them as much as was in his power. I painted his portrait the other day, and I am also going to paint a portrait of his daughter, who is nineteen years old. He lost his wife some years ago,

COLORPLATE 119

which greatly contributed to his becoming a broken man. I believe I may say we have been friends from the very first, and every week I shall go stay at his house one or two days in order to work in his garden, where I have already painted two studies. . . .

Letter from Anton Hirschig to Dr. A. Bredius

OUD-HOLLAND

Recollections of Vincent van Gogh

1934

I still see before me all that work, which is now preserved, as if it were sacred, with the greatest care, jumbled together in the dirtiest sty imaginable, a sort of hovel in a backyard barn where goats were penned up. It was dark there, the brick walls were unplastered and full of straw. At the end there were steps. There was hung the work of Van Gogh, and every day he brought in new pieces. They lay on the ground and hung on the walls, and no one cared for them. There was *The Town Hall of Auvers on Bastille Day* with flags, a portrait of the daughter of the wine merchant *where we lived*, and so many others.

I still see him sitting on the bench in front of the window of the little café, with his cut-off ear and bewildered eyes in which there was something insane and into which I dared not look. And I will never forget when he entered with his hand on his stomach, while we were waiting to eat.

Anton ("Tommy") Hirschig (1867–1939), Dutch artist who, upon arrival in Auvers on 16 June 1890, had taken the room adjacent to Van Gogh's at Ravoux's inn.

COLORPLATE 118

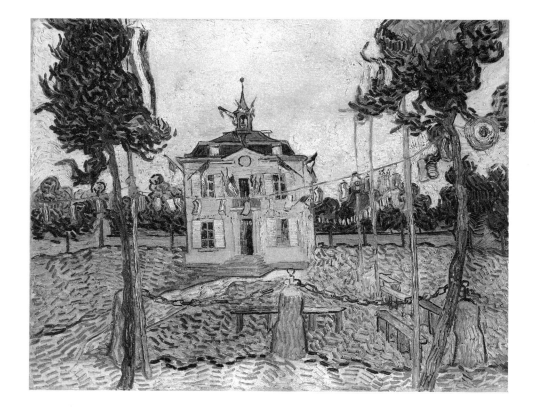

Town Hall of Auvers on Bastille Day. 1890. Canvas. 28⅜ × 36⅝" (72 × 93 cm). Private Collection.

"But M. Vincent, where are you coming from? What's the matter with you?"

"I was too fed up and so I killed myself!"

I see him in his little bed in the small attic, prey to the most terrible suffering.

"Is there then no one to open my stomach?"

It was sweltering under this roof.

When he was dead, he was terrible to behold, more terrible than when he was alive.

From his coffin, which was badly made, there escaped a stinking liquid: everything was terrible about this man. I think that he suffered a great deal in this world. I never saw him smile.

Adeline Ravoux Carrié

LES CAHIERS DE VAN GOGH

"Recollections on Vincent van Gogh's Stay in Auvers-sur-Oise"

1956

Vincent van Gogh arrived at our house at the end of May 1890; I cannot be more precise about the date from memory. They say that earlier he had stayed briefly at the Hôtel St.-Aubin upon his arrival in Auvers, but I never heard about that. You could see the little room in which he lived with us, on the second floor, the one whose door is situated across from the staircase. Having gone last May 7 to Auvers, I was able to rectify some errors the present innkeeper had made on this subject relative to the room on the first floor, which Vincent never occupied. The room on the ground floor where he painted ("the artists' room," as we called it) still exists, though it is reduced by a hallway. The account of my trip to Auvers was published in *Les Nouvelles Littéraires* of 12 August 1954.

Of his clothing I only remember a jacket of blue twill, much shorter than an ordinary jacket, which he wore constantly. He put on neither a collar nor a tie. For headwear he used a felt hat with a large brim and, in sunny weather, a straw hat like gardeners or fishermen wear. On the whole, he neglected his dress.

He was a man of good size, his shoulders lightly bent to the side of his wounded ear, his look very bright, soft, and calm, but hardly of a communicative character. When we spoke to him, he always responded with an agreeable smile. He spoke French very correctly, groping little for words. *He never drank alcohol.* I insist on this point. The day of his suicide, he was in no way drunk, as some people allege. When I found out much later that he had been confined to an insane asylum in the Midi, I was very surprised, since in Auvers he always seemed to me calm and mild. He was well appreciated in our place. We called him, familiarly, "Monsieur Vincent." He never mingled with the clients of the café.

He took his meals with our other boarders, Tommy Hirschig (whom we called Tom) and Martinez de Valdivielse. Tommy Hirschig was a Dutch painter, 23 or 24 years old, it seemed to me, who arrived at our house a little after Van Gogh. He knew very little French and continued

Upon his arrival in Auvers on 20 May 1890, Dr. Gachet took Van Gogh to another, costlier, inn; but later, the artist went to Arthur Gustave Ravoux's inn. The innkeeper's daughter, Adeline (1877–1965), was thirteen when she posed for Van Gogh's June portrait of A Woman in Blue.

This is among the many points of disagreement among the various witness accounts. According to the recollections of Dr. Gachet's son (Paul Gachet, Souvenirs de Cézanne et de Van Gogh—Auvers, 1873–1910, 1953) *Van Gogh had a room on the floor below. Anton Hirschig, however, confirms that he had an attic room.*

Photograph of Ravoux's Restaurant. 1890. Arthur Gustave Ravoux is seated at far left; his daughter Adeline stands in the doorway. Rijksmuseum Vincent van Gogh, Amsterdam.

to speak it badly, with vocabulary mistakes that provoked uncontrollable laughter. He was a gay chap, not a hard worker, more preoccupied with pretty girls than paint. His relations with Vincent seem to have been superficial. Moreover, it was difficult to follow because they conversed in Dutch. Vincent did not seem to take him seriously. Hirschig left our house in Auvers a little after the death of Van Gogh. For my part, I believe that it was the low price of our board (3 francs 50 per day) that attracted Van Gogh to us. In any case, it was certainly not Dr. Gachet who presented him. We had no relationship with this doctor, *whom I never saw at our house before the death of Vincent.*

Martinez de Valdivielse was a Spanish etcher, exiled from his homeland for his Carlist opinions. He received large subsidies from his family. Martinez had a house in Auvers and only took his meals with us. He was a large, handsome man with a long, graying brown beard and a profile befitting a medallion. Very vibrant and nervous, he surveyed the house from one end to the other. He expressed himself very well in French and spoke gladly with Father, whom he regarded highly. The first time that he saw a canvas by Van Gogh, he exclaimed with his usual impetuosity, "Who is the pig that did that?" Vincent, standing behind his easel, replied with his usual coolness, "It is me, sir." Thus did they make each other's acquaintance.

They became close enough to have had long conversations, mostly about art and the artists whom they knew, one expressing himself with spirit and enthusiasm, the other calmly. I do not think that Martinez appreciated Van Gogh's painting very much. Moreover, Vincent did not talk about him in his letters, at least in those that were brought to public attention. In Van Gogh's correspondence, he only cites among his relations Dr. Gachet. But I believe that a certain *legend* that chooses to give credence to Vincent's dining at the doctor's house *every* Sunday and Monday is probably wrong, or at least highly exaggerated, because I have no memory of M. Vincent *repeatedly* missing the meals that he regularly took at our place. In reality, I am persuaded that there were no intimate or sustained relations between the doctor and the artist. That is a problem for scholars to tackle.

The menu was typical for meals served at the time in the restaurants: meat, vegetables, salad, dessert. I do not remember any culinary preferences of M. Vincent. He never sent a dish back. He was not a difficult boarder.

The religious question was never brought up in the house. We never

In a letter to Theo (638), Van Gogh noted that he had been invited to dinner at Gachet's "every Sunday and Monday" but had found it quite an "ordeal"; if he only dined occasionally with Gachet, he did nonetheless spend at least two or three days a week at his home.

Gachet's very close and supportive friendship with Van Gogh became strained only during the last few weeks.

saw Vincent van Gogh either in church or with the priest. I did not know any Protestants in Auvers. Moreover, Vincent did not visit anyone in the village, at least to my knowledge. He hardly conversed with us. Father, who had established himself in Auvers only a few months before the arrival of Vincent and was at that time 42 years old, was not one to sustain an artistic conversation, so he discussed only practical matters with him. On the other hand, Vincent became very attached to my little sister, Germaine (today Mme. Guilloux, who lives with me). She was then a baby, two years old. Each night after dinner, he took her on his knee and drew for her on a slate the Sandman, standing in a horse-drawn wagon, throwing sand by the handfuls. Then the little girl would hug everyone and go upstairs to bed.

Vincent never had a conversation with me before doing my portrait, except for several words out of sheer politeness. One day he asked me, "Would it please you if I were to do your portrait?" He seemed to be very keen on it. I accepted, and he asked my parents' permission. I was then thirteen years old, but I seemed sixteen. He did my portrait one afternoon in one sitting. As I posed he did not speak to me; he smoked his pipe continually.

COLORPLATE 118

He found me very well behaved and complimented me on not having moved. I did not become tired, but was amused watching him paint and very proud to pose for my portrait. Dressed in blue, I sat in a chair. A blue ribbon tied back my hair, and since I have blue eyes and he used blue for the background of the portrait, it became a *Symphony in Blue*. M. Vincent may have made a replica of it in a square format that he may have sent to his brother; he says he did in one of his letters. I did not see him execute this copy. There may also be a third portrait of me: I know nothing of this last one. What I can affirm is that I only posed for one portrait.

This variant (measuring 52 × 52 cm) is presently in The Cleveland Museum of Art. The third portrait is in a private collection.

I admit that I was only moderately satisfied with my portrait; it was somewhat of a disappointment, for I did not find it true to life. However, last year a person who came to interview me about Van Gogh, in meeting me for the first time, recognized me from the portrait that Vincent had executed and said, "Vincent divined not the young girl that you were, but the woman that you would become." My parents did not at all appreciate this painting either, nor did the other people who saw it then. At that time very few people understood Van Gogh's painting.

Reference to the interview by Maximilien Gauthier in Les Nouvelles Litteraires *of 16 April 1953, which quotes her as coming to this realization while looking at reproductions of the picture years later.*

We kept this painting until 1905, I believe, as well as the one representing the town hall of Auvers, which Vincent had offered to Father. Again I see Vincent painting the latter canvas from our sidewalk in front of the café: it was the 14th of July and the town hall was decked with flags and there was a garland of lanterns around the trees.

After fifteen years the paint was flaking off these pictures. We were then in Meulan. Across from our café was the Hôtel Pinchon, where some artists were boarding. There were two Americans: One was named Harry Harronson—he also lived in Paris at 2, rue du Marché-au-Beurre, I believe—and the other was nicknamed in Meulan "le petit père Sam." There were also a German and a Dutchman who said he was part of the Van Gogh family. They knew that Father owned two paintings by Van Gogh. They asked to see them and then insisted that Father surrender the two paintings to them because, they told him, "Paintings become damaged, then require special care." Facing the danger of seeing these paintings eventually deteriorate, Father told them, "Well, each of you give me ten francs." It was thus that these two paintings by Van Gogh were surrendered for forty francs: *The Woman in Blue* and *The Town Hall of Auvers on Bastille Day*.

Van Gogh spent his days in a more or less uniform way: He ate breakfast; then around nine o'clock he left for the countryside with his easel and his paintbox, with his pipe in his mouth (which he never put down); he went to paint. He returned punctually at noon for lunch. In

the afternoon he often worked on a painting-in-progress in "the artists' room." Sometimes he just worked on until dinner; and sometimes he went out around four o'clock until the evening meal. After dinner he played with my little sister, drew his Sandman for her, and then went immediately up to his room. I never saw him write in the café; I think that he wrote at night in his room.

Here is what I know about his death.

That Sunday he had gone out immediately after lunch, which was unusual. At dusk he still had not returned, which surprised us a lot because, being extremely proper in his relations with us, he always arrived on time for meals. We were then all seated on the terrace of the café, as we tended to do on Sundays after the hustle-bustle of a day more tiring than a weekday. When we saw Vincent arrive, night had fallen—it must have been about nine o'clock. Vincent was walking bent over, holding his stomach, exaggerating even more his habit of holding one shoulder higher than the other. Mother asked him: "M. Vincent, we were worried. We're glad to see you back. Did you run into some trouble?"

He answered in a suffering voice, "No, but I. . . ." He did not finish, but crossed the room and climbed the staircase to his room. I was a witness to this scene.

Vincent made such a strange impression on us that Father got up and went to the stairway to listen for anything unusual. He thought he heard moaning, so he quickly went upstairs, where he found Vincent lying on his bed, curled up, his knees by his chin, moaning loudly. "What's wrong with you?" asked Father. "Are you sick?" Vincent then lifted his shirt and showed him a small wound in the area of the heart. Father exclaimed, "You poor man, what did you do?"

"I wanted to kill myself," answered Van Gogh.

We got these details from Father, who related them many times in front of my sisters and me, because the tragic death of Vincent van Gogh remained for our family one of the most memorable events of our lives. Father, who later became blind, willingly went over his memories of the old days, and Vincent's suicide was one of the events that he recounted the most often and with the greatest precision.

I digress here so that we should not doubt the fidelity of Father's memory, which was prodigious. He sometimes recounted to our café clientele his memories of the War of 1870, some of which were brought to the attention of a chronicler from *Le Petit Parisien*, a specialist in historic matters—a M. de Saint-Yves, I believe—and he verified Father's stories. All the details that he gave were confirmed; one never caught him in error.

The value of Father's testimony having thus been established, I shall continue to recount his memories of the death of the great painter. I admit that the way in which certain biographers spoke about my father shocked me considerably. Father was not a vulgar man. His reputation for honesty was proverbial. One never called him "le père Ravoux." He commanded respect.

Here is an account of the confidences that Vincent van Gogh shared with Father during the Sunday night to Monday that he spent by his side.

Vincent had gone toward the wheat field where he had painted before, situated behind the château of Auvers, which then belonged to M. Gosselin, who lived in Paris on the rue de Messine. The château was more than a half kilometer from our house. You reached it by climbing a rather steep slope shaded by big trees. We do not know how far away he stood from the château. During the afternoon, in the deep path that lies along the wall of the château—as my father understood it—Vincent shot himself and fainted. The coolness of the night revived him. On all fours he looked for the gun to finish himself off, but he could not find it. (Nor was it found the next day either.) Then Vincent got up and climbed down the hillside to return to our house.

This digression is wholly in keeping with the tenor of the article, which seeks to staunchly defend the Ravoux-family account of the events against the Gachet-family account.

Obviously I did not witness the agony of Van Gogh, but I was a witness to the majority of the events that I am now going to relate.

Having discovered the wound to be in the area of the heart, Father quickly came down from the room where Vincent was groaning and asked Tom Hirschig to go find a doctor. There was in Auvers a doctor from Pontoise who had a pied-à-terre where he gave consultations. This doctor was absent. Father then sent Tom to Dr. Gachet, who lived in the upper part of the town but did not practice in Auvers.

Was Dr. Gachet close to Van Gogh? Father was totally unaware of his being so; the doctor had never come to the house, and the scene that Father witnessed had only convinced him otherwise.

Gachet practiced in Paris but tended to friends and poor villagers in Auvers.

After the doctor's visit, Father told us, "Dr. Gachet examined M. Vincent and improvised a dressing with bandages he had brought with him." (We had warned him that a wounded man was involved.) He judged the case as being hopeless and left immediately. I am absolutely certain that he did not return—neither that night nor the next day. Father reiterated, *"During the examination and while he prepared the bandage, Dr. Gachet did not say a word to M. Vincent."*

After seeing the doctor home, Father went back up to M. Vincent and kept watch over him the whole night. Tom Hirschig stayed next to him.

Before the doctor had arrived, Vincent called for his pipe, and Father lit it. He again resumed smoking after the departure of the doctor and continued that way a portion of the night. He seemed to suffer a lot and moaned at times. He asked Father to approach his ear so that he could hear the gurgling of the internal hemorrhaging. He remained silent almost the whole night, sometimes falling asleep.

According to the Gachet account, the doctor, after lighting Vincent's pipe, left to notify Theo (he did so in a letter of 27 July 1890) while the son held vigil at the inn.

During the morning of the next day, two officers of the Méry brigade, probably diverted by rumors, presented themselves at the house. One named Rigaumon questioned Father in an unpleasant tone, "Is it here that there was a suicide?" Father, having begged him to soften his manner, invited him to follow him to the dying man. Father preceded the officers into the room, explained to Vincent that French law prescribed in such cases an investigation, which the officers were coming to make. They entered, and Rigaumon, always in the same tone, questioned Vincent, "Is it you who wanted to commit suicide?"

"Yes, I believe so," answered Vincent in his usual soft tone.

"You know that you do not have the right."

Still in the same even tone, Van Gogh answered: "Officer, as I am a free being in this body, I am free to dispose of it as I please. Do not accuse anyone; it is I who wanted to kill myself."

Father then begged the officers, somewhat harshly, not to insist any further.

At sunrise Father occupied himself with warning Theo, Vincent's brother. The wounded man, being then drowsy, was not able to give precise information. (He had had a surge of energy that had completely exhausted him during the officers' visit.) But, knowing that Vincent's brother was a dealer for the gallery of Boussod & Valadon on the boulevard Montmartre in Paris, Father sent a telegram to this address as soon as the post office opened. Theo arrived by train in the middle of the afternoon. I remember seeing him arrive running. The station was, after all, quite nearby. He was a man of slightly smaller stature than Vincent, better dressed, with agreeable features, who seemed somewhat meek. His face was distorted by grief. He immediately went up to his brother, whom he embraced while speaking to him in their native language. Father left and did not witness their exchange. He only rejoined them that night. After the emotion he experienced upon seeing his brother, Vincent fell into a coma. Theo and my father watched over the wounded man until his death, which occurred at one o'clock in the morning.

It was father who, with Theo, filled out the declaration of death in the town hall the next morning.

Child with Orange. 1890. Canvas. 20⅛ × 19⅝″ (51 × 50 cm). Private Collection.

Our house was in mourning as if for the death of one of our own. The door of the café stayed open, but the shutters were closed. In the afternoon, after he was put in the coffin, the body was brought down into the "artists' room." Tom went to pick greenery to decorate the room, and Theo arranged everything around the canvases that Vincent had left there: *The Church in Auvers, Irises, Daubigny's Garden, Child with an Orange,* etc. At the foot of the coffin they arranged his palette and his brushes. The trestles were lent by our neighbor, M. Levert, the carpenter, whose two-year-old child Vincent had painted in *Child with an Orange.* He also built the coffin.

(*Les Nouvelles Littéraires* published a photograph of our house in Auvers wherein one can see Father, my sister Germaine, the Levert child, and me.)

The burial took place two days after his death, in the afternoon. About twenty artists accompanied the body to the village cemetery. Father assisted, as well as Tom and Martinez and some neighbors who saw M. Vincent every day when he left to paint.

On the way back, Father was accompanied by Theo, Tom, Dr. Gachet and his son, Paul, who may have been about sixteen years old then. They entered the "artists' room" where the coffin had been and where the canvases were exhibited. Theo, wanting to thank those who had taken care of his brother, offered to let them take as a remembrance several canvases by the artist who had just passed away. Father was happy with *my portrait* and that of *The Town Hall of Auvers,* which M. Vincent had given to him whilst alive. When the proposition was put to Dr. Gachet, he chose numerous canvases and gave them to his son, Paul: "Roll them up, Coco," he said, to make a package of them. Then Theo took my sister Germaine to choose a toy: It was a woven wood-chip basket containing a miniature set of iron kitchen utensils. Finally Theo took away his

COLORPLATES 115, 111, 125

Actually, he was buried the following afternoon, July 30.

These canvases were among those included in the impressive 1954 Gachet bequest to the Louvre.

brother's belongings. We never saw him again. A long time after, we learned that he had fallen gravely ill almost immediately after his brother's suicide and that he died several months later. His body was brought back to Auvers, where he was buried next to his brother.

What were the motives for the suicide of Vincent?

Here was Father's opinion: Theo had just had a little boy, and Vincent adored his new nephew. He was afraid that his brother, married and having an added burden, would not be able to support him as he had until then. That is the motive that Theo expressed to Father, and he told him that the last letter written by Vincent was in this vein. The letter that was published is no. 652 in the series of the *Lettres de Vincent à Théo*; was it brought to our knowledge in its entirety? The motive of the suicide is not discernible there.

Of this confidence made by Theo to Father about Vincent's financial straits we find no trace in the letters, which leads me to believe that there exist some lacunae in the publication of his letters. Would the correspondence of Vincent van Gogh pose problems that they wanted to avoid?

Of his amorous disappointments, of the little success of his painting, of his life, we never knew anything, and we would certainly have been unaware of his financial difficulties if Theo had not spoken about it to Father when they were watching over Vincent, since he paid his board regularly.

I have finished my account. I would like for it to be published in its entirety, without modifications to the text. I was interviewed recently by journalists who reported my remarks with more or less fidelity, or who mixed with my statements their own personal evaluations, sometimes, disagreeably, going so far as to distort what I had told them, or who used my memories for ends that, if I had known them, would have made me decline the interview. I am without a doubt the last surviving person who *personally* knew Vincent van Gogh in Auvers, and I am certainly the last living witness to his final days.

Despite the gaps in the late correspondence, Theo's financial worries (equally the sickness of his son and problems at work) were broached—but so as not to alarm Vincent—in letters of June and July (T39, T41).

Daubigny's Garden with Black Cat. 1890. 22 × 40⅛″ (56 × 101.5 cm). Rudolf Staechelin Foundation, Basel.

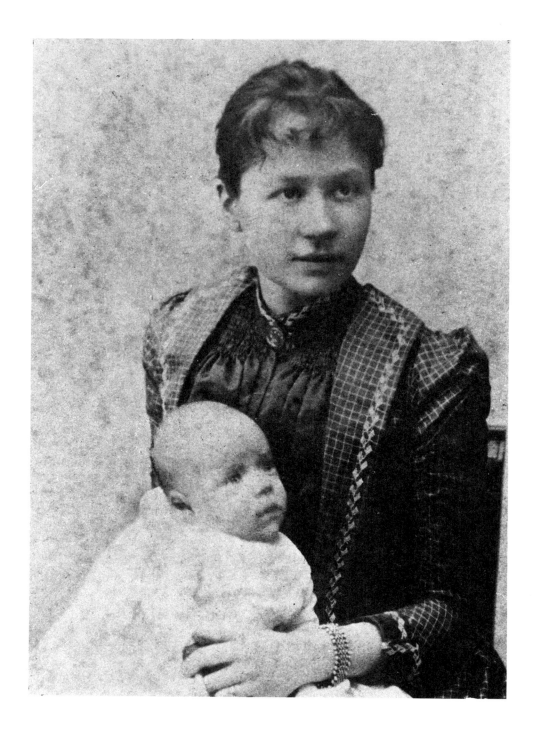

Photograph of Johanna van Gogh with her baby son, Vincent Willem. 1890. Rijksmuseum Vincent van Gogh, Amsterdam.

Thus, it seems to me that my testimony, from which all literary prejudices are excluded, has an essential value for the history of the life of Vincent van Gogh in Auvers, and it could not be confused with the fairy tales that for many years were propagated by we know not whom or for what aim. I add that my testimony cannot be exploited in a valuable way for chronicling the history of Vincent's life at Auvers, except on the condition of respecting, entirely, the tenor of the whole.

It may be that these authentic memories of eyewitnesses run counter to a certain *legend* now being discussed.

But those who first—and the following authors who referred to their statements—wrote the story of Vincent van Gogh's life should admit that it was not until 1953, on the occasion of the centennial of the birth of the great artist, that the press then concerned itself with discovering the one to whom the name *The Woman in Blue* was given. Thus, during sixty-three years no recollections by a first-hand witness of the life of Vincent in Auvers-sur-Oise were sought. One then had to build on some questionable foundations a *legend of the life of Van Gogh at Auvers-sur-Oise.*

In good conscience, I reported what I saw and what I heard from my father, who stayed *alone next* to Vincent the tragic night of 27 July 1890.

The Gachet version of events has more or less held sway over the Van Gogh literature since the publication by V. Doiteau and E. Leroy of La Folie de Van Gogh *(1928).*

I wish to stay absolutely outside of the controversies of the art historians. But I remain persuaded that my account is a document that is useful to conserve and to which it will be necessary to refer when one aims to write a truthful history of Vincent van Gogh's stay in Auvers-sur-Oise.

L'ECHO PONTOISIEN

7 August 1890

AUVERS-SUR-OISE—Sunday, 27 July, one Van Gogh, 37 years of age, Dutch subject, painter, staying in Auvers, shot himself with a revolver in the fields and, being only wounded, returned to his room, where he died two days later.

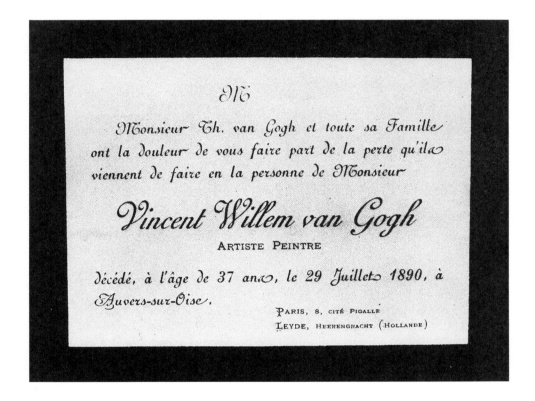

Announcement of Vincent's death sent by Theo to friends. Rijksmuseum Vincent van Gogh, Amsterdam.

Letter from Emile Bernard to G.-Albert Aurier

On Vincent's Burial

1 August 1890

Van Gogh died at 1:30 A.M. on 29 July 1890 and was buried the following day at the Auvers cemetery. Two days later, Bernard wrote this letter to Aurier.

My dear Aurier,

Your absence from Paris must have left you unaware of a dreadful piece of news that, nevertheless, I cannot put off telling you:

Our dear friend Vincent died four days ago.

I imagine that you have already guessed that he killed himself. Indeed, Sunday evening he went into the Auvers countryside, left his easel against a haystack and went and shot himself with a revolver behind the château. From the violence of the impact (the bullet passed under the

Emile Bernard. *Vincent van Gogh's Funeral in 1890*. 1893. Canvas. 28¾ × 36⅝″ (73 × 93 cm). Private Collection.

heart) he fell, but he got up and fell again three times and then returned to the inn where he lived (Ravoux, Place de la Mairie) without saying anything to anyone about his injury. Finally, Monday evening he expired, smoking [the] pipe he had not wanted to put down, and explaining that his suicide was absolutely *calculated* and lucid. Characteristically enough, I was told that he frankly stated his desire to die—"Then it has to be done over again"—when Dr. Gachet told him that he still hoped to save him; but, alas, it was no longer possible. . . .

Yesterday, Wednesday, 30 July, I arrived in Auvers at around ten o'clock. Theodorus van Gogh, his brother, was there with Dr. Gachet, as was Tanguy (he had been there since nine o'clock). Charles Laval accompanied me. The coffin was already closed; I arrived too late to see him again, he who had left me four years ago so full of hopes of every kind. The innkeeper told us all the details of the accident, the impudent visit of the gendarmes, who went to his very bedside to reproach him for an act for which he alone was responsible . . . etc. . . .

On the walls of the room where the body reposed, all his last canvases were nailed, making a kind of halo around him and, because of the lustre of genius that emanated from them, rendering this death even more painful for us artists. On the coffin, a simple white drapery and masses of flowers, the sunflowers that he so loved, yellow dahlias, yellow flowers everywhere. It was his favorite color, if you remember, symbol of the light that he dreamed of finding in hearts as in artworks. Also nearby, his easel, his folding stool, and his brushes had been placed on the floor in front of the casket.

Many people arrived, mostly artists, among whom I recognized Lucien Pissarro and Lauzel, the others unknown to me; there were, as well, people from the area who had known him a little, seen him once or twice, and who loved him, for he was so good, so human.

There we are, gathered around this coffin that conceals a friend in the greatest silence. I look at the studies: a very beautiful episode of the Passion interpreted after Delacroix's *The Virgin and Jesus*. Convicts walking in a circle in a high-ceilinged prison, a canvas after Doré, a symbol of terrible ferocity for his end. For him, was life not this vault, were these not the poor artists, the poor accursed, treading under the whip of Destiny? . . .

In November 1888, Van Gogh had exchanged self-portraits with artist Charles Laval (1862–1894), Gauguin's companion in Martinique and Pont-Aven.

Lauzel: Apparently A.-M. Lauzet (1865–1898), landscape painter and lithographer who, from 1889 to 1890, made reproductions after Monticelli, a project of great interest to Van Gogh; the possibility of collaboration had been broached in early 1890.

At three o'clock the body was raised. Friends carried it to the hearse. A few people in the gathering cried. Theodorus van Gogh, who adored his brother, who had always supported him in his struggle for art and independence, did not stop sobbing painfully. . . .

Outside, there was a fierce sun. We climbed the hill of Auvers talking about him, about the bold thrust he gave to art, the great projects that he was always planning, about the good that he did every one of us.

We arrived at the cemetery, a small, new graveyard dotted with new headstones. It is on the knoll overlooking the crops, under that great blue sky that he would have loved still . . . perhaps.

Then he was lowered into the grave. . . .

Who would not have cried at that moment; that day was too much made for him for us not to imagine that he could still have lived happily. . . .

Dr. Gachet (who is a great lover of art, possesses one of today's fine Impressionist collections and is himself an artist) wanted to say a few words to consecrate Vincent's life, but he, too, wept so much that he could only bid him an extremely confused farewell . . . (the most beautiful). He briefly retraced Vincent's efforts, and pointed out their sublime goal and the immense liking that he had for him (whom he had known only a short time). He was, he said, an honest man and a great artist. He had only two goals: humanity and art. It is the art that he cherished above all else that will ensure that he lives on. . . .

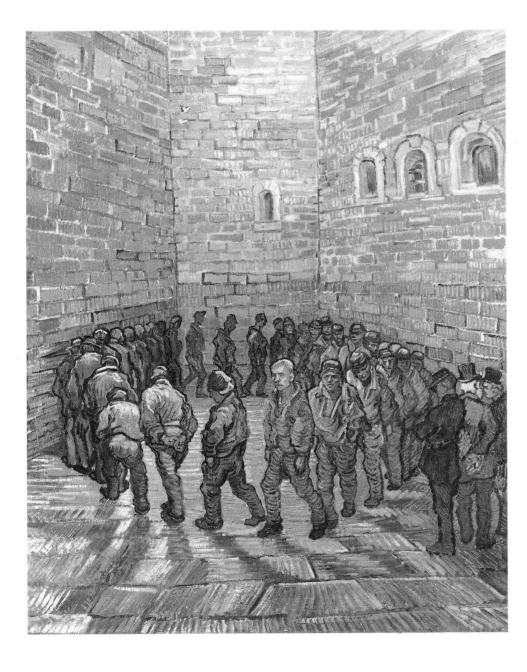

Prisoners' Round (after Gustave Doré). 1890. Canvas. 31½ × 25¼″ (80 × 64 cm). Pushkin State Museum of Fine Arts, Moscow.

Then we went back. Theodorus van Gogh was broken with grief; everyone who assisted retired to the countryside; others returned to the station, very moved.

Laval and I came back to Ravoux's, and we talked about him. . . .

But that's quite enough, my dear Aurier, quite enough, isn't it, about that sad day? You know how much I loved him and you can guess how much I wept for him. So do not forget him and try, you, his critic, to say a few more words about him so that everyone may know that his burial was an apotheosis truly worthy of his great heart and his great talent.

Yours affectionately,
Bernard

Octave Mirbeau

ECHO DE PARIS

"Le Père Tanguy"

30 January 1894

Octave Mirbeau (1848–1917), novelist, critic, amateur painter, and early defender of Impressionism, whose circle of friends included Zola, the Goncourts, Monet, Mallarmé, and Rodin.

"Ah! poor Vincent! What misfortune, M. Mirbeau! What great misfortune! Such a genius! And such a nice boy! Wait, I will show you more of his masterpieces! For there is no denying it, right? They are masterpieces!"

And brave père Tanguy returned from the back of his shop with four or five canvases under his arms and two in each hand and set them up lovingly against the stretchers of the chairs placed more or less around us. As he sought the right natural light for the canvases, he continued to groan:

"Poor Vincent! Are they masterpieces, yes or no? And there are so many! And there are so many! And so beautiful, you see, that when I look at them I get a lump in my throat; I want to cry! We won't see him again, M. Mirbeau, we won't see him again! No, I can't get used to the idea! And M. Gauguin, who loved him so much! It's worse than if he had lost a son!"

He traced in the air with his finger a closed circle, as painters do:

"Look, that sky! That tree! Hasn't he got it? And all that, and all that! What color, what movement! Must a man like that die? I ask you, is it fair? . . . The last time he came here, he was sitting right where you are! Ah! how sad he was! I said to my wife: 'Vincent is too sad. . . . His eye is somewhere else, very far from here. I'm sure there is still something wrong there! He is not cured at all. He is not cured at all!' That poor Vincent! I bet you don't know his *Vase with Gladioli*. It's one of the last paintings that he did. A mar-vel! I have to show it to you! The flowers, you see, no one felt them like him. He felt everything, poor Vincent! He felt too much! It made him want the impossible! I'm going to find the *Vase with Gladioli* for you. M. Pissarro, who looked at it for a long time, and all those gentlemen said, 'Vincent's flowers look like princesses!' Yes, yes, there's some of that! Wait for me just a minute. I'm coming back with the *Gladioli*."

I remember this scene at père Tanguy's, a few days after the tragic, grievous death of Van Gogh, whom the little man familiarly called Vincent, as his friends did. And with an aching heart, I see again, under the blue beret that sheltered him, the face—so fine, so enthusiastic, so decent—of this old man, who was, I firmly believe, the most decent man of his time.

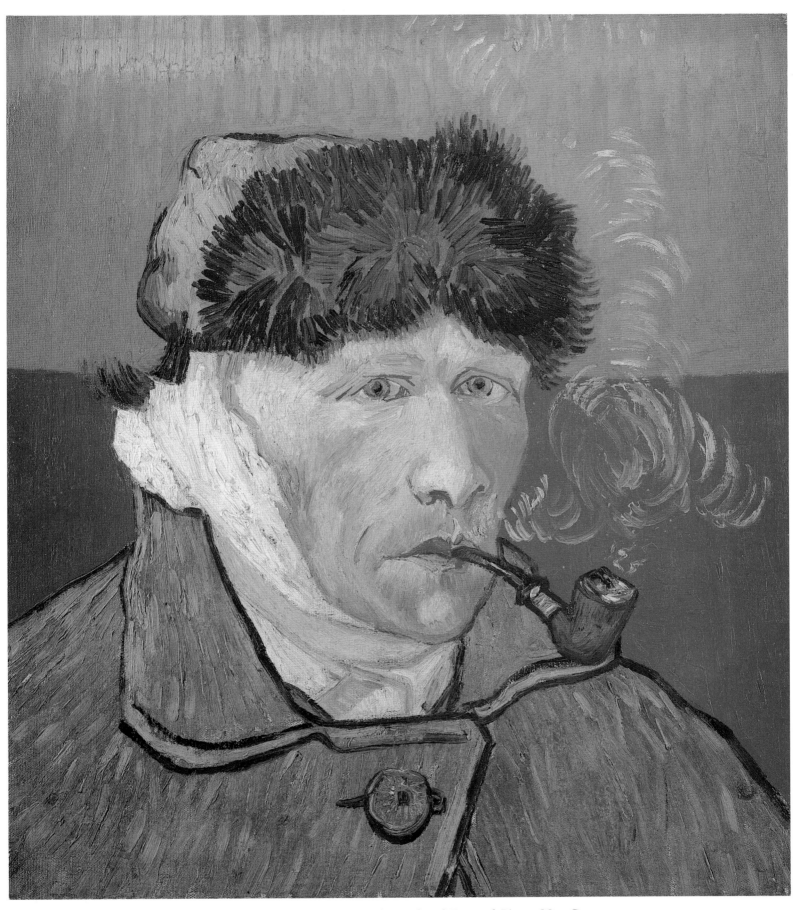

COLORPLATE 79. *Self-Portrait with Bandaged Ear and Pipe.* 1889. Canvas.
20⅛ × 17¾″ (51 × 45 cm). Private Collection.

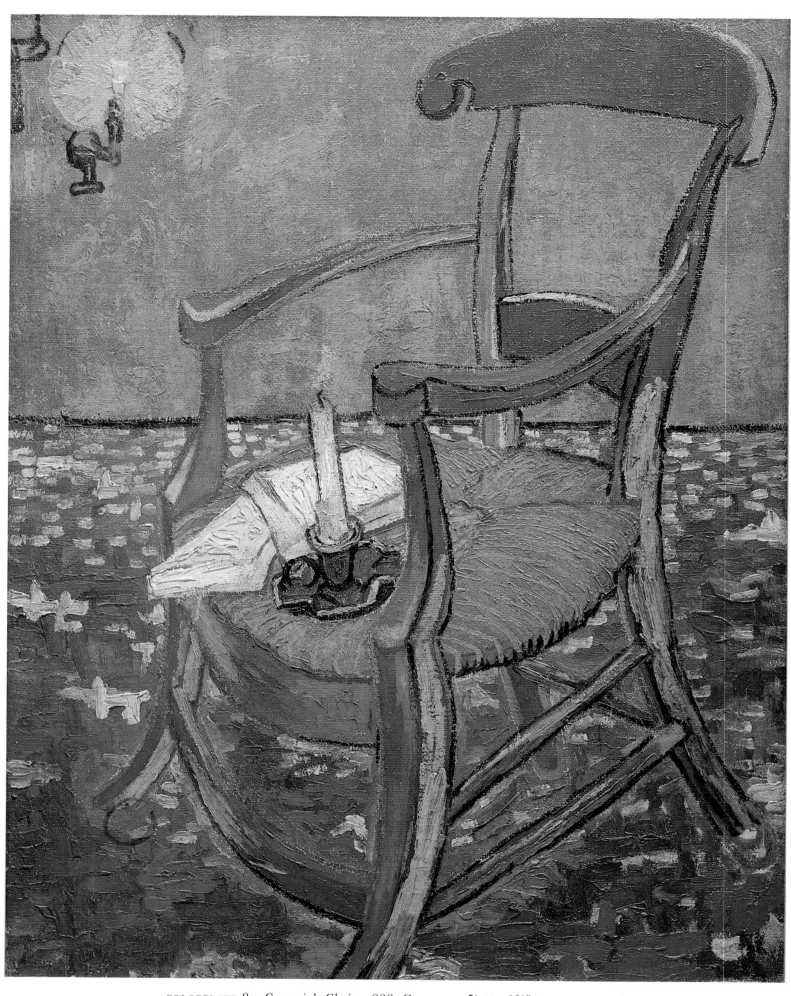

COLORPLATE 80. *Gauguin's Chair*. 1888. Canvas. 35⅞ × 28⅜″ (90.5 × 72 cm).
Rijksmuseum Vincent van Gogh, Amsterdam.

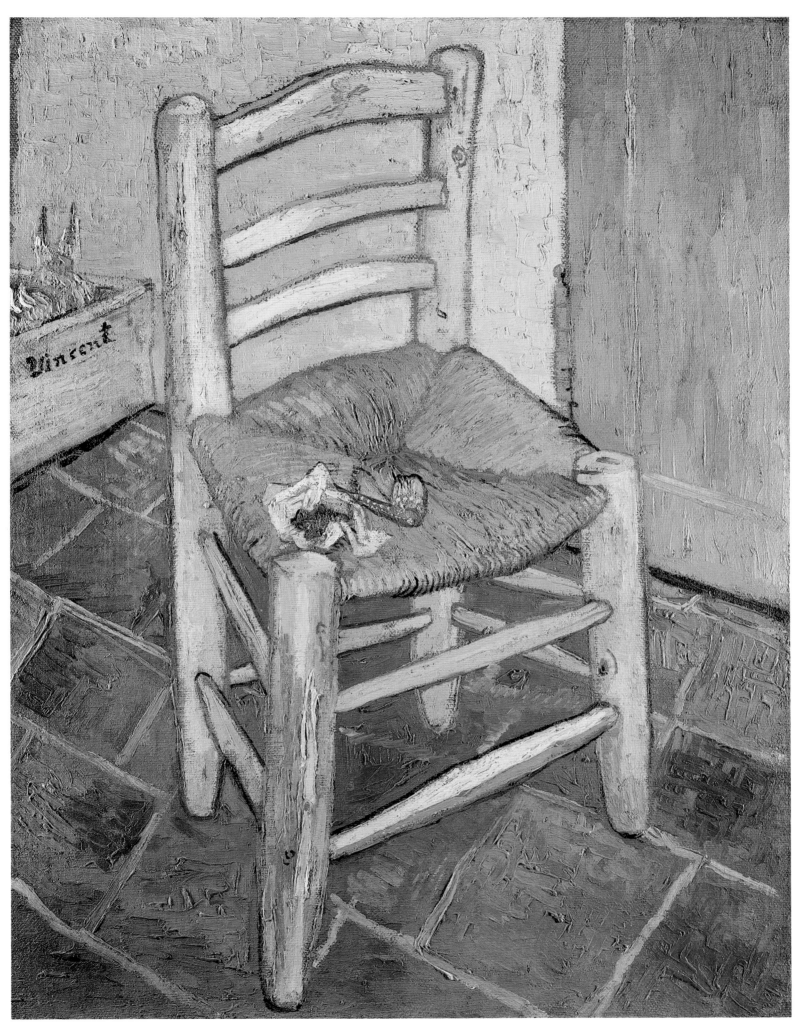

COLORPLATE 81. *Van Gogh's Chair.* 1888. Canvas. 36¼ × 29¾″ (93 × 73 cm).
The National Gallery, London.

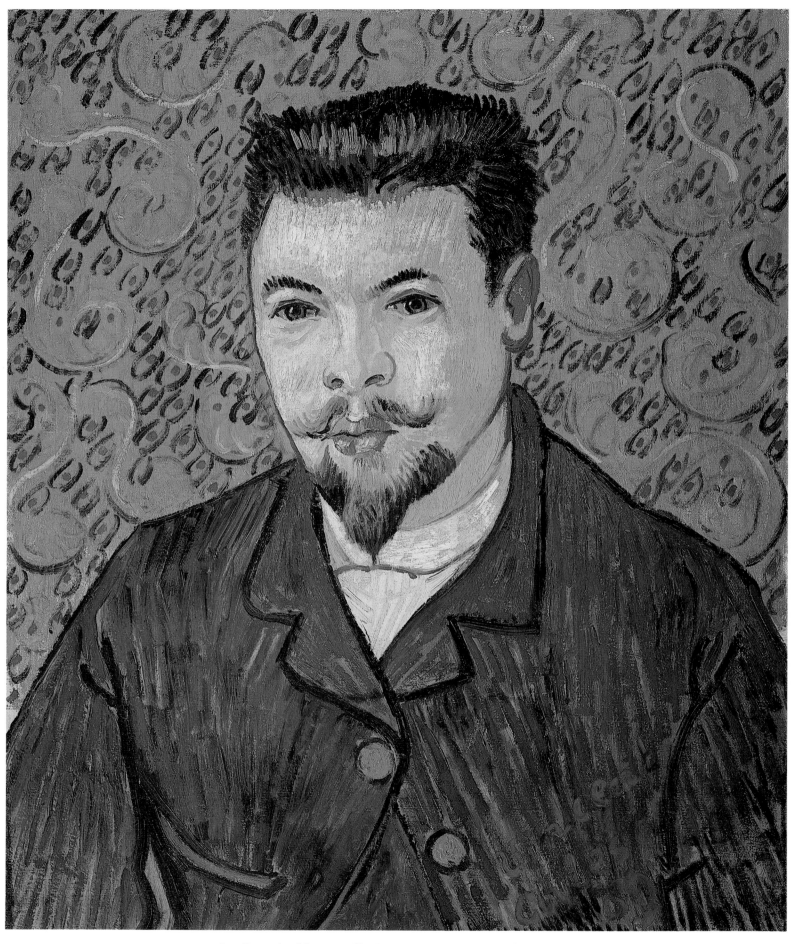

COLORPLATE 82. *Portrait of Doctor Félix Rey.* 1889. Canvas. 25¼ × 20⅞″ (64 × 53 cm).
Pushkin State Museum of Fine Arts, Moscow.

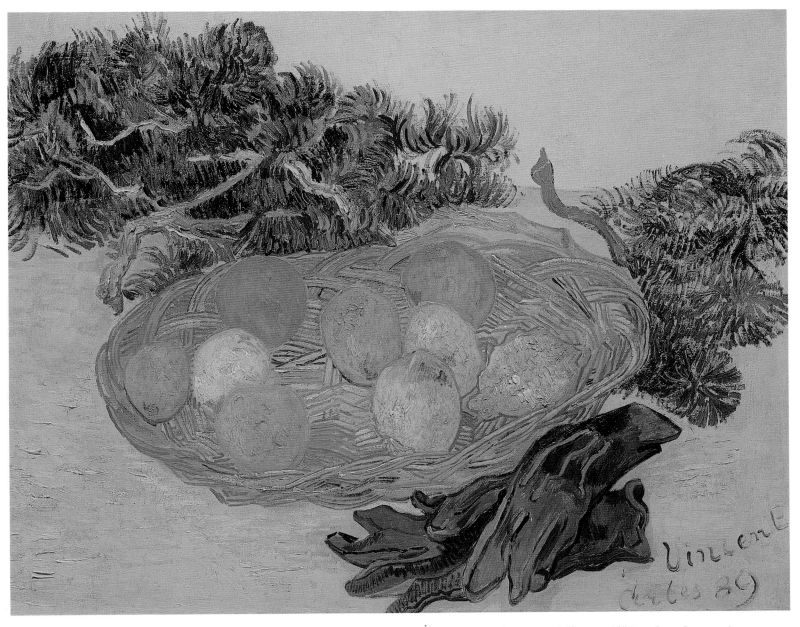

COLORPLATE 83. *Still Life of Oranges and Lemons with Blue Gloves.* 1889. Canvas. 18¾ × 24½″ (47.6 × 62.2 cm).
Collection Mr. and Mrs. Paul Mellon, Upperville, Virginia.

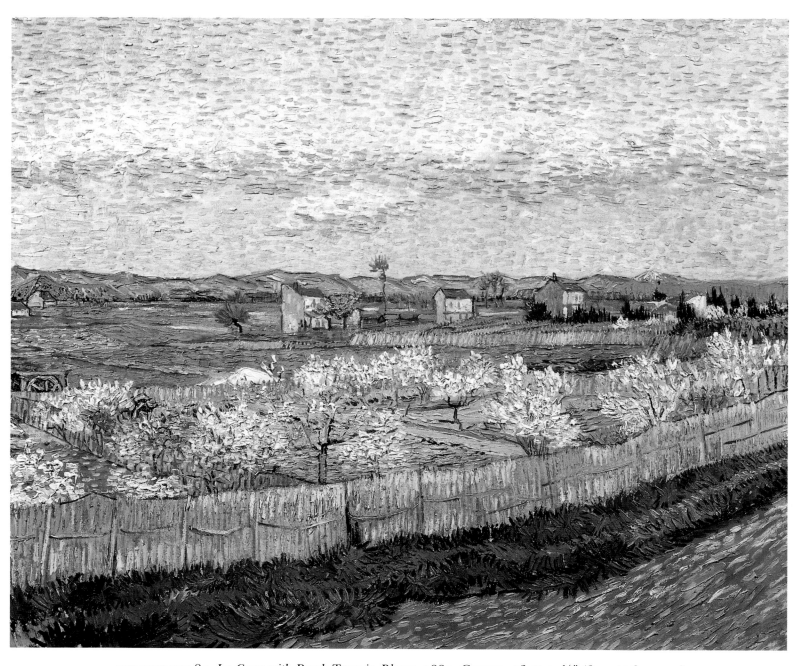

COLORPLATE 84. *La Crau with Peach Trees in Bloom.* 1889. Canvas. 26 × 32¼″ (65.5 × 81.5 cm). Courtauld Institute Galleries, London.

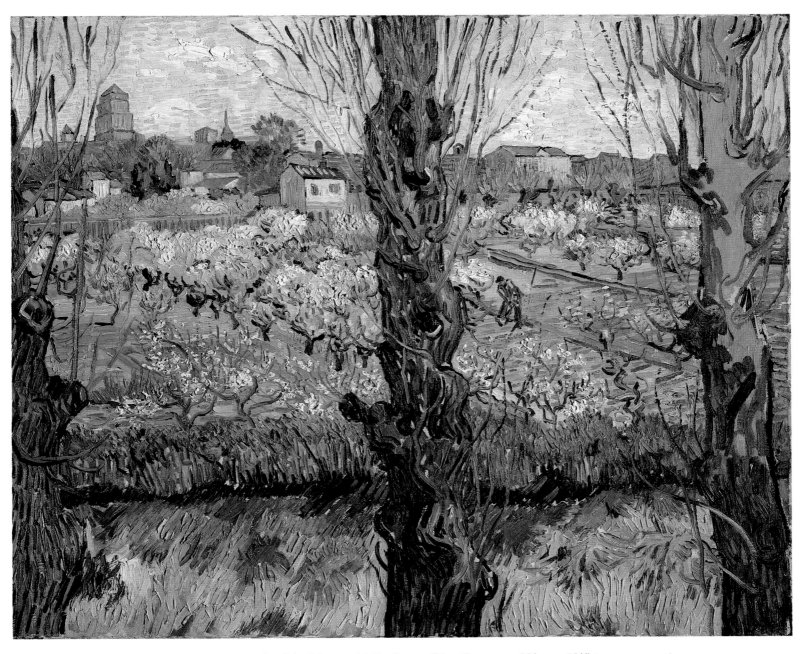

COLORPLATE 85. *Orchard in Bloom with Poplars.* 1889. Canvas. 28⅜ × 36¼″ (72 × 92 cm).
Bayerische Staatsgemäldesammlungen, Munich. Photograph: Artothek.

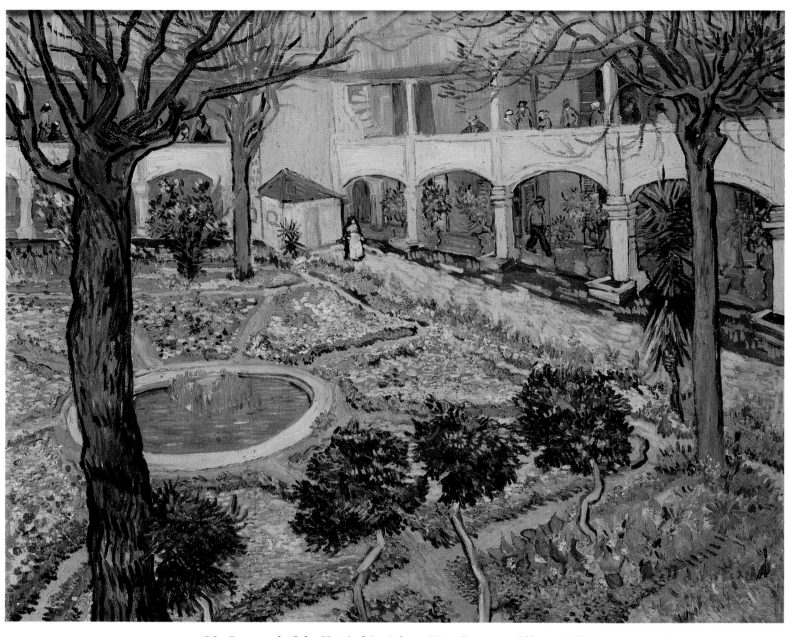

COLORPLATE 86. *Courtyard of the Hospital in Arles.* 1889. Canvas. 28¾ × 36¼″ (73 × 92 cm).
Sammlung Oskar Reinhart "Am Römerholz," Winterthur.

Letter from Gauguin to Theo

On Vincent's Death

ca. 2 August 1890

My dear Van Gogh,

We just received sad news which greatly distresses us. In these circumstances, I don't want to offer you the usual condolences. You know that for me he was a sincere friend, and that he was an *artist*—a rare thing these days. You will continue to see him in his works. As Vincent often said, "Stone will perish, the word will remain." As for me, I will see him with my eyes and with my heart in his works.

Cordially, evr yrs
P. Gauguin

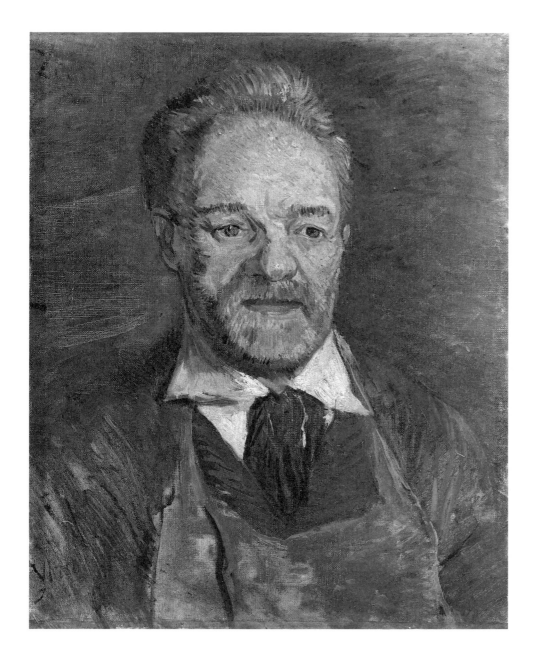

Portrait of Père Tanguy. 1887. Canvas. 18½ × 15⅜″ (47 × 38.5 cm). Ny Carlsberg Glyptotek, Copenhagen.

Letter from Jacob Meyer de Haan to Theo

On Vincent's Death

ca. 2 August 1890

Jacob Isaac Meyer de Haan (1852–1895), Dutch painter who had stayed with Theo from the fall of 1888 to the spring of 1889. His style was greatly influenced by Gauguin in Pont-Aven and Le Pouldu (1889–1890).

Dear Van Gogh,

The tragic news, the death of your dear Brother Vincent, gives me great sorrow: at this moment I feel how much grief this has caused you, you who loved him so very much. Under such circumstances no one is in a position to provide consolation; nevertheless, dear friend, the knowledge that the deceased was an honest man—and yet much more, an Artist of great significance—such things must calm you. He is not dead; he lives for you, for us, and for everyone in the works that he left behind.

I had always hoped to speak to him one day. Likewise to enjoyably work in his company in the manner that I have with Gauguin if the latter had been able to realize his projects of departing for foreign and remote lands.

Likewise Vincent expressed such in one of his last letters to Gauguin.

—however, one can never turn back.

Believe in my total friendship.

Meyer de Haan

Letters from Theo and G.-Albert Aurier

On Posthumous Tributes to Vincent

August – September 1890

THEO TO DR. GACHET, 12 AUGUST 1890

I have been meaning to write to you for several days now, but, probably as a reaction to days of great distress, I have felt so weary that it has been completely impossible.

And yet, it has done me good to be with my mother and to talk with her about my brother, about whom she has told me even more of those little things that make up the story of a man. We also found a packet of letters that he had sent me from 1873 to 1877, of which I read a few, and which touched me once again.

At that time, he was in his period of religious preoccupations and communicated to me what he was going through.

These letters could be enormously useful, if we wished to describe how one becomes a painter and how, once that idea develops, that one cannot but follow the path in that direction.

For the most part they are written in Dutch, but I will translate a few so that you may know their content. In these letters, I have found many curious details of his life in Paris, which I think will interest you as well.

As soon as I return, I intend to call on Durand-Ruel to see if it is possible to hold an exhibition in one of his galleries.

As soon as I returned from Auvers, I had the canvases mounted, so that I can already show them to certain people who might be interested.

Within two weeks of Vincent's death, Theo had single-mindedly initiated plans to ensure his brother's legacy.

I have received numerous tokens of sympathy for my brother's talent, and many tell me that they felt there was something absolutely inspired about him.

My mother has made a special point of asking that on her behalf, I express to you all her feelings of gratitude—which she has difficulty expressing in French herself—for all that you have done for her poor son, with as much devotion, as much affection as if you were a member of our family.

When I recounted to her the sequence of events, and the last day, when the burial took place, she felt quite touched by all your gestures of sympathy towards me.

I join her in telling you yet again that I had never dared hope to find such goodness and friendship.

Believe me, my dear Doctor, that words cannot entirely convey my sentiments, but I will never forget what you have done for me. I don't know what I would have done if I had not had you. My wife also asks me to send you her kind regards. She and the baby are fairly well, but she has not yet regained her strength. She had to stop nursing the baby for lack of milk. Since then, she has been much better.

I must also tell you that it gave my mother immense pleasure to see the drawing you did of our dear Vincent.

Several people who saw it found it admirable.

We plan to return to Paris at the end of this week, and if by chance you were free to dine with us one evening the following week, we would be infinitely pleased.

If you would be so kind as to send a note to set the date, we shall expect you with infinite pleasure.

Please be so kind as to remember me to your family, and accept my feelings of affection and respect. . . .

Theo had married Johanna Bonger (1863–1925) on 17 April 1889; their son, and the artist's namesake, Vincent Willem, was born 31 January 1890.

This letter was written from Amsterdam, where he had gone to comfort his mother.

THEO TO HIS MOTHER AND WIL, 24 AUGUST 1890

Last Monday I have started work immediately and it has done me good, but it took all my time and there were friends in the evening or I was too tired. If that had not been the case you would have heard from me sooner, for my hurried line of last week was of no importance and there still are so many things I have to tell you. In the first place that Durand-Ruel came with me one morning to see Vincent's work, he stayed more than an hour and then had to leave, for he has not yet seen one of his works from Auvers since those are at Tanguy's. What he saw he found very artistic and very remarkable, but he is still hesitating about an exhibition in his gallery as he is afraid that it will start a controversy, particularly amongst the artists and literary people, whether he is either a great artist or not and that the general public, which is unable to understand this, may take sides against him and Durand-Ruel. He suggested himself if I could receive him again next week to see them once more and also look at the other ones. Proofs of friendship and admiration of his talent and character are still coming in. Pissarro is in town and he saw the latest paintings and was full of admiration; he immediately wanted to make an exchange against a painting that pleased him. I don't know if you remember, Wil. A mulberry tree golden yellow in the autumn against a blue sky. Bernard had said to Dries [Bonger] when they went to Paris after the funeral, that he absolutely regarded Vincent as a master. There was also Serret, you know Wil, the one who makes such beautiful little drawings of children. We have one hanging in our drawing room. He was with me at Tanguy's and he was so very much moved when he saw his last work. He spoke nothing but good of it and Serret happens to be someone who looks through people and sees farther than most. I had to tell him everything and he asked me a lot of questions about Dad and Mum to find out where he got such masterly talent and

Apparently Camille Pissarro did acquire this painting; it was recorded in the collection of Mrs. C. Pissarro in 1901.

COLORPLATE 98

Charles Emmanuel Serret (1824–1900), the French artist who as early as 1885 had expressed interest in Van Gogh's works.

genius from. I wish you had heard him speak, it was marvelous to hear him. Then we had Dr. Gachet to dinner last Wednesday. I will send you a letter one of these days which you should read to see something of what he thinks of him. After the funeral he has been ill from emotion, but he was somewhat better then. While he was ill he wrote about Vincent and he will let it appear some time in a magazine. It may be good. Aurier is not home yet. In the latest issue of the *Mercure de France* there has been a short article about Vincent by one of his friends but it is not good. It says much in his favor, that is true, but it belittles his personality and reduces the seriousness of the contents by introducing me into it and now half of it looks like an advertisement by a tradesman. Still, I will send it sometime, but keep it for yourself. Dr. Gachet brought me a sketch in pencil after a portrait of Vincent, which he had made as an exercise for the etching he wanted to make later on, as well as a small drawing of a sunflower. He stayed that evening till twelve and there came no end to his admiration for the things of Vincent I was able to show him. He promised to return in a fortnight or so. . . .

A reference to Julien Leclercq's September 1890 obituary (which appeared in August), reprinted in this volume.

THEO TO G.-ALBERT AURIER, 27 AUGUST 1890

Permit me to thank you for the worthy note you sent me after the death of my brother. You were the first to appreciate him, not only for his great talent for executing paintings, but because you read into his works and saw very exactly *the man*. Several literary men have expressed a desire to write something about him but I have asked them to wait, so that you could speak first, and if you wished to, could write a biography, for which I could furnish you with all the material, one that is entirely authentic, since I have had frequent correspondence with him since '73 and hold numerous interesting documents. I am busy organizing an exhibit, which I would like to hold on Durand-Ruel's premises. He has not decided yet, but I haven't lost hope of obtaining the space.

For this, I would like to provide a catalogue with a short biography; if you wish, we can consider together whether a weightier volume with illustrations and reproductions of certain letters could be done. I would like to talk all this over with you, and I also have a lot of things to show you that you probably don't know of. When you return to Paris, if you would do me the honor of coming one evening, at your convenience, to see me at home, we can talk about these things and about the man, whom I still mourn, even though I would not deny him the rest he deserves after so much struggling. The notice by M. Leclercq, who you no doubt know, has come to my attention; I don't like it very much, because I find it inappropriate to associate the announcement of a momentous death with what is really an advertisement for an art dealer who, here especially, was very out of place. I prefer that all that is done now for Vincent in no way smacks of advertising; you will understand this, I am sure.

Hoping to have the pleasure of seeing you soon, I pray you'll accept, dear M. Aurier, the expression of my feelings of fellowship.

* * *

P.S.: I was not in a state to correspond earlier; otherwise I would not have waited so long to write you. . . .

G.-ALBERT AURIER TO EMILE BERNARD, 27 AUGUST 1890

Thank you for your long and good letter of twenty days ago and for giving me all the details about the death of our poor friend Van Gogh. I have not answered you sooner, first of all, because I am extremely lazy about writing, as you know, and also because of the many short trips that I made in the Châteauroux area.

I have sent a few words on Van Gogh to the *Mercure*. They were in

vain, since Leclercq got there before me and his article was in type by the time mine arrived. Theodorus van Gogh writes me, telling me in his letter of the exhibition of his brother's works that he intends to organize at Durand-Ruel's. He proposes to furnish me with all the documents necessary for a critical-biographical study on Vincent. You know my administration and my love of Van Gogh's works too well for it to be necessary to tell you with what eagerness I accept this very difficult but very lofty task.

How are you getting on? What about your departure for Madagascar? And Gauguin? I have found nothing really useful for the article that we talked about. If it is still timely, I will get it into the next number of the *Mercure*.

Excuse the brevity of this letter; someone is waiting for me.

I will be back in Paris the 2nd. Write me, either here or in Paris, to give me an appointment. I have been anxious to talk to you. . . .

THEO TO DR. GACHET, 12 SEPTEMBER 1890

It seems that it has been too long since I have written you to keep you abreast of what concerns us both.

This is because I do not yet feel completely well; my head spins, and writing anything makes me somewhat dizzy.

My nerves have again taken the upper hand.

I hope with all my heart that you, at least, are entirely recovered.

I have heard from Bernard that he saw you and that you went together to the grave, where there were already sunflowers (I do not need to ask from whom—thank you, thank you!) and where the stone had been set.

He said that the stonecutter's work was well done.

I have promised myself to pay a visit as soon as I can to the little corner where he rests.

As for the exhibition, I saw Durand-Ruel, senior, who came by my house and found the drawings and several paintings "very interesting"; this was his expression. But when I spoke of the exhibition, he told me that the public would hold him forever responsible if anybody were to laugh, so he was postponing his decision until he had seen the canvases at Tanguy's. He promised to come and get me the following week, but he didn't show up.

Later, I saw the son, who told me that he didn't think his father was reluctant and that in the winter he would have no objection to lending the gallery for this purpose.

I hope this can be done, because by permitting these masterpieces to go ignored I would hold myself to blame, nor could I ever forgive myself if I did not do everything in my power to try to bring this about.

I also received a visit from M. Aurier, who came by one evening to discuss the book that has to be done. He appears entirely determined to do a book on the one for whom we still mourn, and M. Manzi told me that he would be happy to etch the plates for it.

I am sending you a proof of the lithograph you like. I am sending it unmounted because if you want to make an etching of it, you might prefer to retrace it on the back so that the etching comes out in the same direction as the original.

Now I must also tell you that I had a visit from Antoine, the actor's brother, who is an editor at *Art et critique* and appears to have some influence there. If you want to publish something on Vincent, as you were intending to do, he says that there would always be a place for it in his paper and he is sure that you could have all the space you might want.

Needless to say, I would be as happy as can be to read what you thought of him in print, and what you already say so well in your letter that I sent to my mother so that she might see the opinion certain peo-

Michel Manzi (1849–1915), editor, engraver, art dealer, and specialist in chromophotography who from the early '80s was the technical director of publications at the Boussod & Valadon gallery.

An artist as well, Paul Gachet exhibited his paintings, drawings, and prints under the pseudonym, Paul van Ryssel.

Jules Antoine's 1891 review in La Plume, *reprinted in this volume. At the invitation of his brother, André-Leonard Antoine, Van Gogh works were hung in the Théâtre-Libre in late 1887.*

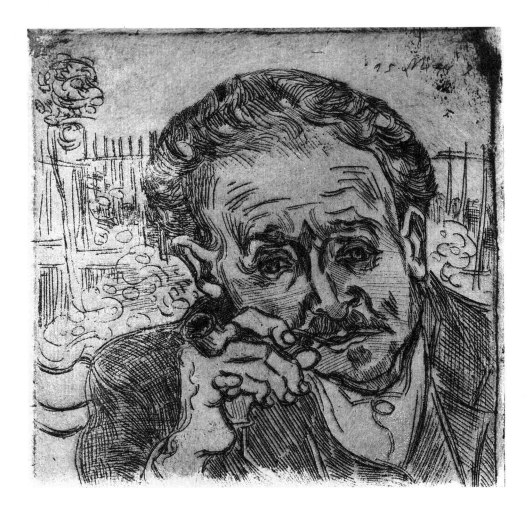

ple hold of him. If you have continued your study of him, you really mustn't leave it in a drawer, where only a privileged few would know of it.

Which seems preferable to you, the exhibition at Durand-Ruel's, if one were able to obtain it, [or] a separate gallery in the Pavillon de la Ville de Paris at the time of the Indépendants exhibition?

Signac suggested the latter idea and said that it would not be impossible to obtain it, since it is almost certain that they will do so for Dubois-Pillet.

I would be so glad to be able to chat with you again; you would give us great pleasure if, as soon as you are able, you would come for a simple dinner and we had another evening to chat of almost nothing but Vincent.

My wife has already reproached me several times for letting you wait too long for news, and she sends her best regards.

Please be so good as to remember me to everyone at home, and believe in my sincerest friendship. . . .

Signac organized, for the Indépendants exhibition of 20 March to 27 April 1891, a retrospective of works by Van Gogh and Albert Dubois-Pillet (1846–1890), a Neo-Impressionist who had died in August 1890. He also offered to assist with plans for a February 1891 Van Gogh retrospective with Les Vingt in Brussels.

THEO TO EMILE BERNARD, 18 SEPTEMBER 1890

It might seem audacious to you that I so bluntly ask you a favor, but it has little to do with me and a lot to do with Vincent. You know that when he was still alive we decided to move in order to show his paintings more comfortably. We have just now moved; but the quantity of paintings is overwhelming. I haven't been able to arrange them together so as to give a coherent sense of his *oeuvre*. When I saw in Auvers how capable you were at such arranging, I had already gotten the idea of asking you for your help when the time came to organize an exhibition. Because Durand-Ruel has absolutely refused to exhibit, for the moment I can only try to hang as many as I can at home so that they are on view for whoever shows the desire to become acquainted with my brother's work. In short,

Apparently Bernard had assisted Theo in hanging Vincent's canvases at the time of the funeral.

could you please give me a hand? You know that, unfortunately, I have hardly any time during the week and you don't have any time on Sundays.

Next week, I have an appointment with a foreigner to whom I must try to sell some awful paintings. So, how is Saturday for you? I could continue to hang paintings on my own on Sunday once we have established a definite plan.

I'll try to come for at least part of Saturday to agree on the general effect. As soon as you get this letter, please send me a note so I can know what to expect. If you agree, we should begin at, say, nine in the morning.

I could then go to the gallery once in the morning and once in the afternoon. I hope that I won't be interrupting you from any interesting work in which, perhaps, you're very involved.

I'm counting on you.

A hearty handshake. Count me your devoted friend. . . .

THEO TO WIL, 27 SEPTEMBER 1890

Bernard has been here on Sunday and the days following to help with the hanging of pictures in our house and he has made a fine job of it, so that those who are interested may already see a number of them until sooner or later it will be possible to have an exhibition. Durand-Ruel had more or less promised to spare a gallery, but when I heard no more about it and looked him up he said that he saw no profit in it for him and so could not agree. There are other possible arrangements but let us be glad that, while we wait, I am able to show a good many in this way. I sold two of them for 300 frs., payable in installments, to an artist in whose place many will see them. We thought it would be a good thing that there were some of them in circulation and so make people talk about him. Bernard has also painted the glass doors of our drawing room as if they were a medieval church window. A shepherd with his flock. It goes very well with the room full of pictures. I wish you could see it all, you would enjoy it and see that, contrary to what Mr. Beanbourg says (I will send you his article), that it does not express a sick mind, but all the ardor and all the humanity of a great man. He is wrong in many respects, as you will note for yourself. I do hope we will succeed in arranging an exhibition, for that will speak more clearly than all this talk, but it will not be easy from the financial side. Just think that the frames will be at least 10 frs. each and then there is the catalogue and the cost of the personnel that will certainly be needed, but many will help me and when I want to there will be people here and there who will be prepared to contribute. . . .

Beanbourg: Likely a reference to the critic, Maurice Beaubourg, who wrote an obituary on Van Gogh in La Revue indépendante *of January 1891, which appears in this volume.*

Emile Bernard

LETTRES DE VINCENT VAN GOGH À EMILE BERNARD

Preface

1911

I answered Theo's letter affirmatively and went to his home on Saturday. The hanging was completed in no time. He left everything up to me.

That is, Theo's letter of 18 September.

When it was finished, the rooms gave the impression of a series of galleries in a museum, because I'd not left a single empty space on the walls. I had taken great care to follow an idea that Vincent had often mentioned in his letters: to make one painting sing by placing it next to another; to place a color scale of yellow next to a scale of blue, a scale of green next to a red, etc. . . . There was the green *Berceuse*, which shone between the yellow and orange sunflowers like a village madonna between two gold candelabra. When everything was done, in order to block out the houses across the street and to create some intimacy in the gallery dedicated to the memory of my friend, I transformed the window into a stained-glass and painted a sylvan picture in the essence of *The Sower*, *The Shepherd*, and *Haystacks*, to summarize the rural affinities of Van Gogh.

But, alas! This repository was not up for long. We had hardly finished it when Theodorus, heartbroken over his brother's suicide, lost his reason and was struck down, paralyzed. The most assiduous care was given to him, but to no avail. He was taken to Holland, where he died six months later.

I had not given up on making Vincent known. Friends and artists

COLORPLATES 59, 60, 61

The exhibition review by Johan de Meester, who had known the Van Gogh brothers in Paris in 1886, is reprinted in this volume.

Following his breakdown, Theo died 25 January 1891.

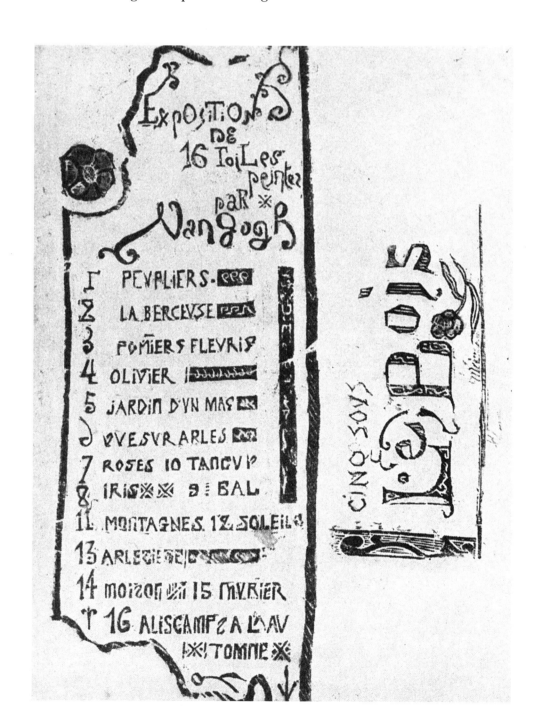

Emile Bernard. Catalog for the Van Gogh retrospective at Le Barc de Boutteville. April 1892. Woodcut.

whom I took to Pigalle, to brother Theo's apartment, recognized his merits as colorist, his originality, his passion, his painter's ardent nature. I took some photographs, which I distributed by subscription.

Mme. Van Gogh, in her haste to take her husband to Holland, had to abandon the Paris apartment.

She soon asked that all of the paintings be sent to her. I assumed the responsibility of supervising their packing. Because of feelings one could easily understand, she didn't want to return to France, to Paris, to the place where the cruelest tragedy had happened.

She retreated to Bussum, near Amsterdam, and opened a boarding-house. "It's a nice house," she wrote to me then, "where baby, the paintings, and myself will be better accommodated than in our Paris apartment where we, nonetheless, felt so at home and where I spent the happiest days of my life. Therefore, you shouldn't fear that the paintings are going to be put in the attic, or in dark cupboards. They'll decorate the whole house, and I hope that you'll come to Holland sometime to see what care I've taken of them." Mme. Van Gogh wanted very much to execute her husband's project; she pursued the idea of doing an exhibition of works by Vincent. To this effect, she gave me six hundred francs, but at the time the galleries were few and very expensive. I could afford nothing with this sum. I decided to do an exhibition at no expense at Lebarcq de Boutteville's, who at that time was my friend and was also showing my paintings. As nearly everything had been taken back to Holland and only Tanguy, the color merchant on rue Clauzel, still had some paintings, I managed an exhibition of Vincent's works at Boutteville's, who was willing to lend me his gallery for a month for this purpose. In rough wood, I myself engraved the catalogue, which included fourteen sizable pieces.

What surprised me the most at the time was Paul Gauguin's attitude. He was a friend of the Van Goghs and had received many favors from them. He owed them his daily existence and, furthermore, he had been introduced to the collectors of Boussod & Valadon (today, Manzi-Joyant) by Theodorus.

* * *

In recognition of all the Van Goghs' frequent acts of generosity, Gauguin, having been informed by me of my project to show Vincent's works, immediately sent the painter de Haan, a Dutchman with whom he was living in Pouldu and who was his student and servant, to Paris to prevent the exhibition I was preparing there. He wrote to me saying that it was not at all good politics to exhibit the works of a madman and that I was going to jeopardize everything through such a thoughtless act, for him, myself, and our friends the Synthetists. Naturally I didn't in the least want to give in to his opinions; his intentions offended me, and I accomplished my project, which, besides, had no repercussions. Albert Aurier, whom I had introduced to Gauguin in the past, didn't say a word in the *Mercure*, caught up as he was with the gnome, de Haan. Julien Leclercq was equally quiet. I had written to Octave Mirbeau, who answered me:

> I wholeheartedly join with you in this exhibition. When should I send the painting? Count on my doing all that I can in the press. I'll even write Magnard today. But there is such resistance in those circles. Please accept my sincere regards.
>
> Octave Mirbeau

Did Octave Mirbeau keep his promises? I never knew anything of it. I withdrew the canvases at the end of the month, with no other satisfaction than to have performed the duty of a friend.

Letter of 9 April 1891 from Johanna van Gogh-Bonger to Emile Bernard is among three letters she wrote to Bernard reprinted in "Emile Bernard et Vincent van Gogh," Art-Documents 17, 1952.

Sixteen canvases were included in the April 1892 retrospective at Le Barc de Boutteville gallery in Paris.

Gauguin's reply to Bernard is reprinted below.

Letter from Gauguin to Emile Bernard

On Van Gogh's Legacy

January 1891

I just received one [a letter] from Sérusier telling me that you're organizing an exhibition of Vincent. How awkward!

You know that I like Vincent's art—but considering the public's stupidity, it's completely out of place to remember Vincent and his madness when his brother is in the same situation! Many people say that our painting is madness. That does us harm without doing any good to Vincent, etc. . . .

Anyway, go ahead—but it's IDIOTIC.

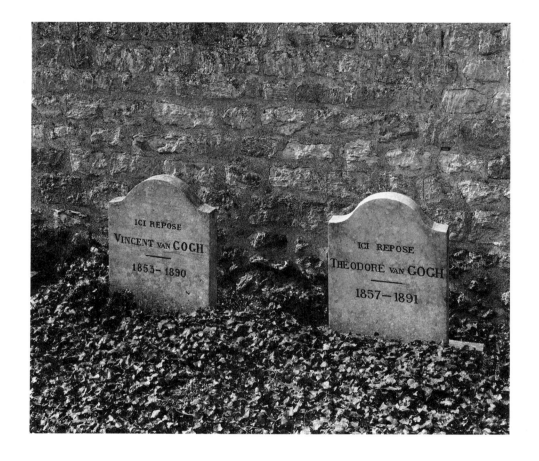

Tombstones of Vincent and Theo at Auvers. Rijksmuseum Vincent van Gogh, Amsterdam.

Julien Leclercq

MERCURE DE FRANCE

"Vincent van Gogh"

September 1890

Vincent Willem van Gogh died last July 29 in Auvers-sur-Oise where he had been working for several weeks after a two-year stay in Provence. He was thirty-seven years old.

One hasn't forgotten the article (*Mercure de France*, no. 1) of our friend and collaborator, G.-Albert Aurier, on the art of this Dutchman of brilliant color. Soon an exhibition of the principal works of the painter will open; perhaps he will have the moment of celebrity that is owed to him—posthumously, alas!—before joining the ranks of the rare daring and personal artists of the end of the century. We must add that this exhibition will take place through the initiative of M. Th. van Gogh, the qualified expert of the Boussod & Valadon gallery, the subtle connoisseur who did his brother's talent complete justice by providing him with the means to dedicate himself entirely to his art. May we be pardoned for this indiscretion: an artist's family, the epitome and synthesis of the general public, so often slights the artist who graces that family, unless he is apotheosized (?) by the Prix de Rome or the critical praises of M. Albert Wolff.

Vincent van Gogh's paintings can be seen at M. Tanguy's, 14, rue Clauzel.

Just prior to writing this obituary, Leclercq, during Van Gogh's last visit to Paris in July 1890, met the artist at Aurier's home.

The promise of official recognition went to Ecole de Beaux-Arts students who received the Prix de Rome or to those who won praise from conservative critic (and arch-enemy of Impressionism), Albert Wolff (1834–1891).

Frederik van Eeden

DE NIEUWE GIDS

"Vincent van Gogh"

1 December 1890

Frederik van Eeden (1860–1932), Dutch poet and writer, whom Van Gogh had read, was also a practicing psychiatrist of Amsterdam who attended to Theo in Paris in the fall of 1890. De Nieuwe Gids was a Dutch journal he founded and edited.

Neither art criticism, nor critical opinion—only an impression, a personal observation—perhaps important because it concerns the work of a brilliant but virtually unknown Dutch artist who died a few months ago.

I venture to write about Van Gogh because I believe that even someone who is not a painter can experience his art very purely. Perhaps even more purely and strongly than painters themselves, because they are more likely than others to become annoyed by his disregard of many things which they practice in earnest.

It will be quite difficult for Van Gogh to become highly regarded, for the esteemed public laughs at him now, as they do at every new and original artistic phenomenon; and the great painters, although they recognize his seriousness and genius, shrug their shoulders at his work, as something sickly, something forced, something unsuccessful.

Myself, however, in need of being enlightened about superior painting and still seeking the way, am so forcefully and directly moved by the work of Van Gogh, as is entirely unusual for me. Perhaps it signifies something. To me finesse of execution and of tonality are less important than they are for people of the trade. I question only what I find to be beautiful and continue to find beautiful. I found his work beautiful, indeed so beautiful. And that remains so, despite many objections from those who are better able to understand it than I.

Thus the competent authorities might regard this appreciation as a curiosity. Yet does it not often happen that great painters, when they are somewhat unsure, summon one or another simple soul and ask, "Now say what you think of it, but honestly!" Surely that helps them sometimes.

Van Gogh worked only briefly in Holland. I found nothing of particular note in a few watercolors from this period, in a style somewhat like Mauve. However, a large piece in oil, a peasant interior, drab and ugly in color, struck me as something extraordinary owing to the strong expression of the figures which were almost Japanese in character.

COLORPLATE 13

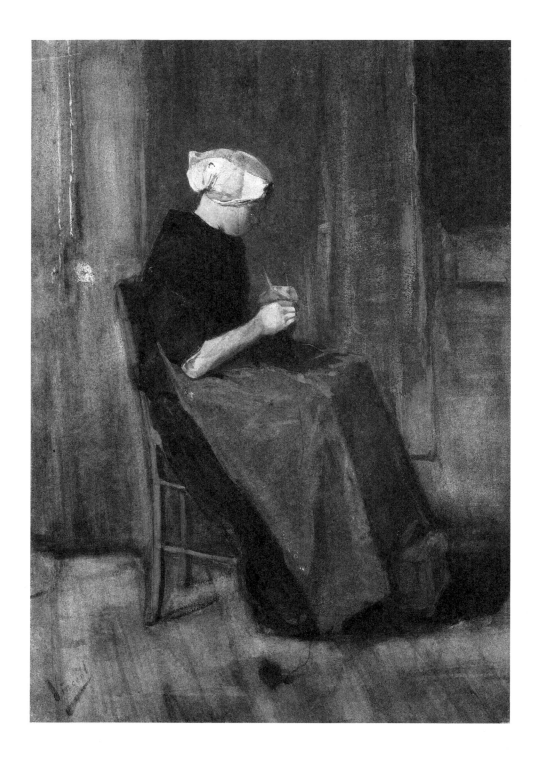

Scheveningen Woman Knitting (with Mauve's retouchings). 1881. Watercolor. 20⅛ × 13¾″ (51 × 35 cm). Collection Leber Katz Partners, New York.

In France, however, Van Gogh set out to educate himself in the school of Indépendants, to which the greatest French artists belong: Degas, Pissarro, Raffaëlli, Monet.

While Van Gogh's work can best be compared with Monet's, I never saw anything important by him. And I doubt from what I have seen of Pissarro, Degas, and Raffaëlli that they could ever give me the impression of beauty. Sometimes I sense the excellence of the work, without appreciating anything of the intentions behind it, but sometimes I do not sense even *that*—so that I might be persuaded to consider child's work as highly artistic, in accordance with others who are better able to judge.

And to test my immunity to the very modern, as regards a known Dutch artist: I failed to admire the famous watercolors of Isaäc Israëls at the exhibition in 1889. I did indeed sense what was unusual and forceful about them, but the sensitivity of execution and color and the beauty of the subject eluded me. Israëls could not teach me to see beauty where he saw it and I did not.

How it happens now that the work of Vincent van Gogh immedi-

ately seized me, with a spontaneity and intensity that surprised even my-self—so that I am hardly able to clear the after images of his works from my mind, so that I see his colors in objects everywhere around me, so that I am surprisingly able to see beauty where I never saw beauty before—that I do not understand. He is still, however, no less modern and surely no less Dutch. Perhaps he is less refined, less subtle, than the other modernists. One of our best critics assured me that Van Gogh is a rhetorician. Perhaps in my case it is like the second-rank reader of verses who is not moved strongly enough by poetry without a little rhetoric and therefore prefers Byron to Shelley.

Vincent—he signed his paintings with this name alone—Vincent uses strong, vivid colors. Not the subdued, finely nuanced, tonal colors of the best contemporary Dutch artists, not the delicate gray, the tempered ultramarine, the soft yellow ochers, but violent, sparkling, loud green, pure vermillion, intense purple, strong cobalt blue, and above all, yellow, fierce yellow, brutal chrome yellow—canvases full of only gleaming, violent, ruthless, yellow.

I always had a passion for such usages, but before I saw Vincent's work, I did not know the full extent of my passion. This tendency toward bright colors is a primitive tendency but, perhaps at the same time, also an expression of refinement. All southern and Asiatic peoples use more vibrant colors than we do. But our Flemish and North Netherlandic primitives of the fourteenth and fifteenth centuries also produced brightly colored paintings, and even earlier the Dutch people knew how to select brilliant colors in superb harmony for clothing and household effects.

It is generally thought, I believe, that brilliant colors cannot be as beautiful as subdued or mixed colors. It is felt that a refined and highly developed taste will dismiss bright coloration as crude and childish. However, the colorfulness of Van Eyck was not crude, and the brightness of Japanese drawings and watercolors was hardly childlike. At the Paris exhibition, there was nothing produced by the modern European art industry that could compare with the colorful ornaments, vases, and clothing from Tunis, Morocco, Algiers, Persia, India, Indo-China, and Japan.

"The Dutch painters lack courage," Van Gogh said, "they do not dare to use genuine colors on their canvases."

But courage is not sufficient in my opinion. Indeed, the Dutch peasants can still be seen wearing green and purple dresses. These are usually described as "screeching colors," and they surely produce a fearfully ugly scream. Our people have lost the ability to clothe themselves with pure colors.

That it takes courage to use such colors proves that to use them is inherently difficult and dangerous. Whoever fails to use them well produces something quite ugly, something much worse than a poorly executed painting in mixed, subdued colors.

I found that Van Gogh did so brutally and very beautifully. This was a special, added pleasure, like hearing someone who is able to sing very loudly without hitting a false note. We must first overcome a certain timidity, since it is thought that loud singing must always be either ugly or affected. But if it goes well and we overcome our shyness, we can then take pleasure in the loud noise. Thus I take pleasure in these bold, vivid colors.

Van Gogh exaggerates quite strongly. Sometimes he paints blood-red trees, grass-green skies, and saffron-yellow faces. I had never seen such things, but I understood him nevertheless. Later, after having seen his paintings, I began to see his colors in things, just as he had seen in them the color-essence that he had extracted from them. There is green in an evening sky, while there is purple in the field below. He painted these two things in sharply contrasting greens and purples and it was beauti-

The Paris World's Fair of 1889, which was highlighted by the engineering feat of the Eiffel Tower.

ful. It was beautiful because it was just right. That is, he had chosen the right color-idea, which had made it beautiful in reality, and he extracted it purely and combined it in a beautiful contrast. He had sharpened the harmony of colors but preserved their true integrity. Must one today demand of an artist that he make his work resemble reality as much as possible? Rather, that he express as strongly as possible the beauty of reality, or of *his* reality, his inner life. As for me, less directly susceptible to the beauty of subtle nuances, for me this crude, strongly accentuated raw expression of color produced a very strong, direct effect of beauty.

Impressions of several of his works are preserved intact in my memory, and they still often give me pleasure in remembrance.

A young apricot sapling, simply that. It stands in the center of the painting; that is the entire theme. The trunk extends upright from just below the center of the frame; the crown fills the upper half of the work. From the trunk—smooth, erect, carefully painted in bands of brown and gray—the crown symmetrically extends its young, supple branches, unfolding a mass of large, pink blossoms—full, as when young trees bloom for the first time. The background, which is dark, extends far and high, practically to the upper edge. There, a little green bush, indicated only by the stem along the upper frame; and some cottages, quite small with exquisite red roofs; and bathed in lovely dots of pale, cobalt blue light. But all of that is seen behind the small tree, through the tree and beyond. It does not disturb the naive splendor of the lovely young thing, standing out courageously in its first bloom. There is nothing disruptive in the foreground, which is quiet and submissive before the shining pale red of the large blossoms. The large pink jewels on the crown of the tree, proudly and righteously borne on the young trunk, become all the more beautiful against the distant blue-white specks of the sky.

And this is a single blossoming tree. He also painted large canvases of orchards of blooming almond and pear and apple trees. They appear as great clouds of tree blossoms, sometimes pink in a transparent blue atmosphere, sometimes brightly lit in the glow of the sun, yellow and green, golden yellow, and greenish yellow, fully sparkling.

These are happy, exaltedly happy, paintings. But there are also those that are more solemn, moody and naive. Unique, childlike portraits of the painter's good friends, those simple folk with whom he lived, landed gentry and villagers from the south of France. In this manner, two little

Van Gogh painted two versions of Two Children *in Auvers in 1890; one is in the Musée d'Orsay, Paris; the other, described here, is in a private collection.*

Sketch of a proposed orchard triptych. Letter to Theo. Ca. 13 April 1888 (477). Rijksmuseum Vincent van Gogh, Amsterdam.

children with large, pale heads sitting next to each other, somewhat timid, yet in response to being painted, nicely smiling. It resembles a tapestry in the way the flat colors are set against one another in strange, awkward lines that pattern their blue smocks, the small white bonnet, pale red-orange hair of one child, and the sallow little faces with blond eyelashes. A house serves as backdrop, but it is devoid of atmosphere, completely flat, in a fresco tone.

Most of his work, however, is somber and wistful and painful to view. A landscape in the rain is oppressive in its dismal anguish. A dreary violet landscape of hills, rising high so that only a small segment of gray rainy sky—empty, infinitely sinister in its bare, deadly lines—and over which is laid streaming rain and white streaming rays, gleaming against the dark land, blackish gray against the light, everything killed in despair.

COLORPLATE 122

And then a long, horizontal painting. A field of grain in strong, dark yellow. The yellow stalks of grain sway savagely against one another; they are ruggedly and crudely painted, filling the entire length of the piece, more than half its height. And above this stark, somber yellow, a heavy dark blue sky of a terrible, deathly blackish blue. A flock of large pitchblack birds flutters on high in the dark blue from out of the tempest of yellow grain. This, to me, was a violent expression of the utmost desperation.

COLORPLATE 124

Next to it as though he then slept and dreamt of his childhood: another field of grain on a canvas of a similar size, but this one still retains the green of youth and quiet of a sunlit summer morning. On the long canvas nothing but the stillness of upward grown stalks in rows, in a hazy, sunlit atmosphere, therein a skylark, and in the foreground, warm sundrenched ground.

And his olive trees! Indeed, four or five works devoted to single olive trees. Who else has so relentlessly pursued and so passionately expressed the intense despair of those somber trees! Oh, the wistful olives, the wretched trees of Gethsemene wrought with pain! He let them stand in solemn mourning against the pallid rocky hills—poor, powerless scattered leaves, bleak in the dry, merciless sunlight fall from the black, knotted twigs atop desolate, short trunks to the barren ground below. And above this pallid, harsh green, shimmering somberness, he then placed a light, splendidly translucent amaranth, of a pure, clear, emerald green, like deep water—with fine gold on the horizon, as the unattainable salvation above hopeless suffering.

Yes, now one will say—the painters will say—that I have drawn comparisons that do not exist, that I have succeeded in making associations that have nothing whatsoever to do with painting. Perhaps. But I am quite certain that such things were so intended. I know that I have understood him insofar as what he wanted to express, and that I considered it beautiful. If others should now disagree, because, in their view, he has not expressed himself well, I still feel justified in stating my views, and I am pleased for having done so. Largely this is because if the public ridicules him and other painters disregard him as a painter, then who will do him justice?

I do not consider art to be as important as the artist, and on occasion, do not pay close attention to whether someone avails himself of paint or words or musical notes. And if there is now someone who is neither, properly speaking, a painter nor rightly something else, but who clearly lets me observe that there is something very powerful and beautiful stirring within him, then for my part I am often content.

Vincent constantly sought, but he never discovered. He always said this himself. Yet he was capable of so much that he understood not only what he sought but how lofty such pursuits were.

And moreover: he undertook such pursuits as no more than two or three in our country have done before—with a passionate zeal, alone, without holding back or stopping, without the slightest regard for what

others would say or think, or for what would happen to his work or to himself. I must express my innate admiration for such thoughts and actions. Is it not a miracle that this appears again and again in our time, in our misty land that is maligned as common and narrow-minded? And was he not one of the noble and immortal race that the masses ridicule but that the truly human among us would call saints?

Johan de Meester

ALGEMEEN HANDELSBLAD

"Vincent van Gogh"

31 December 1890

Johan de Meester (1860–1931), Dutch critic, novelist, and journalist (Paris correspondent for the Amsterdam paper Algemeen Handelsblad, *then editor of* Nieuwe Rotterdamsche Courant) *met the Van Gogh brothers in 1886.*

During these cold, short Christmas days, while the crowds took pleasure in crowding around the motley displays of the stalls on the boulevard, there were some Dutchmen assembled in the somber little rooms of a temporarily uninhabited apartment in Montmartre, and there they admired a few hundred paintings. Sad emotions interfered with their enthusiasm; the art treasures, which lay and stood together here in the cheerless, cold room were the legacy of an artist, dead too early, whose younger brother, in consequence of that loss, was himself by now seriously ill and, transported to his fatherland in hopes of recovery, entrusted to the good care of others the great relics that were so beloved by him. May the sick one quickly recover, if it be only to protect the work of Vincent van Gogh as well as only his love could do!

This exhibition, organized by Theo and Bernard, was held at the end of 1890 in Theo's vacant Montmartre apartment.

Vincent van Gogh unexpectedly died at the end of the summer. Thirty-seven years old, he painted for ten years; the usual period of preparatory *training*. He did more than train in those too-few artistic years! From an artistic family, just as his brother, he had earlier worked in the trade with the firm of Goupil. Applying himself with feverish zeal to all sorts of studies, to various types of work, until he, later than most painters, began to draw and paint. It can be understood almost literally that from that moment on he never rested. We have about 350 canvases by him! Canvases mostly of a meter or more in surface.

Among the canvases is, I believe, not one single Salon piece, and laymen as well as qualified art critics probably should not find much among Van Gogh's bequest which they would think worthy of calling a finished painting. But who could deny that those splendid, passionate, in turn grippingly brutal and fervently delicate, tender drawings, those hard-to-ripen expressions are of an artistic spirit that is as violent as it is sensitive, as naive as it is rich? Vincent van Gogh appears to have been someone of a constitution similar to that of Claude in *L'Oeuvre*, a spirit powerful of deeds, but powerless, and facing a too-highly placed aspiration, a true child of his nervous time and an important subject for the passionate pathologists, who in contrast venture so little in the analysis of genius! . . . In an excellent article from the newspaper *Mercure de France*, he was placed among "les isolés." He was one of the poets who stands "above feeling" and apart from people, but who feels all the better from and for the people, and stands all the nearer to the splendid revelation of nature. His love of art was a religion, a fanatical worship, and a self-sacrifice.

A reference to Aurier's January 1890 article, reprinted in this volume.

The public who so readily listen to the talk about the idleness and revelry of artists should be able to learn something from the life story of Vincent van Gogh; from his poverty, without their having to suffer from

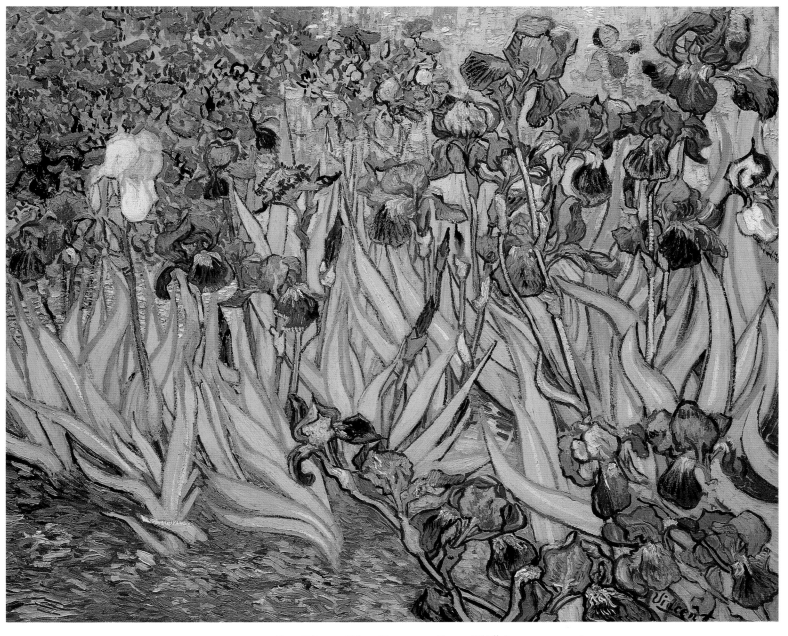

COLORPLATE 87. *Irises.* 1889. Canvas. 28 × 36⅝″ (71 × 93 cm).
Collection of the J. Paul Getty Museum, Malibu, California.

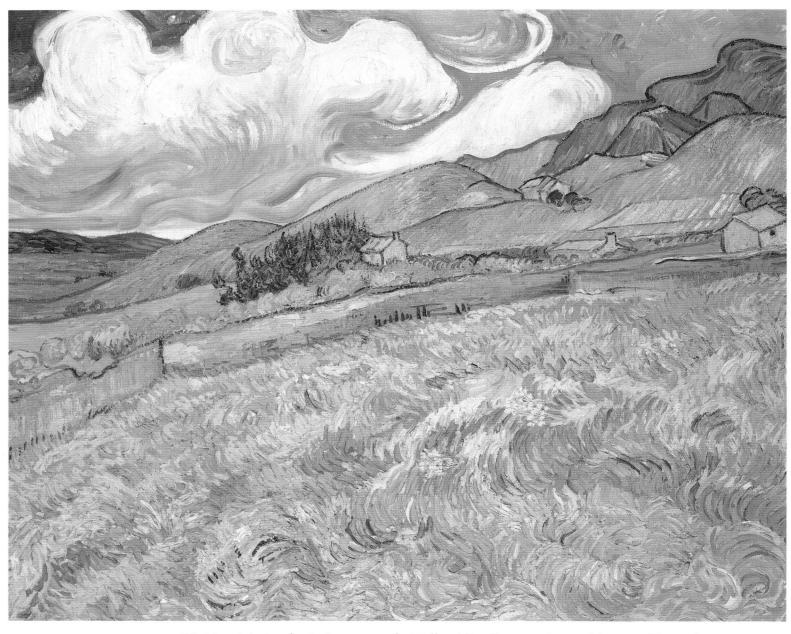

COLORPLATE 88. *Mountain Landscape Seen across the Walls.* 1889. Canvas. 28 × 35″ (70.5 × 88.5 cm).
Ny Carlsberg Glyptotek, Copenhagen.

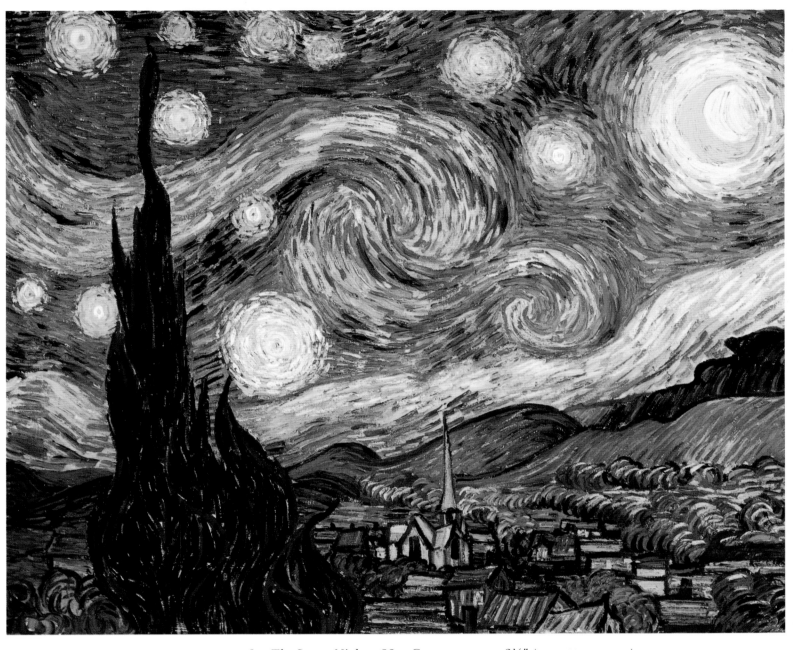

COLORPLATE 89. *The Starry Night.* 1889. Canvas. 29 × 36¼" (73.7 × 92.1 cm).
The Museum of Modern Art, New York; Acquired through the Lillie P. Bliss Bequest.

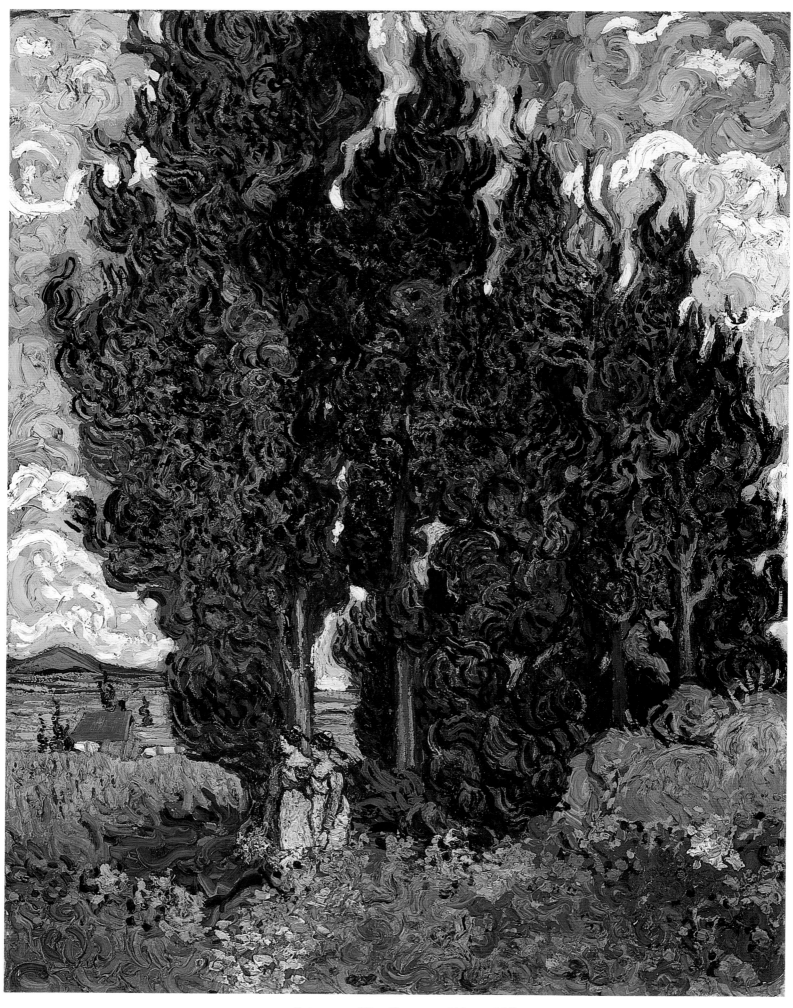

COLORPLATE 90. *Cypresses.* 1889. Canvas. 36¼ × 28¾″ (92 × 73 cm).
Rijksmuseum Kröller-Müller, Otterlo.

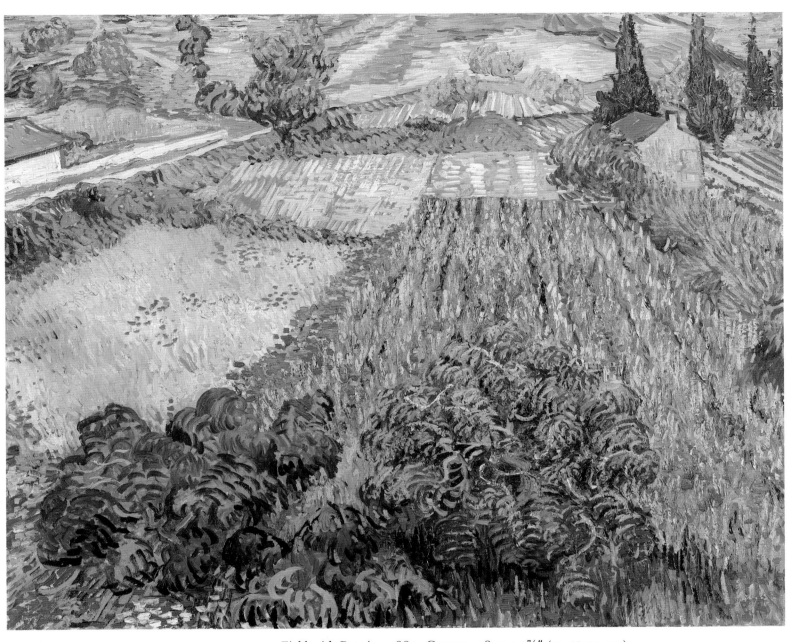

COLORPLATE 91. *Field with Poppies.* 1889. Canvas. 28 × 35⅞″ (71 × 91 cm).
Kunsthalle Bremen.

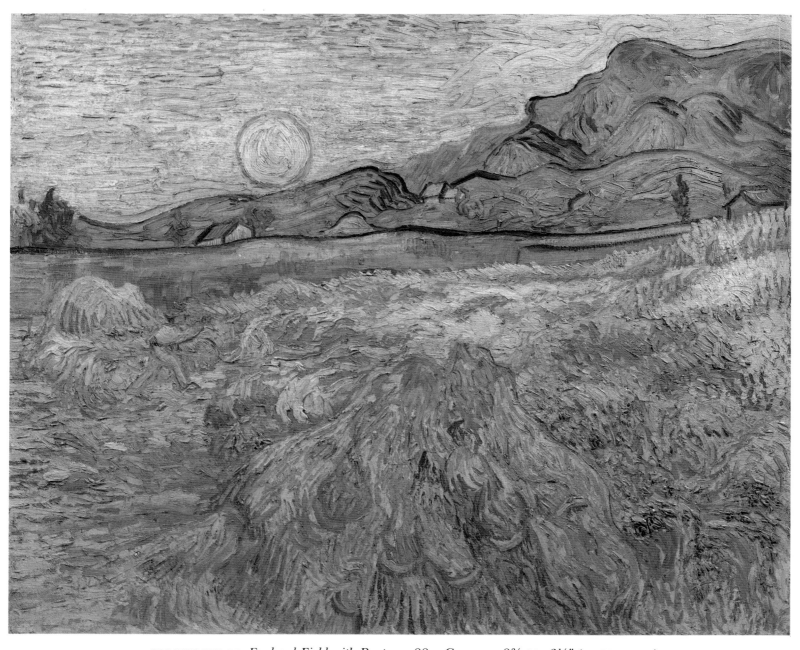

COLORPLATE 92. *Enclosed Field with Reaper.* 1889. Canvas. 28⅜ × 36¼″ (72 × 92 cm).
Rijksmuseum Kröller-Müller, Otterlo.

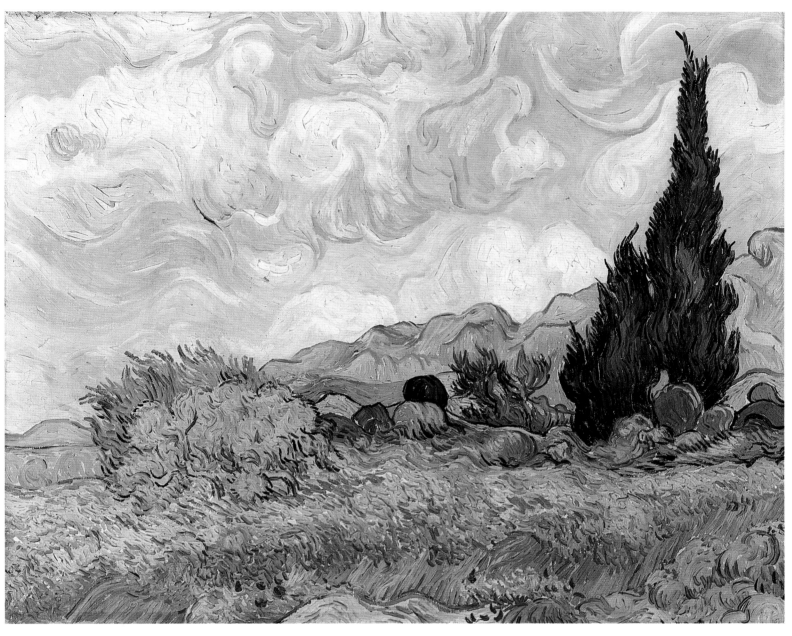

COLORPLATE 93. *Wheat Field with Cypresses.* 1889. Canvas. 28¾ × 36¼″ (72.5 × 91.5 cm).
The National Gallery, London.

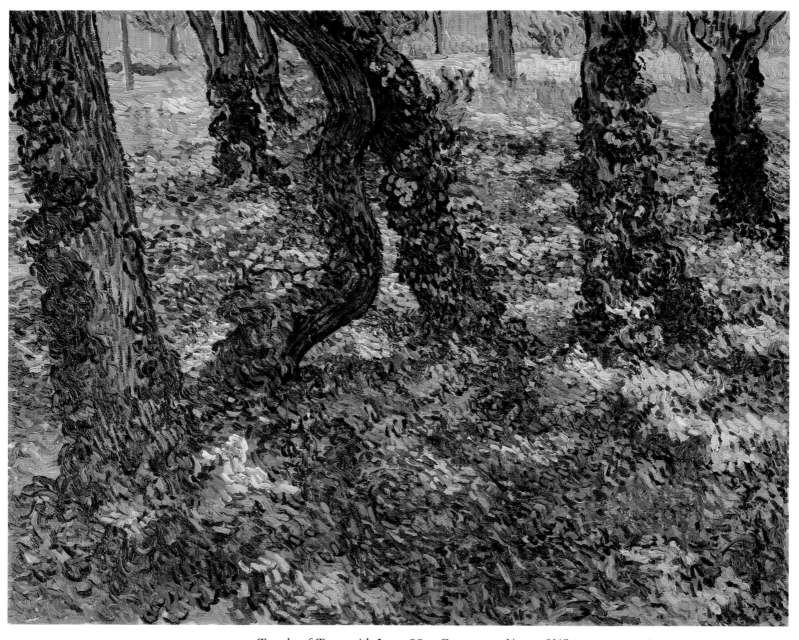

COLORPLATE 94. *Trunks of Trees with Ivy.* 1889. Canvas. 29⅛ × 36¼″ (74 × 92 cm).
Rijksmuseum Vincent van Gogh, Amsterdam.

it; from his life as a day-laborer; from his work on summer mornings at three or four o'clock till late at night, the whole day in the sunny field with some bread and a bottle of water; from the winters in his studio with no other luxury than the fresh flowers that he painted with so much love. In all his portraits, one sees him in a blue workman's jacket and with the pipe that was his only delicacy. The money that he saved, after the expense of the many panels, etc., he spent on drawings and prints, of which he left behind an essentially important collection. A second legacy for the faithful brother, who always had the satisfaction of being able to take care, materially, of the big child that this artist was.

Vincent van Gogh, as a painter, was entirely self-formed. He worked for a long time in The Hague, where Mauve among others attended to him; and he set out in Paris to study in an artist's studio. But foremost, as he was alone, alone with his nature, he could make progress, he could satisfy his enormous creative urge.

This not only anti-academic but insufficient training, this lack of quiet study, naturally left an impression on his work that, in comparison to the refined contemporary Dutch art, has something very primitive and, partly, something raw about it.

Van Gogh's first work still bears the Dutch stamp; there are heath pictures, with somberly dreamy outlines of sheep pens, which have the intimate poetry of truly national painting. Interiors with figures were obviously inspired by Jozef Israëls. But leaving aside the faultiness of technique, the figures already have something singular about them: they are sharper in outline and in conception, and the somber colors which now and then appear to have been obtained with peat are not beautiful and somber but powerful.

Having gone from the Netherlands to Paris, he made some fine, somewhat gray views of Montmartre and street corners from the neighborhood of his beloved *Moulin*, but scarcely was he in the sunny South when he let his temperament run free. That work is always meant realistically; the colors are never idealized, nor is the least truth sacrificed for the achievement of harmony, but how really romantic the entirety often is. One great, free canvas: dark, golden-yellow grain, through which a pink path meanders with difficulty, heaves, heavy and fat, until reaching the long horizon of darkest blue—and over the field they spread themselves, like claws, great dark birds. Indeed, the piece makes one think of a drawing by the young Victor Hugo! There is no doubt that Van Gogh intended to create a symbol: this canvas is called *The Desolation of the Fields*. Also in that desire to express an idea, he stands apart from the new Dutch painters, who more and more try to be exclusively painters, i.e., colorists. It appears that Van Gogh genuinely believed himself to be a prophet, a reformer, and was captivated not only by beautiful color and light effects, but also by grand ideas about elevating and, above all, propagating art. He was a confirmed democrat (also in his color), and he wanted art to be more for the general public. Because of that, he consciously imbued his drawings and the composition of his canvases with the greatest naiveté, but the colors, judged and chosen solely according to their underlying value, would probably be difficult for the public to understand; those who, after all, like to see things as they are, distinctly observed, and who do not believe in the effect of light and air and the surroundings on color. The public will not hear of blue trees and of an orange sandy path (in strong sunlight). Van Gogh's room at the house of a farmer in Provence, with an orange bedstead, golden-yellow chairs, harsh blue wallpaper, purple chimney, green table, and brick-red floor, would perhaps be no more pleasing to the public in spite of the clear attempt to make them as simple as possible, almost childishly simple, with emphatic outlines and in colors that make one think of a penny-print. But colors that are true and work excellently in juxtaposition always remain art; what appears as raw and deters you in the be-

COLORPLATE 124

Despite his lack of artistic training, Victor Hugo (1802–1885), the great Romantic writer, produced a substantial graphic oeuvre typified by fantastic landscapes and storm-tossed seas.

COLORPLATES 74, 73

ginning will be recognized and admired for the strong sense of underlying value relationships that speak from Van Gogh's colors.

One day later, as a matter of fact, he painted flowers, so fine in their scintillation, that one thinks of the lovely art of Japan. Blooming orchards and blooming fields were his lust and his life: he made them with the strongest sun of the South; he made them under pouring rain; he made them as seen from close-up—single, low little stems or, if need be, only the stubble on a blooming field of grass—or as seen from afar with the use of perspective that he always handled with particular love and in which he, the *self-made* artist, proved himself an excellent draftsman.

His work from the field is staggering; he was in the habit of painting not small studies but the whole canvas since he wanted to paint in such a way that would be directly from nature. Often he also copied—but in a singular way. In his enthusiasm for Millet, he painted freely after a number of his canvases; that is to say, he took a similar though not identical subject and strove as much as possible for the same feeling, while still preserving his own color. Also he appeared to be passionate about Holbein; a few heads of children and women carry in their beloved tautness and naiveté the traces of that veneration. He essentially put

The Daughter of Jacob Meyer (after Holbein). 1881. Pen and pencil. 16½ × 11¾″ (42 × 30 cm). Rijksmuseum Kröller-Müller, Otterlo.

himself into his colors; though remaining true to himself, he was a follower of the theories of the French moderns, of Monet, Pissarro, and the like. As a Dutchman, he stands apart; that in Provence he fell immediately under the influence of glowing colors and effects of sunlight, after his dark pieces from North Brabant, argues for the lively receptivity and eager willingness of his artistic nature.

Last year, there were to be seen here, in an exhibition of young Frenchmen, a few canvases by Vincent van Gogh. Now there shall be a few sent to the exhibition of Les Vingt in Brussels.

It is to be wished that the fatherland as well will have the opportunity to see the singular art of Van Gogh and make acquaintance with this talent that did not reach its full growth, and perhaps never would reach it, but that—does one explain the other?—was uncommonly rich and strove for the heights.

De Meester elaborates on a number of these ideas in the March 1891 study on Van Gogh reprinted in this volume.

Letters from Johan de Meester and Andries Bonger

Reactions to De Meester's "Vincent van Gogh"

December 1890–January 1891

JOHAN DE MEESTER TO ANDRIES BONGER, LATE DECEMBER 1890

Here is the little article that I published in the *Handelsblad*. I hope that you will find in it the tone of affection and admiration that I wanted to convey in complete simplicity. Excuse me if it seems to you that I accentuated one interesting aspect of my friend—more than you would have done—the side that interested me the most as a pessimistic psychologist; the impression that *The Desolation of the Fields* made upon me was so strong that I needed to cry triumphantly to this joyous world: Here is an artist of your materialistic and joyous epoch who is capable of compassion for the desolation of existence.

De Meester had sent a copy of his December 1890 article to Theo's wife, Johanna, and brother-in-law, Andries Bonger.

COLORPLATE 124

ANDRIES BONGER TO JOHAN DE MEESTER, 31 DECEMBER 1890

In what do we disagree? The whole business is summed up at the end of your letter: that I did not wish to extend the comparison between Vincent and Claude to its furthest consequences, as you have done. The reason is that you and I have entirèly different opinions about Claude. You see in Claude a *failure*; as for myself, I see in Claude *the man who will always be a failure* if he has the pride, the presumption, the beauty, but also the stupidity, to attempt the sublime. I have not considered Vincent "a sick man," as Zola seems, too much, to regard Claude. In my opinion, this is the flaw of Zola's novel, which is magnificent drama of an artist's aspirations, given complete significance in the ending, in the observations of the two friends (Bompard [sic] and Sandoz) over the grave—clearly stated in the following: "the mania of modern pathologists for seeking to dissect genius." You know that the Italians (Lombroso, e.g.) consider genius and madness to be brother and sister; that is also what *L'Oeuvre* set out to prove, but Zola only succeeded in part. What Shakespeare set out to say with Hamlet, Zola said with Claude.

Cesare Lombroso (1835–1909), nineteenth-century social theorist; his The Man of Genius *(1890) examines the relationship between genius and mental illness, devoting a section to epilepsy.*

What both said, and therefore what Hamlet and Claude represent, I believe I have felt in that wheat field that made me tremble, so much did I feel in it the audacious man who feels himself a Titan, who is a child of God, an embryo of six or seven months, it is true, but a child of God, who becomes angry with his Father because his Father does not want to recognize him. But go say that in the *Handelsblad*. Van Gogh—what you write me further confirms my opinion—was not a patient painter, a colorist, content to explore beautiful colorings; he was a fanatic, much more a poet filled with aspirations than an agitated artist. And the latter is, as I myself perceive *L'Oeuvre*, Claude the sublime. You see that you were preaching to the converted. Lapidoth has promised me the *Nieuwe Gids*, where apparently Van Eeden has said that Vincent was not, fundamentally, a painter, but that he, Van Eeden, found that this was most beautiful.

COLORPLATE 124

Frits Lapidoth, Dutch critic and Paris correspondent for Die Nederlandsche Spectator, *wrote the review of the 1892 Le Barc de Boutteville exhibition reprinted in this volume.*

Reference to Van Eeden's tribute to Van Gogh, reprinted in this volume.

ANDRIES BONGER TO JOHANNA VAN GOGH-BONGER, 8 JANUARY 1891

Your sortie against De Meester's article is affected. . . . There is nothing in this article that could pain you or that could rouse anyone's indignation. If I could have presumed what he would write, I would have prevented him. I find the article affectionate, full of nonsense and contradictions. He is in error when he entitles the wheat field with crows *The Desolation of the Fields*, but his comparison with a drawing by V. Hugo is apt. Instead of criticizing that, you would have better proved that you understood Vincent if you had found the comparison between Vincent and Claude absurd. I have written a long letter to De Meester on the subject, and I have shown him that there it makes no sense whatever. He asked permission to publish my letter, but I refused because it is pointless to do so. The article is of too little interest to be contradicted, and no one paid any attention to it.

COLORPLATE 124

Maurice Beaubourg

LA REVUE INDÉPENDANTE
"The Deaths of Dubois-Pillet and Vincent van Gogh"

January 1891

Maurice Beaubourg (b. 1866), French critic, novelist, and playwright.

Two artists of nearly opposite temperaments and of distinctively different methods—though united by a common ideal, *independence in matters of art*—have just passed away almost one after the other.

One could recently read on the last page of *Le Temps* a note from Le Puy, reprinted by most of the other papers, in which it was announced "that a certain M. Dubois-Pillet, Chief of Police in this prefecture and painter—Pointillist—just died."

A few days earlier, a few intimates accompanied to the Auvers cemetery a young man, taken in particularly sorrowful circumstances, who was still little known except by rare critics or art lovers (aside from M. Albert Aurier, I don't know anyone who ever spoke of him), M. Vincent van Gogh.

* * *

In the retrospective at the 1891 Indépendants exhibition, Dubois-Pillet, the Neo-Impressionist artist who had helped found the Societé des Artistes Indépendants (1884) and who had died three weeks after Van Gogh, was represented by 64 works; Van Gogh, only ten.

M. Vincent van Gogh, in contrast to M. Dubois-Pillet, was a passionate rather than a calm man, intuitive rather than scientific, and in his works he was never able to limit himself to being tachistic or pointillistic, to belonging to one school in preference to another, or even to painting one day with the methods he used the day before.

One thing only is characteristic of his talent: *impasto*. But he uses it the way he uses everything else: *when it pleases him to do so*.

A stunning colorist, he seems hypnotized and maddened by the splendor of the hues that he depicts; furiously and feverishly rushing toward the realization of each of his paintings with the frenzy of a drunken soldier who throws himself without a thought into the fray.

One must not see only one painting by M. Vincent van Gogh—one must see them all to understand his complex and restless nature, the temperament of a visionary, smitten both by Sun and by Universal Goodness, dreaming concurrently of phalansterian organizations and of orgies of molten, golden tones, wherein all of creation would be consumed in flames. Thus, an exhibition of his works—at present scattered here and there—at his brother's and at M. Tanguy's, the dealer on the rue Clauzel, now seems to me to be called for.

A curious thing: This eccentric artist was born in Amsterdam [sic], the classic land of little domestic interiors, where there are just so many panes in each window, so many tiles on the ground. His father—toward whom he demonstrated from his youth an almost excessive affection (the influence of his father was such that, for quite a time, he imitated and copied him in everything)—was a simple Protestant pastor, who, although he may have shaped him from the religious and social point of view, must have had a negligible influence on his vocation as an artist.

Actually, Van Gogh was born in Groot-Zundert, in North Brabant.

I picture him as very wise and very cold, trying to turn his son away from the difficult path of painting, which leads nowhere since photographs or chromolithographs suffice for daily consumption. Yet nothing was to stop him, and the young man, who manifested very personal gifts, ignored the advice.

His debut was with a mass of small studies—vividly and furiously dashed off with strokes of his palette knife and strokes of his thumb, almost punches—with which he adorned the walls of the restaurants and brasseries that he frequented. M. Seurat met him in one of those popular soup-kitchens on avenue Clichy, now closed. A large hall, glassed-in and crowded with tables, was decorated with his canvases (1887).

In another café, also closed, the Tambourin, boulevard de Clichy, other canvases were left as pledges to the proprietor.

Already he ranked among the isolated, among the misunderstood and solitary artists, outside of any school or tradition, in the manner of that wonderful Paul Gauguin, who, at least, is finally near a much sought-after success with his exotic paintings, so strange and so ardent, those unforgettable bas-reliefs,

> *Be loving,*
> *And you will be happy!*

The new concepts, at once humanitarian and poetic (as I have said, Vincent van Gogh loved, simultaneously, Goodness and the Sun), besieged every day his overstimulated brain. There were, at every moment, new inspirations.

"He had cherished the idea," writes M. Aurier, "of inventing a very simple, popular, almost childlike sort of painting capable of moving humble folk, who do not seek refinement, and of being understood by the most naive in spirit." And yet, almost at the same time, he was achieving veritable symbolic complexities, wherein the least object, the least color, represented an entire twelve-canto poem, suggested an entire philosophy. Just so did the celebrated draftsman William Blake in his apocalyptic illustrations.

One can see from this what a distance lay between him and the Pointillists, whom my colleague Arsène Alexandre of the *Paris* has so cleverly christened "the followers of the tiny stroke"!

Indeed, none of his works call them to mind. Certain of them do make one think rather of Claude Monet's style—and yet!

He was first and foremost an egoist in temperament, one who painted much more for himself and for his own satisfaction than with an eye to a public that would have ridiculed him [or] to fellow-artists who would have had a single goal: to indoctrinate him to their theories, have him fall in line with their principles.

He leaves a series of paintings quite different one from the other, executed no doubt under the diverse influences of agitation and exaltation, whose history could explain the successive evolution of his bizarre talent, often enthusiastic and sincere, at times eccentric and demented.

And so, from this latter perspective, it would be rather difficult for me to admire, despite all my good will and numerous efforts, a small canvas titled *Mulberry Tree*, of luminous chromium and hard cobalt, which is apparently the joy of M. Pissarro.

On the other hand, what a sparkling *Sunset* is the one exhibited at Tanguy's. And this little pink orchard, sky-blue and golden, where the apple trees have their roots half immersed in the clear water! And these yellow reapers under a yellow firmament beneath a yellow sun!

One canvas among others, whose title I do not know, is of a ravishing, silvery and soft coloring. One must look from afar at this field where the pale gold sheaves, which have just been baled, cast shadows of an almost pearl-gray mauve, transparent and delicate.

And this other painting, perhaps the most perfect of Van Gogh's, where poplars stripped of their leaves rise up in the foreground and orchards still white with flowers and barely leafing lay before a village that stands out in *grisaille* atop a hill in the background.

I will also cite some bizarre scenes: the *Prisoners of London* and a *Billiard Room*, its drawing somewhat primitive, in which gas jets that throw light on the players are nevertheless quite amusing. Some flowers as well, irises or roses, stand out crudely against yellow, rose, and Veronese-green backgrounds.

Arsène Alexandre (1859–1937), art critic whose unfavorable review in the 13 August 1888 issue of Paris *had denounced Pointillism's sterility as adopted by Seurat's "unscrupulous comrades," causing much friction within the movement.*

COLORPLATE 98

COLORPLATE 58

COLORPLATE 92

COLORPLATE 85

COLORPLATES 63, 111

Sheaves of Wheat. 1890. Canvas. 19⅞ × 39¾" (50.5 × 101 cm). Dallas Museum of Art; The Wendy and Emery Reves Collection.

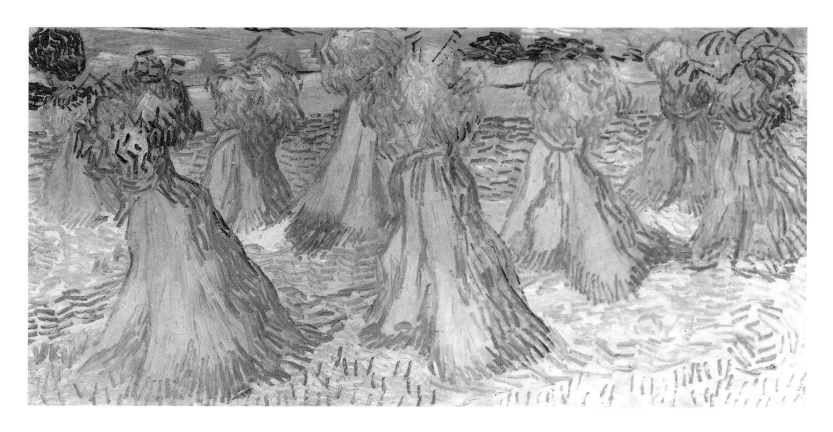

All the last part of the work dates from Auvers. Earlier he painted the great *Cypresses* in relief against the outskirts of Arles, the somewhat banal *Lavenus* of Marseilles. His *Sunset*, which I was praising just now, is from Auvers, the *House* and *Daubigny's Garden* from Auvers, a very beautiful green-on-green *Undergrowth*, with almost no sky, also from Auvers. M. Aurier cites *La Berceuse*, the *Zouave*, and the *Little Girl with a Rose*, which I do not know and which are earlier.

But from Vincent van Gogh's last paintings one may presume to know what this extraordinary soul of an artist—insanely restless, joyous or devastated, according to the circumstances, and always uneasy, eager, never content—would have been able to do if enabled to realize what he dreamed. One may guess at what point this painter, so troubled and troubling, might have arrived—his character having mellowed, the eccentricities of impasto having ceded to a rational technique—had he achieved a neat, definitive formula, one in which he would have had confidence, which would have permitted him to give himself up to the incredible, and on the whole admirable, passion of his temperament.

COLORPLATE 125

COLORPLATES 60, 51, 53

Johan de Meester

NEDERLAND

"Vincent van Gogh"

March 1891

Vincent van Gogh was a painter who painted only briefly. When he died in July, the public heard nothing about his sudden, early death. The work that he left behind has now been gathered in a room, and now and then something from there is sent to the unpopular exhibitions of "the younger generation," but people hear nothing more about it. Nor is it even likely that people will ever hear much about the art of Vincent van Gogh. Why should the Luxembourg or the Louvre, why should the Museum in Amsterdam, choose to extend its hospitality to this work? All the paintings are so original, so glaring, so harsh in coloring, and so few are finished.... Yet there is more talent in them than in many a piece that has obtained a prominent place in the aforementioned collections.

But Vincent van Gogh's talent was headstrong and troublesome, not at all respectable and obliging. It was also presumptuous, and somewhat pedantic, and thereby caused considerable torment, especially to him. Oh, those fortunate people, who are as satisfied with themselves as with others, as with the society as a whole, likewise satisfied about the existing art—one expression of culture and of an enthusiastic mind—so satisfied that they get gray hairs and are still content.

Vincent van Gogh hated those people. Yet his heart professed love more readily than hate. If he despised some people it was because he had esteemed them too highly. Is not all doubt the shadow of belief? The belief of Vincent van Gogh was very great and very lofty. It was precisely through such an outer impulse that he immersed himself in painting, this time to continue, or rather, to hurry, onward until death.

After ten years of work he left behind more than three hundred canvases. But here the individual manner in which he worked must be defined clearly. Convinced that his art had to be an expression of the impression of Nature—"*la nature vue a travers un temperament*"—he fol-

De Meester paraphrases Zola's famous statement: "A work of art is a corner of creation seen through a temperament."

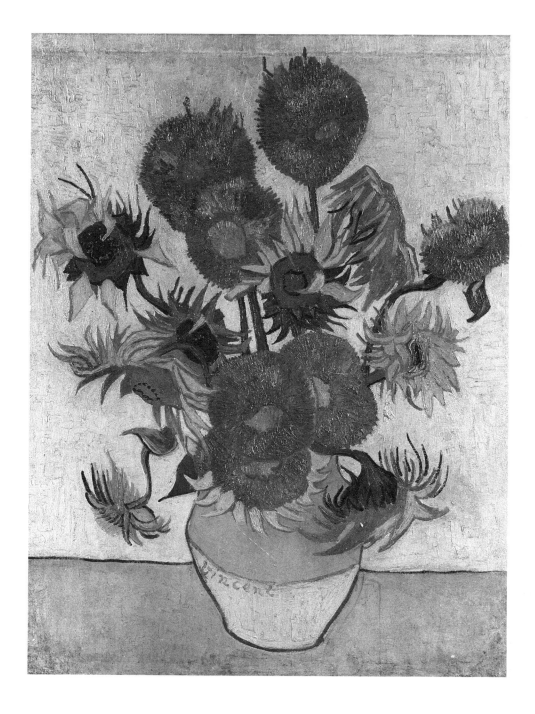

Sunflowers. 1889. Canvas. 37⅜ × 28¾" (95 × 73 cm). Rijksmuseum Vincent van Gogh, Amsterdam.

lowed closely the guiding star, living entirely in and by it and never for a moment withdrawing his art from its influence. The energetic preacher from the Borinage was likewise fully eager to share his view of art with others; in the years when others had contented themselves with studies, with the pursuit of details, he had already wanted to express what he had repeatedly found, but he wanted to present his findings correctly and exclusively, therefore he painted each painting entirely outdoors, not inside a studio from studies made out-of-doors.

Vincent van Gogh's rural lifestyle was physically harder than that of the most industrious farmer. At three or four o'clock, at the crack of dawn, he went out into the field in the summers and worked there for the entire long warm day, quenching his thirst with a jar of water, nourishing himself with some bread or other provision that was easy to take along. And the body that suffered such a difficult existence had an equally restless, powerful spirit, a spirit that bore the great immensity before its eyes! In the fiercest sun of Provence and in downpours, Vincent sat in the field, and likewise went out now and then during the winter, but he then abandoned himself to his passion for flowers.

It was in his flower paintings, I believe, that Van Gogh was the purest, the most singular, painter. When he executed landscapes, the

thinker, the poet, the Symbolist was too easily awakened in him, but with flowers he often succeeded in limiting himself to their charm and to bringing to life on canvas the splendor of their colors. Flowers glitter and sparkle, and Van Gogh was captivated with strong colors. He placed golden yellow crawfoots and sunflowers and fiery dark irises on a golden yellow ground and created from this a canvas measuring more than a meter. Whereas he extracted from a landscape a small detail of an orchard: set against the green ground on dark branches, heavy, wantonly bursting blossoms shine with beautiful, virginal, iridescent color, resplendent in their youthful nakedness. Or alternatively—because the flowers seduced this tyrant into courtliness, he surrounded his female figures with them, or painted them in the decorative manner of the Japanese, whose art he was enthusiastic about.

The art of the Japanese seems to have been clearly in his mind when he turned to landscapes, to the rolling fields or to orchards. Apart from this love, one can easily see in his work a fascination with the spirit of Holbein and especially with the spirit of Millet. He wanted to be simple and naive (later I will explain to you that he had a particular reason for this), and several heads of young girls and children possess all the pure tautness of Holbein portraits. Like Millet, he tried to live as a peasant of the land—first in our own Brabant, later in different regions of France, principally in Provence—to penetrate that life spiritually in order to be able to experience and reproduce from it all that was beautiful, highly poetic, and entirely essential to art. He painted various works after Mil-

Two Peasant Women Digging. 1885. Canvas on panel. 12⅝ × 16⅞″ (31.5 × 42.5 cm). Rijksmuseum Kröller-Müller, Otterlo.

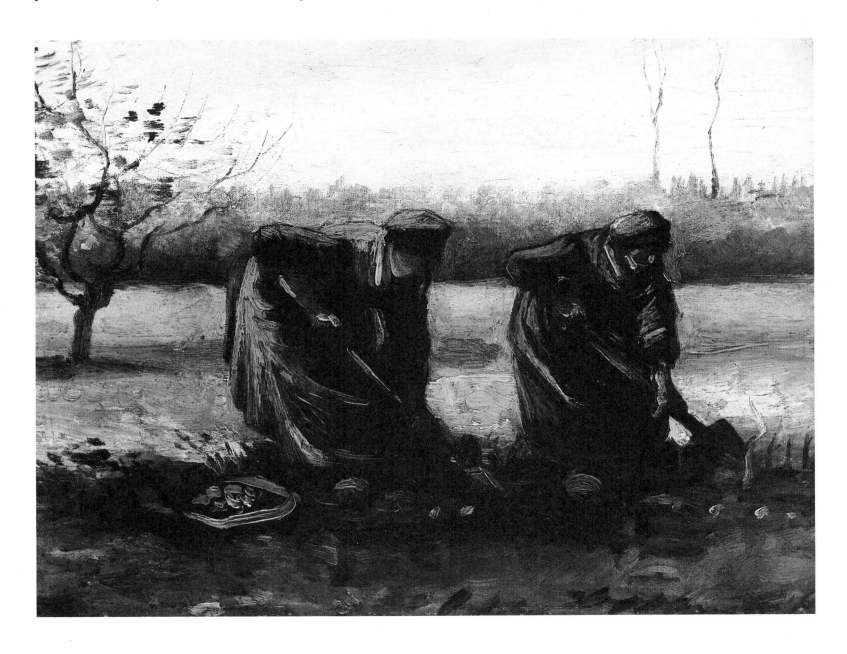

let, but in an individual manner. Often, armed with nothing more than a small engraving, he copied the composition of the master, respecting the integrity of Millet's subject and sentiment while at the same time endeavoring—because his anti-academic and highly independent spirit did not allow otherwise—to fully preserve his own character. Such preservation was his goal. As in his imitations of the early masters' primitive manner and his imperfect copying after Millet, Van Gogh's individuality, harshness, and tautness did indeed stem partly from faulty technique and lack of slow preparation; yet, it must be explained, it could not be otherwise—neither finer nor more mature. Even so, there is no doubt that Millet's palette did not satisfy Van Gogh.

Or, at any rate, it no longer pleased him. It was during his French period that he painted his "Millets." A Dutch period preceded this, when he typically painted small landscapes: evening views on the North Brabant heath in very sober, muted tones. Nonetheless a large interior, probably inspired by Israëls, dates from the same period, which, partially owing to faulty technique, gives expression to his artistic nature. It is much more forceful in conception, is much stronger in light, and is severely more somber in color. Unlike the general sobriety of his Dutch period, this work already anticipates the later forcefulness of Van Gogh's style. Indeed, the mere comparison of several still lifes, pitchers, pots, apples, or potatoes, made in the fatherland to similar still lifes made in France reveals how much his color changed. How dark the former, how light and full of air the latter! Van Gogh always succeeded one notch beyond most other artists: if he was dark like the Dutch, he was darker than they; if he was light and colorful like the French, he surpassed their brightness.

COLORPLATE 13

Critics will be found, namely among Dutch artists of refined technique, who in their idealistic love for harmonious color schemes, would reject the colorist merits of Vincent van Gogh. He surely did not idealize. But nor was he satisfied with the ugly, screaming and rather conventional colors of so many French moderns. He found Provence beautiful, and he strove to reproduce what he saw as keenly as possible and did so with very strong colors, in search of a value relationship that was not based on some ideal harmony, but which approached as closely as is possible in oil, the harmony of nature.

And at the same time, he sought the power of nature, its rich abundance. A sunlit path, a walkway somewhere in the South, appears thus: the sandy road is orange; the trees lining it are blue; a strip of bright green grass runs next to it and then, along the side, in the shadow, is a pink path. It will certainly be a long time before the public believes in blue trees, but in the end they will indeed learn to see, and moreover to understand, that something can be green in and of itself but become blue by its surroundings, through the effect of light and atmosphere. From just one such experience, they will readily understand Van Gogh's colors, rather than, as today, considering them foolish. Quite frequently other artists consider them harsh, ugly; without ever daring to see how expertly he manipulated the spectrum or the extraordinary talent that sensed and understood the essence of color tones. Instead, they lament that the painter resorted to such a range. Van Gogh put himself into the color; there is a similarity—but nothing more—to the color of Monet, of Pissarro. The latter, a Frenchman of seventy years, was enthusiastic about the talent of the Dutchman who died so young. And among the younger French painters our compatriot has earned quite a following.

COLORPLATE 74

A painting just as strongly lit and just as remarkable as the aforementioned path depicts the room that he rented from a farmer in Provence. The bedstead is orange, the chairs are golden yellow, the wall paper is bright blue, the chimney purple, the table green, and the floor brickred. One must have something in order to use such colors and to produce with them something good, something harmonious!

COLORPLATE 73

Van Gogh's bedroom is depicted—one of four rooms in the Yellow House that he had rented in May 1888 from a hotel proprietor in Arles.

This canvas is also unique in its design, which is extraordinarily naïve and obvious. It is as if he worked to teach children how to look! And to some extent this is indeed true. Vincent van Gogh—I have already alluded to this aspiration—wished to make art popular; convinced that art could offer and provide much to the masses, he believed that it must be propagated by making it easier to understand. Hence, so many everyday images, such obvious design, such colors as those in a penny-print. The painter remained like the theology student, who, self-taught out of necessity, departed for the Borinage.

Now Van Gogh practiced painting for its own sake just as little as he had theology. He was no artist of instinct, he was an artist because of a particularly rich temperament that found in painting the best opportunity to express his view of nature and of life. Only a short time before his death he reportedly said that to paint was actually only a matter of secondary importance to him: "There are many other things to do besides this."

Anyway, he also wanted to fully express all that was stirring in his rich soul. Again and again he lapsed into symbols in his paintings. He particularly tried to express the titanic and the chaotic in nature. The trees or their trunks or, in other examples, their crowns, become giants which, while violently splitting the ground, simultaneously appear to be wide, heavy, and tall. And behind them the sun sets in a glowing northern light. And in the foreground lie bits of heath or piles of hay, which seem to take on the shape of hunchbacks. Now and then there is a human figure in the field; sometimes that figure forms the principal subject, as in the many sowers that he painted, those farmers with their inspired yet bestial nature, whose silhouettes, whose hand movements, and whose work had apparently made a deep impression on the artist and whose essence he so readily penetrated, so that in several instances one can detect something of his own features in those of the industrious peasant.

COLORPLATES 49, 77

Nowhere is he more Symbolist than in *The Desolation of the Fields*, an oblong canvas: dark golden-yellow, heavily convoluted and bristly stalks of grain, traversed by a dull pink path which unfolds up an incline toward the dark blue, stormy horizon, and above the grain, black birds swoop like fluttering claws. This canvas reminded me of a drawing made by Victor Hugo, when he was still young, depicting the turbulent sea. Painting and drawing both express the chaotic with great force, just as a romantic feels it, for this painter, who tried to be so realistic in his color, was a romantic in his symbols. Tremendous feelings must have coursed and howled within him, and it is still very much in question whether painting was sufficient enough to express them.

COLORPLATE 124

I had the occasion to see what is purportedly his last work, *Undergrowth*, a splendidly sumptuous piece drawn from a rich, joyous nature—a very good painting. I studied it for a long time, but it was impossible for me to see in it the supreme expression, the final adieu of Van Gogh's temperament. That temperament was more abundantly tempestuous, as it was more powerful with every complete revelation. Moreover, however much we recognize the talent of this painter of only ten years, his image takes on entirely new dimensions when we see him seized with the anxieties of a modern Byron and wrestling with the riddle that the artist ultimately found as little solved in nature as the theologian had found solved in the Christian doctrine.

COLORPLATE 123

As a Dutchman, Van Gogh is of a unique individual character, and he strove for a broadening influence of art with a strongly democratic sense that appears to be entirely unartistic to our native artists. Because of this, he already occupies a separate place among our painters. But he stands alone, above all, in that highly passionate search for, that confrontation with, that measuring of oneself against the Unfathomable. More than an artist or maker, he was a philosopher, a seeker. He showed his greatest power in the powerful admission of his own impotence.

José Hennebicq

LES JEUNES

"Les Vingt—Eighth Exhibition"

March 1891

José Hennebicq (b. 1870), Belgian writer and dramatist.

Van Gogh had a highly personal conception of nature. Far from seeing it as serene, calm, pleasant, he understood it as brutal, tormented, harsh—savage. Thus it appears in his drawings done in Provence and at Arles, and above all in his *Sower*: A massive earth-creature hurls the impregnating seed with a clumsy, heavy gesture—in a field where an enormous tree with twisted trunk and bare branches stands in the foreground—while on the horizon an immense moon rises.

COLORPLATE 77

The earth smelling of manure; the gigantic moon that seems ready to fall and crush the sower; the menacing tree—everything gives this brutal corner of nature a savage aspect of disturbing harshness and caustic ruggedness.

Gustave Lagye

L'EVENTAIL

"Chronicle of the Fine Arts at the Salon of Les Vingt"

1 March 1891

Gustave François Lagye (1843–1908), art critic and scholar who catalogued the collections of the Musée des Beaux-Arts in Brussels and Antwerp.

This is to tell you that I acknowledge, for a single moment, Vincent van Gogh's carnivalesque art. . . .

Ernest Closson

IMPARTIAL BRUXELLOIS

"Symbolic Painting"

22 March 1891

Ernest Closson (1870–1950), Belgian writer who devoted most of his career to the historical and ethnographic study of music.

We will return to *The Red Vineyard* by the lamented Vincent van Gogh. If one were to adopt an ordinary point of view to judge this painting, what would one say about this irradiating light, this fusion of rays blazing from this vineyard with its blood-drenched colors, of this orgy of warm and intense tones where blood and fire prevail over color? One

COLORPLATE 76

This painting had been exhibited the previous year with Les Vingt in Brussels.

might say, and not without reason, this is madness. And one would not be mistaken. But if one adopts a more particularized viewpoint of the artist and delves into this thinking, the canvas has a powerful attraction. Van Gogh has desired to show us, in his *Vineyard*, the fermenting fumes and the intoxication, the mad passion and the effervescence of wine. And its orgies of color suggest the insane orgies of which the vineyard may become at once the sole promoter and the primary cause.

Georges Lecomte

L'ART DANS LES DEUX MONDES

"Salon of the Indépendants"

28 March 1891

The powerful vision, the harsh and sincere execution of the unfortunate *Van Gogh*, are masterfully shown by a too-scanty sample of his last canvases.

Octave Mirbeau

L'ECHO DE PARIS

"Vincent van Gogh"

31 March 1891

At the exhibition of the Indépendants, amid some successful attempts and, above all, amid much banality and even more sham, shine brightly the canvases by the greatly lamented Vincent van Gogh. And, in front of them, before this black crepe that frames them in mourning and draws them to the attention of the indifferent crowd of passersby, one is struck by great sadness to think that this painter, so magnificently gifted, so highly sensitive, so instinctive, so visionary an artist—is no longer among us. The loss of him is a cruel one, far more painful and irreparable for art than that of M. Meissonier, even though people were not invited to an ostentatious memorial service, and even though poor Vincent van Gogh, with whom a beautiful flame of genius had died, went as unknown and neglected to his death as he had lived his unjust life.

Moreover, he ought not to be judged by the few paintings currently exhibited at the Pavillon de la Ville de Paris, despite the fact that they seem quite superior in intensity of vision, in richness of expression, and in power of style, to all those surrounding them. Certainly, I am not insensitive to the researches on light by M. Georges Seurat, whose seascapes, with their exquisite, profound luminosity, I like very much. I find a very lively electric atmosphere, the feminine grace, the bright elegance of M. van Rysselberghe. I am attracted to M. Denis's small compositions, of so soft a tone, enveloped in such tender mysticism. I recognize, in M. Armand Guillaumin's limited and unimaginative Realism a fine

Meissonier, who at age 75 had died a national hero on 31 January 1891, had been given an elaborate public funeral.

The Indépendants exhibition was held at the Pavillon de la Ville de Paris on the Champs-Elysées.

Maurice Denis (1870–1943), painter, art theorist, founding member of the symbolic and decorative movement, the Nabis, and anti-naturalist spokesman.

touch, as they say, of honest and sturdy technical qualities. And despite the blacks with which he unduly soils his figures, M. de Toulouse-Lautrec shows a real power, spiritual and tragic, in his study of physiognomies and penetrating character studies. M. Lucien Pissarro's engravings have verve, sobriety, and distinction. Even M. Anquetin, amid obvious derivations, academic conventions, flawed eccentricities, caricatured uglinesses, at times offers us a nice glimpse of light—as in the Parisian horizon in the canvas titled *Pont des Saint-Pères*—and skillful harmonies of gray, as in one portrait of a woman. But none of these uncontestable artists—with whom one ought not confuse M. Signac, whose loud, dry, pretentious incompetence is irritating—captivate me as much as Vincent van Gogh. In his case I sense that I am in the presence of someone higher, more masterful, someone who disturbs me, moves me, and compels recognition.

It is perhaps not yet the time to tell the story of Vincent van Gogh as it ought to be told. His death is too recent, and it was too tragic. The memories I would evoke would revive the grief, which still brings tears. Therefore this study will be necessarily incomplete, for what was great and unexpected as well as too violent and excessive in the harsh yet delightful talent of Vincent van Gogh, is intimately bound up with the fatal mental illness that predestined him, still young, to death.

His life was quite disconcerting. At first he entered the art trade with his brother, who likewise met an early death, who ran the branch of

Mirbeau's account of Van Gogh's life is highly romanticized and inaccurate, but it influenced early appraisals of the artist's development.

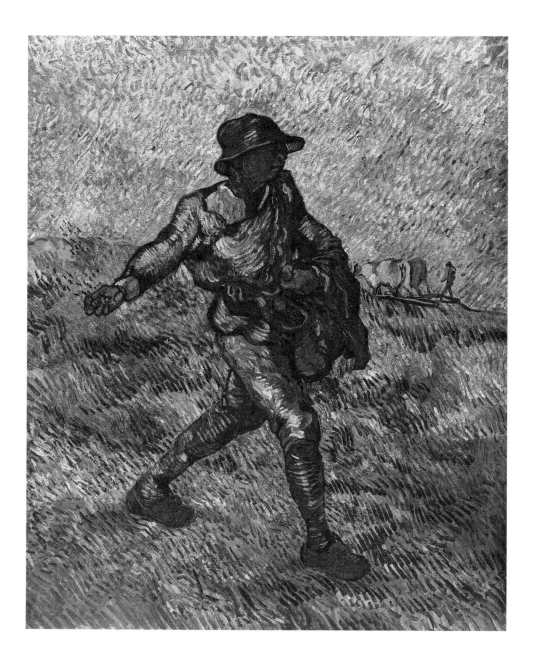

Sower (after Millet). 1889. Canvas. 31⅞ × 25⅝″ (81 × 65 cm). Private Collection.

Goupil's on the boulevard Montmartre. He was a restless, tormented spirit, full of vague yet ardent inspirations, perpetually drawn to the summits where the human mysteries reveal themselves. No one knew then what stirred in him of the apostle or the artist; he himself didn't know. He soon left the trade to study theology. He had, it seemed, a strong literary background and a natural tendency toward mysticism. These new studies seemed, for a time, to have given his soul the direction it craved. He preached. His voice echoed in the pulpits, among the crowds. But he soon suffered disillusionment. Before long, preaching seemed to him to be a vain thing. He did not feel close enough to the souls he wished to convert; his words blazing with love bounced off the walls of chapels and hearts without penetrating them. He thought that teaching would be more effective, and, forsaking preaching, he left for London, where he established himself as a primary-school teacher. For a few months, he taught the little children the ways of God.

Obviously, this all seems rather strange and disjointed; yet it is easily explained. The imperious artist within him, of which he was then still unaware, submerged itself in the apostle, lost itself in the evangelist, and wandered through dream-forests foreign and obscure to him. He felt that an invincible force was summoning him somewhere, but where? . . . that a light would illuminate somewhere at the end of this darkness, but when? There resulted a moral disequilibrium that drove him to the most incongruous actions, and the farthest from himself. It was upon his return from London that his vocation burst forth all of a sudden. He began to paint one day by chance. And it happened that, straight off, this first canvas was almost a masterpiece. It revealed an extraordinary painter's instinct, marvelous and powerful qualities of vision, a keen sensibility that divined the living and restless form beneath the rigid appearance of things, and an eloquence and abundance of imagination that astounded his friends. Then Vincent van Gogh went to work in earnest. Work, without respite, work with all its obstinacies and all its raptures, seized hold of him. A need to produce, to create, took over his life, without stopping, without rest, as though he would make up for lost time. That lasted for seven years. And death came, tragically, to cut down this beautiful human flower. He left behind, the poor deceased, with all the hopes that such an artist could inspire, a considerable body of work, close to four hundred canvases and an enormous quantity of drawings, of which many are absolute masterpieces.

Van Gogh was of Dutch origin, from the homeland of Rembrandt, whom he seems to have greatly loved and admired. If one wished to cite an artistic lineage to this temperament of abundant originality, this ardor, this hyperaesthetic sensibility that was guided only by his personal impressions, one could perhaps say that Rembrandt would be his favored ancestor, the one in whom he most felt himself reborn. One rediscovers in his numerous drawings not resemblances [to Rembrandt] but a similar exasperated worship of the same forms and a parallel richness of linear invention. Van Gogh does not always adhere to the discipline nor to the sobriety of the Dutch master; but he often equals his eloquence and his prodigious ability to render life. Of Van Gogh's unique artistic sensibility we have a very precise and quite valuable indication: namely, the copies that he executed after various paintings by Rembrandt, Delacroix, Millet. They are admirable. But they are not, strictly speaking, copies, these exuberant and imposing restitutions. They are, rather, interpretations through which the painter manages to recreate the works of others, to make them his own while preserving their original spirit and special character. In the *Sower*, by Millet but rendered with such superhuman beauty by Van Gogh, the movement is accentuated, the vision is broadened, the line is amplified to a symbolic significance. That which is Millet remains in the copy; but Vincent van Gogh has introduced something of his own through which the painting immediately

COLORPLATE 110

Van Gogh, who referred to his copies as "translations," would have appreciated this appraisal.

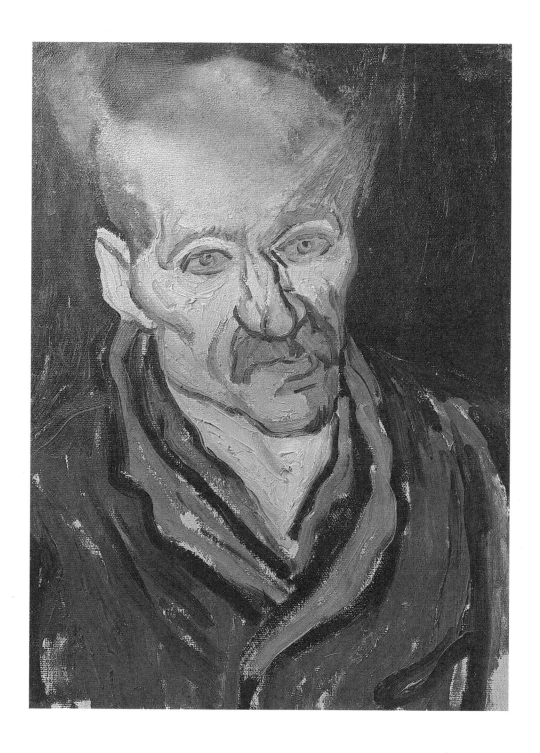

Portrait of a Patient. 1889. Canvas.
12⅝ × 9½″ (32 × 23.5 cm).
Rijksmuseum Vincent van Gogh,
Amsterdam.

takes on a look of new grandeur. It is quite certain he brought to his ob-
servation of nature the same mental habits and superior creative gifts
that he brought to these masterpieces of art. He could neither forget his
personality nor contain it, whatever the spectacle or materialized dream
before him. It overflowed from him in ardent inspirations over every-
thing he saw, everything he touched, everything he felt. He was not,
however, absorbed in nature; rather he had absorbed nature within
himself: he forced it to become more supple, to mold itself to the forms
of his thought, to follow him in his flights of fancy, to submit, even, to
his characteristic distortions. To a rare degree, Van Gogh possessed that
which distinguishes one man from another: style. In a crowd of paint-
ings jumbled together, the eye, at a single glimpse, recognizes with cer-
tainty, those of Vincent van Gogh, just as it recognizes those of Corot,
Manet, Degas, Monet, Monticelli, because they have a particular genius
which cannot be otherwise, and which is style—that is, the affirmation
of personality. And everything under the brush of this strange and
powerful creator is animated by a strange life, independent of that of the
things he paints, a life that is in him and that *is* him. He expends him-

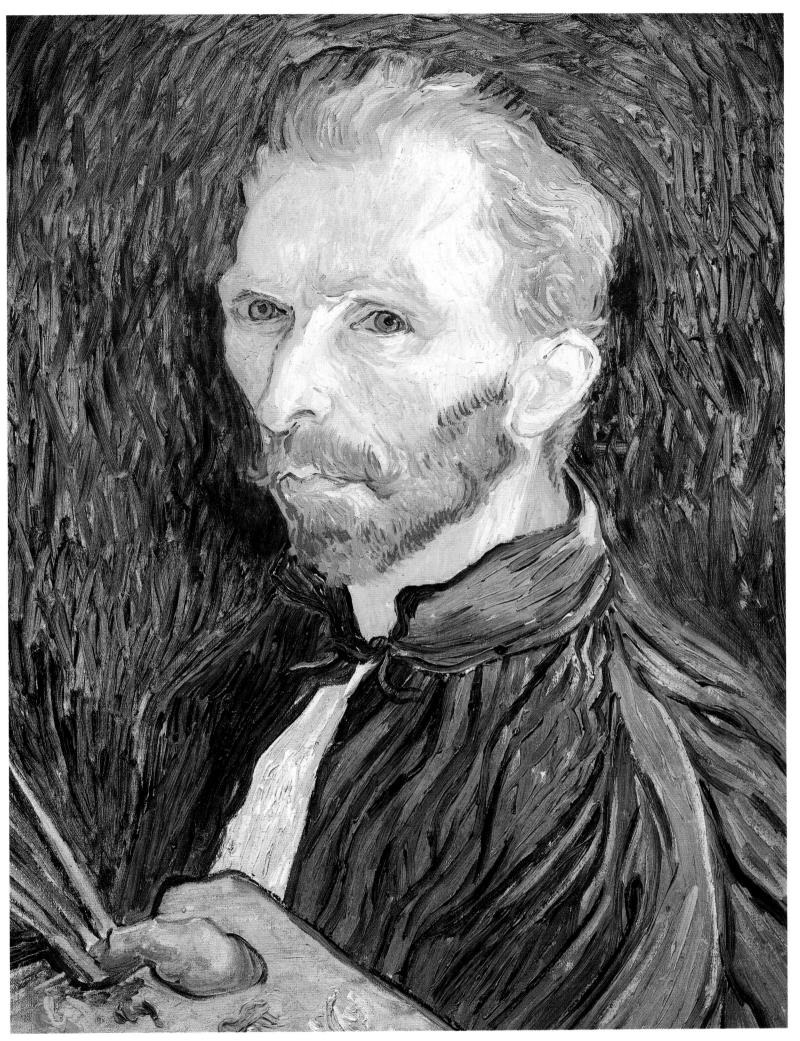

COLORPLATE 95. *Self-Portrait.* 1889. Canvas. 22½ × 17⅜″ (57 × 43.5 cm).
Collection Mrs. John Hay Whitney.

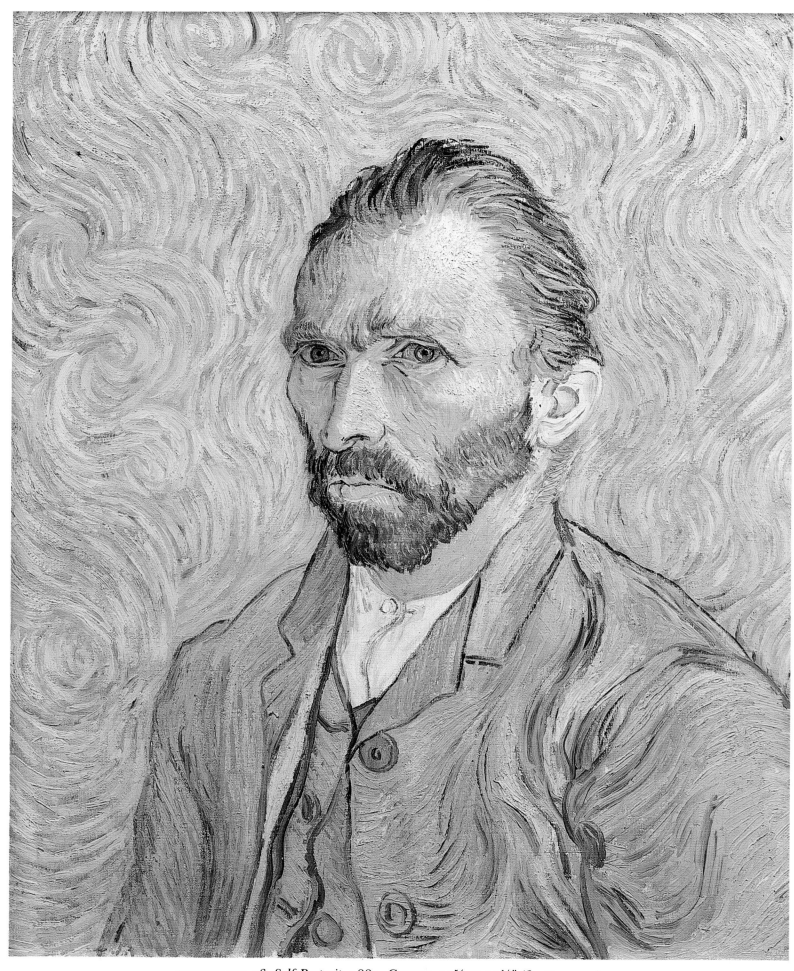

COLORPLATE 96. *Self-Portrait*. 1889. Canvas. 25⅝ × 21¼″ (65 × 54 cm).
Musée d'Orsay, Paris. Photograph: Musées Nationaux.

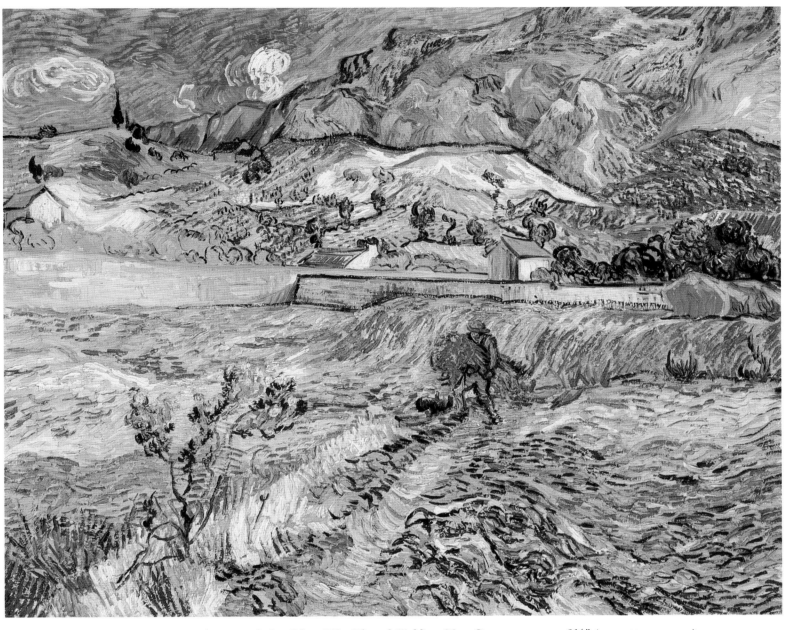

COLORPLATE 97. *Landscape at Saint-Rémy (The Plowed Field).* 1889. Canvas. 29 × 36¼″ (73.3 × 92.1 cm).
Indianapolis Museum of Art; Gift in memory of Daniel W. and Elizabeth C. Marmon.

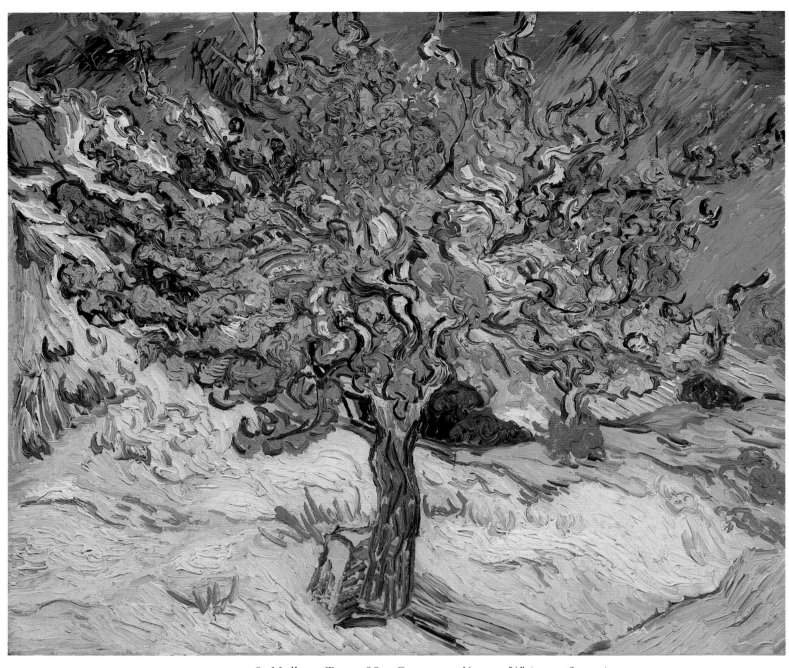

COLORPLATE 98. *Mulberry Tree*. 1889. Canvas. 21¼ × 25⅝″ (54 × 65 cm).
The Norton Simon Art Foundation, Pasadena.

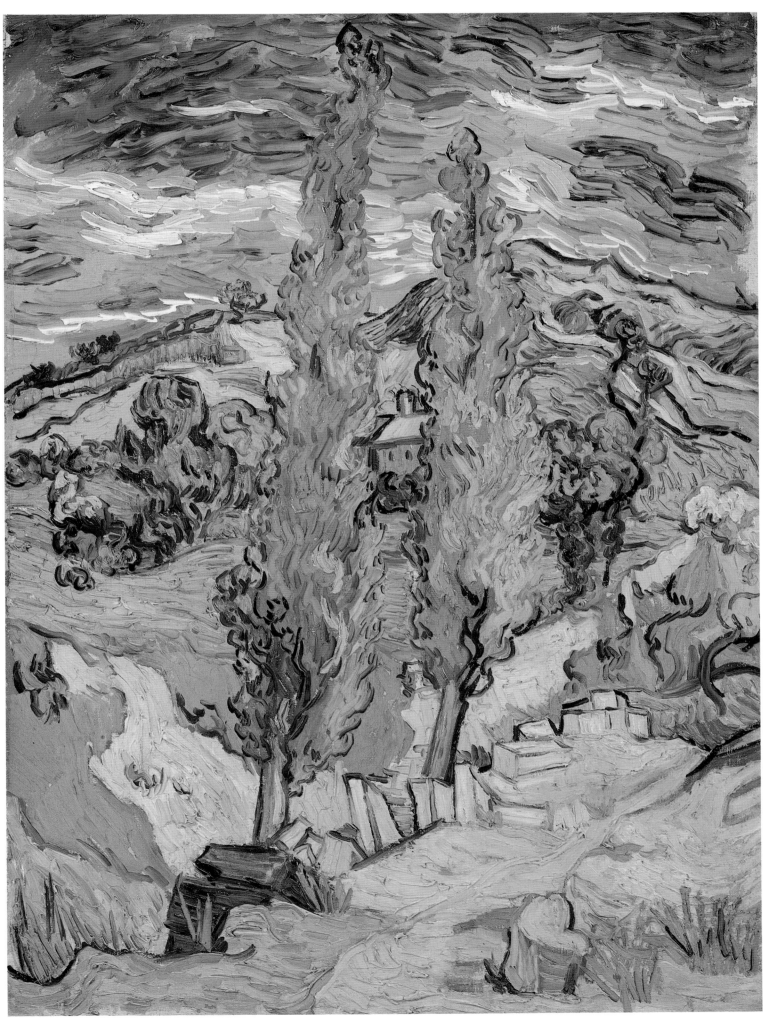

COLORPLATE 99. *Two Poplars on a Hill.* 1889. Canvas. 24 × 18⅛″ (61 × 45.5 cm).
The Cleveland Museum of Art; Bequest of Leonard C. Hanna, Jr.

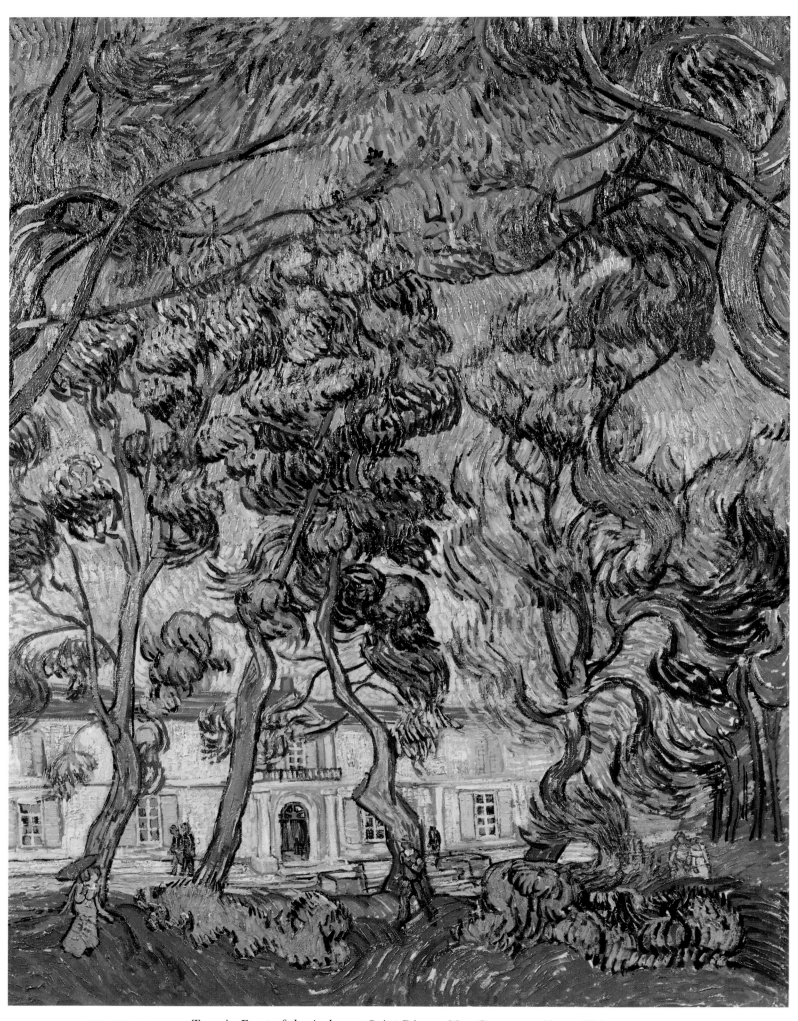

COLORPLATE 100. *Trees in Front of the Asylum at Saint-Rémy.* 1889. Canvas. 35½ × 28″ (90.2 × 71.1 cm).
The Armand Hammer Foundation, Los Angeles.

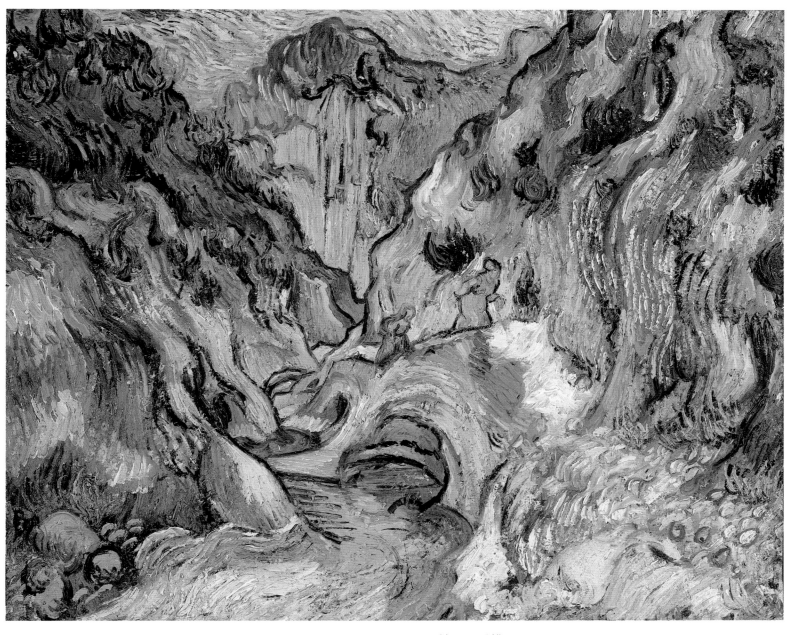

COLORPLATE 101. *Ravine.* 1889. Canvas. 28¾ × 36⅛″ (73 × 91.7 cm).
Museum of Fine Arts, Boston; Bequest of Keith McLeod.

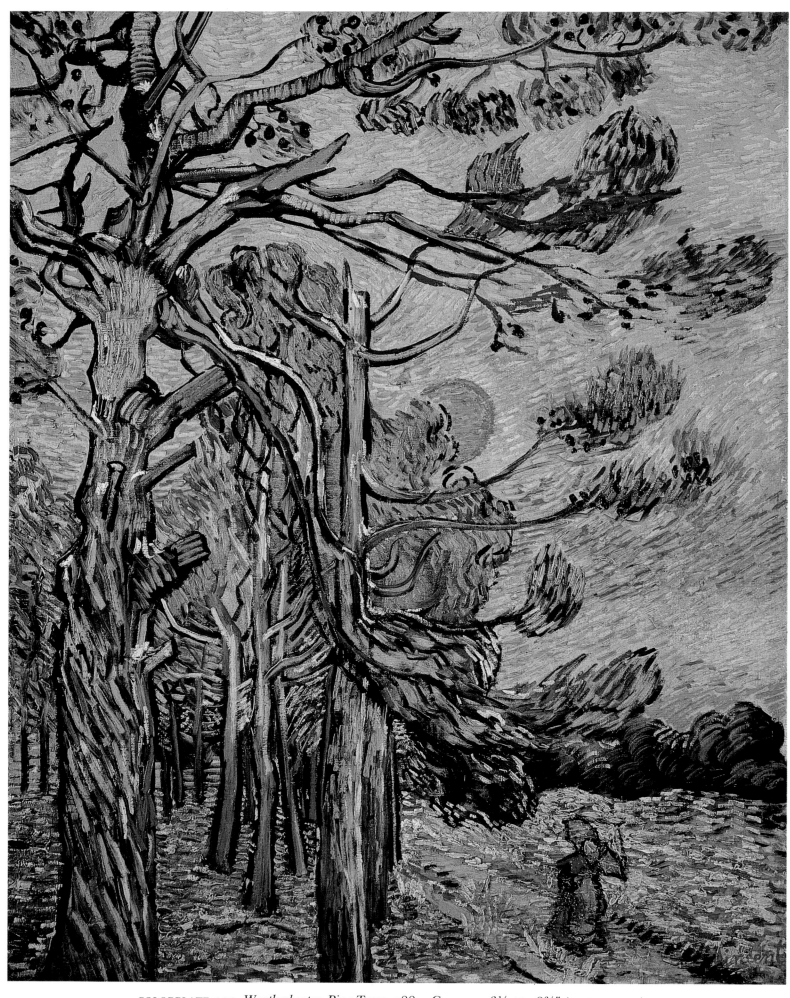

COLORPLATE 102. *Weatherbeaten Pine Trees*. 1889. Canvas. 36¼ × 28¾″ (92 × 73 cm).
Rijksmuseum Kröller-Müller, Otterlo.

self totally, on behalf of the trees, skies, flowers, and fields that he swells to capacity with the astonishing sap of his being. These forms multiply, run wild, writhe, extending even to the formidable madness of his skies where drunken celestial bodies spin and waver, where the stars stretch into disorderly rows of comets. Yet even in the upheaval of these fantastic flowers that rear up and tuft their feathers like demented birds, Van Gogh always maintains his wonderful qualities as a painter and a nobility that is moving, as well as a tragic grandeur that is terrifying. And, in the moments of calm, what serenity in the great sunlit plains, in the orchards in bloom, where the plum and the apple trees snow down joy, where the goodness of life radiates from the earth in flutters of light and expands into the tender paleness of peaceful skies and their refreshing breezes. Oh, how he understood the exquisite soul of flowers: How delicate becomes the hand that had carried such fierce torches into the dark firmament when it comes to bind these fragrant and fragile bouquets! And what caresses has he not found to express their inexpressible freshness and infinite grace?

And how well he also understood the sadness, unknown and divine, in the eyes of the poor, mad, and sick that were his brethren!

Emile Verhaeren

L'ART MODERNE

"The Salon of the Indépendants"

5 April 1891

Emile Verhaeren (1855–1916), Belgian poet, art critic, and writer who was a leading spokesman for the Symbolist movement.

Verhaeren's review originally appeared in February in La Nation.

And two deceased artists: by M. Dubois-Pillet, president of the Indépendants, fifty-four entries, almost a complete exhibition; by M. Van Gogh, his last paintings.

The former certainly did not have time to develop his nascent talent for sad and sober shades; as for the latter, by his undeniable intensity of vision, by his excited brutality, by his force and violence as a surprising and daring colorist, he will perhaps endure as one who asserted a frank, powerful, and naive art.

Having departed, like Gauguin and Bernard, from the staunch Impressionists Cézanne and Guillaumin, he exaggerated their hale and hearty vision. He has his personal technique, his own raw and coarse harmony, his special dream. Certainly, he would have numbered among the masters if death had not struck him down so young in mid-work.

In short, what remains in one's memory, after an extended visit to the Salon des Indépendants, is, among the newcomers and the seekers after the new, a manifold curiosity toward very different fields of art. There is no longer any one school; there are barely any groups, and those few are constantly splitting. All these tendencies make me think of moving and kaleidoscopic, geometric designs that clash at one instant and merge the next, that sometimes fuse, only to separate and flee apart shortly after, but that nonetheless all revolve in the same circle—that of the new art.

Eugene Tardieu

LE MAGAZINE FRANÇAIS ILLUSTRÉ

"The Salon of the Indépendants"

25 April 1891

A crepe of mourning marks the place, reserved for Vincent van Gogh, the so curious artist who unfortunately died during the course of last summer. Vincent van Gogh was a Dutchman; his admirations were for Delacroix, Courbet, Millet, and Rembrandt. His life is one of the most curious psychological novels one could dream of. He was, they say, a relentless worker, a chaste person, and a mystic. A powerful imagination, all a painter's gifts, and no doubt very little of what is vulgarly called "good sense" made him push the theories that he embraced to such an extreme that they became perfectly incomprehensible. Of the ten canvases that are exhibited at the Indépendants, I admit to understanding only two or three: a *field* of beautiful, gentle green that unrolls into infinity under an impeccably azure sky; a *lane in Arles*, of surprising coloration but which makes a fairly striking impression; and a *Resurrection of Lazarus*, a curious interpretation of a well-known masterpiece. The name Van Gogh will no doubt serve as a pretext for some searching discussions on art, from which some new truths could emerge. This strange painter has some passionate admirers; his character won him some strong friendships. We owe to the kindness of his family a sketch made at his deathbed by his doctor and friend, Dr. Gachet.

The "lane in Arles" is probably one of the versions of Les Alyscamps.

COLORPLATE 74

COLORPLATE 110

Jules Antoine

LA PLUME

"Exhibition of the Indépendants"

1 May 1891

Two exhibitions in this hall were already veiled in mourning: those of Dubois-Pillet, an honest man and a sincere artist, and Vincent van Gogh, who died tragically at the end of last year. The ten or so works that compose the latter's showing are insufficient to convey an idea of what this unbalanced, but original and spontaneous painter was. Nevertheless several of them are powerful and bizarre in expression, not because they express real effects accurately—that was not at all the painter's ambition—but because they evoke tragic or gentle sensations with the means of expression of a strong and rare personality.

Seurat and Van Gogh were the two initiators behind the young artists who now share this hall.

Seurat and his friends, preoccupied with luminosity, have still remained through the spirit of their works, Realists, whereas Van Gogh and

Paul Gauguin's partisans, more in quest of ideas, have attempted a return toward the past, which one of their own defined well under the heading of *néo-traditionnisme* in *Art et Critique*.

These are thus two quite dissimilar currents that one might well consult in order to learn about the masters of tomorrow.

Reference to an article by Maurice Denis, "Définition du Néo-Traditionnisme," in Art et Critique, *August 1890.*

Tonio

LA BUTTE

"Notes and Recollections"

21 May 1891

Tonio, apparently the pseudonym for Antonio Cristobal, a fellow-student at Cormon's with whom Van Gogh had exchanged works in 1886.

It is almost a year now since a great, unknown artist was interred in the small cemetery in Auvers.

This artist is named Vincent van Gogh.

He lives on in a body of work where genius bursts forth in more than one place. I will not analyze it now, for my goal is to speak succinctly of Vincent's career and of his endeavors in all genres.

He began in literature in Holland, his native country: he was an elementary school teacher; then he spoke for the weak and the poor; then he became a painter.

He envisaged art as a language that addresses everyone, as a symbol, as a verb. Because he was so human, it was inevitable that Vincent would paint the sorrowful and the suffering; and that was exactly what he did: The small gardens of his country, with their sickly trees, the laborers of the arid fields, and somber interiors were his first efforts; then the quite lamentable miners, the beggars, the children, unsuspecting outcasts, sons and daughters of outcasts, who frolic on the harsh ground, unaware of the suffering that lies ahead.

In France, what strikes him most is our sunlight, to which he was unaccustomed, and our great clear evening skies under which prostitutes prowl like dogs tracking. He painted the effects of lamplight from corners of night cafés, portraits of artisans, and finally the Midi, the terrible Midi that made him dream of the tropics. Arles, France, was his last stop. Auvers took him, never to return him to us, alas!

Student of everyone and of no one, passionate, excitable, Vincent dreamed only of Art, everywhere, in everything, above everything.

"Why not hang canvases in the trees on the boulevard?" he would ask when chatting about all those false-bottomed cliques—the annual salons, the periodical exhibitions—where not even the illusion of friendship reigns.

No doubt because he focused on the qualities of a work, the surroundings mattered little. That is why he attempted to inundate a popular restaurant on avenue de Clichy with his canvases.

It was an immense place, "like a Methodist chapel," he said to Camille Pissarro, whom he wished to inveigle into exhibiting there. And the fact is that the restaurant was as large as an entire building: great walls 10 meters high, 30 wide . . . etc. So he called in helpers, among them, Anquetin, Bernard, Koning and also sought out those artists who had promised works, such as Gauguin, Pissarro, Guillaumin; but everything fell apart all at once (an argument with the owner about patriotic escutcheons that hung among the painters' canvases . . .). Then he had re-

The avenue de Clichy exhibition was at the Grand-Bouillon Restaurant du Chalet in late 1887.

course to the Indépendants, and since then it was there—as well as at Tanguy's (rue Clauzel)—that he showed his canvases: a dazzling array of precious stones, gems, and crystals, as Albert Aurier defined them in the *Mercure de France.*

Emile Bernard

LA PLUME

"Vincent van Gogh"

1 September 1891

Red-haired (goatee, crude moustache, shaved cap of hair), with an eagle's gaze and an incisive mouth set as if to speak; of medium height, stocky without the usual excess, quick-gestured, with an abrupt gait—such was Van Gogh, always with his pipe, a canvas, an engraving, or a portfolio. Vehement in discourse, interminably explaining and developing ideas, little inclined to controversy, yet always involved in it. And such dreams, ah! such dreams!—giant exhibitions, philanthropic artists' communities, the foundation of colonies in the Midi and, elsewhere, a progressive invasion of the public spheres in order to ably re-educate the masses in support of the art that they knew in the past. . . .

A Dutchman, a Protestant, a pastor's son—Van Gogh at first seemed destined to take the holy orders, but although he had engaged himself therein, he left the church for painting. Excessive in everything, he doubtless caused an affront to the narrow doctrine of his masters! Smitten with art, he discovered Israëls and took him as his first model. Rembrandt was next. Then he came to France, to Goupil's, where his brother, Theodorus van Gogh, was established. Thanks to this brother, he was free to paint. He runs to Cormon's, with whom he quickly becomes disgusted, experiments with the complementary colors of Pointillist technique, with which he becomes irritated, and finally begins his free flight after studying the paintings of Monticelli, Manet, Gauguin, etc. . . . Certainly he takes after none of them. Van Gogh is more personal than anyone. Enamored by the art of the Japanese, Indians, Chinese, with everything that sings, laughs, vibrates, he found in these born artists his astounding technique for achieving harmonies and the extraordinary flights of his drawing, just as deep within himself he found the delirious nightmare with which he oppressively bears down on us without respite.

Emile Bernard

LES HOMMES D'AUJOURD'HUI

1891

He was mine, so I want to speak of him, although I am gripped by apprehension when I imagine what the curious few who will read this account of him will think, since generally—and why?—one mistrusts the judgments set forth by friends, indeed, even of relatives of the dead. And

yet how much more valid these seem to be than the others, for whom do we know better than those we love, especially in art, where all friendship is based on like aspirations, on similar views?

I met Vincent van Gogh for the first time at Cormon's studio; and how they laughed then behind his back though he "did not condescend to notice." Then, at Tanguy's, that intense little chapel whose old priest has the good-hearted smile of unappreciated honesty. When Vincent emerged from the back room, with his high and wide forehead, I was almost frightened that he would erupt into flames. But we quickly became friends, and he opened up boxes from Holland and his portfolio of studies. What surprising sketches! Gloomy processions under gray skies, the "common grave"; views of the [Paris] fortifications in rectilinear perspective; the Moulin-de-la-Galette with its sinister arms (over which still lingered a hazy, sober northern fog); then scraggy gardens, roads at dusk, and faces of peasant women with African eyes and mouths. On the table, amid some Japanese prints, were balls of yarn in which interlaced strands played unexpected symphonies [of color].

I was stunned to find, amid this chaos, a repast of the poor in a grim hut, beneath a lamp's dim light. He called it *The Potato Eaters*; it was remarkably ugly and disquietingly alive. . . .

Then he reclosed those drawers, and we spoke of literature. Huysmans captivated him beyond measure. He was especially enthusiastic about *En ménage*, then later about *A Rebours*. He was also greatly taken with Zola; and it was while reading this author that he thought of painting the miserable shanties of Montmartre, where every *petit bourgeois* comes to cultivate a bit of sandy soil at the first rays of morning sun. . . .

As for painting, he loved Monticelli and Delacroix above all, spoke of Millet with adoration and profoundly despised the self-styled modern classicists. Yet, as single-minded as he was, he had the solid faith of those who love art above all else, and he viewed all types of art with equal interest.

Later, when we had become friends, he initiated me into all his projects—and how many there were! What discouraged him was not that he himself was unappreciated, it was seeing Pissarro, Guillaumin, and Gauguin in the kind of financial straits that had compromised or paralyzed their ability or efforts to work. That was when he undertook with his brother, Theodorus (then an expert at Boussod & Valadon), a cam-

COLORPLATES 2, 10

COLORPLATES 29, 30, 12

COLORPLATE 13

Two novels of 1881 and 1884, respectively, by Joris Karl Huysmans (1848–1907) that mark that French writer and art critic's transition from naturalism to "l'esprit décadent."

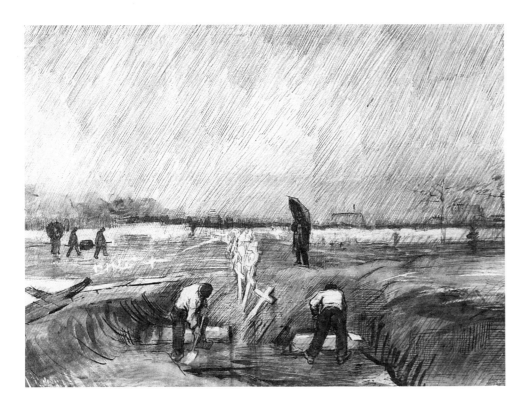

Cemetery in the Rain. 1886. Pen, brush, and colored chalk, heightened with white. 14⅝ ×18⅞″ (36.5 × 48 cm). Rijksmuseum Kröller-Müller, Otterlo.

paign, which consisted of gaining acceptance for these painters in the salons where works by famous, but inept, artists hung. And in this, with the help of a devoted brother, he was entirely successful.

Nonetheless, following an attempt at an exhibition in a working-class restaurant on the avenue de Clichy, he was tempted by the Midi (where Monticelli, his master, had largely lived), and he set out for Arles.

From Arles date a substantial packet of letters, from which we hope someday to publish the most interesting passages. From Arles, too, date the first canvases in a decisive style.

He had painted at Asnières in an indecisive Pointillist style, and then, some still lifes in strokes of *complementary colors*—among others, the famous *Yellow Books*, which he exhibited at the Indépendants in 1888. But only at Arles did he assert himself in a very pictorial, personal technique. Let us cite: *The Rhône, The Sower, La Berceuse, The Olive Trees, The Vineyard.* Oh! how much he loved the olive trees, and how even then he was also tormented by nascent symbolism! "In regard to the Christ at Gethsemane, I toil on my olive trees," he wrote me. Furthermore, each of his works has its story, such as that of *La Berceuse*: "At night out at sea, the fishermen see at the bow of their boat a supernatural woman; the sight of her does not frighten them at all, for she is the *berceuse*, the woman who pulls the cord to rock the basket of a baby when it whimpers; and she is the one who returns to sing to the rolling of the great wooden cradle, the hymns of childhood, the hymns that bring rest and consolation to a hard life."

(But let me not divulge what will be new and captivating when the letters are published.)

So he painted *La Berceuse* with the intention of offering it to an inn either in Marseilles or in Saintes-Maries, where sailors come to drink. Two great sunflowers were to serve as pendants, because he saw in their intense yellow the supreme clarity of love.

Yet Rembrandt haunts him again: he then seems to dream of his native land. From memory he paints a few corners he cherished there; and in the works that we found at Auvers, after the burial, certain studies that look like old Delft tiles, antique enamels, certain rugged stubble fields, certain trees in motion evoke the country of those first breaths or stammerings.

Bernard did publish extracts from Van Gogh's letters in the Mercure de France *from 1893 to 1895.*

COLORPLATE 38

COLORPLATES 69, 49, 77, 60, 104, 105, 76

Favorite Arles motifs of Vincent's, except for the olive trees, which date to Saint-Rémy.

In a January 1889 letter to Gauguin, Van Gogh mentioned placing La Berceuse *in an Icelandic fishing boat to console the homesick. Possibly, in a lost letter to Bernard, with whom he discussed collaborating on brothel scenes, Van Gogh proposed the tavern setting.*

COLORPLATES 59, 60, 61

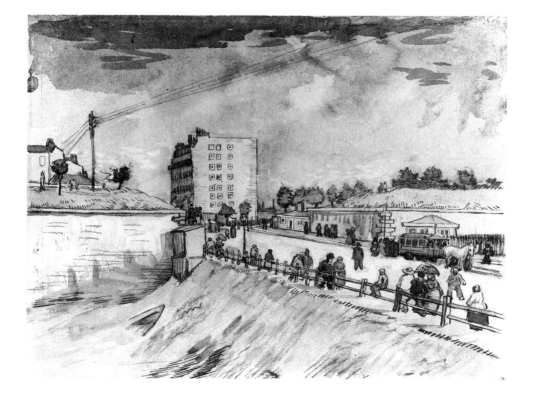

Street near the Ramparts. 1887. Watercolor, pen, and pencil. 9½ × 12⅝" (24 × 31.5 cm). Rijksmuseum Vincent van Gogh, Amsterdam.

Sketch of a projected triptych: *La Berceuse* flanked by *Sunflowers*. Letter to Theo. Late May 1889 (592). Rijksmuseum Vincent van Gogh, Amsterdam.

As incomplete as one work seems, taken by itself, seen in quantity, Vincent proves himself to be quite complex; a steadfast, vital turbulence endows it with a unity that, in the long run, demonstrates a highly balanced, logical, and conscious vision. Some saw only madness in the last canvases. But below the surface, what is that—or what should it be understood as—if not genius? Oh, I know that we have freely murdered our dreams and our abstractions: Having made our excesses the aim of art, we became dreadful egoists, thinking only about ourselves, we were unmindful of the roles of actor and clown that were assigned to us with the billing: Artist. And so they fling abuse at us when, disgusted with realities, we set sail for elsewhere, we absolutely refuse to entertain the crowds! Nonetheless, Van Gogh was a realist and a subjective, who went from dung heaps to dawns, full of love.

Des lichens de soleil et des morves d'azur,

and his brush painted them boldly, and his paint tube spit them out with the sublime breadth of vision of a drunken mystic and a creator in heat.

Let us exult before his biblical harvests at twilight, where sheaves, heavily laden with spikes, stack into mountains; where blades undulate like golden banners. Let us be sad before these somber cypresses that like magnetic lances spear stars on their points; at his nights like firework displays scattering comet-like tails amid the heavy, ultramarine darkness. Then let us dream under these beds of flowers that twinkle like fallen stars, on the peaceful banks of this river that flows without a ripple at the foot of suffering hills, bathing the shanties that the willows veil. And after these successive emotions, let us read in the eyes of his portraits the confessions of those existences, sad or shameful, good or evil. Then we will have begun to understand Vincent and to admire him.

As for me, when I look at this portrait that I have from his hand and that I have done my best to sketch for this publication, and when I think of all that he still could have done, I see the funeral procession that climbed up the hill of Auvers under a tropical sun, amid the rustling of ripe grains, and, also, that ignored grave from the depths of which he summoned his brother, who loved him so much, who was so devoted to him, and whose name will remain indissolubly linked to his own. . . .

Vincent van Gogh died at thirty-seven years of age.

Emile Bernard. *Portrait of Van Gogh* (after a self-portrait). Cover of *Les Hommes d'Aujourd'hui*, vol. 8, no. 390 (1891).

P.A.M. Boele van Hensbroek

DE NEDERLANDSCHE SPECTATOR

On Van Gogh at the Pulchri Studio

9 January 1892

Pieter Andreas Martin Boele van Hensbroek (b. 1853), Dutch art and literary critic who had met Theo in Paris and Vincent when the artist was at Goupil's, Paris (1875–1876).

How an artist can err to the point of madness, art-loving residents of The Hague have been able to see in Pulchri Studio for a fortnight. Drawings were exhibited there by Vincent van Gogh, a man little known here, but a Dutchman by birth and spirit. Many of the younger artists knew him, either here or in Paris, where he lived with his brother Theodorus. If ever a Dutch Daudet arises who can tell the story of these brothers in all its tragic simplicity, the Netherlands will be one masterpiece richer. . . . The drawings he made during those years were now to be seen for the first time. He himself never thought about exhibiting anything, too much convinced that everything was still in progress. True, they were not masterpieces, but from practically each work arose a sigh: If only he could straighten himself out! That was not allowed to happen. Consumed by his temperament, he died a few years ago, soon followed by his brother, who had shared *too much* his enthusiasm and his struggle. Only the names of the high priests remain preserved in art; but if the high goddess of art, who knows her servants, unites them around her, she will greet Vincent van Gogh as one of the choirboys in her temple, one who has given himself entirely to her without the least restraint and who perished serving her with indescribable love.

The first retrospective of Van Gogh's works in the Netherlands opened 19 December 1891 at the Pulchri Studio, The Hague.

Alphonse Daudet (1840–1897), Provençal author whose works Van Gogh admired.

Willem du Tour

DE AMSTERDAMMER

21 February 1892

Willem du Tour, pseudonym of Richard N. Roland-Holst (1868–1936), Dutch Symbolist painter. The February 1892 retrospective at the Kunsthandel Buffa, Amsterdam, was one of several mounted in 1892 and 1893 in the Netherlands by Theo's widow, Johanna van Gogh-Bonger, and a handful of Dutch artists. At the end of 1892, Roland-Holst organized the 112-work showing at the Kunstzaal Panorama, Amsterdam.

Our correct evaluation of Vincent van Gogh's art can run into two dangerous obstacles, and these obstacles are created by the many writers who have linked their appreciation of his art too much to Van Gogh the person, to his fanatical spirit and his consequent behavior. Because of them, Van Gogh's art has become the illustration of his sorrowful life-drama, a drama that is extremely attractive to many owing to the purity and tremendous dedication of the hero; but [it is] also seen by many as a diagnosis of mental illness that is understandable even to the layman.

Many people's appreciation of Van Gogh's work is unreliable because the nature of that admiration is not purely critical-artistic. Furthermore, many others do not approach the works open-mindedly; they interpret anything that strikes them as strange by imagining it to be the expression of an insane artist. Let anyone who wants to learn to appreciate Van Gogh's art go and see the paintings now on exhibit and forget the while all the stories currently in circulation about the artist. Let him go quietly to observe, with an intense desire correctly and purely to analyze the emotions produced by the work. Then one will notice that the roughness of the painting, initially alarming, is nothing but a strong

R. N. Roland-Holst. Cover design of the "Panorama" exhibition catalogue. 1892. Lithograph, first state. 6⅜ × 7⅛" (16.2 × 18 cm). Rijksmuseum, Amsterdam.

willfulness toward sharply outlined, vivid expression, that all the harshness of color and ruggedly energetic execution is a result of Van Gogh's desire to give infinitely more than he was able to give; he did not have the conventional know-how and was too uncompromising to tone down his ideals, but he partially succeeded, as far as producing an expanse of beauty. But let everyone notice above all that his work is made with love—not a tender love, steeped in a soft, luxurious longing for refined, sweet, gentle emotions, but a love emanating from a primitive human nature without real refinement or erudition. And just as a child delights in vivid color, seeking in that core of expression his full childhood fantasy, this child-artist has lived through his short life with the same rapture, to render the essence of color and expression.

Letter from Richard Roland-Holst to Jan Toorop

Follow-up to His Van Gogh Article

3 March 1892

That you like my little article about Van Gogh pleases me very much. Imagine, I received from Mrs. Van Gogh a long letter in which she said, more or less, that I had not dared to profess openly and generously my admiration for Vincent's work. I have preferred to leave that letter unanswered. Mrs. Van Gogh is charming, but it infuriates me when someone gushes fanatically about something of which she understands

Roland-Holst (Willem du Tour) refers to the preceding selection, admired by Jan Toorop (1858–1928), Dutch Symbolist associated with the Art Nouveau movement in the 1890s and a vital force behind the 89-work Van Gogh retrospective held that spring at Kunstkring, The Hague.

nothing, yet blinded by emotion she considers herself to be purely crit-ical. It is a schoolgirl's prattle, *voilà tout*. There are many artists, such as Monticelli, who touch me more than Vincent, because I continue to see something in his work that, especially in his best work, seems to be culled from many others. I feel more for Vincent van Gogh than for Jaap Maris; the reason is certainly found in the direction that Vincent wanted to take and that also occupies me at the moment. But if you talk about pure art sensations, I must say that others made me experience those better and more completely and intensely. In fact, it doesn't really mat-ter; you and others who are competent considered the article good, and Mrs. Van Gogh would prefer the piece that was most bombastic and sentimental—the one that would make her cry the most. She forgets that her grief makes Vincent a God.

Johan de Meester

NIEUWE ROTTERDAMSCHE COURANT

On the Exhibition at Oldenzeel's

6 and 13 March 1892

The March retrospective at Oldenzeel's gallery, Rotterdam, included 20 paintings and a number of drawings by Van Gogh.

Recently two painters of Dutch birth, who each possessed extraordinary yet very different talent and were known to only a few fellow-country-men, died in France, one shortly after the other. One was older than the other. One seeks in vain any work by the older one, Jongkind, in the Rijksmuseum; when the canvases from his estate were sold in Paris re-cently, our government left it to the French to demonstrate that Jong-kind must be honored as a master.

Johann Barthold Jongkind (1819–91), Dutch artist and major precursor of the Impressionists.

With regard to the younger one, the estate of Vincent van Gogh was brought over to the Netherlands through the dutiful concerns of rela-tives; they still belong largely to the family, but the public is offered the chance to become acquainted with them. Recently, drawings by Vincent, as he called himself, were exhibited at the Buffa gallery in Amsterdam; in the second half of this month the *Kunstkring* in The Hague will mount an exhibit of a selection of his works. Due to the good offices of Mr. Oldenzeel, who does so much for the more recent art, one can now see here in Rotterdam the work of the one who died so young, who was a painter for only ten years yet left behind several hundred canvases and drawings.

This exhibit will be like the case of Mr. Toorop's works: the public will be surprised seeing these drawings and paintings for the first time. There will certainly be people who shrug their shoulders, people who had a few drawing lessons in their youth, who had perhaps even han-dled a paintbrush, who therefore can judge and here will explain in good conscience—truly in conscience—that "that doesn't resemble any-thing."... The beauty of his work is not only completely different; it is so opposed to the beauty of paintings that one has previously admired that one unconsciously recoils upon looking at it. If one had not seen these other paintings, one would probably not be surprised, not shrink back, but the old impression is too vivid, the previously admired has

conventionalized the viewer in his taste. The truth of what is said here is evident in that Van Gogh's work again and again found admirers among the simplest country people, in whose midst he spent a portion of his life. Those people had never seen any good painting: Repeatedly they made comments indicating that they saw very well, clearly and correctly, and that they liked what they saw. . . .

He never attended an academy. He never made studies. For him every painting was a study. That large canvas came into existence as one sees it there. Vincent went outside with the canvas and there, with nature before him, he made his painting. Look at it now, as he saw nature: with immeasurable love, with extreme naiveté. Does it not become clear to you? This artist knew nothing, was not schooled in anything, had no tutoring; he saw, he felt, and he strove as far as he could. All schoolbook education is absent in this expression of the seen; the great impression of the visible is as thrown on the canvas—yes, that great impression is not lacking—and that great impression, *that* is what it is all about. . . . His manner of expression is gauche, clumsy, *sans façon*, apparently devoid of style; he applies his brushstrokes the way Zola writes his sentences—just like that naive colossus among writers, this inexperienced youth is attracted by the great, the titanic, the all-encompassing, the bustling: the singular is not enough for them, they want the total, the universal.

<center>* * *</center>

It may be accepted as certain that, in the future, the artist who died young will receive attention primarily for his drawings. Mr. Oldenzeel temporarily has a beautiful collection of them. Some are in portfolio, some are shown to their advantage in the quiet hallway on the second floor of the art dealer's beautiful home. . . . In those drawings, from the very beginning, as well as in what Vincent produced later, one sees very clearly the effort to immediately achieve the expression that synthesized what was represented. He was preeminently modern in this effort. Indeed, many younger artists in Paris have begun to see in him a *chef d'école*. He went through all the stages of their impatient seeking and striving. He took part in Pointillism, he let himself be counted among the Symbolists, . . . but compared to the often childish formation of schools, he always stood out by the personal nature of his work. . . .

Vincent's paintings to a large extent are nothing but colored drawings. Vincent never knew the wonderful luxury of long, slow transposition, careful applications of beautiful color. To him color was also a means.

<center>* * *</center>

He had wanted to achieve a great deal. Perhaps the unattainable attracted him too much. On the other hand, he was so naive! Among the confused dreams of his last days there was one about a popularization of art. He thought that it was selfish to keep art from the people; art had to become such that the people understood it. So he painted large canvases as classroom pictures, but always with some feeling, with artistic qualities. Then, another dream: the propagation of true art, the fight against painting for salons. In this, he counted on his brother, the art dealer who died shortly after him and because of him. For was it not a scandal that Gauguin suffered poverty, that Pissarro was not yet recognized and honored? And Vincent drew up an extensive plan to reform the customs and habits of the art trade. His brother was to bring that plan to fruition. . . . But soon after, in the summer of '90, he died, and his brother survived him by only several months. . . .

Johan Rohde

JOURNAL FRA EN REJSE I 1892
Diary Entries for Amsterdam and The Hague

1892

Johan Rohde (1856–1935), Danish artist whose enthusiasm for Van Gogh led him to purchase a drawing, Garden with Weeping Tree, *from Tanguy in 1892 and to plan the large Van Gogh exhibition at the Frie Udstilling in Copenhagen in 1893.*

AMSTERDAM, APRIL 1892

Saw at an art dealer's the best modern art I have seen so far on my journey—and probably some of the best I will come to see—namely, a couple of landscapes by Vincent van Gogh, an artist who has impressed me so deeply that I have gone from town to town in Holland to see other works by him, but without luck.

One of the landscapes showed a Dutch canal, the other most likely a southern French scene—a sun-drenched field with a harvester.

They were painted in light, soft, aquarelle-like colors, entirely devoid of black and brown, but neither the color, the brushwork, nor the composition was very radical.

The second one was somewhat similar to Pissarro in technique. In all, its style—strange as it may sound—it was very close to Joakim Skovgaard. Both Seligmann and I, independently of each other, thought of the latter when we saw Van Gogh's picture.

THE HAGUE, JUNE 1892

The Van Gogh Exhibition at "de Haagsche Kunstkring" In the month of June, I saw at the Art Association in The Hague an exhibition of Van Gogh's remaining works that had been on a tour of the larger Dutch towns. It didn't seem to draw much attention, and only a few pictures had been sold, although the prices were quite low. The show convinced me that

In February, several works by Van Gogh were shown at Buffa gallery, Amsterdam.

COLORPLATE 92

Joakim Skovgaard (1856–1933), Danish creator of murals and altarpieces in Scandinavia. George Seligmann (1866–1924), Danish painter living in the Netherlands and Rohde's traveling companion in 1892, helped him select works from the family's collection for the 1893 Copenhagen exhibition.

The Hague Kunstkring exhibition, from 16 May to 6 June 1892, included 45 paintings and 44 drawings by Van Gogh.

Garden with Weeping Tree. 1888. Pencil, reed pen, and brown ink. 9½ × 12½" (24.2 × 31.6 cm). Private Collection, New York.

my hunch had been right, that it would contain the best there is of modern Dutch art. Vincent van Gogh is for certain the greatest Dutch painter of this century and, in general, one of the great European trailblazers.

There were probably about fifty oil paintings of all sorts at The Hague—still lifes, landscapes, buildings, interiors, and portraits; in addition, a considerable collection of drawings.

Of the landscapes, which were the most interesting section, the best were again those dating from his stay in France. The Dutch pictures, with his strong colors, were not characteristic of Dutch nature; assuredly it is no coincidence that the heyday of Dutch art did not produce a single really sunny landscape with a clear, blue sky.

It appeared to me that what Van Gogh had done in Holland was not successful or less good—even the drawings.

On the other hand, no lively south European has probably managed to present the southern glow in such glorious colors and beauty as the redheaded, ugly northerner.

Van Gogh's coloring is actually the very simplest; he doesn't seem to have bothered to mix the colors. Frequently, they don't seem to have been on the palette at all but to have been squeezed directly out of the tube onto the canvas. That he was able to make all these strong, pure colors merge—that was his great art, which his lesser imitators will certainly not be able to copy. This artist, as a rule, uses a lot of color; he heaps one upon the other, finally pulling the brush, as it were, through a porridge of them—when he doesn't prefer to do without the brush altogether. I must observe immediately, however, that his best pictures appear to me to be those in which one can follow the deliberate strokes of his superior, big brush. Yes, this painter who, like most of his colleagues, was an experimenter, knew exactly what a brush can achieve by, as it were, molding the thick color; for example, in a field, by placing the sheaves, which are differently illuminated in nature, at different angles in the picture so they will reflect the light in different ways. I have never seen a rolling, vibrating, light-drenched field presented in a more striking manner than in such pictures by Van Gogh.

Nor, probably, does the "contrast" in the juxtaposition of colors appear more strongly in any painter's works than Van Gogh's. True, Böcklin uses strong colors, probably just as strong as Van Gogh, but they *look* strong, too; not so, Van Gogh's. It is only when the pictures of this painter hang side by side with those of others that they appear so violent. Because he constantly reaches the apex of color and light, one color modifies the other. Thus, there was an absolutely delightful picture of a garden in Provence. An evening picture with a sky painted in a pure unmodulated green—a color not unlike that used on hoarding. *One did not see it*; there was a beauty in the whole color of this picture that was incomparable. Yet it is not only the color that interests him but, contrary to the very youngest "chromo-luminarists," also the form; his trees and bushes and clusters of flowers are molded with a vigor and freedom that is seldom seen in a landscape painter *ex professo*.

As far as his motifs, they are usually the very simplest; he does not need, as so many modern painters do, to go from place to place to look for something called motif. He takes what is there—an ordinary garden with man-made paths, clusters of flowers, and pruned trees—and he makes something beautiful and pleasing out of it. Most often it is sunshine he paints, either when the sun is highest in the sky or when it is about to set, and he doesn't shrink from painting the sun itself, which other painters as a rule respectfully avoid. Again and again he takes on this most difficult of all problems of the painter's art. Of course, it cannot be solved, but it has nevertheless given Van Gogh the opportunity to create some of his most interesting pictures.

COLORPLATES 92, 70

Once in a while he also paints gray skies and rain, for instance, rain falling on flowering fruit trees.

Perhaps, however, Van Gogh's talent has unfolded most simply and most beautifully in some unassuming pictures of flowers, for example, a picture of a blue iris and another of pink roses.

No flower painter has ever, as far as I know, done anything more beautiful than these two pictures, painted with Van Gogh's usual brush but presenting not only the color of the flowers but also their entire delicate form, and, of course, with the greatest general effect and decorative skill in the use of color juxtaposition.

Some of the portraits were good in character but rather rough-featured, and individual pictures were not without apparent influence from Raffaëlli. A couple of pictures were almost plagiarized from Millet.

In contrast, a series of pen drawings depicting landscapes took a very prominent place in the exhibition. They were done with such grandeur, decorative skill, and so characteristic a way of drawing that they even captivated as skeptical a viewer of much of the new art—and of Van Gogh's *paintings*—as Kröyer (he had the opportunity to see some similar drawings in Paris), prompting his exclamations of admiration.

Cecilia Waern

THE ATLANTIC MONTHLY

"Some Notes on French Impressionism"

April 1892

One man in particular has the faculty of inflaming your imagination, till you feel ready to declare him one of the bringers of heavenly fire. And yet his art is mad. Your first impulse is to laugh at these staggering cottages with flaming red roofs, or at this blaze of rockets and Catherine-wheels, supposed to represent night. But your laugh dies on your lips; you go on gazing, stupefied yet interested; and when you at last leave the exhibition, you do not know whether you have been looking at the pictures of a madman or not, but you have forgotten all the other pictures in the room. Such was my first impression of Vincent van Goghe's [sic] work, and I was not astonished to hear that the man had committed suicide. I sought every opportunity of seeing more of his art, and thus one day I went to the studio of M. Gauguin, in one of the distant unconventional quarters of Montparnasse, where some of his pictures were to be seen. It was all very remarkable. Among things that were not merely exaggerated, but violently distorted, there were some splendidly conventionalized flowers—gorgeous sunflowers, and huge white roses on an apple-green background. There was an Alpine pass, absurd in color and handling, in streaky waves of dark paint, yet with more of Dante's Inferno and the awesome weirdness of desolate Alpine passes toward twilight than many better pictures. There was his own portrait, drawn with a firmness of hand which accentuated every angularity of that powerful skull and bony face, while he had chosen to give himself a green background that threw the most uncanny greenish reflections over the sandy-blond face. It is the face of a maniac or a criminal, with the eyes of a longing soul.

Another day I was taken to Montmartre, to the little shop of le père Tanguy, full of the works of the *néo-impressionnistes*, and several Van Goghes among them. Many were exaggerated, every one was sincere,

Gauguin acquired a number of works of Van Gogh by exchange: among them, one or two 1887 Sunflowers *(for his Martinique landscape), a self-portrait, and* Ravine.

COLORPLATES 37, 108

COLORPLATE 65

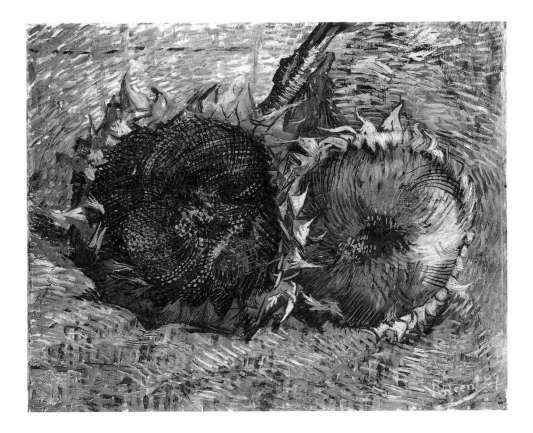

Sunflowers. 1887. Canvas. 19⅝ × 23⅝" (50 × 60 cm). Kunstmuseum Bern.

and two studies of figures were superb. One was a sower of the most splendidly energetic movement; another an old man weeping, bent down over his hands in a perfect abandonment of grief.

Le père Tanguy is himself a martyr to the cause of *néo-impression-nisme.* His shop was very difficult to find, as he is constantly shifting his quarters, from inability to pay his rent. No one knows what or where he eats; he sleeps in a closet among his oils and varnishes, and gives up all the room he can to his beloved pictures. There they were, piled up in stacks: violent or thrilling Van Goghes; dusky, heavy Cézannes that looked as if they were painted in mud, yet had curious felicities of interpretation of character; exquisite fruit-painting by Dubois-Pillet, which showed how he could paint when he chose; daring early Sisleys, that made the master of the shop shake his kindly head at the artist's later painting; and many others, all lovingly preserved, and lovingly brought out by the old man. Le père Tanguy is a short, thick-set, elderly man, with a grizzled beard and large beaming dark blue eyes. He had a curious way of first looking down at his picture with all the fond love of a mother, and then looking up at you over his glasses, as if begging you to admire his beloved children. His French and his manners were perfect; and when he took off his greasy cap and made his bow, it was with all the grace and dignity of the old school. He has gone on for years finding the impressionists in colors, etc., and the artists I was with told me, after we left the shop, that many a time had he been sorely in need of money and had gone to remind some artist of an outstanding bill, but found some excuse for his call and come away again without mentioning it, because it seemed to him as if the artist were in straits.

I could not help feeling, apart from all opinions of my own, that a movement in art which can inspire such devotion must have a deeper final import than the mere ravings of a coterie.

The subject of the old man weeping, "Worn Out," was explored in a painting, two drawings, and a lithograph by Van Gogh.

Francis

LA VIE MODERNE

"Van Gogh Exhibition"

24 April 1892

Le Barc de Boutteville, that valiant and hospitable protector of the young and the derided, has brought together in his rue Pelletier shop sixteen canvases by Vincent van Gogh.

For a long time this painter was considered a kind of madman, very much a prankster making fun of the public.

Indeed, Van Gogh had, perhaps, the good fortune to be somewhat mad—but a prankster, never. One has only to look at the series exhibited today to understand that he was an enthusiast acting in earnest. One sometimes denies inspiration in painters; Van Gogh, however, who never had a teacher and did not touch a brush before he was twenty, was incontestably an "inspired" one.

The first paintings are relatively quite reasonable. One feels that he is trying himself out, that he is studying; next comes the need to produce freely, without attending carefully to anything anymore; then he does his canvases in a feverish state, skillfully modeling in the paint itself.

Let no one think that he spread his colors haphazardly: on the contrary, his paintings denote an experienced colorist's uncommon eye.

I must admit to seeing Van Gogh until now only as a colorist, so I am very interested in the drawings that show Vincent from another angle. Van Gogh, whom no professor taught the art of drawing, has nevertheless executed some drawings of the highest order. Isn't that an undeniable example of what I advanced just now concerning inspiration?

They are landscapes, almost always without figures and very simple in composition: an immense plain, a few sheaves of hay—that suffices the artist.

Let those who deride him go to Le Barc. They will be forced to admit that many so-called serious artists would be incapable of doing landscapes in pen like those on exhibit.

Theo's plans in the fall of 1890 for a Paris retrospective were brought to fruition by Bernard in the April 1892 show at Le Barc de Boutteville, a gallery that promoted many unestablished Post-Impressionists.

Cartoon from Francis's review "Exposition Van Gogh chez Le Barc de Boutteville." In *La Vie Moderne*. 24 April 1892.

Camille Mauclair

LA REVUE INDEPENDANTE

"Galerie Le Barc de Boutteville"

1892

Camille Mauclair, pseudonym of Séverin Faust (1872–1945), novelist, poet, essayist, and art critic.

Here are exhibited seventeen canvases and several drawings by Vincent van Gogh. The canvases are marvels of intense color, of a glowing, glorious vision of nature. They are striking for the tragic exaggeration of certain aspects and for the incredible fury of the colorist's feeling. The plains, the rocks, are endowed with terrible and chaotic aspects. The stagnant waters are inextricable from fields and flowers. The skies are

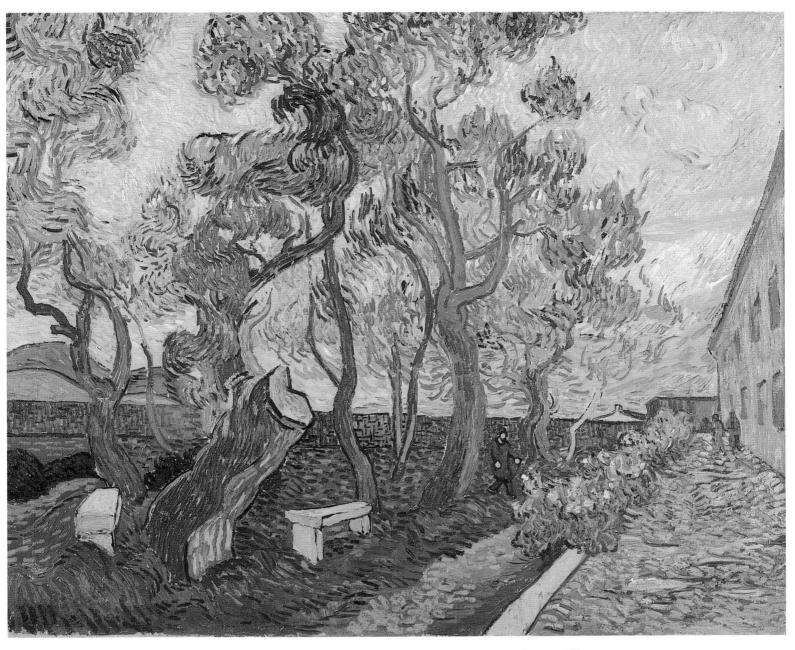

COLORPLATE 103. *Corner of the Asylum and Garden.* 1889. Canvas. 29⅛ × 36¼″ (73.5 × 92 cm).
Museum Folkwang, Essen.

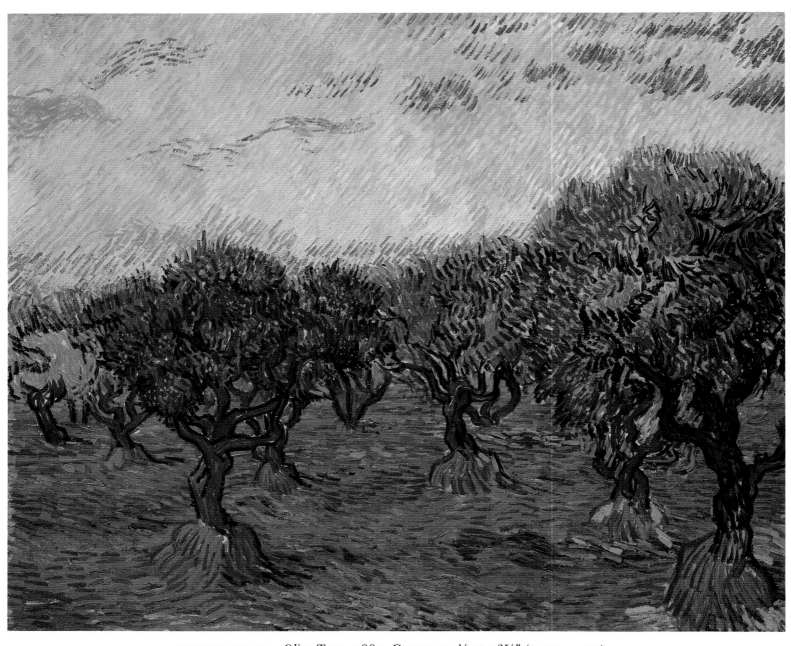

COLORPLATE 104. *Olive Trees.* 1889. Canvas. 29⅛ × 36⅝″ (74 × 93 cm).
Göteborgs Konstmuseum, Göteborg. Photograph: Sixten Sandell.

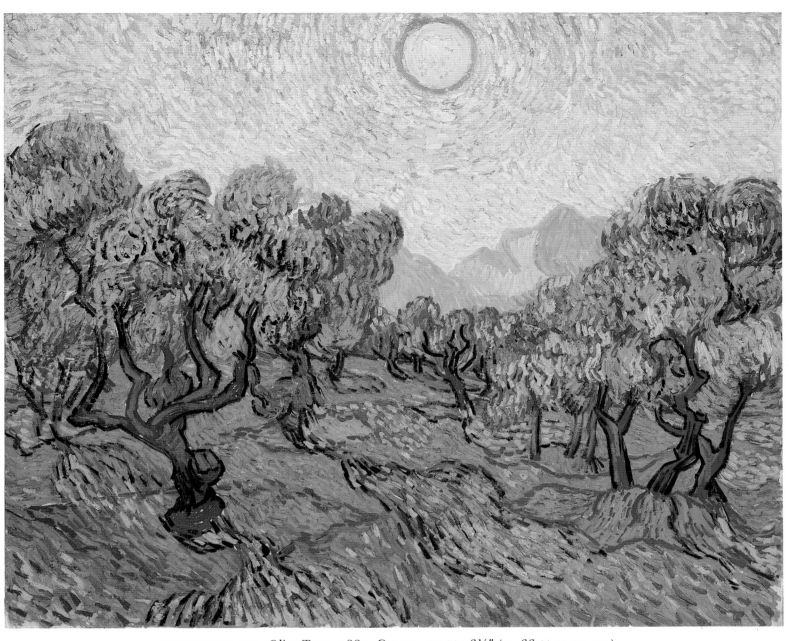

COLORPLATE 105. *Olive Trees*. 1889. Canvas. 29 × 36½″ (73.66 × 92.71 cm).
The Minneapolis Institute of Arts; The William Hood Dunwoody Fund.

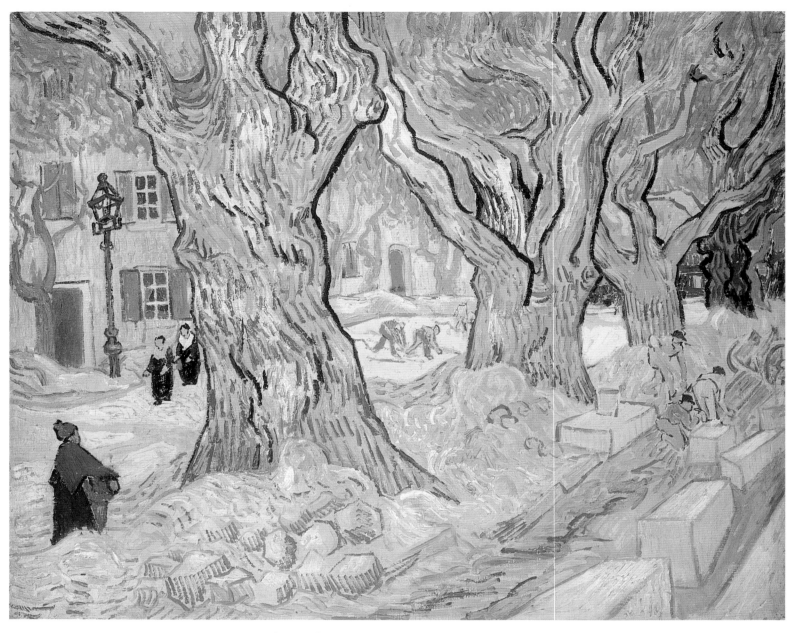

COLORPLATE 106. *The Road Menders.* 1889. Canvas. 28 × 36⅝″ (71.1 × 93 cm).
The Phillips Collection, Washington; Acquired: Miss Elizabeth Hudson, 1949.

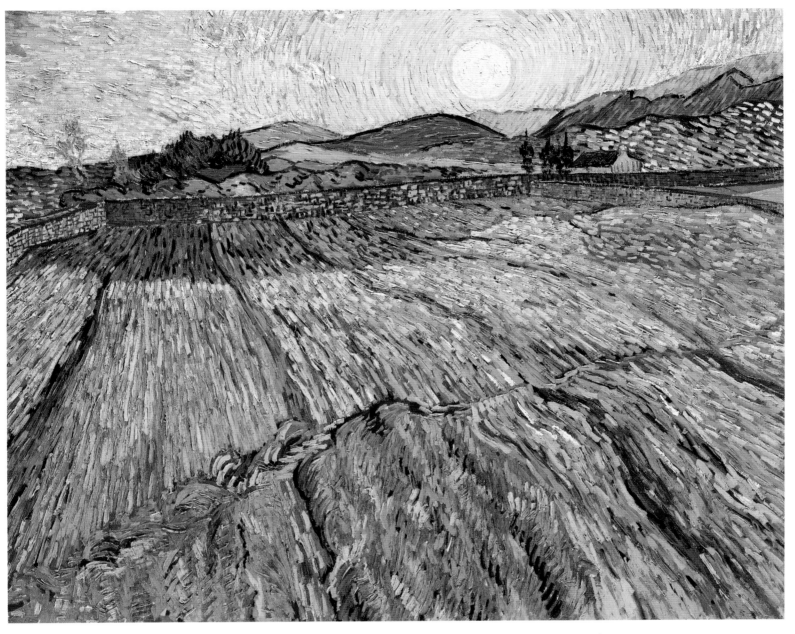

COLORPLATE 107. *Wheat Field with Rising Sun.* 1889. Canvas. 28 × 35⅞″ (71 × 90.5 cm).
Private Collection. Photograph: Sotheby's, New York.

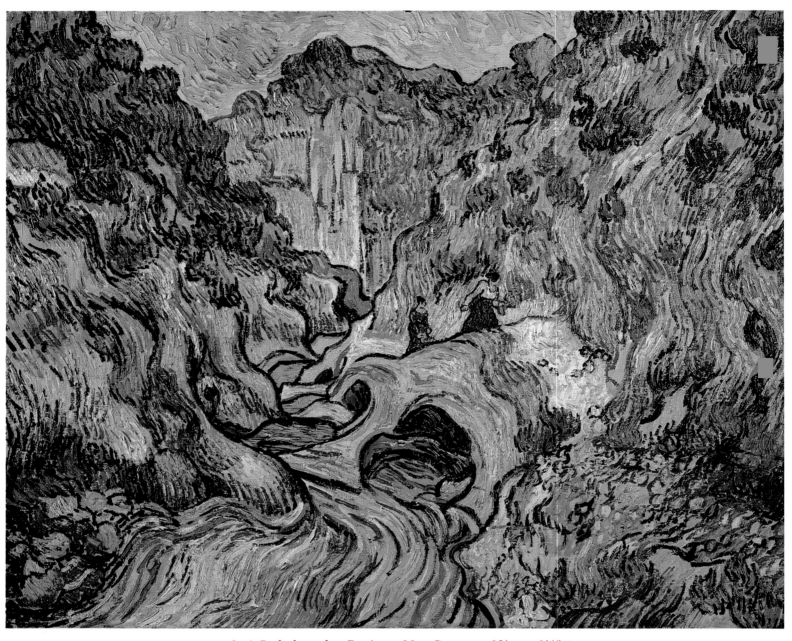

COLORPLATE 108. *A Path through a Ravine.* 1889. Canvas. 28⅜ × 36¼″ (72 × 92 cm).
Rijksmuseum Kröller-Müller, Otterlo.

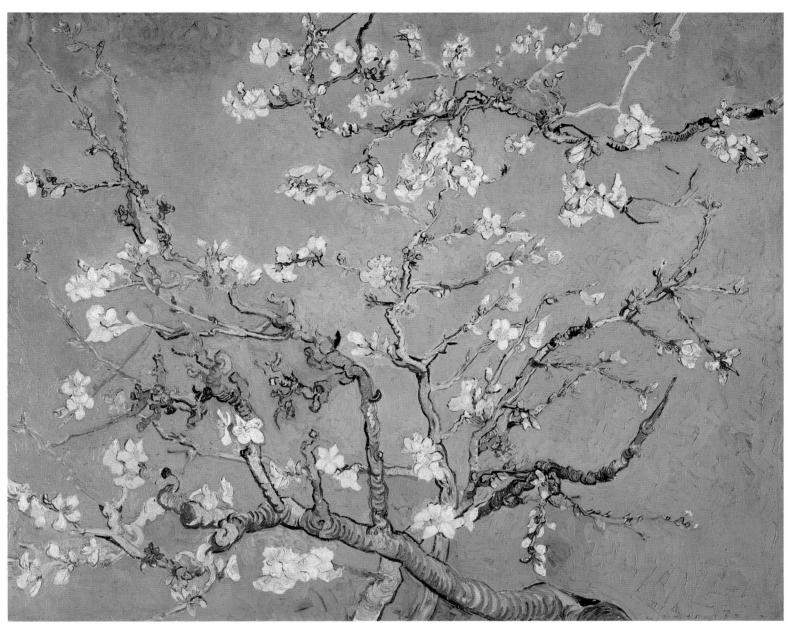

COLORPLATE 109. *Branches of an Almond Tree in Blossom.* 1890. Canvas. 28¾ × 36¼″ (73 × 92 cm).
Rijksmuseum Vincent van Gogh, Amsterdam.

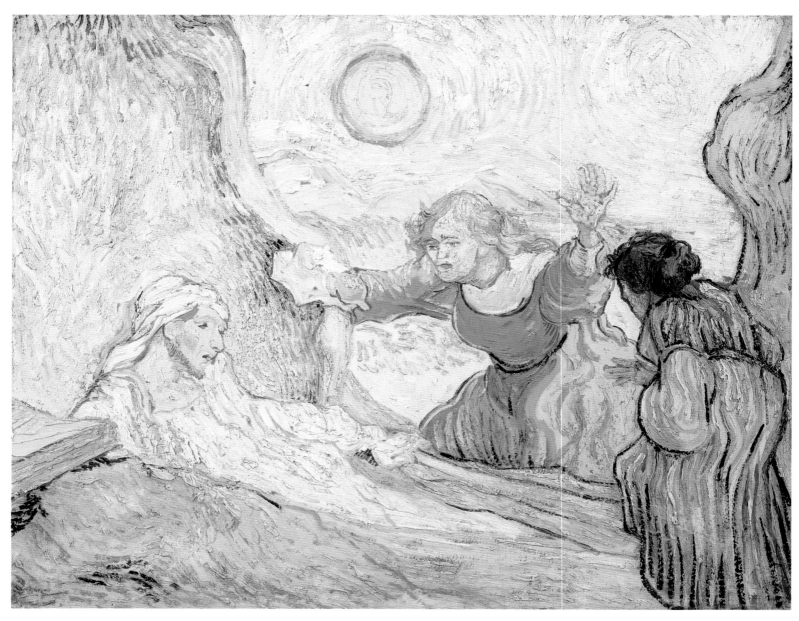

COLORPLATE 110. *Raising of Lazarus* (after Rembrandt). 1890. Canvas. 19¼ × 24¾″ (48.5 × 63 cm).
Rijksmuseum Vincent van Gogh, Amsterdam.

furnaces of marvelous flames, magical spectrums of chrome azure, mauve, and purple. The observation of reality crumbles and is bewildered as before an unknown drama of the corporeal and the ethereal: everything breathes abnormality and fulmination. Everything seems unfinished, unexpected, terrible, and yet we do not see here, regrettably, those strange last canvases where the skies are populated with comets and worlds in labor revolved in frightful dizziness. Alongside these dreams, exquisite roses and dazzling sunflowers astonish and charm with their gentleness. The awkwardness of design merges with bizarre observation in the studies of beings, and the drawings are of a somewhat outdated Japanese mannerism. All of it by a great, yet incomplete, artist, who appeared like a meteor and disappeared too soon, like Monticelli, like Seurat perhaps, to long-standing regret.

Charles Saunier

L'ENDEHORS

"Vincent van Gogh"

24 April 1892

Charles Saunier (b. 1865) wrote on French nineteenth- and twentieth-century painting and decorative arts.

THE OLD MAN MAD FOR DRAWING HOKUSAI

A madman for color, this painter. Yet no one seemed more predestined to the pain of tranquil things. Born in Amsterdam [sic] to the Dutch life, to a Protestant pastor father; a coddled childhood augured a peaceful existence embellished by the flowering of rare tulips, perpetuated by some close-knit and healthy family group, like those honest parents of Adriaan van Ostade who, for two centuries smile in their frame at the Louvre. He was helpless. Like that other bastard, Anacharis Cloots, who naively left the beautiful country of Clèves for the excitement of France, Vincent van Gogh went against the grain of his race: he loved rebellions, light and color—all colors. And his physical nature responded well to his intellectuality: a thin frame, prominent jaw, a strong nose, and very large eyes beneath arched furrowed brows, deeply sunken eyes absorbed in the contemplation of some object or else vaguely annihilated by interior thought—give his physiognomy a character of illuminated goodness.

Destined for theology, Vincent van Gogh abandoned it for art. Rembrandt inflames his enthusiasm, as do Delacroix and Corot, the sweet poet. In Paris, after spending time at Cormon's atelier, he felt free; it was Corot who obsessed him. A study of the Moulin de la Galette is characteristic in this regard. The silvery skies. The delicate greens just distinctive enough, the haziness, and also the imperceptible note of mauve and orange, dear to the painter of Ville d'Avray, present here in the shawls of two strolling women. Soon the Monticelli's, in revealing to him unknown splendors, exasperate his neuroses for color. How could one remain indifferent before the magical evocations, the splendid scenery, the brilliant kaleidoscope of the painter from Marseilles? Thus, from Vincent van Gogh, studies of flowers, or rather: against sumptuous, carmine-lacquered backgrounds burst velvety geraniums, frail roses, corollas of gold or azure. But, forever smitten by the potential of light and color, he visits the Midi: Arles, Saintes-Maries, Marseilles. Then, on his canvases, in powerful flat tints or in tints passionately divided, blaze forth skies: a blue, massive overhanging, pink over fields of silvery olive trees,

The Ville d'Avray painter: a further reference to Corot.

gilded by the splendors of the setting sun. In other canvases, tall cypresses surge upwards, protecting dreaming figures; the autumnal Alyscamps: beneath a green sky, among the yellowed trees and ancient tombs an Arlésienne and a few officers melancholically trample the dead leaves.

Weary of this parched nature, Vincent van Gogh retires to the banks of the Oise and applies his imagination to rendering the vernal joy of the orchards, the freshness of the flowering hillsides: thatched cottages veiled by rosy apple blossoms, grassy terrains twinkle with little white flowers, hedges guarded by heavy sunflowers, or delightful cottages painted pink and embellished with shutters, like that of Daubigny's House at Auvers, or moreover: the distinct mauve of the summer shadows in wheat fields on the hottest days, the splendor of a gold-scrolled sky hanging over tawny fields where the reapers move about, drowned, washed out by the iridescent light.

Concurrently, the boldness of his tonalities asserts itself in remarkable flower studies: from a Japanese vase spread the graceful curves of fresh roses standing out against a cheerful green background: his special idealism took pleasure in symbolic compositions inspired by Rembrandt's etchings or Delacroix's drawings. Hence this *Resurrection of Lazarus*, in mauve and lemon yellow, which created a sensation at the Indépendants of 1891; these ink sketches with the simplicity of wood-

Probably a reference to the vertical canvas, Les Alyscamps, *presently in a private collection.*

COLORPLATE 110

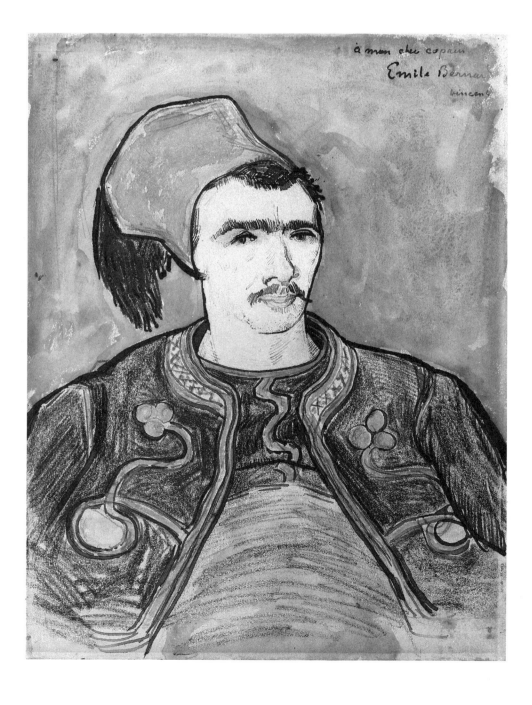

The Zouave (dedicated to Emile Bernard). 1888. Pencil, reed pen, brown ink, wax crayon, and watercolor. 12⅜ × 9¼″ (31.5 × 23.6 cm). The Metropolitan Museum of Art, New York; Gift of Emanie Philips, 1962.

cuts. At times the exacting and levelheaded observer asserted itself in drawings enhanced with watercolor (see, at Le Barc's, a precise study of a Zouave), in psychological portraits; against the background of an atelier decorated with various Japanese prints, the old color merchant Tanguy, gentle and smiling beneath his straw hat, is seen seated, in a sweater, hands crossed in a self-conscious very characteristic gesture.

COLORPLATE 39

Vincent van Gogh's technique was complex. Most often he proceeded by flat tints, occasionally by divided tones—but without method—finally by masses of paint troweled on and modeled with the brush handle; hence the extraordinary mulberry tree sculpted in a thick layer of cobalt and chrome yellow. This painter loved light and color and desired a simple art. But, by means of his personal synthesis of lines and tones, he arrived more often at a complex, wholly intellectual art. He nevertheless gave a clear, precise impression of cheerfulness in his Auvers orchards and did attain simple goodness in the portrait of Tanguy.

COLORPLATE 98

If this original artist, who died young at thirty-four [sic] years old, was unable to entirely realize his dream, others whom he loved had attained the ideal. One such was Camille Pissarro, whose simple and very good, albeit artistically sumptuous, art evokes the phrase Vasari used in speaking of Giotto: "He renewed art because he put more goodness into it."

Frits Lapidoth

DE NEDERLANDSCHE SPECTATOR

"Paris Chronicle"

5 May 1892

Frits Lapidoth (1861–1932), Dutch critic and novelist.

Our poor countryman Van Gogh has his unfortunately temporary little memorial in the rue Lepelletier. Those strange paintings bear witness to the striving for an artistic formula by an indisputable genius, who was overcome in the struggle for an artist's existence. The work by "Vincent," as one calls him here, will endure as a historical document. I am convinced that something of which we do not yet dream will be discovered along the path he indicated: a truly modern art, somewhat like the music of Wagner. But Wagner was a complete genius. His successors are below him, whereas the students of the genius Van Gogh, though perhaps less gifted than the master, produce work that is considerably more complete. It could be that Wagner remained alone, as a giant, a truly classical artist. A sequel to Van Gogh's painted *oeuvre* is not only possible but necessary. I think that no single artist with an ounce of love for his profession and an ounce of feeling for the truly artistic can leave that little store in the rue Lepelletier, which doubles as an exhibition hall, without trembling with deeply felt emotion, without a tear of mourning and a strong feeling of respect for the great artist who lived like a petty farmer and died as a certain, great, modern king. . . .

The memorial is the Le Barc de Boutteville exhibition.

Richard Wagner (1813–1883), German composer lauded by Baudelaire and the Impressionists and "adopted" by the Symbolists as the master of correspondences between music and poetry.

But reality calls me to the Salon on the Champs Elysées. One understands better there than anywhere else why Vincent van Gogh, with the stubbornness of a martyr, rejected making any effort to come closer to the public at large. If there is something willfully eccentric in his work—I speak hypothetically—this must be explained by the artist's aversion to the clever, vacuous canvas-smearing that dozens of contemporary painters offer to the public yearly, and for which some of them are crowned and decorated.

Charles Merki

MERCURE DE FRANCE

"Apologia for Painting"

June 1893

The Symbolists, idea-ists, and other decoratists being rather permanently installed at M. Le Barc's, whoever wants to carp about their future can go smoke cigarettes in front of his store's stove, which is always copiously stuffed as soon as winter sets in. A confrontation costs no fatigue and becomes almost pleasant to undertake. Waiting for the ideal critic—nothing of M. Taine's sort, naturally—who will effect the miracle of establishing peace in the quagmire, cool-headedly set things back in order, and discuss with complete certainty the theories and the experiments of everyone. The amusement of a quarter-hour will be perhaps to examine—instead of accumulating praise or invective—what the most recent newcomers pretend with their disconcerting pancakes, or perhaps to establish, with the exponents of the "new trends in painting," whether the adventurous attempts in which one has tried to recognize the theories manifested are worth such long and boring quibbles, and whether there are any pieces at all in the art of the past worth saving from the ruins—and finally, to ascertain whether the bewilderment of the curious in front of Vincent van Gogh's pastries and Madame Jacquemin's corpses is in all honesty not a little bit legitimate.

* * *

The disastrous effect is worse if we consider, concurrently, the new painting in its multiple incarnations. Let us go into M. Le Barc's, into the last room of the Indépendants, so properly named the *Room of Horrors*.

* * *

The landscapes, of course, are not all worthy of scorn.

* * *

But I don't consider myself happy in naming Van Gogh. He is a genius, a born colorist (you know that today genius is recognized the world over). Not only has he found admirers but also imitators. His color—so abundant and, in many places, a few centimeters in height—has caused infatuation. How can one not believe in a practical joke? This man fought with his paintings. He stoned them to death with pellets of earth. He took the mortar from a pot and flung it in front of him, relishing the joy of bombarding an unbeliever. Full trowels of yellow, red, brown, green, orange, and blue having splashed out like bursting fireworks, or like a basket of eggs thrown from a sixth floor, he sprayed streams of paint on the whole affair and traced on it, eyes closed, a few lines with his finger dipped in ink. Apparently all this is supposed to represent something; it's by pure chance, undoubtedly. As a current gossip has it, one can't tell "if the coach is a pair of shoes, or the shoes a coach."

COLORPLATES 28, 72

VAN NU EN STRAKS

Preface

August 1893

A. M. Hammacher has suggested that this unsigned preface to the Van Gogh issue of the Flemish journal, Van Nu En Straks, edited by founder August Vermeylen, was by Henry van de Velde (1863–1957), Belgian architect, critic, and spokesman for the Art Nouveau movement. The issue included numerous excerpts from the letters and dedicatory prints by Toorop, Roland-Holst, and Thorn Prikker.

Given the opportunity to fill these pages with something of beauty, and also having everything we needed at our disposal, our desire—until recently just a vague idea—to erect a memorial to the glory of Vincent van Gogh began to take shape.

We wanted the tribute to be a lasting one: a tribute that would acknowledge both the vanity of the artist wanting to survive through his work and the immediate pride of achievement ennobled by a clear vision. Yet, we might have hesitated to undertake this project if only supplied with construction materials of dubious value. However, we were able to discover a rich quarry—a place where Vincent piled up sentences like solid stones.

The catalogue of the recent Amsterdam exhibition, organized by friends as anxious as we to honor Vincent, revealed this hidden treasure to us. With great excitement, we approached Mrs. Van Gogh, Theo's widow, and asked permission to draw from this wealth that she so reverently preserved.

Meanwhile, the *Mercure de France*, to which the painter Bernard had sent his enthusiastic tribute, preceded us in the publication of letters from the last period of Vincent's life—the period when he lived in France. These letters have drawn much attention there.

It is only fair that this grandiose project was conceived there; a stately monument, supported only on Vincent's native soil, would have collapsed, pedestal and all. Distance is unable to shatter the dream: even Van Gogh himself, while deep in Provence, never forgot his native country or the empty skies above his hillside dwelling.

Architects and planners would probably see this construction method as strange—building the base of our monument (our part of the work) from a selection of letters from 1882, when the artist first tried his hand at painting, even though the top had already risen high into the clouds. But this is how the spirit of the artist always operates. We might believe that he toils for Him who dwells on high, and that he proceeds on the basis chosen by Him.

Nevertheless, even when such work starts in the vast heavens that never seem vast enough, all work must end here on the terrible earth. The law of gravity extends its power to the realm of hopes and dreams, too.

Jan Toorop. "Ik heb gezaaid, ik heb gesproken, ik heb geluid, rijs op, mijn ziel!" ("I sowed, I spoke, I rang, rise up, my soul!").

R. N. Roland-Holst. Vignette.

J. Thorn Prikker. "The Sower."

Woodcuts appearing in *Van Nu en Straks*, Van Gogh issue of 1893. Kunsthistorisch Instituut der Rijksuniversiteit, Utrecht.

It is possible to measure just how little time it took Vincent to sink from this height of rapture and faith to his death. The evidence comes from a series of letters we have made available for the first time.

With heartfelt grief, we are mindful of the black hours that destroyed such an exceptional genius. Yet a disturbing thought crosses our mind: Might he well be the last of such geniuses? This fear should alone bear witness to his genius.

Ambroise Vollard

RECOLLECTIONS OF A PICTURE DEALER

1936

Ambroise Vollard (1868–1939), art dealer and promoter of Impressionist and avant-garde art, through both his gallery and publications. He shrewdly bought Van Gogh works early on, from the Roulin family and others.

[By 1901] . . . I was no longer living at the top of the rue Laffitte, but had taken a big shop with an *entresol* at No. 6, near the Boulevards. To celebrate the opening of my new gallery, I had organised an exhibition of Van Gogh's work, which included more than sixty paintings from his studio in Amsterdam, without counting a lot of his watercolors and drawings. The most important of the pictures, such as the famous *Poppy Field*, was not priced above four hundred francs. But except for the young painters, the public showed little enthusiasm. The time was not ripe. There was a couple, though, who appeared more interested than the rest. The man grabbed the woman suddenly by the arm, and said to her:

This exhibition, which received little public notice, was held in 1897.

COLORPLATE 91

"You who always make out that my painting hurts your eyes—well now! What do you say to *this*?"

The woman, at that moment, was inspecting three portraits of Van Gogh by himself, in each of which one ear was hidden by a lock of hair. I went up to the lady:

"Those portraits," I said, "were painted after Van Gogh had cut off his ear."

"Cut off his ear?"

"He had been spending the afternoon in conversation with a couple of prostitutes. When he came home, he opened his Bible without thinking, and came upon the passage which says that if one of your organs offends you, you should cut it off and throw it into the fire. Applying the text to himself, Van Gogh took a razor and cut off one ear."

"And threw it in the fire?"

"No. He wrapped it in a piece of paper and took it to the ladies' house. 'Give that to Madame Marie,' he said to the maid who opened the door."

"How extraordinary!"

There was another visitor who came back every day towards evening. He would begin by casting a glance at the window, where the *Aliscans d'Arles* [Alyscamps] was blazing, and then come into the shop and walk round. After a bit he would begin to talk. He was unwearied in his enthusiasm for the *Poppy Field*. One day I missed him at his usual hour. He did not turn up again till several days later.

"I haven't been able to come all this time. My wife just had a little girl. We are already thinking of her future, and we have decided, by way of

dowry for her, to buy things that are bound to go up in value—pictures, for instance."

I saw my *Poppy Field* sold. Instinctively I glanced at it. My man followed the glance.

"If I had money to spare," he said, "that painting would have been in my house by now. But, you see, I have a child on my hands now; I must take life seriously. Fortunately I have a cousin, a professor of drawing of the City of Paris, who will be able to advise us."

It was some time before I saw my man again; and then one fine day he reappeared with a portfolio under his arm. "It's done," he announced. He tapped the portfolio: "The little one's dowry is in here!" He took out a *Fantasia* by Detaille:

Edouard Detaille (1848–1912), French academic history painter who specialized in battle scenes.

"My cousin managed to get this for me for only fifteen thousand francs. In twenty years' time it will be worth at least a hundred thousand."

About twenty-five years later, the man with the Detaille watercolor came into my shop in the rue de Martignac.

"Now," he said sadly, "the time has come to part with it. My daughter is getting married."

I asked him if he remembered my Van Gogh exhibition, and the "poppy" picture that he appeared to like so much.

"That's a long while ago," he said. "Fortunately I kept my head. What would a picture-dealer give me nowadays for that *Champ de Coquelicots*?"

"Well, my friend, you'd get more than three hundred thousand francs."

"What about my Detaille, then?"

"Your Detaille! The Musée du Luxembourg has had what was considered his masterpiece—the *Battle of Huningen*—taken up to the garret, and even the rats won't look at it."

One day at my place Renoir saw some charcoal drawings by Van Gogh of farm laborers at work:

"God! What a fine thing that is! What would Millet's snivelling peasant look like beside it!"

Jean Renoir

RENOIR, MY FATHER

1958

Jean Renoir (1894–1979), film director and son of the painter.

In talking to me of the time when he lived in the rue Houdon, my father happened to mention Van Gogh's death: "Not a very flattering event. Even old Durand was not aware of what Van Gogh's painting meant." This indifference towards a man who was obviously a genius was, in his view, a condemnation of "this whole century of babbling idiots." I asked if he believed that Van Gogh had been insane. He replied that to be a painter you had to be a little mad. "If Van Gogh was mad, then I am, too. And as for Cézanne, he would be a strait-jacket case." And he added: "Pope Julius the Second must have been insane. That's why he understood painting so well."

The art dealer Durand-Ruel had declined to sponsor a retrospective of Van Gogh's works in 1890.

Leon Daudet

L'ACTION FRANÇAISE

"The Prince of Light: Claude Monet"

8 December 1926

Leon Daudet (1868–1942), son of Alphonse Daudet and a writer and founder of the royalist Catholic paper L'Action française.

But wait: I can once again see, though it was many years ago, Monet speaking with Mirbeau about another famous painter, Vincent van Gogh, on the subject of a path of irises, a canvas that in Mirbeau's nervous, blond-haired hands gloriously shimmered in the light.

"How, ah! how," Monet was saying, "did a man who loved flowers and light to such an extent, and who rendered them so well, how then did he still manage to be so unhappy?"

The critic Octave Mirbeau had acquired Van Gogh's Irises *in 1892.*

COLORPLATE 87

Julien Leclercq

EXPOSITION D'OEUVRES DE VINCENT VAN GOGH

15–31 March 1901

The March 1901 exhibition at the Bernheim Jeune gallery in Paris included 65 paintings largely from Van Gogh's French period (1886–1890) and had a great impact on the emerging Fauves, among them Derain, Vlaminck, and Matisse.

The numerous exhibitions and the great sales of the last five or six years have finally assured the victory of the Impressionist movement, preeminently a French movement in art, which had from its beginnings very great repercussions and which now constitutes a handsome chapter in the history of painting. A classification and selection process has taken place among the works of the first masters of the movement: to each one has been attributed a part in the originality and influence of the collective effort.

Monet, Degas, Renoir, Pissarro, and Sisley are today incontestably glorious names. Cézanne is in the process of receiving recognition after a long period of unassuming labor. There are still two or three among the first to throw themselves into that heroic battle whose work is insufficiently recognized and whose place is imperfectly demarcated. They are Armand Guillaumin, Paul Gauguin, and Vincent van Gogh. For them, too, the time will come. The time *has* come. The present exhibition will allow those who are unaware of Vincent's work to render him justice. Alas! it can be only a posthumous reparation.

* * *

At The Hague, at Drenthe, at Nuenen, Vincent painted, in a black, vigorous manner, some landscapes, a great number of portraits, and studies of peasants and rustic scenes. The *Potato Eaters*, from Nuenen, is a characteristic work and the most important from this period. Upon his arrival in Paris, Vincent did not immediately adopt a lighter palette. The *Moulin de la Galette* dates from the first month of his stay.

But the Impressionists, especially the most brilliant among them,

COLORPLATE 13

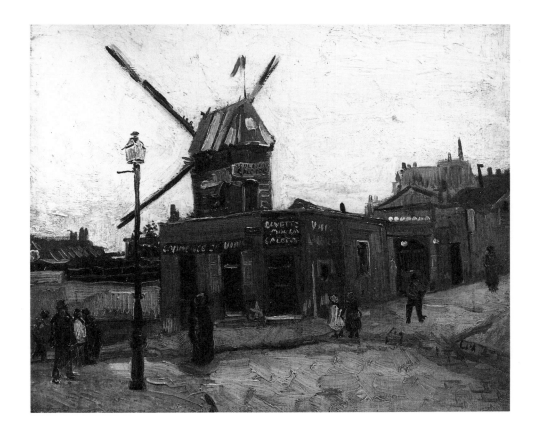

The Moulin de la Galette. 1886. Canvas.
15⅜ × 18⅛″ (38.5 × 46 cm). Rijks-
museum Kröller-Müller, Otterlo.

Claude Monet, were soon to have an influence on him. His compatriot
Jongkind, whose work was disdained for a long time, was just then ap-
pearing in abundance in the shop windows of the dealers in the rue Laf-
fitte, and Raffaëlli, with his Parisian character, was having an influence
as well. And that is not all. The long-standing admiration that Vincent
had for Delacroix was becoming more ardent. At the same time, he dis-
covered [the work of] Monticelli in Delarbeyrette's shop. The works of
1886 and of early 1887 do not have a well-defined character. One finds
among these studies such works as *Impression of July 14th*, which has al-
ready come around to Impressionism and bouquets of flowers, where
one senses [the influence of] Delacroix and Monticelli.

It is in the course of 1887 that he adopted Impressionism frankly and
went on to landscapes like *Bridge at Asnières*, where one sees that the
technical question of a meticulous division of color, instigated by Seurat,
did not leave him indifferent, even though this patient method did not
suit his lively talent. Amid all these influences, Vincent developed quickly.
The Japanese also provoked swift meditations in this painter of prodi-
gious assimilation. A great jolt, sudden isolation, the contemplation of
nature's vibrancy, all this coalescing with a rich font of natural acquisi-
tions would soon cause his personality to burst forth.

It was in February 1888 that he left Paris for Provence. Despite a poor
state of health against which he was fighting, and above all, gifted with
a rather lively and gay nature, he experienced a joy, an amazement, a
surprise. He believes himself to be in Japan; he is intoxicated by color
and light. Does he even appear somewhat suffocated and ill-disposed, at
first, to work? But he commits himself and, after a few attempts on small-
scale canvases—which seems to him prudent, even though his great need
for expansion was already surfacing (*Farmhouse in Provence*)—he en-
tirely abandons himself to his enthusiasm.

*　　*　　*

In three years (1888–1890) he consummated a career, so prodigious, and
so personal that he assumes a quite distinct place among the masters who
had given him his impetus. Vincent differs from the Impressionists in
that the sentiment of the latter, in landscape, derives more or less from

*Among the art dealers on the rue Laffitte:
Bernheim Jeune, Durand-Ruel, and
Vollard.*

*In the 1880s, Monticelli's works were
exhibited at the gallery of Joseph
Delarbeyrette, 43, rue de Provence, near
Theo's workplace.*

COLORPLATE 36

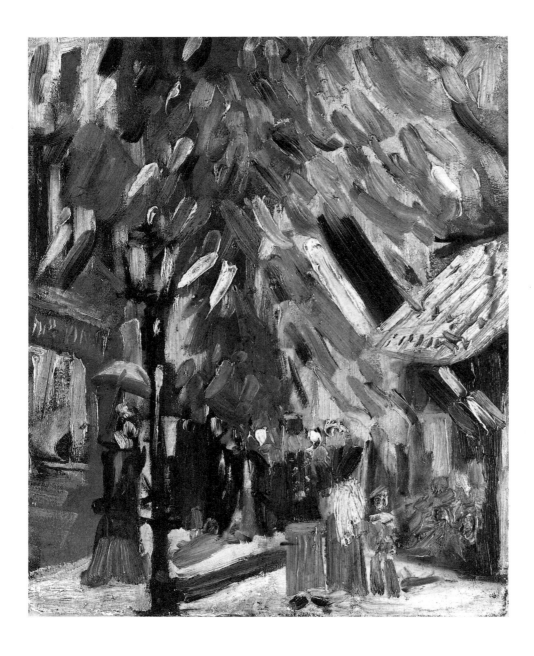

Street Scene in Celebration of Bastille Day.
1886. Canvas. 17⅜ × 15⅜" (44 × 39 cm).
Private Collection.

Corot, while his derives from Delacroix. In the works of the Impression-
ists there is fluidity, atmospheric envelopment, dusty light, and atticism,
and in his works, sonority, imagination, passion.

He was also preoccupied with giving style to his landscapes, render-
ing the lines visibly, while treating the general color tones as masses. The
others sought atmospheric effects.

Few artists have spoken of their art with more knowledge or were
more clear-sighted than Vincent. One could, looking at his work with his
correspondence in hand, produce a complete and significant study. I do
not have the space for that here. I will limit myself to disarming the
malevolence that was quick to pronounce tiresome judgments. Those
who could not appreciate him for lack of understanding or those who
inconsiderately reproached him, and who wanted only to find in his work
those methods that his nature forbade him, Vincent answered in ad-
vance. He had a profound understanding of painting, a sensibility of rare
power and an imaginative and, at the same time, positive character,
which is a Dutch trait. He penetrated to the essence of things, then with-
out losing sight of them, deliberately raised himself above them. His
physical sufferings, which were real and led to periodic disturbances,
never compromised his artistic conscience. They exalted such qualities,
as has happened to others who had likewise embodied the essence of ge-
nius; they sublimated his faculties as they wore out his physical system,
it is true, but they also made him a visionary. One must consider his work

as exceptional and not apply to it the methods of ordinary criticism, of that deplorable criticism based on principles that are passed on from one generation to the next. It is best to listen to him.

<p style="text-align:center">* * *</p>

A few months before Vincent's death, a young, talented and independent-minded critic, G.-Albert Aurier, now also dead, published the first article on him. It was at Aurier's that I saw Vincent briefly, when he was passing through Paris. I have retained the memory of a small, fair, nervous man with vivid eyes, a large forehead, and a chilly air, who made one think vaguely of the attitude of a Spinoza, concealing beneath a timid exterior a vehement activity of thought. At that time—more than ten years ago!—the shop of the good père Tanguy on rue Clauzel was full of Vincent's works. It was there, toward the end of 1888, that we went to see the first works sent from Provence and to learn to know and love him. That was how Octave Mirbeau came to appreciate Vincent, he who was to defend his memory so valiantly.

This visit to Aurier's took place in early July 1890.

Vincent van Gogh rarely signed his works, especially those of the last three years. He believed it was arrogant and that an artist must labor humbly. When by chance he signed them, it was rather to add a note of color in a corner. And even then he only inscribed *Vincent.* He did not believe, with reason, that the name Van Gogh could be pronounced in France, and I also presume that as an Impressionist, he especially did not like to appear too foreign. It is with this single Christian name *Vincent* that he endures and must endure. It is by this name that he enters our French School, to which he truly belonged and wished to belong. His name will always evoke ideas of the magnificence of color.

Hugo von Hofmannsthal

"Colors"

26 May 1901

Hugo von Hofmannsthal (1874–1929), Austrian visionary poet and playwright who is perhaps best known for his librettos for Der Rosenkavalier *and other Strauss operas. In the form of a fictitious letter, he recounted his visit to the 1901 Bernheim Jeune exhibition.*

I still had about an hour. To walk around the great streets was impossible; to go inside somewhere and read a newspaper was just as impossible because they all uttered the same language as the faces and the houses. I turned into a quiet side street. There, in a building, was a very decent-looking shop without show windows, and next to the entrance a sign saying: "Comprehensive exhibition; Paintings and Drawings"—I read the name, but I forgot it immediately. For twenty years I have not been to a museum or set foot in an art exhibit, but I think this will now distract me from my foolish thoughts, and that's what matters most right now.

My dear friend, this was no coincidence; I was meant to see these pictures, meant to see them in that hour in this agitated state, in this sequence. Altogether there were about sixty paintings, medium-size and small ones. Very few portraits. Mostly landscapes; only very few where figures were the most important pictorial element; in most of them it was the trees, fields, rocks, ravines, meadows, farms, rooftops, bits of garden. I can't say much about the style of painting; you probably know about everything that has been done, and as I said before, I have not looked at paintings in twenty years. Nevertheless, I remember very well that, toward the end of my affair with W., when we were living in Paris— she knew a lot about art—I quite frequently saw in artists' studios and

COLORPLATES 87, 91, 93, 98, 108, 112, 125

exhibitions paintings that resembled these: very bright, posterlike, certainly quite different from the paintings in the galleries.

First they seemed to me coarse and shrill in color tones, agitated and quite strange; I had to first find a way to see them as pictures, as a unity, but then, then I saw them all that way, each one individually, and all of them together, and Nature in them, and the strength of the human soul that had been at work here, shaping Nature, and tree and bush and field and slope, and in addition, something else, that which was "behind" the painted surface, the true reality, the indescribably fateful—all this I perceived in such a way as to lose my self-awareness while looking at these pictures, and then I regained it, only to lose it again! My dear friend, for the sake of that which I want to say here and yet will never divulge, I have written you this whole letter! But how could I ever put into words something so incomprehensible, so sudden, so strong, so indivisible! I could obtain photographs of the paintings and send them to you, but what could they give you—what could these pictures by themselves give you of the impression they made on me, which is most likely something altogether personal: a secret between my fate, the pictures, and myself. A peasant plowing his field, a row of powerful trees seen against the evening sky, a dirt road between crooked scotch pines, a garden corner near the back wall of a house, peasant carts with skinny horses in a pasture, a copper basin and a clay pitcher, peasants around a table eating potatoes—but what good is this to you? So, should I tell you about the colors? There is an incredible, most powerful blue that keeps recurring, a green like molten emeralds, a yellow-orange. But what are colors if the innermost life of objects does not burst out of them? And this innermost life was there, tree and stone and wall and road revealed their innermost personality, as though they were casting it at me, but not the delight and harmony of their beautiful, inanimate lives, like the magic currents that at times seemed to emanate toward me from old master paintings: No, only the enormous power of their existence, the raging, incredible miracle of their presence attacked my soul. How can I explain to you that here, every being—the being of every tree, every strip of yellow or greenish field, every fence, every ravine that cuts across the rocky hillside; the being of the pewter pitcher, the earthenware bowl, the table, the clumsy armchair—lifted itself as though newly born out of the terrible chaos of nonexistence, out of the abyss of Non-Being, toward me, so that I felt—no, knew—that these beings were born out of horrible doubt about the world and were now covering up by their existence a horrible abyss, a gaping nothingness, for all time. How can I even begin to tell you how this language reached my soul, revealed to me an enormous justification for the strangest, seemingly most unresolvable conflicts of my inner depths, allowed me to understand all at once what, in my dull gloominess, I could hardly bear to feel, and yet felt so strongly, but was yet unable to tear out of myself—and here an unknown soul of unbelievable strength answered me with a world of revelations! I felt like one who, after having whirled in boundless frenzy, feels the solid ground under his feet while the storm rages all around. In a storm these trees were born before my eyes, and on my account, their gnarled roots in the soil, their twisted branches reaching for the clouds; in a storm these rifts in the crust of the earth, these valleys between the hills, surrendered themselves; even within the weighty boulders was a frozen storm.

Now, going from one painting to another, I could feel something, feel the accumulation and the reciprocity of the beings, how their inner life burst out in colors, how the colors seemed to exist for one another, and how one, mysteriously, powerfully, seemed to carry all others; and in all this one could sense a heart, the soul of the man who created it, who, with this vision, did himself answer his own most terrible doubt; I could see, could know, could delight in viewing peaks and valleys, inside and outside, one and all, in a ten-thousandth of a particle of the time that has

COLORPLATE 125

COLORPLATE 13

COLORPLATE 98

COLORPLATE 108

taken me to write this down, and I rejoiced in a sensation of having two-fold powers, over my life, over my strength, my reason. I felt the time go by, knew that now only twenty minutes remained, now ten, now five, and I found myself standing outside, calling a cab, and went.

* * *

P.S. The man is called Vincent van Gogh. According to the dates in the catalogue, which are quite recent, he ought to be alive. Something in me compels me to believe that he is of my generation, somewhat older than myself. I don't know whether I want to face these paintings a second time. However, I shall very likely buy one of them; I shall not take it with me, but rather entrust it to the art dealer for safekeeping.

Maurice Vlaminck

PORTRAITS AVANT DÉCÈS

1943

Maurice Vlaminck (1876–1958), noted Fauve painter whose 1901–1909 landscapes, in their primary colors and rich impasto, seem directly indebted to Van Gogh.

In 1901, the Bernheim Gallery organized a Van Gogh exhibition.

Bernheim was at that time situated on rue Laffitte between Durand-Ruel and the boulevard des Italiens. A simple art dealer's boutique, the gallery consisted of two rooms; the first, where one entered at street level, was followed by another, smaller room. The lighting was poor. A spiral staircase gave access to the second floor, where the director's office was located.

At that time Vincent van Gogh was known only by a few artists and by a very small number of collectors. Père Tanguy, half junk dealer and half art dealer, and Le Barc de Boutteville, at the bottom of rue Le Pelletier, sold—or tried to sell—a few of his canvases. Their price was moderate: fifty francs . . . one hundred francs.

Vincent van Gogh had killed himself in Auvers-sur-Oise at the end of the year 1890. It took eleven years to assemble some fifty of his canvases at Bernheim's. There were seascapes, harvest scenes, landscapes of Provence, the portrait of *L'Arlésienne*, his self-portrait, the *Cypresses* and *Sunflowers*, the *Bedroom*, and *Starry Night*.

Until that day, I hadn't known of Van Gogh. His realizations seemed definitive to me but because of the boundless admiration I felt for the man and his work, he loomed before me as an adversary. I was happy for the assurances that his work gave me, but what a blow!

I recognized in his work some of my own aspirations. No doubt the same Nordic affinities? And at the same time, a revolutionary, almost religious feeling in the interpretation of nature. I left this retrospective, my inner being deeply shaken.

A violent desire to possess one or two of his paintings took hold of me. I owed money to the baker, the butcher, and the grocer, but my desire was so imperious that I was sure I could find the few hundred francs a Van Gogh painting would be worth at that time.

Derain was on a trip. I wrote to him. By pitching in together, perhaps we could raise the sum required?

The manager who had put together the Van Gogh retrospective was M. Julien Leclercq, "man of letters." I wrote to him and three days later received this reply:

Van Gogh's suicide was actually in July of 1890.

COLORPLATES 75, 79, 93, 69

The version of Van Gogh's Bedroom exhibited in 1901 is that in the Musée d'Orsay, Paris.

André Derain (1880–1954), highly versatile fellow-Fauvist with whom Vlaminck shared a studio.

Hôtel Frankfurter Hof
Mittel-Strasse, 6
Berlin

Sir,

Just as I was leaving for the train station on Tuesday evening, I received your letter. I have just spent forty-eight hours in Holland and here I am this morning in Berlin. Excuse me for not having answered sooner. As a matter of fact, I personally possess five paintings by Vincent van Gogh. Three are presently at my home in Paris, and two others are in Berlin, on loan to the Secession Exhibition. None of these canvases are for sale. But one of my friends has entrusted four paintings to me that he would be willing to give up. Two of these paintings are at my home. The other two are abroad and will not be back in Paris until the end of September.

If you would care to write to M. Jules Donzel, my secretary, at 111 bis, rue Turenne, you can make an appointment to meet him at my place; he stops by there almost every day, and can be available whatever time you indicate. He is qualified to conduct business in my absence, and he will tell you the terms. Prices vary from 200 to 400 francs. He will also show you those that I own, which cannot fail to give you pleasure if you admire Van Gogh.

With my sincerest . . .
Julien Leclercq

I had the appointment with the secretary, and I saw the Van Goghs.

There was a "seascape": streamers in which the vermillion red managed to cut through a red sky . . . then, two landscapes of Auvers-sur-Oise, and a plain over which swirled a flock of crows.

The summer 1888 "seascape," Coal Barges, is in a private collection.

I began the quest for my 400 francs. I asked here and there, but everywhere I met only with refusals. Distressed, I was obliged to abandon my plan. It had been but a dream.

My plea to Derain must not have reached him—no doubt a bad address—because I received a letter that did not mention Van Gogh.

* * *

Some time later, I received this letter bordered with black, written to me by the widow of Julien Leclercq, the owner of the Van Goghs:

Paris, 13 September, 1901

Sir,

After the death of my husband, M. Julien Leclercq, I am willing to sell one or two paintings by the eminent artist Van Gogh.

Knowing that you had written to my husband about this, I am writing to ask if you think that the collector you presented to M. Leclercq would still wish to acquire paintings by Van Gogh? If you think this matter might interest you, I would be happy to show you these paintings at my home on any day you determine.

Please give me an answer as soon as possible, as I intend to return to my country, Finland, in about two weeks.

Yours, sir . . .

Having read this letter, the desire to possess the Van Goghs overcame me again, so I resumed my campaign to raise the funds. My hungry ambition gave me all the nerve I needed. I did the impossible.

I went to see the paintings, but I found the door closed. I was greeted by a blond woman, who told me that Mme. Leclercq was not home. Since I was in no position to buy anything, I wasn't disappointed.

316

The next day, Mme. Leclercq wrote to me:

<div align="center">16 November</div>

Sir,

Was it you that came to see me last Friday afternoon? The Swedish lady who lives in the same house spoke to you and forgot to ask the name of the gentleman who had come to see the Van Goghs. Be informed that, if you would be so kind as to return, I will be home next Monday and Tuesday until six in the evening.

<div align="center">Hoping to see you, yours . . .</div>

I never returned to the rue Vercingétorix. . . . I would have had to be crazy to believe that I could acquire one or two paintings by Van Gogh!

In 1920, twenty years later, I came to stay in Auvers-sur-Oise. Upon my arrival in the area, I set out for the cemetery to pay a posthumous visit to Van Gogh, who slept there in everlasting sleep.

I asked a woman changing the water in a vase of flowers where the painter Vincent van Gogh was buried. She looked at me without seeming to understand what I said.

"Was this a rich man?" she said.

I found the site. His brother lies next to him. A simple sandstone border surrounded the plot.

It was spring. A big, wild thorn bush which had grown there by chance was in bloom and its branches fell on the two tombs. . . .

At the top of the cemetery passes the tree-lined road that goes from Auvers-sur-Oise to Hérouville. On both sides, the plain stretches with its fields of wheat, oats, potatoes. Flocks of crows whirled around in the sky. . .

The road worker who was patching the highway and scything the grass on its embankments had been Van Gogh's friend. They went drinking together. One evening, returning together from having worked on the road, Van Gogh, out of friendship, gave the road worker a landscape, a view of the plain. The day the painter shot himself, the road worker drank all alone to drown his grief.

Some months later, a gentleman from Paris arrived at the road worker's house and offered him some banknotes for the painting that Van Gogh had given him. With the money in front of him, he could not resist. He sold the painting by his friend and for three days, got himself soused. On the fourth day he fell and broke his leg. The wound became infected and he died.

Julius Meier-Graefe

ENTWICKELUNGSGESCHICHTE DER MODERNEN KUNST

1904

<div align="center">
lux mea crux

crux mea lux

—Nietzsche
</div>

Julius Meier-Graefe (1867–1935), German critic, decorative arts historian, and writer on Impressionism and contemporary art; this study of Van Gogh did much to establish the artist's celebrity in Germany.

Van Gogh had penetrated deeper. Perhaps there has never been a man who, without being aware of it, penetrated so deeply into what we today

recognize as artistic. He himself sought only a natural dialogue, not more and not less. With all others, decisive moments crowd themselves between their personality and their work; they have their models and their doctrines; and their creative urge first seeps through this prepared soil before it grows into their own style.

<p style="text-align:center">*　　*　　*</p>

On the other hand, there is another method, one that first became possible in our day. This one becomes the expedient of those who cannot find in their surroundings the forces necessary to enliven their creativity and therefore tear themselves away in order to pursue their own instincts in solitude. Their fate is to be a pariah or a genius—at times both. Our era is filled with them, and they have caused it to seem even more fragmented, apparently devoid of any deeper meaning. Very seldom have they been builders. Yet at times we find great people among them, for whom, whatever time is lost in creativity is compensated for in the most astonishing way, people who, as though indignant at the inertia of their era, develop unbelievable creativity, who seem to find in the loneliness to which they are condemned the impetus for personal deeds that are unrestrainable and shun nothing. Their single-mindedness is their strength, and it can bloom in such a surge of power as to replace at once what we were accustomed to enjoy in the diversity of art-happy generations. Van Gogh was one of them, but as it is with all loners who achieve great things, his seclusion was an unwanted fate, contrary to all his inclinations. Also, the extreme unconventionality of his art, which at first viewing tends to cloud its relationship to other works he would refer to at every opportunity, was nothing less than heightened self-consciousness, natural talent. The much abused phrase about the oneness of the man and the artist in a single personality becomes, in his case, one of the most significant facts that occurred against his will, yes, against his innermost instincts, and was to determine the tragedy of his life. To the student of Van Gogh, it lends the opportunity to meet not only a modern artist but a human being.

<p style="text-align:center">*　　*　　*</p>

He did not paint his pictures; it was like he exhaled them, in a gasping, boiling breath. . . . One can really compare Van Gogh to a volcano and apply to him what an author of the Romantic period wrote about Delacroix: that he carried the sun in his head and a hurricane in his heart. But in his case, one needs to add a pathological significance to these clever words. Whatever this man touched became tremendously exaggerated. To watch him paint was a horrible experience, it was to witness an excess of the worst kind, where paint splashed like blood. He did not paint with his hands but with his naked senses; he developed special organs; he became one with the nature he was creating, painting himself within those fiery clouds, in which a thousand suns threaten to destroy the earth, in those twisting trees that seem to yell to heaven, in the frightening vastness of his plains. At times it seems as though he would have buried himself in the earth in order to paint.

<p style="text-align:center">*　　*　　*</p>

That this pathological phenomenon could result in aesthetic achievement is no more remarkable than the fact that Nature, whatever it might be, is capable of bringing forth things of beauty. Van Gogh regarded the striving for perfection as natural morality. He was a clean animal. Daumier and Delacroix influenced him more than all the Impressionists. Here, the "peasant" who regretted that Paris did not offer more *tableaux en sabots*, had found kindred spirits. When he took from Daumier's *The Drinkers* the group of the three drinkers and the child at the table and made them into one of his most individual paintings, he showed his esteem for Daumier, just as Delacroix did when he used Raphael's com-

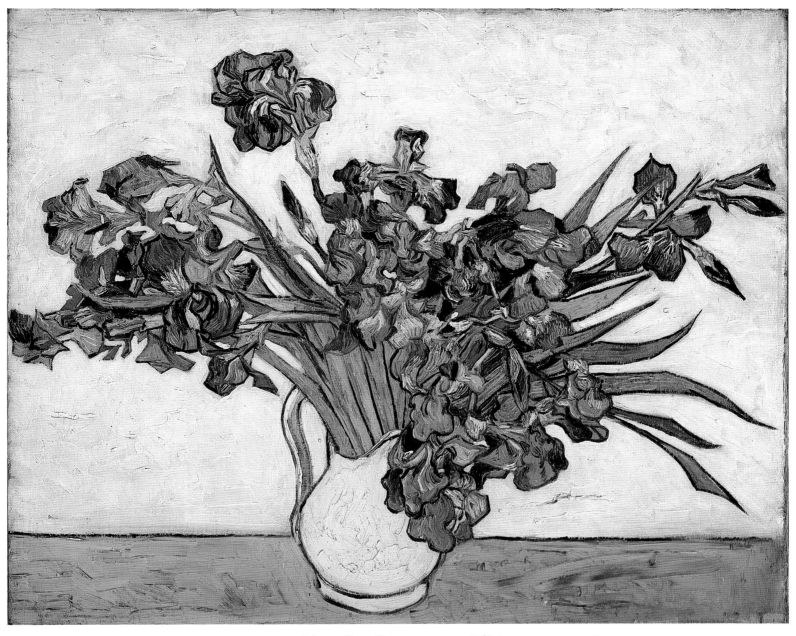

COLORPLATE 111. *Irises.* 1890. Canvas. 29 × 36¼″ (73.7 × 92.1 cm).
The Metropolitan Museum of Art, New York; Gift of Adele R. Levy, 1958.

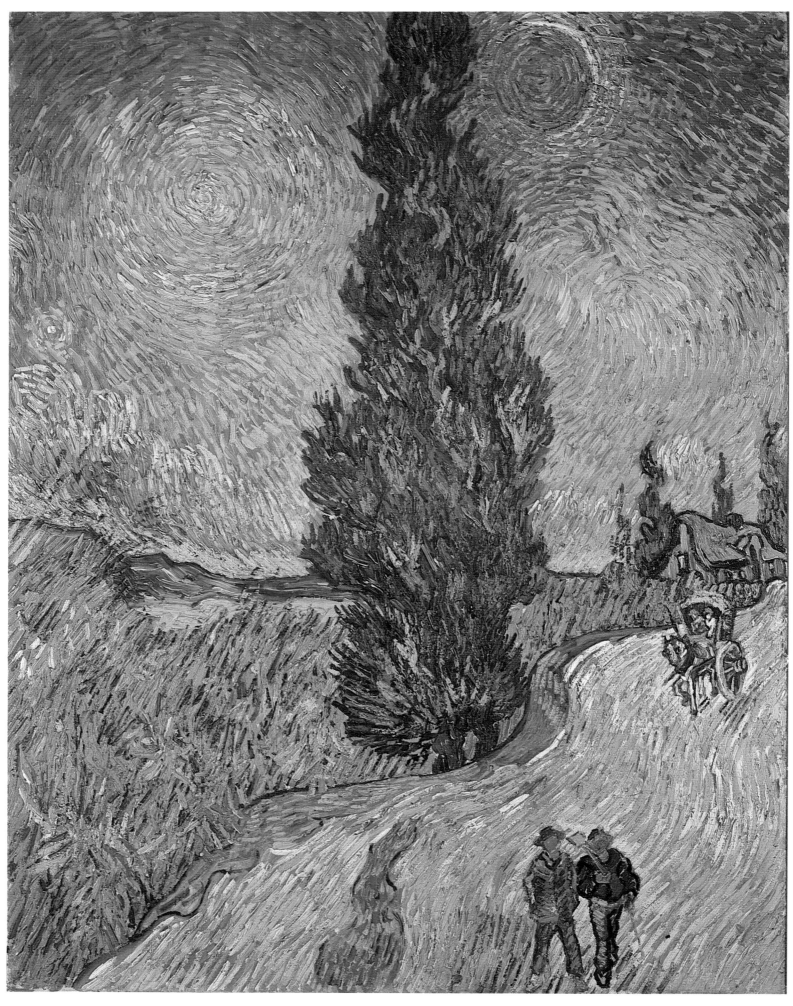

COLORPLATE 112. *Road with Cypresses*. 1890. Canvas. 36¼ × 28¾″ (92 × 73 cm).
Rijksmuseum Kröller-Müller, Otterlo.

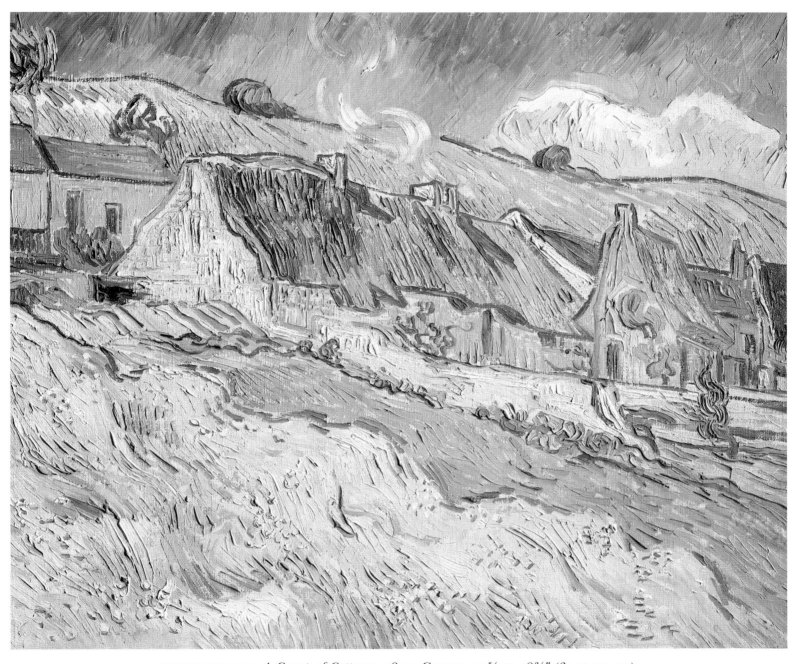

COLORPLATE 113. *A Group of Cottages*. 1890. Canvas. 23⅝ × 28¾″ (60 × 73 cm).
The Hermitage, Leningrad.

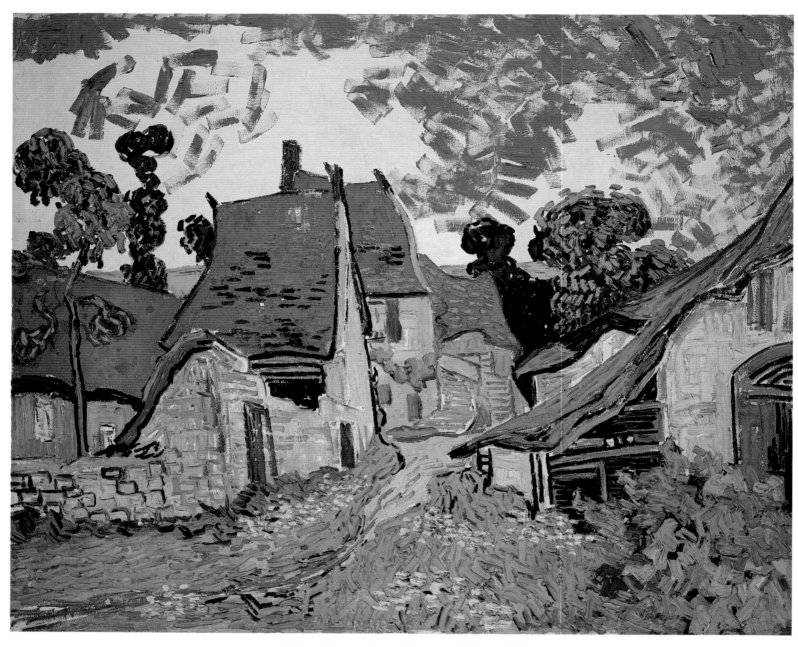

COLORPLATE 114. *Village Street*. 1890. Canvas. 28¾ × 36¼″ (73 × 92 cm).
Ateneumin Taidemuseo, Helsinki.

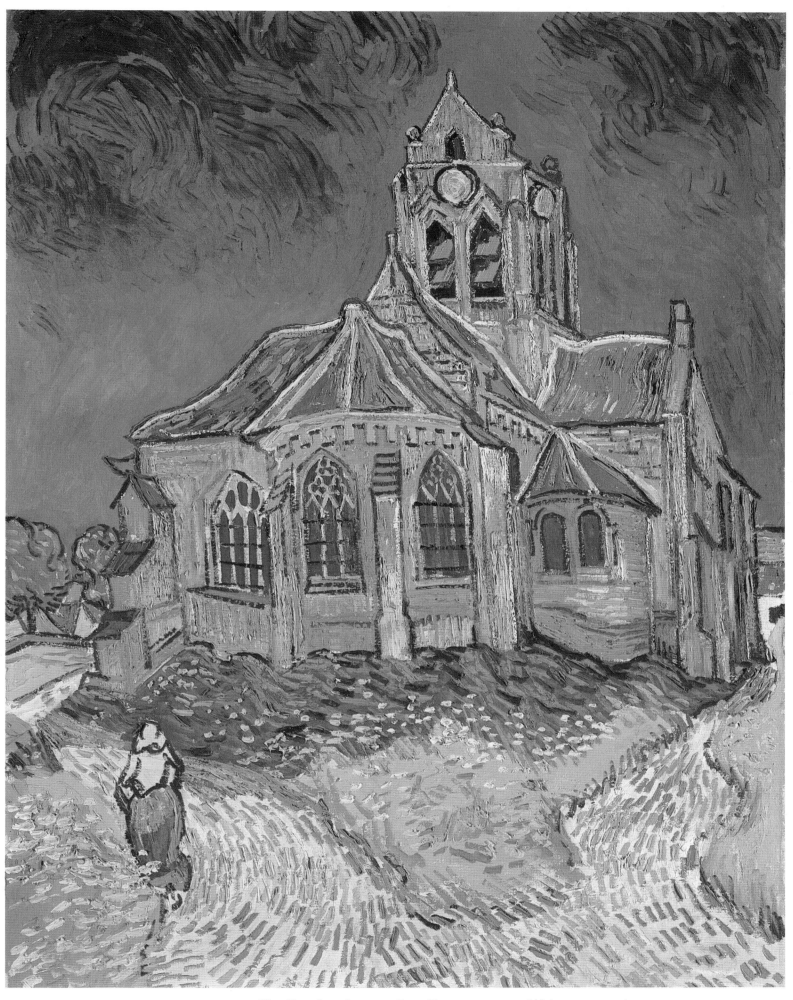

COLORPLATE 115. *The Church at Auvers.* 1890. Canvas. 37 × 29⅛" (94 × 74 cm).
Musée d'Orsay, Paris. Photograph: Musées Nationaux.

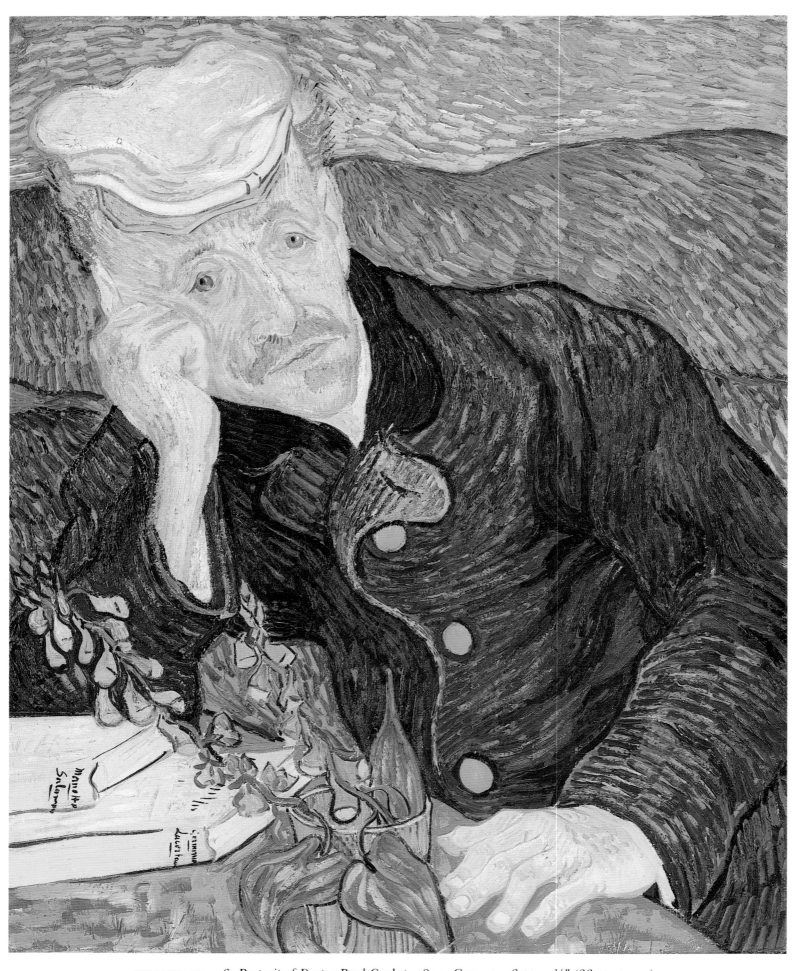

COLORPLATE 116. *Portrait of Doctor Paul Gachet.* 1890. Canvas. 26 × 22½″ (66 × 57 cm).
Private Collection, U.S.A.

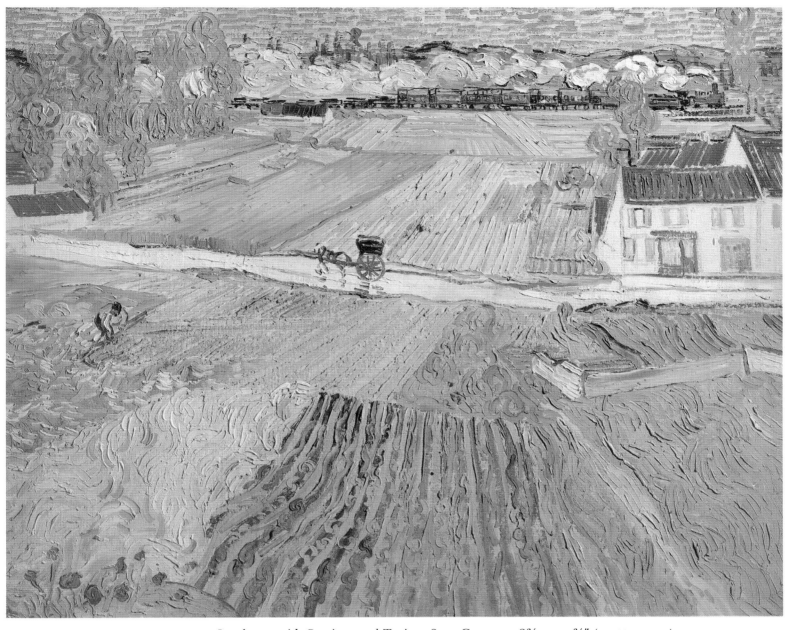

COLORPLATE 117. *Landscape with Carriage and Train*. 1890. Canvas. 28⅜ × 35⅜″ (72 × 90 cm).
Pushkin State Museum of Fine Arts, Moscow.

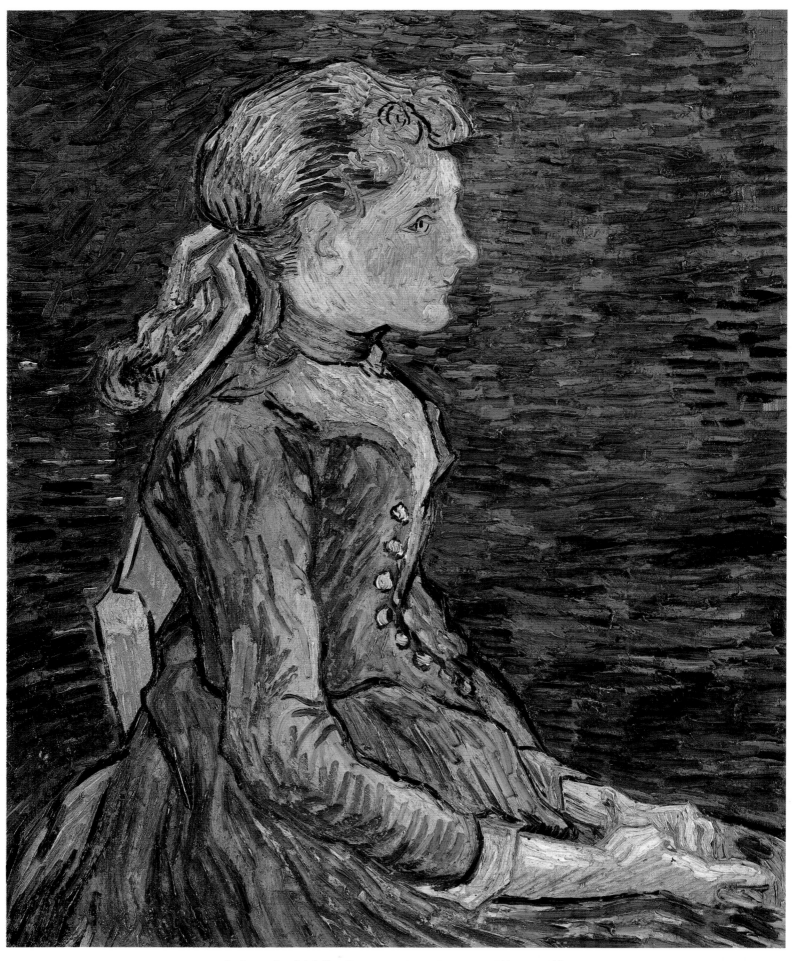

COLORPLATE 118. *Portrait of Adeline Ravoux.* 1890. Canvas. 26⅜ × 21⅝″ (67 × 55 cm).
Private Collection, Switzerland.

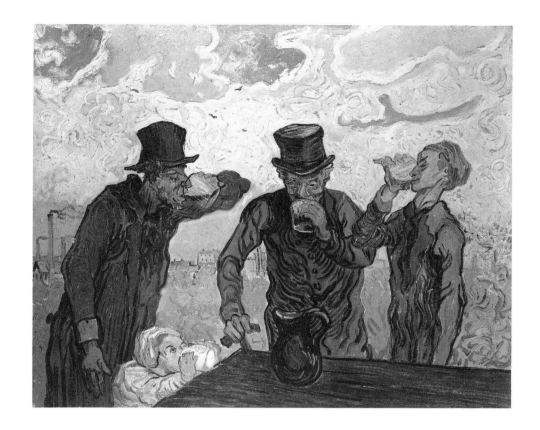

The Drinkers (after Daumier). 1890.
Canvas. 23⅜ × 28⅞″ (59.4 × 73.3 cm).
The Art Institute of Chicago;
Winterbotham Collection.

position in the Vatican for his Heliodorus in Saint-Sulpice. In Daumier
he found the justification for his own linear exaggerations, the remark-
able flamelike play of his ascending lines that seem to arch in order to
strike more surely. In addition, he esteemed Cézanne, with whom he
had, at times, certain common visions, and he revered, beyond all meas-
ure, Monticelli, who had brought him closer to the same South where
Cézanne had painted his fruits and the old gypsy and the other mirac-
ulous color fantasies. . . .

<div align="center">* * *</div>

In a painting by Van Gogh one can discover many pictures. His brush-
strokes not only bestow things that press up against the eye from a dis-
tance with primordial force but, that placed one next to the other play
wondrous games, forming a varied and free ornament that mysteriously
enlivens the background as well as lending to objects that stand out
against it in sharply delineated contours, a rare magnificence of tex-
ture. . . . With his colors he intends nothing less than to fool the eye; no
modeling tempts us to believe in anything corporeal; the picture always
remains a flat surface, like a Gobelin tapestry, but it becomes so rich that
a tapestry could never rival it, be it woven of gold and precious stones,
and this richness is so organic that it affects us like Nature. His palette
can be counted on the fingers of one hand. What for Velázquez was
white, gray, pink, black, for Vermeer lemon yellow, pale blue, and pearl
gray, are for him Prussian blue, pure yellow to orange, emerald and Ve-
ronese greens, and red. The problem of complementary colors was in his
hand, so to speak, not in his head; for him this was not decisive. He
risked the most dangerous combinations, juxtaposing a dynamic bright
Prussian blue to the sweetest red, but chose the quantities with such
unerring skill, pouring, for instance, around the just mentioned combi-
nations such a mass of yellow and deep-green tones as to make the most
daring appear as though it were the most natural. Never did he use blue
without juxtaposing it to yellow, or his luminous red without orange.

<div align="center">* * *</div>

For composition, if Van Gogh ever borrowed from others, apart from
Delacroix and Daumier he would rely on Millet, whom he venerated—

but on that Millet, be it understood, who encompassed Daumier. . . . It was for Van Gogh like a homecoming, and I find this sentiment so admirable that I avoid the superfluous question, How much did Millet enrich him and he Millet? One has to understand that it was not a lack of inspiration that drew him to Millet and Delacroix, but rather it was an excess of creative power that he was only able to contain by forcing it within the fixed limits of a prescribed alien form.

<p style="text-align:center">*　*　*</p>

Vincent found in Millet the basis of a primitive popular art, models for portraits of humanity. He made the earnestness of Millet even more earnest, one could almost say more Lutheran. The ancient Greek spirit that permeates so many of the soft pencil sketches of Millet, where he abandons himself to reveries, like the sound of nature, has in Van Gogh given way to a gigantic, almost barbaric instinct against which the Millet form is reduced to merely a softening element. There is nothing Classical about him, rather he reminds us of the early Gothic stonemasons whose tall figures resemble cliffs and ravines. The technique of his drawings is that of the old woodcutters; certain faces seem to be hewn with dull knives into the hard wood. The ugliness of his people in *The Potato Eaters* has carried the primitiveness of the old painters into the colossal realm, where it resembles horrifyingly incarnated ghosts. Such things as *La Berceuse* he did not intend for amateurs but for hardy folk, and it was one of his—only too natural—disappointments that no farmer was willing to pose for him. In his painted portraits the wooden hardness of the drawing sometimes seems to become blended with gleaming metal. The masterpiece of his self-portraits is with Schuffenecker. Never will anyone forget this enormous head with the square forehead, the gazing eyes, and the despairing jaw. A glistening piece of gold jewelry adorns his deeply incised neckline, like a heathen symbol. Below, tones of dark reddish-blue sink into the coat and next to the harsh wallpaper of the background produce an effect like velvet caterpillars on bare rocks. It is of such a terrible splendor of line, of color, of psychology that it leaves one breathless, no longer knowing whether to be shocked by the grossly exaggerated beauty of it or by the menacing madness in the face that created it.

<p style="text-align:center">*　*　*</p>

It is unlikely that the time will come when he will be appreciated by the layman; it is perhaps more conceivable that, some day pictures will cease to be produced altogether than that those by Van Gogh could become popular. But his part in the development of the modern milieu is today already assured; it is indirect, but all the more profound; his lines and colors are elements that are already in use and will continue to be useful in most varied form. This gives him perhaps far greater significance than can be comprehended by our generation, that is still too close to William Morris. Here, indeed, is something new. The mind that focused on the consciously decorative in the work of today found in Van Gogh—and not only in his late paintings—unexpected, fresh sustenance. Yes, perhaps this treasure holds the only altogether fresh element that our attempts to forge a new style have discovered. If the relationship seems insignificant one has to consider, in all modesty, that our efforts to find a new style are still in their infancy, and as a result this aspect of Van Gogh has merely complemented the manifold relationships, which all progressive art will merge with his riches. Already his handling of the colored surface serves to deepen the teachings of the Japanese, which is, these days, so useful; it extends what Degas and Lautrec added to the importation—I shall come back to this—always keeping in mind the golden principle of simplification, while at the same time achieving a magnificence of effect above and beyond anything that was ever created on the easel. His masterpiece, *The Ravine*, a depiction of a remarkable rocky

COLORPLATE 13

COLORPLATE 60

COLORPLATE 65

Emile Schuffenecker (1851–1934), artist, drawing instructor, and for many years Gauguin's friend and benefactor, by 1900 had amassed an impressive collection of some 120 works by his contemporaries. In 1903, following a divorce settlement, the collection was bought and extended by his brother Amédée, a wine merchant.

William Morris (1834–1896), leading figure in the English Arts and Crafts movement.

COLORPLATE 108

chasm near Arles—an intoxicating rich blue tonality—is a technical example of immeasurable value. It seems that Nature was used only as a pretext to create, through a haphazard, irregular accumulation of strong lines which always seem to disappear into new surfaces, the richness of a tapestry-like texture. If one could successfully transfer such works onto large surfaces and make them durable, one could almost enjoy the illusion of having found a decorative method that equals the mosaics of the ancients and combines them with the splendor and distinction of a Gobelin tapestry.

Modern decorative artists have not remained untouched by Van Gogh. His surfaces proved useful to the young Parisian painters Denis, Ranson, Sérusier, Bonnard and others; his brushstroke benefited the most important modern ornamentalist, Van der Velde. From the great era of the Impressionists, Van Gogh drew not all, but the most important ideas, those that had the potential of far-reaching influence, even beyond the sphere of abstract painting to which this school had confined itself.

Maurice Denis, Paul Ranson (1864–1909), Paul Sérusier (1863–1927), and Pierre Bonnard (1867–1947), all affiliated with the Nabis.

Keeping in mind this connection, and tracing Van Gogh's road back to his most important model, the dear master of Barbizon appears in an entirely new light, deeply enmeshed with everything that moves us today. Van Gogh drew Millet into the great radiant circle of Manet, Monet, and Cézanne, who were in danger of forgetting him, and reminded them of the painterly power that Millet's great fructifier, Daumier, had possessed.

And at the same time, this last of the great Dutchmen, whose breath had been taken away by a foreign land, maintained his native traditions. He brought back to it what the great French generation of 1830 had borrowed, while remaining faithful to its most noble law: to follow Nature, especially one's own.

August Endell

FREISTATT

"Vincent van Gogh"

17 June 1905

August Endell (1871–1925), German Jugendstil artist whose abstract designs and writings on pure aesthetic effect (Formkunst) *anticipated twentieth-century nonobjective art, reviewed the spring 1905 show of over 30 works by Van Gogh at Paul Cassirer's gallery, Berlin.*

He died as a young man a few years ago in a mental hospital. For a long time, his paintings stood unnoticed in a garret. Only recently has the general public begun to take notice of him. Painters have been familiar with his work for quite a while. Two great collections were seen here this winter. Any rational person finds it easy to appreciate these works. Undoubtedly, some of the paintings were created during an episode of insanity; one of them depicts the garden of the mental institution. Accordingly, it is easy to come to certain conclusions and such are being reached by some of the odd people who are the critics in Berlin. But the misfortune is that these paintings are quite unique. When Hodler was here, he had eyes only for them; Lestikow sat for hours in front of them; and Tschudi even wants to acquire one for the National Gallery. It is not easy to maintain that a sick soul produces a sick creation. We barely know to what extent so-called mental illnesses are really illnesses of the soul; and many serious mental disorders never lead to confinement in a mental institution. Nor do we know at all to what extent general good health affects creative performance. We do know of enough perfectly healthy

Ferdinand Hodler (1853–1918), nineteenth-century Swiss artist whose monumental compositions combine naturalism and Symbolism and emphasize symmetry and rhythm. Walter Lestikow (1865–1908), Russian-born painter, who helped found the Berlin Succession. Hugo von Tschudi (1851–1911), director of the National Gallery in Berlin who, despite opposition, sponsored contemporary art in Germany.

human specimens who produce repulsive, saccharine-sweet, petty work. And Mozart, forever sickly, gave us the most refreshing, vivacious art. There is certainly sickness in the style of Nietzsche—not in his thoughts, but in the screaming, shrill covetousness of his words; but who would claim that it was this sickness that led to his final darkness, his mental derangement? Most likely the opposite was true. All such connections are so difficult to define that one must be extremely careful. And whoever has eyes in his head and uses them can see at once that there is no sign of sickness whatsoever in Van Gogh's work. On the contrary.

A strange potency, a rare passion and great strength, emanate from his work; no composure, no noise, rather an admirable sureness and calm in spite of immense power. Granted, it was all painted in great haste; the poor man too quickly lost his strength resulting in a technique that is somewhat coarse and primitive. Contours are traced in heavy lines, while often surfaces are only casually covered with strokes of color. Whomever considers neat workmanship the penultimate of art won't find his due here. But the curious thing is that despite all these imperfections or this seemingly crude technique, the goal always seems to have been attained. True, almost every one of these pictures could have been further developed, but each one is already a complete picture. The tones, the colors, and the forms stand up; the effect is there. And upon closer scrutiny one soon discovers that the degree of completion varies from one area of the canvas to another; always just as far as was necessary to reach the desired effect. Some of the surfaces are painted very flatly; elsewhere, the colors are carefully arranged; then we find only dots, crudely placed next to each other; then very harsh contours; then the whole painted in broad strokes revealing the underlying canvas; then again lines drawn with great variety—bent, twisted like snakes, crimped—all achieving the strangest results. Sometimes his drawings are a failure, betraying a degree of awkwardness that even a beginner would know how to avoid.

But what an amazing command of form. How wonderfully he is able to draw gait, movement, and posture. The swiftness of his vision is astonishing; with immediacy he captures the momentary image. His range of colors is immense. He can render utter darkness and the brightest light; here too, one is astonished by the sureness of nuance. Mastering even the boldest color combinations, he finds the right tones so convincingly that in spite of heavy outlines that for every other painter would tear the picture apart, he achieves formal unity. If his boldness in exaggerating color contrasts is almost incomprehensible, it is even more incomprehensible that this boldness should lead to success.

The strangest painting in this regard is a peasant head shown in the brightest sunlight. A large, protective straw hat holds to the purest, most violent yellow tones. The background is a flaming, vibrant orange of a wonderful intensity; the bearded face is beautifully drawn in the shrillest of reds, and the eyebrows and beard are shaded in a luminous green. "Obviously crazy," some will think and no doubt others have thought. But the astonishing fact is that these wild contrasts seem entirely in harmony, creating an impression of complete sculptural and formal unity, and, above all, conveying the feeling of strong, glowing heat, tension and dull satiety of a ripe summer that has here come to life. Here there is no trace of pose, nothing artificial, nothing bizarre, no pathos, no grand epic statement. The whole reflects simplicity, clarity, stillness, and silence, but with greatness and monumentality such as we find only in the work of the best artists of the past. And this was accomplished by altogether new ways and means.

How many times were attempts made to paint sunlight with very bright colors; how many times were there sharp, loud colors screaming for attention? Yet the effect was insulting and trivial. Van Gogh, however, speaks with a strong voice without shouting. He takes the most in-

This peasant head is Portrait of Patience Escalier, *presently in a private collection.*

tense colors and the wildest contrasts, and what ensues is extensive, weighty, rich, but without noise, without rudeness: iron force and nerves of steel.

But this is only one side of Van Gogh's personality. There is also a gentler side. A small still life on a white background: field flowers in a glass, with white and violet leaves, thick green stalks, and a few blades of grass. The portrait of a young country girl: a delicate, slender, expressive head, a red ribbon in black, smooth hair; atop clear blue eyes her black, sharply outlined brows, and with concise, firm forms a beautiful mouth. The bodice of her dress is striped red and blue; her skirt, dotted in those colors. Seated on a wicker chair, her wonderfully delicate, narrow and sensitive young hands lean against its arms. Then there are landscapes of quiet charm—an orchard: where colorful, bizarre, swaying fruit trees rise up from rich, verdant grass, and blue sky, divided by reddish clouds, is visible through the branches. An olive grove: low, shrublike trees with gnarled branches stand in rows, far apart; their feathery crowns of blueish white-green leaves throw a veil of violet shadows on the light green ground. Then another grandiose landscape: a bright, rolling field fills the space of the foreground while partially mowed, brownish green and red fields extend into the background; a row of sturdy trees borders the road; and above it all, clouds balloon in the blue sky. A unique painting, wonderful in its simplicity and in its greatness.

Boulevard in Arles: sturdy, knotty trees, with trunks in bright tones and foliage in brilliant yellow; the street bright pink and gray, roadwork in progress; the workers are sketched in an amazing way: a few lines for contours, a few brushstrokes fill in the outlines, yet every figure is alive with the most characteristic movement.

Yet, even more colorful tones. A view of Montmartre seen across flower gardens wrapped in veils of light under a beautiful sky of dull green. A flower garden: where only a strip of clear green sky is visible; a white wall roofed in red tiles closes off the background, nearby a few cypresses, and in the foreground, luscious dense flower beds. The garden of the hospital as seen from his room: an old courtyard with an arched colonnade in tones of white and yellow surrounds a center court filled with flower beds, trees, and a splashing fountain with goldfish in the basin; patients and nurses are seen walking along the corridors.

Then, dreamy landscapes, gentle and silent, yet full of strength; the quiet of the twilight, after the last rays of light have faded. A landscape entirely in heavy, spotty strokes, dominated by a brownish red tonality and a somber red moon. The mountains appear ghostlike and two figures silently work in the fields. Another canvas shows nearly the same scene, the same hills but entirely in yellow. The heavens green, the moon yellow, the mountains covered in fog, a shimmering lake extending in the background, rolling wheat fields just being harvested in the foreground.

And then, landscapes of the sunlit, fresh day, saturated in heavy greens. A wonderful sunset: the sky behind a rising mountain chain is almost white, tinged with green; clouds, bathed in a shrill light, are ablaze with a purplish carmine-and-pink glow; and in the foreground sprawls a high green field. Painted with thick, hasty strokes, the work is fully alive. I know of no one else so able to convincingly depict life in a patch of grass, who has made such a penetrating study of it. The same motif occurs over and over. A poplar tree in a wheat field: a strange, blank sky with bands of vivid color, and in the foreground a rather high field with tall, ripe wheat swaying gently in the wind. And then a most enchanting canvas: a deep green field, low shrubs with colorful flowers in front and behind, fields stretching far into the distance. Oddly enough, the horizon seems to be placed above the frame and this painting achieves its most three-dimensional effect when set on the floor. The richness, the

COLORPLATE 53

Road Menders in the Rue Mirabeau *is not of Arles but Saint-Rémy.*

COLORPLATE 106

COLORPLATE 29

COLORPLATE 52

COLORPLATE 86

COLORPLATE 107

This painting is in the Rijksmuseum Kröller-Müller, Otterlo.

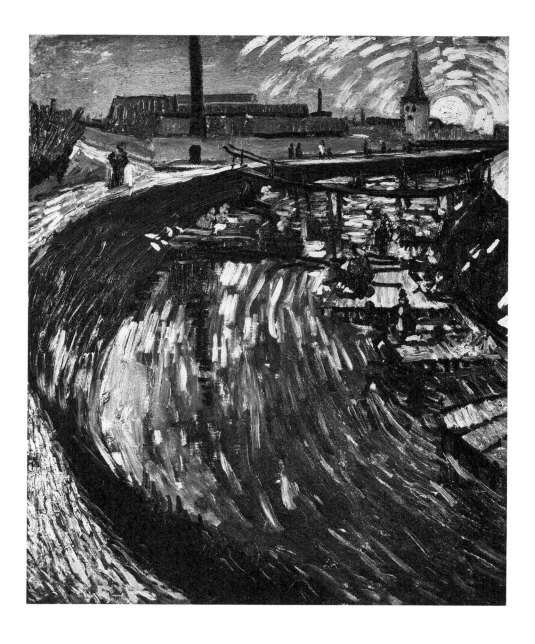

La Roubine du Roi with Washerwomen.
1888. Canvas. 29⅛ × 23⅝" (74 × 60 cm).
Private Collection.

manifold life in this green, is indescribable; our language falls short of words to adequately describe its visual impact. Then a curious picture, one that might, at first, cause us to think of illness, Hospital Garden in Arles: a cluster of tall trees behind which stretches a low, architectural edifice painted in yellow and pink with green shutters; it forms a beautiful contrast to the heavy green trees that fill most of the space. The trees stretch high into the air, and a deep blue sky is visible between feathery, filmy crowns, which convey a sense of wild undulating motion; they resemble screaming parrots. Maybe this already betrays signs of illness, for strange is the power of this bizarre wildness, and as beautiful as a dream is the glistening architecture behind the trees.

Then we find heavy, full, dark tones. A little autumn painting in deep green and rich yellow-brown. A landscape of Provence: an evening sky of dark blue that turns into green; violet mountains, pointed, dark-green trees; shrubs in a darker, cold green on a yellow ground; a low house with red roof and stark white walls that seem brilliantly illuminated. Two wonderful, strong still lifes: a bouquet of irises on a yellow background with thick, rich blue flowers and bright green stalk and leaves; mighty, full sunflowers on blue background, so unlike the kind usually seen here. And a wonderful sunset on the Rhône: The sun has just set behind a landscape scene bathed in yellow light. An iron bridge, like a shadow, cuts across the burning glow. The water glimmers, yellow and somber and human figures promenade on a wharf that seems to come toward us. The figure's movements are wonderful to observe. Everything seems

COLORPLATE 100

The hospital garden is of Saint-Rémy, not Arles.

to be bathed in this wondrous "unreality" that the evening glow casts over the street.

All in all, an amazing and overpowering wealth of creativity, rich in new methods and new problems. An innovator who does not rehash romantic weakness or repeat with artful skill what others have said before him, one who knows how to see and how to say what nobody before him had seen, who feels and understands the abundance of nature and knows how to recreate its immense beauty. A stimulator, a revolutionary, a pioneer who shows mankind a thousand new paths, and whose paintings cannot be studied enough; they should be seen and studied by all. A flash of lightning that suddenly lit up our darkness, revealing hitherto unknown worlds. A miracle and a hope, a happy premonition that out of our time, which so often seems tired and leaden and without hope and life, may yet arise new creativity and new courage. A miracle and, at the same time, an enigma. What ill-fortune could have brought this great power to such an end?

Paul Klee

THE DIARIES OF PAUL KLEE

Munich Entries

1908 and 1911

Two more exhibitions, quite important ones! Van Gogh at Brakl's and Van Gogh again at Zimmermann's on Maximilianstrasse. At Brakl's, a great deal; at Zimmermann's, the very famous pieces, like "L'Arlésienne," and many others. His pathos is alien to me, especially in my current phase, but he is certainly a genius. Pathetic to the point of being pathological, this endangered man can endanger one who does not see through him. Here a brain is consumed by the fire of a star. It frees itself in its work just before the catastrophe. Deepest tragedy takes place here, real tragedy, natural tragedy, exemplary tragedy.

Permit me to be terrified! [1908]

*　　*　　*

At present, I begin to understand many things about Van Gogh. I develop more and more confidence in him, partly because of his letters of which I own a selection. He was able to reach deep, very deep into his own heart.

It cannot be easy, in fact, for anyone to hurry by such a landmark, for the historical clock moves more harshly in the present than in the meditation of art history. It never stops though; it only seems to, on foggy days.

Perhaps he did not say all he had to, so that a few others might still be called upon to complete the revelation?

It is particularly tempting to view Van Gogh in historical retrospect—how he came without a break from Impressionism and yet created novelty.

His line is new and yet very old, and happily not a purely European affair. It is more a question of reform than of revolution.

The realization that there exists a line that benefits from Impressionism and at the same time conquers it has a truly electrifying effect on me. "Progress possible in the line!"

The possibility ripened in me of harmonizing my swarming scribbles with firmly restraining linear boundaries. And this will bear for me a

Paul Klee (1879–1940), Swiss artist, lived in Munich from 1906 to 1920. He saw Van Gogh's works in March and April 1908, at F. J. Brakl's Moderne Kunsthandlung and at the Kunstsalon W. Zimmermann, Munich.

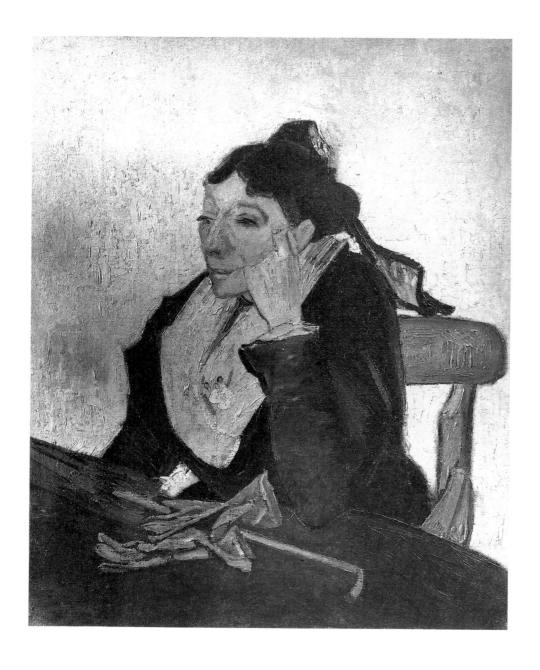

L'Arlésienne: Madame Ginoux. 1888. Canvas.
36⅝ × 29⅛″ (93 × 74 cm). Musée d'Orsay,
Paris. Photograph: Musées Nationaux.

further fruit; the line that eats and digests scribbles. Assimilation. The
spaces still look a bit empty, but not for much longer!

In lucid moments, I now have a clear view of twelve years of the his-
tory of my inner self. First the cramped self, that self with the big blink-
ers, then the disappearance of the blinkers and the self, now gradually
the reemergence of a self without blinkers.

It is good that one didn't know this in advance. [1911]

Wassily Kandinsky

APOLLON

"Letter from Munich"

3 October 1909

*Wassily Kandinsky (1866–1944),
Russian nonobjective painter and theorist,
wrote this first of five "letters" as Munich
correspondent for a new St. Petersburg
monthly,* Apollon.

When I returned to Munich a year ago, I found everything still in the
same old place. And I thought: this really is that fairy kingdom in which
pictures sleep on the walls, the custodians in their corners, the public with

their catalogues in their hands, the Munich artists with their same broad brushstroke, the critics with their pens between their teeth. And the buyer, who in former times went indefatigably with his money into the secretary's office—he too, as in the story, has been overcome by sleep on the way, and left rooted to the spot.

But one of my old friends told me: "They're waiting for something," "Something's got to happen," "Everyone who knows about such things realizes it can't go on like this," etc. . . . And I learned that two furious attacks had been mounted, two bombs been daringly exploded, although the attacks had been beaten off in the same furious and concerted manner, while the bombs, although they went off with a loud bang, had exploded without hurting anybody.

These two incidents were:

First, the exhibition (which took place nearly three years ago) of recent French artists at the Kunstverein, which everyone had been trying to bring up to date, without the slightest success: Cézanne, Gauguin, Van Gogh, Manguin, Matisse, etc., for the most part from Schuffenecker's collection. The organizer of this exhibition was one Meyer, a German domiciled in Paris.

And second, the large collection of Van Gogh (about a hundred paintings), which was shown eighteen months ago at Brakl's Moderne Galerie. (Brakl, the most advanced art dealer in Munich, "introduced," among others, the members of the Scholle group: Münzer, Eichler, Georgi, Püttner, and, first and foremost, Fritz Erler, now actively feted in Munich. All these artists, as is well known, are among the principal contributors to [the periodical] Jugend.)

Die Scholle: regionalist group of artists centered in Munich.

Both these experiments ended in apparent failure.

Out of the entire Van Gogh collection, it seems that only one single work was bought, with his last pfennig, by a Russian artist living in Munich.

Alexi von Jawlensky (1864–1914) may have been the buyer; by 1912, he seems to have owned House of Père Pilon.

The above-mentioned Frenchmen, moreover, were not recognized as "serious artists," and the better "local masters," those pillars of the artistic establishment, protested both verbally and in writing (!) at such an affront to serious art and public taste. . . .

Maurice Denis

L'OCCIDENT

"From Gauguin and Van Gogh to Classicism"

May 1909

Van Gogh and Gauguin brilliantly sum up this epoch of confusion and renaissance. Alongside Seurat's scientific Impressionism, they represent barbarism, revolution, excitement—and finally wisdom. At the beginning their efforts defied all classification, although their theories were barely distinguishable from the older Impressionism. Art for them, as for their predecessors, was the rendering of a sensation, the exaltation of the individual sensibility. All the elements of excess and disorder that arose from Impressionism exasperated them at first, and it was only little by little that they became aware of their innovative role and noticed that

their Synthetism or their Symbolism was precisely the antithesis of Impressionism.

Their work has gained its influence from its brutal and paradoxical aspect. We see proof of this in the northern countries—Russia, Scandinavia, Finland—where their influence preceded, and paved the way for that of Cézanne. If it were not for the destroying and negating anarchism of Gauguin and Van Gogh, Cézanne's example, with all the tradition, restraint, and order that it comprises, would not have been understood. The revolutionary elements of their work were the vehicles for the constructive elements. Yet, for the attentive observer, as early as 1890 it was easy to discern, in the extravagances of the works and the paradoxes of the theories, the prologue to a Classical reaction.

* * *

Art is no longer solely a visual sensation that we take in, a photograph, however refined—of nature. No, it is a creation of our spirit, of which nature is only a pretext. Instead of "working around the eye, we were searching for the mysterious center of thought," as Gauguin used to say. Imagination thus becomes, once again, according to Baudelaire's vow, the queen of the faculties. In this manner we liberated our sensibility, and art, instead of being a *copy*, became the *subjective deformation* of nature.

From the objective point of view, the decorative, aesthetic, and rational composition to which the Impressionists gave no thought, because it ran counter to their taste for improvisation, became the "counter-part," the necessary corrective to the theory of equivalents. The latter sanctioned, for the sake of the expression, all transpositions, even caricatural ones, all excesses of character: the *objective deformation*, in its turn, obliged the artist to transpose everything into Beauty. In short, the expressive synthesis, the symbol of a sensation, came to be an eloquent transcription of it and, at the same time, an object composed for the eye's pleasure.

Intimately linked in Cézanne, these two tendencies are also found, in different forms, in Van Gogh, Gauguin, Bernard, all the older Synthetists. It is in keeping with their thought and sums up well the essence of their theory, if one reduces it to these two deformations. But while the decorative deformation is the most habitual preoccupation of Gauguin, it is, on the contrary, the subjective deformation that gives Van Gogh's painting its character and lyricism. In the former, beneath rustic or exotic appearances, one finds at the same time, a rigorous logic and artifice of composition wherein survives, I dare say, a bit of Italian rhetoric. The latter, on the contrary, who comes to us from the land of Rembrandt, is an exasperated Romantic: he is moved more by the picturesque and the pathetic than by plastic beauty and order. The two artists thus represent an exceptional instance of the two strains of the movement, classical and romantic. Let us seek in these two masters of our youth a few concrete images to illustrate this too-abstract and perhaps obscure essay.

In Van Gogh's impetuous and irregular execution, in his brilliant studies, and his violence of tone, I find everything that now fascinates the young *tachistes* and the reason why they content themselves with splashes of pure color or a few stripes. They admire his aggressive attitude in the face of nature, his abnormal, exasperated, but truly lyrical vision of things, his scrupulous saying of everything that he feels, the insistence with which he asserts the most capricious permutations of his sensibility—and by what rudimentary means!—by a furious stroke, by the enormous relief of impasto. His works betray that unruly manner of attacking the canvas that the last Romantics considered to be a sign of genius; not unlike the type of painter grossly characterized by Zola in *L'Oeuvre*. In this mystical, exquisite and poetic painter, the inane and trivial influence of Naturalism has left its traces, which I still perceive in

"The Theory of Two Distortions"— subjective and objective—was a basic premise of the Nabis.

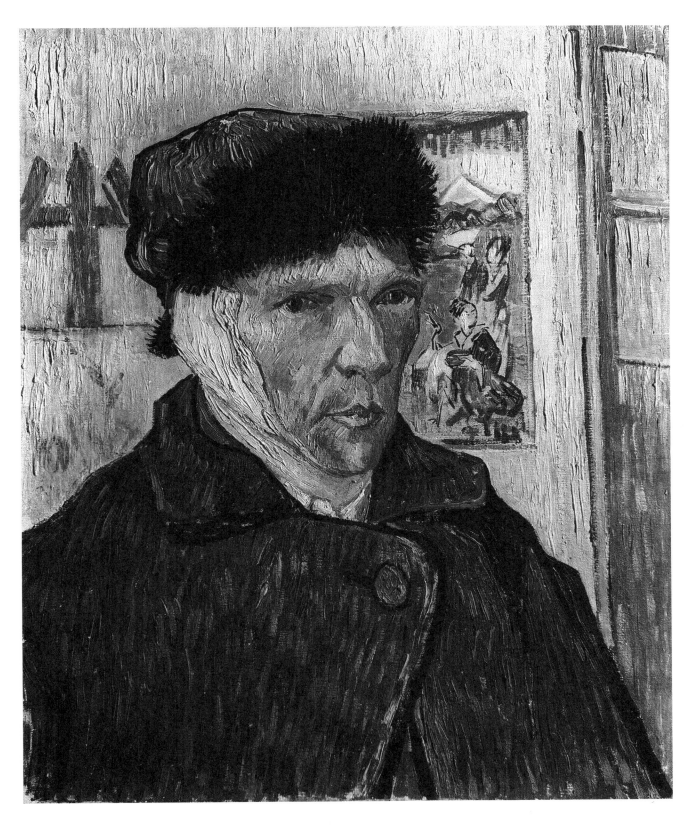

the emergent generation. The word "temperament," with all it implies of animal nature, retains its prestige. Van Gogh, finally, brought about in the young a relapse into Romanticism. . . .

I have before me a beautiful self-portrait by Vincent: the green eyes, the red beard and hair upon a sallow, but proudly composed face. The background, where a Japanese print may be seen, counts for little. It is a study, but a considered, premeditated study. I see in it the defects that I have just pointed out, but also an intense expression of life and truth. The tragic quality of this visage synthesized with unusual success by a few energetic strokes and a few patches of color; the summary but definitive indication of the *essence* of the subject; the emotion that vibrates in this rough sketch by a true painter—all this makes of this study a work of the grandest style.

Self-Portrait with Bandaged Ear. 1889. Canvas. 23⅝ × 19¼" (60 × 49 cm). Courtauld Institute Galleries, London.

Maurice Denis owned this self-portrait.

Walter Sickert

THE FORTNIGHTLY REVIEW

"Post-Impressionists"

2 January 1911

Walter Sickert (1860–1942), English painter encouraged by Degas and Whistler and a liaison between French avant-garde and progressive English art.

I think Voltaire somewhere thus defines madness. If I remember him rightly, he says that madness is to think of too many things, too quickly, one after another, or to think too exclusively of one thing. I must say I wish Van Gogh would bite some of our exhibitors, who think not of too many things, nor too insistently of any one thing, but as the yokel said, of "maistly nowt."

Van Gogh was represented by 22 works in the Grafton Galleries "Manet and the Post-Impressionists" exhibition in London, 8 November 1910 to 16 January 1911.

"Maistly nowt": mostly nothing.

 I have always disliked Van Gogh's execution most cordially. But that implies a mere personal preference for which I claim no hearing. I execrate his treatment of the instrument I love, these strips of metallic paint that catch the light like so many dyed straws; and when those strips make convolutions that follow the form of ploughed furrows in a field, my teeth are set on edge. But he said what he had to say with fury and sincerity, and he was a colorist. *Les Aliscamps* is undeniably a great picture, and the landscape of rain does really rain with *furia*. Blonde dashes of water at an angle of 45 from right to left, and suddenly, across these, a black squirt. The discomfort, the misery, the hopelessness of rain are there. Such intensity is perhaps madness, but the result is interesting and stimulating. . . .

Kenyon Cox

HARPER'S WEEKLY

"The 'Modern' Spirit in Art"

March 1913

Kenyon Cox (1856–1919), American painter, illustrator, and critic, would have seen 18 Van Gogh works at the 1913 Armory show.

In the work of Van Gogh which was shown at the armory I can find little either of the great qualities he is said to have possessed or of the madness that finally overcame him. All I can be sure of is an experiment in impressionistic technique by a painter too unskilled to give quality to an evenly laid coat of pigment.

Arthur B. Davies

PERSONAL RECOLLECTIONS OF VINCENT VAN GOGH

Foreword

1913

Arthur B. Davies (1862–1928), American painter known for his pastoral scenes; as President of the Association of American Painters and Sculptors, he played a major role in organizing the Armory show. This excerpt is from his contribution to the English edition of Du Quesne-Van Gogh's memoir.

The paintings of Van Gogh show soundness and lucidity of mind, in form and in color, and contain sure indications of generous human sympathies. All this combines to make an art work which is essentially aristocratic. His powerful stride leads us into the domain of cosmic unity, where the great artists cluster in Pleiades. Because so satisfyingly permanent they give that zest to life, showing that the ascendancy of any human being, though handicapped by depressions and the sense of imminent misfortunes, will prevail over all those seemingly inherited material conditions.

It is blindness not to recognize in Van Gogh's paintings a fine balance of faculties, simplicity, and seriousness based upon a natural expression. He had no eye for compromise, for the devil of academic security of possession. He has ruled his domain with kingly power and made his visions beautiful, painting them in characters of rugged construction.

To see his master works is to realize his loyalty to his subjects, a singleness of purpose which is almost painful. His masterstroke is a prayer of thankfulness, his final thought a law of eternal energy.

As a seeker after some "new spirit," Van Gogh again verifies that, in avoiding conventional realism, art is vitally augmented change, suggesting so much, completing so little, yet comfortable to the natural order of intuition and duration.

The ordinary person is not naturally delighted with a great break, as made by Cézanne, Van Gogh, Gauguin, Matisse, and Brancusi; with the determination not to go on imitating facts but to produce, instead, things of plastic, decorative beauty. Mankind nevertheless is always able to discern that sincerity is a necessity of occupation in an art work, and that there is a relation of the fact to the perfect idea, and to the perfect artist.

Wilhelm Trübner

DIE KUNST FÜR ALLE

"Van Gogh and the New Direction of Painting"

1 January 1915

Wilhelm Trübner (1851–1917), German painter who evolved an Impressionistic-Expressionist style.

Trübner's article was accompanied by illustrations by German engraver Peter Halm (b. 1854).

Some ten years ago, when they were first shown in Berlin at the Cassirer Gallery, Van Gogh's paintings caused a great stir amongst art professionals. Because these paintings demonstrated a highly developed sense

of color, Van Gogh's inherent lack of formal training—which was, in a sense, disturbing and detracted somewhat from the quality of these works—was not enough to diminish the success of the master. One is used to judging the greatness of an artist by the level of his abilities; therefore, confronted with these paintings, one must say: had Van Gogh also possessed great artistic skills, he would have stood on equal footing with the great masters of all time, while the way he actually stands before us can better be likened to the relative stature of, perhaps, Hans Sachs to Shakespeare or Andreas Hofer to Napoleon Bonaparte.

Seeing now, in June 1914, the more than 100 works by Van Gogh at the Cassirer Gallery, one begins to think that, considering the artist's very short life, his lack of technical refinement was almost necessary in order for him to bring to the surface all the rich, raw material that was slumbering in him, even though, in his great haste, the master did not have time to develop it sufficiently. Indeed, the appearance of Van Gogh's works has opened up new territories, seemingly large enough to keep several generations of artists occupied with exploring them.

After the success of this artistic phenomenon, it became apparent that it would now be possible to create works of art of lasting value without having to struggle, as with traditional principles of art and technical knowledge, and soon various tendencies developed in different countries, some of them greatly exaggerating the new ideas and totally excluding any artistic know-how. Thus, the art of painting was greatly facilitated. Just as it had become easy after the discovery of America to discover America all over again, it had now, with this type of painting, become easy to dumbfound the world over and over. We can observe parallel trends in the art of ballet, with the new fashion of barefoot dancers, and likewise within the medical sciences in nature healers, who, by similarly sidestepping the difficulties of their professions, attract a great number of followers to themselves and thus exert considerable power.

Nevertheless, in the realm of art, the right of some of those new currents to exist cannot be questioned, since they have developed naturally and logically from what preceded them. Yes, they even ought to be welcomed wholeheartedly, because they seem able to restore important components of artistic creativity, such as courage, boldness, and youthful exuberance, as well as a certain nonchalance and naiveté, qualities that had been almost systematically driven out by the pedantry of tedious schoolmasters. Were we, however, to allow these young movements to govern alone, as the stormy youth demand, we would soon approach artistic anarchy; it is in art as in politics: Absolute rule of one party will benefit only that one, while it would have a detrimental effect on all others. Therefore, we should strive for equality and collaboration amongst all existing directions in art in order to further future development on a sound basis without sacrificing the achievements of former times.

In accordance with such tendencies of our time, where art currents with modest artistic technique want to seize the reins, it has become fashionable to ascribe the highest praise—"monumental talent"—to artists with the most primitive ability. But just as in music there is a distinction between primitive ability and monumental talent, so should be the case in the pictorial arts. In the realm of music, e.g. the members of a male choir or the chorus of a Royal Court Theater could be designated as representing the more primitive elements, while opera singers and soloists constitute the higher artistic echelon. Would one attempt to perform a monumental work of music, such as an oratorio, by making use of only the choir and not the soloists? Such a thing could only evoke pitying laughter from the public. However, in the field of the pictorial arts, the public maintains just such a primitive viewpoint, so that contrary to the established hierarchies in music, one finds the soloists in the background and the male choir moving to the front. Primitive art that,

In spring of 1905, Paul Cassirer mounted the first one-man show of some 30 works by Van Gogh in Berlin, and, in fall of 1910, another exhibition of 74 works. The 1914 exhibition included 146 works.

Hans Sachs (1494–1576), prolific German poet and dramatist, was the leading spirit of the Nuremberg Meistersinger school. Andreas Hofer (1767–1810), militia captain who led the defense of Tirol against Bavarian rule; later, betrayed by Napoleon, Tirol fell to the French, and Hofer was executed. The distinction here is between men of talent and men of genius.

in style, comes close to poster art will never achieve lasting monumentality, no matter how many followers become enthused with this superficial art form. . . .

Kasimir Malevich

ESSAYS ON ART 1915–1933
Essay of 15 July 1919

Kasimir Malevich (1878–1935), Russian Suprematist artist.

The latest movements in painterly art have been greatly guided by two figures: Cubism by Cézanne and Dynamic Futurism by Van Gogh.

During the 1910s, Malevich, by his own definition, had worked in a "cubo-futurist" idiom.

Van Gogh was approached from the old viewpoint of thematic content and examined from the aspect of the natural, the unnatural and the psychological. But Van Gogh approached the model as beds. Apart from an extract of purely painterly texture from the visible forms of the living world he also saw in them living, moving elements; he perceived the movement and aspiration of every form. For him form was simply a tool through which dynamic power passed. He saw that everything trembles as the result of a single, universal movement: he was faced with conquering space, and everything rushed into its depths. There was an incredible tension of dynamic action in his brain which he could see more clearly than in grasses, flowers, people or the storm. The movements of his brain's growths were locked in elemental striving in his skull, and, perhaps, finding no outlet, were fated to die in the furrows of his brain.

His landscapes, genre-paintings and portraits served him as forms for expressing dynamic power, and he hastened in the ragged, pointed painterly textures to express the movement of dynamism; it was as if a current passed through every growth, and their form made contact with world unity. All the purely Impressionist aims that have been attributed to Van Gogh are as false as in the case of the progenitor of the Impressionists, Monet, who sought painterly texture in light and shade as Van Gogh did dynamics in the texture of color. But thanks to the fact that with Van Gogh, Cézanne and Monet all these actions were in the form of a subconscious germ they fell into the all-embracing junk of objectivity, a situation that was worsened by the critics who attached to them the collective label of Impressionism.

But in spite of all labels the subconscious and the intuitive grew, and eventually Cézanne's "Impressionism" developed into the Cubist body, whilst Van Gogh's became Futurist Dynamism. The latter began to express dynamics with great force by means of the splitting and scattering of things thrown by energic power onto the path of universal unity of movement towards conquest of the infinite.

Futurism rejected all the signs of the vegetable world, and of flesh and bone, and discovered forms of dynamic expression in a new iron world; it discovered a new sign: the symbol of speed, the machine which is preparing to run in a million forms onto the new beaches of the future. Only by some obscure concept of reason it runs around the globe gobbling up all in its path, as if filling its belly in readiness for a long journey, and, thanks to the fact that reason cannot part with its cookhouse baggage it dashes from side to side in economic material flowerbeds.

Both Cézanne and Van Gogh built the painterly on aesthetic action and the formation of their textures depended to a great extent on the proportional, aesthetic mixing of a quantity of color rays, from which they formed a layered, bristly or rough texture. Cézanne developed

weight in his textural layered surfaces, Van Gogh separated the textural waves from the object, the latter being for him only form, saturated with a maximum of dynamic power. . . .

Guy Pène du Bois
ARTS AND DECORATION
"Vincent and the Family Heirlooms"
November 1920

Guy Pène du Bois (1884–1958), American figurative painter, writer, and music and art critic who, from 1913 to 1920, served as editor for Arts and Decoration.

Artists, like dogs, have their days—days in which they are placed upon high pinnacles and admired or adored from way below by a mass of submissive enthusiasts never so happy as when sent to their knees. The funniest thing about art is not the artist. He is jumped from obscurity into the thrones of the mighty, into the realm of genius without turning so much as a hair.

Perhaps the admiration of pictures may be resolved into an admiration of personalities. Perhaps the intensity so generously and generally described as the main attribute of Vincent van Gogh, as an example, is a reflection of the fact of his suicide. Who can tell?

The exhibition of the work which has remained in the possession of his family, held at the Montross Gallery, must leave the most enthusiastic admirers of Vincent—they grow in number rapidly this year—in some doubt of a particular aspect of the ground for their enthusiasm. Among the paintings in that collection not one suggests an intensity of enough isolation to have led to suicide. The man is enjoying the world as he paints these canvases and especially a world of art which gives color to many of his impressions. He is far from isolation. He is far from that soul-eating intensity so much beloved by his romantic biographers. We

The Montross Gallery exhibition, which opened 23 October 1920 in New York, was the first one-man show of Van Gogh's works (32 paintings and 35 works on paper) in the United States.

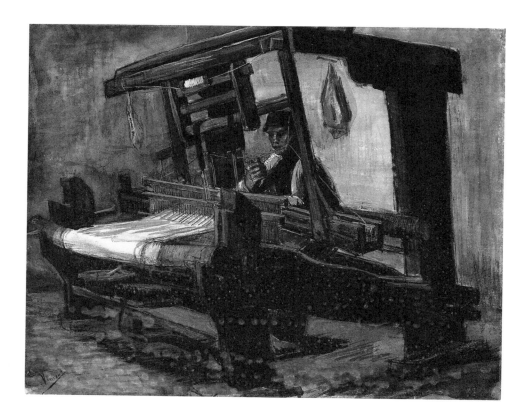

The Weaver. 1884. Pencil and watercolor. 13¾ × 17¾" (35 × 45 cm). Rijksmuseum Vincent van Gogh, Amsterdam.

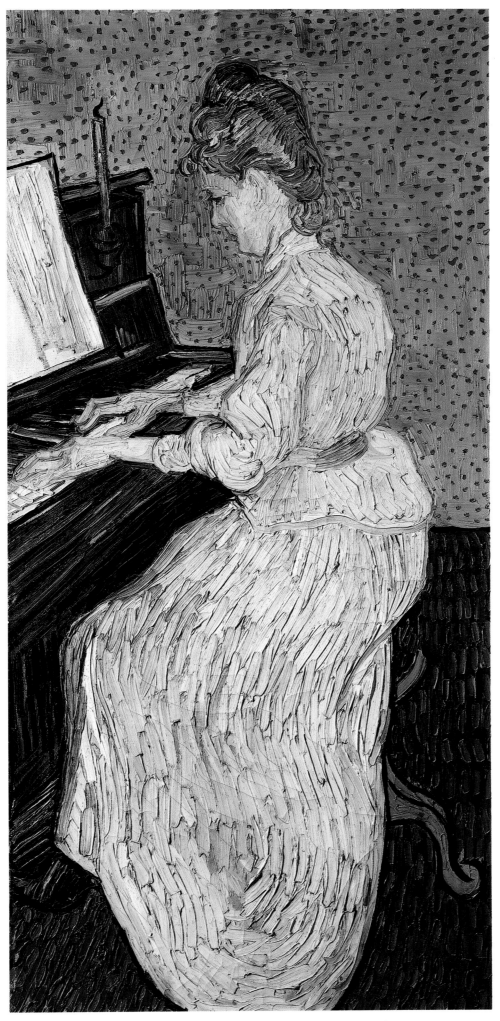

COLORPLATE 119. *Marguerite Gachet at the Piano*. 1890. Canvas.
40⅛ × 19⅝″ (102 × 50 cm). Öffentliche Kunstsammlung,
Kunstmuseum, Basel. Photograph: Colorphoto Hans Hinz.

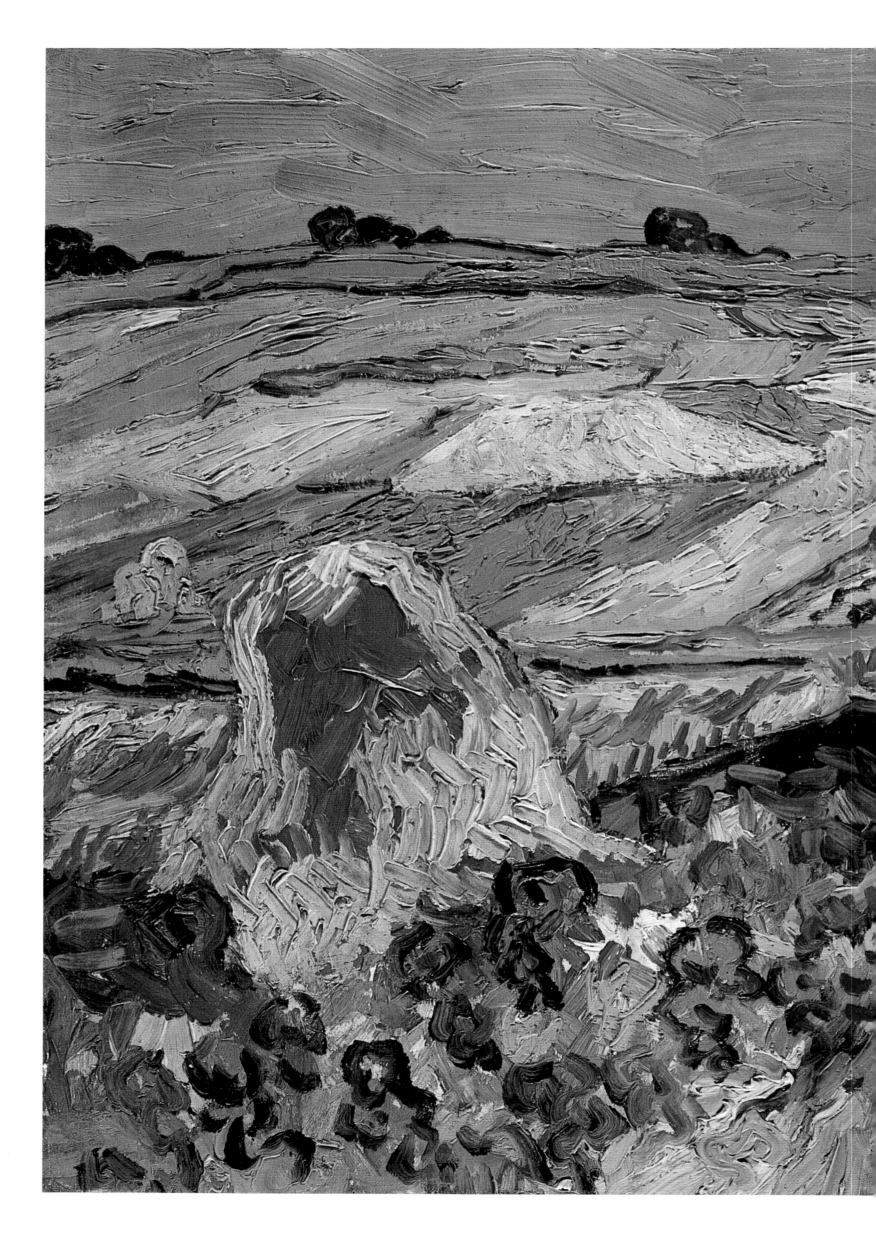

COLORPLATE 120.
Wheat Fields at Auvers. 1890.
Canvas. 19⅝ × 39¾″
(50 × 101 cm).
Kunsthistorisches Museum,
Vienna.

COLORPLATE 121. *Undergrowth with Two Figures.* 1890. 19⅝ × 39⅜″ (50 × 100 cm).
Cincinnati Art Museum; Bequest of Mary E. Johnston.

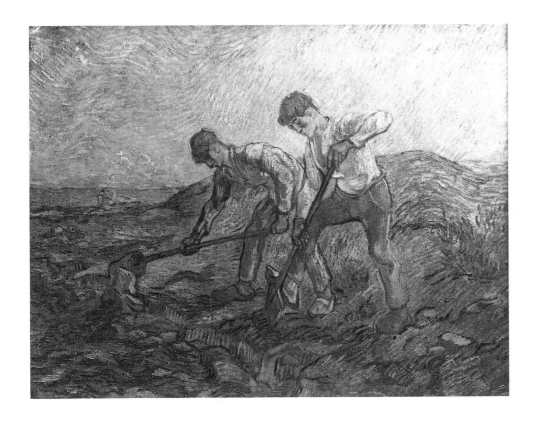

might almost conclude here, knowing less of his history, that his desperate final act was the result of a despair engendered exclusively by impotence.

Instead of finding a subjective giant marching roughshod over the objectivities of nature, marching thus armed with a formidable vision, we find a very humble little man seated before nature with every faculty open to that which she may have to tell him. Every faculty, with the exception of one or two or even three, which have been closed or directed by art influences. No artist is ever entirely rid of these. Vincent in Holland was a low-toned painter, in France he became an Impressionist. It is difficult to decide from the evidences of this collection whether he ever successfully ceased being an Impressionist. The most convincing of his canvases have their root in that school of painting. The later ones, which seem to reach further technically, do not carry a comparable conviction. They are almost empty shells. They have the fabric of a dogma, but none of the meat on which it grew.

I do not mean that it is an uninteresting collection. It is, on the contrary, a mighty interesting collection. And particularly at this time when the star of Van Gogh is in the ascendant popularly; when, indeed, it appears that Cézanne, Gauguin and Matisse are, this year at least, to make room for him, are to be forced to make room for him. The art public, in its consistent fickleness, has decreed the arrival of his turn. He will on that account bear a very close general inspection. It is unfortunate that that cannot very well be done within the confines of the Montross Gallery show.

It is an early Van Gogh that we view—the artist in the making—a man with a sensitive and timid brush, in some instances, and those the most successful, and in others belaboring his canvases with heavy swabs of paint, bold loads of it, which very seldom hide the want of anything comparable to them in boldness or might of message. He shouts things in these instances that should have been hardly worth the weight of a whisper.

Indeed, the man who painted the postman, a too decorative canvas to belong to Impressionism, is a man who has lost or momentarily discarded much of the sensitiveness, delicacy and sobriety which informs

349

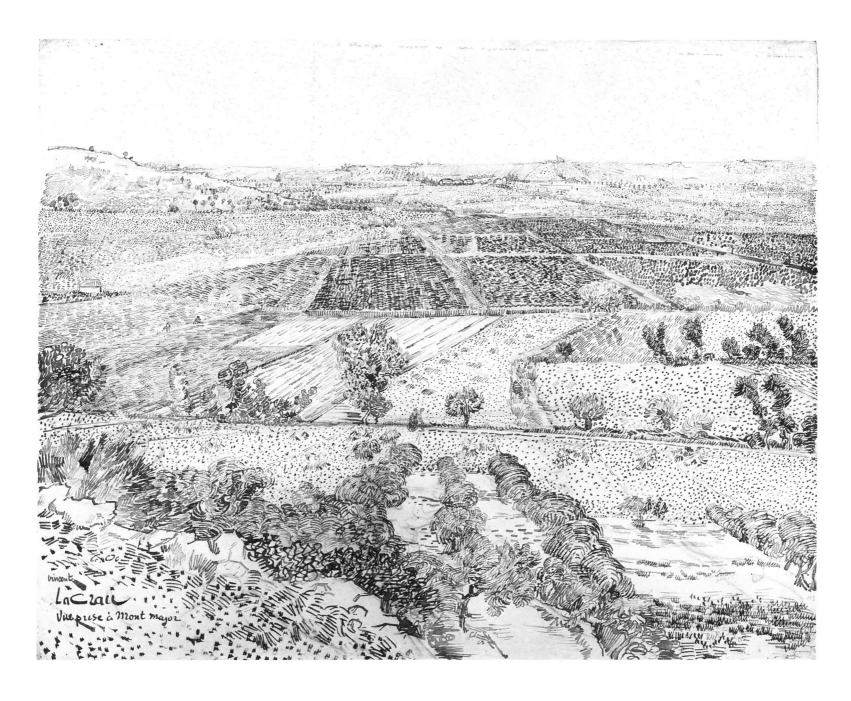

View of La Crau from Montmajour. 1888. Pencil, reed pen, quill pen, and brown and black ink. 19¼ × 24″ (49 × 61 cm). Rijksmuseum Vincent van Gogh, Amsterdam.

his purely realistic earlier portrait of himself, who has gone wilfully rather than naturally or progressively from being humble to being arrogant. We even spy a stutter in the arrogance, a want of assurance, a weakness. He is not certain of the validity of the pose he strikes. He wonders a little. He stumbles a lot. But he begins to be the Van Gogh which the world will later acclaim as a contributor to the sum of its knowledge. He is no longer content to receive from nature. He must now put the conclusions of his long assimilation into concrete shape. Return the debt with interest. Still, he is only the fledgling of the man who will later make vivid a picture of the dynamic forces of nature, who will show us the shooting of trees toward the sky, who will give us an almost madly energetic conception of the push, of the vitality of growth.

He is making marks of a new and of a different character in two or three of these landscapes, marks which are in the style of the full-fledged man, but which, through want of potency, fall very short of the man. This collection was shown before the war in Munich and Cologne. Could it be that the more convincing examples of the later work have all gone from it into the collections of the assiduous German buyers of the works of that modern trinity, Cézanne, Gauguin and Van Gogh? This modernist of the Montross show is not comparable to Cézanne and Gauguin. (We are dealing with the paintings.) Indeed, he would appear casually

to contribute less than Matisse, whose translucent color has given a new note to painting, or, at least, accentuated an old one. The Primitives lose considerable clarity through the amber veneer of many coats of varnish.

The drawings, which fill an entire gallery, will give a very definite or a very intimate conception of the force and patience and conscientiousness of the man. They are in many styles and mediums. They show the progress of the man toward the style which was ultimately to express him. He borrowed as much from art, we see here, as he did from nature.

Some of the interiors, the two of farmhouses especially, might have come out of The Hague school; one, the weaver, while going much less into the literal reproduction of a fact still suggests those stories of the life of Christ drawn in watercolor by Tissot; others bring us to certain Germans who have felt that the rendition of strength is reached through the exaggeration of anatomical factors, while through the collection is to be found a constant recurrence of the influence of Millet. Apparently the man who liked to sign himself simply Vincent was a tireless investigator whose humility permitted the honest reception of all kinds of influences.

Apparently also, as may be seen in such a drawing as the View of Mt. Major, or in one of willows in a country garden, it was when he forgot the precedence of art and devoted himself exclusively to nature that the master began to make his appearance. It was here he found himself.

Theo van Doesburg

DE STIJL

"The Will To Style"

March 1922

Theo van Doesburg (1883–1931), Dutch painter and polemicist for the de Stijl movement.

The struggle for direct expression was initiated very forcefully by Van Gogh (example: *L'Arlésienne*). With crude certainty he forced his experience of contrast on to the canvas surface. He attempted to annul duality by means of a volumic, well-defined form of structure to balance the static and the dynamic and to impose the spiritual upon the material. However, this annulment of duality (of life as experienced by the unbalanced, imperfect man of the past) could not be achieved without the destruction of the illusion of nature, without the dissolution of closed form, without the *annulment of the form*. Beginning now the new will to style will consider closed form an obstacle. . . .

COLORPLATE 75

Oliver Brown

EXHIBITION: THE MEMOIRS OF OLIVER BROWN

Leicester Galleries Exhibit, London, 1923

1968

Oliver Brown (d. 1966), for many years Director of the Leicester Galleries in London, played an active part in promoting modern art in England.

Early in the year 1923 I had a friendly talk with an acquaintance and an occasional visitor to the exhibitions which led to an event that caused a great stir in the London art world. Mr. Simmons, our visitor, was a theatrical costumier with premises off the Haymarket. He told us that when on holiday in Holland he had been greatly moved by the work of Vincent van Gogh in the municipal museum of Amsterdam, and had asked a Dutch painter of his acquaintance named Isaäcson where he could see more of Van Gogh's painting. The artist took him to see Madame Van Gogh-Bonger, the widow of Theodore van Gogh, Vincent's devoted brother, who had been a picture dealer in the Goupil Gallery in Paris. He was thrilled to see a large collection of Vincent's work on her walls, and asked why she had never shown a collection of them in England. "Nobody has ever asked me," was her reply.

The Dutch artist, J. J. Isaäcson, one of Van Gogh's first critics.

Mr. Simmons' account of his visit made a great impression on me, and I lost no time in writing to Mme. Van Gogh-Bonger. She seemed pleased with the idea, and in the summer I visited Amsterdam. Though Mme. Van Gogh-Bonger was then seriously ill I was able to make arrangements with her son, the nephew of Vincent, V. W. van Gogh, a young engineer who was most considerate and helpful. He entertained me in Amsterdam, on my arrival, at the Engineers' Club, and after lunch took me to his little house in a suburb of the town. The walls in every room were crowded with his famous uncle's pictures. I was astonished to find so many together. Nearly all of them were for sale, save for a few to be retained if possible for Holland. Even in the bathroom upstairs I noticed several canvases propped between the bath and the wall. It looked as if two exhibitions would be possible and I found it difficult to make a choice for the first, but I finally selected about forty pictures and drawings. They included what are now world-famous masterpieces. Among the paintings were: "A Pair of Boots" . . . "Park at Asnières" . . . "The Postman" . . . "Orchard in Arles" . . . "*Berceuse*" . . . "Vincent's Bedroom in Arles" . . . "The Sunflower" . . . "The Yellow Chair" . . . "The Bridge of Arles" . . . "The Zouave" . . . "The Olive Orchard" . . . and "The Cornfield with Rooks." . . .

COLORPLATES 25, 32, 73, 61, 81, 51, 124

This unique exhibition in December 1923 met with great success. It was the first complete showing of Vincent van Gogh in England, although there had been a fine selection at the Post-Impressionist Exhibition in 1912. There was also a room of twelve large fine drawings made with a quill and a self-portrait of 1887 (a painting). There was one loan only from an English collector: Mrs. Alfred Sutro, herself an admirable artist, lent us "The Restaurant at Arles" of 1888. A few of the best pictures were not for sale, notably "The Chair" and "The Sunflowers," but the Trustees of the Tate Gallery were so anxious to have these two that the family were persuaded to part with them to the Tate in the end through the Trustees of the Courtauld Fund.

Forty works by Van Gogh were in the 1923 Leicester exhibition.

This was the 1910–11 Grafton Galleries exhibition.

COLORPLATES 81, 61

Looking back, it is surprising to realise how few of the paintings were sold to our English visitors and how modest some of the prices seem now. "The Postman Roulin" was sold to a German dealer, "A Man and a Woman Walking in a Wood" went to a well-known French dealer for under £1,000. The Earl of Sandwich bought an early landscape of the Dutch Period and a woman collector who lived in London bought a little painting called "On Montmartre" on the advice of Augustus John.

The exhibition caused such a stir in London that I considered how we could ever rival it. (However, our kind and helpful friend, V. W. van Gogh, was so pleased at the way it was presented that he and his mother promised to provide us with further examples of Vincent's genius.) What other artist would make as deep an impression was the next question that presented itself!

COLORPLATE 121

Augustus John (1878–1961), British painter.

Roger Fry
THE BURLINGTON MAGAZINE
"Van Gogh"
December 1923

Roger Fry (1866–1934), highly influential English art critic, painter, Curator of Paintings at The Metropolitan Museum (1905–1910) and editor of Burlington Magazine.

The Exhibition of Van Gogh's works at the Leicester Galleries gives us, for the first time in England, the opportunity of seeing something of the extraordinary artistic Odyssey which this strange being accomplished in the incredibly short time between his first devoting himself to painting and his tragic end. It is characteristic of his intensely personal and subjective talent that at each period he managed to convey so much of his beliefs, his passions, and of their effect on his temperament. Perhaps no other artist has illustrated his own soul so fully, and this all the more in that he was always the passive, humble and willing instrument of whatever faith held him for the time being in its grip. What strikes one all through his work, and with a fresh astonishment every time one sees it, is the total self-abandonment of the man. He never seems to be learning his art. From the very first his conviction in what he has to say is intense enough to carry him through all the difficulties, hesitations and doubts which beset the learner. He works, like a child who has not been taught works, with a feverish haste to get the image which obsesses him externalized in paint.

One could see that he must have always worked at high pressure and topmost speed, even if his large output in so few years did not prove it. He has no time and no need for that slow process of gradually perfecting an idea and bringing out of it all its possibilities. He is too much convinced at the moment ever to have doubt, and he is too little concerned with the fate of his work or of himself to mind whether it is complete or not, so long as he has, somehow, by whatever device or method that may come ready to his feverish hand, got the essential stuff of his idea on to the canvas. This is not the way of the greatest masters, of the great classic designers, but no one can doubt that it was the only way for Van Gogh. And so the fiery intensity of his conviction gave certainty and rhythm to his untrained hand.

What astonishes one most in this series is not only the rapidity of the work itself but the rapidity of the evolution which he accomplished. The *Pair of Boots* . . . is a still-life study in which the influence of his early Dutch training and his enthusiasm for Israels are still apparent. This be-

The December 1923 exhibition of 40 Van Gogh works was the artist's first one-man show in England, though a decade before saw the Grafton Galleries Post-Impressionists show that Fry helped organize.

The still life dates from the latter half of 1886.

COLORPLATE 25

longs to the year 1887. The latest work is the *Cornfield with Rooks* . . . done at Auvers just before his death in 1890. And the difference of spirit between these two is immense.

COLORPLATE 124

In between lies Van Gogh's *Annus mirabilis* 1888, the year of his sojourn in Provence, of his comradeship with Gauguin and his first tragic outbreak. And in that year he had not only to sum up, as it were, all his past endeavor, but to accept and digest the influence of so dominating a character as Gauguin's. We see him in the *Zouave*, . . . frankly accepting Gauguin's oppositions of flat, strongly colored, lacquer-like masses, but this is the only obvious evidence of Gauguin's effect on Van Gogh's art. *The Sunflowers* . . . is one of the triumphant successes of this year. It has supreme exuberance, vitality, and vehemence of attack, but with no sign of that loss of equilibrium which affects some of the later works. It belongs to a moment of fortunate self-confidence, a moment when the feverish intensity of his emotional reaction to nature put no undue strain upon his powers of realization.

COLORPLATE 51

Van Gogh's portraits of the Zouave were executed in June 1888, some four months prior to Gauguin's arrival in Arles.

COLORPLATE 61

Van Gogh had a predilection for harmonies in which positive notes of yellow predominated. In his thirst for color and light combined, he found in such schemes his keenest satisfaction. Here he has chosen a pale lemon-yellow background to set off the blazing golden glow of the petals of his sunflowers, which tell against it as dusky masses of burnished gold. Here, as so frequently in Van Gogh's art of this period and as in most of Gauguin's work, preoccupation with the arrangement of the silhouette is very apparent. And, moreover, the source from which both artists got the idea—the Japanese print—is evidently disclosed. A lapse from this careful organization of the surface unity on decorative lines is seen, however, in another work, . . . *The Yellow House at Arles*. . . . Here the composition shows perhaps a reminiscence of that momentary period when Seurat and Pissarro were his guiding lights.

COLORPLATE 66

There is, by the by, a most interesting landscape here of fruit trees with figures which is carried out almost entirely in the style of Pissarro, modified, of course, as all the many styles Van Gogh tried were, by his peculiarly emphatic temperament; though, perhaps, this is less clear here than elsewhere. Certainly one feels that he was bound to abandon so carefully planned, so slowly constructed and so minutely observant a method of painting for some other that would promise a more rapid realization of his idea.

But to return to the Arles picture. Perhaps nowhere else has Van Gogh expressed so fully the feeling of ecstatic wonder with which he greeted the radiance of Provençal light and color. He had shrunk at nothing in order to find a pictorial phrase in which to sing of the violence of the sun's rays upon red-tiled roofs and white stone walls. To do this he has saturated and loaded his sky, making it, not indeed the conventional cobalt which is popularly attributed to Mediterranean climes, but something more intense, more dramatic and almost menacing. How utterly different is Van Gogh's reading of Provençal nature from Cézanne's contemplative and reflecting penetration of its luminous structure. Here all is stated with the crudity of first impressions but also with all their importunate intensity—and they are the first impressions of a nature that vibrated instantly and completely to any dramatic appeal in the appearances of nature. In striking contrast to Cézanne, too, is Van Gogh's indifference to the plastic structure of his terrain, which is treated here in a cursory and altogether insignificant way. The artist's interest was entirely held by the dramatic conflict of houses and sky, and the rest has been a mere introduction to that theme.

While working in Arles, not far from Cézanne in Aix-en-Provence, Van Gogh himself noted how different was his approach to the Provençal subjects that inspired "father Cézanne."

The canvases of the succeeding year, 1889, show another rapidly accomplished evolution. The brushwork becomes more agitated, or rather the rhythm becomes more rapid and more undulating, and all the forms tend to be swept together into a vortex of rapid brushstrokes. There are no examples here of the more extreme developments of this

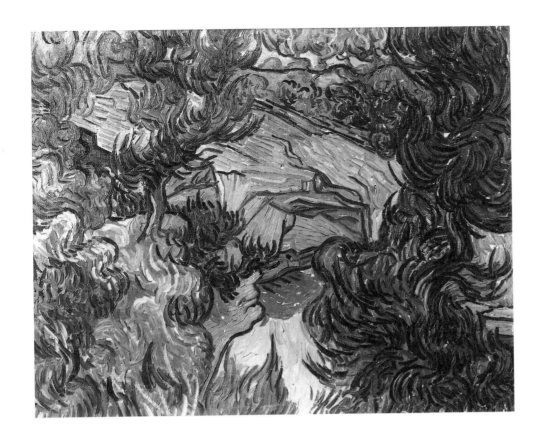

Entrance to a Quarry. 1889. Canvas.
23⅝ × 28¾″ (60 × 72.5 cm).
Rijksmuseum Vincent van Gogh,
Amsterdam.

period. One *Rocks in a Wood* . . . is quite unusual for this period. It shows, indeed, the new vehement rhythmical treatment of the forms and the agitated handling; but with this goes a singularly well-balanced composition without any strong dramatic effect, and with a peculiarly delicate and tender harmony. It expresses altogether an unfamiliar mood.

The one masterpiece of this period, *The Ravine*, is not here, unfortunately—I believe it is now in America. In this, by some fortunate influence, all the agitated vehemence of handling of this period serves only to give vitality to the structure of the rocks, and here, under the dominance of a more steadily held impression, Van Gogh has been able to persist until the loaded paint has become fused into a substance as solid and as precious as some molten ore shining with strange metallic lusters.

It is in the *Cornfield with Rooks* that, as far as this exhibition goes, we get a glimpse of Van Gogh's last phase of almost desperate exaltation. Here the dramatic feeling has become so insistent as to outweigh all other considerations. There is no longer any heed given to questions of formal design, and Van Gogh ends, as one might have guessed from his temperament that he must end, as an inspired illustrator.

COLORPLATE 101

COLORPLATE 124

Hans Purrmann

KUNST UND KÜNSTLER

"Van Gogh and Us"

February 1928

*Hans Purrmann (1880–1966), German
artist whose Fauvist–Expressionist works
betray a debt to his friendship with
Matisse.*

*Café Stephanie, in Schwabing, the
bohemian center in north Munich, was
where writers, composers, and artists from
Russia, Hungary, Austria, Italy,
England, and America met.*

I heard about Van Gogh for the first time in Munich. A gloomy story was circulating in the Café Stephanie: An extremely interesting modern painter, a Dutchman, had shot himself in despair in front of his easel in

an open field in France. So the story went. The reality was obviously quite different.

Paintings by Van Gogh remained unknown to us for a long time; art in those days was not yet a subject for book publishers; in Germany as well as in France, publicity was totally unavailable to aspiring artists. Not even in Munich were there galleries for modern art; books and picture reproductions were hardly ever published. We tried to see the very few photographs and books that surfaced in the art-book trade by sheepishly asking to have them shown to us as though we wanted to buy them, though we very rarely had the money for it.

But just as ideas that are new, that mysteriously buzz through the air can be revolutionary, so it was with the talk about Van Gogh's art, even though hardly anyone had seen his paintings. It would be quite a while before we would learn anything about his style from poor-quality Dutch reproductions. Those we studied with fervor: How was it possible that such a stimulating and inflammatory power could emanate from these poor reproductions? Without problem and without reserve, these works were immediately understood by us; their effect was so remarkable that I cannot recall today where I first saw the original paintings. This is a suggestive art, an art that radiates waves of excitement that seem to connect mind with mind and transfer enjoyment from painter to viewer!

How slowly, compared with this, did Cézanne succeed in charming us. Though he did captivate and shock us, he also provoked laughter and ridicule, as how could we accept such a view of Nature—incomprehensible! He assaulted us with his art: "Certainly, for the next century the whole world will be engaged in discussions about me. You can correct your artistic errors by comparing your work with mine. I am not the patchwork you are taking me for; through unprogrammatic, pure painting in perfect balance I will bring about all new art"!

This sinister Cézanne, who did not want to understand Van Gogh, told him: "Your methods lead to confusion! you don't work in the manner of our ancestors, your 'thing' is East Asia, your picture is not a picture, everything becomes a graphic work, a Japanese print. Light and dark are the most important elements of our artistic perception, even though I, myself, do not stress them, at least not with Light and Dark!"

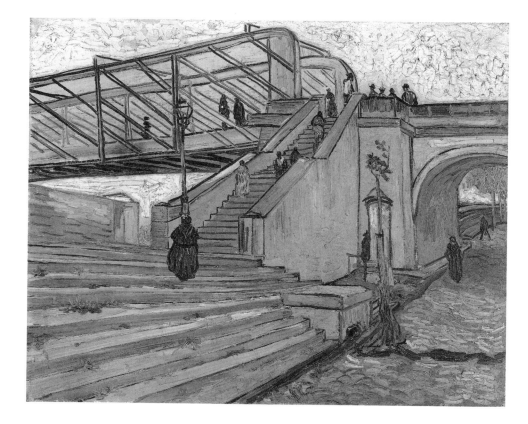

The Trinquetaille Bridge. 1888. Canvas. 28¾ × 36¼" (73 × 92 cm). Private Collection, U.S.A.

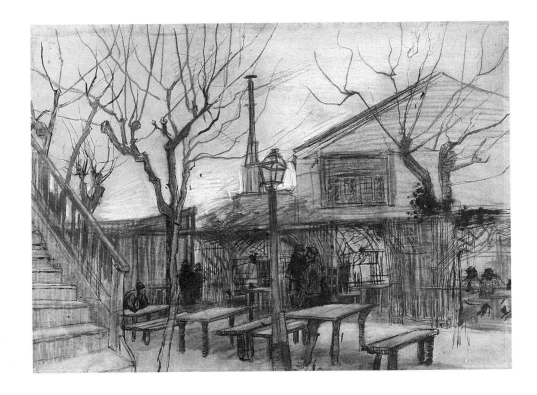

Terrace of a Café (La Guinguette). 1886.
Pen and pencil, heightened with white.
15 × 20½″ (38 × 52 cm). Rijksmuseum
Vincent van Gogh, Amsterdam.

Was not Cézanne the only one of the Impressionists who refused to submit to the Japanese influence? The great Manet, Degas, Whistler, and Lautrec boldly revived the woodcut; Monet went even further than that with his series paintings, following in the footsteps of Hokusai in his pictures of Mount Fuji, he ended up fatally transforming his own style of painting. Van Gogh, however, went the furthest in his enthusiasm for the Japanese; less restained, less bound to tradition, he sacrificed his painting to the style of the woodcut. From Holland he brought a heavy palette that seemed to drown in brown, and a manner of drawing that, in its realistic sense of form, came close to that of the Japanese. With how much enthusiasm he must have studied the woodcuts to be able to so refresh his own work, in which up to now one dominant color had drowned the color scheme, and to learn from them color distribution that remains harmonious even when he used colors side by side that were opposite from each other in the spectrum!

Van Gogh—whose weak constitution was tortured by sickness and utter poverty, whose feeble body needed to be invigorated by absinthe and coffee—had to find a way, in his art, of expressing his sensations of Nature and of Life with utmost speed. He absorbed impressions in an almost delirious state of mind, which would then quickly evaporate; fate did not allow him to dwell in tranquil contemplation, to string impression to impression, to build cathedrals in his paintings. This feeling of having only limited time to live must have weighed heavily on him, and it probably explains his wish to create a kind of cloister for painters where, collectively, they would achieve what was unachievable for the individual.

This call, this unprecedented cry in modern art has somewhat subsided; some of the water would be spilled instead of poured into a vessel. Today we face his paintings with some indifference and identify that which is most self-evident, their strong impression of Nature—and yet we must remain grateful to this painter who once made us tremble when we experienced his wide fields, his bridges, his railroad viaducts, his parks, his still lifes of color-symbolism, his flamelike trees that seem to reach into the burning atmosphere, his starry skies, his sunsets—so unromantic, so new—upon seeing them for the first time!

We picture-viewers of today, lacking the social and conditioned respect for nature and tradition that had such a strong hold on us at one

Numerous Van Gogh works could be seen in Berlin at this time: the Galerie Wacker hosted a 119-work show from 6 December to 1 February; at Paul Cassirer's was a 92-work retrospective from 14 January to 1 March 1928.

time, force ourselves to suppress a certain underlying dissatisfaction. Though we do this with conviction, out of our enormous sympathy toward this immensely gifted man, we nevertheless realize that those presuppositions that would have allowed us to honor him as one of our greatest contemporaries have since disappeared.

John Sloan

GIST OF ART

1939

John Sloan (1871–1951), American painter of city genre scenes, founding member of "The Eight," and influential teacher. Gist of Art is based on "principles and practice exposed in the classroom and studio."

If making pictures that somebody buys makes the art commercial, Picasso is a commercial artist. So was Van Gogh, but not while he was alive. Why does Van Gogh get on the front page of the paper? Because he is a great artist? No. It is the sob story about his life that gets him on the first page. Now the critics recognize him, are proud of it. Do our critics think they are superior to the French critics of the 1870's who condemned Van Gogh? Art criticism in this country is in its infancy. France has had it for three hundred years. I am no good at dates—I may have understated it by a thousand years. You can be quite sure that any art critic we have today is missing the Van Gogh of today, just as the French critics did in the nineteenth century. Van Gogh received a hundred and nine dollars for his work while he was alive and now some of his pictures sell for fifty thousand dollars. Was Van Gogh a success? From the commonplace point of view he was not. But I think he was a success. Reading through his letters, you will find that he felt he was a success with himself. But not with the academy, the juries, the dealers. His art was the product of his inner self in response to the life around him.

Van Gogh's activity as an artist, confined to the decade 1880–1890, did not receive critical attention until 1888!

Possibly a reference to Anna Boch's 1890 purchase of a Van Gogh painting for 400 francs.

* * *

I question whether you can really be an artist when you have given up your independence. What I am really saying is that the artist who paints for himself is an amateur. In that sense I am proud to be an amateur. So was Rembrandt and so, too, Van Gogh.

David, Marussia and Nicholas Burliuk

COLOR AND RHYME

"Why Van Gogh?"

1950–1951

David Burliuk (1882–1967), Russian–American painter, art polemicist, and initiator in the Russian Futurist movement, was among the original contributors to Der Blaue Reiter in Munich.

The 1950/51 issue of the journal Color and Rhyme, edited by David Burliuk, his wife Marussia, and his son Nicholas, was dedicated to Vincent van Gogh.

When we entered the train bound from Chicago to New York on July 11th, 1949, it was really a very hot day. Ours was a new car which had just been put into service. Velvet covered the seats. The metal around the windows and the linoleum on the floor were shiny and glossy. We were stunned to be face to face with the bent body of a girl called

Mousme so fascinatingly painted by Vincent van Gogh in Arles in 1888. COLORPLATE 53
On an opposite wall, nicely matted and under heavy glass, was a pot on COLORPLATE 44
an orange background, blue cups, and a checkered pitcher resting on a
blue tablecloth.

This moment of American life really illustrates the popularity of the
great master's works. During the last twenty years, reproductions of Van
Gogh have been distributed by the tens of thousands in the modest
homes of Americans in every state. When we received hospitality and
shelter in a house of a farmer in Florida in 1946, there was a reproduc- COLORPLATE 73
tion of Van Gogh's bedroom over our bed. His works have invaded the
walls of the residents of this country.

When the Museum of Modern Art was opened in New York in 1929,
in the foreword to the catalogue of this historical exhibition of Cézanne,
Gauguin, and Van Gogh, Alfred Barr Jr. mentioned my name among the
first ten painters of International Modern Art who from 1904 first fol-
lowed the traditions of these three great painters. At about the same
time, Duncan Phillips in his book, "Art and Its Understanding," repro-
duced one of my paintings alongside of Van Gogh and made compari-
sons of my coloring and tone qualities to that of the great master.

In *Vanity Fair,* New York, September 1919, a large article appeared
with my portrait and the reproductions of my two canvases. The author
of the article, Oliver M. Sayler, American correspondent in Moscow in
1917 and 1918, outlined my aesthetical credo and expressed his impres-
sions of my paintings as follows:

"The entire end of one room was given up to his canvases, but he
might as well have limited his contribution to one, for a single painting
made you forget all the rest. 'The Angel of Peace Who Came Too Late,'
Burliuk calls it. With its unspeakably tragic conception, its dull blues and
its smouldering reds, and the strange tortuous detail resembling that of
Van Gogh, the picture is a relentless and heart-breaking epitome. . . ."

But much earlier in 1906 my sister Ludmilla, my brother Waldemar COLORPLATES 78, 82
and I saw works of Van Gogh in the collection of Serge Stchukin in
Moscow. That was a great stimulation to our work, and since that time
we started to follow the principles which were hinted at by the brush and
palette of Van Gogh. From 1912 to 1914 I gave a series of sensational
lectures in the capitals and many provincial towns of Russia again and
again repeating the name of Vincent van Gogh and demonstrating to the
curious audience his works by means of slides.

I am mentioning all this for the purpose of showing that the style and
story of Van Gogh are very deeply rooted in me and that during the
decades of my life the creations of this master have become a part of my
existence.

And now Marussia and I are on the threshold of an enormous en-
terprise. We are going to Arles, San Remy, and Auvers in France in or-
der to try to find some of the places where sixty years ago Van Gogh
created his now famous landscapes and subjects, and to paint them as
they exist today.

At last we are on the trail of Van Gogh. Friends will ask, why not Cé-
zanne? Why not Renoir, or Bonnard? This question is easily answered.
We must always remember the date of our birth and that of our par-
ents. Van Gogh and Gauguin were born respectively in 1853 and 1848.
My father was born in 1857; Cézanne in 1839. Cézanne was the great
olympian. He was an extremist in his attention to the mastery of the
problems of form and in his nonchalance to the "anecdotes" of life. Only
a few times did Cézanne paint people playing cards, or acrobats, or por-
traits of his wife. When he painted the portrait of Madame Cézanne, she
became as important to his brush as another piece of fruit. It was not Eve
with the apple, but the apple with Eve.

During the last ten years of his life, Cézanne was proclaimed a great
apostle of new art, an impeccable architect of new canons and a new

credo of beliefs in modern aesthetics. Tens of thousands of his followers closed the windows and doors of their studios and started furiously to attack the tables burdened with empty bottles on carefully folded table-cloths with and without designs and defenseless apples. This is not the place to criticize or take the crown away from the head of the victor. Cézanne is the indisputable giant and founder of modernism.

In October of 1888 by invitation of Vincent van Gogh, Paul Gauguin (1848–1903) joined his friend at Arles. Two years before, Gauguin visited Martinique near the American Continent which a little bit later was depicted in the American magazines by the pen of Lafcadio Hearn (1850–1904). Then, the West Indies were discovered with their beauty of the blue waters of the south and the statuesque grace of the girls of the islands. We must not forget that Cézanne was a son of a banker, and Paul Gauguin was a typical Parisian bourgeois also working in a bank.

Olympian immobility, self-assurance and superiority are the qualities of Cézanne. Gauguin, in comparison with his elder art brother, is full of aestheticism. He is a romantic imbued with the literary traditions of the time. Gauguin is a decorator, a novelist, for whom the fantasy of the central Pacific islands became an irresistible magnet. All his life the beauty of the naked south sprayed with the aromas of tropical orchids had the same fixation for Gauguin as Moby Dick for the hero of Herman Melville (1819–1891).

Of the great trio of Cézanne, Gauguin, and Van Gogh, the latter was still comparatively the hidden and unappreciated asset of the century when the charts and boundaries of the former two were already being explored and expanded by their followers. When collectors and museums were satiated by the works of the others, Van Gogh still remained among the aesthetic assets of the century. And only in the last twenty years has Van Gogh's popularity begun to grow. The cause for this can be easily detected by thumbing the reproductions of his works. There, the student finds a variety of subjects and themes, a large range of aspects of life, often augmented by the master who uses for his creations not only nature but, also, works on "ready-made" material, borrowing it from Gauguin, Daumier, Millet, and Doré (1832–1883). Art of Vincent victoriously marches under the banner with the words: truthfulness and lust for life!

When Gauguin was leaving his one-eared friend in Arles, he remarked that Vincent was still experimenting. What at that time appeared as an Achilles' heel, and from the standpoint of contemporaries a weakness, within the years that followed became an immortal strength like that of a turret for all artists who now try to flee from escapism to reality. From the trio, Van Gogh is the most realistic, the most diversified in his subjects and nearly universal in his short-time attempt to reflect the conglomerate facets of life.

These are the reasons why we selected Van Gogh and his art. We shall follow the trail blazed by him and see for ourselves the location of Arles and the other above-mentioned places which were painted and drawn by this great realist of our times. America is now deeply interested in Van Gogh, and we are certain that Burliuk's friends will attentively follow our work, our aesthetic exploration of the glorious past.

David, Marussia and Nicholas Burliuk

COLOR AND RHYME

"Our Travel to Europe, 1949–1950"

1950–1951

In the Burliuks' special Van Gogh issue, some 14 motifs by Van Gogh are rediscovered, documented, and illustrated by David Burliuk's painted versions.

We will write a book and paint an exhibition: "On the trail of Van Gogh, Courbet, and Corot."

* * *

OCTOBER 8, 1949:

At twenty after seven we arrived in the city whose name has been in our imagination so many times, which we had repeated so many times, while constructing the plan of work that we had outlined.

People disappear. Things remain. The great artist Van Gogh left for the future hundreds of wonderful paintings. . . . We had decided to come from America to Arles and try to find the "models" that inspired him to paint the canvases that made him famous and that every viewer remembers, known to every cultured person. Who, for example, does not remember "Van Gogh's Bedroom" in Arles. Who when he hears the words "Night Cafe" (now Cafe de l'Alcazar) does not see the crooked billiard table, dried blood-colored walls of the cafe and the clock glistening with its glass under four gas lamps. Or who does not remember "The Arlesienne," Mme. Ginoux, painted by Van Gogh in November of 1888. People disappear. Things remain. We this moment are already standing on the threshold of amazing experiences. We are in Arles, and with the first rays of the sun we can walk the streets, peer at the houses seeking the local outlines familiar to us through the paintings of Van Gogh, and to call forth from the distant past clear, close shadows.

COLORPLATES 73, 63

COLORPLATE 75

* * *

OCTOBER 16, 1949:

A man walks past us followed by two goats. . . .

For the time we follow him. And it is a lucky hour because the path leads along the right bank of the canal filled with muddy, greenish, soapy water. Passing the length of the wall of the deserted factory, the eyesight prompts that something is familiar in the place where we are walking for the first time, like an old dream, something seen before. We open the album of the reproductions of Van Gogh, and there is no doubt that before us is "La Roubine du Roi."

On this same spot one July evening in 1888, Vincent for the first time started to paint the sunset, gazing at the burning image of light with an unarmed eye. Later, he daily repeated this most dangerous method of an exulted astronomer watching the phenomenon. In the burning by inspiration and diseased mind of the genius, the cult of the phenomenal hurricane of light comes into existence; the turbulence of light, its explosions, the curlish twists of the brightly orange, red flame. The eye of the artist is wounded by the sun.

It is decided to paint this motif next week as it looks today. On the horizon the tower of the Carmelites monastery is distinctly visible. Sixty years have changed the subject—a canal, a fisherman, and three primitive angling rods.

At the foot hills, five kilometers away, in the blue haze is visible

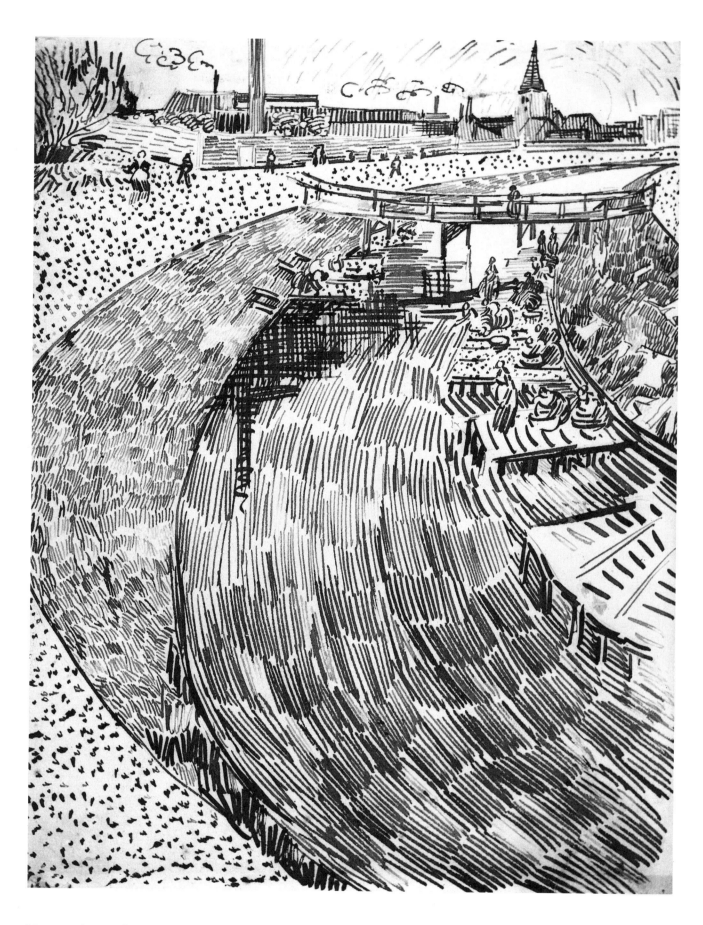

Montmajour, famous Benedictine abbey where lived from 40 to 60 monks, ruins of various buildings, giants, that were erected there on the hill from the second to the eighteenth centuries. These buildings are sharply described on the painting of Van Gogh, "Market Garden" painted in Arles in June of 1888. This canvas with a blue spot in the foreground and a bamboo fence, with a haystack on the left and a house with a red roof on the right and a happy white horse in harness running in the center of the landscape is familiar to everyone. This painting

La Roubine du Roi with Washerwomen. 1888. Reed pen and ink. 12⅜ × 9½″ (31.5 × 24 cm). Rijksmuseum Kröller-Müller, Otterlo.

COLORPLATE 45

without fail, is reproduced in color. In the history of the landscape few examples exist that so well show the distance of the plain, its surface, the design of its planes, numerous details, by means of laconic expression.

* * *

OCTOBER 20, 1949:

Even though art work is not physical, but the work with a brush out-of-doors, the sitting or standing during many hours under the rays of the sun, gusts of wind, dust, passing automobiles, often annoying throngs of viewers of all ages, the walking to the motif there and back, wasps, flies, the carrying of the easel, paint box, and canvas, can tire a person out. As a result, the work of an artist can not be compared to that of the office toiler . . . Van Gogh, what is apparent from his painting, "To Tarascon," carried with him, in addition to the enumerated, a folding chair and an umbrella that was popular in those days.

The question of nourishment for the artist, like for every worker, is tied with the character of his work. Van Gogh constantly complained that the restaurants took from him money but did not give him sufficient amount of plain food. We, having large resources compared to the object of our study, are feeling in Arles the same difficulty. Our basic foods here are bread and French fried potatoes.

Studying daily one after another the subjects that Van Gogh had painted, it became apparent that all the landscapes, scenes with houses, the so-called city views, were painted by him in the vicinity of Lamartine Square and the iron railroad bridge across the Rhone on the outskirts of Trinquetaille. Only once or twice did Van Gogh walk into the Forum Square in town where he painted "The Cafe at Night" and "Les Alis-

COLORPLATES 63, 74

The Painter on the Road to Tarascon. 1888. Canvas. 18⅞ × 17⅜″ (48 × 44 cm). Destroyed (formerly Kaiser Friedrick Museum, Magdeburg).

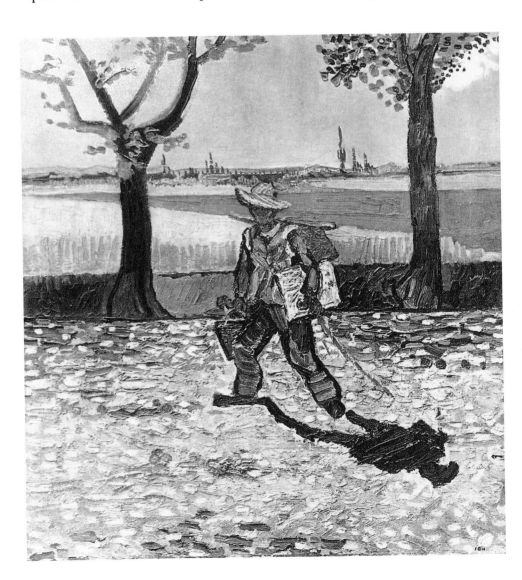

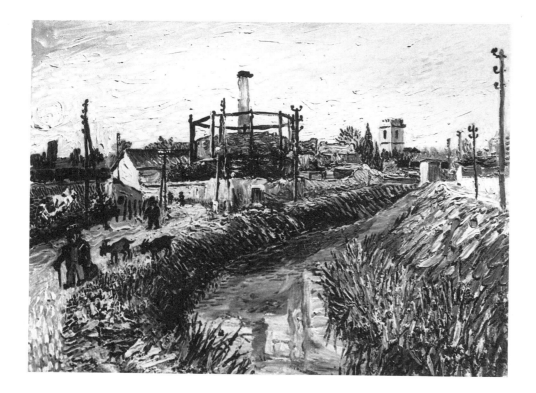

camps"—an ancient Roman cemetery on the south side. All the land-
scapes, numerous views of gardens, famous "Market Gardens," were
painted by the master at a distance not further than one mile in the con-
stant vicinity of Mireille Street. Van Gogh did not select a subject, but he
painted that which first came before his vision.

* * *

OCTOBER 22, 1949:

At two we are on the motif, "La Roubine du Roi." We came to Arles in
order to try to find the subjects that Vincent had painted 60 years ago.
A Latin proverb states about time, including us in its flight: "Time
changes and we change with it." An ancient philosopher repeats the
words, "A double change occurs."

Van Gogh was in Arles in 1888 and 1889. Now in town everywhere
are visible the changes not only brought about by three generations, but
by techniques and the improvements which were brought about by the
Twentieth Century. The canals were made wider and deeper. Highways
were built. Where once were field and gardens, now are streets. Many
southern maples were planted that in a half century reached huge di-
mensions, shielding and covering that which the artist was then able to
see, and, at times, changing the landscape that existed then.

On the paintings in the vicinity of Mireille Street, Arles, by Van Gogh
smoke stacks are visible. All this is now forgotten and in ruins. Arriving
on the motif of "La Roubine du Roi" Burliuk recognizes the outline de-
picted on the landscape of Van Gogh. On the left of the canal, the same
road is visible, that after passing along the stone wall of the factory, leads
to Mireille Street. In the center of the landscape, just like 60 years ago,
a massive, square factory smoke stack towers. But in front of it now is a
rusty structure of a gas tank that changes the entire view.

When you are looking at the place that served as a model for the
great artist, you are surprised by the accuracy of details that his eye per-
ceived, the drawing true to characteristics, and the keenness of his ob-
servation. Now near the tower of what used to be a monastery, now a
barber college, are visible two tall decorative pines. In the quickly
sketched in landscape of the sunset, Van Gogh did not forget to men-
tion the thin young pair by two strokes of his magic brush.

* * *

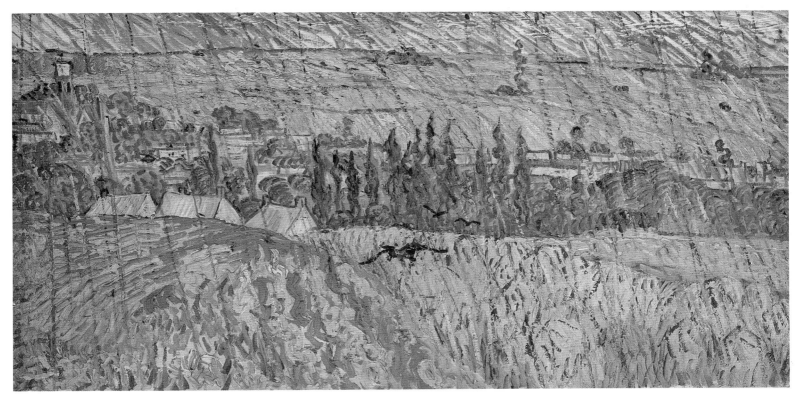

COLORPLATE 122. *Landscape in the Rain.* 1890. Canvas. 19⅝ × 39⅜″ (50 × 100 cm).
The National Museum of Wales, Cardiff.

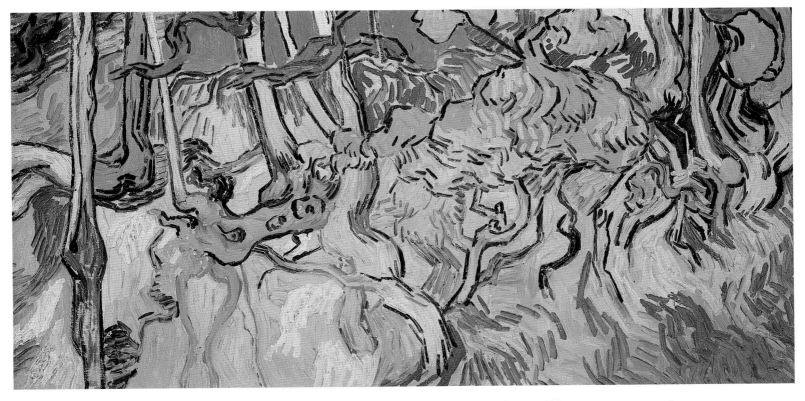

COLORPLATE 123. *Roots and Trunks of Trees.* 1890. Canvas. 20⅛ × 39¾″ (50.5 × 100.5 cm).
Rijksmuseum Vincent van Gogh, Amsterdam.

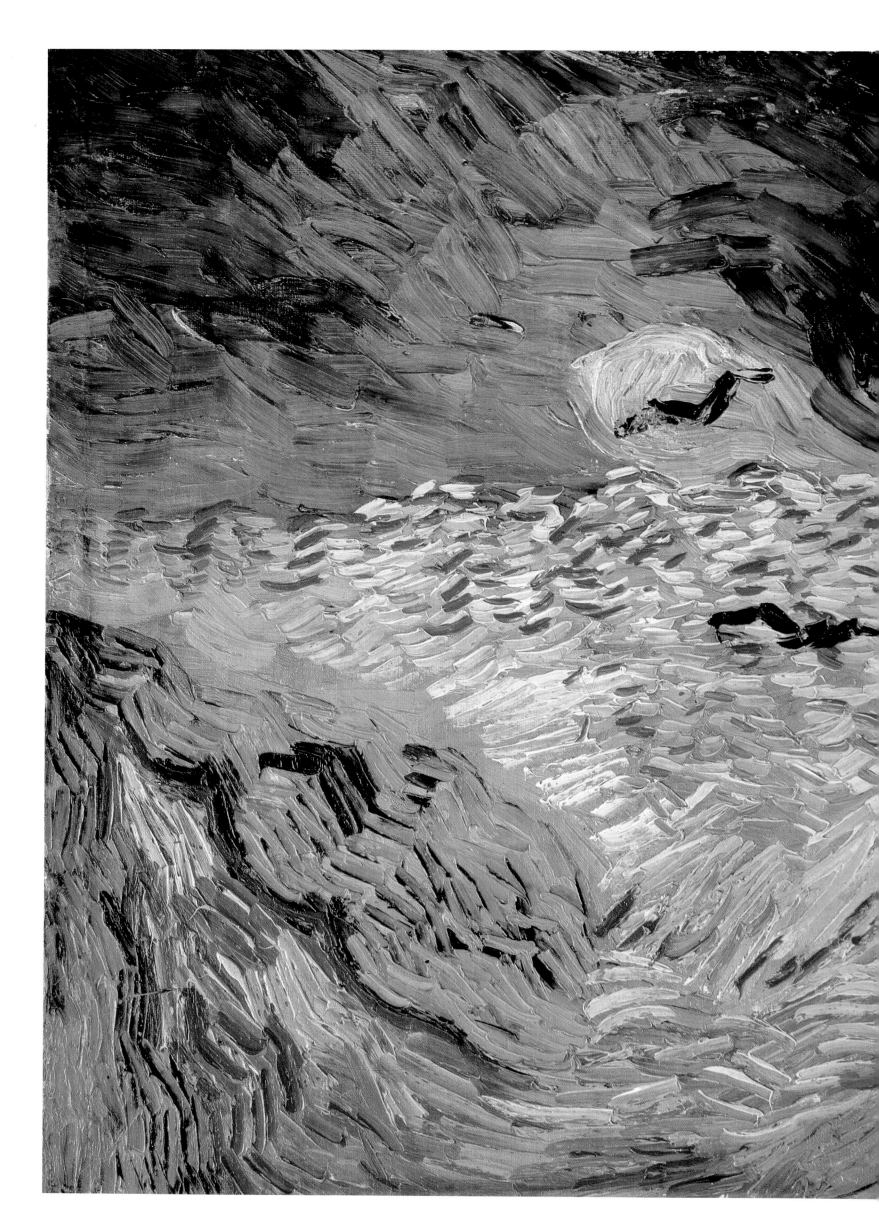

Borinage, giving of yourself without reservation, but not, even at your best, being well understood by others

Miserere

in this spiritual and Christian solitude that revives you so well. Could you not have been understood—not only by certain painters but by so many other pilgrims?

For me, child of the old suburb of Longues Peines, how can I not be touched by a distant memory that you finally found, during your too-short life, a more complete pictorial communion in my French country?

How happy and blissful we are when we see again, with an open eye, the whole of your work, see how in the more and more tactile and eloquent exaltation of color, without neglecting your Old Masters you found, so young, your moorings at last, in spite of so many setbacks and misfortunes, never having forgotten, no more than your admirable, beloved brother, the essence of this pictorial art.

Charley Toorop

"Encounters with Van Gogh"

February 1953

Charley Toorop (1891–1955), Dutch monumental figure painter and daughter of the artist, Jan Toorop.

Vincent van Gogh was already there for me before I began to paint; actually, at my artistic awakening. His art brought on the first conflict I had with my father, who saw it so differently; for me it was the break-through to a new world. It has always remained an experience to see his work.

The large exhibition of his work in Amsterdam after the Liberation was even more a personal Liberation for me than the historical one. That his work could hang so splendidly and that we could see it like that again: the masterful drawings of the French landscape, the painted landscapes, the figures, and the still lifes.

In 1951, I saw for the first time in Paris the Impressionists in the Jeu de Paume. Enjoyed it, magnificent, Renoir, Courbet, etc.—but upstairs on the first floor there, all at once, the self-portrait of Van Gogh with that pale face and those piercing eyes against that agitated green background. At home at night, and until late in the night, I saw that painting before me still. It was the most beautiful painting I had seen that day. Again, a short time ago in Rotterdam, the Boymans Museum had a show of the French art from the Petit Palais. Splendid, I enjoyed it, Courbet, Toulouse-Lautrec, etc.—but then, again, all at once, that little wall with those paintings by Vincent from the Brabant period. And then, again, a sense of being captivated gave way to an intense realization of Van Gogh's deep, uncompromising love for reality.

COLORPLATE 96

Jan Sluyters

"His Paintings Have Nothing Strange about Them"

March 1953

Jan Sluyters (1881–1957), leading Dutch figurative painter of the 1920s and '30s who evolved his own form of Expressionism called "Colorism."

The first that I heard of the painter Vincent van Gogh was about 50 years ago. I myself was twenty and a student of the Amsterdamse Academie voor Beeldende Kunsten. One of my fellow students had seen some works by Van Gogh somewhere at an art dealer's. He had amused himself exquisitely there. Such anatomical mistakes and totally unnatural colors as he had never seen; he got the impression that a joker was busy leading the general public by the nose. Just when, with violent gestures, he was displaying to us his findings, the door of our painting class opened and the Director appeared on the threshold. He asked us what important problem we were discussing, and one of us said that we were talking about the paintings of Van Gogh. The Professor's face suddenly became very serious, and with a solemn voice he spoke the prophetic words: "The name of Vincent van Gogh ought not to be pronounced in the Rijksacademie voor Beeldende Kunsten." The Professor rattled his bunch of keys, turned around on his heels, and left our class in silence. At that time Van Gogh was as good as utterly obscure to us, except for a few initiates—but after 1910 there came a resurgence of the name Vincent van Gogh. It was spoken of, discussed. Ninety percent, without reservations, found his work ugly, and they were honest in their opinion. The remaining ten percent idolized Van Gogh, but a good ninety percent of this was snobbery or affectation. Those who understood Van Gogh best did not call him Van Gogh but spoke of the Great Vincent. After that, everything evolved according to plan. The ten percent of admirers became the twenty, thirty, forty, eighty, and by this time the 100 percent mark has long since been passed. History repeats itself!—because with all artists of stature we see the same course of events. The few exceptions, such as Michelangelo, Raphael, Rubens, had the luck to have worked in a time in which people were able to see and to judge. But Van Gogh did not belong to these exceptions, no more than our great Rembrandt.

When we look at the work of Van Gogh now, we can hardly understand what was the origin of so much misunderstanding. The artist himself certainly did not make it so difficult for people: his paintings have nothing strange, mysterious, or abstract about them. They are the most natural impressions of a perfectly healthy temperament, and they are painted with the intention of being understood by all people. People—how well I know it—have often written about mental disorders, etc., etc., but of those so-called nervous disorders I have discovered no trace in his entire *oeuvre*. On the contrary, I would not be able to place any artist next to him who addressed himself more directly to his fellow human beings or in a more straightforward presentation. He shows, and explains to us, the usual things of daily life in the most uncomplicated way. Fanatically, yes!—but naturally. How could someone not entirely captivated by what he experienced convey to us his impressions so simply yet convincingly without putting the stamp of his emotions on it? His nature—orthodox and Protestant—expresses itself in the way he handles the paint—with conviction and without hesitation—and lends to his canvases, just as in his drawings, the character of inflexibility. But everything is dominated

by his intense desire to address himself through his works to all people and to be understood by all. For me, the work of Van Gogh is "folk art" in the most elevated sense of the word. I see Van Gogh (with Cézanne and Gauguin) as the continuation of French Impressionism, and as such his work forms a link in the natural evolution of pictorial art. If we stand now before the work of Van Gogh, it can only surprise us that one half-century ago those paintings had, like a red cloth on a bull a single effect on the masses. But even more astonishing to me is the phenomenon that, precisely in this time when nonrepresentational art is praised by many younger artists as the highest expression of beauty, a man like Van Gogh—their antipode—is honored by these same artists with great enthusiasm! What can the deeper meaning of this contradiction be?

Oskar Kokoschka

Oskar Kokoschka (1886–1980), Austrian Expressionist artist, writer, and teacher.

MEDEDELINGEN

"Van Gogh's Influence on Modern Painting"

1953

On the occasion of the commemoration of the centenary of Van Gogh's birthday I have been asked for a statement on his influence on modern painting. Though I am of the opinion that an art critic would answer this question better, I may, so far as the limited space allows, suggest one or two points possibly overlooked by experts who deal with artistic style and content and psychological approach to art.

It has always been the practice of artists to build their edifice with some bricks of the past. But Van Gogh's effect on contemporary art I should like to compare to that of delayed action because modern painters, under his influence, seem to feel that something is changing, something new is coming, but they do not know how and why.

No visitor could ignore the evidence of the disruption in the traditional approach to art in any exhibition of Van Gogh's painting which included work by the Fauves, Cubists, Surrealists or Non-objective artists. Society's general uneasiness on how to give a verdict on art lends a sombre significance to all art, that of the past and that which is to come.

However, as far as the objective content of Van Gogh's painting is concerned, no new elements seem to justify the revolutionary change: his subjects were not different from the flowers, still lifes, portraits and landscapes chosen by the Impressionists from whom he had taken over. The next thing the connoisseurs, picking busily around their barnyard of traditional art, were to ask was, why, for instance, the art of the Impressionist was still impressively compact, whereas Van Gogh's art did not give them this feeling of security any longer. The masterly constructed paintings of Manet, Monet, Sisley, Pissarro and Renoir could be taken to pieces, studied in detail and analysed in accordance with patched-up art theories drawn from classic art by experts of varying merit and reputation. These experts had the advantage of belonging to a world whose general structure of mind depended on the spiritual heritage of the 18th century, just like their favorite painters, whose work they classify according to their favorite method. The 18th century was neoclassicist; even Goya, it must be remembered, was the king's painter. The following

century was too sophisticated to be surprised by the social changes or even to notice them at all. The social elite could afford to watch a vision of materialistic progress but of compact superficial stability. Remember Cézanne's pyramids, cubes and cylinders.

Alas, such a world has become an alien one to us. The fact alone of two world wars, with all their tragic implications for the common man, like transfer and expropriation of whole nations, contains clear indications that no illusions are possible about the changed reality. In a world full of impropriety, human nature has substantially altered from progress to something close to regression. Millions of slave-workers still in camps!

As I said before, Van Gogh's originality must not be looked for in the objective content of his painting, but rather in his strange ability to catch the passing thoughts of *malaise de la vie* of our time. The sunflower, the basket of potatoes, the unavoidable self-portrait, undulating cypresses and distant views gained under his brush a tension and finality, as if, with the upsurge of the mechanical age, the last breath of everyday life would come to its end. The elegance and easygoing leisure of human existence in a world perceived as a still life or *nature morte* would be no more. Like the daemonic world of another Dutch painter, Hieronymus Bosch, whose work reveals the hellish estrangement of man, so Van Gogh's world is no longer lulling society into security.

The average man of today, who has risen to fear the deluge that is coming over the world, recognises this vision of Van Gogh as a reality. It must be remembered that the painter started as a missionary in one of the poorest mining districts. It is the fiery tongue of his magic which dominates the subject. Life has to be experienced and not dreamt! So long as the objective nature of reality is twisted, idealised according to a canon of unreal beauty, none can be sure that some Utopians are not dreaming of a metaphysic Arcady. Like Virgil's islands of herdsmen and shepherdesses it never can be found on a map but is preached from all the political soapboxes of today. Where the esoteric artist has nothing to give to the ordinary man and woman of his day, *malaise de la vie* becomes apparent, man finds himself estranged in his environment. When social problems were simple, artists could be pleasant and social consci-

The fifteenth-century artist, Hieronymus Bosch (active by 1480, died 1516), was actually Flemish.

Still Life with Baskets of Potatoes. 1885. Canvas. 26 × 31⅛" (66 × 79 cm). Rijksmuseum Vincent van Gogh, Amsterdam.

ence was dumb. On the other hand, Van Gogh's reaction, the days of Impressionism being over, has to be understood as a violent reaction of modern man's bad conscience, his "collective guilt" as it has been called, to his environment of extreme technical progress, where he finds himself shanghaied and pressed into service of the mechanism of ultimate self-destruction. Society is in danger of losing control of the mind, aestheticism answers human despair with a chuckle.

There is no doubt that art mirrors society's mind. Whenever social revolution occurred it resulted in the handing over of the spiritual heritage of the older culture to a younger, barbarian civilisation. Drawn from a lower strata, renaissance in art is an organic growth; where it differs from Impressionism is that it puts the stress on tension and finds expression in a new magic of the form. It is the task of the phenomenalists to explain this process. Let us understand Expressionism as the living voice of man, who is to recreate his universe.

Certainly, the hellfire of burning towns today is reality to the common man as was the bestiarium of Hieronymus Bosch's imagination engendered in plague and pestilence, foulness and devilry of the wars fought for religious ideologies during the Schism of Catholicism. Bosch's rival artists may have dreamt of the celestial beauty of metaphysical life in Heaven. Likewise our generation is wishfully thinking of the social justice on Earth to come. That trend of advanced and abstract art, at present internationally so domineering, which does away with the image of man and all man-made objects and human environment, is just in keeping with the unrealistic philosophy of our prophesied brave new world.

Now, why then do Van Gogh's critics make capital out of his mental illness in confidential asides to their public? Perhaps to obscure the crucial problem of society in modern industrial civilisation.

I agree with those who believe that the cheap publicity given to Van Gogh's illness, merely material for entertaining biographical thrillers, should give way to a new understanding of the work of this man of genius, which should be seen with new eyes on the occasion of the centenary of his birth. The artist did face the reality of existence, however disconcerting, rather than close his eyes before the tragic futility of mechanistic life!

I believe that he had no illusions about the future; nor did he intend to carve a niche for himself in the cold halls of fame, where the laurels of those rivals in fashion, skill and technique soon dry to dust. But most certainly he would have been the last to hope to leave the imprint of his mind on the abstract artists, since there seems little point in their painting and sculpturing anything.

Nobody took any notice of him when he died. But the spell of this highly disturbing ghost, like those of the painters of great eminence of the past, will always linger on in the artistic firmament.

René Magritte

CAHIER DE NEVELVLEK–
VAN GOGH

"Van Gogh and Freedom"

May–June 1955

*René Magritte (1898–1967), Belgian
Surrealist artist.*

It has often been said that the Impressionist painters discovered a new sensibility—a sort of ingenuous happiness, of light intoxication—in a nature that was no longer regimented by more or less rational conventions. This sensibility did not pose any problems in a world without interruption: the painter no longer distinguished himself by *what he saw*, his consciousness was entirely *in sympathy*. To be sure, this sensibility only achieved purity when the painters abandoned their theories or their originality, for this purity has never been the property of one particular art: Certain chords in a Debussy suite give a blue sensation, a certain nude by Renoir causes us to hear happiness. But this new sensibility, which appeared with Impressionism, is not to be confused with, for example, Jean-Jacques Rousseau's love of nature, for that love was accompanied by a concern for "seeing clearly." It should be noted that the public and most critics or art historians have not perceived the sentiment revealed by the Impressionists. The public and exegetes "explain" something that is only a question of love.

Severe illumination, which oriented Classical painting, had been put into question and absolutely abandoned by the Impressionist painters. Various techniques inaugurated by them were employed by Van Gogh. But the uncertainty, the fever, and the violence of Van Gogh's explorations have left a painful mark on them. The twisted trees, the swirling clouds, the contrasts of acid tones do not suffice to fully express Van Gogh's great anguish. He even went so far as to try to express himself with a razor—and cut off an ear. With him, we are far from the atmosphere of freshness and enchantment that bestowed a new youth to the world the Impressionists represented. Van Gogh's delirious painting and his actions "keep" to a plane alien to Impressionism.

With Van Gogh, a domain opens in which artistic expression is subject to psychological and psychiatric examination. Aesthetics quit philosophy to be treated by so-called more "exact" sciences. Thanks to the interest of such scholars in artistic expression, the "art" of the inmates of lunatic asylums or prisons is the object of doctoral studies; "Sunday" painters, such as le douanier Rousseau, are more attentively observed than Leonardo da Vinci or Courbet; finally—so that nothing mediocre may be overlooked—the drawings and writings of schoolchildren are solemnly exhibited before a respectful procession of sentimental adults. It should be noted that a Gérard de Nerval, for example, escaped to this world from which poetry flees.

The question posed by the "artistic" phenomenon under discussion and by Van Gogh, who is involuntarily responsible for it, is that of freedom. The Impressionists had bestowed on freedom a sense of truth, for they tried to achieve purity. To do this they needed a love of truth and intelligence that allowed them to free themselves from the problems to which the so-called "traditional" artists had consecrated themselves. Can one say that Van Gogh was liberated? It is scarcely possible. He subjected himself to passions that gave him a blind force in exchange for his

*Gérard de Nerval, pseudonym of Gérard
Labrunie (1808–1855), writer of poetry
and prose whose last works, as precursors
of modern hallucinatory writing, present a
remarkable record of his mental
derangement; he committed suicide
in 1855.*

378

submission. It is this blind force that Van Gogh brings to mind above all, and I cannot assign to it a value that commands admiration or love. I am of the opinion that violent sentiments reduce the world to something rather vulgar. When I look at what remains of Van Gogh's furious activity, I find in it the memory of a delirious life, a life without freedom.

Françoise Gilot and Carlton Lake

LIFE WITH PICASSO

1964

In collaboration with the American art critic Carlton Lake, Françoise Gilot recounted her relationship with Picasso; from 1943 to 1953 she lived with and modeled for the artist and gave birth to two children, Claude and Paloma.

"Beginning with Van Gogh, however great we may be, we are all, in a measure, autodidacts—you might almost say primitive painters. Painters no longer live within a tradition and so each one of us must recreate an entire language. Every painter of our times is fully authorized to recreate that language from A to Z. No criterion can be applied to him *a priori*, since we don't believe in rigid standards any longer. In a certain sense, that's a liberation but at the same time it's an enormous limitation, because when the individuality of the artist begins to express itself, what the artist gains in the way of liberty he loses in the way of order, and when you're no longer able to attach yourself to an order, basically that's very bad."

I brought up the question of Cubism. Wasn't that a kind of order, I asked him. He shrugged. "It was really the manifestation of a vague desire on the part of those of us who participated in it to get back to some kind of order, yes. We were trying to move in a direction opposite to Impressionism. That was the reason we abandoned color, emotion, sensation, and everything that had been introduced into painting by the Impressionists, to search again for an architectonic basis in the composition, trying to make an order of it. People didn't understand very well at the time why very often we didn't sign our canvases. Most of those that are signed we signed years later. It was because we felt the temptation, the hope, of an anonymous art, not in its expression but in its point of departure. We were trying to set up a new order and it had to express itself through different individuals. Nobody needed to know that it was so-and-so who had done this or that painting. But individualism was already too strong and that resulted in a failure, because after a few years all Cubists who were any good at all were no longer Cubists. Those who remained Cubists were those who weren't really true painters. Braque was saying the other day, 'Cubism is a word invented by the critics, but we were never Cubists.' That isn't exactly so. We *were*, at one time, Cubists, but as we drew away from that period we found that, more than just Cubists, we were individuals dedicated to ourselves. As soon as we saw that the collective adventure was a lost cause, each one of us had to find an individual adventure. And the individual adventure always goes back to the one which is the archetype of our times: that is, Van Gogh's—an essentially solitary and tragic adventure. That's why I said a few minutes ago that we were all autodidacts. That's literally true, I think, but I realized even when Cubism was breaking up that we were saved from complete isolation as individuals by the fact that however different we might have the appearance of being, we were all Modern-style artists.

* * *

"Painting isn't a question of sensibility; it's a matter of seizing the power, taking over from nature, not expecting her to supply you with information and good advice. . . . Van Gogh was the first one to find the key to that tension. He wrote, 'I'm building up to a yellow.' You look at a wheat field, for example; you can't say it's a real cadmium yellow. But once the painter takes it into his head to arrive at an arbitrary determination of color, and uses one color that is not within nature's range but beyond it, he will then choose, for all the rest, colors and relationships which burst out of nature's straitjacket. That's the way he asserts his freedom from nature. And that's what makes what he does interesting."

INDEX

Page numbers in italic denote illustrations. Colorplate numbers are given in parentheses.